THE HISTORY OF ASIAN ART

A GLOBAL VIEW

THE HISTORY OF ASIAN ART

A GLOBAL VIEW

PREHISTORY TO THE PRESENT

DE-NIN D. LEE • DEBORAH HUTTON

WITH 484 ILLUSTRATIONS

Half-title page: Tray with women and boys on a garden terrace, Yuan dynasty, fourteenth century. Carved red lacquer, diameter 21⅞ in. (55.6 cm). Metropolitan Museum of Art, New York.

Title page: Detail of Mir Miran, *Queen Udham Bai Entertained*, Mughal, 1742. Opaque watercolor and gold on paper, mounted on an album page, 10⅞ × 12⅞ in. (27.5 × 32.7 cm). San Diego Museum of Art, California.

First published in the United Kingdom in 2023 by
Thames & Hudson Ltd, 181A High Holborn, London WC1V 7QX

First published in the United States of America in 2023 by
Thames & Hudson Inc., 500 Fifth Avenue, New York,
New York 10110

The History of Asian Art: A Global View © 2023 Thames & Hudson Ltd,
London

Designed by Christopher Perkins

British Library Cataloguing-in-Publication Data
A catalogue record for this book is available from the
British Library

Library of Congress Control Number 2022937482

U.K. edition ISBN 978-0-500-09416-7
U.S. edition ISBN 978-0-500-84520-2
U.S. Not for Sale edition ISBN 978-0-500-84521-9

Printed and bound in Slovenia by DZS-Grafik d.o.o.

Be the first to know about our new releases,
exclusive content and author events by visiting
thamesandhudson.com
thamesandhudsonusa.com
thamesandhudson.com.au

Table of Contents

Preface

Our approach to the history of Asian art has been shaped by our students, our experiences in the classroom, and our recent work on *The History of Art: A Global View* (published by Thames & Hudson in North America in 2021 and in the U.K. in 2022). Firstly, we wanted a book that would reflect the changing student body and respond to its questions about artistic expression, cultural identities, and human histories. We knew an engaging approach would encourage students—regardless of their particular heritage and experience—to see how studying Asian art expands and deepens their sense of humanity. Additionally, we wanted a book that would focus on the art of East Asia, South Asia, and Southeast Asia without isolating the regions from each other or cutting Asia off from the rest of the world. Instead, a global and inclusive approach would show how these regions and their art were often dynamically interconnected and, in significant ways, intertwined with places beyond Asia. Finally, we wanted a book that would be timely and relevant. It would reveal how Asian art history is related to the conditions of our present lives and demonstrate how the methods of art historical inquiry equip students to understand the world around us better.

We recognize that no book is perfect, but we have paid careful attention to the content, structure, and design of this book. The **content** aims to be coherent, informative, and relevant; the **structure** undergirds the global approach and allows for flexibility in teaching; and the **design** is driven foremost by student needs. A cohesive package of **digital resources** meets the challenge of teaching the breadth of Asian art, enhancing teaching and reinforcing learning. We believe that overall, *The History of Asian Art: A Global View* offers many benefits that existing textbooks are missing.

Content

This book strives for a more inclusive attention to **geography** through expanded discussions of art from Southeast Asia (including examples from Vietnam, Cambodia, Thailand, Laos, Indonesia, Malaysia, Singapore, and the Philippines) and Korea. It also discusses artworks from the Himalayan region (Tibet and Nepal) and Mongolia (including art dating after the Mongol Empire).

We recognize the **heterogeneity** of Asian art by, for example, including Ainu art in Japan, Islamic architecture in China, Portuguese architecture in South Asia, and portraits of East African noblemen in South Asia. Artwork has also been carefully selected to emphasize the range of media: textiles, clay and jade, lacquerware, painting (murals, portable painting), architecture and gardens, calligraphy, metalwork, photography, performance, installation, video, and digital art. Discussions also recognize explicitly the heterogeneity that lay beneath terms such as "China," which suggests a homogeneous culture when historically some periods are markedly affected by the presence of different groups, including the Tabgatch, Kitan, Mongol, and Manchu.

Readers will find **timely, relevant** content, including attention to **gender and sexuality**, and the roles of women as artists and patrons. Throughout the book, discussions of these topics are not segregated, but rather knit into the body of the text. Additional attention is given also to the work of **modern and contemporary** Asian artists—Chapter 17 focuses on art from the 1980s to the present and includes work by artists of the **Asian diasporas**. Chapter 18 offers an **ecocritical perspective**, featuring contemporary Asian artists whose work makes visible the urgent, worldwide problems of the Anthropocene.

Structure

The chronological structure reflects the global approach, which draws attention to the dissemination of objects, ideas, materials, and technologies while also offering manifold opportunities for approximately contemporaneous cross-cultural comparisons of ancient, medieval, Early Modern, and modern Asian art. Some chapters are pan-Asian in scope, while others focus on East Asia (or sub-regions thereof), South Asia, and Southeast Asia. Chapters of manageable length (on average just eighteen pages each) are further divided into more specific subsections to provide optimal **flexibility** to instructors, who may teach courses focused more selectively on East Asian art or South and Southeast Asian art, while maintaining a global perspective and allowing for occasional and strategic intra-regional references.

Interspersed among the chapters of *The History of Asian Art: A Global View* are two-page **Seeing Connections** features that compare how different parts of the world approached similar problems; exchanged objects, materials, techniques, styles, and ideas; or developed and used styles and media. These interchapters choose key moments (for example, the Silk Road), materials (such as cloth), developments (such as the spread of photography), or phenomena (such as Orientalism) to demonstrate how Asian art has always been part of a larger global history of art.

Design

Several features of this textbook are designed particularly with the student experience in mind. We are sensitive to the linguistic challenges, and so the book begins with a **note on languages** and a **pronunciation guide**. Additionally, in each chapter, on-page **glossary** definitions give readers instant access to new terms, or a refresher if they do not remember an unfamiliar word. (The glossary in the back of the book combines all the terms in one place.) Plentiful **maps** assist with geographical orientation, and clear, annotated **figures and diagrams** enhance the understanding of architectural structures, sites, and processes.

Feature texts within chapters address one of the following four themes. A key goal of the book is to introduce students to **Art Historical Thinking**, especially those issues, concepts, and controversies that arise in the study of Asian art. The basis of visual analysis, **Looking More Closely** features draw attention to important details to consider when attempting to understand the meaning and significance of an artwork. To understand the materials and techniques involved, **Making It Real** features are attentive to how art was made. Detailed diagrams and illustrations enhance the explanation. Primary-source excerpts—often English translations—are featured in **Going to the Source** features. These give students a chance to consider historical perspectives, and gain familiarity with how to use primary sources.

Digital Resources

Digital resources are available to qualified adopters in North America, here: https://digital.wwnorton.com/histasianart. If you are outside North America, please contact education@thameshudson.co.uk.

INQUIZITIVE AND EBOOK The adaptive assessment tool **InQuizitive** is fully integrated with an interactive ebook, which features zoomable images, architectural panoramas, animations and videos focusing on historical eras and themes, media and processes, and practice in visual analysis. After completing their InQuizitive assignments, students come

to class prepared, leading to more engaging discussions. Efficacy studies designed by a research scientist have shown that assigning InQuizitive improves average student grades by nearly a full point, boosting a C grade to a B, and a B to an A. InQuizitive's unique confidence slider gives students extra incentive to understand and retain what they have read.

INSTRUCTOR AND STUDENT RESOURCES For instructors, media resources are available at your fingertips for easy integration with your Learning Management System (LMS), with links that can readily be incorporated into a syllabus or lecture, and resources that can be searched and browsed according to a number of criteria. Our resources were written by the authors and a team of experienced instructors, thoroughly reviewed and checked. The **Instructor's Manual** includes resources such as chapter outlines and summaries; lecture ideas and teaching tips; sample syllabi; discussion questions; recommended readings; and suggested videos and websites. A chapter-by-chapter **Test Bank** featuring more than 650 test questions is available in Norton Testmaker, where you can create assessments online, search and filter test bank questions by chapter, type, difficulty, learning objectives, and other criteria. You can also customize questions to fit your course and easily export your tests to Microsoft Word or Common Cartridge files for import into your LMS. All the **images** in the book are available as both jpgs and Power Points—or use our prepared **lecture slides** as a basis for your lecture: they are designed to be accessible for all users. Finally, the **Global View Gallery** includes hundreds of images, searchable by key word, for instructors to download to supplement your lecture slides.

With purchase of the Norton ebook or InQuizitive, students can access our student website (https://digital.wwnorton.com/histasianart), which offers materials designed to improve your understanding and your grades. The **audio glossary** aids pronunciation of non-English-language terms and artist names; **terminology and image flashcards** help you review key vocabulary and artworks. Students can also watch a series of **videos** exploring in more depth some artworks from the book and explaining key art techniques.

Acknowledgments

Thames & Hudson would like to thank the following specialists who read the book in manuscript form and provided expertise in specific areas and time periods:

Buddhist art Denise Leidy, Ruth and Bruce Dayton Curator of Asian Art, Yale University Art Gallery, and Brooke Russell Astor Curator of Chinese Art (emerita), The Metropolitan Museum of Art
Himalayan art Kerry Lucinda Brown, The Savannah College of Art and Design
Japanese art Chelsea Foxwell, The University of Chicago
Early and medieval Chinese art Kate A. Lingley, University of Hawai'i at Mānoa
Early Modern and modern Southeast Asian art Melody Rod-ari, Loyola Marymount University
Korean art Charlotte Horlyck, School of Arts, School of Oriental and African Studies (SOAS), University of London; Sooa McCormick, Curator of Korean Art, Cleveland Museum of Art; and Seojeong Shin, American University
Medieval South and Southeast Asian art Emma Natalya Stein, Assistant Curator of Southeast Asian Art at the Freer and Sackler Galleries, the Smithsonian's National Museum of Asian Art

We would also like to thank the many other reviewers who read and commented or gave assistance on the book:

Rebecca M. Brown, Johns Hopkins University; Kevin Carr, University of Michigan; Cortney E. Chaffin, University of Wisconsin-Stevens Point; Aditi Chandra, University of California, Merced; Bonnie Cheng, Oberlin College and Conservatory; Sooran Choi, The City University of New York; Madhuri Desai, The Pennsylvania State University; Christine Ho, University of Massachusetts at Amherst; Amy S. Huang, The University of Iowa; Monica Jovanovich, Golden West College; Burglind Jungmann, University of California, Los Angeles; Ikumi Kaminishi, Tufts University; Santhi Kavuri-Bauer, San Francisco State University; Elizabeth Kindall, University of St. Thomas; Paul Lavy, Universiity of Hawai'i at Mānoa; Sohl Lee, State University of New York at Stony Brook; Alexandra Lezo, Los Angeles Valley College; Amy McNair, University of Kansas; Malia Molina, Grossmont College; Meredith Morris, Grossmont College; Jeffrey Moser, Brown University; Thomas F. O'Leary, Saddleback College; Cindy Persinger, California University of Pennsylvania; Julianne Sandlin, Portland Community College; Susana Sosa, Fresno City College; Deborah Stein, San Francisco State University; Andrew Jay Svedlow, University of Northern Colorado; Chang Tan, The Pennsylvania State University; Lisa W. Tom, University of Rhode Island; Mary-Louise Totton, Frostic School of Art, Western Michigan University; Uranchimeg Tsultem, Herron School of Art + Design, IUPUI; Akiko Walley, University of Oregon; and Saleema Waraich, Skidmore College.

We would also like to thank the many people who helped us with references, images, and informal feedback. They are too numerous to mention individually here, but they include our students at Emerson College and The College of New Jersey who piloted early versions of our manuscript. A special thank you to Shelley Drake Hawks for providing crucial access to her personal library. Finally, we are grateful for support from our home institutions.

The Authors

De-nin D. Lee is Associate Professor of Art History in the department of Visual & Media Arts at Emerson College in Boston. Her research in Chinese painting has ranged from focusing on object biographies to exploring the intersection of landscape and environment. She is author of *The Night Banquet: A Chinese Scroll through Time* and editor of *Eco–Art History in East and Southeast Asia*. Her essays have been published in *The Journal of Song-Yuan Studies*, *Verge*, and *Picture Ecology: Art and Ecocriticism in Planetary Perspective*.

Deborah Hutton is Professor of Art History in the Department of Art and Art History at The College of New Jersey. Her research explores art made for the Muslim courts of South Asia between the sixteenth and early twentieth centuries. Her book *Art of the Court of Bijapur* won the American Institute of Indian Studies Edward Cameron Dimock Jr. Prize in the Indian Humanities. She co-authored (with Deepali Dewan) *Raja Deen Dayal: Artist-Photographer in 19th-century India* and co-edited (with Rebecca Brown) *Asian Art: An Anthology*; *Blackwell Companion to Asian Art*; and *Rethinking Place in South Asian and Islamic Art, 1500–Present*.

Lee and Hutton also both contributed to Thames & Hudson's *The History of Art: A Global View*.

Note on Languages and Pronunciation

The number of languages in Asia is immense. Moreover, their written forms vary widely. In studying Asian art history, readers will encounter many terms and names that have been translated, transliterated, or Romanized. An example of a translated term would be "goddess" for the Sanskrit *devi*. "*Devi*" itself has been transliterated, meaning its sounds were originally written in a different letter-based script, in this case, Devanagari in which *devi* is written देवी. A Romanized word uses the Latin alphabet to approximate the sound of a spoken word from a character-based language. For example, 風水 is Romanized as *fengshui*. *Fengshui* in translation would be geomancy, the practice of advantageously siting buildings and cities with regard to the natural environment.

Translations entail some measure of approximation. For example, the Sanskrit term *pradakshina* is commonly translated as circumambulation, but scholars debate whether a more precise meaning is "to process (walk/move) to the right" or "to process to the south." Systems of transliteration and Romanization also change from time to time. For Sanskrit terms, this book uses the International Alphabet of Sanskrit. For East Asian languages, it uses the *pinyin*, the Revised Romanization, and the Hepburn systems for Chinese, Korean, and Japanese terms, respectively. Readers may encounter other systems (for example, this book discusses Daoism, the same belief system that elsewhere is spelled Taoism).

Just as translation is approximate, so too is pronunciation. Accents and dialects mean that there is often more than one way to pronounce a word. Additionally, when studying a subject like Asian art that involves so many different languages, few people if any at all have the linguistic skill to pronounce all of the terms with ease. To help with pronunciation, we have included the following guide, which may be copied and cut to form bookmarks for easy reference. Additionally, online as part of our Instructor and Student Resources, we offer an audio recording of this guide, and recordings of important terms and artist names from this book.

Finally, naming conventions also differ from culture to culture. In East Asia, for example, surnames generally precede personal names. In this book, in the first occurrence of an East Asian name, SMALL CAPS indicate the surname, as in the case of XU Bing. Generally, we refer to individuals by surname, but occasionally, conventions dictate the use of a personal name, temple name, sobriquet, or reign name instead. Such instances will be noted parenthetically, as in the case of UTAGAWA Yoshitora (known as Yoshitora). In modern and contemporary periods, some artists and others have decided as individuals how to order and spell their names. In those instances, we honor their choices.

Sanskrit (revised International Alphabet of Sanskrit Transliteration)	Chinese (Mandarin *pinyin*)	Korean (revised Romanization)	Japanese (Hepburn)
special consonants: You will notice that sometimes consonants are followed by an "h"—this changes their pronunciation as follows: k = as in ro**ck** kh = as in ro**ck**-hard g = as in ju**g** gh = as in ju**g**-handle c = as in **j**oy ch = as in **ch**alk j = as in ju**g** jh= as in he**dge**hog t = as in **b**oat th = as in **b**oat-house d = as in **g**ood dh = as in **g**ood-house p = as in **c**up ph = as in **c**up-holder (NOT as in "f") b = as in **c**lub bh = as in **c**lub-house s = **s**ong sh = **sh**ould **vowels:** a = ah i = ih or ee u = oo as in w**oo**d or oo as in b**oo**t e = ay ai = i as in b**i**te or like o = oh au = aw as in s**aw**	**special consonants:** c = ts as in ca**ts** q = ch as in **ch**eese x = sh as in **sh**e ch = ch as in **ch**alk sh = shr as in **shr**ed zh = j as in **J**oe **vowels:** a = ah ai = eye ang = ahng ao = ow e = u as in b**u**tter ei = ay as in b**ay** i = ee except: ci = ts si = ss zi = z chi = chir as in **chir**p shi = shir as in **shir**t zhi = jur as in **jur**y ie = ee-ih iu = ee-oh iong = ee-ohng o = oo-uh ou = oh ong = ohng u = oo ue = oo-ih ui = oo-ay uo = oo-uh	**special consonants:** b = b as in **b**ed, but a bit like p as in **p**et d = d as in **d**oe, but a bit crisper like t as in **t**oe g = g as in **g**et, but a bit sharper like **k** as in **k**ite j = j as in **j**ust, but a bit crisper like **ch** l = l as in **l**ake, but a little like r as in **r**ake **vowels:** a = ah ae = a as in h**a**nd e = as in s**e**t eo = aw as in s**aw** eu = u as in p**u**t i = ee o = oh oe = we as in **we**t u = oo ui = wi as in **wi**n wa = wa as in **wa**ter wae = way we = we as in **we**t wi = wee wo = wo as in **wo**nder ya = ya as in **ya**wn yae = yay ye = ye as in **ye**t yeo = you as in **you**ng yo = as in **yo**-yo yu = as in **yu**le	**special consonants:** ts = ts as in ca**ts** **There are basically five consistent vowel sounds, as follows:** a = ah i = ee u = oo as in c**oo**l e = ay o = oh Omicrons over vowels—ā, ī, ū, ē, ō—indicate long vowels (hold these vowels longer). For example, for the Jōmon period, borrowing a musical analogy, we would give the first syllable (Jō) two beats and the second syllable (mon) one beat.

The History of Asian Art: At a Glance

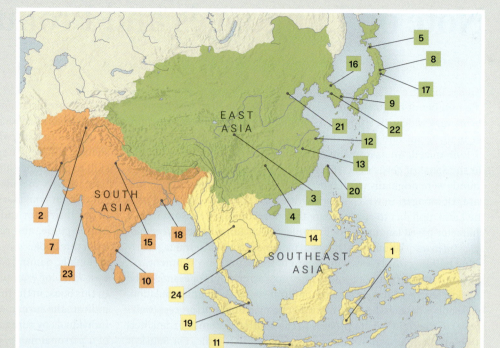

Artworks are numbered in chronological order from the earliest to the most recent.

	Prehistoric 37,000 BCE–400 BCE	Ancient 1500 BCE–500 CE	Medieval 500–1500	Early Modern 1500–1800	Modern 1800–1980	Contemporary 1980–present
South Asia	2 Group of seals, Mohenjo Daro.	7 The *bodhisattva* Maitreya, Gandhara.	10 Great Relief at Mamallapuram.	15 Bichitr, *Jahangir Preferring a Sufi Shaykh to Kings*, Delhi.	18 Abanindranath Tagore, *Bharat Mata*, Kolkata (Calcutta).	23 Tejal Shah, *Southern Siren: Maheshwari*, Mumbai.
Mainland East Asia	3 *Guan* (jar), Majiayao culture.	4 *Fang ding* with human face, Ningxiang.	12 Ma Yuan, *Apricot Blossoms*, Hangzhou.	13 Vase, Jingdezhen.	20 Chang Dai-chien, *Peach-Blossom Spring*, Taipei.	21 Xu Bing, *Book from the Sky*, Beijing.
Peninsular and Island East Asia	5 *Dogū*, Jōmon culture.	8 *Haniwa* horse, Yamato.	9 *Pensive Bodhisattva*, Three Kingdoms period.	16 Jeong Seon, *Panoramic View of the Diamond Mountains*.	17 Katsushika Ōi, *Three Women…*, Tokyo.	22 Kimsooja, still from *Cities on the Move*, Seoul.
Southeast Asia	1 Painting in the Maros-Pangkep caves, Sulawesi.	6 Clay jar, Ban Chiang.	11 Borobudur, Java.	14 Ceramics from the Hoi An hoard.	19 Lim Yew Kuan, *After the Fire (Bukit Ho Swee)*.	24 Sopheap Pich, *Morning Glory*, Phnom Penh.

Introduction

0.0 Detail of The Singh Twins,
The Last Supper.

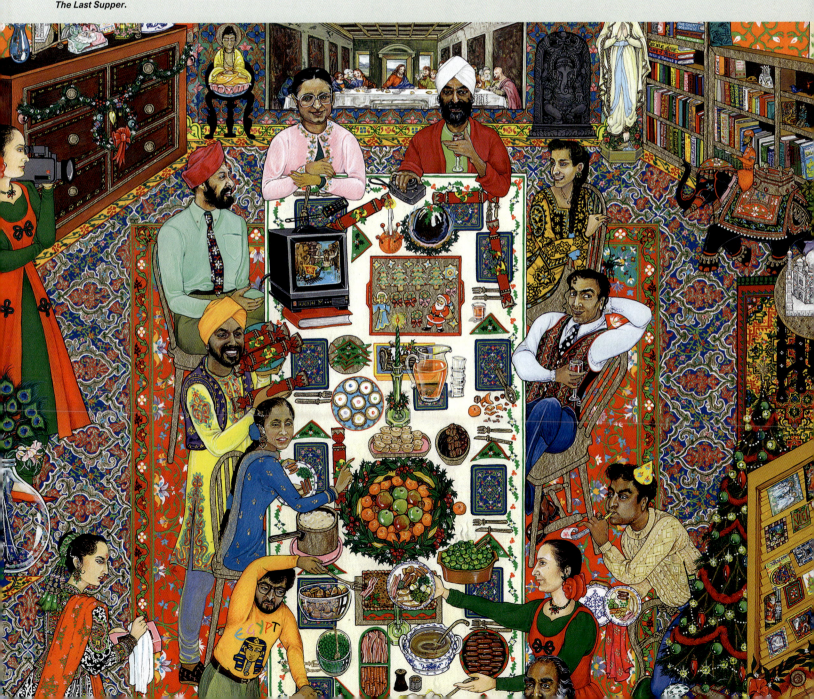

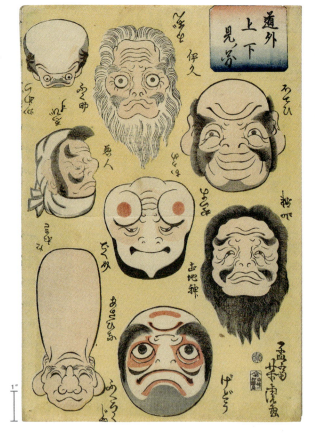

0.1 Utagawa Yoshitora, *Comical Upside-down Pictures,* 1861. Polychrome woodblock print: ink and colors on paper, 13⅞ × 9⅝ in. (35.2 × 24.4 cm). Museum of Fine Arts, Boston, Massachusetts. **EAST ASIA**

You Are Invited

Imagine that you are living not here—wherever that may be—and now, but that you have been transported across space and time. You find yourself walking in a bustling, mid-nineteenth-century city on an island in the Pacific Ocean. A vendor catches your eye and gestures toward a colorful display chock-a-block with images of charismatic actors and beautiful courtesans, eerie ghosts and valiant heroes, bright flowers and quick birds. Looking past a picture of a giant wave, you spot a curious composition of disembodied faces (**Fig. 0.1**). Do the faces look somewhat odd or contorted? To make sense of them, the image must be turned upside down and back again. Try it.

By looking carefully and repeatedly at *Comical Upside-down Pictures* by the Japanese printmaker UTAGAWA Yoshitora (known as Yoshitora, fl. *c.* 1836–87), we perform essential art historical work. Putting eyes, hands, and mind to work, we develop our capacities to see from different points of view and to understand what at first appeared incomprehensible. Moreover, we come to realize and appreciate (in the fullest sense of this word) in the unfamiliar the presence of something familiar, some expression of human excellence or experience. In this case, Yoshitora's visual wit can reach across cultures to tickle everyone's funny bone.

Finding common ground and recognizing human excellence are but two themes captured in a painting by contemporary artists and sisters known as the Singh Twins (b. 1966) (**Figs. 0.0** and **0.2**). The painting's subject is the ritual of the family dinner. And, to emphasize the idea of the meal as ritual, the artists invoked Leonardo da Vinci's *The Last Supper* (1495–98), which they cleverly

0.2 FAR RIGHT **The Singh Twins,** *The Last Supper,* 1994–95. Poster color, gouache, and gold dust on mountboard, 24½ × 17⅝ in. (62.2 × 44.8 cm). **SOUTH ASIAN DIASPORA/U.K.**

integrated into their composition, in the background, below the picture window. What other familiar icons of religion, art, and popular culture can you spot in this densely worked picture (see **Fig. 0.0**)?

Flanking the famous image of Jesus and his twelve disciples in the background, a diverse assemblage of sacred figures, including the Buddha, elephant-headed Ganesh, and the Virgin Mary, observe the holiday meal. The table is laden with roast turkey, Christmas cookies, a festive fruit display, and a color TV. Should this hand-painted record be lost, not to worry—the filmmaker in the family is capturing this event, too.

The Singh Twins portrayed this supper enjoyed by a family of Sikh-British immigrants with affection, but not sentimentality. As self-conscious and critical painters, they brought considerable knowledge of artistic traditions around the world to bear on their painting, *The Last Supper*, and they did so in ways that defy conventional categories and expectations. At this stage in your study of art history, you may or may not be able to identify the diversity of religious icons, household furnishings, and other items depicted in *The Last Supper*. Likewise, you may or may not be able to explain the stylistic strategies the Singhs used to reinforce their cross-cultural vision. (For more about this artwork, see p. 342). The purpose of this book is to expand your knowledge and strengthen your skills for understanding Asian art, including art of Asian diasporas, such as the example just discussed. This expansive geographical approach is in keeping with this book's title, *The History of Asian Art: A Global View. The Last Supper*—and much more art—reaches out to all viewers, including you. You are invited to join the feast.

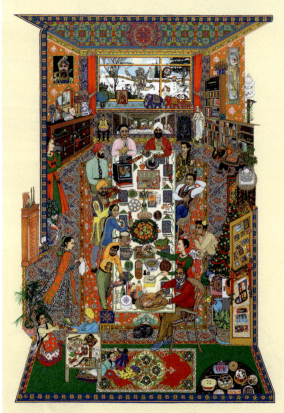

Seeing Reason, Reasons to See

We live in a world increasingly dominated by visual information. On any given day, images appear all around us, shaping how we understand our environment and ourselves. Often this influence goes undetected. Unconsciously we embrace this or that idea; unthinkingly we pursue one or another action. Art history uncovers the causal relationships between what we see, on the one hand, and what we think and do, on the other hand. By exercising the fundamental skills of art history—careful observation, critical analysis, contextualized explanation of visual forms and their meanings—we are better equipped to navigate this image-centric world.

In this endeavor, studying Asian art history adds further value by revealing the preconceived ways of viewing the world that each of us has—views that can lead to misconceptions and blind spots. For example, consider what you see in **Fig. 0.3**. Do you find the artwork magnificent, or monstrous? Does it represent friend, or foe? Do you imagine it is the product of sophisticated technology, savvy politics, or something else? What do you think was its purpose—that is, how do you think it was used when it was made five hundred years ago? In assigning words, phrases, and ideas to images and objects, we connect what we see with our eyes to what we already know in our minds. Our brains summon what our cultures and societies have taught us in order to help us make sense of all that is set before our eyes. Thus, our initial perceptions—magnificent, monstrous, or what have you—may say more about us and our culturally constructed ways of seeing than about the artwork itself.

In truth, this over-life-sized, ornate, gilt-copper head represents Bhairava, the wrathful—but not malevolent (he is believed to protect his devotees)—form of the Hindu god Shiva. Its mask-like appearance and our culturally constructed ways of seeing might have led us to imagine a devotee wearing the head in some animated ritual, but

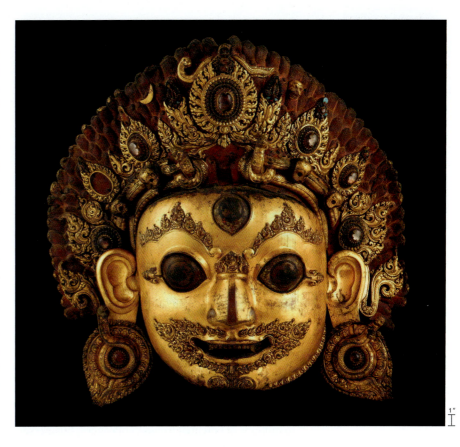

actually it was designed as a beer dispenser. During the annual Indra Jatra festival, marked by both Buddhists and Hindus in Nepal's Kathmandu Valley, the kings of the Malla dynasty (c. 1201–1779) sponsored lavish public celebrations. At one such festivity, this head dispensed sanctified beer from a small hole in its mouth. While imbibing a blessing from the deity, drinking revelers might also note the king's largesse and think better of him. When we study art from other times and places (as we did with the mask-like head of Bhairava), we encounter

0.3 Mask-like head of Bhairava, Malla period, sixteenth century. Gilt copper with rock crystal and paint, 32 × 36 in. (81.3 × 91.4 cm). Metropolitan Museum of Art, New York. **SOUTH ASIA**

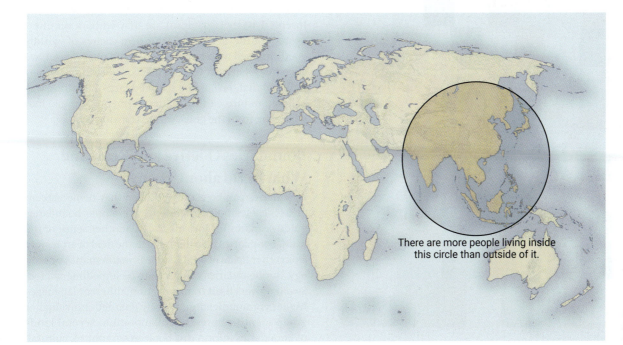

There are more people living inside this circle than outside of it.

Map 0.1 The population of Asia makes up almost 60 percent of the world population.

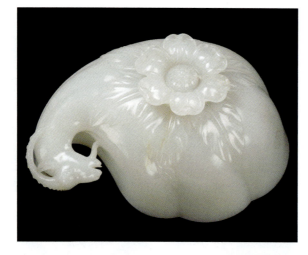

0.4 **Wine cup of Shah Jahan,** probably made in Shahjahanabad, India, Mughal Empire, 1657. White nephrite jade, length 7⅜ in. (18.7 cm), width 5½ in. (14 cm). Victoria and Albert Museum, London. **SOUTH ASIA**

0.5 *Bojagi* **(wrapping cloth),** late nineteenth–early twentieth century, Joseon dynasty, Korea. Patchwork of silk gauze with plain-weave and weft-float patterning, 28¾ × 35 in. (73 × 88.9 cm). Los Angeles County Museum of Art, California. **EAST ASIA**

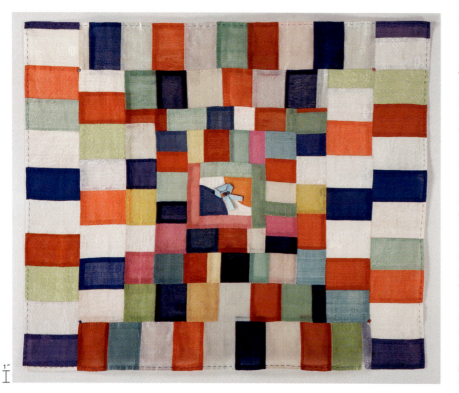

not merely the art, but also the particular ways of seeing and structuring the world associated with it. Such encounters enable us to recognize our assumptions and, if we are receptive, to expand our vision.

If our world is increasingly image-centric, so, too, is it increasingly globalized. Consider the point made in **Map 0.1.** If Asia is home to more than half of the world population (actually, close to 60 percent), then studying Asian art offers something meaningful to connect you to millions of potential friends, colleagues, businesses, and communities.

In addition to encouraging international connections, studying Asian art history offers you a deeper understanding of human experience, and the chance to develop greater self-knowledge. Why? Not only is Asia home to a number of the world's major religions and philosophies, but also its diverse art captures and makes visible a vast assortment of the most profound expressions of what it

means to be human. Ponder, for example, the contradictory significance of this exquisite wine cup sized to fit in the palm of the drinker's hand (**Fig. 0.4**). It was engraved with one of the titles of its owner, the Mughal emperor Shah Jahan (ruled 1628–58). Each time the emperor lifted it to drink, he touched the work of exceptional artisans, but he also put to his lips a reminder of his vulnerability and mortality, for the cup's material—jade—was thought to counteract poison. If art can deliver a more intimate, human side to famous individuals, it can also preserve material traces of myriad unrecorded lives. This wrapping cloth, or in Korean, *bojagi*, bears witness to the needlework of one or more women whose names are not recorded (**Fig. 0.5**). It also suggests the experiences of the many women and men who used *bojagi* for wrapping objects for Buddhist rituals and for gift-giving. Personal belongings, too, were wrapped in *bojagi* as people moved from place to place.

Throughout our lives, we too face the contradictions of what it means to be human. Like Shah Jahan, we may accrue a measure of knowledge and power, yet inevitably remain vulnerable and beholden to circumstances beyond our control. Like the women and men of the Joseon dynasty (1392–1910), we may embark on unexpected journeys, bringing our own caches of worldly goods imbued with our memories and our hopes. If we encounter Asian art with all due consideration, we may well find that, just as the sculpted face of Bhairava was believed to turn earthly matter (fermented grains) into a blessing from the gods, we are transformed.

Boundaries (Fictive and Real) and What to Do about Them

Boundaries can be useful, as when they demarcate an area for concentrated attention. For example, boundaries guide searches for lost hikers. In another sense of the word, boundaries help distinguish the field of art history from other fields of study, such as mathematics or ecology. But boundaries can prove to be impediments, too. Swollen rivers limit transportation; different languages hinder communication; fiercely guarded individual or group identities prevent collaboration. Several kinds of boundaries inform this book: geographical, cultural,

linguistic, chronological, and conceptual. Each affects the study of Asian art history in significant ways, and needs careful consideration.

Where is the geographical boundary that divides Asian art from other art? Asia, as one of the seven continents, may seem to be a straightforward, measurable unit (Map 0.2). But a closer look reveals the complicated reality hidden by the category "Asia," a geographic term invented by the ancient Greeks. Whereas the Greeks used "Asia" to refer to the regions of their eastern colonies, presently the term has a much wider scope. Yet, even now, Asia's scope is imprecise and debatable: does it end at Pakistan and Afghanistan? Does it encompass areas of eastern Russia or the Arabian Peninsula? Does it include New Zealand and other islands in the Pacific? The boundaries of "Asia" are not altogether clear. Additionally, the continental division implies a rough equivalency between Asia and, say, the continent of Europe. But is that true? Indonesia, for example, just one country in Asia—and not even the largest one—is comprised of more than 13,000 islands with over 200 ethnic groups. Indonesia is so varied that its national motto is "Unity in Diversity."

Recently, recognizing factors such as biodiversity, language, and culture, some contemporary geographers argue that *each* of Asia's regions—West Asia, Central Asia, East Asia, South Asia, Southeast Asia—is equivalent to Europe in terms of size and diversity. This book primarily discusses art related to three of those regions: East Asia, South Asia, and Southeast Asia—the areas typically included under the umbrella of "Asian art."

What exactly is meant by East Asia, South Asia, and Southeast Asia? East Asia commonly refers to areas of present-day China and Taiwan, Korea, and Japan. Currently, China occupies the greatest landmass in East Asia. To the northeast, the Korean peninsula is divided into the independent nations of North Korea and South Korea. Across the sea, four islands of a more extensive archipelago account for most of Japan's territory. At times Mongolia is also considered as part of East Asia. South Asia consists of the modern-day countries of India, Pakistan, Bangladesh, Nepal, Bhutan, and Sri Lanka. At times Afghanistan or certain portions of it are also considered part of South Asia. Southeast Asia can be subdivided into two general regions. Mainland Southeast Asia includes the present-day countries of Myanmar (Burma), Thailand, Laos, Vietnam, and Cambodia. Island Southeast Asia includes the Philippines, East Timor, Brunei, Indonesia, Malaysia, and Singapore.

These three regions of Asia encompass a vast geographical diversity, which impacts visual culture. Appreciation for that heterogeneity might begin with a somewhat peripheral view. In *Assembly of Clouds*, the painter Nyam-Osoryn Tsultem (1923–2001) presented a dramatic view of the Mongolian steppe with its treeless grasslands, distant mountains, and boundless sky (Fig. 0.6). The severe climate supports a shortened growing season, and thus Mongolian nomads must move with their animals, which relates to aspects of material culture, for example the Mongol esteem for textiles (useful and portable), and to historical events, such as the Mongol conquests in

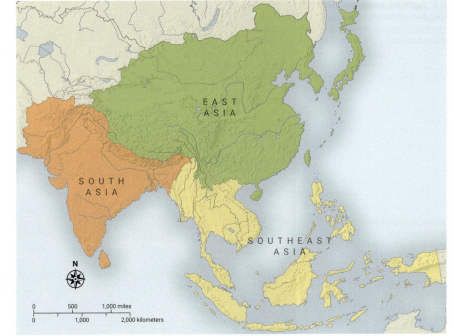

the thirteenth to fifteenth centuries. In contrast to the Mongolian steppe, north India's fertile plains encouraged settled societies and city-building. Its abundance of sandstone and limestone allowed those cities to boast grand, masonry monuments. Geographic conditions affect not only the art that is made, but also what survives. The arid climate and remote location of the Buddhist caves of Dunhuang, in what is today the north-central part of China, have helped to preserve thousands of mural paintings (see Fig. 6.9). In contrast, the tropical environment of some Southeast Asian islands means that only the

Map 0.2 Areas of East Asia, South Asia, and Southeast Asia.

0.6 Nyam-Osoryn Tsultem, *Assembly of Clouds*, 1977. Oil on canvas, 5 ft. ¾ in. × 5 ft. 10⅛ in. (1.54 × 1.78 m). Mongolian National Modern Art Gallery, Ulaanbaatar. **EAST ASIA**

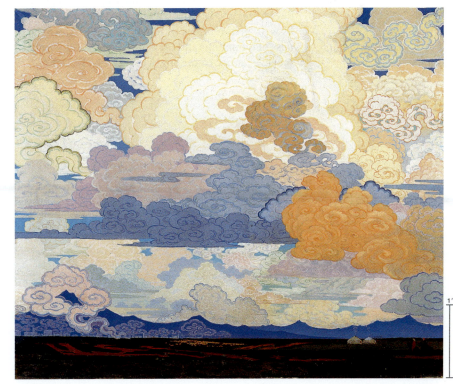

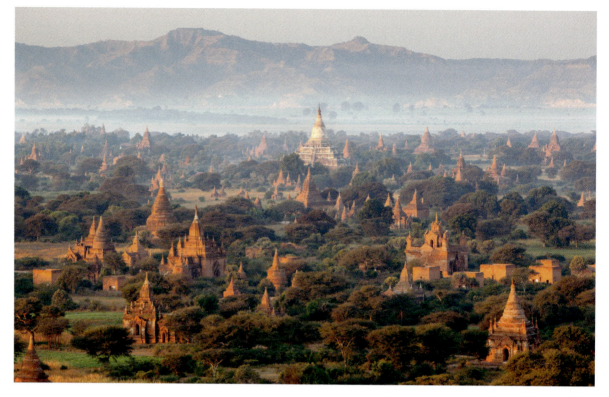

0.7 Buddhist temples of the kingdom of Pagan, Myanmar, eleventh–thirteenth centuries.
SOUTHEAST ASIA

stupa a mound-like or hemispherical structure containing Buddhist relics.

International Style a modern form of architecture that emerged in the 1920s and 1930s, characterized by the use of simple cubic forms, absence of applied ornamentation, open interior spaces, and the use of industrial steel, glass, and reinforced concrete.

0.8 Le Corbusier, Assembly Building, Chandigarh, India, 1950s.
SOUTH ASIA

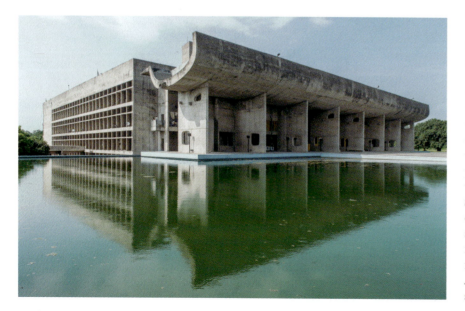

most carefully preserved items endure. Asia's diversity extends beyond geography and climate to its languages, religions, cultural practices, and ethnic groups as well, all of which add to the variety of its art. Indeed, the diversity of Asian art is probably its most salient but often under-appreciated characteristic.

However vast and heterogeneous, the regions of East Asia, South Asia and Southeast Asia possess some internal coherence, perhaps most apparent in the spread of Buddhism and Buddhist art. In this regard, the Buddhist temples of the kingdom of Pagan (849–1297) in present-day Myanmar (**Fig. 0.7**), may be related to *stupas* in India as well as to temples in Japan. Likewise, the sacredness of mountains and the centrality of water permeate much Asian art, from Song dynasty (960–1279) landscape

paintings (see Figs. 8.2, 8.3, and 8.4) to the twelfth-century Hindu temple of Angkor Wat in Cambodia (see Fig. 7.18), to the *Volcanic Ash Series* by transnational contemporary artist Arin Dwihartanto Sunaryo (see Fig. 18.1). Trade connects the regions as well, with ceramics, textiles, spices, and semi-precious minerals traveling, throughout history, both overland and by sea. Languages and writing systems can connect cultures, too, such as the adaptation of written Chinese by neighboring groups. Larger historical trends, such as European colonization and globalization, also left their mark. A few chapters in this book treat art across all three regions of Asia. Most chapters, however, in recognition of Asia's rich diversity and historical complexity, focus on one of these regions, or a part of a region, such as China.

Using geography as a determinant casts a wide net on what Asian art is, and includes examples that may surprise, such as the Assembly Building in Chandigarh (**Fig. 0.8**). After achieving independence from the British Empire in 1947, India needed a new capital for the state of Punjab. The country's first prime minister, Jawaharlal Nehru (1889–1964), hired the Swiss-French architect Le Corbusier (1887–1965), considered one of the pioneers of European Modernism, to design this new capital city. Le Corbusier worked with a team of Indian architects to conceive the city's plan and key buildings. The project—the most ambitious of the architect's career—used the ostensibly universal vocabulary of **International Style** Modernism: bare concrete stripped of nearly all ornamentation, and gridded layouts juxtaposed with sweeping freeform shapes. This stylistic approach was intended to embody the new nation's aspirations and make real its vision for its future. In the case of the Assembly Building, geographic boundaries work inclusively, admitting artworks that originate or are located

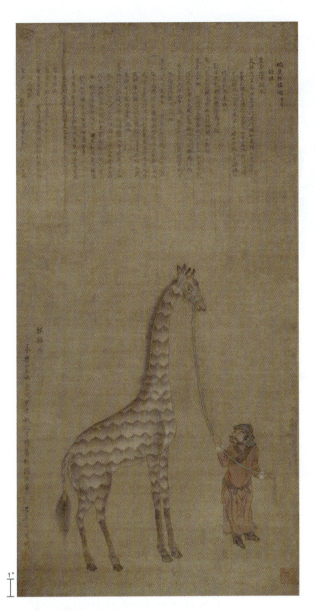

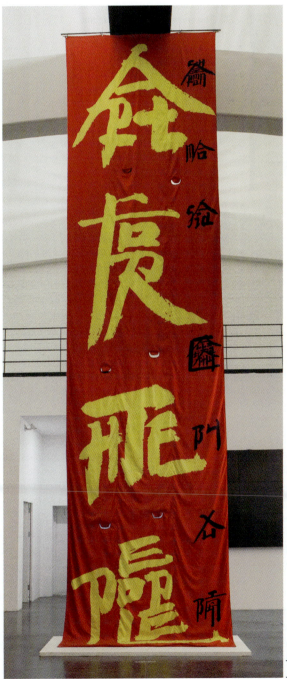

also raises the challenge of linguistic boundaries. When Xu first came to the United States for a brief stay, he spoke limited English. More intrigued than frustrated, he turned his experience into art, creating an intercultural form of writing called Square Word Calligraphy. If you can read this sentence, then you can read the message in **Fig. 0.10**. Take a moment to puzzle it out (and look at the caption if you need a hint.) In effect, Xu used Square Word Calligraphy to transform a linguistic barrier into a bridge. The study of Asian art—no matter what your first or second languages—involves unfamiliar names and foreign terms, as well as reading in translation. Throughout, this book sees the diversity of Asian languages as a source of cultural wealth, and it strives to build linguistic bridges (for more, see "Note on Languages and Pronunciation," p. 9).

0.9 FAR LEFT **Formerly attributed to Shen Du, *Tribute Giraffe with Attendant,*** Ming dynasty, sixteenth century. Hanging scroll: ink and color on silk, 31½ × 16 in. (80 × 40.6 cm). Philadelphia Museum of Art, Pennsylvania. **EAST ASIA**

in Asia, regardless of who made them or what they look like. But the same geographic boundaries, if applied too rigidly, would exclude artworks like the Singh Twins' *The Last Supper* (see **Fig. 0.2**).

Today, more than ever, artists with Asian ancestry are traveling long distances and bringing their cultures with them. They may undertake short-term artist residencies in foreign cities or keep studios in two different countries. They may have immigrant parents, live in exile, or enjoy dual citizenship. Yet, in centuries past, artists were not limited to one location either. They went on pilgrimages, sought patronage at far-away courts, and even suffered banishment to remote regions. This book replaces a static, insular view of Asia and Asian art history with a dynamic, global one, recognizing the movement of artists as well as objects. Like the astonishingly long-necked African mammal that arrived at the Ming dynasty court in China in the early fifteenth century (**Fig. 0.9**), neither people nor things adhere strictly to national borders and geographical boundaries.

The example of contemporary artist XU Bing (b. 1955) not only relates to the issue of physical movement, but

0.10 Xu Bing, *Art for the People,* 1999. Mixed-media installation, 36 × 9 ft. (10.97 × 2.74 m). Ullens Center for Contemporary Art, Beijing. **EAST ASIA**

A Maya's dream.

B Queen Maya grasps a tree while giving birth.

C The presentation of the Buddha.

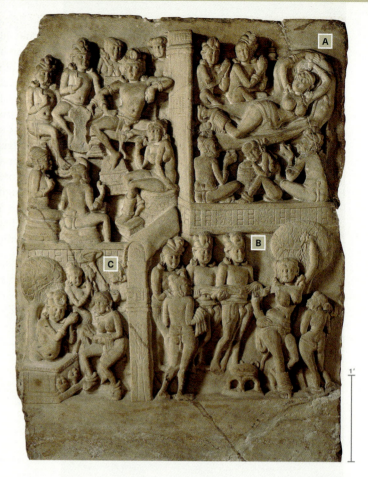

0.11 RIGHT **Four scenes from the birth of the Buddha**, drum slab from a *stupa*, Amaravati, India, first century. Limestone, 5 ft. 2⅛ in. × 38 × 5⅝ in. (1.56 m × 96.3 cm × 14 cm). British Museum, London. **SOUTH ASIA**

"If you want to see something," the poet Howard Nemerov advised, "look at something else." In art history, comparing one artwork to another often leads to insights that could not be generated by looking at one artwork alone. As an example, here are notes from a student who was asked to compare a first-century stone sculpture of the story of the Buddha's birth (hereafter "Birth") to an eleventh-century painting of the *Parinirvana of the Buddha* (hereafter *Parinirvana*) (**Figs. 0.11** and **0.12**). The sculpture is a relief, meaning that the sculpted elements are still attached to a background of the same material. Currently in the collection of the British Museum, London, the relief sculpture is a fragment from a *stupa* at Amaravati in present-day India. The painting was made in Japan and belongs to a Buddhist temple there.

A meaningful comparison requires a common basis, such as the same subject matter. When asked to consider potential similarities, the student used iconography to determine the subject matter:

Iconography and subject matter: *The relief sculpture is divided into four scenes. The repetition of the female figure on the right side—reclining above (**Fig. 0.11 A**) and grasping a tree below (**Fig. 0.11 B**)—tell*

us that she is Queen Maya. And, we can confirm that the subject is the birth of the Buddha by noticing the tiny footprints on the receiving cloths depicted in **Fig. 0.11 B** *and* **Fig. 0.11 C**. *In this early period, the Buddha was commonly represented aniconically—that is, without human form. So, here the footprints represent him. Together, the four scenes—Maya's dream (top right in* **Fig. 0.11**), *the interpretation of that dream (top left), the birth of the Buddha (lower right), and the presentation of the Buddha (lower left)—create a sequence of actions.*

In Parinirvana, *the large reclining figure at center has markings such as the* urna, *a dot between the eyes, which identify the Buddha (***Fig. 0.12 A***). Bodhisattvas are identifiable by their halos and crowns, while monks have shaved heads and wear robes. The Buddha's mother, Queen Maya, watches from the heavenly realm at upper right (***Fig. 0.12 B***).* Parinirvana *shows a single event: the end of the Buddha's life when he experiences a complete liberation from embodied being, or transformation into nothingness. Both artworks portray narrative subject matter, specifically important stories from the Buddha's biography.*

Having determined a common basis for comparison, this student made notes on particular aspects of form.

Medium and Color*: Parinirvana is a painting of ink and colors on silk, and the palette of colors is modulated [its colors are created by mixing more than one hue]. The many colors are distributed all throughout the scene, generating visual excitement, or splendor. "Birth" is carved into a yellowish limestone, and the natural color of the limestone is the sole source of color. But, when light strikes the sculpture, viewers see a range of tones. For example, the negative space between Queen Maya's right arm and her torso is quite dark (***Fig. 0.11 B***).*

Line and Shape: *In* Parinirvana, *lines represent the rough contours of the trees, and an important implied line [not actually drawn, but suggested] is the sightline of Queen Maya, who gazes at the Buddha (***Fig. 0.12 B***). The gently leaning tree and Queen Maya's gaze alleviate the static quality of the Buddha's horizontal body. In "Birth," the railings and walls form dominant lines dividing the scenes (***Fig. 0.11***). Within the scenes,*

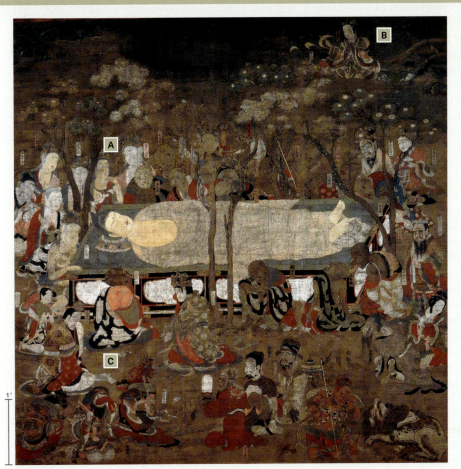

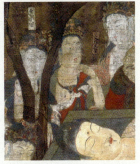

A *Bodhisattvas* gather near the Buddha's head. **B** Queen Maya descending from the heavenly realm.

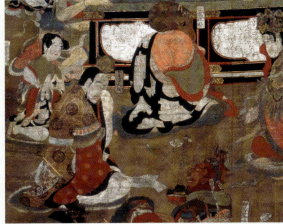

0.12 *Parinirvana of the Buddha*, Kongōbuji, Kōyasan, Wakayama prefecture, Japan, *c.* 1086. Ink and colors on silk, 8 ft. 9 in. × 8 ft. 10 in. (2.67 × 2.69 m). Kōyasan Reihōkan Museum, Kōya, Japan. **EAST ASIA**

C The monks' patterned robes.

curved bodies and bent limbs form a rich variety of shapes, which create the illusion of lively movement throughout the artwork.

Pattern: *In Parinirvana, the flowering trees are made to form attractive patterns. Queen Maya and the bodhisattvas wear elaborately patterned textiles and delicate gold crowns. The monks' robes are patterned like pieced quilts* (**Fig. 0.12 C**). *In "Birth"* (**Fig. 0.11**), *two low-relief patterns are: (1) the railing pattern that alternates between stylized flowers and simplified patchwork of beams and cross-beams and (2) the almond-shaped leaves in the trees.*

Space and Perspective: *Both artworks depict figures in three-quarter view [halfway between frontal and profile], and both use isometric perspective [in which the lines have no vanishing points] to represent objects in space. Additionally, overlapping figures suggest that some are behind and others in front. In "Birth," several scenes feature in the foreground figures whose backs are completely turned to the viewer.*

If the goal was to develop a thesis exploring how the artists strove to give immediacy to biographical events, the student might have also considered visual elements such as the figures' postures, gestures, and facial expressions, or the overall style of the artworks. However, this student was interested in understanding the artworks' contexts. Toward that end, the student made the following preliminary notes:

Ritual context: *How and where were these artworks originally seen and used by religious practitioners? "Birth" formed part of the exterior ornament of a stupa, and Buddhists would have viewed it while circumambulating, a ritual of walking around a sacred object. It would have been located among many sculpted scenes of the Buddha's life and past lives. What were the other scenes? Parinirvana would have been hung inside a Buddhist temple, which would have held a variety of icons and sacred objects. As a fairly portable painting, would it have been displayed only occasionally and, if so, when?*

Patronage: *Who commissioned the sculptures at the Amaravati stupa? Was it a single*

royal patron or groups of laypeople, as in the case of the Great Stupa at Sanchi (see Fig. 3.3)? Who commissioned the Parinirvana? Was it one or more members of the imperial court, the aristocracy, or someone else?

Provenance: *Parinirvana is in the collection of Kongōbuji, a Japanese temple. Did it originate there? "Birth" is one of many Amaravati sculpted slabs that were taken out of India during the period of British colonial rule. What were the precise circumstances of the stupa's dismantling? Do any fragments still remain in India?*

When asked to write a comparison essay, the student referred to these notes to guide additional research. For example, the preferences and needs of patrons often determine the subject matter and style of artwork. As research proceeded, the student developed a thesis and outline. Some notes proved irrelevant while others were expanded upon in the final essay. For assistance writing art history essays, see Further Reading (p. 21).

The geographical scope of this book is exceeded only by its chronological ambition. The earliest ceramic potsherds in Asia (and indeed in the world) are dated to 23,000 BCE, and new art is being made every day. Such a vast inventory cannot possibly be examined in a lifetime, let alone a single book. For the sake of coherence and accessibility, this book tries to strike a balance between breadth and depth. The primary goal is not to introduce every important work of Asian art, but rather to spark curiosity and provide a solid foundation for further study. A careful selection of artworks guides a narrative that unfolds chronologically, beginning in Chapter 1 with prehistoric times. Each region has its own chronological development, which guides individual chapters. At the same time, to allow for a global perspective, this book makes use of several overarching historical periods: ancient (Chapters 2–4), medieval (Chapters 5–10), Early Modern (Chapters 10–14), modern (Chapters 14–16), and contemporary (Chapter 17 and Epilogue). Every chapter ends with a chronological overview of periods and events. Throughout, coeval terms for governments and periods such as the Mughal Empire and the Heian period are preferred to anachronistic usage of modern nation-states such as India or Japan, respectively. The purpose here is to restore to historical circumstances a sense of dynamic possibility. When a national name is used, it is for convenience or lack of a better alternative; it is not intended to carry with it the weight of the modern nation-state.

The boundaries just discussed—geographical, cultural, linguistic, and chronological—are at once fictive and real. Landmasses do stretch across the earth, but where, really, is the boundary between "Europe" and "Asia"? Such boundaries disappear in the work of the contemporary Chinese artist HUANG Yong Ping (1954–2019). Inspired by the Modernist art movement **Dada** as well as the Chinese **Daoist** philosophical ideas, Huang placed two famous textbooks, *History of Chinese Painting* by Wang Bomin and *A Concise History of Modern Painting* by Herbert Read, in a washing machine and ran the machine for two minutes. He then put the resulting pulp on display (**Fig. 0.13**), inviting viewers to reconsider conventional art historical divisions. Likewise, the presence of such words as "karma" in our everyday conversation suggests that the divisions between cultures and languages, between past and present, may be in our heads. When it comes to boundaries, perhaps the most pervasive and too often pernicious one is the boundary that separates self from other. While recognizing the distinctions among various cultures, can we nevertheless pursue the study of Asian art as part of our shared human inheritance?

Asian Art as Global Art

This book takes the view that Asian art is global art, and thus a part of our common human inheritance. Seeing Asian art in this way is not intended to weaken the claims to cultural heritage made by any particular citizenry or ethnic group. Rather, the intent here is to expand our individual horizons as well as to remove a barrier to learning by assuming at the outset the possibility for connecting personally to art from other times and places.

Key parts of this book have been carefully designed to support learning. For example, important terms, such as **iconography**, appear in boldface with their definitions provided in the margin *and* in the glossary at the back of the book. This book includes plentiful maps, architectural plans and elevations, and useful reference diagrams, such as the standard iconography of the Buddha (see Fig. 3.11). In each chapter, one or more features explain media and techniques, translate primary sources, guide close looking at artworks, or discuss art historical concepts. For example, the feature Looking More Closely: Visual Analysis on p. 18 provides an introduction to **formal** and **contextual analysis**. To promote independent exploration, chapters conclude with a list of further readings, summary questions that encourage discussion of themes stretching across cultures and time periods, and a prompt for further research.

Between chapters, *The History of Asian Art: A Global View* presents short essays under the rubric, "Seeing Connections." These essays use a common theme, whether it be writing as art or the spread of photography, to examine several artworks from around the world. The selection always includes at least one example of Asian art, but juxtaposes it with works from nearby or distant lands. The purpose, in part, is to present Asian art history in a global context, thereby highlighting the interconnectedness of human experiences of art. By comparing art within a common theme, we see more clearly the universal concerns as well as the distinctive properties that particular artworks possess. "Seeing

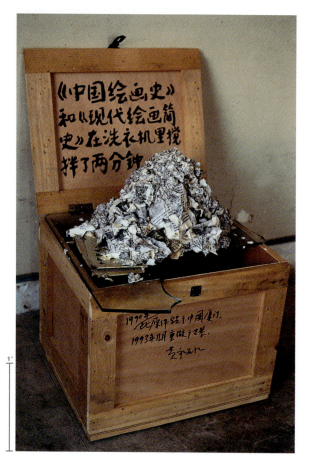

0.13 Huang Yong Ping, *The History of Chinese Painting and the History of Modern Western Art Washed in the Washing Machine for Two Minutes*, 1987/1993. Chinese teabox, paper pulp, glass, 30¼ × 27½ × 19 in. (76.8 × 69.9 × 48.3 cm). Walker Museum of Art, Minneapolis.
EAST ASIAN DIASPORA / FRANCE

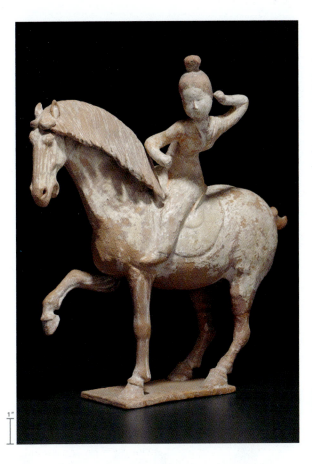

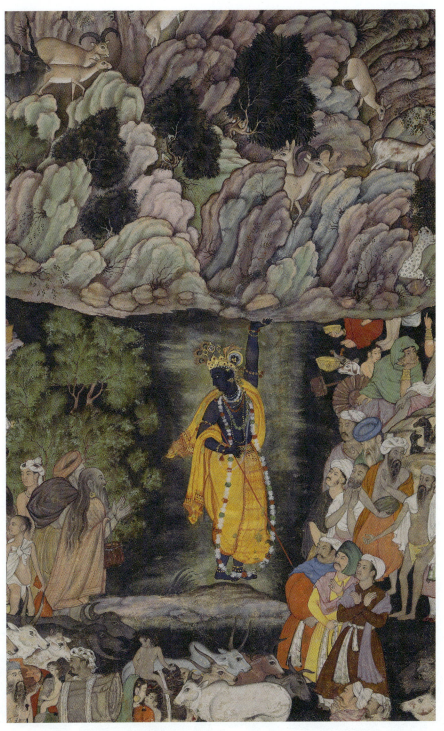

Connections" also demonstrates the variety of perspectives for analyzing artworks. A sculpture such as the Tang period *Polo Player* (**Fig. 0.14**) might be discussed as a furnishing for tombs, a representation of gender, evidence of the spread of equestrian sports via the Silk Roads, or in any number of other unexpected or illuminating contexts. The "Seeing Connections" feature underscores this book's commitment to a global perspective, but it also demonstrates the multiplicity of ways to think about art and invites you to find your own connections.

A few concluding thoughts: although this is a book about art—including some of the most beautiful art in the world—it has little to say on the matter of beauty. Instead, it selects some visually compelling examples to discuss art and architecture in relevant historical and contemporary contexts. Some sculptures give magnificent form to unseen deities; other objects demonstrate unsurpassed technological achievement. Some paintings give voice to anguish and longing; other images celebrate love and transcendence. Artwork can prop up dictatorships; but it can also speak truth to power.

Recognizing these conditions, let us make a careful study of art and in so doing remind ourselves of our common humanity and of our potential for human excellence. In this painting detail (**Fig. 0.15**; for the complete painting see Fig. 11.5), the beloved Hindu god Krishna rescues humanity. As torrential rains threaten lives and livestock, Krishna effortlessly lifts Mount Govardhan, making of it a monumental umbrella under which all may shelter. Drawing inspiration from this image and Xu Bing's calligraphy banner (see **Fig. 0.10**), this book embraces a universal message of art for the people.

Discussion Questions

1. What one idea from the Introduction shifts your conception of Asia most significantly? Explain.
2. Which artwork surprises you and why?

Further Reading

- Barnet, Sylvan. *A Short Guide to Writing about Art.* 9th edn. Upper Saddle River, NJ: Pearson, 2008.
- D'Alleva, Anne. *Look! The Fundamentals of Art History.* Upper Saddle River, NJ: Prentice Hall, 2006.
- Gocsik, Karen and Adan, Elizabeth. *Writing about Art.* New York: Thames & Hudson, 2019.

0.14 ABOVE LEFT *Polo Player*, Tang dynasty, 618–907. Painted unglazed earthenware, 13⅞ × 14 × 5¼ in. (35 × 35.5 × 13.3 cm). Art Gallery of New South Wales, Sydney. **EAST ASIA**

0.15 ABOVE RIGHT **Detail of "Krishna Holds Up Mount Govardhan to Shelter the Villagers of Braj,"** folio from a *Harivamsa* (*Legends of Krishna*) manuscript, Mughal Empire, *c.* 1590–95. Ink, opaque watercolor, and gold on paper, 11⅜ × 7⅞ in. (28.9 × 20 cm). Metropolitan Museum of Art, New York. **SOUTH ASIA**

1.0 Detail of Petroglyphs, Bangudae,
Ulsan City, South Korea. EAST ASIA

1

Asian Art before History

37,000 BCE–300 CE

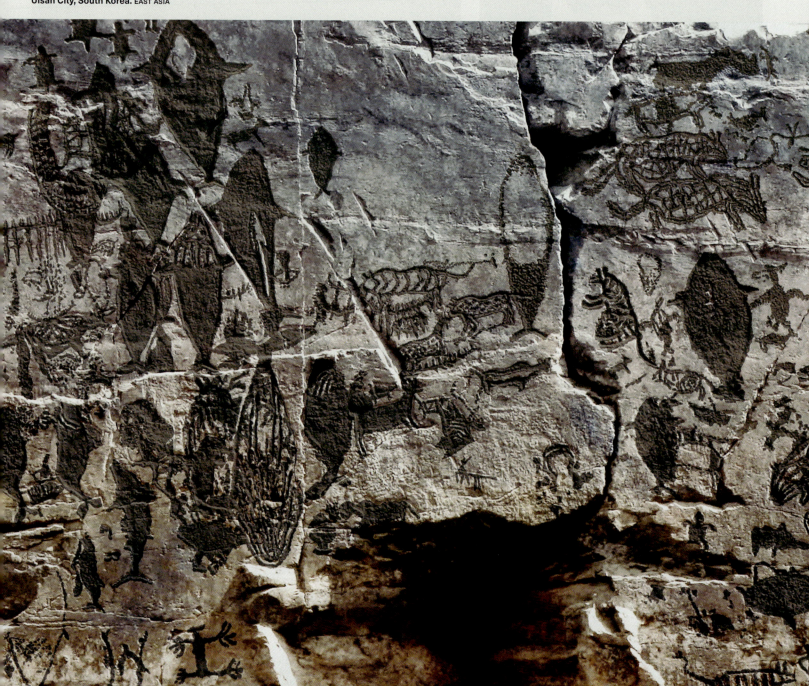

Introduction

The title of this chapter, "Asian Art before History," provokes a question: how can there be art *before* history? History here refers to the presence of deciphered writing. Writing—the technology of transcribing spoken language into fixed visual form—is a vital means of communication within a society or culture, and it leaves a record for later generations. Around the world, writing has been independently invented a handful of times, but it also may be adapted. Not surprisingly, across different cultures, written history does not begin all at once. For that reason, this chapter ranges broadly across time, from roughly 37,000 BCE to 300 CE, to examine a limited selection of early objects and sites.

In the periods before writing—or more precisely, writing that we today can read (South Asia's Indus culture had a form of writing, but it has not yet been deciphered)—objects made by the people living at the time, from painted vessels for storing food and other items to beaded necklaces for adorning the body, become the primary windows into the culture. These artifacts are both early artworks and key pieces of evidence. In geological terms, the earliest artifacts date to the end of the Pleistocene epoch, commonly known as the Ice Age (2.5 million to 11,600 years ago), but most were made after the Last Glacial Maximum, during the early part of the subsequent Holocene period.

In popular usage, "prehistorical" may imply out-of-date or, worse, crude. That is not the meaning here; the absence of writing does not mean the absence of culture. To the contrary, the plethora of surviving artworks—foundations of ancient cities, objects worked in jade, fragments of clay and stone sculptures, and cast bronze instruments—present visible, material clues to the complexity and creativity of our human ancestors. Because common questions and themes animate the study of prehistorical art regardless of region, this chapter discusses examples from a few Neolithic and Bronze Age cultures across Asia.

Time Travel, or Picturing the Distant Past

A crowd of mysterious human hands reaches near a creature with fur and long horns (**Fig. 1.1**). Some hover close to its neck, others float around its head. What animal is pictured here? Whose hands are these?

More than 36,000 years ago, in the Maros region of the Indonesian island of Sulawesi, it appears that humans put their hands against the surface of a cave wall. Holding a mixture of **ocher pigment** and water in their mouths, they took a breath through their nostrils. Exhaling, they directed a blast of Paleolithic spray paint toward their hands to make reverse handprints. Elsewhere in the caves, they dipped their palms in a tinted solution and then pressed them on the wall to form red handprints, up to twenty-six in a single grouping. Pieces of ocher, like pieces of charcoal, could also be dragged across a surface, leaving marks. In the detail pictured here, the unknown artist has used the dry quality of the earthy mineral in combination with the rough, irregular surface of the limestone cave to create a visual effect that aptly captures the furry coat of an animal, possibly an anoa, or midget buffalo, native to Sulawesi. In addition to the Maros-Pangkep caves, Southeast Asia (**Map 1.3**, see p. 36) is home to some of the oldest human fossil remains (Java's Solo Man, who lived 1.8–1.9 million years ago).

ocher a naturally occurring clay pigment that ranges in color from yellow to red, brown, or white.

pigment any substance used as a coloring material in paint, such as dry powders made from finely ground minerals.

1.1 Painting in the Maros-Pangkep caves, Sulawesi, Indonesia, *c.* 37,000–34,000 BCE. **SOUTHEAST ASIA**

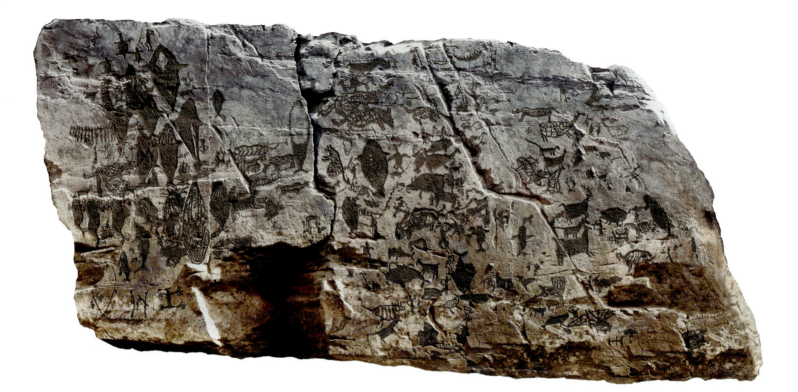

1.2 Petroglyphs, Bangudae, Ulsan City, South Korea, c. 6000–1500 BCE. **EAST ASIA**

petroglyph an image created on a rock surface through incision, picking, carving, or abrading.

radiocarbon dating a scientific method of determining the age of an object, based on the presence of carbon-14 in organic material.

figurative art that portrays human or animal forms.

motif a distinctive visual element in an artwork, the recurrence of which is often characteristic of an artist's or a group's work.

composition the organization of elements in a work of art, distinct from its subject matter.

perspective the two-dimensional representation of a three-dimensional object or a volume of space.

style characteristics that distinguish the artwork of individuals, schools, periods, and/or cultures from that of others.

Some 2,600 miles (around 4,200 km) north of Sulawesi, a pod of seven whales—including a juvenile riding the back of an adult—swims up the face of a great Bangudae rock cliff in present-day South Korea (**Fig. 1.2**). Located 100 feet (30 m) above the Daegokcheon Stream at the southeastern tip of the Korean peninsula (**Map 1.1**), their **petroglyphic** sea is alive with turtles, seals, and fish. Animal life thrives, too, on land: deer, pigs, wolves, and tigers. Amid this zoological richness we find another creature, the human. Humans may be few, small, and not central to the composition, but their ingenuity is depicted through the presence of schematic boats. Weapons, such as the harpoon already lodged in a whale, demonstrate human power, too (**Fig. 1.0**, p. 22). An arresting, shield-like mask (middle of the bottom-right quadrant) suggests a ritual dimension to the activity of hunting.

Who made the images in the Maros-Pangkep caves and at Bangudae, and what do the images mean? The unknown artists depicted recognizable things, but their pictures bear only slight resemblance to the modern world. Indeed, the images belong to the distant past, and analyzing them in our quest for answers about early art and culture is a form of time travel.

Archaeologists and art historians employ a number of different methods for determining when images were made. For the earliest sites, one scientific method is **radiocarbon dating**, which uses isotopes to measure decay in organic material. Using this method to date calcium deposits that formed a layer atop the paintings, researchers recently adjusted the date of Sulawesi's cave paintings, making them among the oldest examples of **figurative** art in the world (other examples include the Lascaux caves in France, Altamira Cave in Spain, Apollo 11 Cave in Namibia, and the Kimberley region in Australia). Although closer to us in time, precise dating

of the Bangudae petroglyphs is difficult because of the absence of organic material. Shells discarded in nearby middens (refuse heaps) provide an approximate date.

To understand more about the possible meanings of early artwork and the cultures that made them, art historians rely on keen observation, such as inventorying the **motifs** used and looking for patterns. Besides identifying *what* is represented, art historians are also interested in *how* things are depicted. This concern includes analysis of materials and techniques, such as the many ways that ocher can be used to produce images; it also addresses **composition** and the visual qualities of individual motifs. At Bangudae, viewers gaze at whales from above, at boats and land animals from the side. Instead of a fixed **perspective**, the composition uses a mobile point of view, aiding immediate recognition of all creatures and objects. As for individual motifs, some animals appear in silhouette; others are outlined and have patterned bodies. The use of different schemes can indicate particular animal species by their spotted coats or striped fur. But different schemes, or diverse **styles**, can also suggest the labors of multiple artists.

The involvement of multiple artists is more obvious in the Maros-Pangkep caves, which literally preserve the marks of many hands. Further, the Maros-Pangkep paintings cannot be described as a single composition. Rather, they are spread across the walls of multiple caves. In some areas, the painting seems to represent a thing or depict an activity, but elsewhere, the painting might better be interpreted as the activity itself. Images of hands, for example, might attest to individuals as participants in a ritual.

Although much remains unknown about the cultures associated with the Maros-Pangkep cave paintings and with the Bangudae petroglyphs, partial answers emerge from the visual clues preserved in the pictures.

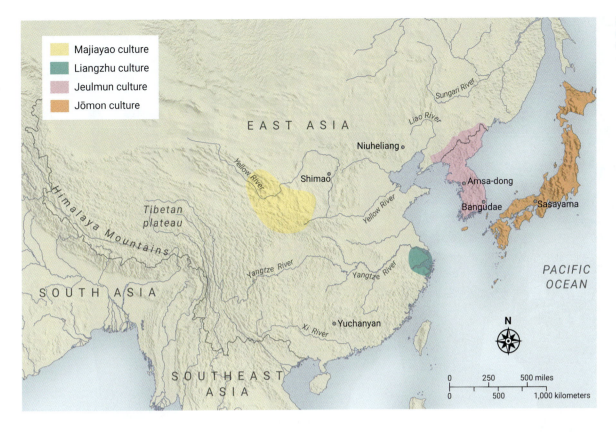

Majiayao culture
Liangzhu culture
Jeulmun culture
Jōmon culture

EAST ASIA

Sungari River

Liao River

Niuheliang

Shimao

Yellow River

Tibetan
plateau

Yellow River

Amsa-dong

Bangudae Sasayama

Himalaya Mountains

SOUTH ASIA

Yangtze River

Yangtze River

PACIFIC
OCEAN

Xi River Yuchanyan

N

SOUTHEAST
ASIA

0 250 500 miles
0 500 1,000 kilometers

Early artists in Asia, just as their successors have done ever since, made tools, dedicated their time, and used their ingenuity and creativity to translate human experiences of the world into images.

East Asia: Early Ceramics,
c. 18,000–2050 BCE

East Asia is the name used for the lands that stretch from the Taklamakan and Gobi deserts eastward to the mountain ranges and coastlines of a substantial peninsula and many islands; it includes the high-altitude plateau formed by the Himalayas, fertile river valleys, and tropical forests (**Map 1.1**). In East Asia, ceramics constitute a major medium of art. Continuously manufactured for millennia, they are widely distributed and offer a primary means of identifying scores of ancient cultures across geographical regions, as well as of observing development over time. Some of the earliest **potsherds** of **terra-cotta** vessels, radiocarbon-dated to 18,000 BCE, come from the site of Yuchanyan. On the Korean peninsula and Japanese archipelago, cultures were making pottery well before 10,000 BCE.

This terra-cotta vessel was excavated from the Amsa-dong site in present-day Seoul (**Fig. 1.3**). Like other early ceramics in East Asia and indeed from around the world, it shares some characteristics: it was shaped from clay, unglazed, and baked at a temperature below 1200 degrees Celsius (2200 F), making it hard but not entirely watertight. Many rounded vessels, like this one with its pointed base and wide mouth, were created by rolling the clay into long coils. The coils would then be wound to form an upside-down cone shape. Then, the walls could be smoothed and ornamentation added.

Some of the earliest vessels on the Korean peninsula have raised decorations, but the ornamentation on this vessel is a distinctive comb pattern that began to appear in the middle western region around 5000 BCE and spread to the rest of the peninsula. The period from *c.* 8000 to *c.* 1500 BCE is named after this comb pattern: Jeulmun. The ornament on this example has the effect of dividing it into three horizontal **registers**. Close to the base, **incised** parallel lines create angles that point left and right. The middle register is the widest, and the lines here form a **chevron** pattern, which echoes and reverses the vessel's overall shape. At the mouth, the pattern changes once more to narrow bands of hash marks.

potsherd broken piece of ceramic, especially one found at an archaeological site.

terra-cotta baked clay; also known as earthenware.

register a horizontal section of a work, usually a clearly defined band or line.

incised cut or engraved.

chevron pattern in the shape of a V or upside-down V.

1.4 Flame vessels, from Sasayama, Niigata prefecture, Japan, Middle Jōmon period, *c.* 2500 BCE. Terra-cotta, largest vessel height 8⅜ in. (46.5 cm); diameter 17¼ in. (43.8 cm). Tōkamachi Museum, Japan. **EAST ASIA**

earthenware pottery made of clay, unglazed, and baked to a temperature below 1200 degrees Celsius (2200 F), producing not entirely watertight but nevertheless hard and durable objects. Also called terra-cotta.

Neolithic a period of human history in which polished stone implements prevailed, roughly beginning about 10,000 BCE and persisting until the use of bronze metal implements. In East Asia, the Neolithic ends and the Bronze Age begins roughly around the second millennium BCE.

The variation of repeated lines produces a coherent and balanced composition.

For potters, the size of a vessel poses a challenge in terms of ensuring the strength of the self-supporting walls. In this regard, building an inverted cone shape proved an effective solution. The pointed base was slightly awkward, but it required only a slight depression in the ground to maintain an upright position. Its size and decoration may indicate the owner's prestige, but relatively large vessels, such as this one, were also useful for storing food. This vessel was excavated near other terra-cotta bowls and stone tools, suggesting daily use for food storage and cooking.

Similarly to the early cultures of the Korean peninsula, the Jōmon culture in Japan produced remarkable **earthenware** vessels. Jōmon culture, which flourished in the Japanese archipelago from about 13,000 to 400 BCE, is named for its cord-marked terra-cotta pottery. When rolled against a clay surface, woven cords produce a variety of patterns and textures. By combining this technique with three-dimensional sculptural adornments, artists created especially exuberant vessels (**Fig. 1.4**).

These Middle Jōmon (*c.* 2500–*c.* 1500 BCE) artifacts have wide mouths and surface decorations that organize the body into horizontal registers, similarly to the Jeulmun vessel. Vertical lines divide portions of the lower registers into panels, which are filled with patterns occasionally interrupted by wavy lines or curlicues. This bounded visual energy expands considerably as the vessels' silhouettes broaden at their shoulders. Clay coils swirl in sinuous bands that rise and sometimes transform into looped handles. Form and decoration also merge at the mouth. The curved forms lead the viewer's eyes around and around, while the play of textures appeals to the sense of touch. Cockscomb or flame-like embellishments are distinctive to the Middle Jōmon period. This assemblage was excavated from a single site in Sasayama, west of present-day Kyoto.

What do the visual and physical characteristics of these "flame" vessels suggest about the culture that made them? The elaborate forms suggest a level of artistic experimentation, which benefits from long-term settlement and surplus time. Some ornamental parts are relatively fragile, and so the vessels may have been prestige objects, used for ritual feasting and ceremonial display rather than everyday use. Soot and residue inside most of the vessels likely resulted from cooking food.

Several other **Neolithic** cultures on the East Asian continent also made terra-cotta vessels and objects. Instead of using incised lines, textures, or sculptural elaborations (compare **Figs. 1.3** and **1.4**), some turned to painting for ornamentation. Creating a single object thus required another set of skills, the painter's knowledge of pigments and ability to fix them onto a surface. This painted terra-cotta jar (**Fig. 1.5**), from the Machang phase (*c.* 2350–*c.* 2050 BCE) of the Majiayao culture in the upper reaches of the Yellow River, uses two pigments: black for outlines and emphasis, and a lighter, reddish hue for fill.

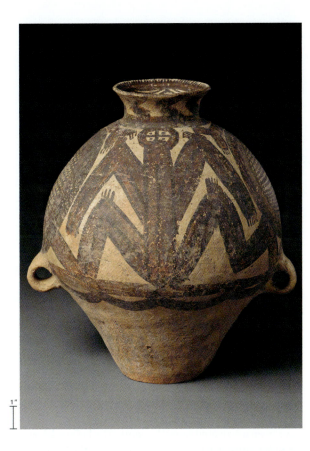

It has a broad body between its relatively small base and narrow neck. Three lug handles (two can be seen in this view) break the contour, but the body is otherwise smooth.

How does the jar's shape inform, or interact, with its painted ornament? Like the Jeulmun and Jōmon examples, this jar's composition is divided into registers, but here, painted lines and patterns at the neck and lower register (punctuated by the lug handles) underscore the divisions. They function like a frame to draw attention to the broad middle register. There, geometric shapes resolve into anthropomorphic or **zoomorphic** designs. Between two large medallions filled with a cross-hatch pattern (in this image, the edges of the medallions are visible on the right and left sides, just above the lug handles), four bent limbs and a head emerge from a central vertical body. Additional markings emphasize knees, elbows, feet, and fingers—alternatively, these may be fur or claws. Instead of a recognizable face, the head is quartered into sectors, each bearing a single dot. Clearly, the artist shifted back and forth between **abstract** patterns and **representational** forms.

The most typical designs of the Majiayao culture during this time period are abstract, spiral patterns that appear on such objects as children's rattles and large **amphorae**. Artifacts bearing representational forms are less common, and this one has provoked speculation. Is the figure a frog? Or is it a human being, perhaps a spiritual leader whose dress evokes the transformative capacities of ritual? Archaeologists and art historians continue to grapple with the relationship between ornament and shape, to consider manufacturing processes and exchange networks, and to analyze the specific evidence of excavation sites in order to understand better the meaning and significance of these and other early East Asian ceramics.

East Asia: Art from Neolithic Cultures, c. 4000–400 BCE

Clay was ubiquitous, and the consideration of a common medium (terra-cotta, or earthenware) and its use for making a common artifact (vessels) facilitates an immediately broad perspective that encapsulates all of East Asia. But clay could also be shaped into a variety of forms more distinctive to individual cultures, of which there were many. For this unusual, earthenware head, clay is combined with another material—turquoise—inset for eyes (**Fig. 1.6**).

Pliable clay has been shaped into the likeness of a female face. Although features such as the eyes and ears are simplified, the modeling of the brow, cheeks, and nose suggests an attempt to capture flesh over bone. Using turquoise for the eyes enhances the sense of **naturalism**. As a result, the head captivates viewers' attention and provokes speculation about the object's purpose in the Neolithic Hongshan culture (c. 4700–2900 BCE), located in the northeast region of present-day China. Excavated from a complex that included graves, sacrificial pits, and the ruins of a temple, the head may have had a ritual function. The Hongshan culture is known for its painted pottery and **jade** objects of animal forms. This head along with several clay figures with female features suggest the possibility that female deities were part of Hongshan religious beliefs and practices.

Intentional forms with elusive meanings are also characteristic of the early artworks of the Liangzhu culture, which was located in the Yangtze River delta region near present-day Shanghai and flourished around

1.5 FAR LEFT *Guan* (jar), Neolithic period, Machang phase of the Majiayao culture, c. 2350–2050 BCE. Terra-cotta with pigments, 12⅜ × 9¼ in. (31.4 × 23.5 cm). Metropolitan Museum of Art, New York. **EAST ASIA**

zoomorphic having an animal-like form.

abstract altered through simplification, exaggeration, or otherwise deviating from natural appearance.

representational art that depicts a recognizable person, place, object, or other subject.

amphora an ancient pottery vessel with a narrow neck, large oval body and two handles, used for storage or bulk transportation of foodstuffs.

naturalism representing people or nature in a detailed and accurate manner; the realistic depiction of objects in a natural setting.

jade a general term for hard, typically green minerals, including nephrite and jadeite.

1.6 **Head from Niuheliang,** Liaoning province, Hongshan culture, c. 4000–3000 BCE. Earthenware and turquoise, height 8⅞ in. (22.5 cm). Liaoning Institute of Archaeology, Shenyang, China. **EAST ASIA**

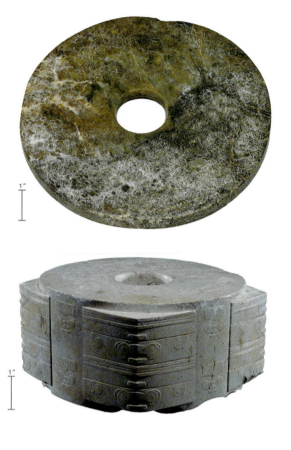

nephrite a hard, fibrous mineral used in the Liangzhu culture for making ritual objects; often called jade.

bi flat, perforated disks made of nephrite, first found in the Liangzhu culture.

cong hollow, squared tubes made of nephrite found in the Liangzhu culture.

Holocene the current geologic period, beginning approximately 11,600 years before the present.

rammed earth a building technique in which damp earth is compressed, usually within a frame or mold, to form a solid structure.

dogū clay figurines made during the Final Jōmon period, c. 1000–c. 400 BCE.

differs. The example in **Fig. 1.8** is quite short and, at the corners, features a repeated pattern in two primary registers that are each further sub-divided. On the sides of the *cong*, the artist has incised detailed linear images that portray a human-like figure wearing a sizeable feathered headdress and seated on a wide-eyed creature. The large eyes also appear on the corners of the *cong*, but in a more simplified form. The meaning of these motifs is not known, but one hypothesis suggests that the figure wearing the headdress may be a spiritual leader or priest.

The names *bi* and *cong* were given to these objects centuries later, when the Zhou culture (c. 1050–256 BCE) encountered the jade disks and tubes. In written documents, the Zhou associated the perfect circular form of the *bi* with *Tian*, the celestial aspect of the cosmos, or heaven, and they related the squared *cong* to the earth. Their associations are plausible, but remain contingent until sufficient evidence clearly supporting or refuting the Zhou interpretation arises.

With the temperate conditions of the **Holocene** period, Neolithic cultures not only created distinctive artifacts but also built structures, some of which were quite extensive. The Hongshan head was found in a semi-subterranean ritual complex; Liangzhu jades were buried in cemeteries; earthenware vessels of Jeulmun and Jōmon cultures have been uncovered in settlements. The largest known Neolithic city in East Asia is associated with the Longshan culture: the Shimao site in present-day China. The Shimao site covers an area of nearly 1000 acres—4 km square, or 20 percent larger than New York City's Central Park. Dated to about 2000 BCE, the site includes inner and outer walled districts, within which are numerous burials,

3500–2000 BCE. Roughly contemporary with the Majiayao culture, the Liangzhu culture also made pottery, but it is better known for its distinctive jade artifacts (**Figs. 1.7** and **1.8**). Whereas clay is soft and malleable before firing, **nephrite** (commonly called jade) ranks among the hardest materials. Because nephrite has a fibrous rather than crystalline structure, it cannot be cut or chipped with a hammer and chisel. Instead, nephrite is worked by grinding. Artists must use drills and abrasives, such as sand with water, to grind jade into desired shapes. Nephrite is translucent, and when polished, it produces the effect of depth. Finally, unlike many metals, nephrite stays cool to the touch, and the constancy of the material means it does not tarnish over time.

Compared to shaping clay, working jade is a time-consuming and laborious process, and while jade objects are undeniably hard, they are also quite brittle. Thus, jade objects require added care in working and handling. Archaeological analysis suggests that Liangzhu jades were major status symbols because they accompanied elite burials. The value of this jade disk, called a **bi**, derives in part from the skilled labor required to make it, but also from its visual and physical properties (**Fig. 1.7**). The object takes the form of a perfect circle with a hole in the center. Its rich colors, from deep green and reddish-brown to white, do not correspond to its shape but rather form patterns of their own, according to the varied concentrations of iron in the stone.

Along with *bi*, hollow jade tubes called **cong** accompanied elite Liangzhu burials (**Fig. 1.8**). This plan of an excavated Liangzhu gravesite (known as Burial M3) shows the presence of numerous *bi* and *cong* (**Fig. 1.9**). While all *cong* have a square cross-section, their height

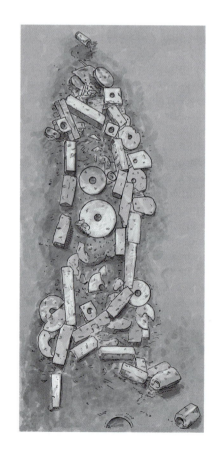

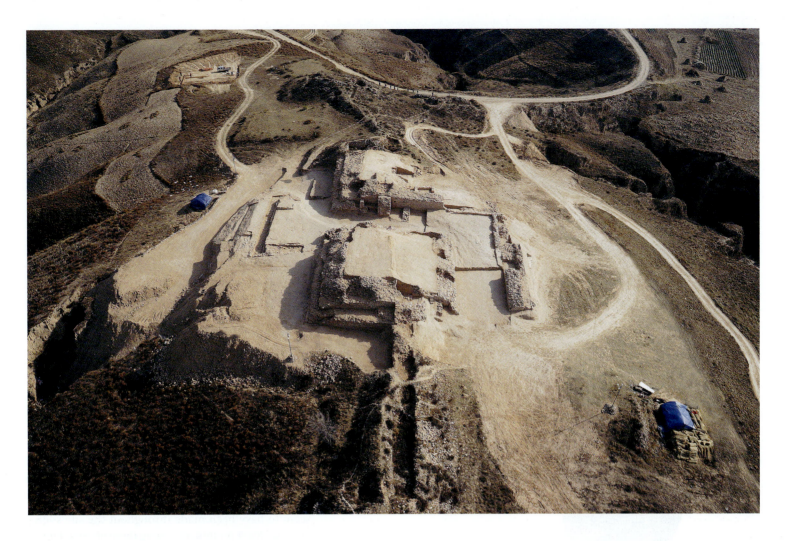

1.10 ABOVE **Eastern gate of the Shimao site,** Shaanxi province, China, *c.* 2000 BCE. Aerial view with northeast at the top. **EAST ASIA**

1.10a RIGHT **Plan of the eastern gate of the Shimao site,** Shaanxi province, China, *c.* 2000 BCE. **EAST ASIA**

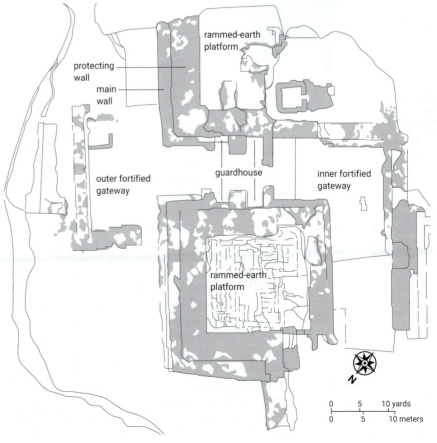

house foundations, two kilns, and a multi-stepped terrace, possibly a center of political or religious importance. The eastern gate—a complex arrangement of stone-lined, **rammed-earth** platforms, guardhouses, and inner and outer gates—punctuates a thick wall of stone and mud (**Figs. 1.10** and **1.10a**) Such robust fortifications indicate a history of Neolithic warfare, but they also attest to growing populations, wealth, social complexity, and engineering ability.

Over the prehistoric period, human populations in East Asia swelled, but growth was neither steady nor uniform. On the Japanese archipelago, a rising population during the Middle Jōmon period was followed by a puzzling trajectory of downs and ups. One factor for the changes could be a cooling climate, but food specialization probably played a role, too. Later settlements were smaller on average and changes are apparent in the archaeological record. For example, the later Jōmon periods show an uptick in the production of clay figurines, or *dogū*. Unlike the lively Middle Jōmon "flame" vessels, some *dogū*, including this one from the Final Jōmon period (*c.* 1000–*c.* 400 BCE), take static forms (**Fig. 1.11**, p. 30). The frozen, timeless quality

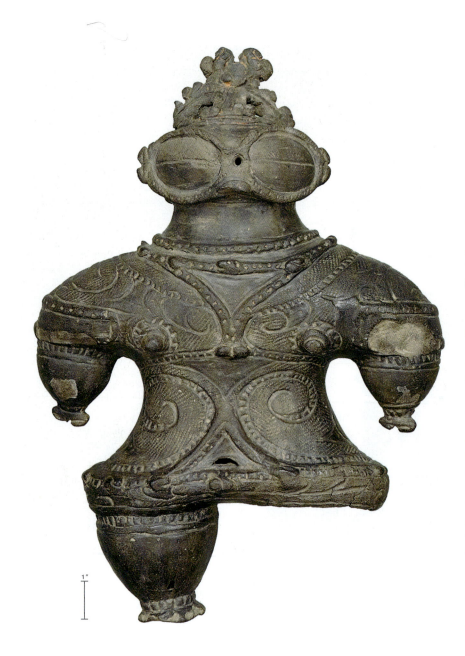

In East Asia, Neolithic cultures yield gradually and not all at once with the advent of **bronze** technology. Alongside the development of bronze on the East Asian mainland, written language appears on **oracle bones** of the Shang dynasty (*c.* 1500–*c.* 1050 BCE; see Fig. 2.3). Over the course of the first millennium BCE and into the first centuries of the common era, major cultural and artistic changes accompany the emergence of regional powers, centralized states, and indeed the first empires. As writing spreads from one area to another, enabling the creation of written records, art in East Asia is literally no longer prehistorical.

Early South Asian Art: The Neolithic and Bronze Ages, *c.* 7000–250 BCE

South Asia consists of the present-day countries India, Pakistan, Bangladesh, Nepal, Bhutan, and Sri Lanka (sometimes Afghanistan also is seen as part of South Asia). Some of the earliest artifacts from the region were discovered at the Neolithic site of Mehrgarh, located near the Bolan Pass in what is now Pakistan (**Map 1.2**). There archaeologists have uncovered thousands of objects, as well as graves, settlement remains, and evidence of agricultural production, including the cultivation of cotton (see Seeing Connections: Matters of Cloth, p. 57). The large site was home to successive settlements that can be divided into what appear to be eight distinct but continuous phases, datable to between *c.* 7000 and 2500 BCE. While some artifacts, such as copper tools and painted pottery, belong solely to the later phases, other objects seem to have been made throughout the site's long lifespan. Most prominent among these are small terracotta female figurines, such as the one illustrated here (**Fig. 1.12**), which is around 3½ inches (8.9 cm) high. Notice its elaborate hairstyle, prominent nose and breasts, and small waist; these features are typical in the Mehrgarh figurines, as is the large necklace, which is similar in form to actual beaded jewelry found at the site. Traces of

1.11 *Dogū,* Final Jōmon period, *c.* 1000–400 BCE. Terra-cotta, height 15 in. (38.1 cm). Tokyo National Museum, Tokyo. **EAST ASIA**

bronze an alloy consisting primarily of copper with some tin, and often small amounts of other metals and//or minerals.

oracle bones turtle plastrons and ox shoulder bones used for divination in the Shang state. Oracle bones are among the earliest examples of Chinese writing.

1.12 FAR RIGHT **Female figurine,** Mehrgarh, Pakistan, *c.* 3000 BCE. Terra-cotta, height approximately 3½ in. (8.9 cm). National Museum of Pakistan, Karachi. **SOUTH ASIA**

results from the symmetrical composition with the head facing forward, arms at the side, and legs vertically aligned, although one leg is missing. The swirling surface patterns, which might indicate tattoo designs or clothing embellishments, generate some sense of movement across the abstracted body, but the oversized eyes command the most attention.

Several theories as to the figurine's meaning and purpose have been proposed. Aspects of the figurine's body—breasts and wide hips—led to an early interpretation that it is a symbol of fertility or motherhood. But, like the vast majority of *dogū*, this one was intentionally broken, possibly as part of a ritual, and the missing limb suggests its use as an offering in ceremonial activities, perhaps asking for protection during childbirth or while hunting. Alternatively, the hollow body led some scholars to suggest that it provided a residence for a soul. The precise meaning of this *dogū* continues to be debated, and given that the roughly 18,000 *dogū* that have been recovered present a range of forms, *dogū* may have fulfilled a variety of functions.

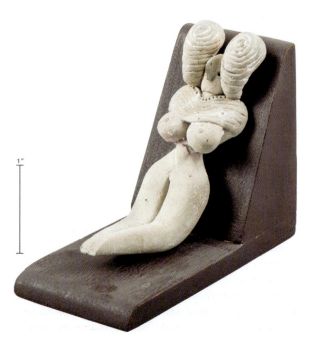

pigment on some figurines suggest that they were originally painted, further highlighting certain elements of their design. More generally, the visual emphasis on the figures' breasts and hips link them to similar Neolithic figurines found across a wide geographic span, from the Mediterranean region to Siberia. Some scholars have suggested they are evidence of prehistoric goddess worship or that the figurines relate to the concept of fertility in some way. While such theories cannot be verified and have been increasingly called into question in recent years, it is evident that fertility—whether of the land, animals, or humans—was crucial to the survival of these early societies as they took up agriculture and animal husbandry.

Terra-cotta female figurines continued to be made during the region's **Bronze Age** culture that followed. That culture—known as Indus or Harappan—often overshadows Neolithic Mehrgarh, finds from which are not as well known. However, the developments at Mehrgarh are crucial for understanding the complex society of the later Indus period. They demonstrate that Indus culture did not emerge suddenly out of nowhere, but rather was one part of a much longer history of gradual development in the Indo-Gangetic plain, a large area that encompasses the mighty Indus and Ganges Rivers, both originating in the mountain range of the Himalayas and flowing southward to the seas.

THE INDUS CULTURE

Centered on the Indus River basin and spanning from present-day Afghanistan to the western Indian state of Gujarat, one of the world's oldest complex societies flourished between *c.* 2600 and 1900 BCE (**Map 1.2**). Some scholars refer to this society as Indus because it grew from settlements located in that river's valley. Others prefer to call it Harappan, after Harappa, the first site excavated in the early twentieth century. The ancient Mesopotamians, who lived in cities and settlements situated around the Tigris-Euphrates river system in West Asia at the same time that the Indus culture flourished in South Asia, called it Meluhha. Nobody today knows what the members of this ancient society called themselves, because scholars have not yet deciphered their written language. Thus our knowledge of Indus culture comes from visual clues provided by excavated artifacts and urban structural remains.

Archaeologists have identified more than 1,000 sites associated with Indus culture, ranging from villages to cities, but fewer than 10 percent of them have been excavated. Based on evidence uncovered at those sites, archaeologists estimate the society's total population at one million, double that of Mesopotamia at the same time. During the society's peak, its inhabitants traded with Mesopotamians as well as with people in the Persian Gulf region. The Indus people made the long journey west by boat and traded their craft items, including pottery and carnelian beads, possibly for wool products. They had a system of weights, a written language, an established social structure, and well-planned urban development, but Indus society differed from Mesopotamia, Old Kingdom Egypt, and Shang China (for the latter, see Chapter 2)—the other major early complex societies—in

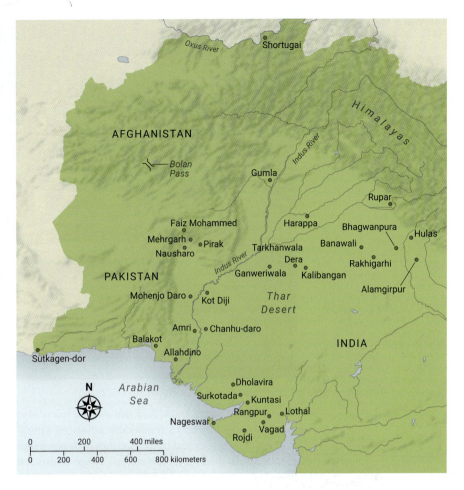

Map 1.2 **Sites associated with the Indus culture,** *c.* 2600–1900 BCE.

some striking ways: there is no evidence of human sacrifice, no monuments glorifying kings or battles, no elite burials with precious objects, and no grand religious structures. Some Indus artifacts provide evidence of religious practice. Whether such practices are precursors to Hinduism, the dominant religion of South Asia today, is a key topic of scholarly debate.

ARCHITECTURE OF INDUS CITIES

The architecture of Indus cities offers insights into the lives of their inhabitants. The two largest cities, both located in present-day Pakistan, were Harappa and Mohenjo Daro. Harappa, which began to be settled around 3500 BCE, is in the northeast portion of the Indus river valley. Mohenjo Daro, located roughly 350 miles (560 km) south along the river, had a population estimated at 35,000 to 40,000. The city, like the other major Indus sites, featured a separate raised area, often called the citadel, which held the important public buildings. Its main urban area, often called the lower city, featured wide streets oriented to the cardinal directions of north, south, east, and west: an orderliness that indicates centralized urban planning. The lower city sat on a series of platforms constructed of mudbrick; the platforms' outer walls were made of more durable baked brick. The construction of such platforms, which protected the city from the periodic flooding of the Indus River, must have involved an immense amount of labor.

The lower city contained both public structures and private houses (**Fig. 1.13**, p. 32). Many of the houses, which

Bronze Age a period of human history characterized by the use of bronze, beginning around 4000 BCE, but different according to particular geographical area. The Bronze Age ends with the advent of iron technology.

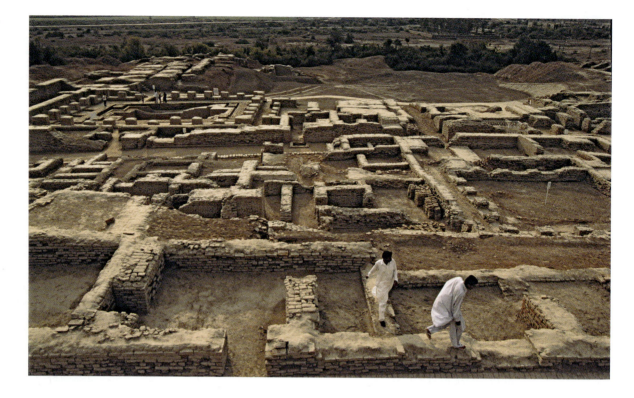

were made of baked brick, had two stories; many also had wells. The city had a remarkably advanced sanitation system. Houses had indoor latrines with pipes that emptied into drains on side streets. These drains fed into covered sewers on the main streets that carried the waste to the city's outskirts. This degree of urban planning suggests that the culture had a centralized authority responsible for overseeing the financing and construction of such work.

One of the city's largest surviving structures is the so-called Great Bath, located in the citadel area (**Fig. 1.14**). Measuring 39 by 23 feet (11.8 by 7 meters), it features two staircases leading down to a smooth brick floor that was covered with a layer of bitumen, a thick, sticky, asphalt-like substance that would have made it watertight. Many scholars believe that the structure had a religious or ceremonial function, and perhaps a connection with later Hindu traditions of bathing in sacred water. While such theories are based on assumptions that cannot be proven—indeed, we do not even know if it was used for

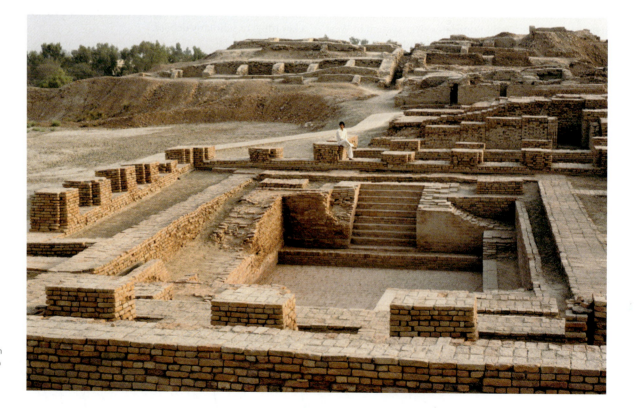

1.14 **The Great Bath,** located in the raised citadel area of Mohenjo Daro, Pakistan, Indus period, *c.* 2600–1900 BCE. **SOUTH ASIA**

bathing or for storing water—it is clear that the control of water was a vital part of Indus society. At another ancient Indus site, Lothal in Gujarat, big reservoirs surrounding the city collected river water and rainwater as part of a well-planned hydraulic system.

SCULPTURES AND SEALS OF THE INDUS CULTURE

A variety of small objects have been found at Indus sites: jewelry, pottery, carved stone weights, children's toys, dice, and sculptures ranging from rustic terracotta forms to elegant bronze figures. One puzzle is the absence of any monumental sculpture. Perhaps large sculptures were made of organic materials that no longer survive, such as wood, or perhaps people took the more substantial sculptures with them when they abandoned their cities around 1900–1700 BCE. It is also possible that no large sculptures were made at all. Of the sculptures found at Mohenjo Daro, one of the most famous is the so-called priest-king, a 7-inch-tall (17.8 cm) bust (head and shoulders) of a man (**Fig. 1.15**). The contrast between his elongated, half-closed eyes and his full lips and **striated** beard gives the work a refined, **stylized** appearance. Made from steatite, a soft stone, the bust would have been carved, fired to harden it, painted, and finally adorned with actual jewelry. That jewelry, along with the figure's groomed beard, armband, **diadem**, and robe with **trefoil** pattern, indicate that it represents someone of high status. Despite its common identification as a priest-king, whether the Mohenjo Daro figure depicts a deity, priest, ruler, wealthy trader, revered ancestor, or some other type of individual is unknown.

Another intriguing sculpture from Mohenjo Daro, this one cast in bronze, depicts a naked young woman, head tilted back, with one hand on her hip and the other hand resting on her slightly bent left leg (**Fig. 1.16**). Based on the pose, some scholars have suggested that it represents a dancer. Others attribute her appearance to her age; the figurine may represent an adolescent girl still growing into her long, slender limbs. Her wide, full mouth is similar to the mouth of the priest-king bust, while the naturalism of her curly, braided hair and subtly curved back differentiate her from it—a reminder that artistic styles often coexist at any given time or place. The figure is adorned with jewelry: a pendant necklace and an array of bangles on its wrists. Similar thick bangles, made from a wide variety of materials from clay to conch shells, **stoneware**, and hammered sheets of gold, have been found at various Indus sites.

striated marked by lines or grooves.

stylized treated in a mannered or non-naturalistic way; often simplified or abstracted.

diadem a crown or ornamented headband worn as a sign of status.

trefoil a decorative shape, consisting of three lobes, like a clover with three leaves.

stoneware a type of ceramic that is relatively highfired and results in a non-porous body (unlike terra-cotta or earthenware).

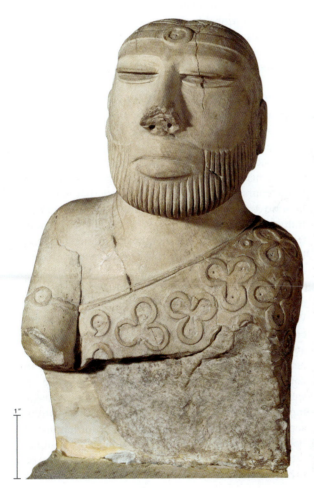

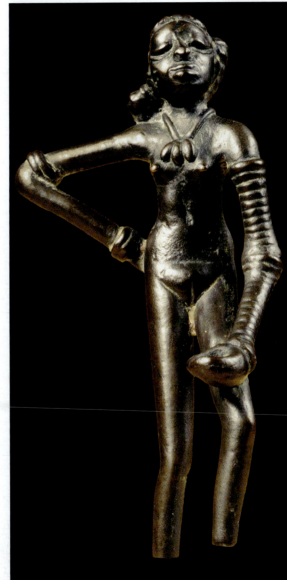

1.15 FAR LEFT **Priest-king bust,** found at Mohenjo Daro, Pakistan, Indus period, c. 2600–1900 BCE. Steatite, height 7 in. (17.8 cm). National Museum of Pakistan, Karachi. **SOUTH ASIA**

1.16 LEFT **Female figurine,** found at Mohenjo Daro, Pakistan, Indus period, c. 2600–1900 BCE. Bronze, height 4 in. (10.2 cm). National Museum, New Delhi. **SOUTH ASIA**

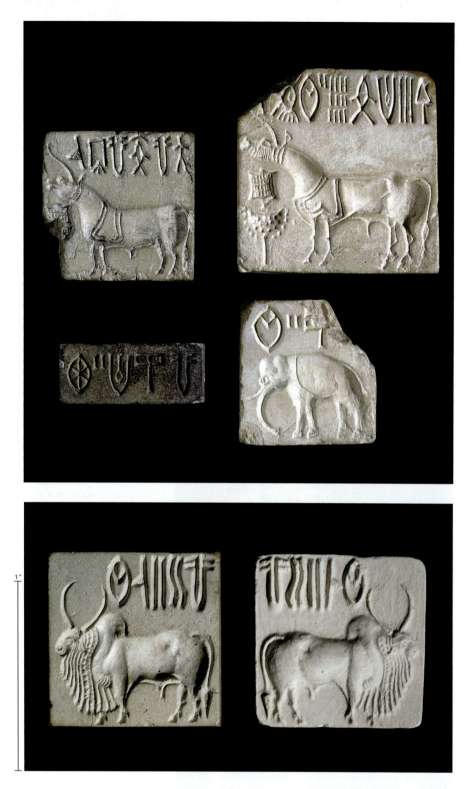

originally had knobs on the back, for gripping as they were pressed down to leave an imprint in wet clay or a similar material. In the imprint, the writing and images would appear raised and in reverse. The knob had a single hole, presumably for a cord to pass through, so that the seal could be worn around the owner's neck.

Many of the thousands of Indus seals display a row of writing above an image of an animal, often a bull, water buffalo, or Indian bison. Rhinos, tigers, elephants, and other animals are also depicted, suggesting that animals played a role in symbolic communication. The carvers skillfully planned their designs to show the curves of the animals' muscles. Intriguingly, 60 percent of the seals found at Mohenjo Daro bear images of what appears to be a one-horned horse or bull-like animal, which some scholars have called a unicorn. This depiction could be an artistic convention—a way of showing an animal with two horns from the side, in profile—but terra-cotta figurines of one-horned animals have also been found. Did a one-horned horse or bull-like animal actually exist at the time, or do these seals depict a mythical creature?

Another intriguing aspect of the seals is their writing, which has yet to be deciphered. The seals typically feature between three and ten characters. The longest piece of Indus writing found includes only twenty-seven characters, making it difficult to study the language. However, scholars have determined that the writing was read from right to left, and the script seems to be logosyllabic, meaning that each symbol is a syllable or part of a word. In a classic conundrum, deciphering the script is probably the key to figuring out many of the puzzles presented by the archaeological evidence, but more archaeological evidence is needed to decipher the script.

THE POST-INDUS BRONZE AGE

By around 1900 BCE Indus society was in decline, with its major sites abandoned by about 1700 BCE. The reasons are unclear, but most scholars believe that the decline happened gradually and resulted from a combination of factors, including environmental changes, such as shifts in the courses of rivers. The old theory that invasions by Indo-Aryan tribes from the Iranian Plateau ended Indus society has been disproven. People did migrate from West and Central Asia to the Indo-Gangetic plain, but that migration seems to have begun centuries later, around 1500 BCE.

These new people who migrated around 1500 BCE called themselves Aryans, meaning "Noble Ones." We know about them through the Vedas, sacred literature composed between around 1500 and 800 BCE and transmitted orally for about one thousand years before being written down. Because the people who composed and transmitted the literature spoke an early version of Sanskrit, an Indo-European language, modern scholars can read the Vedas. These philosophical and religious texts provide information on both society and religion at the time. For example, the Aryans kept horses. Their society seemed to be primarily agricultural and rural, unlike the Indus

1.17 TOP **Group of seals showing one-horned animals, an elephant, and Indus script;** BOTTOM **Seal showing a bull paired with its impression,** Indus period, *c.* 2600–1900 BCE. Steatite, approximate width of single seal ¾ to 1⅛ in. (1.8 to 2.8 cm). British Museum, London. **SOUTH ASIA**

They seem to have been commonly worn by members of every level of society.

The most numerous objects found at the sites are seals, or stamps, that functioned as identifying markers (**Fig. 1.17**; see also Looking More Closely: The Proto-Shiva Seal). They were most likely related to trade in some way, suggesting its importance to Indus society. Most of the seals are small, averaging just ¾ to 1⅛ inches (1.8–2.8 cm) per side. They are made from steatite (like **Fig. 1.15**, the bust sculpture), with writing and/or images carved into a rectangular or square flat front. The seals

An important part of studying art history is distinguishing what we actually see from what we think we see based on the connections we make. This task can be challenging not only for new art history students but also for seasoned scholars, who are trained to apply what they know about other traditions or time periods to the object at hand.

One of the most celebrated artifacts from the Indus culture is called the Proto-Shiva seal (**Fig. 1.18**) because some early scholars interpreted its main figure as an early or "proto"

version of the god Shiva, one of the main deities worshiped in Hinduism (see Figs. 3.14 and 3.15). Shiva was first depicted in art around the first century CE (2,000 years after this seal was made), and since then, his image has become common in South Asian art. His visual manifestation takes a variety of forms, including a meditating ascetic and an abstract form called a *linga*. When studying this seal, scholars saw a figure seated in a yoga pose (hands resting on knees, legs folded under body, feet pointed downward) on a low throne

surrounded by animals, and they associated it with Shiva's titles of Master Yogi and Lord of the Animals. While this is a compelling interpretation, it is worth looking closely at what the images on the seal actually depict (see details **A**, **B**, and **C**). The large size of the central figure compared to the surrounding animals, and the way in which most of those animals look toward him, suggest that the figure is probably connected to religious beliefs, but those beliefs are less clear than the object's modern name suggests.

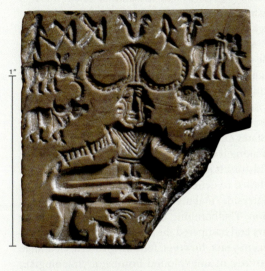

1.18 Proto-Shiva seal, with drawing of the seal impression, from Mohenjo Daro, Pakistan, Indus period, c. 2600–1900 BCE. Steatite, 1⅜ × 1⅜ in. (3.5 × 3.5 cm). National Museum, New Delhi. **SOUTH ASIA**

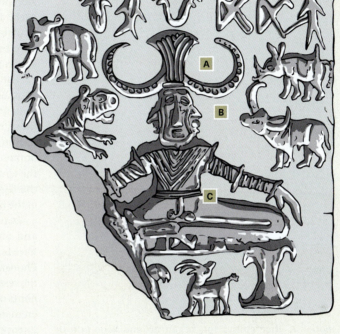

A Scholars saw a headdress with buffalo horns and related it to Shiva's sacred mount, a bull. Are bull and buffalo horns in fact the same?

B Some early scholars deduced that the figure has three faces, an attribute of Shiva. Does the figure truly have three faces, or is he wearing a mask? Perhaps he is meant to have a fourth face in the back, in which case we might associate him with the four-faced Hindu god Brahma.

C Scholars observed an erect phallus and connected it to Shiva's generative energy. Are the markings below the figure's waist phallic, or are they part of his belt buckle? Fertility and reproduction were common aspects of many early religious traditions around the world. So, even if the markings are phallic, do they necessarily link the figure to Shiva?

culture, which had no horses and the inhabitants of which lived in cities and traded over long distances. The Aryans' religion, Vedism, provided the basis for many aspects of Hinduism. It centered on belief in reincarnation and cosmic as well as social hierarchy.

Aryan society was divided into distinct groups, and this hierarchy became more and more rigid over time. By the sixth century BCE, spiritual leaders reacting against what they saw as the injustices of the social system began to emerge. The two most important of these figures were Siddhartha Gautama (c. fifth century BCE) and Mahavira (c. 540–468 BCE), the founders of Buddhism and Jainism respectively (see Chapter 3). Curiously, archaeological remains from this period are relatively minimal. What has been found consists chiefly of simple pottery and copper and iron implements. Thus, from the fall of the Indus culture until around 250 BCE—a period of about 1,500 years—there is no surviving evidence of a writing system, sculpture, or urban structures in this region.

Early Southeast Asian Art: The Neolithic, Bronze, and Iron Ages, c. 3000 BCE–300 CE

Southeast Asia can be subdivided into two regions: mainland Southeast Asia (the present-day countries of Myanmar, Thailand, Laos, Cambodia, and Vietnam) and maritime or island Southeast Asia (Malaysia, Brunei, the Philippines, Singapore, and Indonesia) (**Map 1.3**, p. 36). Although Southeast Asia is the location of some of the oldest human fossil remains (Java's Solo Man, dating to 1.8–1.9 million years ago) as well as some of the oldest cave paintings in the world (see the example from the Maros-Pangkep caves, **Fig. 1.1**), there is still much we do not know about the early history of the region. Based on the archaeological record uncovered so far, scholars have pieced together a general chronology suggesting that people migrated from China to Southeast Asia, moving southward from the mainland to the islands, between roughly 4000 BCE and

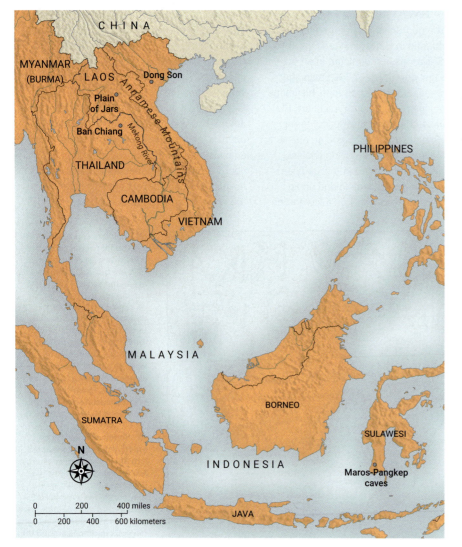

Map 1.3 Southeast Asia, showing the Plain of Jars region, Ban Chiang, and Dong Son.

megalith a large stone used as, or as part of, a monument or other structure.

Rather, approximately 2,500 to 3,000 large stone jars lie scattered over 386 square miles (621 km) in the northern foothills and plateau of the Annamese mountain range that runs through Laos into Vietnam and Cambodia. The solid stone jars, which can be up to 9 feet (2.7 m) high and 3 feet (91.4 cm) wide, are clustered together in groupings, ranging from 1 to 350 jars. Most are sandstone, but some are made of granite and limestone. They were fashioned with iron tools, which dates their construction to between about 500 BCE and 200 or 300 CE. Some jars have rims; stone lids, which the rims would have supported, have been found nearby. A few vessels contain bones and cremated human remains, indicating that they had some relationship to burial practices. But what exactly was that relationship? And what society constructed these impressive megaliths, which can weigh up to 15 tons (13,600 kg) each? Even if the stone was sourced from the closest available deposits, making and moving such jars would have taken a vast amount of human labor and power, suggesting a social structure that organized the work.

The mid-to-late twentieth century was not kind to Laos. Between 1964 and 1973, during the Vietnam War, the United States Air Force dropped 260 million cluster bombs there, making it one of the most heavily bombed countries in history. It is estimated that some 78 to 80 million bombs failed to detonate upon landing; they still litter the countryside, making it dangerous to live or work in the region. The bombing destroyed or damaged many of the jars and hampered the study of those that remain.

In recent years, however, following careful clearance and marking of unexploded bombs, archaeologists have been able to study several of the jar sites. Of these, Phonsavan is the most impressive and complete. There, the vessels are scattered around a hill containing the remnants of an ancient crematorium. Archaeologists found cremated remains inside some of the jars, but they also uncovered burial pits in the adjacent ground. Thus, it is unclear whether the jars were burial sites themselves, grave markers, or something else. Some archaeologists think that the jars were used as distilling vessels, meaning that a corpse would be placed inside the jar to decompose for a length of time before being moved to the crematorium for the next phase of the funeral rites. Excavations have also unearthed burial offerings, including glass and carnelian beads, bronze bells and bracelets, iron spearheads, and cowrie shells that must have come from the coast. This evidence suggests that the area was part of an ancient overland trade route connecting the Mekong River and the Gulf of Tonkin.

The best-known and most important site for early pottery production in Southeast Asia is Ban Chiang in northeast Thailand. Discovered by accident in 1966 and excavated in the 1970s, it changed people's perceptions of early Thai culture, which was relatively unknown before that time. The site has a long history of occupation, from as early as 3000 BCE, and objects from the Neolithic, Bronze, and Iron Ages have been found there. As with other early Southeast Asian finds, the surviving objects are primarily grave goods.

The most visually distinctive of these goods are buff-colored ceramic vessels featuring rust-colored designs.

1600 BCE. Rice cultivation began around 3000 BCE in parts of Southeast Asia, and whether bronze casting came from China or was developed locally is still debated, but this significant technological development had spread throughout all of Southeast Asia by 500 BCE, when iron technology also appeared. Societies in Southeast Asia seem to have been localized and village based, with evidence of trade networks and stratification (meaning the dividing up of people into different categories based on socio-economic and other factors) by around 1000 BCE. Material evidence of writing systems or urban centers, comparable to those found in China, the Mediterranean, and the Indus region, dates to later, around 300–500 CE.

During the Neolithic, Bronze, and Iron Ages in Southeast Asia (*c.* 3000 BCE–300 CE), a wide variety of artifacts was produced, from wall paintings to glass beads. Most found objects from these periods are grave goods, meaning they come from human burials. The three main types of objects are **megaliths**, ceramics, and bronzes.

Perhaps the most enigmatic and visually striking of the megalith sites is the Plain of Jars, in what is today the Xieng Khouang province of central Laos (**Fig. 1.19**). It is not actually a plain, nor is it a single site.

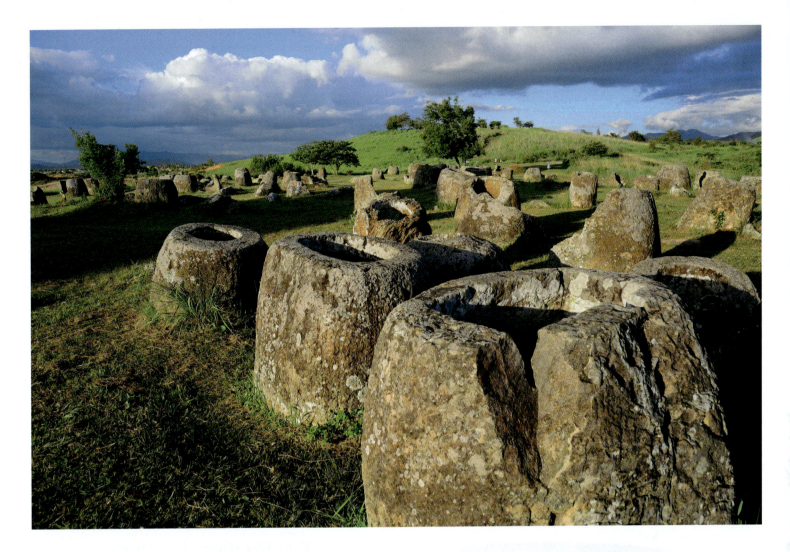

The earliest Ban Chiang pottery, datable to *c.* 1000–300 BCE, featured impressed or incised designs. These early examples of pottery were often broken intentionally before they were added to the grave. In contrast, pots made between *c.* 300 BCE and 200 CE (**Fig. 1.20**) bear painted designs and were buried intact, though the reason for this change remains unclear. The pots were placed on top of the body, along with iron and bronze objects and glass beads.

Ban Chiang ceramics display a huge range of decoration, and some scholars speculate that designs varied from village to village. In general, however, they rarely depict people or animals, in contrast to earlier art from Southeast Asia, such as the Maros-Pangkep cave paintings (see **Fig. 1.1**). The artists seem to have preferred abstract designs, particularly spiral patterns, covering the jar's entire surface area. Especially notable is the skill of the painting's execution and the way it corresponds to the vessel's form. The makers applied the lines freehand, creating spirals that follow the jar's contours, with their centers at the widest part of its body. Different patterns were used for the narrow point of the neck. Overall, the subtlety of the design highlights the elegance of the jar's shape.

While small bronze items have been found at both Ban Chiang and the Plain of Jars, the most impressive—and largest—bronze specimens from early Southeast

1.19 TOP **A cluster of stone burial jars on the Plain of Jars,** Xieng Khouang province, Laos, Iron Age, *c.* 500 BCE–300 CE.
SOUTHEAST ASIA

1.20 ABOVE **Clay jar,** Ban Chiang, northeastern Thailand, 300 BCE–200 CE. Painted pottery, height 15 in. (38.1 cm). British Museum, London.
SOUTHEAST ASIA

Asia come from Dong Son in what is today northern Vietnam. The Dong Son culture, which seems to have been concentrated around the Red River valley, had extensive agricultural settlements with some fortified sites. There, roughly between 600 BCE and 200 CE, bronze drums were made, including the Song Da drum shown here (**Fig. 1.21**). It is 2 feet (61 cm) high; the largest that have so far been found are more than 3 feet (91 cm) high and weigh up to 220 pounds (100 kg). Roughly 200 have been discovered over a substantial geographic area from present-day Cambodia to Indonesia, with still more currently being found. This spread demonstrates the extent of the trade network at the time, as well as the appeal of the drums. Most were discovered in the tombs of high-ranking figures, but they also seem to have been objects of prestige in leaders' day-to-day lives.

All Dong Son drums share a similar design: a flat face, sides that taper inward, a flared foot, and handles on the sides. The top bears a concentric design in **low relief**. Cast using either the **piece-mold** or **lost-wax** technique, these drums display considerable metal-casting skill. Hollow and without a bottom, the drums would have reverberated sound when hit. Some scholars believe players would have tilted the drums or perhaps placed them on their sides, suspended with ropes through the handles, to hit them. Others believe they were pounded from above. The relief on one surviving drum includes an image of a scaffolding system built above a drum from which individuals used poles to strike its top.

The surface designs offer other intriguing clues about cultural practices and the drums' significance. Rings of geometric designs alternate with rings featuring humans and animals. Birds, particularly water birds, play a prominent role, and frogs repeatedly appear on many of the drums, suggesting a water theme. There are also men with feathered headdresses performing rituals, some using drums (as noted); scenes of rice cultivation and war; and houses and boats. Notably, the houses are depicted raised on piles with large boat-shaped roofs, very similar to the distinctive houses that the Toraja, an Indigenous ethnic group, still construct on the island of Sulawesi in Indonesia. The very center of the surface, where the drum would have been hit, is typically marked with what might be a star or sun shape; however, some scholars have suggested it is a splash, related to the water imagery found on the drum. The prevalence of the water theme on the Dong Son drums has led some art historians to speculate that they were used in rituals to summon the monsoon rain. Others have suggested the drums were used during death rituals or war.

These drums encapsulate three broad themes found throughout much of Southeast Asian visual culture: the centrality of water, the extensiveness of trade, and the significance of the invisible to an object's potency. Art historians often think about the visible as the most important aspect of art. But in Southeast Asia, in certain contexts, the invisible—the unseen world believed to be inhabited by spirits—was a big part of the motivation for the creation and design of an artwork, and success in communicating with the invisible world was the measure of its value. The creators of the Dong Son drums may have believed that the instruments' reverberations connected the physical tangible world with the power of the unseen realm.

More Questions than Answers

On the face of it, what is past is settled. Yet even a relatively short introduction to the earliest art in Asia demonstrates that the past more closely resembles an ever-changing construction zone. Indeed, the construction of Asia's mega-cities and their transportation infrastructures has inevitably required digging deep into the ground, routinely unearthing the remains of forgotten cultures. At many sites, such as Shimao in present-day China and elsewhere throughout Asia, the work of international teams of archaeologists is ongoing. New scientific methods of dating are revising timelines (only in 2011 were the Maros-Pangkep cave images determined, by means of analyzing the radioactive decay of uranium isotopes, to be 35,000–40,000 years old), and thanks to advances in satellite photography and ground-penetrating radar like LiDAR, which stands for "light detection and ranging" (see Art Historical Thinking: Situating Monuments within Wider Visual Contexts, p. 157), more and more sites and objects are being located. As archaeologists, art historians, and other scholars study these artifacts, long-standing conventional views of ancient cultures are challenged, revised, and supplanted. As soon as discoveries are made, digital means of communication can spread the news around the world. Our appreciation for our ancestors' skills and creativity deepens as the study of ancient art routinely provides fresh surprises that astound us and fuel more questions.

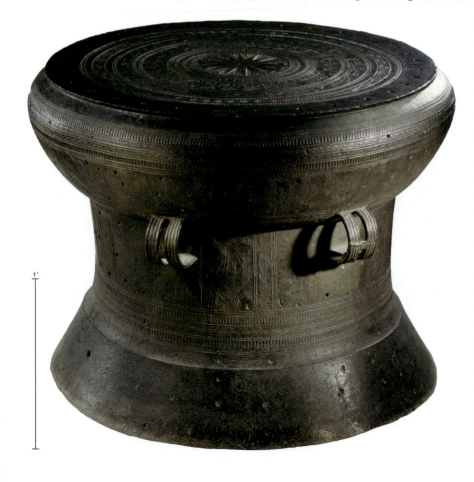

1.21 Song Da drum (also known as the Moulié Drum), from northern Vietnam, Dong Son culture, 600 BCE–200 CE. Bronze, height 24 in. (61 cm), diameter 30 in. (76.2 cm). Former Moulié collection, Musée national des arts asiatiques Guimet, Paris.
SOUTHEAST ASIA

Discussion Questions

1. This chapter discusses several media for artwork: clay, jade, and bronze among them. Choose an artwork to explain how the physical and visual properties inherent to the medium are related to the resulting artwork.

2. One of the major themes of this chapter is how much remains unknown about these early Asian cultures. What are some of the things that are unknown, and what would we have to discover to be able to answer them?

3. Artwork may represent the human body accurately or it may purposefully distort it. Select from this chapter one work that depicts a human body to describe and analyze. Which features of the body are emphasized? What artistic strategies are used to achieve that emphasis? Discuss possible reasons for that emphasis.

4. Further research: numerous more Neolithic cultures than can be described here flourished in Chinese regions. Find an artwork from another of these cultures to describe, analyze, and relate to those artworks discussed in this chapter.

Further Reading

- Barnes, Gina Lee. *Archaeology of East Asia: The Rise of Civilization in China, Korea and Japan.* Havertown, PA: Oxbow Books, 2015.
- Brumm, Adam, et al. "Oldest Cave Art Found in Sulawesi." *Science Advances* 7, no. 3 (2021): n.p.
- Coates, Karen J. "Plain of Jars." *Archaeology* 58, no. 4 (2005): 30–35.
- Habu, Junko. *Ancient Jomon of Japan.* Cambridge, U.K.: Cambridge University Press, 2004.
- Li, Liu and Chen, Xingcan. *The Archaeology of China: From the Paleolithic to the Early Bronze Age.* Cambridge, U.K.: Cambridge University Press, 2012.
- Robinson, Andrew. *The Indus: Lost Civilizations.* London: Reaktion Books, 2015.

Chronology

	CHINESE REGIONS		SOUTH ASIA
c. 18,000 BCE	The date of the earliest ceramic vessels found in Yuchanyan Cave	c. 7000–2500 BCE	The Neolithic site of Mehrgarh is inhabited
c. 4000–3000 BCE	The clay head inset with jade eyes is made by the Hongshan culture, Liaoning province	c. 3500 BCE	The Indus city of Harappa begins to be inhabited
c. 3500–2000 BCE	Jade *bi* and *cong* are made by the Liangzhu culture, Yangtze River delta	c. 2600–1900 BCE	Indus society flourishes; the Great Bath is constructed at Mohenjo-Daro; bronze sculptures and steatite seals are produced
c. 3300–2000 BCE	Painted pottery is made by the Majiayao culture, Gansu province	c. 1900–1700 BCE	Indus cities begin to be abandoned
c. 2000 BCE	People of the Longshan culture build and live in a walled city at the Shimao site, Shaanxi province	c. 1500–1000 BCE	Indo-Aryan groups migrate into northwest India from Central Asia
	JAPANESE ARCHIPELAGO	c. 1500–800 BCE	The Vedas are composed in northern India
c. 13,000–2500 BCE	Early evidence of Jōmon culture dates to the Incipient Jōmon period (c. 13,000– c. 8000 BCE), followed by the Initial Jōmon (c. 8000–5000 BCE) and Early Jōmon (c. 5000–2500 BCE) periods		SOUTHEAST ASIA
c. 2500–1500 BCE	Vessels with flame-like ornamentation are made during the Middle Jōmon period	c. 37,000–34,000 BCE	Cave paintings are made in Sulawesi, Indonesia
		c. 3000 BCE onward	Rice cultivation is practiced in Southeast Asia
c. 1000–400 BCE	Following the Late Jōmon period (c. 1500– 1000 BCE), during the Final Jōmon period *dōgu* figurines characterized by large eyes and wide hips are made	c. 1000 BCE– 200 CE	Ban Chiang ceramics are produced in Thailand
	KOREAN PENINSULA	c. 600 BCE– 200 CE	The Dong Son culture in Vietnam produces and distributes bronze drums
c. 8000–1500 BCE	Ceramics with comb-patterns are made during the Jeulmun period	c. 500 BCE– 300 CE	Iron technology develops in Southeast Asia
c. 6000–1500 BCE	The Bangudae petroglyphs are created	c. 500 BCE–300 or 200 CE	The Plain of Jars is created in Laos

Art in Early East Asia through the Han Dynasty

1200 BCE–200 CE

2.0 Cavalryman and horse, from Pit 2,
tomb complex of the First Emperor of Qin,
China, Qin dynasty, *c.* 210 BCE.

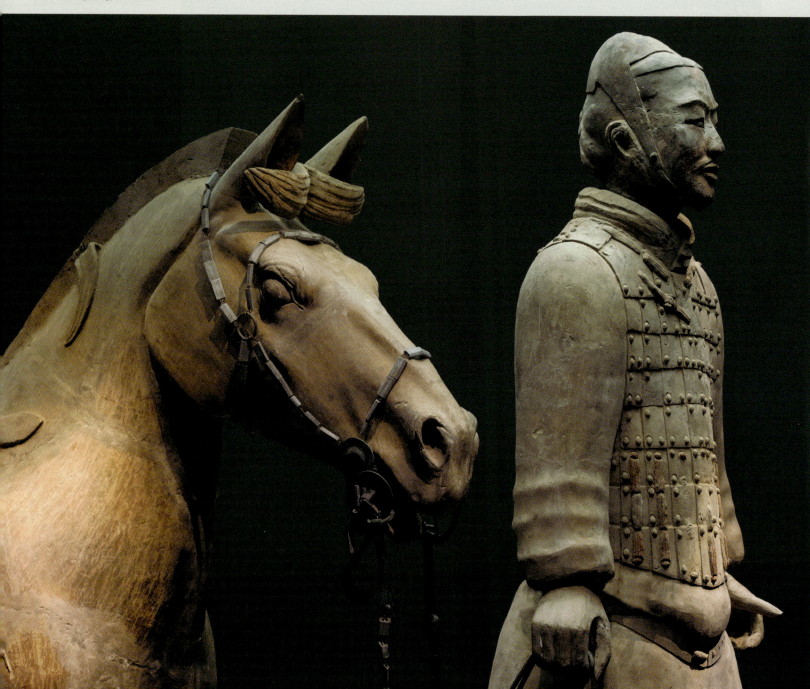

Introduction

The story of ancient art in East Asia continues on from the end of the Neolithic period with the formation of early states with larger populations and centralized governments. These states also possessed the wealth, power, and knowledge for making ever larger and more elaborate objects in a fairly new medium: bronze. Bronze represents a significant technological achievement, requiring not only metallurgical knowledge of how to combine copper and tin to form a durable and attractive alloy, but also the organization and coordination of many kinds of unskilled and skilled labor. In areas of present-day China, archaeologists have found evidence of bronze technology as early as 2750 BCE. By 1200 BCE objects of extraordinary size and sophistication—including weapons, ritual vessels, and sculptures, which served both practical and symbolic functions—were being cast in several distinct regions. These artifacts attest to a dynamic Bronze Age comprised of multiple centers that undoubtedly experienced indirect exchange, and may even have had direct contact with one another.

In the area of the Shang state (centered around Anyang), written records dating from about 1200 BCE supplement the material record, adding to our knowledge of a centralized government, hierarchical society, and religion that venerated ancestors. Writing proved valuable to the Zhou (c. 1050–256 BCE), too, who conquered the Shang. The continuity of writing and record-keeping undergirds a linear progression of history from one dynasty to the next, but the material record presents a more complex picture. Just as the Shang state was not alone in making bronze objects, so too during the Zhou there is evidence of cultures outside the Zhou realm. Over the course of the Zhou, bronze technology spread across the East Asian mainland, giving rise to a variety of techniques, styles, and forms, the latter including elaborate assemblages of bells.

The last centuries of the Zhou were marked by strife among numerous warring states, terminating in the brief, but nonetheless significant Qin dynasty (221–206 BCE), which established a centralized, imperial government. The bureaucratic control that propelled the Qin to successful conquest is also apparent in the terra-cotta army of the tomb of the First Emperor. Strict adherence to standards generated order and efficiency, but repressive measures fueled rebellion. The ensuing Han dynasty (206 BCE–220 CE) was more moderate and longlasting. The expansive empire extended west to include important trade routes that led to West Asia and Europe, and east to parts of the Korean peninsula. A variety of artifacts attests to the heterogeneity of the Han, during which time Confucianism and Daoism informed attitudes about the human world, the cosmos, and life after death.

Art from Three Early Bronze Age Cultures, c. 1200–c. 1050 BCE

Often the term "Shang dynasty" is used interchangeably with "Bronze Age" in China, but this usage encourages two misconceptions. First, it suggests an abrupt change at the start of the dynasty (c. 1500 BCE), when in truth, the transition from the **Neolithic** to the **Bronze Age** was more gradual, as indicated by archaeological sites such

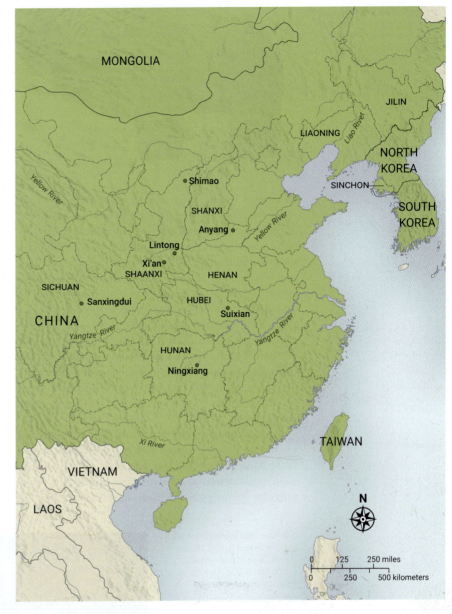

as Shimao (see Fig. 1.10). A second misconception is the emphasis given to the Shang over contemporaneous, bronze-producing cultures. As in the case of ceramics (see Chapter 1), stylistic traits in **bronze** objects suggest distinctiveness, but also contact, among several Bronze Age cultures. Here, we examine artifacts—especially, but not exclusively, bronzes—from three cultures or regions: the Shang; Ningxiang in present-day Hunan province (sometimes described, due to its location, as "southern"); and the site of Sanxingdui in present-day Sichuan province (**Map 2.1**).

An archaeological discovery that has proven immensely valuable for understanding Shang culture is the tomb of Lady Fu Hao (died c. 1200 BCE), a consort to the king Wu Ding. Excavated in 1976 in Henan province, near the royal necropolis of the Shang, the tomb is much smaller than the king's final resting place, but Fu Hao's tomb had not been disturbed or looted, as had other royal Shang tombs.

More than one thousand objects made of bronze, ceramic, bone and ivory, stone and **jade** were buried with Fu Hao. Many of these objects had ritual functions, but

Map 2.1 East Asian sites, c. 1500 BCE–c. 206 BCE.

Neolithic a period of human history in which polished stone implements prevailed, roughly beginning about 10,000 BCE and persisting until the use of bronze metal implements.

Bronze Age a period of human history characterized by the use of bronze, beginning around 4000 BCE, but different according to particular geographical area; ends with the advent of iron technology.

bronze an alloy consisting primarily of copper with some tin, and often small amounts of other metals and/or minerals.

jade a general term for hard, typically green minerals, including nephrite and jadeite.

2.1 Figure of an elephant, from the tomb of Fu Hao, Anyang, Henan, China, Shang dynasty, c. 1200 BCE or slightly earlier. Jade, length 2⅜ in. (6 cm). Institute of Archaeology, Beijing.

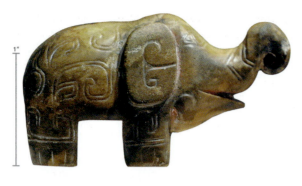

some were luxury items. Among the latter is an exquisitely made small jade elephant (**Fig. 2.1**). Parts of the animal have been simplified, including the legs, but sensitive modeling is evident in the contours of the body, mouth, and trunk. Fine lines define the eyes and ears, and a pattern of hooked spirals covers the body. The curl at the end of the trunk cleverly provides a hole that allowed the elephant to be worn as a pendant. The less stylized form, compared to other Shang jade objects, connects it with jade-working traditions from areas outside of Shang culture with which the Shang traded or had other connections (for jade in earlier, Neolithic cultures, see Figs. 1.7–1.8). Whether the object was made in those other regions or by Shang artists in the foreign style is unknown.

In addition to jewelry and luxury goods, Fu Hao had 130 bronze weapons buried with her, including this ceremonial ax blade, or *yue* (**Fig. 2.2**), which may have been used for ritual decapitation in human sacrifice. The rectangular openings in the blade suggest that originally

it would have been tied to a wooden handle. The wood has long since disintegrated, but the bronze blade—no longer gleaming, but oxidized over time to form a greenish **patina**—remains evidence of the advanced state of bronze technology in the Shang dynasty.

Even though functionality was a major consideration for Fu Hao's ax blade, its visual qualities were not neglected. The ax's symmetry is underscored by the design of two identical mirror-image tigers, each with open jaws that surround a human head. Although simplified, the head has a **naturalistic** quality as it emerges from the background. By contrast, the **stylized** tigers are composed of squared spirals and curlicues locked into a two-dimensional plane. The powerful image of the tigers about to make a meal of the human head aptly captures the ax's potential function as the instrument of ritual decapitation. Besides possibly relating to the ax's use, the design also provides evidence of the circulation of images and ideas around 1200 BCE. Visual precedents for the tigers-and-human-face **motif** are found in artworks from regions south of the Shang state.

Another important feature on this ax is Fu Hao's name, which is cast below the human and animal decoration and attests to her ownership of the ax (**Fig. 2.2a**). In addition to bronze casting, the Shang culture is characterized by its invention of written language. Writing was bound to divination, ritual, and power, and most surviving examples appear to be royal in origin. **Oracle bones** consisting of turtle plastrons (the underside of the turtle's shell, **Fig. 2.3**) and ox shoulder blades were used for divination in the Shang state, as well as to support the authority of the king. Such objects preserve some of the

2.2 RIGHT ***Yue* (ceremonial ax),** from the tomb of Fu Hao, Anyang, Henan, China, Shang dynasty, c. 1200 BCE. Bronze, 15½ × 15⅛ in. (39.4 × 38.4 cm). Institute of Archaeology, Beijing.

patina a layer of color applied to, or occurring along with related physical changes naturally over time upon, an object.

naturalistic representing people or nature in a detailed and accurate manner; the realistic depiction of objects in a natural setting.

2.2a BELOW **Drawing of the inscription of Fu Hao's name,** cast into the ceremonial ax (modern drawing).

stylized treated in a mannered or non-naturalistic way; often simplified or abstracted.

motif a distinctive visual element in an artwork, the recurrence of which is often characteristic of an artist's or a group's work.

oracle bones turtle plastrons and ox shoulder bones used for divination in the Shang state. Oracle bones are among the earliest examples of Chinese writing.

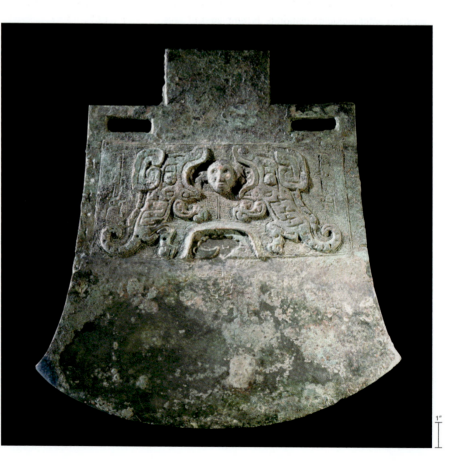

earliest examples of Chinese writing. They are evidence of royal attempts to communicate with ancestors in the spiritual realm. Following these communications, the king would offer the appropriate sacrifices to ancestors, who it was believed would ensure the dynasty's prosperity by interceding with the gods.

The sacrificial offerings—food and drink—were then served to the ancestors in ritual vessels made of bronze, a distinguishing characteristic of Shang culture. Some bronze vessels were made for the aristocracy, whose

offerings to their ancestors had little or no political implications. But a great many were used by the king, whose offerings to royal ancestors were essential for maintaining power and authority, and so the manufacture of bronze vessels represented both a political priority and an economic commitment. Compared to Neolithic cultures, the Shang state commanded significantly more resources. A hierarchical, centralized bureaucracy organized human labor and specialized knowledge to transform raw minerals into gleaming bronze vessels. Whereas making an object from clay and jade required only a few artists, creating a bronze object required dozens, perhaps hundreds of artists and workers. The Shang king's ability to devote so much labor to bronze manufacture came from his political authority, and the resulting royal vessels were used in rituals that further legitimized his power.

There is evidence of both human and animal sacrifice in Shang royal burials, so Fu Hao's ax may have been used in such rituals. However, the central ritual of the Shang state involved food offerings to ancestors in the belief that their perceived ability to communicate with the gods benefited the dynasty. The Shang manufactured thousands of ornamented, shiny bronze vessels in a variety of shapes and sizes for the purpose of communion with the spiritual, unseen realm. The visual power of any one vessel would be substantially magnified when assembled by the dozens, and sometimes hundreds, to form impressive sets.

This rectangular cauldron, or *fang ding*, is one of a pair bearing Fu Hao's name (**Fig. 2.4**). The *fang ding* and Fu Hao's ceremonial ax share a common visual vocabulary of stylized animals, spirals and hooks, and a preference for symmetry. Dominating the ornament, the composite animal mask on all four sides of the vessel's body is typical of the Shang. The animal, called a *taotie* by

2.3 FAR LEFT **Oracle bone, Shang dynasty,** *c.* 1300–1050 BCE. Fragment of tortoise plastron (photograph superimposed on reconstruction drawing of whole plastron), 3 × 3⅞ in. (7.6 × 9.8 cm). Freer Gallery of Art, Smithsonian Institution, Washington, D.C.

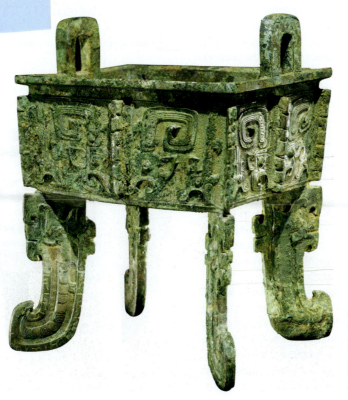

2.4 *Fang ding* **with** *taotie* **design,** from the tomb of Fu Hao, Anyang, Henan, China, Shang dynasty, *c.* 1200 BCE or slightly earlier. Bronze, height 16⅝ in. (42.2 cm). Institute of Archaeology, Beijing.

taotie the name given to the composite animal mask frequently found on Shang bronzes.

MAKING IT REAL • Piece-Mold Bronze Casting

The bronze vessels of the Shang and Zhou dynasties are distinguished not only by their forms and ornament, but also by their process of manufacture. Instead of the lost-wax technique (known in Africa and Europe), Shang and Zhou bronzes typically make use of piece-mold casting. Rituals for feeding the ancestors required many, nearly identical vessels organized into sets. For example, Fu Hao's tomb included forty *jue*, spouted vessels for offering drinks. Piece molds allowed for the division of creative labor, and thus they presented the most efficient means of making not one, but multiple bronze vessels that were nearly identical.

To make a piece mold for a *fang ding*, a ceramicist first presses slabs of damp, pliable clay around the exterior of a model (Fig. 2.5). Two additional clay mold pieces form the interior cavity and the space within the legs. The piece for the interior cavity could be made by shaving down the original model.

Next, the clay mold pieces are baked and fitted together with spacers that allow molten bronze to be poured into the mold. After the metal has cooled, the mold pieces must be broken (and effectively destroyed) in order to release the newly cast bronze object.

The final steps involve finishing and polishing. In the early development of bronze technology, seams in the mold may have allowed extraneous metal to seep out at the corners. In many cases this seepage was cut away, but in other cases the excess bronze inspired further elaboration of protruding flanges (see **Figs. 2.4** and **2.6**). The flanges extend the vessel beyond its own frame. This dynamic effect would have been heightened by the vessel's reflective surface, but as a result of oxidation many bronzes now have a greenish color and mottled texture called a patina.

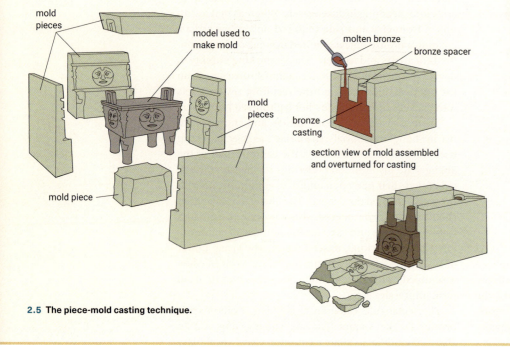

mold pieces

model used to make mold

mold pieces

mold piece

molten bronze

bronze spacer

bronze casting

section view of mold assembled and overturned for casting

2.5 The piece-mold casting technique.

boss a round, knob-like projection.

zoomorphic having an animal-like form.

anthropomorphic described or depicted with human characteristics (in art: images of people).

later antiquarians of the Song dynasty (see Chapter 8), is organized around a central ridge rising from snout to forehead. To the sides are large horns, eyes like **bosses**, ears, and curved teeth, or tusks. Sometimes the creature's body is splayed, with right and left halves placed to the sides of the mask-like face, but in this example, smaller creatures occupy the spaces toward the corners. Fine, squared spirals crowd the spaces around the *taotie*, creating a dense visual pattern that contrasts with the plain, sturdy quality of the rim and handles.

Since the Shang themselves did not record their understanding of the *taotie*, its precise meaning is a matter of ongoing debate. Some scholars contend that the *taotie* represents something, perhaps a sacrificial animal or a deity assuming animal form. Others argue that the *taotie* evolved as an ornamental pattern emerging from the relationship between design and technique in bronze casting. A third interpretation emphasizes function and impact, claiming that objects decorated with *taotie* conferred prestige on powerful members of society while instilling fear among the lower classes.

Impressive as it was, the Shang was not the only Bronze Age culture on the East Asian mainland. Typically, Shang ritual vessels feature straight legs, but the legs on Fu Hao's *fang ding* are **zoomorphic**, a stylistic feature more typical of bronzes found in Ningxiang, south of Anyang. Conversely, Ningxiang bronzes demonstrate appreciation for forms and styles of Shang vessels.

The form of this *fang ding* (**Fig. 2.6**) from Ningxiang in present-day Hunan province is based on Shang precedent, but a human face replaces the taotie. **Anthropomorphic** imagery of any kind is rare in the Shang culture; moreover, the style of the face rejects the Shang vocabulary of hooks and spirals in favor of a more naturalistic modeling

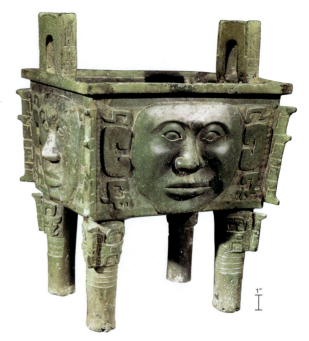

2.6 FAR RIGHT ***Fang ding* with human face,** from Ningxiang, Hunan, China, *c.* 1200–*c.* 1050 BCE. Bronze, height 15⅛ in. (38.4 cm). Hunan Museum, Changsha, China.

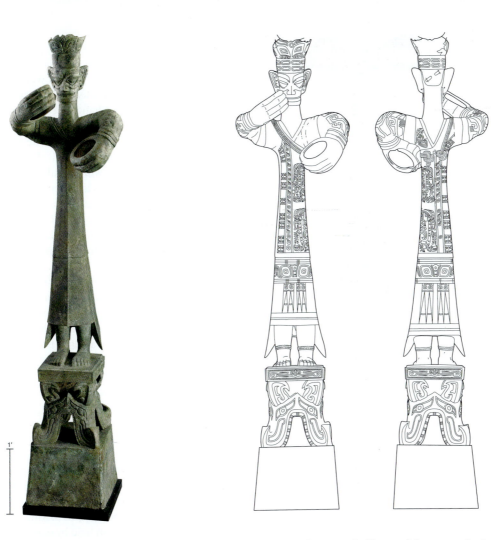

2.7 FAR LEFT **Standing figure** from Pit 2, Sanxingdui, China, c. 1300–c. 1100 BCE. Bronze, height 8 ft. 7 in. (2.62 m). Sanxingdui Museum, Guanghan, Sichuan province, China.

2.7a LEFT **Standing figure, drawing of front and back,** showing detailed ornamentation.

of deep-set eyes, broad nose, curved cheekbones, and fleshy lips. The face, gazing steadily outward from all four sides of the *fang ding*, invites speculation but offers no firm answers as to its identity and purpose. The **abstract** patterns surrounding the faces, and the flanges projecting from the corners, follow Shang conventions. These features, along with the *fang ding* form, suggest that this southern culture, for which we have no name, may have adopted the same types of ritual food offerings that were central to the Shang.

The Ningxiang *fang ding* suggests that the Shang shared many cultural elements with other areas, but archaeologists have also uncovered evidence of early cultures whose works differed greatly in style. In 1986, at a site at Sanxingdui in Sichuan province, some 800 miles (almost 1,300 km) west of the Shang state, archaeologists found sacrificial pits filled with elephant tusks, jades, and bronzes belonging to a previously unknown culture quite unlike the Shang. One of the most startling discoveries was a life-size figure cast in bronze (**Figs. 2.7** and **2.7a**).

Elevated on a base of stylized elephant heads, this figure appears to belong to an otherworldly realm. Its long, arrow-like silhouette draws attention to a face dominated by oversized eyes that suggest acute vision. Enlarged ears and hands also imply superhuman powers. The hat or headdress adds both height and stature, and the figure's dress is finely ornamented, resembling embroidery. The enormous hands have been abstracted as if stretched in order to form cylinders. Given their slight angle, perhaps they once held one of the many elephant tusks found in the excavated pits. We do not know the figure's identity, but the visual evidence suggests a person of authority or significance. Additional bronze objects from the Sanxingdui site include oversized masks and human heads with **gilding**.

The pits at Sanxingdui also contained ritual vessels comparable to those of the Shang and the southern region. Careful archaeological and art historical analysis suggests that this culture was contemporaneous with the Shang and developed equally advanced bronze technology. Although it certainly had indirect and possibly had direct contact with the Shang, its bronze artifacts indicate a markedly different and unknown set of religious beliefs and practices.

Dissemination and Transformations of Bronze, *c.* 1050–256 BCE

The bronzes from Hunan and Sichuan provinces defy the narrative of a single Bronze Age culture in East Asia during the time of the Shang dynasty. Similarly, bronze daggers excavated in Liaoning and Jilin provinces and on the Korean peninsula (see **Map 2.1**) remind us that it is important to recognize the co-existence of diverse cultures and artistic styles in later centuries.

This slender bronze dagger from the Mumun period (1500–300 BCE) features a blade with the typical lute-shaped profile of the type known as Liaoning or, alternatively,

abstract altered through simplification, exaggeration, or otherwise deviating from natural appearance.

gilded covered or foiled in gold.

2.8 Liaoning-type dagger, Mumun period, c. 1000–c. 400 BCE. Bronze, length 17 in. (43.2 cm). National Museum of Korea, Seoul.

megalith a large stone used as, or as part of, a monument or other structure.

low relief (also called bas-relief) raised forms that project only slightly from a flat background.

Gojoseon (**Fig. 2.8**). Excavated in Sinchon county, South Hwanghae province in present-day North Korea, the dagger functioned as an object of social prestige in a culture that practiced intensive farming and **megalithic** burials. Bronze objects were comparatively rare in this region, and this dagger is further distinguished by the fine decoration on its handle. Close inspection reveals intricate saw-toothed patterns, triangles, and lozenges (diamond shapes) cast in **low relief**.

Whereas bronze artifacts were fairly uncommon on the Korean peninsula in these early centuries, they proliferated in regions associated with the Zhou dynasty (c. 1050–256 BCE), established by invaders from the west who conquered the Shang. The Zhou adopted aspects of Shang culture, including writing, ancestor worship, and bronze manufacture. To these, the Zhou added a particular belief concerning political legitimacy, called the mandate of Heaven, which could be won or lost according to the ruler's behavior. Accusing the last Shang king of wickedness, the Zhou conqueror claimed for himself the mandate of Heaven, establishing a new dynasty and putting blood relatives in positions of power throughout Zhou territories in a manner that would now be described as feudal.

A fairly orderly operation of the feudal system characterized the time when this round food vessel (**Fig. 2.9**), called a *gui*, was cast, around 1050–771 BCE. The *gui* has four zoomorphic handles that divide its belly into quadrants. The four large panels of the *gui* feature a fantastic animal with an elephantine head, a body in the form of a spiral, and intimidating quills projecting above the spiral shape. Cicadas fill the narrow spaces underneath the handles. Because the cicada's life cycle includes a period of underground dormancy before re-emergence, this insect suggested to Zhou people an extraordinary power: rebirth.

In addition to these zoomorphic designs, this vessel includes a long inscription cast into the bottom of its interior. The inscription gives it a name: the Xing Hou *Gui*, or the *gui* of the Marquis of Xing ("marquis" being a high-ranking position held by descendants of the Duke of Zhou). Further, it provides a great deal of information about its context and function, especially compared to Fu Hao's *fang ding*, which bears only her name (see **Fig. 2.4**, p. 43). The inscription reads in part (**Fig. 2.9a**):

...the king issued his decree to Rong and the Inner Court Scribe announcing, "Assist the Marquis of Xing in his [ritual] observances! I give you three kinds of servants: Zhou people, Dong people, and Yong people." We [Rong and the scribe] cross our hands and lower our

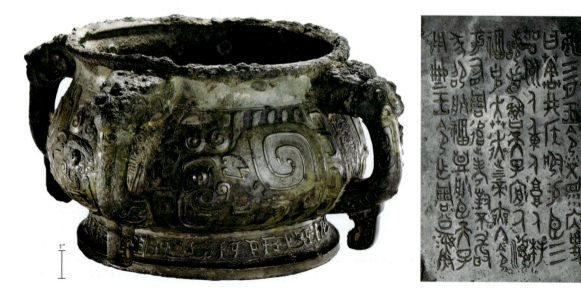

2.9 RIGHT **The Xing Hou *Gui* (vessel),** dedicated to the Duke of Zhou, early to middle Western Zhou dynasty, c. 1050–771 BCE. Bronze, 7½ × 15¾ × 15¾ in. (19 × 40 × 40 cm). British Museum, London.

2.9a FAR RIGHT **Inscription cast into the Xing Hou *Gui* (detail).**

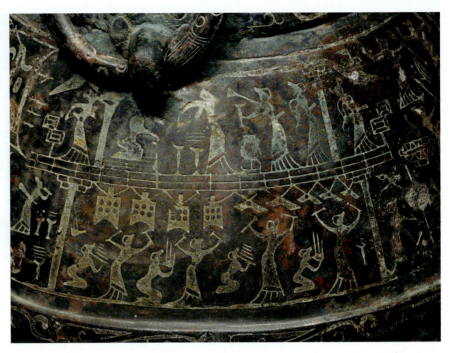

heads to praise the Son of Heaven for effecting this favor and blessing.... May Di, the High Ancestor, not end the mandate for the existence of the Zhou. We honor our deceased ancestors... Using a record of the king's decree we made this vessel for the Duke of Zhou.

The *gui* is a food container, but the inscription makes it a historical document, too. It attests to the gratitude and allegiance of a person named Rong. The king granted Rong several groups of people for the purpose of supporting the Marquis of Xing. In casting this record into the body of the *gui*, Rong made visible his political connections, his religious beliefs, and his confidence that the Zhou continued to possess the mandate of Heaven. For Rong and his contemporaries, the value of this vessel derived from the combination of the material properties of bronze, its use in sacrificial rituals to the ancestors, the imagery of powerful creatures that adorn its exterior, and the declaration cast in its interior.

Ideally, the dukes, marquises, and other lords would have cooperated with the Zhou king. In reality, however, they competed with him at times, especially during the later centuries of the Zhou dynasty. In that tumultuous period, political philosophers such as Master Kong, also known by the Latinized name Confucius (551–479 BCE), sought advisory positions at various courts. By Confucius' time, the Zhou capital had shifted east, giving rise to the historical divisions now called the Western Zhou (*c.* 1050–771 BCE) and Eastern Zhou (770–256 BCE) periods.

During the increasing political instability of the Eastern Zhou period, a variety of new features, forms, and techniques emerged in bronze manufacture. Lengthy inscriptions offered one means of making a vessel distinctive. Other strategies included unusual shapes and bird-like patterns; the application of elaborate, **lost-wax filigree**; and contrasting **inlays** of semi-precious stones or metal. This wine vessel, called a *hu*, uses inlaid metal to depict human activities (**Fig. 2.10**).

Separated by bands of abstract designs, three wider **registers** show scenes of women and men. The top register features figures—possibly female, as an association between women and sericulture emerges around this time—gathering mulberry leaves. These leaves would have fed silkworms, the cocoons of which are the raw material of silk. (Some pieces of silk survive from the Warring States period, *c.* 450–221 BCE, which includes the last portion of the Eastern Zhou dynasty and the decades before the first unification of China under the Qin state.) In lower registers, archers take aim at passing birds, rowers paddle watercraft, and soldiers in tunics engage in combat. Human figures are represented in profile, and scenes are stacked atop one another with little attempt to render depth or atmosphere. Instead, the emphasis is on conveying the activities with clarity.

In a scene set between columns in the *hu*'s middle register, several kneeling figures play panpipes while other standing figures extend both arms up toward stone chimes and bronze bells hanging from above (**Fig. 2.10a**). A complete set of such bells survives in the excavated tomb of the Marquis Yi of Zeng (**Fig. 2.11**, p. 48). This brightly **lacquered** wood rack, with uprights in the form of sculpted soldiers (see the left and right ends of the rack), supports an array of thirty-six bells. The bells are decorated with multitudes of snake-like forms and prominent bosses. To achieve a wide tonal range, the bells come in a variety of sizes weighing between 14 and 175 pounds (*c.* 6–80 kg). The oblique shape of each bell permits it to sound two different tones, depending on where it is struck. What prompted such expert engineering and prodigious use of bronze for objects other than weapons and ritual vessels? The answer lies in the important role assumed by music, especially as the tools of Shang kingship—bronze and writing—were desacralized as they came into widespread use. Sacred music, as Confucius maintained in his writings, was essential for the proper conduct of rituals. (Note that on the bronze

2.10 ABOVE LEFT *Hu* with pictorial decoration, Eastern Zhou period, mid-sixth to mid-fifth centuries BCE. Bronze with metal inlay, 13 × 8¾ in. (33 × 22 cm). Royal Ontario Museum, Toronto, Canada.

2.10a ABOVE RIGHT Detail of inlaid decoration on the *hu*.

lost-wax casting a method of casting metals such as bronze in which a clay mold surrounds a wax model and is then fired; when the wax melts away, molten metal is poured in to fill the space.

filigree a type of decoration typically on gold or silver, characterized by ornate tracery.

inlay decoration embedded into the surface of a base material.

register a horizontal section of a work, usually a clearly defined band or line.

lacquer a liquid substance derived from the sap of the lacquer tree, used to varnish wood and other materials, producing a shiny, water-resistant coating.

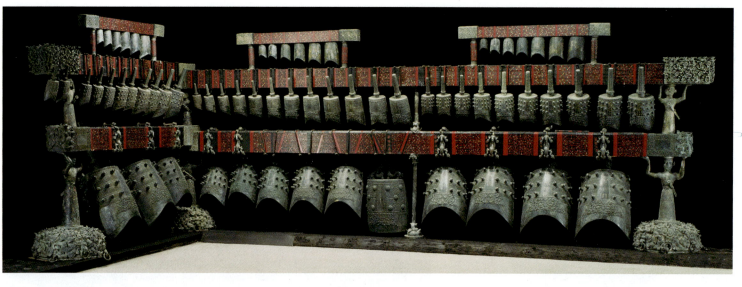

2.11 Racks of bells from the tomb of the Marquis Yi of Zeng (died *c.* 433 BCE). Suxian, Hubei, China. Bronze and lacquered wood, length 24 ft. 6 in. (7.47 m), height 8 ft. 10 in. (2.69 m). Hubei Provincial Museum, Wuhan, China.

hu shown in **Fig. 2.10a**, a scene of courtly ritual appears in the register directly above the scene featuring musicians.) Such performances, like the singing of national anthems in public ceremonies today, were intended to create unity and harmony (quite literally) and may have been especially affecting in the Warring States period.

Conquest and the Terra-cotta Army of the First Emperor of Qin

Confucianism was but one of the many philosophies that proliferated during the fractious Warring States period. Where Confucianism sought to nurture mutually responsible relationships as the basis for a harmonious society, one of the rival philosophies known as Legalism relied on a system of rewards and punishments to ensure social stability. Among the warring states, Qin adopted Legalism and, from their homeland in the western regions, Qin armies marched eastward, conquering their opponents in order to establish a single, centralized state in 221 BCE.

Along with military might and technological knowhow, the Qin overwhelmed their enemies with superior organization. Rules and standards were established centrally, and lower-level administrators carried them out across the empire. In this way, the Qin standardized writing, weights and measures, and axle widths and roads, making the Qin state more efficient than its neighbors in communications, trade, and transportation.

Even while standardizing measurements and building his empire, the First Emperor of Qin began work on his tomb and its extraordinary **terra-cotta** army (**Figs. 2.12** and **2.13**). Sometimes this formidable person is called Qin Shihuangdi, which is not a name, but a title: "Shi" means "first"; "huangdi" means "emperor"; and "Qin" is the name of his dynasty. The resulting Qin Empire gives us the source of the name "China."

Located in present-day Xi'an, the site of the First Emperor's tomb is monumental, measuring 1.2 miles (2 km) north–south by 0.6 mile (1 km) east–west (**Fig. 2.12**). Beneath the burial mound, his tomb has yet to be excavated, owing to concern about how to preserve the contents. But outside the walled complex, archaeologists

terra-cotta baked clay; also known as earthenware.

have revealed several cemeteries—for convicts, conscript laborers, and craftspeople, as well as officials who sought a prestigious burial site near the emperor—and furnished pits related to the First Emperor's tomb. In a cluster of pits east of the complex, archaeologists have uncovered thousands of terra-cotta warriors who stand in rank and file, forever facing enemy lines and suggesting how the First Emperor succeeded in uniting so immense a realm (**Figs. 2.0** and **2.13**). Although the terra-cotta army was intended to serve the emperor in the afterlife, it provides evidence of the military power, technology, and bureaucracy that propelled the Qin state to victory during his lifetime.

The manufacture of these life-size sculptures of soldiers and horses, along with the three-quarter-sized, gilt-bronze four-horse chariots, metal weapons, and exquisite bronze birds found elsewhere in the pits, depended on a high level of technology. Qin artisans demonstrated mastery of clay and control of kiln conditions

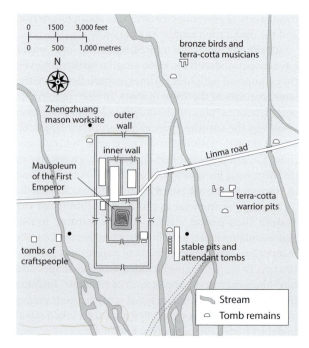

2.12 FAR RIGHT Tomb complex of the First Emperor of Qin (plan drawing).

well beyond Neolithic capability, but they did not need a deep understanding of human physiology or advanced skills in portraiture. Each terra-cotta soldier looks different from the others, but this does not mean that each was individually conceived. Rather, the soldiers reflect the standardization and division of labor that the First Emperor imposed on his empire, taking the form of limited variations of terra-cotta legs, torsos, arms, hands, heads, hair, and headgear (Fig. 2.0, p. 40). Some of these parts or modules, such as the heads, required more artistic skill. Other modules, including the legs, could be made by low-skilled workers, such as makers of roof tiles and sewer pipes.

The key to assembly and quality control was a system of work units headed by foremen or master potters, whose names are marked on the sculptures. These are not signatures that memorialize individual artistic expression; rather, they function as signs of accountability. The modular approach to manufacturing made possible the sheer quantity of soldiers, which number more than seven thousand. Just as importantly, modular manufacturing generates both efficiency *and* variation. On the basis of just a few different body parts, the terra-cotta army mimics the individuality within conformity that characterizes real armies.

Wearing armor over a tunic, the life-sized cavalryman at the beginning of this chapter stands at attention (Fig. 2.0). His hair is neatly gathered beneath a cap that is tied under his chin. His facial expression is alert and serious.

His eyebrows and eyes are simplified, but nevertheless fairly accurate. Showing none of the exaggerations of the standing figure from Sanxingdui (Fig. 2.7), the style here may be described as naturalistic, and had the original paint been preserved, this terra-cotta cavalryman's resemblance to a real soldier would have been even more pronounced. The cavalryman leads a fit and well-groomed horse that is saddled and ready for battle. The attention given to replicating such military gear as the cavalryman's uniform is also visible in other terra-cotta army soldiers, who brandished real weapons of war.

The First Emperor's tomb and his terra-cotta army offer insight specifically about the Qin dynasty, but we can also see them more generally as artifacts emerging from early East Asian cultures. Recall, for example, the different uses of clay in Jeulmun, Jōmon, and Hongshan cultures for making terra-cotta vessels and figural sculptures (see Chapter 1). Early ceramic technology also undergirds the manufacture of bronzes. From Neolithic times through the Qin dynasty, finely crafted objects continuously conferred prestige on the elite, and belief in the afterlife drove the living to bury their dead with grave goods. Writing played a role, if not always prominently, in artifacts as a means of communicating with gods, of binding sociopolitical relationships, or of ensuring quality in manufacture.

In other ways, however, the Qin dynasty repudiated earlier cultures. Even as the Qin state standardized writing in order to promote effective communication,

2.13 **Army, tomb complex of the First Emperor of Qin, Pit 2,** *c.* 210 BCE. Terra-cotta, life-size. Lintong, Shaanxi province, China.

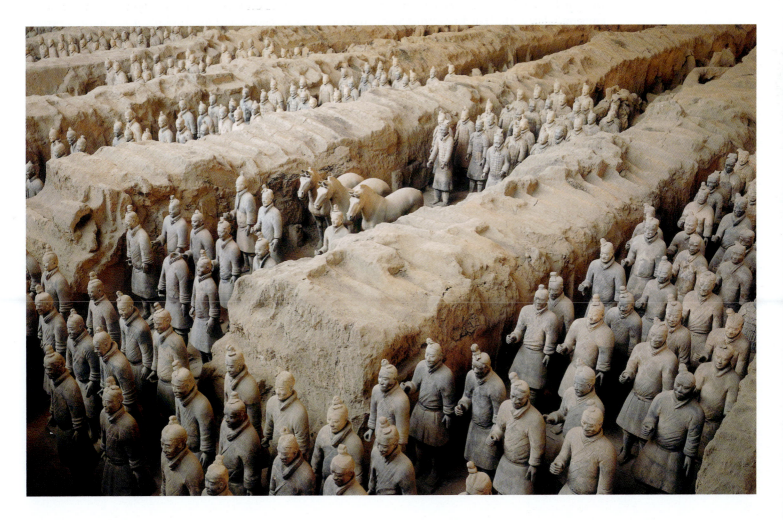

The burial chamber (or chambers) at the center of the tomb of the First Emperor has yet to be excavated. Uncertain of the contents and of how best to preserve them, archaeologists have deferred excavation. In the absence of firm knowledge, the record of the great Han dynasty historian Sima Qian (died 86 BCE) has served as a source for answers, but it has also invited skepticism. Sima writes:

> As soon as the First Emperor ascended the throne, excavation and building was begun at Mount Li. Later, when he unified the empire, over seven hundred thousand conscripts from throughout the empire were sent to work there. They dug through three subterranean streams, and poured molten copper for the outer coffin. The tomb was filled with models of palaces and miradors, hundreds of offices, extraordinary artifacts, and wondrous treasures. Artisans were ordered to fashion crossbows and arrows, which were set to shoot trespassers automatically. For the hundred streams, the Yangtze and Yellow Rivers, and the great sea, quicksilver was set to flow mechanically. Heavenly constellations were placed above; regions of the earth placed below. Candles were made of whale oil, to ensure burning for as long as possible.

The Second Emperor decreed: "It would be inappropriate to allow out those of the late emperor's consorts who did not bear sons." Accordingly, all were ordered to accompany the deceased Emperor to the grave. After the interment, some pointed out that the artisans who made the mechanical devices might divulge all the treasure that was in the tomb; therefore, after the rituals concluded and the treasures enclosed, the inner gate was shut and the outer gate lowered, thereby immediately trapping inside all the laborers and artisans. None could escape. Trees and grasses were planted so that the tomb resembled a hill.

Discussion Questions

1. According to Sima Qian, how was the tomb of the First Emperor of Qin made and what form did it take?

2. How does Sima Qian's account corroborate, complement, and contradict archaeological evidence from the tomb site?

it destroyed masses of written knowledge as a means to limit and control thinking. The First Emperor decreed that private copies of certain books be surrendered to the state. Sima Qian described their subsequent destruction as "burning of the books." Legalism aided conquest, but the brutality was met—unsurprisingly—with rebellion. The Qin dynasty lasted only four years beyond the First Emperor's death. The Han dynasty that followed would establish a more stable empire, but even more enduring was its promotion of Confucianism, which would sweep through East Asia and beyond.

Diverse Worldviews during the Han Dynasty, 206 BCE–220 CE

The Qin unified the realm, but its repressive government policies hastened its collapse. Whereas the Qin lasted a mere fifteen years, the subsequent Han dynasty ruled from its western capital Chang'an and then its eastern capital Luoyang for nearly four centuries (**Map 2.2**). The Han also expanded territorial boundaries eastward into the Korean peninsula and westward along the Silk Routes (see Seeing Connections: Art of the Silk Road, p. 116). Overland trade in one direction sent silk textiles to the Roman Empire, and, in the opposite direction, Roman glassware reached Han consumers and points further east. The prestige of the Han dynasty lends its name to designate written Chinese words (*hanzi*) and as the ethnic identifier of Han Chinese.

Artworks attest to the co-existence of diverse worldviews within the Han domain. The Han dynasty adopted Confucianism for governance. Confucianism urged learned gentlemen to practice self-cultivation and participate in government service. Confucius also advocated a set of reciprocal relationships based on respect and care, instead of a strict set of rules and punishments, as the foundation for a harmonious world. These relationships included those between rulers and subjects, and between parents and children. The voluntary fulfillment of such mutual obligations, as well as the practice of self-cultivation, ensured that human societies would flourish. By representing paragons of virtue, artwork enshrined and promoted Confucian values, such as filial piety, which included venerating ancestors.

Although Confucian philosophy played a central role during the Han dynasty, it did not provide satisfaction to all human yearnings. For example, artworks excavated from Han dynasty tombs preserve marvelous visions of the afterlife, which was not a particular concern for Confucius. Some of these artworks may be related to Daoism, a competing worldview advanced by Master Zhuang (also known as Zhuangzi, 369–286 BCE). To answer the question of what happens after death, Daoism offered paths to immortality and to paradises populated by immortal beings, such as the Queen Mother of the West. As advanced by Master Zhuang, Daoism also presented an alternative philosophy. Whereas Confucianism maintained that government service was the learned

Map 2.2 East Asia, archaeological sites of the Han dynasty (206 BCE–220 CE) and the Yayoi period (c. 400 BCE– c. 300 CE; see Chapter 4).

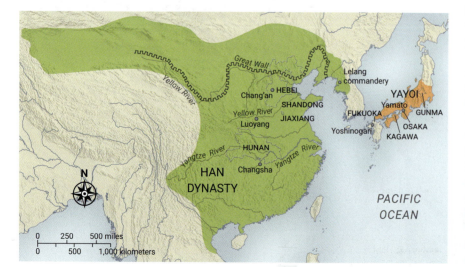

gentleman's highest goal, Zhuangzi believed that society's artificial expectations and behaviors posed obstacles to human flourishing. Instead of taking positions at court, Daoist sages sought refuge in wilderness, where they pursued the Way, a perfect condition of being as manifest in the orderly patterns of the natural world and the cosmos.

Although Confucian and Daoist scholars debated one another, ordinary people appear to have been comfortable mixing elements of both, alongside other forms of popular religion, in their everyday lives and ritual practices. Several artworks from tombs and a family shrine convey the multiplicity of Confucian and Daoist beliefs, as well as more generally cosmological attitudes present during the Han dynasty.

Among the most important archaeological sites of the Han dynasty, the tombs of the Marquis of Dai, his wife, and their son have yielded thousands of objects of historical and art historical interest (Figs 2.14, 2.14a, 2.14b). Of the three tombs, that belonging to the marquise, or Lady of Dai (née Xin Zhui), was remarkably well preserved. Thick layers of white clay and charcoal together trapped water, creating a stable, waterlogged environment, which allowed items made of perishable materials such as wood and silk to endure over two thousand years. These items included lacquer vessels for ritual and everyday use,

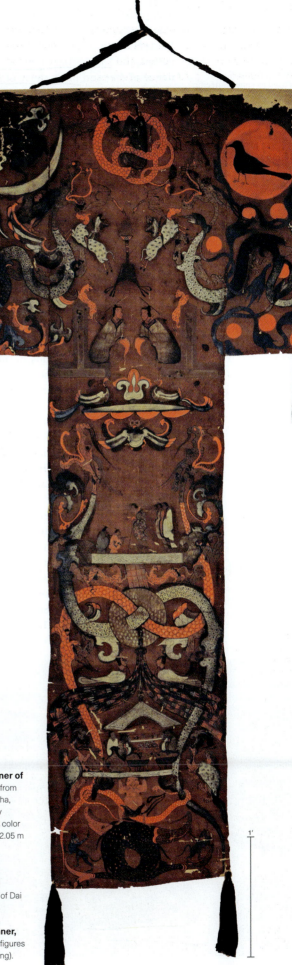

2.14 RIGHT **Funerary banner of the Lady of Dai** (Xin Zhui), from Mawangdui Tomb 1, Changsha, Hunan province, China, early second century BCE. Ink and color on silk, 6 ft. 8¾ in. × 36¼ in. (2.05 m × 90 cm).

Fig. 2.14a ABOVE LEFT **Funerary banner, middle register,** showing the Lady of Dai (line drawing).

2.14b LEFT **Funerary banner, bottom register,** showing figures and ritual vessels (line drawing).

a fully stocked pantry, richly embellished silk textiles, and wooden figurines of servants (see Seeing Connections: Matters of Cloth, p. 57). Within a set of four nesting coffins, the Lady of Dai's still-intact body provided evidence of diet and likely cause of death, heart disease. Draped atop the innermost coffin, a painted silk banner makes visible the imminent journey of the human soul to the afterlife (Fig. 2.14). The T-shaped painting, featuring serpentine bodies of fantastic animals, creates a dizzying effect, but the **composition** has an internal logic. The unknown artisans have divided the space into three registers, corresponding to distinct realms.

In the bottom register, just above fishlike animals, a squat, muscular figure supports a scene of ritual (Fig. 2.14b). Behind a set of sacrificial wine containers and lidded cauldrons, a half-dozen or so human figures face a mound-shaped object painted with swirls of red and white, and trimmed with dabs of white on black. The patterns resemble those on the Lady of Dai's robe, suggesting that the mound represents her shrouded body.

In the middle register above a jade disk, or *bi* (see Fig. 1.7)—which by the Han dynasty was associated with the celestial aspect of the cosmos, or "heaven"—a ramp leads to a platform where a central figure (the Lady of Dai) wears an elaborately decorated robe and leans on a cane (Fig. 2.14a). Two male servants kneel before her, and behind her a trio of female attendants stands respectfully. The presence of servants attests to the Lady's social status, and the use of a cane (analysis of the body revealed a broken hip that had not healed properly) suggest that this image portrays the Lady of Dai while she was still alive in the mortal realm.

Two otherworldly figures wearing mortarboard hats stand guard at posts leading to the banner's upper register. The crescent moon and the largest of nine red suns, along with the creatures affiliated with them—the toad and the crow—indicate the heavenly expanse. Just below the moon, a barefooted figure of a female human reaches upward toward it. Some scholars see this figure as a third appearance of the Lady of Dai. Like an immortal

in the spiritual realm, she ascends to the moon in the manner of the fabled moon goddess, Chang'e. At center, the creator goddess Nū Wa (depicted as a woman with a snake's tail) presides over this strange cosmos comprised of the living and the dead, the watery underworld and the celestial realm, the mundane and the supernatural.

The artist's pliable brush and vivid colors conjure in exquisite detail the worlds of human imagination. Art historians may never be certain of the precise meaning of all the depictions, which do not align exactly with either Confucian or Daoist texts and **iconography**. Nevertheless, the banner clearly brings together the visible world—including ritual objects that would have been familiar to past cultures of the Neolithic period and Bronze Age, as well as contemporary costumes and practices—and the invisible realm beyond the grave. Thin stays, or straps, at the top of the banner suggest that prior to being buried with the Lady of Dai, the banner was hung and displayed as an element of funerary ritual.

Concerns about death and the afterlife led to the making of the final outfit of a Han prince, Liu Sheng (died *c.* 113 BCE). His entire body was encased in a burial suit made of jade pieces fastened with gold thread (Fig. 2.15). The suit includes an antique bi at the crown of the head (not visible in the photograph) and several jade plugs to seal bodily orifices. Since the Neolithic period, jade had been valued not only for its attractive color but also and especially for its fixed properties. It was hard, durable, and did not tarnish with time (see Figs. 1.7 and 1.8). Liu Sheng and his wife, Princess Dou Wan, who also wore a jade suit in death (not pictured), may have expected that the unchanging characteristics of jade could preserve their bodies in the afterlife, bestowing immortality on them.

Another object excavated from Prince Liu Sheng's cave-tomb suggests a related belief in an island far out at sea populated by Daoist immortals (Fig. 2.16). This bronze incense burner consists of two parts: a bowl-shaped base elevated on a foot comprised of writhing dragons (an **auspicious** creature in East Asia, one associated with water and rain), and a perforated cover in the

2.15 Jade burial suit of Prince Liu Sheng, from Tomb 1, Mancheng, Hebei, China, Western Han dynasty, *c.* 113 BCE. Jade and gold thread, length 6 ft. 2 in. (1.88 m). Hebei Provincial Museum, China.

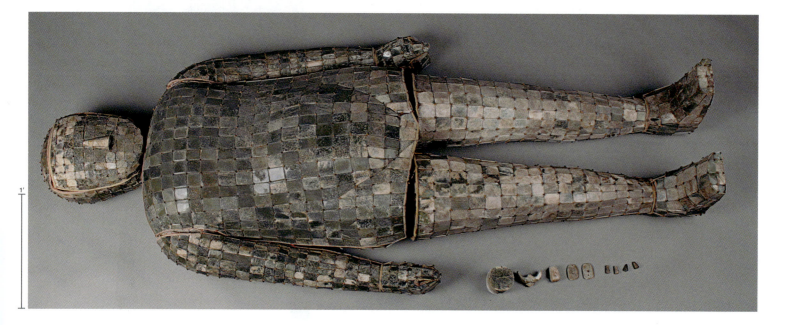

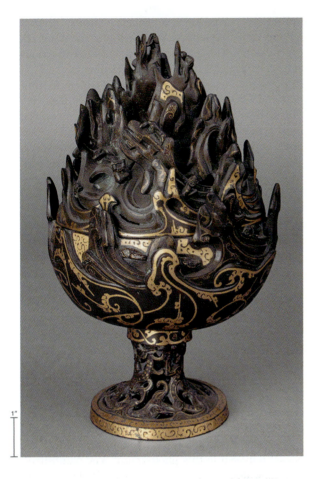

shape of a craggy mountain. The smoke and perfume of incense burning in the base would have emerged through the holes, thereby surrounding the miniature mountain with an envelope of mist. Such immediate sensory stimulation was perhaps thought to help bridge the distance between the mundane world and the Island of the Immortals. On Liu Sheng's incense burner, finely inlaid gold depicts the roiling waves surrounding the island. Their stylized curves and hooks are related to bronzes of preceding periods (see **Fig. 2.4**), to such paintings as the Lady of Dai's banner (see **Fig. 2.14**), and to embroidery (see Seeing Connections: Matters of Cloth, p. 57). Tiny animals and human-like creatures amid the mountain cliffs complete the illusion.

Whereas the Lady of Dai's banner and prince Liu Sheng's incense burner depict fantastical places, some images from the funerary shrines of an otherwise unknown Wu family in Shandong province turned to history for inspiration. The pictorial program of the Wu Family Shrines may be studied through **rubbings**, which make the details of the images easier to see. Made against the interior face of a stone slab that was one part of the shrines, this rubbing depicts a dramatic scene (**Fig. 2.17**). The upper register shows the large silhouettes of officials wearing caps and long robes. Finer lines represent their faces, hair, fingers, and patterned sleeves. They and their assistants face an opening slightly to (the viewer's) right of center. The opening leads to a triangular space, and the resulting shape bears some resemblance to a flask. Within the thick outline of that space, crucial action takes place on a river or canal, as indicated by fishermen working at bottom and the waterfowl taking flight above. In between, two crews on boats direct their attention to a falling bronze *ding*, or cauldron, which has escaped the efforts of men on either side of the river to get hold of it. Their rope has been severed by a dragon, the head of which emerges from the cauldron, the men tumble backward onto their rears, and the cauldron sinks deeper

2.16 FAR LEFT **Incense burner in the form of the Island of the Immortals,** from Tomb 1, Mancheng, Hebei, China, Western Han dynasty, *c.* 113 BCE. Bronze inlaid with gold, height 10¼ in. (26 cm). Hebei Provincial Museum, China.

rubbing an image made by applying powdered ink onto a sheet of paper placed against a shallowly carved or textured surface.

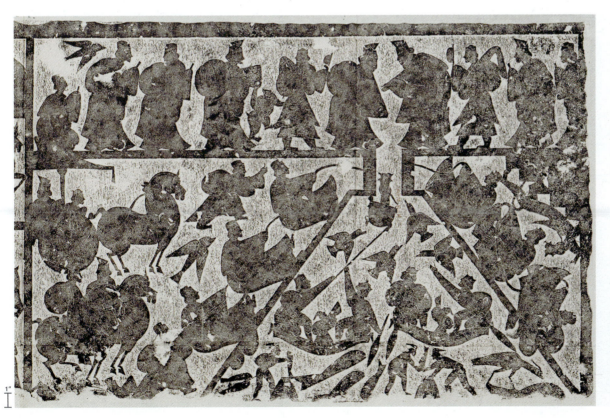

2.17 Scene of the Raising of the Cauldron, Wu Family Shrines, Jiaxiang county, Shangdong province, China, Eastern Han dynasty, *c.* 147–51 CE. Ink rubbing of a stone relief, height 28¼ in. (71.8 cm). Princeton University Art Museum, New Jersey.

illusionism making objects and space in two dimensions appear real; achieved using such techniques as foreshortening, shading, and perspective.

into the water. Why has a mere cooking vessel drawn the attention of so many, including a high-ranking minister, or perhaps a head of state, shaded beneath the canopy of a horse-drawn carriage?

The unknown artisans of the Wu Family Shrines would have expected informed viewers to recognize the story of the Nine Cauldrons. Purportedly cast in the Shang dynasty (*c.* 1500–*c.* 1050 BCE), the cauldrons represented the realm and, importantly, bestowed political legitimacy, understood as Heaven's Mandate, upon their owner. It was believed that, upon the fall of the Shang, the cauldrons transferred to the Zhou (*c.* 1050–256 BCE). After the Zhou collapsed, one of the cauldrons fell into a river. The subject of this scene is the failed attempt of the First Emperor of Qin to recover it. Recognizing his tyrannical tendencies, Heaven refused to grant him political legitimacy; as an instrument of Heaven, the dragon prevents him from possessing the bronze cauldron.

The representation of space here can be described as simplified or unrealistic; the line of officials in the top register, for example, floats improbably above the canopied chariot and falling cauldron. But consistency of viewpoint and **illusionism** are less important, as the artist intentionally prioritizes the elements of narrative and scene. The bronze cauldron serves as the composition's visual heart, around which all other motifs are arrayed.

The morally instructive images at the Wu Family Shrines promote the Confucian values of order, virtue, and disapproval of brutality not only by capturing a significant lesson from history about Heaven's attitude toward tyrants, but also through such formal qualities as the gravitas of the huge silhouettes of officials and the orderly composition. In addition, the shrines themselves promoted the Wu family as one that espoused

Confucian virtues, chief among them filial piety. Respect for ancestors is demonstrated not only in the resources expended in making the shrine, but also in the serious subject matter of its decorative program.

Further evidence of Confucian beliefs comes from an object, a lacquer basket, from another tomb (**Fig. 2.18**). This lacquer basket is from the tomb of a minor official posted to Lelang (Korean: Nangnang), one of several outposts of the Han Empire in what is today North Korea. The basket and its lid have been varnished with lacquer, which dries to a hard, durable finish that protects perishable materials. In this case, lacquer has preserved not only the wood and fibers of the basket, but also the paintings depicting ninety-four figures, the majority of whom are paragons of virtuous behavior.

Although the paintings include some women, most of the figures are men, whose moral actions gave them lasting reputations. Seated against a dark background with an occasional freestanding screen separating them, the figures lean toward one another, sometimes gesturing in animated conversation. The flexibility of the brush enabled the painter to capture the billowing drapery of robes and the supple shapes of noses. Variations of color, posture, gesture, and gaze generate an overall liveliness and naturalism. These are not individualized portraits, however, nor are they placed into separate, narrative contexts. Instead, nearby inscriptions provide names, such as Shan Dajia and Li Shan (on the long side of the basket not seen in this photograph). The painting on the basket does not depict Li Shan rescuing his youthful master from marauders nor assisting with the rightful restoration of family properties; rather, the inscriptions nudge viewers to recall this exemplary story of loyalty. This strategy of using images and words together is also

2.18 Painted lacquer basket and lid, from Tomb 116, Lelang (Nangnang, North Korea), Eastern Han dynasty, first century CE. Basketry and lacquer, length 15⅜ in. (39 cm). Central Historical Museum, Pyongyang.

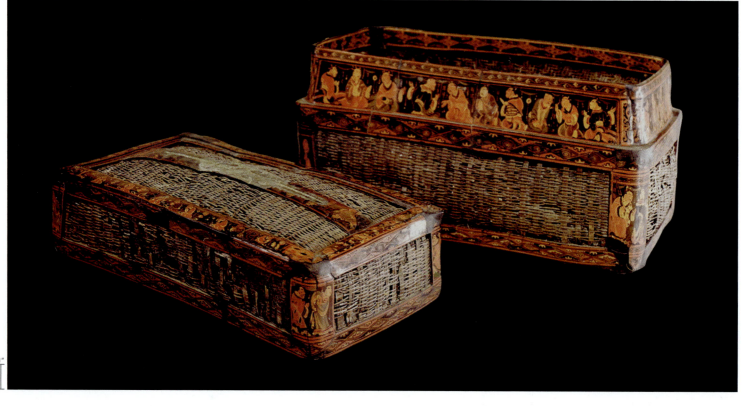

2.19 **TLV-pattern mirror,**
Han dynasty. Bronze, diameter
7¾ in. (19.5 cm). National Museum
of Korea, Seoul.

1"

found in some of the compositions at the Wu Family Shrines, and it continued in later East Asian painting.

Images and words, too, are found on another object from a Lelang tomb, a bronze mirror that also brings together art and technology, time and space, amusement and auspiciousness (**Fig. 2.19**). The polished, reflective side of the mirror is not shown here; its decorated back has a knob at the center, through which a cord could be threaded for ease of handling. Between the prominent square panel surrounding the knob and the concentric bands of geometric patterns, plain shapes resembling Roman letters I, L, and V repeat. Similar mirrors feature a shape more like a T than an I, giving the mirror type its "TLV" name. Popular during the Han dynasty, TLV-pattern mirrors are an art historical mystery: what was the meaning of this design, and what purpose did such mirrors serve?

A variety of archaeologically excavated material has shown that the TLV pattern originates in a board game called *liubo*. The rules of *liubo* are not fully understood, but it is known that two players took turns throwing six sticks to determine the movement of six chess pieces on a board with T-, L-, and V-shaped markings. Contemporaneous images of *liubo* picture winged immortals wearing feathered clothing playing, and historical evidence records a belief that by besting an immortal in *liubo*, a human winner could be rewarded with immortality. Thus, TLV-pattern mirrors in a tomb attest to an important Daoist idea.

The ornament on this TLV-pattern mirror includes animals, some of which may be associated with cardinal directions, such as the black tortoise of the north (between the two o'clock and three o'clock position, with a long tail extending from the shell) and the vermilion bird of the south. When combined with a recognition

of the mirror's round shape (invoking heaven) and its square panel (referring to earth), the directional animals underscore geography, or spatial relationships that likewise underlie the *liubo* gameboard. The mirror pairs space with time, through the addition of twelve characters cast into the square panel. These characters, known as the twelve branches, are related to a method of keeping time, in use for example in oracle bones (see **Fig. 2.3**). In this regard, the mirror conveys general cosmological interest in the commensurate and orderly workings of heaven and earth.

Indeed, the *liubo* board served as the structure for a method of divination to determine auspicious and inauspicious days for significant events, such as marriages and excursions. So, besides signifying immortality and referencing cosmology, the mirror could be thought of as an object that could be used to protect against harm and to ensure well-being throughout life. This apotropaic quality is further reinforced by such practices as wearing a mirror on one's back to deflect evil spirits.

Beyond understanding the meaning and function of this particular mirror, or even TLV-pattern mirrors generally, we may also place this object in a greater art historical context. Alongside other artworks dating to the time of the Han dynasty, it attests to that dynasty's wealth, expanse, and heterogeneous beliefs. Considered as part of a history of bronze mirrors in Asia, it occupies a midpoint: appearing well after that type of object was placed in Shang burials, but before ever-more varieties of ornament, adaptations of purpose, and inventions of meaning would occur throughout East Asia (see Figs. 4.3 and 4.8). Set into a history of bronze technology and early empires, the mirror might best be considered metaphorically, as it was in Confucian and Daoist texts. Never passively reflecting

the world, mirrors offered revealing moral lessons that warned especially, but not exclusively, against vanity and superficial worldly desires. For this reason, written histories such as that authored by Sima Qian came to be called mirrors, and they endeavored to transmit to their audiences moral stories to guide behavior.

Over the course of what is approximately the millennium and a half discussed in this chapter, several centers of bronze casting in areas of present-day China attest to distinct cultures on the one hand and, on the other, to some degree of contact among them. One of these cultures, Shang, developed written language, used oracle bones to communicate with ancestors, and made ritual offerings to them in sets of bronze vessels. After conquering the Shang, the Zhou adopted significant aspects of Shang culture, among them written language and ancestor worship. Use of ritual bronze vessels continued, too, but the archaeological record attests to dissemination of bronzes, innovations in bronze production, and variety in bronze objects.

Early empires, Qin and Han, contrast in their approach to governance, but the practice of furnishing tombs suggests consistency, as well as continuity with the past. Tombs and burial goods—made of bronze, jade, silk, lacquer, and other materials—testify not only to ongoing belief in the afterlife, but also to cosmological ideas, Daoist pursuits, and Confucian principles. Although many artworks discussed in this chapter would be buried deep underground, these bodies of thought would endure, as would artistic practices developed over the course of these early empires; together, they would inform artwork in centuries to come.

Discussion Questions

1. This chapter features a new medium in East Asia: bronze. Choose an object to explain how the physical, visual, and/or sonorous properties of bronze were manipulated to make the resulting artwork fulfill its functions.

2. Some artworks in this chapter were buried in tombs; others picture realms associated with the afterlife. Compare and discuss items in the tombs of Fu Hao and the Lady of Dai, then compare and discuss items associated with the First Emperor of Qin and with the Han dynasty prince Liu Sheng.

3. Artworks offer a visible means to demonstrate power. Select an artwork or two from this chapter to explain the particular artistic strategies used to make power visible. Do you see those artistic strategies operating elsewhere or presently? Explain.

4. Further research: archaeological excavation of any one site generates far more artifacts than may be included in this chapter. Research one of the sites from this chapter (tombs of Fu Hao, the Marquis Yi of Zeng, the First Emperor of Qin, the Lady of Dai, Prince Liu Sheng, or the pits at Sanxingdui). What additional artifacts would you bring into the discussion for reconstructing the past? Explain.

Further Reading

- Barbieri-Low, Anthony J. *Artisans in Early Imperial China*. Seattle, WA: University of Washington Press, 2007.
- Barnes, Gina L. *Archaeology of East Asia: The Rise of Civilization in China, Korea and Japan*. Havertown, PA: Oxbow Books, 2015.
- Ledderose, Lothar. *Ten Thousand Things: Module and Mass Production in Chinese Art*. Washington, D.C.: Trustees of the National Gallery of Art, 2000.
- Wu, Hung. *The Art of Yellow Springs: Understanding Chinese Tombs*. Honolulu, HI: University of Hawai'i Press, 2010.

Chronology

c. 1500–*c.* 300 BCE	The Mumun culture (Korean peninsula)		*c.* 770–256 BCE	The Eastern Zhou period, including the Warring States period (*c.* 450–221 BCE); a set of bronze bells is cast for the Marquis Yi of Zeng
c. 1500–*c.* 1050 BCE	Shang royalty cast ritual bronzes		221–206 BCE	The Qin dynasty; the tomb of the First Emperor and his terra-cotta army are built
c. 1300–*c.* 1000 BCE	The Sanxingdui culture casts the standing figure and other bronzes		206 BCE–220 CE	The Han dynasty (includes Western Han, 206 BCE–9 CE, and Eastern Han, 25–220 CE)
c. 1200 BCE	The earliest form of written Chinese is cast on Shang dynasty bronze objects and inscribed on oracle bones		*c.* 186 BCE	A funerary banner is interred in the tomb of the Lady of Dai
c. 1200 BCE	The tomb of Lady Fu Hao of the Shang dynasty is filled with objects of bronze, jade, ivory, stone, bone, and ceramic		*c.* 113 BCE	A jade burial suit and bronze incense burner are made for Prince Liu Sheng of the Western Han dynasty
c. 1050–*c.* 771 BCE	The Western Zhou period; the Xing Hou *Gui* and other bronzes are cast		109 BCE–313 CE	Lelang (Korean: Nangnang) is an outpost of the Han dynasty; brick-chamber tombs are built and furnished with objects like the lacquer basket and bronze mirror
c. 1000–*c.* 400 BCE	Liaoning-type daggers are cast (Mumun culture, Korean peninsula)		*c.* 147–151 CE	The Wu Family Shrines are built

Matters of Cloth

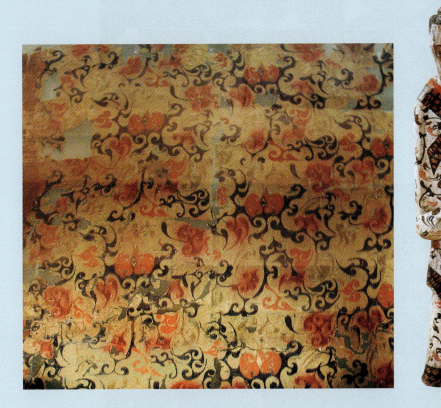

1 ABOVE LEFT **Piece of embroidered silk cloth,** from the tomb of the Lady of Dai, Mawangdui Tomb 1, Changsha, Hunan province, China, early second century BCE. **EAST ASIA**

2 ABOVE RIGHT **Figurine wearing a painted silk robe,** similar in pattern to the cloth piece in Fig. 1, from the tomb of the Lady of Dai, Mawangdui Tomb 1, Changsha, Hunan province, China, early second century BCE. Wood, approximate height 18½ in. (50 cm). **EAST ASIA**

cloth. The embroidery, also done in silk, was completed by hand after the fabric was woven on a loom. Thus, an intricately embroidered design (**Fig. 1**) would have signified the Lady's wealth. A silk robe of similar design is painted on a wooden figurine from her tomb (**Fig. 2**) and shows one use for such a textile.

Wool is the hair (or fleece) from sheep and similar animals. A distinctive crimp or curl characterizes wool fiber, making it warm, durable, and easy to spin into yarn. Around 6000 BCE, West Asian people (from areas of present-day Iraq and Iran) began selectively breeding sheep for wool. During antiquity, Central Asian nomadic people developed techniques of felting, knitting, and weaving to make finished wool items. These nomads also produced knotted or piled carpets, that is, carpets in which short lengths of yarn have been knotted between rows of woven fabric to form a plush pile. By using different colored yarns for the knotted pile, they created abstract and figurative patterns. The oldest known such carpet comes from an ancient tomb in Siberia belonging to the Central Asian Pazyryk tribe (**Fig. 3**). On this carpet, multiple borders, including one featuring elk and another featuring horsemen, frame a central geometric pattern that repeats. Its elegance confirms that wool carpets not only protected from cold but also beautified dwellings. In later centuries, wool-carpet production spread westward to Europe and North Africa and eastward to South Asia and the Himalayas.

A medium and a material for art, cloth may be fashioned into garments, furnishings, or sundry other items of utilitarian and aesthetic value. Since Neolithic times, cloth has formed an intrinsic part of visual culture. Around the world, historically, three main fibers figure prominently in textiles: silk, wool, and cotton. Each material has distinct properties that inform the finished product and its uses.

Silk is a protein fiber that comes from the cocoons of silkworms. It creates a thread that is exceptionally thin, strong, shiny, and smooth. The cultivation of silkworms and creation of silk fabric originates in Neolithic times, or about 4000–3000 BCE, in areas of present-day China. There, silk has long connoted elegance, wealth, and high status. The Han dynasty tomb of the Lady of Dai (see Fig. 2.14) preserves a variety of silk fabrics, including cut velvet and embroidered

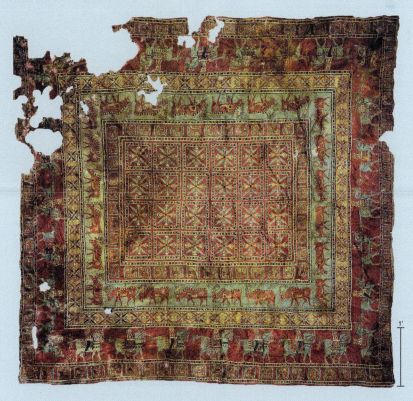

3 **Wool pile carpet,** excavated from tomb in Pazyryk Barrow No. 5, Siberia, Pazyryk culture, fifth to fourth centuries BCE. 6 ft. ⅛ in. × 6 ft. 6¾ in. (1.83 × 2 m). State Hermitage Museum. St. Petersburg, Russia. **CENTRAL ASIA**

4 RIGHT **Cotton textile fragment with lotus vines, medallions, rosettes, and inscription,** found in archeological excavations in Egypt, made in Gujarat, India, radiocarbon-dated to 1010 CE +/− 55. Cotton, block-printed with resist, and dyed blue, approximately 7 × 28 in. (18 × 71 cm). Ashmolean Museum, Oxford, U.K. **SOUTH ASIA**

5 BELOW RIGHT **Wall painting showing the** *bodhisattva* **Vajrapani,** from Cave 1, Ajanta, India, fifth century CE. **SOUTH ASIA**

Cotton is a cellulose fiber that grows in the seed pods of cotton plants. When spun and woven, it creates a lightweight, soft, and breathable fabric ideal for use in warm climates. The earliest evidence of cotton cultivation, *c.* 6000–5000 BCE, comes from Mehrgarh in South Asia (see Chapter 1). Throughout history, cotton textiles have formed an important part of South Asia's economy, and craftsmen there became adept at making brightly colored, intricately patterned, and finely woven cloth (see Fig. 10.9). The unknown artisans of this fragment of cotton fabric used dye from the indigo plant to color it deep blue (**Fig. 4**). By carefully applying a substance that would resist the dye, they created a pattern of lotus vines and rosettes in the cloth's natural color. This eleventh-century cotton textile fragment, along with others made in the western Indian region of Gujarat, was discovered in an archaeological site outside of Cairo, Egypt. It thus attests to the extent of textile trade.

Made of biodegradable matter, most early textiles have decayed. Besides rare surviving examples, art historians depend on depictions of cloth for further insight into the kinds of textiles belonging to a given society and how they were used. Some of the earliest surviving paintings in South Asia, murals at the Buddhist monastic site of Ajanta (see Chapter 5) feature religious icons and narratives; they are also a source for reconstructing a lost material culture. In the murals, deities and humans wear clothing made from a range of patterned textiles. The *bodhisattva* Vajrapani (**Fig. 5**), for example, wears a red-, black-, and white-striped cloth tied around his waist. Nearly every figure at Ajanta is depicted with a different textile, providing a glimpse into the role that cloth played in the visual culture of the period.

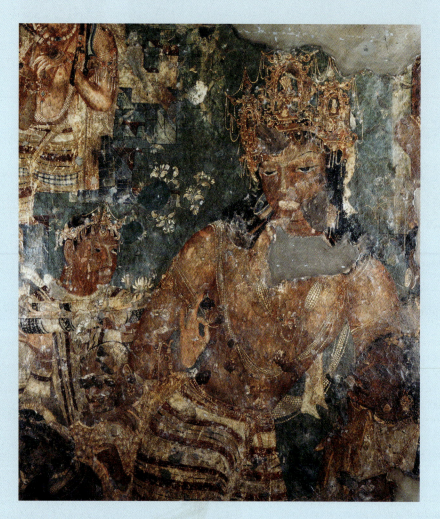

Discussion Questions

1. Choose a textile discussed elsewhere in the textbook and compare it to one of the examples presented here, paying particular attention to the materials and construction techniques.

2. Choose an artwork discussed elsewhere in the textbook that represents a person or deity in which their clothing has been depicted with some level of detail. Through close looking, analyze what the image reveals about textiles from the period.

Further Reading

- Crill, Rosemary, ed. *The Fabric of India.* London: V&A Publishing, 2015.
- Denny, Walter B. *How to Read Islamic Carpets.* New York and New Haven, CT: Metropolitan Museum of Art and Yale University Press, 2014.
- Schoeser, Mary. *Silk.* New Haven, CT and London: Yale University Press, 2007.

3

Early Buddhist, Jain, and Hindu Art in South Asia

250 BCE–500 CE

3.0 Detail showing the Buddha's
Enlightenment from Scenes from the life
of the Buddha, Gandhara, Pakistan.

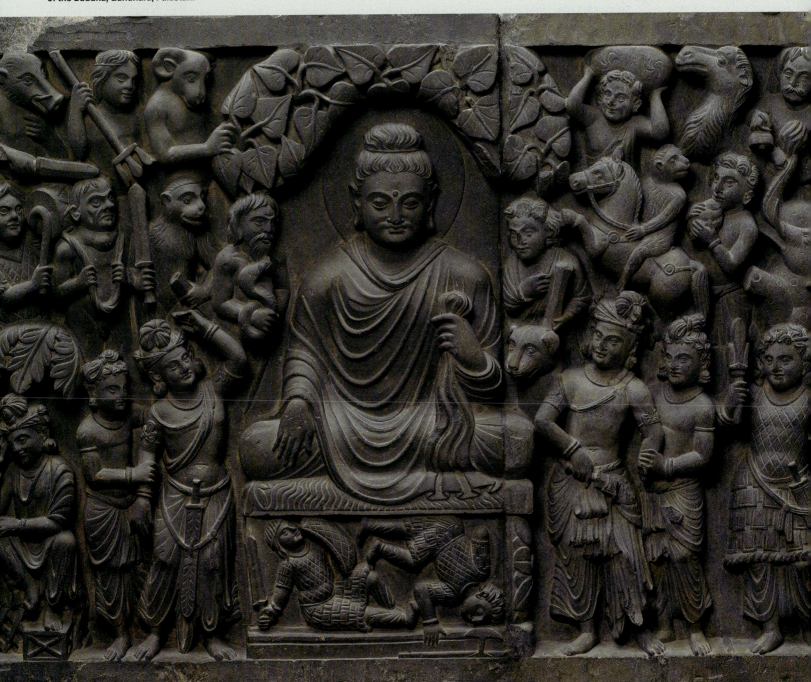

buddha; Buddha, the a buddha is a being who has achieved the state of perfect enlightenment called Buddhahood; the Buddha is, literally, the "Enlightened One"; generally refers to the historical Buddha, Siddhartha Gautama, also called Shakyamuni and Shakyasimha.

Introduction

Around 250 BCE, the Indian ruler Ashoka of the Maurya dynasty had imposing stone pillars constructed at various locations throughout his empire. These columns ended an almost 1500-year period for which there is no evidence of monumental art or architecture in South Asia. Ashoka was the first ruler to adopt Buddhism, a religion that in subsequent centuries would spread throughout Asia and beyond. Ashoka's pillars—through their specific locations and iconography—served in part to connect his power to that of the Buddha, initiating a period of artistic production on the Indian subcontinent closely tied to religious developments.

Besides Buddhism, the two other important religions in ancient South Asia were Hinduism and Jainism. All three are considered dharmic faiths because they share core concepts such as *dharma* (the correct way for individuals to conduct themselves in accordance with cosmic order) and reincarnation that stem from the earlier religion of Vedism to which they are connected. At the same time, differences among the faiths are reflected in their art. Between roughly the third century BCE and the sixth century CE, many of the visual forms that today are associated with these three religions came into being. Those forms include icons of the Buddha and Jinas, Hindu temples, and sculptures of Hindu gods. Artists worked within evolving visual conventions to facilitate the identification of sacred figures as well as narrative stories central to each faith. Concurrently, new architectural features emerged to meet the needs of changing ritual practices.

Many of these developments happened with the aid of royal patronage during the Maurya (*c.* 322–185 BCE), Kushan (*c.* first century–375 CE), and Gupta (*c.* 320–550 CE) empires. The royal courts of each of these empires also required the services of artists to produce secular art, such as palaces and

textiles—little to none of which survives, but which we know existed through references in textual sources and visual depictions in religious paintings and sculptures. Some, possibly most, artwork encompassed elements of both the secular and the sacred; the Ashokan pillars mentioned above, as well as coins minted for the Kushan emperor Kanishka in the second century CE, are two such examples. While many questions still remain about the art from this period, the visual evidence that does survive speaks to the innovative and multifaceted nature of South Asian art during the ancient era.

The Emergence of Buddhist Art in South Asia

The threat of invasion by Alexander the Great (ruled 336–323 BCE) of the ancient Greek kingdom of Macedonia and his conquering armies enabled the territorial expansion of the Indian sovereign Chandragupta Maurya (ruled 322–298 BCE). Powerful and highly centralized, the Maurya Empire (*c.* 322–185 BCE) eventually controlled most of South Asia from its capital Pataliputra (modern-day Patna) in eastern India (**Map 3.1**). The empire reached its height under the third ruler, Ashoka (ruled *c.* 272–231 BCE). But—as recounted in royal inscriptions from the period—shaken by the amount of death and suffering his hard-fought conquests had caused, Ashoka became a pacifist and embraced Buddhist practices. He spent the rest of his life propagating ethical codes of behavior and contributing to the spread of Buddhism, in part through his patronage of monumental art.

The Buddhist religion was founded only a few centuries earlier by Siddhartha Gautama (*c.* fifth century BCE), a prince of the Shakya kingdom located near the modern border of India and Nepal. By the sixth century BCE, Indo-European Vedic society, which had dominated north India for roughly 1,000 years, had become highly stratified, with Brahmins (priests who maintain sacred knowledge) occupying the highest place. Vedism, the ancient belief system that formed the basis for Hinduism, centered on reincarnation as well as cosmic and social hierarchy. There was growing dissatisfaction among people who occupied the lower strata, and new spiritual movements reacting against the constraints of Vedism began to emerge. Buddhism was one of these movements. At the age of twenty-nine, Prince Siddhartha, deeply affected by the suffering he saw around him, left his palace in search of enlightenment. For six years he tried penance and asceticism before turning to meditation and moderation. While meditating beneath a pipal (or bodhi) tree, he achieved spiritual awakening, after which he became known as **the Buddha**—"Enlightened One." At a place called Sarnath, he "put the wheel of law into motion"—the law referring to Buddhist doctrine—and began preaching the four noble truths of Buddhism: (1) Life is suffering; (2) Suffering is caused by desire; (3) To stop suffering, you must extinguish desire and liberate yourself from attachment; (4) To achieve liberation, you must follow the eightfold path: right views, intention, speech, action, livelihood, effort, mindfulness, and concentration.

Map 3.1 The extent of the Maurya Empire, *c.* 250 BCE, and the placement of Ashoka's rock edicts and pillars.

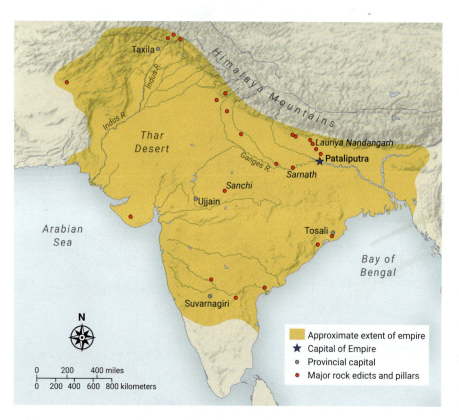

Approximate extent of empire
★ Capital of Empire
● Provincial capital
● Major rock edicts and pillars

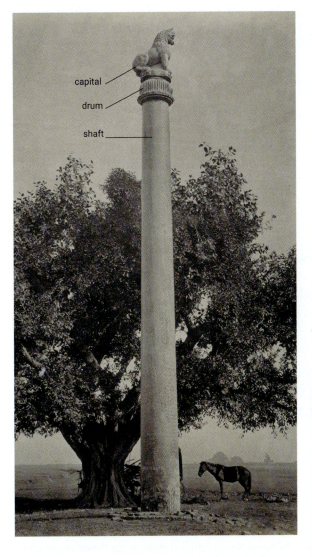

capital

drum

shaft

The pillars, nineteen of which remain, are the earliest surviving examples of monumental South Asian sculpture. Rising 40–45 feet high (around 12–13 m), the pillars were made of sandstone, often polished to a high shine. The pillar at Lauriya Nandangarh, one of only two still intact at the original site of construction, consists of a **monolithic** shaft, on which the edicts were inscribed, and a **capital** featuring a lion seated on a bell-shaped, lotus-bud **drum** (**Fig. 3.1**). While not strictly religious, Ashoka's columns drew on the power of Buddhism. Many were erected near Buddhist monasteries, where monks, who were literate, could read the edicts to laypeople. The pillars acted as symbolic connections between heaven and earth, linking Ashoka's laws to the Buddha's. The lion imagery also reinforced the connection between Ashoka and the Buddha. In early India, as in many world cultures, lions symbolized kingship. Here, they also reference the Buddha, who was known as Shakyasimha (the lion of the Shakya clan) and whose voice was said to resemble a lion's roar.

The most famous Ashokan pillar capital, which is also the national emblem for the Republic of India, is from Sarnath, the site of the Buddha's first sermon (**Fig. 3.2**).

3.1 FAR LEFT **Ashokan edict pillar,** Lauriya Nandangarh, Champaran district, India, *c.* 250 BCE. Photograph by Sir Benjamin Simpson, 1865. British Library, London.

monolithic a single large block of stone.

capital the distinct top section, usually decorative, of a column or pillar.

drum a cylindrical stone block that forms part of a column.

Buddhism shares with Vedism the ideas of reincarnation, karma (the sum of a person's actions that determines his or her future existences), *dharma* (duty or righteousness), and *samsara* (the cycle of existence), with the ultimate goal being non-existence (called *nirvana* in Buddhism). Unlike Vedism, early Buddhism had no priests acting as intermediaries between the individual and the gods; no complicated, costly rituals; and no caste system of hereditary class divisions. The appeal of this new faith led the Buddha to gain followers, who continued to spread the message after his death.

By the time of Ashoka's conversion, Buddhism was widely practiced alongside Vedism and other religions, but Ashoka was the first ruler to adopt the faith, giving it new prominence. While there is no reason to doubt the sincerity of his conversion, it was also a shrewd political move because it constrained the power of the dominant Brahmin caste and helped solidify his rule. Ashoka proclaimed the codes of behavior his subjects were to follow through edicts inscribed on rock faces and monumental freestanding stone pillars located throughout his empire (see **Map 3.1**). These edicts, primarily written in Prakrit, a vernacular language, using Brahmi script, are the oldest surviving writings in South Asia except those of the Indus culture (see Chapter 1). For historians, Ashoka's edicts are a rich source of information about his reign.

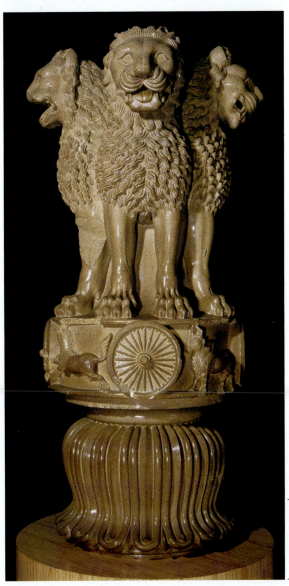

1'

3.2 Lion capital from the Ashokan pillar at Sarnath, India, Maurya period, third century BCE. Sandstone, height 7 ft. 7 in. (2.31 m). Sarnath Museum, Varanasi, India.

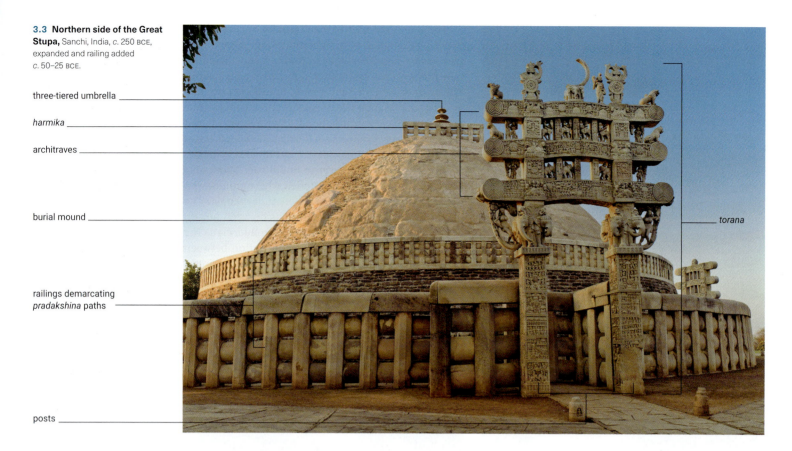

3.3 Northern side of the Great Stupa, Sanchi, India, *c.* 250 BCE, expanded and railing added *c.* 50–25 BCE.

three-tiered umbrella

harmika

architraves

burial mound

railings demarcating *pradakshina* paths

posts

torana

stylized treated in a mannered or non-naturalistic way; often simplified or abstracted.

naturalistic representing people or nature in a detailed and accurate manner; the realistic depiction of objects in a natural setting.

relief raised forms that project from a flat background.

chakravartin literally, "wheel-turner," a Sanskrit title used to refer to an ideal, just ruler, often in relationship to the dharmic faiths of Buddhism, Hinduism, and Jainism.

terra-cotta baked clay; also known as earthenware.

stupa a mound-like or hemispherical structure containing Buddhist relics.

harmika a square, fence-like enclosure that symbolizes heaven and appears at the top of a *stupa*.

pradakshina in Hindu, Buddhist, and Jain practice, the ritual of walking around (circumambulating) a sacred place or object.

It features four lions placed back to back, facing the cardinal directions, implying the universal reach of both Buddhism and Ashoka's power. The lions' faces and manes are carefully **stylized**, while their legs and claws are rendered in a **naturalistic** manner. Originally, a wheel (*chakra*), similar to those carved on the drum, sat atop their heads (see the small **relief** carving in the lower center of **Fig. 3.5**). The wheel referenced both the "wheel of the law" that the Buddha set in motion at Sarnath and the idea of the emperor as a **chakravartin** (literally, "wheel turner"). The drum is further adorned with four animals—a bull, a lion, an elephant, and a horse—that relate to a Buddhist myth of a lake at the earth's center, with each animal channeling a stream through its mouth to one of the four corners of the world.

Because no precedents for monumental sculpture of this type have been found in South Asia, art historians have long debated how and why such art emerged. Many scholars now suspect that some of the pillars predate Ashoka, and that he had the inscribed edicts added. Recent excavations at Pataliputra also reveal the use of wood, brick, and **terra-cotta**—materials less durable than stone—which suggests that much of India's early visual culture no longer survives. Nevertheless, Ashoka's reign was an important turning point in the development of South Asian art.

When the Buddha died, his disciples divided his cremated remains into eight parts, which they enshrined in eight *stupas*. Ashoka later redistributed the Buddha's ashes among a much larger number of simple brick *stupas* (traditionally said to be 84,000, but that number was likely an exaggeration), spreading Buddhism throughout his empire. One such *stupa* was at Sanchi in central India,

the location of an important Buddhist monastery. About 200 years later (*c.* 50–25 BCE), at a time when Buddhist monasteries were thriving, the Ashokan-era *stupa* was enlarged and embellished. In many ways, *stupas* are the first Buddhist monuments, and the Great Stupa at Sanchi (**Fig. 3.3**) is the biggest and most complete early example. The Great Stupa fulfilled three main functions of monumental art within Buddhism. First, it provided a focus for meditation. Second, through visual storytelling, it helped with religious teaching. Third, its sponsorship provided a means of gaining spiritual merit. Like much early Buddhist art, the Great Stupa was not the product of royal patronage. Rather, it was supported by around one thousand individual donors, both men and women, whose names, occupations, and hometowns are recorded at the site. Some donors were Buddhist monks and nuns, but most were ordinary lay people.

The Great Stupa consists of a hemispherical mound 120 feet (36.6 m) in diameter and 52 feet (16 m) high, faced in brick and stone and originally probably plastered and painted, but otherwise unadorned. Because the *stupa* is a solid mound, there is no interior space. Instead, the exterior of the architecture was the site of ceremonial activities. On the top, a stone *harmika* encircles a three-tiered stone parasol that marks the central axis. The *harmika* symbolizes heaven, and the parasol symbolically shelters the Buddha's relics encased within. Its three tiers signify the three jewels of Buddhism: the Buddha, his doctrine, and the monastic community. Two railings encircle the *stupa*, demarcating the paths for **pradakshina**, a ritual circumambulation of the structure. This walking ritual helped focus the worshiper's mind in preparation for meditation. The smaller path,

accessed by a stairway, is located about 15 feet (4.5 m) above the ground. The larger, ground-level outer railing is punctuated by four elaborately carved *toranas* marking the cardinal directions. The *toranas* are the *stupa*'s only highly ornamented elements.

Constructed of fine sandstone, each tall *torana* consists of two posts supporting three 8-foot-wide **architraves**. This structure, better suited to wood than stone because wood's tensile strength allows it to span distances with minimal support, suggests the *toranas* were based on an earlier tradition of wooden architecture. Just below the first architrave, each post is adorned with richly carved figures. These include an animal capital, which on the eastern *torana* features elephants, and a bracket composed of a voluptuous naked female figure bending from the hips and holding onto a mango tree (**Fig. 3.4**). With her legs crossed so that one foot rests on the tree trunk, the woman, bedecked in jewelry, wraps her arms around branches heavily laden with mangos. She is often described as a *yakshi*, although she may have been intended to represent a human rather than divine figure. Either way, she clearly embodies the ancient South Asian belief in a young woman whose fertility is such that her touch can cause a tree to bear fruit. This imagery might seem surprising in a Buddhist monastery, where celibacy is the rule and concentrated meditation is the path to enlightenment. However, early Buddhist art did not exist in isolation. It drew upon local visual practices that emphasized **motifs** seen as bestowing happiness, prosperity, and protection, ones which frequently combined spirituality and sensuality. In South Asia at the time, female fertility was strongly associated with abundance and prosperity, and **auspicious** female figures were often placed at gateways and other vulnerable junctures (see also **Fig. 3.19**). The woman-and-tree motif, specifically, can be found on many other artworks from the period (see Seeing Connections: Art of the Silk Road, p. 116). Thus, the Sanchi sculptors, who no doubt also worked on secular commissions as well as monuments relating to other religious traditions, were guided by widespread artistic practices.

Narrative reliefs depicting scenes from the Buddha's life as well as *jatakas* cover the *toranas*' architraves and posts. The reliefs are deeply carved, and the compositions are packed with people and objects. The sculptors' objective was not **mimesis** but rather readability: things are shown from their most recognizable viewpoints (trees from the side, footprints from above) and scale varies as needed. Stories are told in a range of ways with regard to time—evidence of the sculptors' creativity. Some reliefs depict a single moment, while others summarize an entire story in one frame.

torana a gateway marking the entrance to a Buddhist, Hindu, or Jain sacred structure.

architrave a beam resting on top of columns or stretching across an entranceway.

yakshi a semi-divine female earth spirit.

motif a distinctive visual element in an artwork, the recurrence of which is often characteristic of an artist's or a group's work.

auspicious signaling prosperity, good fortune, and a favorable future.

jatakas stories of the historical Buddha's previous lives.

mimesis the attempt to imitate or represent reality.

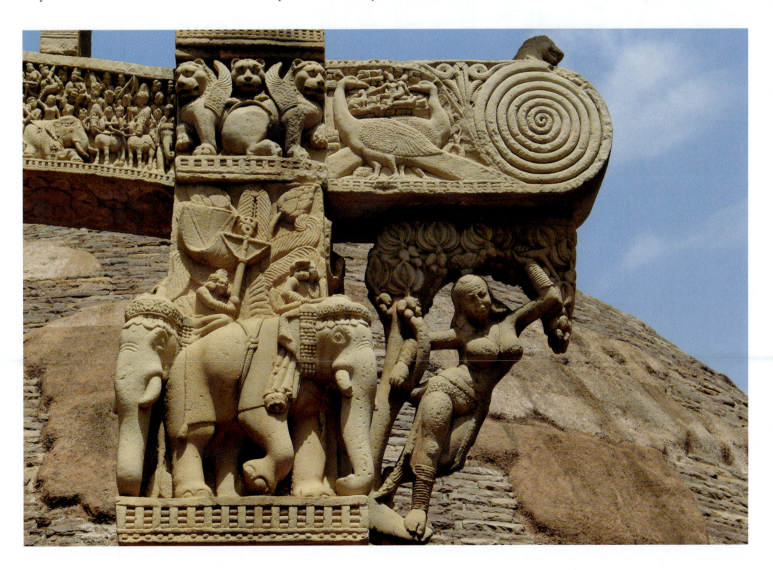

3.4 Detail from the eastern *torana* of the Great Stupa showing a bracket with a female figure wrapped in a mango tree, Sanchi, India, c. 50–25 BCE.

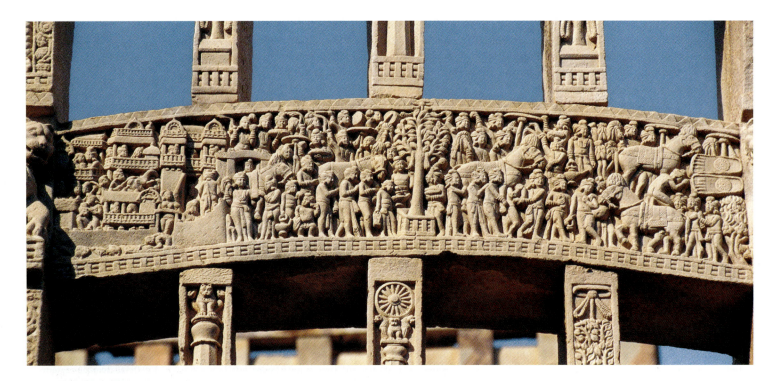

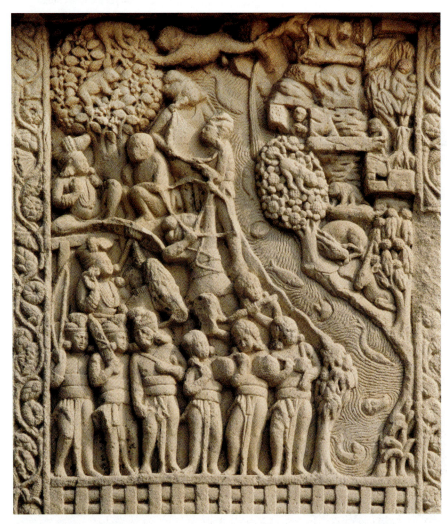

3.5 TOP **The Great Departure,** relief carving on an architrave of the eastern *torana*, Great Stupa, Sanchi, India, *c.* 50–25 BCE.

3.6 ABOVE **The Great Monkey** *jataka,* relief carving on a pillar of the western *torana*, Great Stupa, Sanchi, India, *c.* 50–25 BCE.

The Great Departure relief on the eastern *torana* uses **continuous narrative** to tell the story of Siddhartha Gautama leaving his palace in search of enlightenment (**Fig. 3.5**). The palace appears on the left, along with Siddhartha's horse, Kanthaka. Deities hold up Kanthaka's legs, allowing the animal to depart undetected. Kanthaka appears three more times moving to the right and once moving to the left. The relief does not depict Prince Siddhartha himself; instead, a parasol (*chhatra*), a symbol of royalty in South Asia, indicates his presence. On the right edge, footprints inscribed with wheels (*chakras*) indicate that Siddhartha has dismounted from his horse. His groom kneels before him to bid farewell before returning to the palace with Kanthaka, shown on the lower right. The absence of the parasol here indicates that Siddhartha is no longer sitting on the horse.

While the depiction of the Great Departure story flows from left to right to left again like a sideways "J," the visual retelling of the Great Monkey *jataka* (**Fig. 3.6**) is more complex, requiring viewers to untangle the narrative threads. In this *jataka*, the Buddha-to-be is a monkey-king who sacrifices himself to save his tribe. The Sanchi sculptors conveyed the story through five key moments; however, they did not organize those moments chronologically within the rectangular pillar panel, nor did they depict every part of the story. The panel thus requires viewers not only to know the *jataka* already, but also to make active connections between what they know and what they see: a human king on horseback accompanied by soldiers (bottom left) arrives at a large mango tree (top left) growing on a bank of the Ganges River (shown flowing down the middle of the rectangular composition). Angered that monkeys are eating the delicious mangos he desires for himself, the king orders the animals killed. An archer near the middle of the scene prepares to carry out the command. The monkey-king, seeking to ensure that his tribe may escape the impending massacre, stretches

across the river, creating a bridge from the mango tree to a bush on the opposite bank (top center). The monkeys scamper to safety, seeking refuge on the other bank (top right); however, one monkey—the monkey-king's arch-nemesis—jumps on the monkey-king's back (not shown), breaking it and mortally wounding him. The human king, moved by this royal sacrifice, orders his men to retrieve the dying monkey-king, indicated in the relief by two men carrying a stretcher (top center, directly below the monkey-king). In the final scene, the dying monkey-king conveys the importance of self-sacrifice to the human king (top left, beneath the mango tree). By the time viewers have recounted the entire *jataka*, their gaze has crisscrossed the whole composition.

At Sanchi, there was no overall visual narrative program. Rather, the donors of each architrave or pillar panel seem to have chosen what *jataka* or scene from the Buddha's life they wanted represented. As a result, on the Great Stupa's gateways, the Buddha's Enlightenment is depicted four times, the Great Departure twice, and the Great Monkey *jataka* just once. Throughout the Sanchi reliefs, however—as in other early Buddhist art—the historical Buddha is never shown in human form. Instead, key episodes of his life are represented by symbolic objects—for example, a pipal tree signifying enlightenment. In some cases, the reliefs depict later Buddhist worship of those objects, but in other reliefs, the objects seem to be stand-ins for the Buddha himself or Buddhism more generally.

Scholars still debate why the Buddha was not shown in human form for roughly five or six centuries after his death. Some believe that early Buddhism had a prohibition against **anthropomorphic** images of the Buddha, although no written evidence supporting this idea has been found. Others argue that there was a philosophical stance against depicting the Buddha, who early Buddhists viewed as a teacher not a deity. Yet other scholars contend that **icon** worship in general was not part of ancient South Asian culture, and in this regard, Buddhist art was just reflecting broader practices of the era. Scholars also debate exactly when and why that changed, because within a century or two of Sanchi's construction, not only were images of the Buddha being made, but also they often served as focal points of Buddhist worship.

The Kushan Period and Images of the Buddha

For several centuries after the fall of the Maurya Empire in 185 BCE, various small kingdoms vied for power until the Kushan Empire emerged around the first century CE and ruled until *c.* 375 CE (**Map 3.2**). The Kushans originated as a nomadic group from inner Asia; they are referred to as the Yuezhi in Chinese historical texts of the period. Eventually they gained control over an area encompassing present-day Tajikistan, Uzbekistan, Afghanistan, and Pakistan, and then extended their reach eastward, conquering north India to the Ganges River. The overland trade routes now known as the Silk Road passed through the territory of the wealthy and cosmopolitan Kushans, who also controlled important Arabian seaports, leading to close contacts

with the Roman Empire, Parthian and Sasanian Iran, and Han China (see Seeing Connections: Art of the Silk Road, p. 116). A range of religions—Zoroastrianism (a monotheistic religion founded in ancient Iran), Greek and Roman polytheism, Buddhism, and Vedism—were practiced within Kushan borders, and various languages, including Greek, Bactrian, Pali, and Sanskrit, were spoken. The Kushans even minted distinctly designed coins in different parts of their empire to reflect local religious and linguistic practices.

A gold coin from the region of Gandhara (present-day Pakistan and eastern Afghanistan) embodies the Kushans' eclectic and cosmopolitan governing practices (**Fig. 3.7**, p. 66). The coin, which follows Roman weight standards, is inscribed in Kharosthi, the ancient script used in Gandhara and nearby regions of the Silk Road. On one side is an image of the Kushan emperor Kanishka I (ruled early to mid-second century CE). He is depicted with a full beard, pointed hat, long coat, and boots, indicative of his Central Asian heritage (kings of the ancient Iranian Parthian Empire dressed similarly). He also is presented as a god-king, with flames emanating from his right shoulder. He holds a spear in one hand and

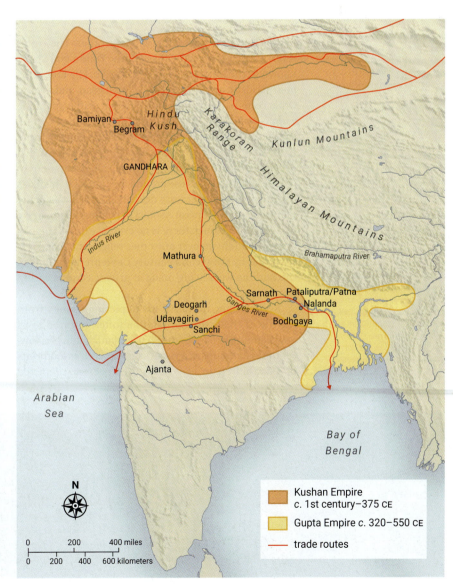

continuous narrative multiple events combined within a single pictorial frame.

anthropomorphic described or depicted with human characteristics (in art: images of people).

icon an image of a religious subject, used for contemplation and veneration.

Map 3.2 The Kushan Empire and the Gupta Empire.

Kushan Empire *c.* 1st century–375 CE

Gupta Empire *c.* 320–550 CE

— trade routes

½ ″

vajra a term meaning
thunderbolt or diamond; in
Hinduism and Buddhism,
a ritual weapon with the
properties of a diamond
(indestructibility) and a
thunderbolt (irresistible force)
to cut through illusions that
obstruct enlightenment.

frieze any sculpture or painting
in a long, horizontal format.

mudra a symbolic gesture in
Hinduism and Buddhism,
usually involving the hand
and fingers.

parinirvana the death of
someone who has achieved
nirvana, or enlightenment,
during his or her lifetime.

bodhisattva in early Buddhism
and Theravada Buddhism,
a being with the potential
to become a buddha; in
Mahayana Buddhism, an
enlightened being who vows
to remain in this world in
order to aid all sentient beings
toward enlightenment.

appropriation borrowing
images, objects, or ideas
and inserting them into
another context.

yaksha a semi-divine male
earth spirit.

reaches out to a small altar with the other. The coin's
reverse features an early image of the Hindu god Shiva,
known to the Kushans as the god Oesho. His four arms
hold a trident, an antelope, an elephant goad, and a *vajra*.
Other coins pair Kanishka with different deities spanning
various Hellenistic, Iranian, and Indian traditions—and,
significantly, with images of the Buddha in human form.

Indeed, although precise dating poses problems, evi-
dence suggests that anthropomorphic representations of
the Buddha came into use around the time of Kanishka's
reign. Later Buddhist texts describe Kanishka as being
like the Maurya emperor Ashoka in helping to propagate
Buddhism. Although there is no evidence that Kanishka
favored Buddhism over any other religious beliefs, it is
clear that by the second century CE, representations of
the Buddha were being made at artistic centers within
his empire.

Accordingly, narrative art depicting scenes from
the life of the historical Buddha (often referred to as
Shakyamuni, or Sage of the Shakya clan) that in previous
centuries had employed visual symbols, such as footprints
or a bodhi tree, to suggest his presence, now depicted

the Buddha in human form. For example, a nine-and-a-
half-foot long **frieze**, intended to be read from right to
left, narrates four scenes from the life of Shakyamuni
(**Fig. 3.8**). The first episode depicts his miraculous birth:
he was born from the right side of his mother, Queen
Maya. She went into labor while visiting her father's
garden, and the relief depicts her in a garden setting
accompanied by her father and attendants. Notably,
Maya holds onto a tree branch above her head in a pose
recalling that of auspicious female figures such as those
adorning Sanchi's *toranas* (see **Fig. 3.4**). The next panel
represents the Buddha's enlightenment. Surrounded by
the demon Mara's armies, who attempt to distract him,
Prince Siddhartha sits in meditation beneath the bodhi
tree. That it is the moment of his spiritual awakening is
confirmed by the gesture of his right hand pointed down
to the earth in the **mudra** of earth-touching (see **Fig. 3.11**).
The third scene depicts the Buddha's first sermon, given
at the deer park in Sarnath, where he "put the wheel of
law into motion." The deer and wheel imagery adorn-
ing the platform on which he sits identifies the event.
The final scene shows the Buddha's **parinirvana**. While
Shakyamuni lies on his deathbed, mourners around him
wail, except for one disciple, who sits calmly in medita-
tion, recognizing that the Buddha has escaped the cycle
of *samsara*. These four scenes are amongst the most
important and frequently depicted events in Buddhist
narrative art from the period.

In addition to the Buddha's bodily representation in
narrative art, stand-alone icons of the Buddha, as well as
bodhisattvas, were popular by the second century CE. Like
stupas, these sculptures became focal points for worship,
further signifying the extent to which attitudes toward
images of the Buddha had shifted. These devotional
images seem to have appeared at roughly the same time
in two distinct locations and styles. Around the time of
Kanishka's reign, there were two main locations for artis-
tic production: one in Gandhara and one in Mathura (see
Map 3.2). Because of Gandhara's proximity to the long-
distance trading routes stretching from the Mediterranean
to China, its visual culture maintained strong ties to both
the Greco-Roman Hellenistic world and Sasanian Iran as
well as the Indian subcontinent. Although Mathura also
was located on a major trade route, its visual culture was
more fully embedded in northern Indian artistic styles
and conventions. These differences are visible in the
Buddhist imagery each location produced.

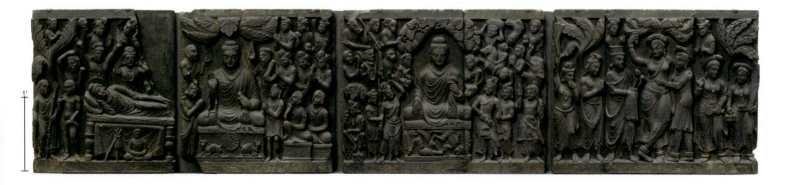

1′

Mathura artists used mottled red sandstone to create full-bodied, smiling figures such as this sculpture of the Buddha in a seated position (**Fig. 3.9**). Notice how the Buddha stares directly at the viewer, with his hand in a welcoming *mudra*. The hair is smooth, and the Buddha has a light-weight, sheer shawl draped over one shoulder. At Gandhara, in contrast, sculptors used gray schist stone and **appropriated** select aspects of provincial Roman portraiture as well as earlier Hellenistic visual traditions (see Art Historical Thinking: Influence, Appropriation, or Adaptation?, p. 128). These artistic connections are visible, for example, in the heavy, draped clothing and thick, wavy hair of the *bodhisattva* Maitreya pictured here (**Fig. 3.10**). Gandhara-sculpted figures also tend to look downward and bear serious expressions, as this Maitreya does.

In the past, art historians focused on establishing which location—Gandhara or Mathura—was first to depict the Buddha and *bodhisattvas*. Nineteenth-century European scholars argued that Gandhara was first and that the inspiration came from Greco-Roman statues of male gods, such as Apollo. In contrast, early twentieth-century Indian scholars asserted that Mathura was first, with **yakshas** as the probable inspiration. In each case, scholarly analysis was shaped by cultural bias and the colonial politics of the era: a useful reminder that we never interpret art from a neutral perspective. Rather, our interpretations reflect our own cultural assumptions and worldviews.

Today, the two styles (Gandhara and Mathura) are typically viewed as arising at the same time—the sculptural equivalent of the different Kushan coins responding to regional conventions—with the anthropomorphic turn in Buddhist art reflecting changes within the religion itself as well as in South Asian culture more generally. During this period, Buddhism began to evolve. The idea gradually took hold that one should not just seek personal liberation, but rather the liberation of all beings. Correspondingly, *bodhisattvas* gained prominence as compassionate figures who delayed *nirvana* in order to help others on the path to enlightenment. This new idea and the doctrines that developed to support it eventually became known as Mahayana Buddhism, which also recognized many more buddhas. (In contrast, Buddhist

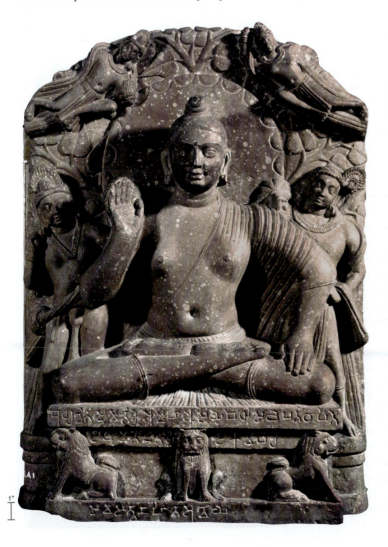

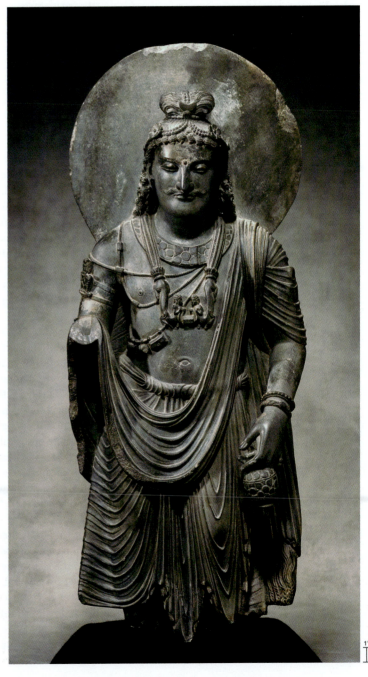

3.9 BELOW LEFT **The Buddha,** Mathura, India, Kushan period, early second century CE. Red sandstone, height 27¾ in. (70.5 cm). Government Museum, Mathura, Uttar Pradesh, India.

3.10 BELOW RIGHT **The *bodhisattva* Maitreya,** Gandhara, Pakistan, Kushan period, *c.* 100–300 CE. Stone (schist), height 41 in. (1.04 m). Asian Art Museum, San Francisco.

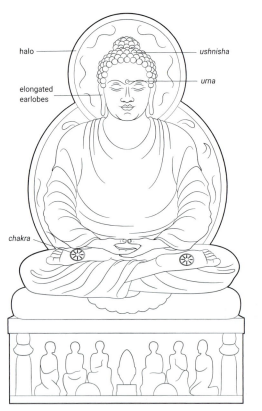

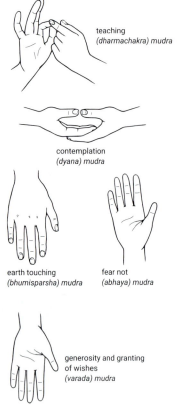

halo

ushnisha

urna

elongated
earlobes

chakra

teaching
(dharmachakra) mudra

contemplation
(dyana) mudra

earth touching
(bhumisparsha) mudra

fear not
(abhaya) mudra

generosity and granting
of wishes
(varada) mudra

Art of the Gupta Era, *c.* 320–550 CE

The Gupta Empire (*c.* 320–550 CE) that followed the Kushan Empire was a time of cultural and intellectual achievement, including the founding of the Buddhist university at Nalanda and advances in mathematics (the invention of zero) and astronomy (the calculation of the solar year). By the fifth century, Sanskrit, a language originally associated with Vedic ritual, had been adopted by the royal court. Under Gupta rule, Sanskrit became central to expressions of political power and cosmopolitan courtly culture, in addition to religious beliefs. As a result, Sanskrit-language literature thrived, with the composition of the *Panchatrantra* animal fables, the *Puranas* (myths related to the Hindu gods), and the *Kama Sutra* (a Sanskrit text on sexuality, eroticism, and emotional fulfillment). The Gupta monarchs were Hindus (by this point, Vedism had evolved into the practices and beliefs associated with Hinduism), but they were pluralistic in their support of religion, leading to the flourishing of art related to Hinduism, Jainism, and Buddhism.

BUDDHIST ART IN THE GUPTA PERIOD

The Gupta era saw the development of what some art historians consider to be the quintessential representation of the Buddha. Gupta images of the Buddha became the inspiration for those made in other regions, from China to Java, with artists in each place modifying their

3.11 The marks of the Buddha and common *mudras* (hand gestures).

iconography images or symbols used to convey specific meanings in an artwork.

ushnisha one of the thirty-two markers of a buddha or a *bodhisattva*; a protuberance from the head, usually a topknot of hair.

urna one of the thirty-two markers of a buddha or a *bodhisattva*; a tuft of hair or small dot between the eyebrows that symbolizes a third eye.

halo a circle of light depicted around the head of a holy figure to signify his or her dignity.

3.12 FAR RIGHT The Buddha preaching the first sermon, Sarnath, India, Gupta period, *c.* 475 CE. Sandstone, 61 × 34 × 10½ in. (1.55 m × 86.4 cm × 26.7 cm). Sarnath Archaeological Museum, India.

orders that maintained older practices of focusing on the historical Buddha and one's personal efforts toward enlightenment became known as Theravada Buddhism.) However, the growth of Mahayana beliefs cannot completely explain the appearance of buddha and *bodhisattva* images. The new imagery most likely also reflected a more general South Asian cultural shift toward depictions of religious figures as objects of devotion, because the development of Jain and Hindu imagery also dates to this period.

The standard **iconography** of Buddhist imagery seems to have been established quickly. The Buddha is typically shown frontally, in a seated, standing, or reclining position. If seated, he is often shown in a meditative pose: his feet, soles facing up, on his thighs. Religious texts describe thirty-two signs indicating his perfection, but many of these attributes—such as his straight, white teeth or long, thick eyelashes like those of a royal bull—are not visually represented. The three most commonly portrayed markers are his ***ushnisha, urna,*** and elongated earlobes, the latter indicating the heavy jewelry he wore as a royal youth before renouncing it (**Fig. 3.11**). He often has a **halo**, signifying his divine aura. Occasionally his hands are webbed, and wheels (*chakra*) are imprinted on the soles of his feet and the palms of his hands. *Bodhisattvas* also bear many of these signs, but because they have not yet adopted monastic life, they are depicted as handsome royal figures wearing elegant clothes and jewelry. Specific *bodhisattvas* have additional iconographic elements. For example, in early depictions of Maitreya, he holds a sacred water flask in his left hand (see **Fig. 3.10**); in later representations, he may or may not have it.

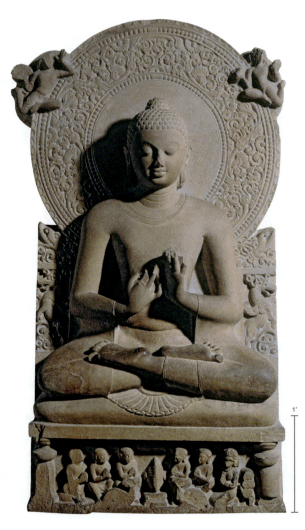

images to suit local needs. During this period, maritime trade increased, with Gupta merchants traveling to and occasionally settling in various Southeast Asian locations. Meanwhile, Buddhists from across Asia came to the Indian subcontinent to study at Nalanda University and to visit sites associated with the Buddha's life. This movement of people also led to the movement of ideas and objects, including portable **bronze** Buddhist devotional sculptures made by Gupta artists.

Gupta artists appropriated aspects of Kushan-era images and combined them with fresh elements. A late fifth-century sandstone statue of the Buddha from Sarnath exemplifies this new representation (**Fig. 3.12**). The Buddha is seated, with his legs crossed and his hands in a teaching *mudra* (see **Fig. 3.11**), referencing Sarnath as the location of his first sermon. The Buddha's standard iconography, including *ushnisha* and elongated earlobes, is present, and the carving shows a high degree of refinement. The Buddha's cloak-like shawl is large and close-fitting, as in the earlier Mathura style, but it is no longer sheer and it now covers both shoulders. His hair is composed of distinctive, small, snail-shell curls. His eyes are downcast, like those of Gandhara figures, but now his tranquil, oval face bears a slight smile. The elegantly carved round halo and rectangular base, paired with the triangular composition of the Buddha at center, add to the sense of stability and stillness. Altogether, the image presents the Buddha in a state of spiritual bliss that comes from attaining enlightenment.

JAIN ART IN THE GUPTA PERIOD

Alongside these developments, Jain sculpture blossomed. Like Buddhism, Jainism adopts the Vedic ideas of karma, *dharma*, and *samsara*, with liberation from existence as the ultimate goal, and it emphasizes personal actions rather than complicated religious rituals. Jainism's founder, Mahavira (*c.* 540–468 BCE), was a chieftain who left home at the age of thirty, gave up his worldly possessions, and adopted a path of austerity, penance, and meditation. Once he achieved enlightenment, he became a Jina, or "Spiritual Conqueror," and taught others the path. According to Jain beliefs, Mahavira was the last of twenty-four Jinas in this cosmos, each born into a royal family but renouncing the world in search of enlightenment. Jains are instructed to live modestly, perform ritual acts of devotion, and practice nonviolence, including strict vegetarianism. Jainism does not seek converts and therefore did not spread as extensively as Buddhism, which does.

Statues of Jinas are the most common and recognizable form of Jain art. It is certain that sculptures of Jinas were being produced at Mathura during the Kushan dynasty, if not earlier, but there is no archaeological record of them being made or used beyond Mathura before the Gupta era. By the sixth century CE, they could be found throughout north and western India. Jain sculptures are remarkably consistent, depicting the Jina sitting or standing in a rigid meditative posture, with a symmetrical, idealized form that emphasizes the geometry of the body. In fact, it is nearly impossible to tell which of the twenty-four Jinas is being depicted, with two exceptions:

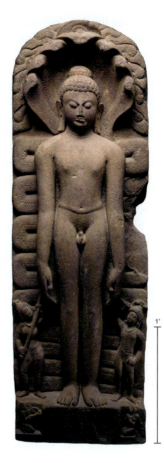

3.13 **Jain Tirthankara (Jina) Parshvanatha,** India, Gupta period, sixth century CE. Sandstone, height 44 in. (1.12 m). Metropolitan Museum of Art, New York.

Rishabhanatha is recognizable by his long hair, and Parshvanatha by the seven-headed cobra sheltering him.

Upon first glance, this sculpture of Parshvanatha (**Fig. 3.13**) that dates from the sixth century CE may seem to resemble closely a statue from the fifth century CE of the seated Buddha (see **Fig. 3.12**). Their similarities result partly from being crafted in the same artistic style. The broad, rounded shoulders, the smooth planes of the chest, the hair of snail-shell curls, and the oval face are all hallmarks of Gupta art. The sculptures share iconography, too, in parallel with the many similarities in the two *dharmic* faiths. Like the Buddha, Jinas have elongated earlobes, signifying their early life as royalty who wore heavy earrings. Likewise, Jinas are often depicted with *ushnishas.* When standing, Jinas are revealed to have arms that reach to their knees; the Buddha is also sometimes shown with long arms, another of the thirty-two signs of perfection manifest in both Jinas and buddhas. The Buddha is frequently depicted in meditation; Jinas always are.

What, then, are the distinguishing features of a Jina? A Jina often bears an auspicious mark on his chest called a *shrivatsa* (not visible on this figure), but the clearest difference is dress. The Buddha wears typical Indian monastic dress, including a simple undergarment and a large rectangular shawl covering one or both shoulders. Because Jainism emphasizes austerity rather than the middle path of Buddhism, Jain monks' clothes are more minimal. If the icon belongs to the Shvetambara or "white-clad" branch of Jainism, the Jina wears a simple loincloth. If the icon has been made for the Digambara or "sky-clad" branch, which regards any monk's clothing

bronze an alloy consisting primarily of copper with some tin, and often small amounts of other metals and/or minerals.

darshan the auspicious devotional act of seeing and being seen by a deity, holy person, or sacred object in Hinduism.

aniconic the indirect visual representation of divine beings through symbols or abstract images.

linga an abstract representation of the Hindu god Shiva that denotes his divine generative energy.

as an indulgence, the Jina is naked, as in this sculpture. (For more on Jain art, see Seeing Connections: Art and Ritual, p. 159, and Figs. 7.15, 7.16).

HINDU ART IN THE GUPTA PERIOD

Vedic traditions did not disappear during the centuries that Buddhism and Jainism developed, but they did transform into a collection of practices and beliefs that today are classified as Hinduism. Over time, a form of devotionalism called *bhakti* supplanted many of the more complicated Vedic rituals and sacrifices. *Bhakti* emphasizes a devotee's personal relationship with a god, in which **darshan**, the act of seeing and being seen by the god, and *puja*, a prayer ritual in which one shows reference to the god, are the focus of worship. Additionally, during this period, older Vedic gods decreased in importance as local belief systems with their own gods and goddesses were incorporated into Hinduism. In some cases, such as that of Vishnu (see **Fig. 3.14b**), minor Vedic gods became major Hindu deities. These new gods feature prominently in the Hindu epics the *Mahabharata* and the *Ramayana*, written during the first century CE, and the Gupta-era *Puranas*.

While Hinduism is often described as a polytheistic faith, in fact Hindus ultimately believe in one god whose infinity is beyond human perception. A variety of gods and goddesses, therefore, are needed to represent different aspects of the One God. Further increasing the complexity of Hindu iconography, the major gods and goddesses exist in more than one form. In general, the three main deities worshiped, and therefore depicted in Hindu art, are Shiva, Vishnu, and Devi.

Shiva is both the creator and the destroyer, embodying the paradoxical and cyclical nature of life. He appears in various manifestations, from meditating yogi (**Fig. 3.14a**) to glorious dancer. His most powerful form is his **aniconic** representation, called a *linga*. A columnar shape with a curved top, a *linga* can be interpreted as an erect phallus, referencing Shiva's role as creator and probably deriving from earlier religious practices that celebrated fertility. It also can be understood as an abstract signifier of divine energy. Sometimes Shiva's iconic and aniconic forms are combined, as they are in a sandstone sculpture dating from the fifth century CE of a *linga* bearing Shiva's face (**Fig. 3.15**). His matted dreadlocks and blissful expression are consistent with his representation as a meditating ascetic.

Vishnu is the preserver, the savior of humankind, and the creator of the universe (see Looking More Closely: Hindu Narrative Art, p. 74). He is often represented as a four-armed king (**Fig. 3.14b**). At times of crisis, Vishnu descends from his abode to this world. He has ten incarnations, called *avatars* (ones who descend) in Sanskrit, including Rama, Krishna (see Fig. 0.14), and the Buddha. This may explain why Buddhism declined in India while it was taking hold through the rest of Asia: Hinduism

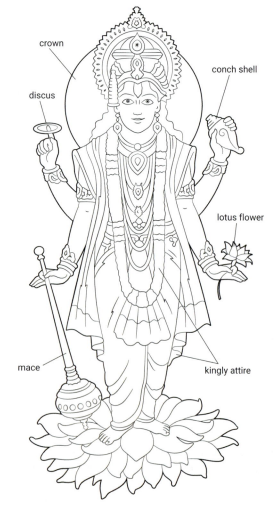

3.14 The three main Hindu deities and their iconography
CLOCKWISE FROM TOP LEFT
3.14a Shiva, 3.14b Vishnu, and 3.14c Devi (in the form of Durga vanquishing Mahishasura).

incorporated it, turning the Buddha into one of Vishnu's incarnations. The tenth *avatar*, Kalki, has yet to come.

Devi is the Great Goddess, and she tends to take one of two general forms. When she appears as the partner of a male god (for example, as Parvati, Shiva's consort, or as Lakshmi, Vishnu's consort, as in **Fig. 3.18**), the goddess is beautiful and benevolent. When she is on her own, however, she is fierce, fearless, and full of energy, such as when she appears as Durga to vanquish the buffalo demon, Mahishasura (**Fig. 3.14c**).

Art, particularly figural art, plays a central role in Hindu religious practice. *Darshan* and *puja*, the two central aspects of worship, require images of the gods, and narrative art is needed to tell their stories. Images of Shiva, Vishnu, and Devi began to appear during the Kushan dynasty (**Fig. 3.7**), and simple brick Hindu temples existed from as early as the third century CE. Monumental Hindu art, however, began to be made only under the patronage of the Gupta rulers, who employed art as a way to connect their power to that of the gods.

The most important Gupta-era Hindu site—and the only one that can be definitively linked to Gupta imperial patronage—is Udayagiri in central India (**Map 3.2**). Archaeological evidence suggests that the sacred site, on the northeast face of the Udayagiri hills, had been in use since the second century BCE, but was substantially developed under the patronage of the kings Chandragupta II (ruled *c.* 380–415 CE) and Kumaragupta (ruled *c.* 415–55 CE). By the fifth century CE, it consisted of twenty **rock-cut** caves, as well as other structures (for more on rock-cut cave architecture, see Chapter 5). The centerpiece of the site is a 13-foot-high (almost 4 m) sandstone relief

3.15 FAR LEFT *Linga* **with the face of Shiva,** Madhya Pradesh, India, Gupta period, first half of the fifth century CE. Sandstone, height 6⅞ in. (17.5 cm). Metropolitan Museum of Art, New York.

rock-cut carved from solid stone, where it naturally occurs.

3.16 **Rock-cut relief sculpture of Varaha saving Bhudevi (the earth goddess),** Udayagiri, India, Gupta period, fifth century CE.

sculpture of the Hindu god, Varaha, saving Bhudevi, the earth goddess, from the bottom of the primordial ocean (Fig 3.16, p. 71).

The imposing relief, which takes up the back wall of a shallow niche, is one of the earliest examples of Hindu narrative art. A close study of the relief highlights the choices and considerations facing the artists who made such works. South Asian artists from these early centuries are largely anonymous; their names are not inscribed on artworks or recorded in histories. However, the lack of information regarding artists' identities does not mean they were unskilled or passive in the art-making process. Even though royal patrons, Hindu priests, and long-standing visual conventions played significant roles in the creation and design of monumental artworks, the myriad of decisions, large and small, made by highly skilled artists was crucial to the visual potency of the final product, as exemplified by the Varaha narrative relief.

The story of Varaha, Vishnu's third *avatar*, is told in the *Puranas*: when Vishnu hears that the earth goddess Bhudevi is drowning at the bottom of the cosmic ocean, he descends to earth in the form of a boar so that he can burrow down to save her. The demon Hiranyaksha tries to stop him, but Varaha prevails, using his tusks to lift Bhudevi to safety. Rather than depicting multiple moments in the story, the Udayagiri sculptors chose to show a single scene—the triumphant climax when Varaha emerges from the sea with Bhudevi hanging from his tusk. Rows of deities and sages in the background pay homage to the miraculous event, as does a hybrid snake-king (*naga-raja*) in the foreground. The snake-king, with his hands in the *mudra* of divine offering, looks up at the god in admiration. Because snakes are traditionally associated with water, his presence in the scene also functions as a visual signifier of the sea below. The topography of Udayagiri during the Gupta dynasty would have further emphasized this aspect of the tale: during the rainy season, water from a nearby pond covered the bottom of the relief. Indeed, the relief's specific location most likely was specifically chosen for its ability to augment the art.

Every choice, whether iconographic, compositional, or stylistic, made by the artists helped to accentuate Varaha's heroism. Varaha can be depicted either fully as a boar, or—as he is here—as hybrid figure with a boar's head and man's body. The choice to represent him with a human body helps convey his valor. Note, for example, Varaha's triumphant posture and the strong diagonal line it creates. His pose, together with the positioning of Bhudevi at his shoulder and the snake-king at his foot, forms an acute triangle, both stable and dynamic, that visually pierces the horizontal rows of Hindu sages behind them. The juxtaposition between the shallow carving and small scale of the sages and Varaha's size and deep modeling further emphasizes the god's awe-inspiring appearance. Finally, Varaha's broad, rounded shoulders and smooth chest—which conform to Gupta artistic style (compare to Figs. 3.12 and 3.13)—complete the effect.

One of the goals of Hindu art is to heighten the religious experience. Images of gods are meant to make them accessible to the devotee, but also stress their superhuman qualities and convey the particular aspects of the divine that they manifest—in the case of Vahara, he is the heroic savior of earth. However, politics also plays a role in the creation of monumental art. This relief undoubtedly was meant to be read as a political allegory—the Gupta

3.17 Temple to Vishnu, Deogarh, India, late Gupta period, early sixth century CE.

kings as rescuers, bringing stability back to the region after the fall of the Kushan Empire. Indeed, Chandragupta II is even likely depicted in the relief; based on inscriptional evidence at the site, scholars believe he is the now-fragmentary kneeling figure to the right of the snake-king. We can imagine that Chandragupta appreciated the connection between Varaha's heroism and his own rule.

One of the earliest freestanding Hindu temples is the sixth-century CE shrine to Vishnu at the central Indian site of Deogarh (**Fig. 3.17**). A 16-foot-square (4.88 meters-square) sandstone structure, raised on a **plinth** and topped by a tower (now crumbling and therefore missing its top), it provides an excellent example of a Hindu temple layout

in its simplest, yet still refined, form. A Hindu temple is the deity's home on earth, conceptualized—that is, theoretically understood—as a cave at the base of a sacred mountain. The *garbhagriha* ("womb-chamber"), symbolizing the cave, houses the main devotional icon. It has a single entranceway and is topped by a *shikhara*, symbolizing a mountain peak. Because Hinduism is not a congregational faith, no large interior space is required, and the majority of sculptural decoration is on the temple's exterior. A devotee of Hinduism would stand at the *garbhagriha*'s doorway to receive *darshan* and perform *pradakshina* in order to view the exterior sculpture. At Deogarh, the main icon is now missing, but historians

plinth a base or platform upon which a structure rests.

garbhagriha a Hindu temple's innermost sanctum; a small, dark space, where the main icon of a deity is housed.

shikhara literally, "mountain peak," the tower above the inner sanctum of a Hindu temple, used specifically for north Indian temples.

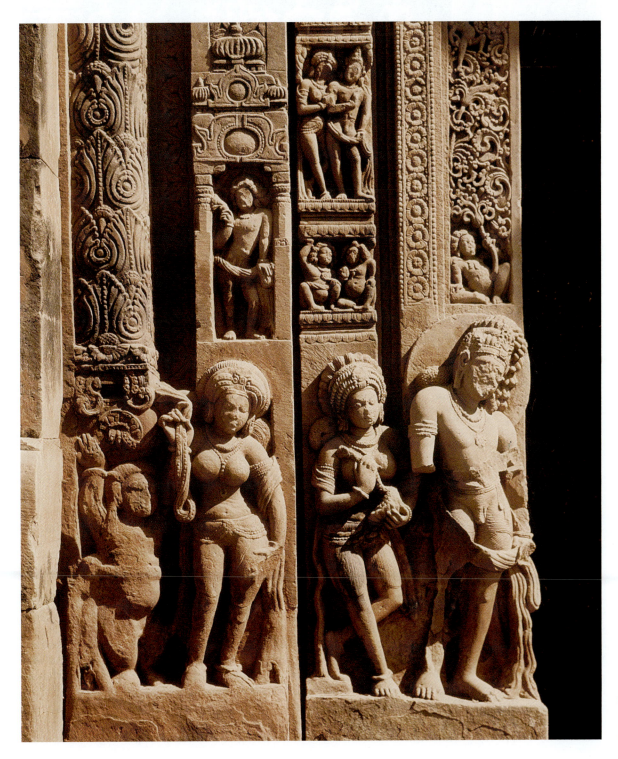

3.18 Detail of the doorway on the west facade of the Temple to Vishnu, Deogarh, India, late Gupta period, early sixth century CE.

Visually complex and laden with religious meaning, Hindu narrative art sometimes requires step-by-step unpacking.

For example, let us take a closer look at the Deogarh temple's south panel.

A First, notice that to the panel's immediate left is an image of the elephant-headed god Ganesha, remover of obstacles and worshiped at the start of a task. His presence suggests that *pradakshina* begins here.

B Next, study the panel's iconography to determine what is depicted. The royal crown on the central, reclining figure indicates that it is Vishnu. He sleeps cushioned by the serpent of infinity Ananta, identifiable by his multiheaded cobra hood. Here, the hood acts as a protective canopy. Vishnu's consort, Lakshmi, massages the god's leg. According to the *Puranas*, as Vishnu slept and dreamed, a lotus grew from his navel. The blossom eventually opened to reveal Brahma, the god of creation. Here, perhaps for artistic reasons, the lotus vine is not attached to Vishnu's navel, but rather drapes elegantly along his body.

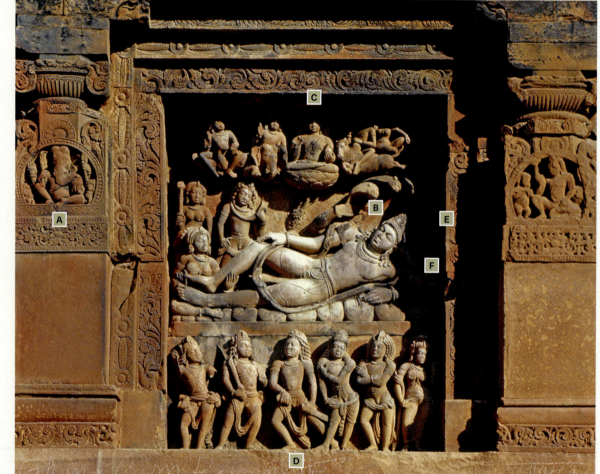

C At the top of the panel, Brahma is shown seated on a lotus flower and flanked by other deities there to witness the miraculous event. For example, directly to Brahma's right are Shiva and Parvati, riding on Shiva's mount, the bull Nandi.

D The figures positioned in a row at the base are personifications of Vishnu's four weapons (at right) stopping two demons (at left) from attacking Vishnu as he sleeps.

E Next, analyze the relief's style, which indicates roughly when it was made. In this case, Vishnu's broad, rounded shoulders, smooth chest, and oval face confirm the relief is in the Gupta style, dominant in central India during the fifth and sixth centuries CE.

F Finally, consider the visual strategies employed by the artist(s), and how they enhance the viewing experience. Here, the sculptors divided the composition into three rows, or registers, which increase the relief's legibility. This clarity provides the composition with a sense of stability and calm, echoing that of Vishnu's long slumber. Vishnu is both the largest figure and the only one positioned horizontally, increasing his prominence in the scene.

3.19 Sculptural panel showing Vishnu reclining on the serpent Ananta, Temple to Vishnu, Deogarh, India, late Gupta period, early sixth century CE.

facade any exterior face of a building, usually the front.

mithuna in South Asian cultures, an amorous couple, representing fecundity and considered auspicious.

assume it was a sculpture of Vishnu. It is also likely that originally there were four smaller shrines at the plinth's corners, complementing the main structure.

The temple's exterior decoration consists of a heavily ornamented doorframe on the west **facade** and three rectangular sculptural panels, one on each remaining side. The doorway is topped by a small image of Vishnu sitting on a serpent, and framed by a series of densely carved bands combining vegetal and architectural motifs with figures (**Fig. 3.18**, p. 73). These include river goddesses, dwarfs, *yakshas* and *yakshis,* as well as **mithunas** in various states of intimacy. The sculpted forms emphasize the figures' fecundity, and thereby, their auspiciousness; one dwarf-like figure even has a vine growing from his navel.

Since the doorway leading to the temple's inner chamber is simultaneously a vulnerable juncture in need of protection and a powerful threshold marking the movement from one realm to another, such auspicious imagery is particularly important.

The temple's south panel depicts Vishnu creating the god Brahma, who himself is the creator of the world. The east sculptural relief depicts Vishnu in the form of twin sages meditating and preaching the importance of *dharma*, and the north panel shows Vishnu liberating an elephant king who had become trapped by a sea demon. At most Hindu temples, the entrance faces east, so circumambulation proceeds in what is classified today as a clockwise direction. However, because the Deogarh temple faces west, *pradakshina* was most probably performed in the other direction (counterclockwise). This interpretation is confirmed by the small image of Ganesha, the elephant-headed god worshipped at the beginning of a task, that immediately precedes the sculptural panel on the south side (see **Fig. 3.18**). Thus, a devotee performing *pradakshina* would first encounter a birth/creation scene, then a scene promoting the importance of *dharma* on Earth, and finally a scene of liberation. While each panel is a complete artwork itself, together they convey a larger message that scholars call the iconographic program.

In the centuries that followed Gupta rule, as Hindu temples grew in size and grandeur, the imagery on them became increasingly profuse and their iconography more complex and multi-layered (see Chapter 7). Architectural treatises written in the seventh and eighth centuries CE further articulated aspects of Hindu temple design. However, as the temple at Deogarh demonstrates, by the early sixth century CE, the fundamental parts of a Hindu temple and their symbolic import were in place. Likewise, by the fifth and sixth centuries CE, images of the main Hindu gods and goddesses, as well as of Jinas, buddhas, and *bodhisattvas*, were being made in forms that today are still associated with these religious traditions.

Discussion Questions

1. Compare the role that art plays in Buddhism to its function in Hinduism. What are the similarities, and what are the key differences?

2. One theme of this chapter is the distinction between iconography and style. Compare three Gupta artworks discussed in this chapter—one Buddhist, one Jain, and one Hindu—in terms of style and iconography.

3. Pick an example of narrative art from this chapter. Think about the visual choices made by the artist(s) to tell the story. What are some other ways to tell the same story visually, and how would they change the viewing experience?

4. Research question: the Great Stupa at Sanchi is the best-preserved and perhaps best-known early *stupa*, but there are other important early *stupas* as well: that at Bharhut in central India and Amaravati in the eastern Deccan (the plateau connecting north and south India), for example. Choose one of the two *stupas* listed and research the relief carvings from the site. Specifically, compare the *stupa*'s narrative art to that from the Great Stupa at Sanchi.

Further Reading

- Asher, Frederick. "On Maurya Art." In Rebecca Brown and Deborah Hutton (eds.). *A Companion to Asian Art and Architecture*. Malden, MA: Wiley-Blackwell, 2011, pp. 421–43.
- Blurton, Richard T. *Hindu Art*. London: British Museum Press, 1992.
- Dehejia, Vidya. *Indian Art*. London: Phaidon, 1997.
- McArthur, Meher. *Reading Buddhist Art: An Illustrated Guide to Buddhist Signs & Symbols*. London: Thames & Hudson, 2002.

Chronology

c. 540–468 BCE	The life of Mahavira, the founder of Jainism	c. early–mid-second century CE	The reign of the Kushan ruler Kanishka
c. fifth century BCE	The life of Siddhartha Gautama, the founder of Buddhism		
c. 322–185 BCE	The Maurya Empire rules much of South Asia	c. 100–300 CE	Anthropomorphic images of the Buddha appear
c. 272–231 BCE	The reign of the Maurya emperor Ashoka, who converts to Buddhism, constructs *stupas*, and erects stone pillars proclaiming ethical codes of behavior	c. 300–500 CE	Early Hindu *Puranas* are composed
c. 100 BCE–900 CE	Rock-cut and cave architecture flourishes in South Asia	c. 320–550 CE	The Gupta Empire rules in north India; Gupta artists make both stone and portable bronze Buddhist sculptures
c. 50–25 BCE	The Great Stupa at Sanchi is enlarged and embellished	early sixth century CE	Stand-alone Hindu temples are developed in South Asia; the temple to Vishnu is built at Deogarh
first century CE	The Hindu epics the *Mahabharata* and the *Ramayana* are written	sixth century CE	A sandstone standing statue of the Jain Tirthankara (Jina) Parshvanatha is made
c. 1st century–375 CE	The Kushan Empire rules an area stretching from Central Asia to north India		

Gold Crowns across Asia

The natural element gold possesses unusual properties. It is highly malleable; it does not tarnish; and it both absorbs and reflects light in such a way as to appear radiant. But, outside of human societies, gold is of little value and has no meaning. How does gold gain its potency? Across Asia, fine craftsmanship has transformed gold into elaborate, exquisite crowns. And across a range of cultures, when worn atop the head, crowns immediately signify the elevated status of rulers and royalty. Three examples, dating from the first to the six centuries CE, also suggest the transmission of artistic techniques and forms from the region of present-day Afghanistan across the steppes and over the sea to the Japanese archipelago, a distance of more than 3,800 miles (6,100 km).

In 1978, a Soviet-Afghan archaeological team unearthed some 20,000 artifacts from a group of six burial mounds at the Tillya Tepe site

1 BELOW **Crown, Tillya Tepe,** tomb VI, Shiberghan, Afghanistan, *c.* 25–50 CE. Gold and imitation turquoise, height 5 in. (13 cm). National Museum of Afghanistan. **SOUTH ASIA**

2 RIGHT **Crown, Silla kingdom,** excavated from the north mound of the Great Tomb at Hwangnam (Hwangnamdaechong), Korea, *c.* 450–500 CE. Gold and jade, height 10¾ in. (27.5 cm). Gyeongju National Museum, Korea. **EAST ASIA**

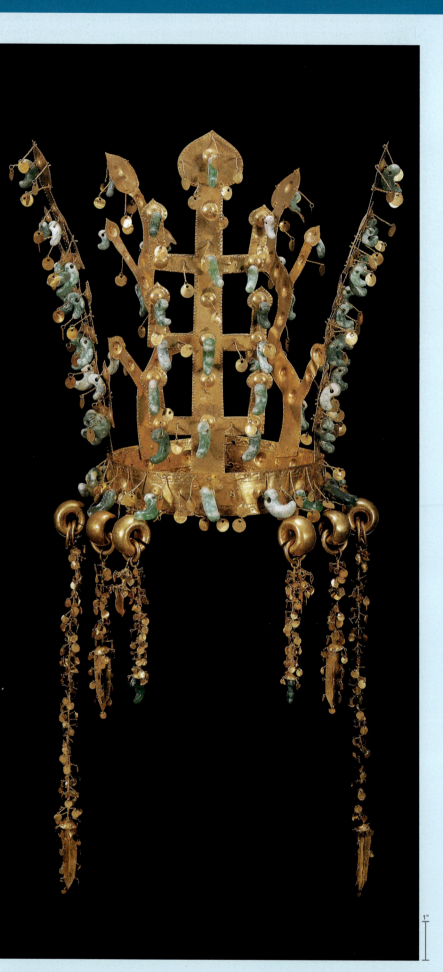

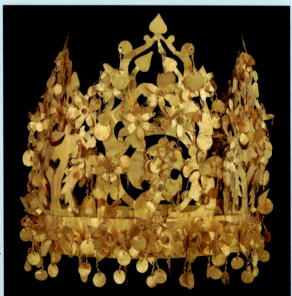

3 Crown, Fujinoki Tomb, Japan, Kofun period, sixth century CE. Gilt bronze, height 13¾ in. (35 cm). The Museum, Archaeological Institute of Kashihara, Nara prefecture, Japan. **EAST ASIA**

near present-day Shiberghan in Afghanistan. Collectively known as the Bactrian Gold hoard, the artifacts included many coins and much jewelry. The Tillya Tepe crown, from a tomb of an unidentified nomadic woman, is particularly splendid and ingenious (**Fig. 1**).

Shape and size certainly informed the meaning and significance of crowns, but superior craftsmanship is inextricably involved, too. In order to maximize visual impact, the unknown goldsmiths of this crown cut thinly hammered sheets of gold and shaped them into a band or circlet that fits snugly around the head. Stylized gold flowers with gold-beaded centers adorn the circlet, and five trees of cut gold rise above it. Their branches meander, forming curved silhouettes and openings in the shapes of hearts and crescents. On some trees, birds perch symmetrically, adding further complexity and gracefulness to the design. Finally, round spandrels dangle from fine hooks and links. Slight movements cause the spandrels to shimmy, catching light and reflecting it in all directions. Skilled artisans shaped raw gold into a resplendent composition, but they also considered practicality. This crown is collapsible, thus protecting its delicate form if and when its nomadic wearer moved from place to place.

Nomadic cultures have a long history in Asia, flourishing especially in steppe regions. The Tillya Tepe crown demonstrates, contrary to the views of sedentary cultures that found nomadic life antithetical to their own, that a lack of permanent residence does not imply an absence of luxury material goods. Nomads also played a key role in the movement of artifacts and the transmission of ideas across the Eurasian continent. About five centuries after the Tillya Tepe crown was buried, crowns with remarkably similar characteristics accompanied royalty into the after-life in the Silla kingdom (traditional dates 57 BCE–935 CE) on the Korean peninsula (**Fig. 2**).

As with the Tillya Tepe crown, unknown goldsmiths assembled carefully cut sheets, wire, and spandrels into a circlet with stylized trees. Here, the composition has a more rigid, geometric quality; and the trees appear more elongated. As a result, the crown projects firmness and stature. It is further distinguished by its incorporation of a contrasting material, jade. Jade ornaments (*goguk*) in comma shapes dangle alongside hundreds of gold spangles. Longer assemblages hang from thick hoops, drawing attention to the royal face they frame. The fragile quality of this crown has spurred debate as to whether or not it was worn prior to its burial with a queen. Regardless, because the tree forms relate to shamanic beliefs, the crown implies that royalty commanded a degree of religious power.

Both the Tillya Tepe and Silla kingdom crowns were made of gold, but many more crowns were made of another material that mimicked gold: gilt bronze. Possibly made in the Korean archipelago, this crown (**Fig. 3**) from the Fujinoki Tomb in Japan dates to the sixth century during the Kofun period. Although the bronze over time oxidized, resulting in a green patina, still, areas of gold remain. A thin coating of gold once covered the bronze circlet of paired mountains from which rise paired trees. Fringe ornaments in the shapes of birds and boats surround the trees, and spandrels take leaf shapes. The use of gilt bronze may indicate that the demand for gold outstripped supply as the popularity of crowns spread. This crown's golden appearance would have sufficiently attested to the high rank of its wearer.

Discussion Questions

1. Search this textbook for another artwork that makes use of gold. How does the use of gold affect the composition and meaning of that artwork?

2. Search this textbook for an image of a ruler or other high-status individual. Does a crown or other headdress play a role in determining status? Describe, analyze, and explain.

Further Reading

- Hiebert, Fredrik and Cambon, Pierre (eds.). *Afghanistan: Hidden Treasures from the National Museum, Kabul*. Washington, D.C.: National Geographic Society, 2008.

- Kidder, Jr., J. Edward. "The Fujinoku Sarcophagus." *Monumenta Nipponica* 44, no. 4 (Winter 1989): 415–60.

- Lee, Soyoung and Leidy, Denise Patry. *Silla: Korea's Golden Kingdom*. New York: The Metropolitan Museum of Art, 2013.

4

Changing Centers of Power and Art in East Asia

400 BCE–600 CE

4.0 Colossal seated buddha, Yungang
Caves (Cave 20), Shanxi province, China.

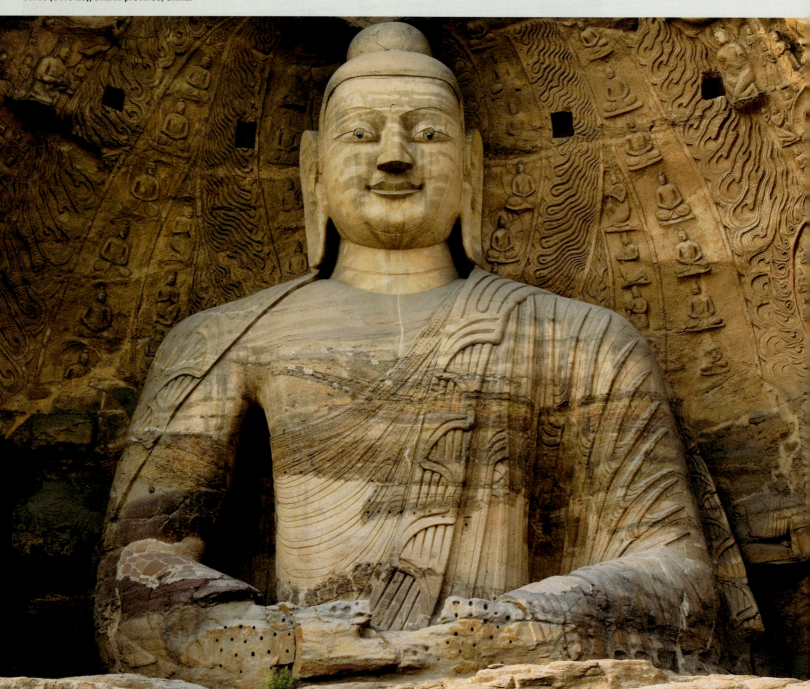

Introduction

The art of East Asia in the ancient era responds to sweeping socio-political changes. As centralized states superseded Neolithic chiefdoms in the areas of present-day Japan and Korea, a vast empire—the Han dynasty—collapsed on the Chinese mainland. Migration and trade had profound effects on art, too. Some artworks from this period may look typically "Japanese," essentially "Korean," or distinctively "Chinese," but these countries and their respective cultures had yet to take form. Thus, in this context, the names "Japan," "Korea," or "China" are not intended to carry the weight of modern nation-states. Rather, the focus is on a subset of the historical and diverse cultures that developed in the roughly one thousand years between the fourth century BCE and the seventh century CE.

On the Japanese archipelago, increasing centralization of political power characterized the Yayoi (*c.* 400 BCE–*c.* 300 CE) and Kofun (*c.* 300–538 CE) periods (Map 2.2 and Map 4.1). Excavations of settlements and tombs have yielded artworks that indicate growing wealth and ritual changes, related in part to migration from, and contact with, the Korean peninsula. Written documents (in literary Chinese, the language used for administrative purposes all over East Asia) supplement the archaeological record, attesting to early historical events, including the role of powerful female rulers.

On the Korean peninsula, the presence of military outposts of the Han dynasty (206 BCE–220 CE) stimulated the transformation of many chiefdoms into three centralized kingdoms. First, Goguryeo emerged in the north, then Baekje and Silla—having absorbed the city-states of Gaya in 562—formed in the southwest and southeast (Map 4.1). There are traditional dates in the first century BCE for the founding of these kingdoms, but here the range *c.* 200–668 CE begins with the formation of Goguryeo, and it ends when Silla conquered its adversaries, the other two kingdoms. Art—including mural paintings, gold crowns, and a gilt-bronze incense burner—of the Three Kingdoms period is preserved in large, mounded tombs and temple sites. It attests to the dynamic encounter of diverse cultures and adaptation to local conditions.

On the Chinese mainland, fragmentation, military invasion, and political rivalry dominated the centuries after the Han collapse in 220 CE, and scholars give this period of division several different names. Of the many relatively short-lived regimes, the Eastern Jin (317–420) and the Northern Wei (386–534) made considerable impact on the history of art (Map 4.1). At the Eastern Jin court, the arts of poetry, calligraphy, and painting flourished. Under the auspices of the Northern Wei, Buddhism took root and brought with it new forms of art, such as devotional icons and monumental rock-cut cave-temples.

Art of the Yayoi and Kofun Periods in Japan, *c.* 400 BCE–538 CE

On the islands of Japan, the Neolithic Jōmon culture (see Chapter 1) gradually declined and pushed northward as a result of both depleted resources and the arrival of a new culture, the Yayoi (*c.* 400 BCE–*c.* 300 CE; see Map 2.2). Fueled in part by immigrants and technology transfers from continental East Asia, especially the southern Korean peninsula, the Yayoi culture is recognizable by large-scale permanent settlements, wet-rice agriculture,

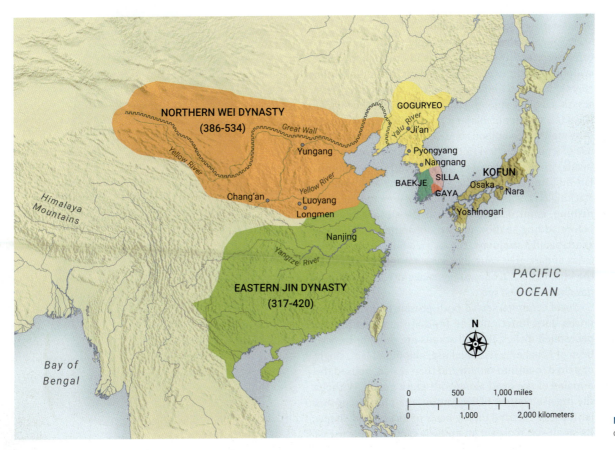

Map 4.1 **East Asia,** *c.* fifth century CE.

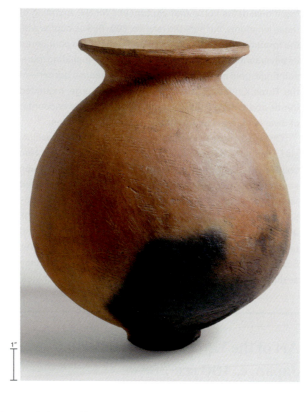

4.1 Jar, Japan, Yayoi period, c. 100–300. Earthenware with incised decoration, 10 × 9 in. (25.4 × 22.9 cm). Metropolitan Museum of Art, New York.

burnishing (of ceramics) polishing the surface by means of rubbing with a hard tool.

slip a layer of fine clay or glaze applied to ceramics before firing.

low relief (also called bas-relief) raised forms that project only slightly from a flat background.

4.2 FAR RIGHT *Dōtaku* **(bronze bell),** reportedly from a site in Kagawa prefecture, Japan, Yayoi period, second to first century BCE. Bronze, height 16¾ in. (42.5 cm). Tokyo National Museum, Tokyo.

and the making of bronze and iron objects. Yayoi sites such as Yoshinogari (in present-day Kyūshū, the island nearest the Korean peninsula), with its moat, watchtowers, storehouses, and differentiation between ordinary and elite dwellings, demonstrate the shift from farming villages to more socially stratified chiefdoms. Within these chiefdoms, artisans fashioned objects of clay and bronze, and valuable artifacts placed in graves attest to the high social status of some individuals.

Yayoi ceramics contrast sharply to the highly textured vessels of the Jomōn. Instead of the flamboyant sculptural qualities especially evident in Middle Jomōn "flame" vessels (compare to Fig. 1.4), Yayoi pottery possesses relatively smooth surfaces and balanced shapes (**Fig. 4.1**). The shape of this jar is uncomplicated, comprised of a small foot, a bulbous body, and a flared mouth. The use of a potter's wheel (introduced via the Korean peninsula) gives symmetry to the foot and to the mouth. For building the body, the longstanding technique of stacking clay coils continues, but a new technique, **burnishing**, is introduced to polish the surface smooth, before adding shallow incised decoration comprising short, parallel striations. The jar's red hue contrasts with areas of dark gray, caused by glaze forming from ash in the kiln. Other Yayoi ceramics make use of clay **slip** or have been painted red.

Yayoi ceramics served both prosaic and ritual purposes. Jars functioned as food storage containers; pedestaled dishes and tall stands are thought to have been of ritual or ceremonial use; and burial jars, singly or paired mouth-to-mouth and then sealed, housed the remains of the dead along with grave goods. Without the precise context of excavation, the purpose of this jar must be inferred on the basis of its size and shape. Its small size makes it an unlikely candidate for use as

a burial jar, and its stout shape does not immediately suggest an exclusively ceremonial function. Rather, this jar seems well suited for storage.

Cultural change indicated by stylistic variation in Yayoi ceramics is underscored in the archaeological record by the presence of objects made of a material new to the Japanese archipelago: bronze. By casting bell-like objects known as *dōtaku*, the Yayoi demonstrate adaptation of bronze technology from the East Asian continent. *Dōtaku* may have been inspired by small bells from the Korean peninsula, but Yayoi bells range in height from a mere 4 inches to more than 4 feet (from 10 cm to more than a meter). Some have fairly plain surfaces, while others are boldly decorated in **low relief**. This example has typical saw-tooth pattern and spirals located on the upper loop and running down the side flanges (**Fig. 4.2**). Less commonly, it also features figural decoration on twelve panels, six on each face. The scenes include animals, human activities, and architectural structures.

On the side pictured here, the top row depicts (from left to right) a salamander and a dragonfly. The second row includes a human figure leaping and another shooting a deer. In the bottom left panel, two human figures grasp long implements, directing them at a central vessel. They could be pounding rice. The panel at bottom right illustrates a raised structure with an elaborate projecting roofline. The structure might be a granary, or storehouse, an important building that protected the community's harvest from moisture and pests. It also bears some

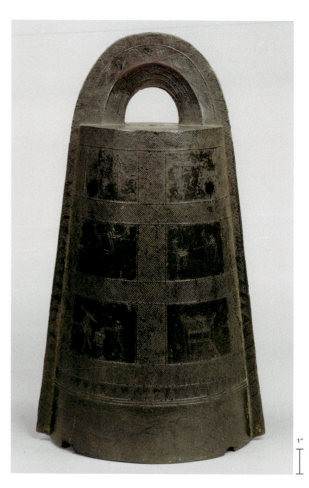

resemblance to a later Shintō temple, the Inner Shrine at Ise. Shintō (literally, "the way of the spirits") is the indigenous, animistic religion of Japan. It centers around spirits or supernatural entities called *kami*, which are associated with things in the natural world, such as the sun and the wind, rocks and trees, mountains and waterfalls. Through fierce events such as earthquakes, people witness the powerful presence of *kami*, but more often *kami* are knit into the intimate fabric of everyday life. *Kami* may be malevolent or beneficent, and they may be worshiped at the particular sites where they are thought to take form or dwell (such as a venerable tree or waterfall) or at shrines.

The Inner Shrine at Ise, first rebuilt in 690 CE, is dedicated to the *kami* Amaterasu, the sun goddess and legendary ancestor to the Japanese imperial family (see Seeing Connections: Art and Ritual, p. 159). Although the building illustrated on the *dōtaku* cannot be identified with certainty, and any connection to later Shintō temples is conjectural, the picture nevertheless preserves evidence of an early architectural form and its symbolic importance.

Some *dōtaku*, like Zhou dynasty bells (see Fig. 2.11), were made to produce sound. These *dōtaku* had clappers hanging inside them that struck internal rims. Other *dōtaku* lacked these features, and their highly ornamented surfaces suggest that they were meant primarily to be looked at. In both cases, *dōtaku* served ritual purposes, and they were deliberately buried, commonly in even-numbered groupings—sometimes with bronze weapons and mirrors—in isolated hilltop locations.

Bronze objects and other prestige items have been excavated from Yayoi tombs, such as one in northern Kyūshū—some 20 miles (around 32 km) north of Yoshinogari—which yielded bronze swords, a halberd, a spearhead, and a mirror (**Fig. 4.3**). At the time, functional weapons were made of a stronger metal, iron, so the tomb's bronze blades may have been for ceremonial use only. The mirror's concave surface bends light, concentrating it in the distorted reflection, like a spoon. The mirror's power to manipulate light suggests that it, too, had a symbolic function. A variety of symbolic meanings were present in the case of mirrors in the context of the Han dynasty (see Fig. 2.19), and these meanings could be adopted, amended, or replaced according to local needs. This tomb also contained beaded necklaces and a distinctive E-shaped stone bead, known in later Japanese periods as a *magatama*, which may also have a C-shape. By virtue of their fine craftsmanship, their rarity or exotic nature, and/or their symbolic meaning, all of these objects functioned as prestige goods and together confirm the high status of the unidentified tomb occupant. One hypothesis suggests the person was a spiritual leader.

In addition to offering clues to the tomb occupant's status and role in society, the artifacts locate the Yayoi culture in a larger geographical context and historical chronology. The bronze blades echo the Liaoning-type dagger (see Fig. 2.8), and the bronze mirror may have been made on the Korean peninsula. As with the blades and the mirror, the resemblance between the E-shaped bead and the C-shaped jade beads (in Korean called *gogok*)

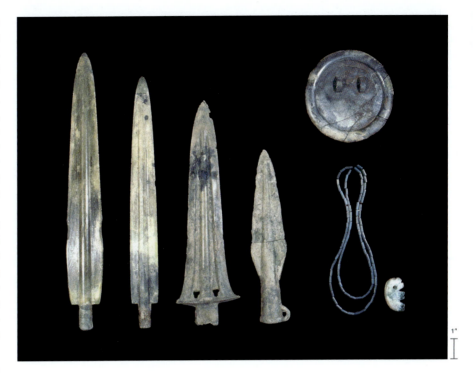

4.3 Sword blades, halberd, spearhead, tubular beads, *magatama* bead, and mirror, from Yoshitake Takagi, Fukuoka prefecture, Japan, Yayoi period, second century BCE. Bronze and steatite, length of sword at left: 13⅛ in. (33.3 cm). Fukuoka City Museum, Fukuoka, Japan. Agency for Cultural Affairs.

on such artifacts as the crown from the Silla kingdom (*c.* 300–676 CE) in Korea suggests contact—through trade, migration, or another conduit—between the cultures on the Japanese archipelago and the Korean peninsula (see Seeing Connections: Gold Crowns across Asia, p. 76). Described in the earliest Japanese chronicle *Kojiki*, or "Record of Ancient Matters" (eighth century CE), this grouping of a sword, a mirror, and a bead is known as the Three Sacred Treasures. In the Shintō religion, they constitute the regalia given by the sun goddess Amaterasu to her earthly, royal descendants. However, the Yayoi materials predate the chronicle by as much as a millennium, so any connection between the two is tenuous and provisional.

The third-century CE transition from the Yayoi period to the Kofun period (*c.* 300–538 CE) was marked by the abandonment of Yayoi ritual practices, as evidenced by the deliberate destruction of *dōtaku*. Resources and ritual focused instead on monumental tombs, which appeared not only on the Japanese archipelago but also on the Korean peninsula. *Kofun* literally means "ancient tomb," and the Kofun culture is named for the thousands of mounded tombs it left behind. The term "Mounded Tomb Cultures" refers to the early states of both the Kofun in Japan and the Three Kingdoms of the Goguryeo, Baekje, and Silla in Korea (see **Map 4.1**), and it acknowledges their connections to one another.

According to the *Weizhi* (a Chinese text from the Jin dynasty, 265–420 CE), competition among numerous chiefdoms during the Yayoi–Kofun transition ended with unification and the creation of a state called Yamatai by Queen Himiko in about 180 CE. It also records a younger, female relative who subsequently ascended the throne. By contrast, Japanese chronicles written in the eighth century (*Kojiki* and *Nihon Shoki*) describe the reign of Empress Jingu (169–269 CE). But burial sites associated with either female ruler have not been excavated, and questions about their identities persist. Still, the evidence

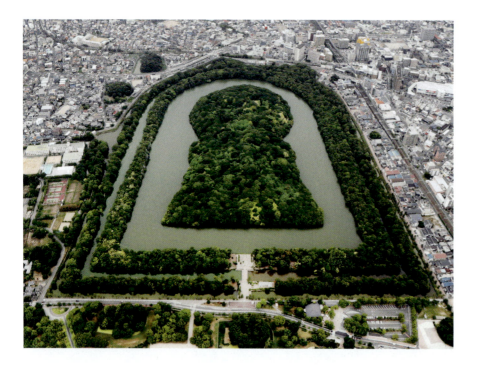

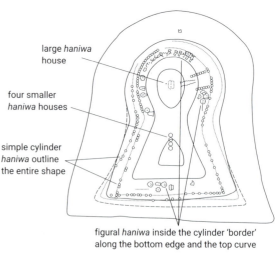

large *haniwa* house

four smaller *haniwa* houses

simple cylinder *haniwa* outline the entire shape

figural *haniwa* inside the cylinder 'border' along the bottom edge and the top curve

4.4 ABOVE LEFT **Daisen Tomb, aerial view,** Sakai, Osaka prefecture, Japan, Kofun period, late fourth–early fifth century CE.

4.5 ABOVE RIGHT **Futatsuyama Tomb, diagram of distribution of *haniwa*,** Gunma prefecture, Japan, late sixth century CE.

suggests remarkable roles for female leaders in early state formation. The historical picture that emerges toward the end of the Yayoi period features a crisis in which one or more powerful women assume leadership positions. The resolution of the crisis involves adopting new rituals and ritual forms, notably monumental, mounded tombs furnished with elite goods, and the crisis ends with the rise of the powerful state of Yamato, tentatively identified with Yamatai, during the Kofun period (*c.* 300–538).

Many *kofun* are located in Yamato (present-day Osaka-Nara). The Yayoi had built tombs and buried valuable objects with high-ranking individuals, but during the Kofun period the keyhole-shaped tomb—circular at one end—came to prominence. Scholars debate the origin and meaning of this shape, which may be related to beliefs about the mythical Queen Mother of the West (a **Daoist** deity), or it may have emerged by broadening one end of the access path across the moat to the typically round tombs of the preceding Yayoi period. Besides shape, another difference in Kofun tombs is their markedly larger size. Among them, the Daisen Tomb, attributed to the ruler Nintoku (ruled 395–427 CE), is the largest.

Located near present-day Osaka, the Daisen Tomb covers an area of 458 acres. It is approximately 1,640 feet long (around 500 m), and its burial mound rises to a height of 90 feet (27.43 m) (**Fig. 4.4**). Beneath the circular portion of the keyhole-shaped mound is where the burial chamber likely lies, but because the Daisen Tomb is associated with the imperial family, it has not been excavated. Three concentric moats demarcate the boundary between the world of the living and that of the dead. Its construction required an immense workforce, unprecedented in Japan. The ability to mobilize this level of resources suggests an expanding state and the concentration of power.

Power and wealth are also apparent in the contents of *kofun*, which have yielded gold and gilt-bronze crowns, jade ornaments, bronze mirrors, iron weapons, equestrian trappings, and high-fired, gray stoneware such as *sueki* (literally, "offering ware"). These prestige goods, in combination with historical records, reveal continued cultural contact between Kofun-period Japan and kingdoms on the Korean peninsula, such as Goguryeo and Baekje.

The furnishings for *kofun* were not limited to their interiors. *Kofun* mounds were marked on the outside with *haniwa,* hollow terra-cotta figures, architectural forms, and cylinders (**Fig. 4.5**). *Haniwa* means "clay cylinders," and most are cylindrical in form. They evolved from the Yayoi practice of placing jars and jar-stands on burial mounds, and initially adornments were limited chiefly to shields, parasols, and houses. Human forms, like the example illustrated here, appeared in the fifth century (**Fig. 4.6**). *Haniwa* also come in the shapes of animals, including boars, monkeys, and horses (**Fig. 4.7**). Wearing armor and a helmet, the *haniwa* warrior appears to stand atop a pedestal, but originally the cylindrical component would have been buried. The cylindrical legs of the *haniwa* horse were also probably partially buried.

The sculptor used several different techniques to shape this warrior figure. Flat slabs of clay were cut to model the feet and sword sheath. Coils of clay were stacked to form cylindrical leg guards, or worked and attached to form straps. Incisions with sharp implements created the patterns on the armor. Longer cuts formed the warrior's eyes. The effect is simplified yet arresting, principally owing to the warrior's facial expression, which can be interpreted as either wary or indifferent, as well as to the ambiguity of the gesture. Is the warrior about to draw his sword, or will he keep it sheathed? The same techniques for shaping clay could be adapted to create the *haniwa* horse. Its form is simplified, but it possesses a distinctive liveliness nonetheless.

When combined with many more *haniwa*, perhaps numbering into the thousands for the largest *kofun*,

Daoist referring to Daoism: originating in China, a philosophy and religion that advocates pursuit of the Dao (the "Way"), as manifested in the harmonious workings of the natural world and universe; Daoist practice also includes worship of immortals and numerous popular deities.

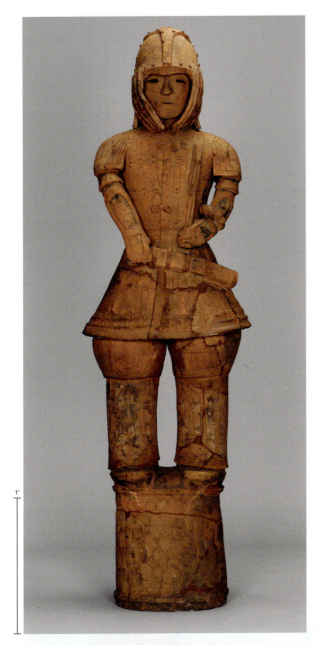

this warrior and this horse would have contributed to an impressive array including military troops, servants, entertainers, animals, and buildings. The number of figures present generally confirmed the deceased's status, but their precise purposes are not altogether clear. Their shapes suggest symbolic functions in the unseen after-life. *Haniwa* in the form of spiritual leaders ostensibly provided ritual performances; those clad as warriors offered protection; and those shaped like houses represented shelter. Some scholars suggest that the cylinders of non-figural *haniwa* once held offerings, perhaps for the deceased.

Status was also demonstrated by prestige objects—such as bronze mirrors, beads, staffs made of jade, and golden crowns (see Seeing Connections: Gold Crowns across Asia, p. 76)—interred with the dead. This funerary practice, despite variation in the particular assortment of objects, demonstrates a degree of continuity with the preceding Yayoi. In 1881, an excavation of the monumental Samita Takarazuka Tomb in Nara purportedly yielded thirty-six bronze mirrors among the grave goods. This one is unusual for its ornament, which features four different buildings radiating from the central knob, which may be threaded with a ribbon (**Fig. 4.8**). One (at the viewer's left) appears to be an elevated structure with rooftop embellishments projecting diagonally upward. Possibly representing a raised storehouse, it bears comparison with the image cast on the Yayoi *dōtaku* (see **Fig. 4.2**). It also brings to mind the Inner Shrine at Ise, which is similarly elevated from the ground (see Seeing Connections: Art and Ritual, p. 59). The other three buildings on the mirror may represent residences (clockwise from the top): a three-**bay** house raised off the ground, a house with a **gabled roof**, and a pit dwelling.

The specific architectural motifs of this mirror indicate that it was manufactured locally, in contrast to mirrors bearing the TLV pattern (see Fig. 2.19) or images of deities and mythical beasts, which were more likely to be imports from mainland East Asia. The presence

4.6 FAR LEFT *Haniwa* **warrior,** from Iizuka-cho, Ōta City, Gumma prefecture, Japan, Kofun period, sixth century CE. Earthenware, height 51⅜ in. (1.3 m). Tokyo National Museum, Tokyo.

bay a space between columns, or a niche in a wall, that is created by defined structures.

gabled roof a roof with two sloping sides.

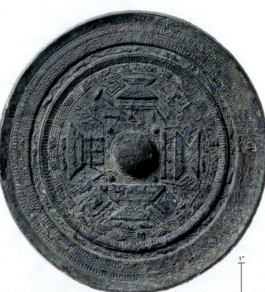

4.7 FAR LEFT *Haniwa* **horse,** Kofun period, sixth century CE. Earthenware, height 47¾ in. (1.21 m). Los Angeles County Museum of Art, California.

4.8 LEFT **Mirror with design of four buildings,** from the Samita Takarazuka Tomb, Kawaicho, Kita-Katsuragi County, Nara prefecture, Japan, early Kofun period, fourth century CE. Bronze, diameter 9 in. (22.9 cm). Imperial Household Agency, Tokyo.

corbeled vault an arched ceiling constructed by offsetting successive rows of stone (corbels) that meet at the top to form an arch shape.

lantern ceiling a ceiling with four sloped surfaces rising at an angle from the walls to meet a flat, square plane parallel to the floor.

genre (painting) an art historical category for paintings that show scenes of everyday life.

auspicious signaling prosperity, good fortune, and a favorable future.

Buddha a buddha is a being who has achieved the state of perfect enlightenment called Buddhahood; the Buddha is, literally, the "Enlightened One"; generally refers to the historical Buddha, Siddhartha Gautama, also called Shakyamuni and Shakyasimha.

of a variety of mirrors in Kofun tombs attests both to the circulation of prestige objects and to the transfer of bronze technology from the East Asian mainland. A more particular association between mirrors and female power, whether embodied in the Daoist Queen Mother of the West or the Shintō sun goddess Amaterasu, seems also to play a role in legitimizing women rulers of Yamato, the first centralized state in the Japanese archipelago.

Art from the Three Kingdoms Period in Korea, *c.* 200–668 CE

On the Korean peninsula, the first several centuries of the common era saw the transformation of local settlements into three centralized states that controlled most of the territory: Goguryeo in the north, Baekje to the southwest, and Silla in the southeast (see Map 4.1). The Gaya Federation, comprised of independent chiefdoms, accounted for the territory between Baekje and Silla. As in the case of the Yayoi-Kofun transition, the building of mounded tombs was a major marker of social stratification in these states. Some of the most splendid prestige objects were preserved in tombs of the Silla kingdom. Among them, elaborate gold crowns connect the Silla kingdom to other cultures located as far west as present-day Afghanistan, as well as to the Kofun culture (see Seeing Connections: Gold Crowns across Asia, p. 76). An examination of three other artworks, one from each of the Three Kingdoms, suggests that, considered in

the context of the prevailing dynamic situation of geo-political confrontation and cultural contact, there was tremendous artistic variety in the region.

Positioned in the northern part of the peninsula, the Goguryeo kingdom exerted military pressure against imperial neighbors to the west (the Han and then the Northern Wei dynasty) and nomadic steppe cultures to the north. Contact with foreign culture also spurred creativity, as evident in the murals found in stone-chambered tombs from the period. Goguryeo tombs evolved over the course of about six centuries, but generally they consisted of one or two chambers, an earthen or stone mound over the main chamber, and later ones had **corbeled**, **lantern ceilings**. Of about 10,000 tombs, approximately 100 in the vicinities of present-day Pyongyang (in North Korea) and Ji'an (in China) preserve murals. Mural subjects included portraits of the deceased, guardian animals symbolizing the cardinal directions, divine beings, **genre** scenes, and in later times, patterns of lotus flowers. The range of subject matter and decorative motifs suggests familiarity with the visual imagery of Daoism and Buddhism that was typical of the Three Kingdoms period (for Daoism and Buddhism, see Chapter 2).

Named for a mural of dancers on the east wall, the Muyongchong Tomb features on the west wall a dynamic scene of hunting (Fig. 4.9). Three mounted hunters draw their bows. One hunter, accompanied perhaps by a dog, chases a tiger. A buck and doe flee from a second hunter who turns backward while his horse is in full gallop.

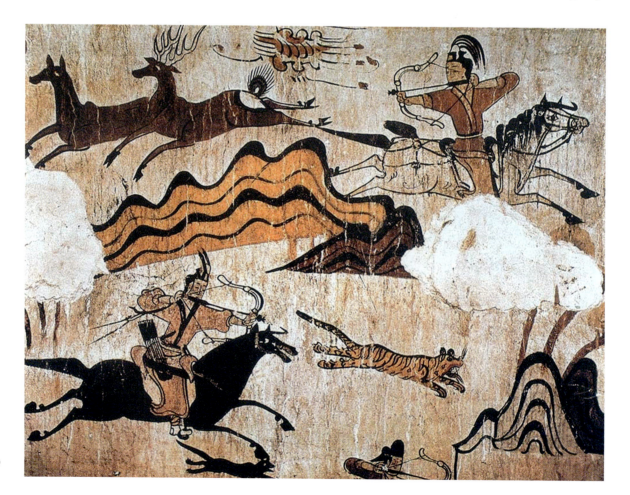

4.9 Hunting scene, mural on the west wall of main chamber, Muyongchong Tomb, Tonggou, near present-day Ji'an, China, Three Kingdoms period, Goguryeo kingdom, fifth century CE.

His posture demonstrates a tactical skill, made famous by the military of Parthia (247 BCE–224 CE), based in areas of present-day Iran. In this tomb, the Parthian-shot motif is inserted among undulating, miniature mountain ranges. A variety of curved lines and arcing bodies enliven this hunting scene, a pictorial accompaniment to grave furnishings that would have provided the deceased with the familiar activities and comforts of life.

This scene of hunting is just one component of the tomb's decorative program. Scenes of everyday life on the walls surround the deceased, who is shown conversing with two other figures at the far end of the chamber. Creatures representing the cardinal directions, along with decorative patterns, adorn the lantern ceiling. Such motifs, along with the practice of tomb building, are informed by Han dynasty models, familiar to the Goguryeo. Military outposts such as Lelang (Korean: Nangnang) had been conquered, but Han culture was nevertheless a source for ideas about the cosmos and the afterlife. The Muyongchong Tomb murals convey knowledge of Han mortuary art and architecture as well as identification with equestrian culture common across the vast Eurasian steppes.

Tombs are the primary, but not the only, source of artifacts from the Three Kingdoms period. This gilt-bronze incense burner (Fig. 4.10) comes from the site of a Buddhist temple supported by the royal family of the Baekje kingdom. The burner may have been used in ceremonies—possibly Buddhist rituals, but court rituals and ancestral veneration are also possibilities—sponsored by the Baekje court. When introduced in areas of East Asia, Buddhism promised wealth, wisdom and the fulfillment of wishes. Thus, the religion exerted enormous appeal in the context of political rivalry and military confrontation, such as existed among the three kingdoms. In time, all three kingdoms would adopt Buddhism as a state religion (see Chapter 6), but the form of this incense burner draws on Daoist sources, too.

The incense burner is comprised of several parts. A writhing dragon—an **auspicious** creature in East Asian cultures—forms a base. The dragon supports a bowl in the shape of a lotus flower with petals adorned with tiny creatures, including birds and fish. The lotus is an apt metaphor for the **Buddha**: although it grows in muddy waters, the flower itself blooms unstained. Lastly, the burner's elaborate lid takes the form of a mountain landscape topped by a magnificent phoenix. Another mythological animal, the phoenix is often paired with the dragon. In that combination, the phoenix is the creature of the air, while the dragon is associated with water. The phoenix/dragon pairing can also symbolize the generative feminine/masculine principles that bring all matter into being.

The burner's landscape of five mountain ranges is inhabited by humans and animals, including five musicians and five waterfowl—the number five resonating with a Daoist idea of the five elements (wood, fire, earth, metal, and water). Five perforations hidden among the peaks emit smoke from burning incense, completing the illusion of an enchanting realm: the Daoist island where immortal beings dwell (compare to Fig. 2.16). This

4.10 Incense burner,
Neungsan, Buyeo prefecture, South Chungcheon Province, Three Kingdoms period, Baekje kingdom, sixth century CE. Gilt bronze, height 24⅜ in. (61.7 cm). Buyeo National Museum, Seoul.

artifact demonstrates not merely the transmission of Daoist ideas but, assuming the Buddhist temple context, their adaptation. Finally, the incense burner's elongated shape and elegant style is reminiscent of late Goguryeo murals, an indication of exchange between Goguryeo and Baekje kingdoms.

The third of the Three Kingdoms, Silla, is known for the extraordinary craftsmanship of gold crowns, earrings, and belts, which have been excavated from royal tombs (see Seeing Connections: Gold Crowns across Asia, p. 76). Although this stoneware jar and stand (**Fig. 4.11**) were made of a less luxurious material, they were grave goods, too. The shape and ornament of this stand are typical of Silla. Rising from a broad rim, the stand tapers before flaring at the mouth, providing a suitably elevated yet stable seat for a bowl or jar. Ornamentation consists of a pattern of incised wavy lines alternating with square-shaped perforations, placed regularly within horizontal registers. The jar, which may or may not have formed a set with this stand, presumably would have held the ritual offerings for the deceased.

The gray stoneware represents a significant technological advance in the manufacture of ceramics. Compared to terra-cotta (see Fig. 1.3), stoneware is harder, denser, and watertight. It requires higher firing temperatures, which were made possible in a wood-fired climbing kiln, typically built running up a hillside. The uniformly gray color results from controlled reduction of oxygen within the kiln during firing. High-fire stoneware was first produced only in areas of the Han dynasty and the Three

4.11 Long-necked jar and stand, excavated from mounds on the eastern side of the Korean peninsula, Three Kingdoms period, Silla kingdom, fifth–sixth centuries CE. Stoneware with incised decoration and perforations, height of jar: 11⅞ in. (30.2 cm), height of stand: 13⅝ in. (34.6 cm). Museum of Fine Arts, Boston, Massachusetts.

Kingdoms. From Silla, the technology and style of this stoneware were transmitted eastward, transformed into the *sueki* ware of the Kofun period in Japan.

Period of Division in China: Elite Culture in the South, 220–581 CE

In the third century of the common era, as new centralized states were taking form in areas of present-day Korea and Japan, in Chinese regions the collapse of the Han dynasty in 220 brought civil war. After some fifty years of fighting, the empire split into northern and southern halves. Fleeing the turmoil, Han refugees left the cities such as Chang'an and Luoyang that had long served as dynastic capitals (see **Map 4.1**). In the south, they established new, regional courts. These courts, especially the court of the Eastern Jin dynasty, located in the vicinity of present-day Nanjing, drew talented officials whose activities reached beyond governance into poetry, **calligraphy**, and painting. Previously the domain of anonymous artisans, calligraphy and painting gained status, becoming essential components of elite culture.

The earliest writing in East Asia, the oracle bones of the Shang dynasty (see Fig. 2.3), make clear the close relationship between writing and power. In that context, writing was bound to ritual sacrifices of food and drink, presented in bronze vessels to deceased ancestors who could appeal to the gods to ensure the well-being of the state. However, even though viewers might find much to praise in examples of oracle-bone script from the Shang dynasty and seal script from the Zhou dynasty, such writing was not considered art (see Looking More Closely: Writing as Art, p. 88). Not until the Eastern Jin period was writing transformed from an instrument of power into a vehicle of aesthetic expression, too.

The art of calligraphy, as distinct from the practice of written language, may be traced back to the Eastern Jin official WANG Xizhi (*c.* 303–*c.* 361 CE). Because calligraphy is greatly esteemed in East Asia, it is fitting that Wang is the first artist to be associated with a specific artwork in this region. In earlier works, typically the names of patrons are preserved (see Figs. 2.2a and 2.9a), indicating that their stature far exceeded that of the anonymous artists.

Wang Xizhi's masterpiece, the *Orchid Pavilion Preface*, is a prose essay that introduces poems that Wang and his friends composed while on holiday. Although the original is lost, Wang's preface is preserved in instructive, tracing copies such as this one (**Fig. 4.12**). In the absence of genuine examples, copies became highly valued in East Asian cultures. Collectors have affixed their vermilion (cinnabar-paste pigment) seals to this copy, attesting to its value and **provenance**. In these contexts, copies were made without intent to deceive. Rather, they emerged from the desire to perpetuate artworks made of perishable materials and to disseminate them to wide audiences as instructional examples.

Wang's writing begins at top right and proceeds in columns to left. The text reads in part:

> In the ninth year of the Yonghe reign [353]...early in the final month of spring, we gathered at the Orchid

4.12 *Orchid Pavilion Preface,* **detail,** Tang dynasty copy attributed to Feng Chengsu after a lost original by Wang Xizhi. Handscroll: ink on paper, 9⅝ × 27½ in. (24.4 × 69.9 cm). Palace Museum, Beijing.

Pavilion...for the ceremony of purification. Young and old congregated, and there was a throng of men of distinction. Surrounding the pavilion were high hills with lofty peaks, luxuriant woods, and tall bamboo. There was, moreover, a swirling, splashing stream, wonderfully clear, which curved round it like a ribbon, and we seated ourselves along it in a drinking game, in which cups of wine were set afloat and drifted to those who sat downstream...

As the words are read for their meaning, they are simultaneously appreciated visually for their form. Wang wrote some characters in standard script, indicated by individual, clearly separated strokes. For other characters, he did not lift his brush but instead connected strokes in semi-**cursive** script (see Looking More Closely: Writing as Art, p. 88).

Wang's writing demonstrates control and discipline in the balanced composition of each character within an invisible box and in the careful completion of individual strokes. Yet his writing is also elegant and spontaneous, which results from his modulation of strokes from thin to thick and back again, and from the variety of ways in which he wrote repeated characters. For example, the character for the number 1—a single horizontal line—appears four times in **Fig. 4.12**, but written differently each time. Characters requiring more strokes permit greater variation. Wang's level of proficiency was such that he could write with the kind

of natural fluidity that outstanding jazz musicians bring to their improvisation. In both cases, knowledgeable audiences know what patterns to expect and can appreciate subtle variations.

In the case of Chinese calligraphy, however, there is an added dimension of moral judgment. Writing—the outcome of years of sharpening the mind and disciplining the hand—is believed to convey an individual's character. In this regard, Wang's calligraphy represents the highest level of Confucian self-cultivation, which celebrates moderation as a virtue. Wang could have written with greater energy or added idiosyncratic flourishes, but instead he carefully curbed such tendencies to produce a work that balances shared conventions with individual expression.

Celebrated in his lifetime as the sage of calligraphy, Wang's style of calligraphy was emulated by emperors and commoners alike. Although he was in fact taught by a woman surnamed Wei (possibly his aunt), early Chinese culture did not admit a woman as head of its most revered art. Calligraphy joined art with integrity, but clearly it was not free of gender bias. Still, its power attracted throughout East Asia future artists—male and female—who pursued this esteemed tradition (see Figs. 8.6, 13.4, and 13.10).

Wang Xizhi was not the only talented official associated with the Eastern Jin court. His younger colleague GU Kaizhi (344–406 CE) demonstrated remarkable gifts in a different medium: painting. Like Wang's calligraphy,

cursive (of a script) flowing, with some letters joining together.

Unlike languages that rely on an alphabet to translate sounds into visible marks (for example, the language in which this book is printed), written Chinese uses graphs, or more commonly, "characters." Visually, each character is a composition unto itself, an arrangement of straight and curved lines that fit into a designated, often unmarked, space. The characters may be symmetrical or asymmetrical, balanced or unbalanced, spacious or dense, lively or static.

The sample of calligraphy reproduced here (**Fig. 4.13**) is attributed to the Yuan dynasty official and polymath Zhao Mengfu (1254–1322 CE), who transcribed the title of the "Thousand Word Essay." The written Chinese language consists of several thousand individual characters, and brushstrokes for these characters must be executed in strict order. As a result, it takes years to develop competency and mastery with brush and ink. With its poetic lines and use of one thousand different characters exactly once each, the "Thousand Word Essay" functioned as early as the sixth century as a primer for learning written Chinese. Already an accomplished scholar, Zhao used it instead for practicing the art of calligraphy. He wrote the essay's title six times, using a different script each time. The repetition of the same characters—the title words "thousand," "word," and "essay"—allows viewers to distinguish between the conventions shared by all scripts and the distinctive features of a particular script.

| Cursive | Standard | Draft cursive | Clerical | Small seal | Great seal |

4.13 Six Chinese scripts: the same three characters, for "thousand," "word," and "essay," are repeated in each column. Detail from *Thousand Character Essay in Six Scripts*, attributed to Zhao Mengfu. Palace Museum, Beijing.

Early writing on bones and clay required a sharp, pointed implement, leaving lines of even thickness. Zhao mimicked the archaic forms and lines of two variations of seal script in the rightmost columns of **Fig. 4.13**. By contrast, characters written with a pliable brush and ink—whether on bamboo slips, silk, or paper—have greater range. Ink can be darker or fainter, wetter or drier. Lines can be thicker or thinner, or they can be highly modulated—that is, shifting quickly from thick to thin as the sensitive brush responds to the rapid changes in pressure from the writer's hand.

Such modulation is visible in the other four columns of Zhao's calligraphy.

Clerical script, named for the clerks who transcribed documents, shows the effect of the new medium of brush and ink. In clerical script, individual brushstrokes may constrict or flare, as in the case of Zhao's third column from the right. Yet overall, in writing in clerical script, he maintains a degree of restraint. By contrast, cursive script appears quite fluid and free, and accordingly Zhao connected all the strokes that comprise a character into a single fluid line in the column at far left. The development of cursive script was the foundation for an association between calligraphy and a person's character. The idea that an individual's writing style and moral fiber were interconnected led to the recognition of writing as art.

Gu's *Admonitions of the Instructress to Court Ladies* survives only in later copies. It too should be understood in the context of Confucian virtues.

The first of nine extant scenes of *Admonitions* depicts a dramatic confrontation involving a dark beast (**Fig. 4.14**). Two palace ladies shield themselves behind the king, whose alarm is signaled by his hatstrings, which rise on either side of his face. A third lady has deliberately inserted herself between the king and the beast. Her fluttering scarves have not yet settled from her forward momentum. She risks bodily harm, but two palace guards wielding spears have arrived. They take aim at the creature, while a fourth lady hastily retreats.

Apart from the figures, the space is otherwise empty. As with calligraphy, in which unmarked areas are integral to the composition, East Asian painters paid careful attention to **negative space**. Thus their paintings need not be completely covered with pigment in order to be considered finished. Viewers would take an active role in interpreting scenes as taking place in palace quarters. Those who did not recognize the subject matter would have been provided with a hint from a now missing inscription, taken from a poem by ZHANG

Hua (232–300 CE), an official who served the preceding Western Jin court:

> When a black bear climbed out of its cage, Lady Feng rushed forward.
> How could she have been without fear? She knew she might be killed, yet she did not care.

The scene depicts a historical event. During a wild-animal show staged for the Han dynasty Emperor Yuan (ruled 48–33 BCE), a bear escaped. One consort, Lady Fu, ran to safety. But another, Lady Feng, bravely protected the emperor. In *Admonitions*, Lady Feng's courage is contrasted with Lady Fu's instinctive fear.

Two key characteristics of East Asian painting may be observed in Gu's *Admonitions*. First, the painting's format is a **handscroll**. Holding the painting with their own hands, viewers must unroll it from right to left, conforming to the same direction in which the language is conventionally written and read. The resulting experience is intimate, and, like a film, it unfolds in time. Second, *Admonitions* integrates words and images. Not only did Gu base his painting on Zhang's poem, but he

negative space areas of a composition not occupied by objects or figures.

handscroll a format of East Asian painting that is much longer than it is high; typically viewed intimately and in sections, as the viewer unrolls it from right to left.

also transcribed the salient passages onto the painting itself. These texts divide the scenes, and the resulting artwork may be described as an alternating sequence of texts and discrete scenes.

The other scenes still preserve inscriptions, including this one (**Fig. 4.15**) depicting ladies attending to their toilette, which admonishes against vanity. One lady uses a hand-held mirror to check her appearance; a servant fixes the hair of another. Several black-and-red lacquered cosmetic boxes are on the floor, and the lacquered stand in front holds a circular mirror. The poetic passage directly to the right of this scene reads:

Men and women know how to adorn their faces,
But there is none who knows how to adorn his character.

Yet if the character be not adorned,
There is a danger that the rules of conduct may
be transgressed.

Gu depicted women, but not men, adorning themselves. These ladies come alive as their observable activities are used to delve into their underlying psychology. On the one hand, self-righteous viewers might rebuke the vain behaviors of these women. On the other, those same viewers are lured into the very act of gazing at female beauty in the forbidden spaces of the imperial women's quarters. Using mirrors to multiply points of view, Gu invited viewers to reflect on the variety of ways of seeing even as his painting offers instruction in Confucian principles.

4.14 *Admonitions of the Instructress to Court Ladies*, **detail, scene 1,** Tang dynasty copy of a fourth- or fifth-century handscroll painting by Gu Kaizhi. Ink and color on silk, full painting 9¼ in. × 11 ft. 6 in. (23.5 cm × 3.51 m). British Museum, London.

4.15 *Admonitions of the Instructress to Court Ladies*, **detail, scene 4,** Tang dynasty copy of a fourth- or fifth-century handscroll painting by Gu Kaizhi. Ink and color on silk, full painting 9¼ in. × 11 ft. 6 in. (23.5 cm × 3.51 m). British Museum, London.

1'

Along with the principles of Confucianism, Daoist views also were represented in the culture of the Eastern Jin. Early images of men with Daoist leanings are preserved on the brick tiles of a tomb, from which this rubbing was taken (**Fig. 4.16**). The relief depicts the Seven Sages of the bamboo grove along with the recluse RONG Qiqi (far left, playing the zither), believed to be a contemporary to Confucius. Seated beneath a variety of leafy trees, some of the men play musical instruments, including the zither and the lute. Others drink liquor, sit idly, or sleep. All wear loosely tied robes, and their exposed bodies signal their rejection of the proper etiquette pertaining to the life of a Confucian official. Refusing to serve the Western Jin government, the Seven Sages purportedly gathered in a bamboo grove near the home of JI Kang, one of the sages (fourth from right, playing the zither resting upon one knee). There, unencumbered by duties and obligations, they enjoyed the pleasures of rustic life and held speculative debates in their pursuit of the Daoist Way.

As in the paintings of Confucian worthies on the lacquer basket from Lelang (see Fig. 2.18), the unknown designers of the tomb tiles rely on names to identify the sages, who share similar dress and physical features. Still, the designers show marked attention to the human body and the manner in which drapery falls over the shoulders and knees. They also demonstrate an understanding of how to represent three-dimensional objects on a flat surface, in such details as the **isometric** rendering of the small table propping up the elbow of one sage (far right). Spatial concerns are also demonstrated in the use of trees as compositional dividers, so that each sage occupies his own space. Although there is visual separation between figures, the consistent use of fine, flowing lines to depict sages and setting alike creates a unified and lively composition. However, the point of this image is not to display artistic ingenuity. Rather, it captures the rustic conviviality of the Seven Sages' chosen way of life. To that end, trees with decorative foliage substitute for the bamboo grove, creating a natural setting. The sages'

rustic retreat as well as another scene (not pictured) from *Admonitions*, which features an archer and a mountain, suggest the symbolic associations and pictorial possibilities of landscape, an important genre of East Asian painting that would develop in later centuries.

Period of Division in China: Buddhist Art in the North, 220–581 CE

While calligraphers and painters developed increasingly refined ways to convey the Confucian and Daoist ideals of learned gentlemen in the Yangtze River area, to the north a new religion—Buddhism—began taking root. Originating in South Asia (see Chapter 3), Buddhism spread via the trade routes of the Silk Road that connected East Asia with the rest of the Eurasian continent. Han dynasty texts make reference to the Buddha, but at the time, Buddhism did not encounter an audience altogether eager to adopt its teachings. For example, the Buddhist injunction for monks to leave their families and practice celibacy conflicted with deeply held Confucian values that emphasized continuous family lineages and filial piety.

By contrast, during the ensuing period of division, Buddhism—which offered an alternative world-view and could include promises of salvation—appeared more attractive. Moreover, Buddhism could be enlisted to help achieve political goals. Sponsorship of Buddhist art served as a visible sign of the emperor's religious piety, presenting him as a *chakravartin* (see also Figs. 3.1 and 3.2). During the politically unstable period of division in the years 220–589 CE, Buddhism found potential adherents among those who witnessed the weakness and collapse of the Confucian-oriented Han state, as well as those who competed for political primacy. Consequently, many Buddhist artworks, including small icons, monumental sculptures, narrative mural painting, and donor portraits, were created during this period.

Buddhism promotes the making of religious images not only as a devotional act, but also as a means of acquiring religious merit. The religion incorporates the South

isometric a strategy of representing three-dimensional objects and/or space on a two-dimensional surface in which oblique sides are rendered as diagonal, parallel lines, and sides that are parallel to the picture plane are presented frontally.

chakravartin literally, "wheel-turner," a Sanskrit title used to refer to an ideal, just ruler, often in relationship to the dharmic faiths of Buddhism, Hinduism, and Jainism.

ushnisha one of the thirty-two markers of a buddha or a *bodhisattva*; a protuberance from the head, usually a topknot of hair.

Asian belief in rebirth, which is determined by karma, the sum of one's moral and immoral actions. By sponsoring the making of Buddhist images that help to disseminate the Buddha's teachings—a moral action—individuals positively affect their karma. They thus increase the probability of advantageous rebirth as human beings in this world, and decrease their chances of being reborn as animals, or worse, hungry ghosts in a hellish realm. In effect, the creation of Buddhist images leads to the possibility of more people learning about Buddhism; people who, in turn, sponsor the creation of more Buddhist images. Additionally, sponsoring an image on behalf of another person, such as a parent, allowed for some reconciliation of Buddhist practice with filial piety and other kinship responsibilities central to Confucianism.

A small bronze figure of a buddha (**Fig. 4.17**) is datable by its inscription to 338 CE, when an Indo-Iranian group known as the Jie ruled the northern area of China during the time of the short-lived Later Zhao kingdom (319–51 CE). In that year, the Later Zhao king conquered some forty cities in the northern regions of present-day China. The figure is recognizable as the historical Buddha not because his physical likeness is captured, but rather on the basis of iconographical features (see Fig. 3.11): the ***ushnisha***, the monastic clothing consisting of a sarong-like undergarment and a large shawl, and the meditative posture. The Buddha's hands are evidently intended to be in the *dhyana mudra* of meditation, but they are rotated so that the palms do not face up. The resulting hand position resembles the gesture of respect commonly seen in depictions of court officials. The change demonstrates the variation that occurs when artists encounter and adapt new forms from other cultures. Stylistic features of this Buddha, including the slight smile and the heavy appearance of

4.17 Seated Buddha, from Hebei province, China, Later Zhao period, 338 CE. Gilt bronze, height 15¾ in. (40 cm). Asian Art Museum, San Francisco, California.

the drapery, recall earlier models from South Asia (see Fig. 3.8). Holes in the pedestal and a flange behind the head indicate that the icon is now missing some parts, such as a canopy, halo, or guardian lions. Like the icons of other faiths, this bronze sculpture would have been consecrated to complete the transformation from inert metal to an embodiment of the Buddha, who could then receive the prayers and offerings of worshipers.

Because this bronze sculpture has been gilded, the sculpture reflects light. Literally radiant, it suggests the Buddha's luminous aura, described in texts. The high cost of gold imparts value to the sculpture, too. The Buddha's authority is further communicated through composition. A pedestal elevates and separates him from the mundane world, and the positioning of his body—knees to shoulders to *ushnisha*—approximates a stable, triangular shape that appears visually strong and immutable. The Buddha's meditative posture and serene expression remind the viewer of his enlightenment, which is the goal of Buddhism. His monk's attire falls in a manner that combines a degree of naturalism with implausible but attractive symmetry. Overall, the sculpture conveys authority and otherworldliness without appearing domineering or unapproachable.

Monumental rock-cut cave chapels at the sandstone cliffs of Yungang, literally Cloudy Ridge, are evidence that the Tuoba clan from the Mongolian steppe region, who founded the Northern Wei dynasty (384–535 CE; see **Map 4.1**), were patrons of Buddhist art. The site, just west of the Northern Wei capital of Pingcheng (now Datong), is home to about 51,000 Buddhist sculptures, some in shallow niches and others in deeper caves. Some were made under imperial auspices and in expiation for a persecution of Buddhists that took place from 446 to 452 CE. Among them, Cave 20 features a 45-foot-high (more than 13 m) seated buddha (**Fig. 4.0**), and a much smaller, standing buddha to the viewer's right (**Fig. 4.18**). Another such buddha stood on the opposite side to make the original composition symmetrical, and the entire trio would have been enclosed in an artificial, cave-like structure. The extant figures share iconographical markers of the Buddha. In addition to the *ushnisha*, long earlobes, monk's attire, and posture, the sculptures at Cave 20 are marked by the *urna*, haloes, and **mandorlas**. The figures emerge in **high relief** from the rock. By contrast, the alternating patterns of stylized flames and seated buddhas in the haloes are carved in low relief. The iconography of the original trio suggests a possible

4.18 Colossal seated buddha, Yungang Caves (Cave 20), Shanxi province, China, Northern Wei dynasty, c. 460–65 CE. Sandstone, height 45 ft. (13.72 m).

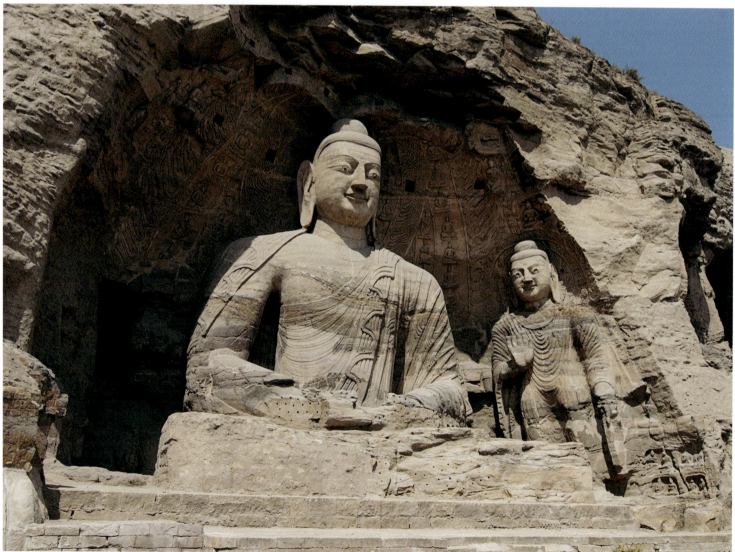

10'

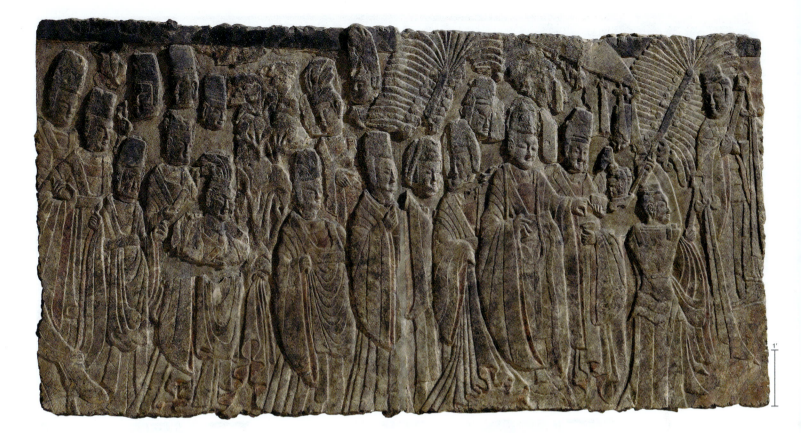

identification as the Buddhas of the Past, Present, and Future (Prabhutaratna, Shakyamuni, and Maitreya, respectively), an indication of the growing pantheon of buddhas in Mahayana Buddhism (see Chapter 3, p. 67).

Square notches cut into the cliff indicate an earlier attempt to use architecture to protect the sculptures after the Northern Wei period artificial cave wall had fallen. That architecture is now gone, as well as the pigments that once colored the sculptures. The figures themselves persist, however. Their smooth, geometricized forms, cheerful smiles, and outward gaze recall early models from South Asia (see Fig. 3.9); while the elaboration of two-dimensional patterns on the robes and haloes suggests long-standing local interest in the expressive possibilities of line.

These possibilities are evident in a low-relief panel depicting Emperor Xiaowen, who ascended to the Northern Wei throne in 471 CE (**Fig. 4.19**). His son, Emperor Xuanwu, commissioned posthumous images of his parents for a Buddhist cave chapel at Longmen (literally, Dragon Gate), close to the new capital of the Northern Wei, which had shifted southward to Luoyang (see **Map 4.1**). In commissioning this artwork, Emperor Xuanwu demonstrates one way of reconciling Buddhism and Confucianism.

Standing beneath a decorated parasol, the nearly life-sized Emperor Xiaowen directs his attention to an incense burner held by one of his many attendants. The figures fill the entire composition, which does not rely on trees or furnishings to provide a setting or divide space. Nor is the composition governed by the rules of symmetry. Instead, the unknown artist used such strategies as overlapping figures to indicate depth, varying the patterns

of falling drapery, representing heads in three-quarter view and shifting the angles and directions they face to create a naturalistic image. Traces of pigment indicate another means to mimic reality. Still, no actual resemblance to Emperor Xiaowen was necessary, as conventions of ritual and attire would have been enough to identify him and for the artwork to fulfill its functions. Paired with a similar relief panel depicting the empress, this sculpture represented the imperial couple in the role of donors, worshiping the Buddha (the central icon of the cave chapel, not pictured) in perpetuity. The cave chapel not only expressed the Northern Wei's commitment to Buddhism, but also demonstrated the Confucian virtue of filial piety, expressed by Emperor Xuanwu toward his parents.

Buddhist beliefs and practices fueled not only the creation of icons and donor images, but also the representation of didactic stories. At the Mogao ("Peerless") Cave temples near the oasis city of Dunhuang, a stopping point along the Silk Road (see Seeing Connections: Art of the Silk Road, p. 116), a vast quantity of Buddhist sculptures and **murals** survives. In one such cave temple dated to the late sixth century, a mural depicts the Mahasattva *jataka* (**Figs. 4.20** and **4.20a**, p. 94). Popularly known as the "tale of the hungry tigress," the *jataka* tells the story of the historical Buddha's previous lifetime as the Prince Mahasattva. While traveling in the wilderness, the prince chanced upon a starving tigress and her cubs. Moved to compassion, the prince gave his body to feed them.

In this mural, the story unfolds in three registers, top to bottom and in zig-zag fashion. Beginning at the top right, Prince Mahasattva and his two brothers take leave of their parents to ride on horseback into the wilderness

4.19 Emperor Xiaowen as donor, from Central Binyang Cave (Cave 3), Longmen Caves, Luoyang, Henan province, China, Northern Wei dynasty, *c.* 522–23 CE. Limestone relief with traces of paint, 6 ft. 10 in. × 12 ft. 11 in. (2.08 × 3.94 m). Metropolitan Museum of Art, New York.

mural a painting made directly on the surface of a wall.

jataka stories of the Buddha's past lives.

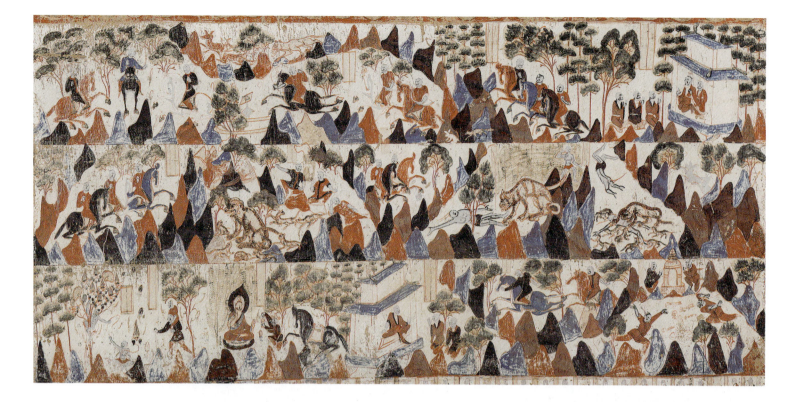

stupa a mound-like or
hemispherical structure
containing Buddhist relics.

to hunt. On the journey, they encounter a starving tigress
and her cubs (second register, left). While the broth-
ers search elsewhere for food, Mahasattva is moved to
compassion. He throws himself off the cliff, using his
own body to feed the creatures (second register, right;
Fig. 4.20a). At bottom right, the surviving brothers express
their grief in dramatic gestures (**Fig. 4.20**). After reporting
the sad news to their father (bottom register, middle), they

return to worship at the ***stupa*** (bottom register, right),
which presumably now contains Mahasattva's remains.

The mural emphasizes human actions, and toward
that end, landscape motifs are subordinated to the
narrative. Mountains, for example, are quite miniature
and simplified, taking the form of overlapping blue,
brown, reddish, and gray triangles. In some cases,
mountains along with schematic trees form boundaries

that separate one moment from the next. Unlike the potential effect of discrete scenes, which might interrupt the flow of time, the Mahasattva *jataka* mural maintains an energetic pace. Viewers are drawn into the colorful and dynamic composition, and they must actively match what they see in this mural to the *jataka* as they may already know it. The image makes visible a central Buddhist virtue, compassion; and it transforms what may be a gruesome sight into a dynamic, celebratory vision, reminding viewers of the kinds of attitudes and behaviors they ought to follow. It also illustrates that the material world, including one's own body, is impermanent. If it is already in the process of decay, perhaps it can be put to good use to feed the tigress and her cubs.

Major geopolitical changes, along with the circulation of ideas, characterized the entirety of East Asia during the millennium from about 400 BCE to the late sixth century CE, and undergird its art history. In the regions of present-day Korea and Japan, the first regional states built mounded tombs that preserve a great deal of art, including prestige goods such as gold crowns and bronze weapons. Yet it is important to note that even as objects and ideas are disseminated through trade and migration, artworks may still be distinctive to particular times and places, such as the *dōtaku* of the Yayoi, the *haniwa* of the Kofun, and the incense burner of the Baekje kingdom.

In the Chinese regions, the collapse of the Han dynasty ushered in a period of division. In the regional court of the Eastern Jin, calligraphy and painting emerged as significant artforms practiced by learned gentlemen. In areas of northern and western China, Buddhism took root during the Northern Wei dynasty of Tuoba rulers. Throughout East Asia, contact between cultures stimulated artistic creation, and local conditions drove decisions about adopting, adapting, and inventing new forms of art. This pattern of encounter and creation would continue in the ensuing centuries of the medieval era as Buddhism spread throughout East Asia.

Discussion Questions

1. Some artworks in this chapter were buried in tombs; others picture realms associated with the afterlife. Choose two artworks to compare and contrast how each conveys ideas about life after death.

2. Visual art is often the vehicle for communicating such profound human values as respect for parents or devotion to religion. Choose an artwork from this chapter to explain how it promotes Confucianism, Daoism, and/or Buddhism.

3. Bronze is a medium that can be shaped into instruments, mirrors, weapons, incense burners, and icons. Compare the form and function of bronze objects made in the early centuries of the first millennium across the regions of present-day Japan, Korea, and China. Select one artwork from each of the regions.

4. Further research: find another artwork associated with an early monumental site such as a tomb of the Kofun period or the Silla kingdom. Or, find another Buddhist sculpture dating to the Period of Division (220–581), such as the matching donor panel to that depicting Emperor Xiaowen (**Fig. 4.19**). How would that artwork deepen or expand the content in this chapter?

Further Reading

- Hai, Willow Weilan, *et al. Art in a Time of Chaos: Masterworks from Six Dynasties China, 3rd–6th Centuries.* New York: China Institute in America, 2016.

- Harrist, Robert E, Wen Fong, and Qianshen Bai. *The Embodied Image: Chinese Calligraphy from the John B. Elliot Collection.* Princeton, NJ: Art Museum, Princeton University in association with Harry N. Abrams, NY, 1999.

- Kim, Minku. "Early Paintings of Korea: Murals and Craft Decorations." In J. P. Park, Burglind Jungmann, and Juhyung Rhi (eds.). *A Companion to Korean Art.* Hoboken, NJ: Wiley-Blackwell, 2020.

- Pearson, Richard J. *Ancient Japan.* Washington, D.C.: Sackler Gallery, 1992.

Chronology

	JAPAN			
			c. 500–600 CE	A gilt-bronze incense burner is used in a Buddhist temple, Baekje kingdom
c. 400 BCE–*c.* 300 CE	The Yayoi period			
				CHINA
c. 200–100 BCE	Bronze blades, beads, and a mirror are deposited in the Yoshitake-Takagi site Yayoi tomb		220–581 CE	The Period of Division includes: Eastern Jin (317–420 CE) Later Zhao (319–51 CE) Northern Wei (386–534 CE)
c. 300–538 CE	The Kofun period			
c. 375–415 CE	The Daisen Tomb is constructed		338 CE	The Seated Buddha bronze icon is cast, Later Zhao period
	KOREA			
			353 CE	Wang Xizhi writes the *Orchid Pavilion Preface* (now lost)
c. 200–668 CE	The Three Kingdoms period			
c. 400–500 CE	Murals are painted in the Muyongchong Tomb, Goguryeo kingdom		*c.* 460–65 CE	Colossal Buddhist figures are carved at Yungang, Northern Wei

5

The Dissemination of Buddhist and Hindu Art in South Asia and Southeast Asia

500–1100

5.0 Shiva as Ardhanarishvara, Shiva cave temple, Elephanta, India.

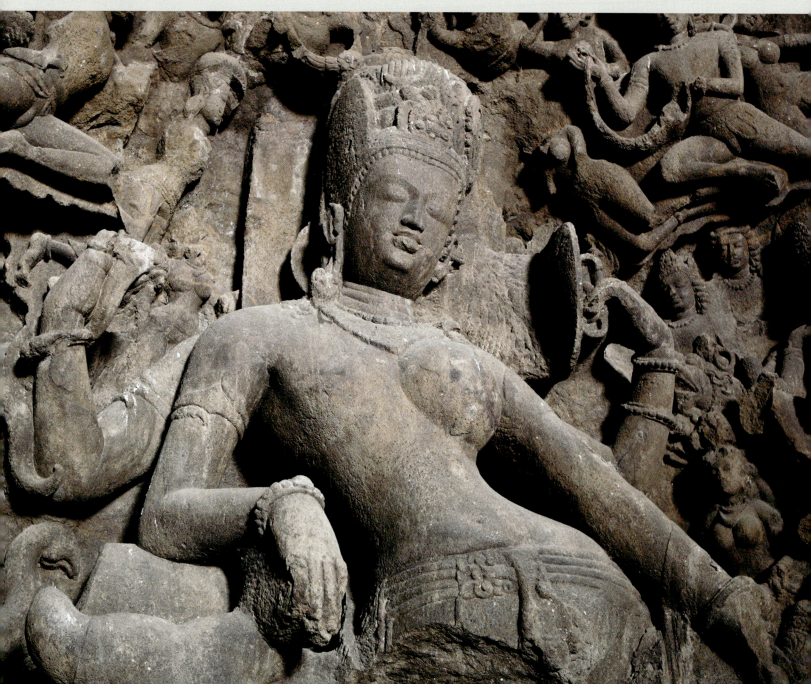

Introduction

By the fifth century CE, art related to Buddhism and Hinduism was firmly established on the Indian subcontinent and being transmitted elsewhere: to other parts of South Asia, to Southeast Asia, and in the case of Buddhism, to East Asia as well. By the seventh century, Buddhist and Hindu art was flourishing as far away as the Southeast Asian island of Java, demonstrating the broad geographic reach of the religions (Map 5.1 and Map 5.2). Art not only provides evidence of their spread; in many cases, art was also the vehicle by which the belief systems were disseminated. Portable objects, such as books and small devotional icons, were transported by monks and merchants alike, and religious sites along busy trade routes became stopping points for travelers. Art also illuminates how Hinduism and Buddhism evolved over time and space, and how people adapted the religions to suit local power structures and cultural norms. Thus, on the one hand, the spread of Hindu and Buddhist art points to the interconnectedness of various Asian regions during the medieval era; on the other, it highlights the importance of regional autonomy during this period.

In South Asia, between the fifth and eighth centuries, rock-cut art, including cave architecture (monumental inhabitable spaces carved by sculptors into mountainsides), flourished. Buddhist cave sites such as Ajanta and Bamiyan exemplify the interconnectedness of art, trade, royal patronage, and monastic communities during those centuries. Sites such as the Shiva cave temple at Elephanta represent how cave architecture created potent religious experiences for Hindu devotees as well. The various rock-cut works at the south Indian site of Mamallapuram, a seaport of the Pallava dynasty (fourth–ninth centuries CE), demonstrate how religiously themed art projected political power.

Southeast Asian sculptures from the seventh and eighth centuries embody Hindu and Buddhist art's unique development in the region, from very early onward, in response to local priorities and belief systems. Likewise, key examples of Sri Lankan art from the eighth through twelfth centuries show the development of religious art there, with the island eventually becoming a center for Theravada Buddhism. At the same time that Sri Lanka was codifying its Theravada Buddhist beliefs, in eastern India, Mahayana beliefs were giving rise to Vajrayana Buddhism (also referred to as Esoteric or Tantric Buddhism), which then spread to other regions, including the Kathmandu Valley in Nepal and the Tibetan plateau. Artistic examples datable to between the fifth and twelfth centuries help us trace that development (for Vajrayana Buddhist art's development in East Asia, see Chapter 6).

Rock-cut Art in South Asia, 500–800

Rock-cut art refers to sculpture and architecture carved directly into naturally occurring, unquarried stone, whether in the form of a large boulder or the side of a mountain. When sculptors carve into a solid mountainside to create inhabitable spaces, the resulting structures are often referred to, more specifically, as cave architecture. Rock-cut art has been made throughout history in many parts of the world; however, South Asia has a

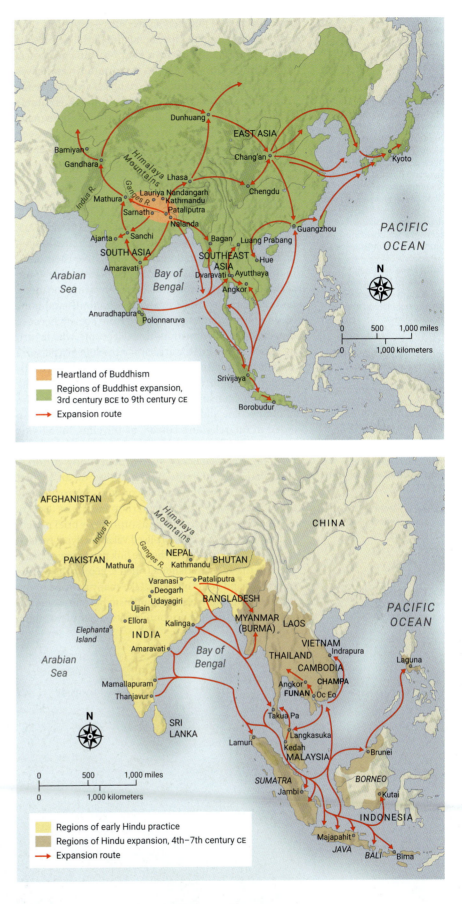

Map 5.1 TOP **The spread of Buddhism throughout South Asia, Southeast Asia, and East Asia,** third century BCE–ninth century CE.

Map 5.2 ABOVE **The spread of Hinduism throughout South Asia and Southeast Asia,** fourth century–seventh century CE.

rock-cut carved from solid stone, where it naturally occurs.

vihara a retreat for Buddhist monks and nuns.

chaitya a Buddhist prayer hall with a *stupa* at one end.

buddha a buddha is a being who has achieved the state of perfect enlightenment called Buddhahood; the Buddha is, literally, the "Enlightened One"; generally refers to the historical Buddha, Siddhartha Gautama, also called Shakyamuni and Shakyasimha.

stupa a mound-like or hemispherical structure containing Buddhist relics.

pradakshina in Hindu, Buddhist, and Jain practice, the ritual of walking around (circumambulating) a sacred place or object.

torana a gateway marking the entrance to a Buddhist, Hindu, or Jain sacred structure.

bodhisattva in early Buddhism and Theravada Buddhism, a being with the potential to become a buddha; in Mahayana Buddhism, an enlightened being who vows to remain in this world in order to aid all sentient beings toward enlightenment.

jatakas stories of the historical Buddha's previous lives.

5.1 Plan of the Buddhist caves at Ajanta, India, *c.* 100 BCE –500 CE.

particularly large number of such sites—with more than 1500 known examples. This abundance most likely results from a combination of the region's specific geological composition with the fact that mountains and caves have long been considered sacred places in South Asian culture. The earliest rock-cut art in South Asia is datable to the third century BCE, and it continued to be made through the twelfth century CE. Its zenith was between the fifth and eighth centuries CE, when multiple, monumental rock-cut sites relating to Buddhism, Hinduism, and Jainism were constructed.

AJANTA

Cave architecture began to be made and used for Buddhist monasteries around 100 BCE, with most such sites located on trade routes. Human-carved caves, like their naturally occurring counterparts, are temperate, sturdy, and secluded, and therefore make ideal retreats for meditation and prayer. However, Buddhist monks and nuns could not be completely removed from society because they depended on donations from laypeople, who in turn increased their merit toward karma (the sum of a person's actions that determines his or her future existences) by supporting them. Constructing cave monasteries along trade routes ensured a steady stream of visitors who might become additional patrons. Their locations also aided in the religion's spread, as traveling merchants were introduced to Buddhist doctrine through such sites.

Ajanta, a monastery site located along a horseshoe-shaped bend in the Waghora River on an ancient trade route in western India, contains approximately thirty caves dating to between 100 BCE and 500 CE (**Fig. 5.1**). The majority were carved over a surprisingly brief period, *c.* 460–500 CE, when the short-lived Vakataka dynasty ruled the region. Inscriptions at the site link patronage of many caves to the ruler Harishena (ruled *c.* 460–80) as well as to princes and court officials. Like many patrons of the time, they were followers of Hinduism but supported the Buddhist site, finding no conflict between the two faiths.

The two main types of Buddhist caves are **viharas** for lodging and **chaityas** for prayer. Cut into the mountainside, a *vihara* consisted of a sizable central hall surrounded by small cells where the monks resided. Each cell contained a carved stone bed and pillow as well as hooks and niches for the monks' meager belongings. At Ajanta, *viharas* also included small shrines with **buddha** images for worship. The inclusion of such shrines within the residences enabled the monks, symbolically, to become the Buddha's companions. *Chaityas*, in contrast to the squarish *viharas*, were long, narrow rooms with a curved end featuring a **stupa**, the focus of devotion. At Ajanta, a carved buddha image adorns the front of each *stupa*, and columns along the sides flank the **pradakshina** path (**Fig. 5.2**). The curved ceiling beams and broad columns, structurally unnecessary in caves, suggest the *chaitya* halls imitated elements of earlier wooden architecture, just as the **toranas** at the Great Stupa at Sanchi (see Fig. 3.4) seem to be based on earlier wooden gateways.

Ajanta's caves are further embellished with murals covering almost every inch of the interior walls and ceilings. These murals are amongst South Asia's earliest surviving examples of painting. In addition to decorative designs of various types, the paintings depict images of **bodhisattvas**, scenes from the life of the Buddha, and **jatakas**. For example, a scene in Cave 1 depicts the Mahajanaka *jataka* (**Fig. 5.3**), in which the ruler Mahajanaka gives up his riches to go in search of spiritual fulfillment. On the left, Mahajanaka sits on a low throne in his palace in a scene teeming with figures. He looks detached as his wife, also seated on a low throne, tries to persuade him to stay. He appears again on the right, leaving on horseback.

The murals are **dry frescos** painted with **tempera**, skillfully made and planned with care. They feature crowded compositions and complex narrative constructions, often employing **continuous narrative**, as the Mahajanaka *jataka* does (**Fig. 5.3**). Settings are defined by architectural elements, such as walls and gateways. The artists employed a type of **perspective** when depicting such elements, thereby providing the painting with depth and a sense of three-dimensional space. Such use of perspective is visible in the gateway through which Mahajanaka passes as he departs. Artists further conveyed space through the overlapping of human figures, who gesture and gaze at one another in a variety of gracefully animated poses. The artists defined forms with outlines and used **chiaroscuro** and **foreshortening**, as can be seen in the depiction of the *bodhisattva* Vajrapani in Cave 1 (see Seeing Connections: Matters of Cloth, p. 58, Fig. 5). Note, in that case, the foreshortening of Vajrapani's forearm as he raises his right hand in the teaching **mudra**. Note also the artists' use of shading and highlights in the modeling of his full lips, slender nose, and hoop earrings. Vajrapani and the royal figure standing to his side are bedecked in delicate crowns and fine textiles. Because of the caves' darkness, oil lamplight would have been required to see the paintings. Even then, viewers would have been able to see only one small part at a time, leading some scholars to wonder if

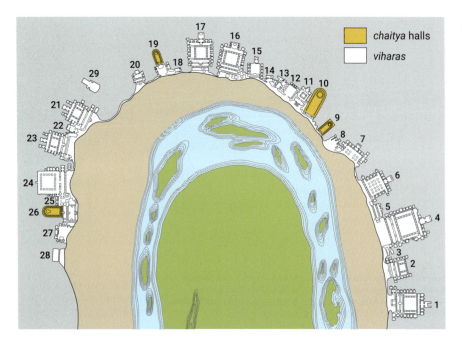

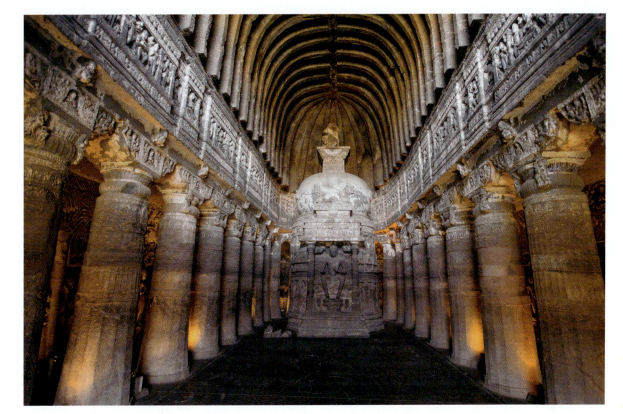

the paintings' primary purpose was spiritual rather than visual. Alternatively, perhaps the gradual revealing of the images as visitors moved through the cave was intended to encourage prolonged, focused viewing, which in turn enabled a deeper appreciation of both the paintings' artistic splendor and their spiritual significance.

Ajanta's wall paintings survive, in part, because the site was occupied only for a short while. After the Vakataka

dry fresco a wall or ceiling painting on dry plaster, as opposed to on wet plaster.

tempera a fast-drying paint made from a mixture of powdered pigment and a binding agent, typically egg yolk.

continuous narrative multiple events combined within a single pictorial frame.

perspective the two-dimensional representation of a three-dimensional object or a volume of space.

chiaroscuro in two-dimensional artworks, the use of light and dark contrasts to create the impression of volume when modeling three-dimensional objects and figures.

foreshortening in two-dimensional artworks, the illusion of a form receding into space: the parts of an object or figure closest to the viewer are depicted as largest, those furthest the smallest.

mudra a symbolic gesture in Hinduism and Buddhism, usually involving the hand and fingers.

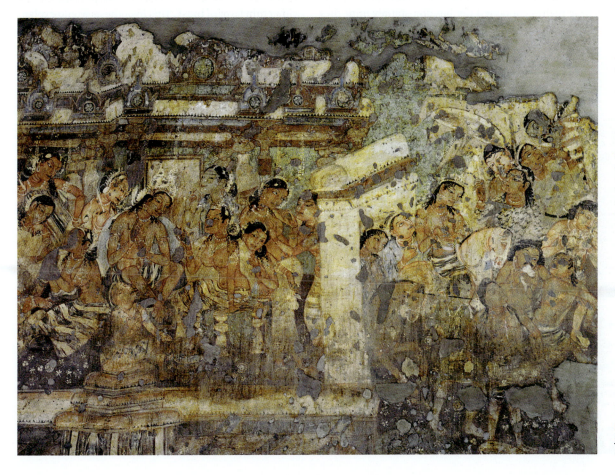

5.3 Detail of Mahajanaka *jataka* **mural,** Cave 1, Ajanta, India, *c.* 460–500 CE.

high relief raised forms that project far from a flat background.

iconoclasm the intentional destruction or rejection of images on religious or political grounds.

parinirvana the death of someone who has achieved nirvana, or enlightenment, during his or her lifetime.

dynasty fell, support for the monks at Ajanta seems to have dwindled. Construction of some caves stopped before work was completed. Eventually, the site was abandoned, and, over time, many of the cave entrances became blocked by debris. As a result, when the entrances were cleared in the nineteenth century, during the British colonial period, visitors and officials found the interiors relatively well preserved.

BAMIYAN

In contrast to the Vakataka-era caves at Ajanta, other Buddhist rock-cut sites were occupied for long periods of time and visited by an array of diverse travelers over the centuries. Bamiyan (also spelled Bamyan) in present-day Afghanistan, for example, was long renowned for its striking landscape and the two colossal buddha images carved into its cliffside. Writers, from the seventh-century Chinese scholar-monk Xuanzang (see box: Going to the Source: A Tang Dynasty Account of Bamiyan) to the early twentieth-century British traveler and historian, Robert Byron, recorded in detail their reactions to Bamiyan and its buddhas, leaving us intriguing information about the site.

The fertile Bamiyan valley is located in the Hindu Kush mountain range linking South Asia and Central Asia. Between roughly the second and eighth centuries CE, Bamiyan was a key stop on the branch of the Silk Road leading from China to India (see **Map 5.1** and Map 3.2), and housed a flourishing Buddhist community. Nearly one thousand rock-cut caves surround two massive niches a half-mile apart from each other on the north side of the mountain face at the valley's edge. These niches contained the buddha statues until they

were destroyed in 2001. In contrast to Ajanta, Bamiyan's caves did not house monks, but rather provided places for prayer and meditation (the monks lived in monasteries on the valley floor). Scholars believe that construction of the caves began in the third or fourth centuries, with the buddha sculptures added later. The smaller statue, datable to the mid sixth century CE, was 120 feet (more than 35 meters) high and represented Shakyamuni, the historical Buddha. The taller one (**Fig 5.4**), constructed in the early seventh century, reached 175 feet (more than 53 m) high and may have represented Vairochana, the cosmic Buddha transcending time and space, or perhaps Dipankara, the Buddha of the Past. Sculptors carved both icons from the cliff in **high relief**. To enable ritual circumambulation at the bottom and the top, they sculpted the buddhas' feet completely in the round and cut galleries from the cliffs near the buddhas' heads.

Several features of the statues, such as the draping of their robes, displayed the lingering influence in the region of the earlier Gandharan style (see Figs. 3.8 and 3.10); however, much of the buddhas' original appearance was lost well before their recent destruction (as early as the ninth or tenth centuries) and has to be re-imagined through what we know of their construction. Because the cliff's stone is a porous conglomerate, it is not ideal for fine carving. To overcome this limitation, after sculpting the bulk of the bodies from the cliff stone, artists added details using clay coating. Some parts, such as the lower arms and hands, were made from wooden extensions also coated in clay. Art historians still debate how the upper portions of the faces were constructed. One theory is that they were fashioned from wooden masks, perhaps covered with a thin layer of brass. This hypothesis would explain

5.4 View of the cliffside at Bamiyan, showing some of the caves and the larger of the two Buddha sculptures, Afghanistan, third–eighth centuries CE (Buddha sculpture early seventh century CE). (Photograph taken before the sculpture's destruction in 2001.)

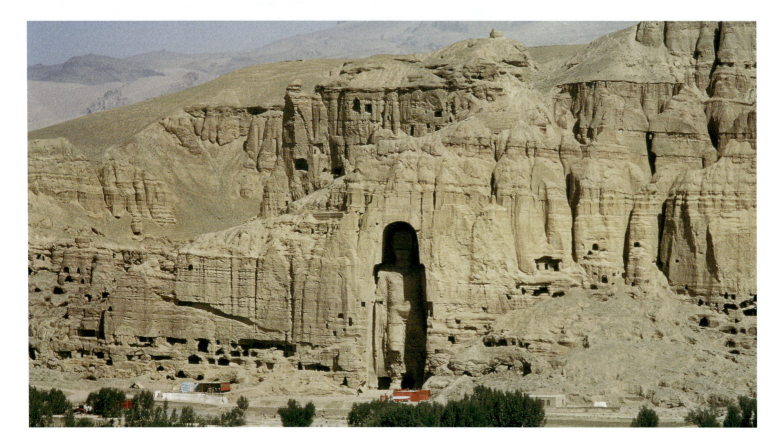

The earliest account of the Bamiyan Buddhas comes from the Chinese scholar-monk Xuanzang (c. 602–664 CE), who visited the valley in 630. Wanting to expand his knowledge of Buddhism, Xuanzang set off for India in 629. Although the Tang government strictly controlled foreign travel, he left the Tang Empire without having gained permission, crossed the deserts and mountains of Central Asia, and made his way to the Indian subcontinent. By the time he returned from his arduous solo journey sixteen years later, he had collected more than six hundred Buddhist texts, as well as multiple Buddhist images and relics, and visited numerous sites. He was not the only—or even the first—Chinese pilgrim to leave a travel record, but his account, *The Great Tang Dynasty Record of the Western Regions,* is the longest and most detailed. His description of Bamiyan is below.

"The country of Bamiyana is more than two thousand *li* [a unit of measure roughly equal to one-third of a mile] from east to west and over three hundred *li* from south to north, being situated among the Snow Mountains. The people lived on the slopes of the valleys and gradually became town-dwellers. The capital city lies upon a cliff and stretches across a valley six or seven *li* in length, with a lofty precipice at its back on the north. It produces winter wheat, but few flowers and fruits. It is fit for cattle breeding, and there are many sheep and horses. The climate is severely cold, and the customs are harsh and rude. The people mostly wear fur and hempen clothes, which are suitable for them... They worship the Three Jewels (the Buddha, the dharma, and the monastic community) with the utmost sincerity and venerate all gods down to the various deities. When merchants coming and going happen to witness visions of heavenly deities, whether as good omens or as predictions of disaster, they worship the deities to pray for blessedness. There are several tens of monasteries with several thousand monks, who follow the Theravada teachings.

To the northeast of the royal city, there is at a corner of the mountains a rock statue of the Buddha standing, one hundred forty or fifty feet in height, a dazzling golden color and adorned with brilliant gems. To the east there is a monastery built by a previous king of the country. To the east of the monastery there is a copper statue of the Buddha standing, more than one hundred feet tall. It was cast in separate pieces and then welded together into shape.

In the monastery situated two or three *li* to the east of the city, there is an image of the Buddha recumbent, more than one thousand feet long, in the posture of entering Nirvana. At this place the king often convened the Quinquennial Assembly, in which he offered everything from his queen down to the national treasures as alms to the monks. When the state repository was exhausted, he gave himself up to the monks, and then his officials paid ransom to the monks to redeem the king. This practice has become the king's regular duty."

Discussion Questions:

1. What are some specific insights that Xuanzang's passage provides about the seventh-century context of the Bamiyan Buddhas?

2. Recognizing that Xuanzang gets at least some details wrong (such as the smaller Buddha being made of copper), how might we go about assessing his account overall?

why the Chinese monk Xuanzang described the smaller Buddha as being made of copper (see Going to the Source: A Tang Dynasty Account of Bamiyan). Scholars do agree that the sculptures were brightly painted in a variety of hues, including deep red and lapis blue, which would have added further to their visual prominence.

In March 2001, the Taliban, an Afghan militant Islamic fundamentalist organization, demolished the two colossal sculptures. The motivation seems to have been a combination of Islamic fundamentalism's trend toward **iconoclasm**, a response to local political vendettas, and a desire to gain global attention. Although the sculptures can never be replaced (despite occasional debates about reconstructing them), in recent years, conservation and archaeological work at the site, of which the buddha sculptures formed only one part, has yielded exciting new discoveries. Researchers have extensively studied the remains of mural paintings that originally adorned around fifty of the rock-cut caves. Using a variety of micro-analytical techniques, they have been able not only to date the paintings to roughly the seventh century, but also to analyze the paint layers. They discovered that in twelve caves the artists used oil-based paints, as in this example in which a Buddhist deity stands next to a tree (Fig. 5.5). Oil helps fix pigments and allows them to adhere to the surface better. The use of it at Bamiyan predates what was previously considered the earliest known example of oil painting (fifteenth-century Europe) by more than six centuries and speaks to the artistic innovations occurring amongst the Silk Road cultures of the period.

5.5 Detail of a cave mural showing a Buddhist deity and a tree, Bamiyan, Afghanistan, seventh century CE. (Photograph taken in the 1970s.)

Archaeologists also discovered in the valley the remains of a massive *stupa*, estimated to be more than 250 feet (76 meters) high, and fragments of another large statue, this time depicting the Buddha's *parinirvana*. Based on the fragments found, archaeologists estimate the sculpture was 62 feet (almost 19 m) long, which is sizable, but nowhere near the size of the 1000-foot-long (more than 300 meters-long) reclining Buddha mentioned

by Xuanzang. Whether Xuanzang misremembered or exaggerated his description, or whether there are more discoveries to be found at the site, is yet to be determined.

ELEPHANTA

In western India, at the same time that members of the Vakataka dynasty were patronizing Ajanta, Hindu and Jain rock-cut art also began to flourish there. Prominent early examples include the sites of Udayagiri (see Fig. 3.16)

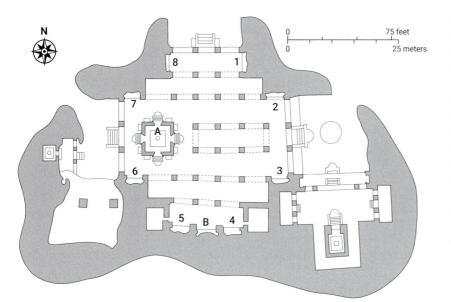

N

0						75 feet
0			25 meters			

A Linga shrine
B Eternal Shiva (3-faced *linga*)
1 Shiva as Master Yogi
2 Shiva trapping Ravana beneath Mount Kailasa
3 Shiva playing dice with Parvati

4 Shiva as Ardhanarishvara
5 Descent of the Ganges
6 Marriage of Shiva and Parvati
7 Shiva destroying Andhaka
8 Shiva dancing

and Elephanta. The island of Elephanta in Mumbai Harbor contains several cave structures carved out of its basalt rock. The primary structure is a temple dedicated to the Hindu god Shiva and most probably was commissioned by the ruler Krishnaraja I (ruled *c.* 550–75) of the Kalachuri dynasty. It exemplifies the power of cave architecture as a site for Hindu pilgrimage. Beginning with the journey by boat from the mainland to the island, the entire experience of visiting this site must have been an immersive one.

Once devotees had reached the island and walked up to the Shiva cave temple on the hill's north side, they would have entered through a columned doorway into a pillared interior, 131 feet (almost 40 meters) across (**Fig. 5.6**). Visitors today to the historical site (it is no longer a functioning Hindu temple) still enter that way. In addition to the main entrance, the excavated cave has two side openings to let in light. Unusually for a Hindu temple, the site features two shrines. Off center from the main entrance, but aligned with the two side openings, is a small square shrine with four doors (**Fig. 5.7**; labeled A in **Fig. 5.6**). The doorways are flanked by imposing guardian figures and dwarf companions. In the center is a stone *linga*, the **aniconic** form of Shiva. The sculptors placed the shrine off center so that it did not block the view of the large Eternal Shiva, a monumental **bust** sculpture with three visible "faces" or heads (one full-face flanked by two in profile), in the center of the back wall (**Fig. 5.8**; labeled B in **Fig. 5.6**). Also flanked by guardians and dwarfs, and rising 18 feet (5.5 m) from a platform in a deep recess, this second shrine, which is part abstract and part figural, displays the transition between the god's aniconic and **iconic** forms. Commonly referred to as a three-faced *linga*, it

5.6 ABOVE **Plan of the Shiva cave temple,** Elephanta, India, sixth century CE.

5.7 RIGHT *Linga* **shrine,** with relief showing marriage of Shiva and Parvati in background, Shiva cave temple, Elephanta, India, sixth century CE.

linga an abstract representation of the Hindu god Shiva that denotes his divine generative energy.

aniconic the indirect visual representation of divine beings through symbols or abstract images.

bust a sculpture of a person's head, shoulders, and chest.

icon, iconic an image of a religious subject, used for contemplation and veneration.

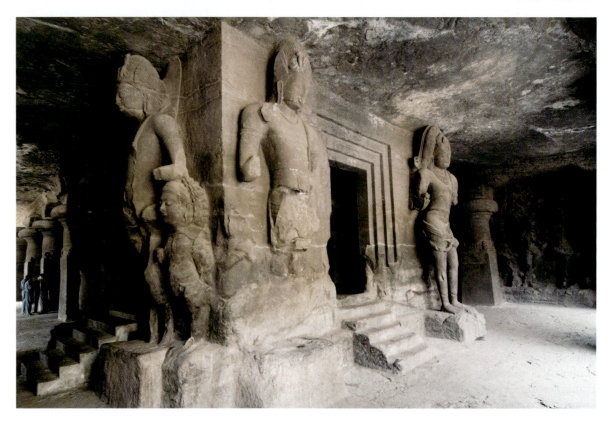

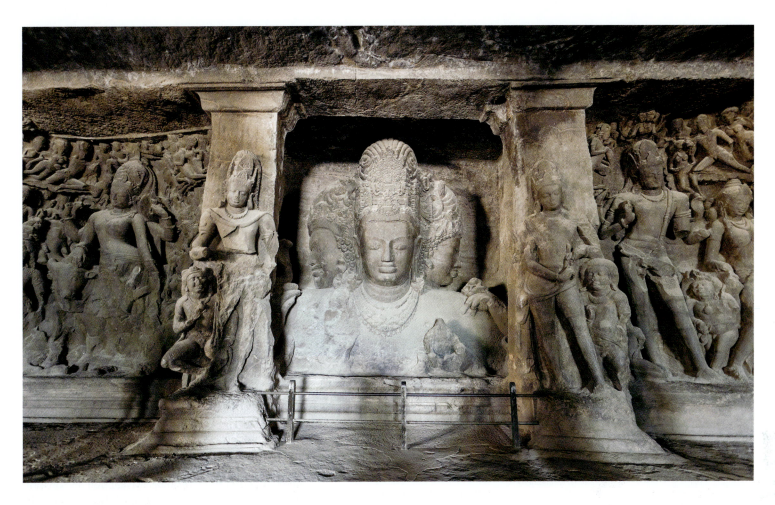

both resembles a *linga* and presents Shiva's faces as they appear in his various manifestations. The column created by the dreadlocks piled on Shiva's head acts as the *linga*'s top, and his shoulders acts as its base. The center face displays the god in his serene form, the face in profile to the right is Shiva's female form, and that in profile on the left his wrathful form. Worshipers would have understood the *linga* to have a fourth face in the back and a fifth face on top.

The walls of the pillared interior feature eight large-scale, deeply carved sculptural **reliefs**, each presenting a different aspect of Shiva (labeled 1–8 in **Fig. 5.6**). For example, the relief to the left of the three-faced *linga* presents Shiva as Ardhanarishvara, his half-male, half-female manifestation (see **Fig. 5.0**; labeled 4 in Fig. 5.6), and that to the right shows him facilitating the goddess Ganga's (the Ganges River) safe descent to earth (for another rock-cut depiction of the Descent of the Ganges story, see **Fig. 5.11**). Although artillery practice by the Portuguese military in the sixteenth century badly damaged the reliefs, much of their iconography, compositional strategies, and imposing visual features are still apparent. For example, in the Ardhanarishvara relief, his left side (viewer's right) is female, with breast and curved hip, while his other side is male. One hand casually rests on his sacred mount, the bull Nandi. The god's smoothly carved, larger-than-life form, at the composition's center, juxtaposes with the assemblage of deities, one quarter his size, filling the background. This visual contrast helps communicate Shiva's power. Scholars still ponder the import of

the eight reliefs' specific arrangement around the cave, but the **iconographic** program clearly embodies the full range of Shiva's energy, from tranquil to dynamic. By circumambulating the entire cave, visitors encounter Shiva in his manifold manifestations, from meditative to wrathful, in a setting that is simultaneously imposing and intimate (for a later representation of the Shiva cave temple in art, see Seeing Connections: Images of Orientalism, p. 262).

MAMALLAPURAM

While rock-cut art was fairly common in western India, as demonstrated by the caves at Ajanta and Elephanta, it was much rarer in the far south of the subcontinent. One notable exception is the site of Mamallapuram, on the east coast of southern India. Around 630 CE, a ruler of the Pallava dynasty (early fourth to late ninth centuries) named Narasimha—also known by the epithet Mamalla or "Great Warrior"—founded a new port city for his kingdom. The city was called Mamallapuram ("City of the Great Warrior") after Narasimha, who had its port expanded to accommodate ships sailing to and from locations as far away as present-day Thailand. Over the next century, but most probably concentrated during the reign of the Pallava ruler Rajasimha (*c.* 700–728), artists constructed at the site a series of granite monuments featuring Hindu imagery. A few structures were made from quarried stone. The majority, however, were rock-cut, many carved from the same large granite outcropping near the town's center. A range of rock-cut

5.8 Shiva as Ardhanarishvara (left), three-faced *linga* (center), and the Descent of the Ganges (right), Shiva cave temple, Elephanta, India, sixth century CE.

relief raised forms that project from a flat background.

iconography images or symbols used to convey specific meanings in an artwork.

5.9 BOTTOM **Five *Rathas*,** Mamallapuram, India, Pallava dynasty, late seventh–early eighth centuries.

5.9a BELOW **Plan of the Five *Rathas*,** Mamallapuram, India, Pallava dynasty, late seventh–early eighth centuries.

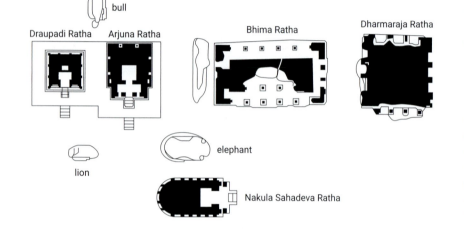

works, including stone thrones replete with stone pillows, have been unearthed at Mamallapuram and now are protected by the Archaeological Survey of India. Likely, more structures remain buried in the sand or under recent construction projects. Currently, the site features three main types of rock-cut monuments: **monolithic** structures fashioned from sizable boulders, excavated pillared cave temples, and cliff faces carved with narrative reliefs.

Mamallapuram (also called Mahabalipuram) presents scholars with many intriguing questions. Chief among them are precisely when and by whom the various monuments were commissioned, why they were built, and why so many of them appear incomplete. All three questions arise when analyzing a group of monolithic monuments commonly referred to as the Five Rathas (**Figs. 5.9** and **5.9a**). The monuments are carved from a series of large boulders situated south of the town's main granite outcropping. *Ratha* means chariot, but the name, which was a later appellation, has nothing to do with the structures themselves. The *rathas*, in fact, are small Hindu shrines, although whether or not they were actually intended for worship remains unclear.

Each *ratha* takes a different form, and together they seem to present a primer on Hindu temple design. The northernmost *ratha*, for example (commonly called Draupadi Ratha, on the left in **Fig. 5.9**), is a stone version of a small wooden shrine with a thatched roof. It is dedicated to Durga, as indicated by a relief carving of the goddess on the interior rear wall. Durga's sacred mount is a lion, and as is typical in Hindu architecture, a sculpture of a lion appears before her temple. However, for the temple to be ritually correct, the lion should face the shrine, which it does not. Likewise, the temple next to it (Arjuna Ratha), which follows typical south Indian temple design, with a rounded cap at the apex of the layered tower, was probably dedicated to Shiva. His sacred mount, the bull, is carved from a small boulder behind the temple. If the shrine was intended for worship, the bull sculpture should face the shrine's entrance, but it does not.

Another *ratha* (Bhima Ratha) has a **barrel-vaulted** roof, another (Dharmaraja Ratha) is two stories high, and the final one (Nakula Sahadeva Ratha) is **apsidal** in shape, meaning that its back wall is curved. Notably, situated parallel to that shrine is a monolithic sculpture of an elephant; the animal's curved backside lines up with the temple's curved back. The elephant may indicate that the shrine was dedicated to Indra, whose mount is an elephant, but it might also be a visual pun: in Sanskrit, an apsidal shrine is called *gaja-prishtha*, meaning elephant-backed. Based on the variety of forms that the *rathas* take and the locations of the sacred mounts, some scholars have hypothesized that the site was built

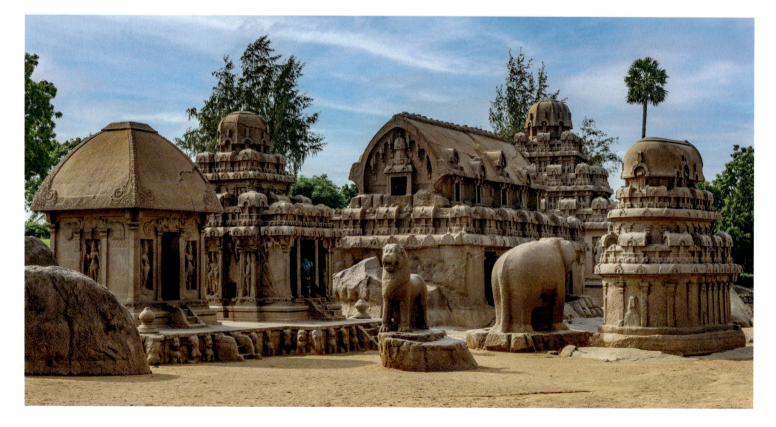

for educational rather than religious purposes, with the sculptors practicing and/or demonstrating their knowledge of temple design.

The two-story shrine (Dharmaraja Ratha) has the name "Mamalla" carved into it, suggesting perhaps that these monuments date to the reign of Narasimha, or Mamalla, making them some of the earliest works at the site. However, this evidence remains inconclusive. Another puzzlement is that the lower sections of several *rathas* were left uncarved (see, for example, the lower part of the barrel-vaulted shrine, Bhima Ratha), seeming to indicate that they were never finished. In fact, almost every monument at Mamallapuram is what would today be considered unfinished. This has led some art historians to hypothesize that the site served as a workshop where sculptors learned their craft, rather than as a center for devotional practices. Others suggest that the works were not left incomplete, but that the concept of "finished" was flexible. Today we take "finished" to mean every inch completed to refinement, but perhaps in South Asia at the time, a work was considered finished once it was functional, and anything beyond that was superfluous. For example, we know that the reliefs on a Hindu temple did not need to be completely carved for it to be functional; the main icon needed only to be awakened ceremonially by the priests for it to be ready for devotional practice.

Pillared cave temples, the interior spaces of which were adorned with large narrative reliefs further demonstrating their sculptors' skills and knowledge of Hindu art, comprised another of Mamallapuram's three main types of rock-cut monuments. For example, the Mahishamardini Mandapa cave, dedicated to the god Shiva, has a relief of Vishnu reclining on the serpent Ananta (the same subject as Fig. 3.19) on its south wall and a relief showing the goddess Durga slaying the buffalo demon Mahishasura on its north wall (**Fig. 5.10**; see also Fig. 3.14c). Like the story of Vishnu's boar incarnation, Varaha, rescuing the earth goddess Bhudevi depicted at Udayagiri (see Fig. 3.16), the story of Durga slaying the buffalo demon is told in the *Puranas*, ancient Hindu religious texts written in Sanskrit. As detailed there, the gods created the goddess Durga (originally known as Chandika) at a time of crisis when the anti-god, or *asura*, Mahisha, ruled the world. Each god gave Durga a weapon so that she embodied their combined power, or *shakti*—an energy force understood as formless, feminine, and divine. She then confronted Mahisha, whose power was such that he could be defeated by neither man nor god. She engaged the anti-god and his army in fierce battle. The goddess, of course, won—decapitating Mahisha and demonstrating her supremacy.

Like most Pallava narrative reliefs, deeply carved, full bodied, dynamic figures crowd the scene. Still, the story is apparent at a glance. The two main figures, Durga and Mahishasura, each occupy a prominent position, wear a crown, and have a royal parasol over their

5.10 **Durga Slays the Buffalo Demon Mahishasura,** north side of the Mahishamardini Mandapa cave, Mamallapuram, India, Pallava dynasty, seventh–eighth centuries. Sculptural relief, approximately 7 ft. 10½ in. × 15 ft. (2.4 × 4.6 m).

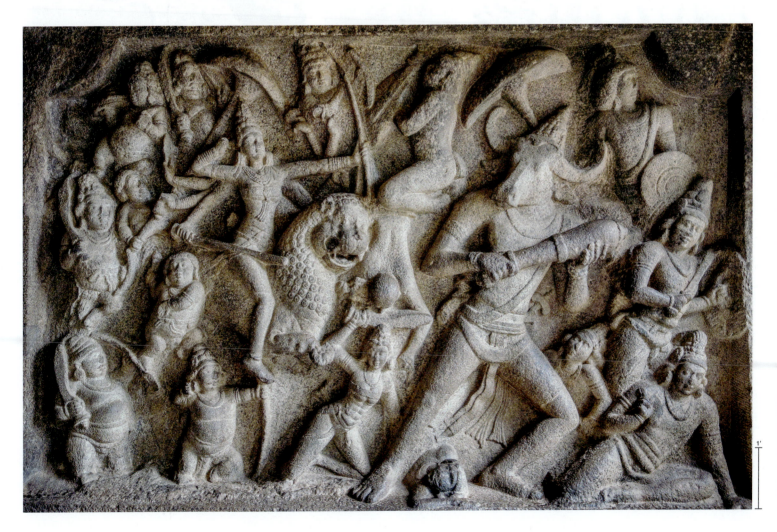

tableau a stationary scene of people or objects, arranged for artistic impact.

5.11 BOTTOM **Great Relief at Mamallapuram,** Mahabalipuram, India, Pallava dynasty, late seventh–early eighth centuries.

5.11 A–E BELOW AND MIDDLE **Details from the Great Relief at Mamallapuram.**

heads, indicative of their importance. Mahishasura, with his human body and buffalo head, is bigger than the goddess. But Durga, mounted on her lion as she draws a bow with two hands and brandishes additional weapons in her remaining six hands, is positioned so that her head is above his. Rather than the moment of victory, the sculptors chose to represent the heat of battle, but the composition hints at Durga's triumph. An implied forward-thrusting curved line formed by Durga's bow, a falling male figure (whose back is to the viewer), and a sword-wielding female warrior together convey that the momentum is with the goddess and her attendants. By contrast, the right-leaning diagonal

of Mahishasura's stance, echoed by the fallen soldiers in the corner, portend his defeat.

The most prominent of the rock-cut works at Mamallapuram is a massive relief, 98 feet (29.87 m) across and 49 feet (14.94 m) high. Scholars have estimated that it would have taken a team of twenty sculptors at least ten years to create the **tableau** (**Fig. 5.11**). The vertical cliff on which it is carved faces the ocean and, in the eighth century, it would have been one of the first sights people saw upon arriving at the port. The sculptors turned a natural cleft in the rock, which divides the relief roughly in half, into a representation of a river populated with *nagas*, snake divinities associated with water. A deep rectangular basin sits below the relief and runs along its length. Originally, on the ledge above, a tank collected rainwater. Scholars hypothesize that the water was probably released to flow down the cleft to the basin as a spectacle on special occasions. On either side of the cleft, more than one hundred larger-than-life-sized figures of humans and animals appear to materialize out of the solid granite. Notably, the relief's lower left quarter appears unfinished.

Art historians have long debated which of two Hindu stories the relief depicts. The relief's emphasis on water, including the river carved into the rock's cleft, suggests that the story depicted is the Descent of the Ganges, in

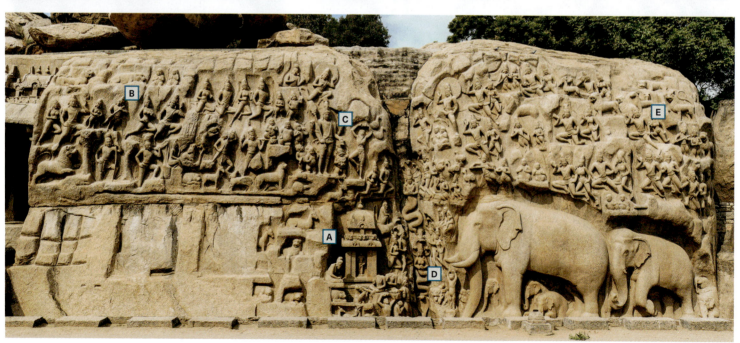

which the king Bhagiratha performs penance to ask for the gods' help bringing the river goddess, Ganga (the Ganges River), to earth, so that his land will no longer be barren. In this interpretation, the seated figure in front of the small shrine to Vishnu immediately to the left of the cleft (Fig. 5.11 A) could be Bhagiratha thanking Vishnu for helping to convince Shiva to break Ganga's fall with his dreadlocks. Yet crucial features typically included in visual retellings of that story, such as an image of Ganga, are absent from the relief.

The alternative story of Arjuna's Penance is suggested by such details as a hunting scene in the upper left quadrant. In that tale, the king Arjuna performs penance so that the god Shiva will give him a sacred weapon with which to win back his kingdom. The scene (Fig. 5.11 B) perhaps shows Shiva, disguised as a hunter, arguing with Arjuna over a boar. Typically, however, the boar in this tale is depicted dead, but here it is shown alive. The absence of key narrative elements makes either interpretation inconclusive. Moreover, neither story is depicted in any sort of order, either chronological or spatial.

One compelling line of scholarship has proposed that the relief is purposefully—and playfully—ambiguous in order to be multivalent—that is, to have multiple values, meanings, or appeals. The sculptors could have made the narrative clear had they chosen to do so (as they did in the Durga Slaying the Buffalo Demon relief, Fig. 5.10), but by combining aspects from both stories, they stress the shared theme of a king performing penance to help his people. For example, directly above the Vishnu shrine a man—who could be either Arjuna or Bhagiratha—stands on one leg, hands over his head, in a posture of penance (Fig. 5.11 C). To his right, stately Shiva holds his hand out in a wish-granting mudra. A dwarf with a lion face on his belly, who may be a personification of the weapon Shiva gave to Arjuna, stands between the two men. A family of elephants—the adult elephant's massive body protecting the babies—dominates the relief on the right side, furthering the theme of protection, but the elephants do not directly relate to either story. Below the largest elephant's tusk, a cat (Fig. 5.11 D) tricks mice into trusting it by pretending to perform penance, in a parody of the human balanced on one leg diagonally above the cat. This element adds humor as well as a warning for viewers: beware of false leaders. Other sculptural details also seem to emphasize the message of protective leadership and connect it back to the Pallava rulers. The Pallavas' royal emblem—a lion with one paw raised—appears at the edge of the cliff to the right (Fig. 5.11 E), linking the rulers to this multivalent message of royal penance and protection. These disparate elements work together in such a way that viewers must actively decipher, and thus fully engage with, the relief's message.

Early Buddhist and Hindu Art in Southeast Asia, 600–800

Inscriptional and archaeological evidence suggest that Buddhism and Hinduism, along with ideas about kingship, elite culture, and philosophy discussed in Sanskrit-language literature, as well as expressed in select visual forms, spread to Southeast Asia between the fourth and sixth centuries CE, concurrent with expansions in maritime trade (see Map 5.1 and Map 5.2). During this period in Southeast Asia, prosperous coastal city-states were emerging. These states included the kingdom of Dvaravati (sixth to eleventh century CE) in central Thailand, the Funan kingdom (first to seventh century CE) in the Mekong Delta region of southern Vietnam and Cambodia, and the Champa kingdom (second to thirteenth century CE) in central Vietnam. The earliest examples of Hindu and Buddhist art in these regions date to the late fifth century; many more examples are datable to the early seventh century, with artistic production flourishing from that point onward.

Exactly *how* South Asian religious beliefs, Sanskrit cultural traditions, and related visual forms spread is unclear. Since Indian sailors and merchants spoke regional languages rather than Sanskrit or Pali (another language associated with early Buddhism), the expansion of trade cannot fully explain the transmission of these new ideas. *Why* these beliefs and traditions appealed to people, particularly the ruling elite, in Southeast Asian coastal states is more apparent. Under Gupta rule in northern and central India, Sanskrit language and literature became central to religious developments, courtly culture, and the expression of political power. As Gupta influence spread to other regions, Sanskrit culture and the religions associated with it (namely, Buddhism and Hinduism) began to operate somewhat like an international language of power. By adopting them, rulers became part of a wider system, referred to by some scholars as a Sanskrit cosmopolis. This system included a repertoire of potent visual imagery that expressed political power and moral standing in ways that resonated at both local and trans-regional levels.

Additionally, early Southeast Asia and early South Asia shared animist beliefs in supernatural powers that organize and animate the material universe. Animist belief systems attribute a soul to things such as sacred mountains and snakes, as well as other animals, plants, inanimate objects, and natural phenomena. As Hinduism and Buddhism developed, they integrated animist beliefs, which meant existing Southeast Asian traditions could be easily incorporated into, and continue alongside, these new religions. For example, a particular supernatural force might be reframed as a manifestation of a Hindu god. For these reasons, compelling variations of Buddhist and Hindu art emerged in these early Southeast Asian states.

In the Dvaravati culture of central and western Thailand, monumental sculptures of wheels seem to have held high status, competing with icons of the Buddha for preeminence. Multiple large sandstone *dharmachakras* (wheels of the law), datable to the seventh and eighth centuries CE, have been found there, but nowhere else in Southeast Asia. The wheel, a key symbol from the aniconic phase of early Indian Buddhist art, carries associations with the idea of the **chakravartin** as well as with the historical Buddha Shakyamuni's sermon at Sarnath, when it is said he "put the wheel of law into motion" by teaching the four noble truths.

chakravartin literally, "wheel-turner," a Sanskrit title used to refer to an ideal, just ruler, often in relationship to the dharmic faiths of Buddhism, Hinduism, and Jainism.

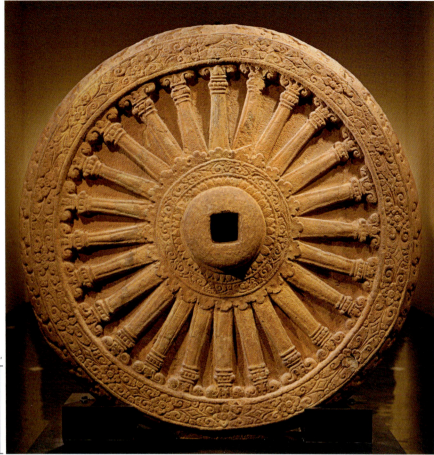

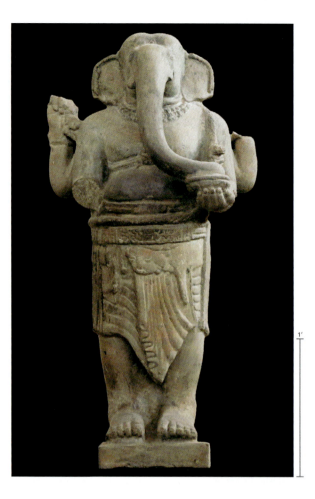

The wheel pictured here (**Fig. 5.12**) measures almost five feet (1.5 m) high. It has twenty-four spokes and combines both delicate and bold carving. The wheels would have been placed on tall columns in a manner similar to the pillars constructed for the Mauryan emperor Ashoka (see Figs. 3.1 and 3.2), except here the wheel took center stage in a way that it never had before. Many wheels, including this one, carry inscriptions in Pali. The inscriptions are engraved between the spokes and describe the Buddha speaking about the four noble truths. However, the inscriptions would have been unreadable when the wheel was placed on top of a pillar, suggesting that their importance was spiritual rather than visual.

The Champa state, which first emerged in the second century CE in present-day central, coastal Vietnam and lasted until the thirteenth century, was an important early site of Hinduism in Southeast Asia. The earliest Hindu architectural remains are seventh-century brick temples called *kalan* in the Cham language, built at the site of My Son. Originally My Son contained more than seventy temples as well as numerous ***steles*** featuring inscriptions written in both Sanskrit and Cham (the site was heavily damaged by United States bombing during the Vietnamese/American War). Situated in a narrow valley between mountain ranges, My Son served as the religious center for the capital of Simhapura, located on the plains below. Along with participating in seafaring activities and trade, the Cham people grew rice. Because of the *linga*'s association with fertility, Shiva worship was popular among rice-growing

people. The temples at My Son, dedicated to Shiva, reflected this popularity.

One temple complex, in addition to its central *linga* shrine, held a robust, free-standing sculpture of Ganesha (**Fig. 5.13**; seen here in a partial view), the elephant-headed god whose potbelly (with its associations with abundance) reveals his origins as an agricultural deity. Aspects of this 3-foot-tall Ganesha embody his father Shiva's asceticism (see Fig. 3.14a): he has a third eye, wears an animal skin, and has a snake wrapped around him (the snake's head is visible behind the bowl of sweets he eats with his trunk). At the same time, he stands erect with a regal bearing and sports an elaborate necklace with settings that once held precious stones. Two of his four arms have broken off; however, an early twentieth-century photograph captures Ganesha with his four arms intact, holding his implements: a rosary (prayer beads), an ax, a bowl of sweets, and a horseradish. Although images of Ganesha, as the god of **auspicious** beginnings, are ubiquitous in South Asian art (see Fig. 3.19a), it is rare to find an icon of him at this scale. In Southeast Asia, particularly in early Cham culture, worship of Ganesha reached heights rarely found in South Asia.

Sculptures of the deity Harihara, such as this seventh-century Cambodian example (**Fig. 5.14**), provide another example of Hindu art's distinct development in Southeast Asia and its connection to regional expressions of power and identity. Harihara is the combined form of the gods Vishnu (Hari) and Shiva (Hara). He embodies the concept of unity in Hinduism: the idea that Shiva and Vishnu

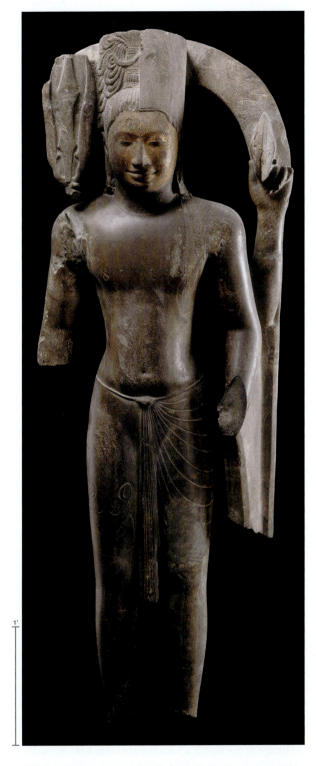

5.14 FAR LEFT **Harihara,** Ta Keo province, Phnom Da, Cambodia, pre-Angkorian period, seventh century CE. Sandstone, height 5 ft. 10 in. (1.78 m). Musée national des arts asiatiques Guimet, Paris.

abdomen. This bodily attention is typical of sculptures from seventh-century Cambodia, which also corresponds with the height of Harihara's popularity.

Images of Harihara first appeared in South Asia in the sixth century CE, and depictions of the deity were made in various regions—from Nepal to Indonesia—through the fourteenth century. However, Harihara's prominence reached a height in seventh- and eighth-century Cambodia unmatched in any other time or place. By the sixth century, the Funan kingdom, which had ruled the Mekong Delta region since the first century CE, was in decline, and a series of small states were vying for power. Local rulers, drawing on the Sanskrit idea of the *chakravartin*, often presented themselves as god-kings. They would claim connection to either Vishnu or Shiva, depending on which particular area they governed. Worship of Vishnu was more popular in southern Cambodia, while Shiva dominated in northern Cambodia and nearby regions. During the seventh and eighth centuries, rulers sought to unify the areas, and sculptures of Harihara can be connected to them. The reason they would have promoted Harihara is clear: the composite deity allowed them to demonstrate the possibility of religious and political unification.

Over the next six hundred years, as both Hinduism and Buddhism thrived in Southeast Asia, artistic and religious innovations continued. Indeed, both the largest Buddhist monument (Borobudur) and the largest pre-modern Hindu temple (Angkor Wat) are located in Southeast Asia (see Chapter 7). Even after Hinduism declined in Southeast Asia (today it is mainly practiced on the island of Bali), its impact on the culture remained strong, as exemplified by the longstanding importance of Hindu epics like the *Mahabharata* and the *Ramayana* on visual culture (see Chapter 14).

Early Buddhist Art in Sri Lanka, 700–1100

Sri Lanka sits in the ocean just 20 miles (32 km) south of the Indian subcontinent. Consequently, there are long, close cultural contacts between the island and mainland South Asia, meaning that both Hinduism and Buddhism spread there early. Of the two religions, Buddhism, which was adopted by local kings and the majority of the population, rose to wider prominence. According to tradition, in 247 BCE, the Mauryan emperor Ashoka (see Chapter 3) sent his son to the island as a Buddhist missionary, and a few years later, he sent his daughter, who brought with her a sapling from the bodhi tree under which the Buddha had gained enlightenment. Many important Buddhist pilgrimage sites and relics are located on the island as a result of this early contact. Sri Lanka also was a crucial node in early Indian Ocean trade because of its strategic location and the highly prized gems, such as rubies and garnets, found there. For these reasons, Sri Lanka played an important role in Buddhism's propagation and development for nearly two millennia, and likewise, Buddhist art flourished on the island.

Today, Theravada Buddhism prevails in Sri Lanka, but before the eleventh century CE, beliefs associated

are just different aspects of the Supreme God. In this example, Harihara's right half (viewer's left) represents Shiva, as indicated by the trident he holds (the top of the trident is visible next to his face), the animal skin he wears, and the matted dreadlocks piled atop his head. Vishnu, on the left half (viewer's right), is recognizable by his kingly crown and the disc he holds in his leftmost hand. The regal, nearly six-foot-tall, sculpted figure was originally framed by an arch, only a portion of which has survived. The figure has also lost his feet and hands, but the skill of its stone-carvers remains apparent. Note for example the subtle modeling of the flesh in the lower

5.15 **Buddhist deity Tara,**
Sri Lanka, Anuradhapura period,
eighth century CE. Gilded
bronze, height 56 in. (1.42 m).
British Museum, London.

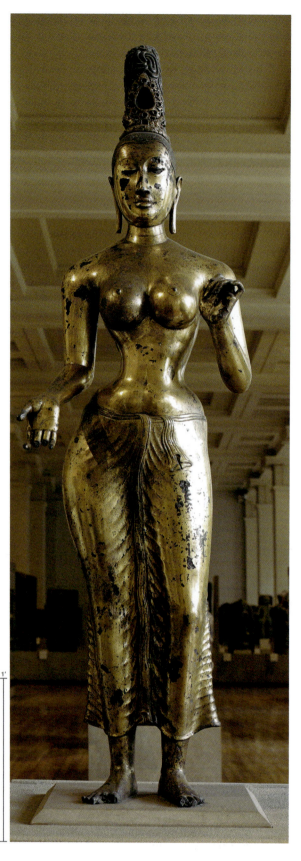

Originally her eyes would have been inlaid with small stones or gems. Likewise, the cavity in her high crown would have contained a precious stone or, more likely, an image of the Buddha. Her right hand is shown in the wish-fulfilling *mudra* while her left hand is believed to have held a lotus flower.

It is rare for a statue this large and luxurious to survive, and it thus provides valuable evidence of the richness of Anuradhapuran visual culture. It also highlights the close artistic links between Sri Lanka and south India as well as the interaction between Mahayana Buddhist beliefs and Hinduism. Originally Tara was a Hindu goddess, but she was absorbed into the Mahayana Buddhist pantheon as the consort of Avalokiteshvara, the *bodhisattva* of compassion. Her tall headdress, smooth face, graceful limbs, and the elegantly wrapped drapery around her lower body give her a regal appearance. Her delicate hand gestures and slight **contrapposto** stance imply movement and animate the form. These stylistic aspects mirror figural imagery from contemporaneous south Indian Hindu courts, evidencing the close contact between the two regions. The statue's full breasts and curving hips also show the continuing and widespread link between female fertility and auspiciousness in South Asian visual culture (see Fig. 3.4).

In 993 Sri Lanka was invaded by the armies of the south Indian Chola emperor Rajaraja I (see Chapter 7). A few years later, the Cholas completely conquered the Anuradhapura kingdom. Sri Lanka regained its independence in 1070, when the ruler Vijaybahu I (ruled 1055–1110) pushed out the Cholas, established a new capital at Polonnaruva in the central part of the island (see **Map 5.1**), and resumed state support of Buddhism. The revival of Buddhist institutions and the expansion of Polonnaruva continued under King Parakramabahu I (ruled 1153–1186), responsible for the construction of the important rock-cut site of Gal Vihara.

Originally known as Uttararama ("the northern monastery"), Gal Vihara ("rock monastery") was the location of a crucial Buddhist assembly ordered by Parakramabahu I. The ruler wanted to unify and control the Buddhist monastic orders by expelling corrupt monks and drawing up a code of conduct. That code of conduct is inscribed on a polished rock face at Gal Vihara. The site also features four colossal, rock-cut sculptures: two seated images of the Buddha, a standing figure with his arms folded across his chest (his identity is uncertain), and an image of the Buddha's *parinirvana* (**Fig. 5.16**). Remains of brick walls indicate that individual sanctuaries originally enclosed the two seated Buddhas and the standing figure. Additionally, the naturally occurring rock outcrop determined the dimensions of each figure. At 46 feet 4 inches in length, the dying Buddha is the largest image at the site. As is typical for depictions of the *parinirvana* (see, for example, Fig. 3.8), the Buddha lies peacefully on his right side with his head supported on a pillow. The figure immediately next to the Buddha's *parinirvana* (the left statue in **Fig. 5.16**) stands 22 feet 9 inches high. Art historians are still debating whether it is another image of the Buddha or depicts the monk Ananda sorrowfully bearing witness to the Buddha's death.

lost-wax casting a method of creating metal sculpture in which a clay mold surrounds a wax model and is then fired; when the wax melts away, molten metal is poured in to fill the space.

gilded covered or foiled in gold.

contrapposto Italian for "counterpoise," a posture of the human body that shifts most weight onto one leg, suggesting ease and potential for movement.

with Mahayana Buddhism also thrived, as this statue of the Buddhist deity Tara demonstrates (**Fig. 5.15**). The striking 4-foot-8-inch icon was made during the eighth century CE, when the Anuradhapura kingdom (377 BCE–1017 CE) ruled Sri Lanka. The sculpture was cast of solid bronze using the **lost-wax** technique and then **gilded**.

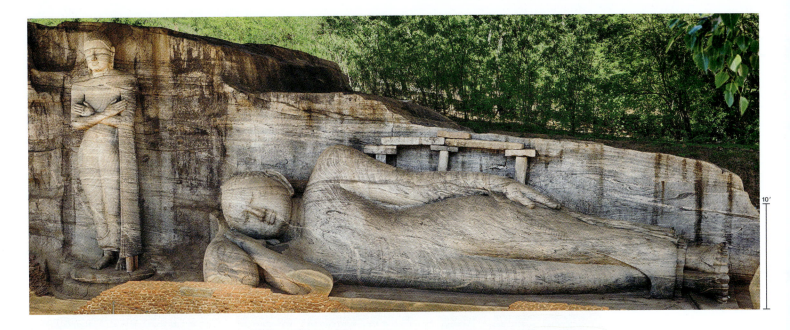

The focus on images of the Buddha and his monastic companions, rather than *bodhisattvas* and goddesses, indicates Sri Lanka's shift to Theravada Buddhism, which Parakramabahu I's reforms helped codify. That religious focus is paralleled by a stylistic shift, visible in the sculptures at Gal Vihara. Compare, for example, the standing figure (**Fig. 5.16**) to the earlier sculpture of the goddess Tara (**Fig. 5.15**). Note the new emphasis on stasis rather than movement, and the highly stylized double folds of his garment, rather than the more fluid single folds of hers. These stylistic elements, along with a new preference for long limbs, broad shoulders, and stoic faces, typify much of Sri Lanka's Buddhist art from this point onward. Thus, Gal Vihara embodies the close relationship between artistic style, religious developments, and political patronage.

Buddhist Art in Northeastern India and the Himalayas, 500–1100

At the same time that Theravada Buddhism was emerging as the dominant belief system in Sri Lanka, the practices associated with Vajrayana Buddhism were being consolidated in eastern India and the Himalayan regions of Nepal and Tibet. (For the spread of Buddhism, including Vajrayana Buddhism, in East Asia, see Chapter 6.) Also referred to as Esoteric Buddhism and Tantric Buddhism, Vajrayana Buddhism is based on texts known as **tantras**, which describe rituals, meditations, and chants (called **mantras**) that help the practitioner progress more quickly toward enlightenment. *Vajra*, which translates as thunderbolt or diamond, is a mythical, indestructible weapon that plays a key role in rituals. The path toward enlightenment in Vajrayana Buddhism is complex and requires the guidance of a teacher. The belief system is centered around the idea of nonduality, meaning the oneness of all things within the universe, even things that appear to be opposites. It incorporates a large pantheon of protective deities, both male and female, as well as numerous buddhas and *bodhisattvas*, all of which are depicted

in art. A central part of its religious practice is visual meditation in which practitioners focus on the image of a specific deity until they realize that the boundary between themselves and the deity is a false illusion, and the two become one.

The emergence of Vajrayana Buddhism can be traced back to before the seventh century CE; it developed from Mahayana Buddhism, with its main beliefs and practices set by the eleventh century. This development occurred largely in the northeastern Indian regions of Bihar and Bengal, which were ruled by the Pala dynasty between the eighth and twelfth centuries. The Pala kingdom was one of several smaller states that emerged after the collapse of the Gupta Empire (for more on the Gupta Empire, see Chapter 3). Because Pala territories included most of the sites associated with the life of the historical Buddha, as well as many prestigious monastic universities, like Nalanda, they became an important destination for Buddhists from surrounding regions. Monks and scholars traveled there for both study and pilgrimage. When they returned home, they brought back portable sacred objects, such as small icons and illustrated manuscripts. In this way, both Pala artistic styles and Vajrayana Buddhist beliefs spread well beyond northeast India. For example, manuscripts from Nalanda are preserved in numerous monastic libraries in the Kathmandu Valley, where they serve as sources for artistic and religious practice among the local Newar Buddhist community of Nepal.

An eleventh-century illustrated **manuscript** made at Nalanda University that eventually ended up in Tibet provides another example of such dissemination. Five **leaves** from the manuscript—a copy of *The Book of the Perfection of Wisdom in Eight Thousand Lines* (in Sanskrit, *Ashtasahashrika Prajnaparamita Sutra*)—survive (**Fig. 5.17**, p. 112). The manuscript is significant not only for its later travels, but also because it embodies the sacred status of certain objects in Vajrayana Buddhism and provides a crucial early example of illustrated books. Like other books of the period, it is made of leaves from the talipot palm (also called fan palm) plant. The long, thin shape

5.16 Gal Vihara, standing figure, height 22 ft. 9 in. (6.93 m), and the death of the Buddha (*parinirvana*), length 46 ft. 4 in. (14.1 m), near Polonnaruwa, Sri Lanka, twelfth century CE.

tantra Hindu and Buddhist esoteric philosophies and spiritual practices; the term also refers to the mystical texts that lay out such philosophies and practices.

mantra a sacred utterance; a word or sound believed to hold spiritual power that is repeated during meditation as a concentration aid.

vajra a term meaning thunderbolt or diamond; in Hinduism and Buddhism, a ritual weapon with the properties of a diamond (indestructibility) and a thunderbolt (irresistible force) to cut through illusions that obstruct enlightenment.

manuscript a handwritten book or document.

leaf (pl. leaves) a single page from an album (a format of painting).

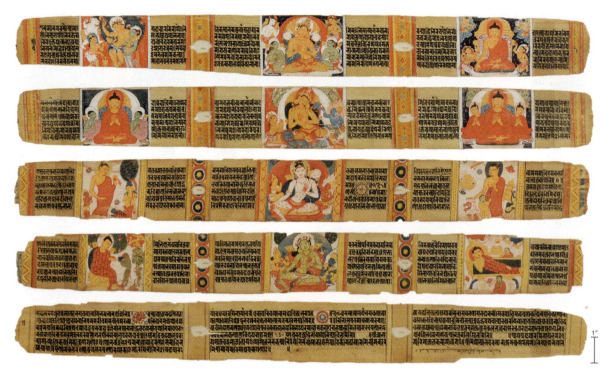

5.17 RIGHT **Five leaves from a copy of** *The Book of the Perfection of Wisdom in Eight Thousand Lines* **(Ashtasahashrika Prajnaparamita),** Nalanda monastery, Bihar, India, Pala period, eleventh century. Ink and opaque watercolor on palm leaf, each approx. 2⅞ × 22⅜ in. (7.3 × 56.8 cm). Asia Society Museum, New York.

5.17a BELOW **Iconography of the five leaves from a copy of** *The Book of the Perfection of Wisdom in Eight Thousand Lines* **(Ashtasahashrika Prajnaparamita).**

The Buddha Shakyamuni's miraculous birth from his mother's side	The goddess Prajnaparamita	The Buddha Shakyamuni's victory over Mara
The Buddha Shakyamuni's first sermon	The Bodhisattva Manjushri	The miracle the Buddha Shakyamuni performed at Shravasti in which he multiplied himself
The Buddha Shakyamuni's decent from the heaven of thirty-three gods	The Bodhisattva Avalokiteshvara	The Buddha Shakyamuni's taming of the rampaging elephant Nalagiri
The offering of honey by a monkey	The goddess Tara	The Buddha Shakyamuni's *parinirvana*

of the leaves determined the pages' dimensions, which average 2½ by 22½ inches. The book originally had a wooden cover, and its pages were bound together with cords passed through the two holes on each leaf. Once a page was read, the cords allowed it to be lifted, flipped, and stacked face down on top of the previous page.

The Book of the Perfection of Wisdom in Eight Thousand Lines, a philosophical treatise on the nature of wisdom, compassion, and reality, was the most commonly illustrated **sutra** during the late Pala period. Written down as early as the second century BCE, it was an important Mahayana Buddhist text that then became central to Vajrayana Buddhism as well. The text states that the book itself should be worshiped like a relic of the Buddha because the words in it provide a direct connection to the historical Buddha. Rather than illustrating the *sutra,* the purpose of the small, exquisitely produced paintings

on the pages is to augment its sacredness. On four of the leaves of the eleventh-century Nalanda manuscript, there are three illustrations each: the central ones depict goddesses or *bodhisattvas,* while those on the sides are scenes from the life of the Buddha Shakyamuni (**Fig. 5.17**). By this time, the Buddha's biography had been distilled into eight standardized scenes, which are shown here in order from top to bottom: his miraculous birth from his mother's side; his victory over Mara (the demon who personifies the obstacles to enlightenment); his first sermon; a miracle in which he multiplied himself; his descent from the heaven of thirty-three gods; his taming of a rampaging elephant; a monkey offering him honey; and his *parinirvana.*

The deity in the center of the first leaf is, appropriately enough, the goddess of perfect wisdom, Prajnaparamita herself (**Fig. 5.17a**). Stylistically, the painting's fluid lines and graceful forms mirror sculptures of the Pala period. The colors, poses, and iconography of the figures follow prescribed standards. Adorned with a crown and halo, Prajnaparamita sits at center with her hands in the *mudra* of teaching. Near her shoulders are two white lotuses. Each bloom holds a small white palm-leaf manuscript, underscoring her connection to the *sutra.* She is flanked by lesser divinities; the two green figures are goddesses who protect against snake bites, as indicated by the snake at the very right of the scene.

Inscriptions written in Sanskrit and Tibetan on the unillustrated leaf (bottom of **Fig. 5.17**) tell us about the manuscript's production and subsequent circulation. It was made at Nalanda monastery around 1073 and most likely repaired in 1151. Later, in the thirteenth century, a Kashmiri monk who travelled to Tibet came into possession of it. Then a century later, it became the property of the monk Buton (1290–1364), who compiled the first Tibetan canon of Buddhism. Each subsequent owner added to the book's sacred status.

sutra in Buddhism, a scripture containing the teachings of the Buddha; more generally, a collection of teachings in Sanskrit, relating to some aspect of the conduct of life.

The Perfection of Wisdom in Eight Thousand Lines sutra is also the primary religious text (copied many times over on palm-leaf and other types of manuscripts) of Nepal's Newar Buddhist community, who played a crucial role in Vajrayana Buddhism's development and propagation. The Newar are the indigenous inhabitants of the Kathmandu Valley, the historical center of Nepal and still the most populous part of the country (until the eighteenth century, references to Nepal meant just the Kathmandu Valley; the modern borders of Nepal were established during the Shah Dynasty, 1769–2008). The region contains many artistically important and religiously sacred sites, patronized by both local Newaris and foreign Buddhist practitioners. Nepal's location as the birthplace of the historical Buddha confers on it, for many Buddhists, a special status. Moreover, because of its location and geographic features (see **Map 5.1**), monks and scholars used the Kathmandu Valley as a waystation on their journeys from northern India to Tibet. While they waited for safe passage, they received Tantric initiations and teachings from Vajra masters there. They also often made gifts to the religious sites where those initiations happened.

Located on a hill overlooking the city of Kathmandu, the Swayambhu complex (**Fig. 5.18**) is the largest and most important of such sacred sites. In fact, Swayambhu is considered the original source for Buddhism in the Kathmandu Valley, and all Newar Buddhist monasteries in the valley are satellites of it. The site of Swayambhu is associated with Manjushri, the *bodhisattva* of Transcendental Wisdom, who is worshiped throughout Nepal because

of his connection to the founding of Kathmandu Valley. According to tradition, Manjushri traveled from China to the valley to visit a shrine comprised of a sacred flame emanating from a lotus. The lotus floated on a lake surrounded by mountains, making it difficult to access. For this reason, Manjushri used his magical sword to cut a gorge in the mountains, which drained the lake and created the Kathmandu Valley. The lotus shrine was then transformed into a hill, and the flame became the Swayambhu *stupa*. The name Swayambhu means "self-created," in reference to this origin story.

Historical accounts state that the Swayambhu *stupa* was built at the beginning of the fifth century CE by a local king named Vrasadeva, and added to during the Licchavi dynasty (*c.* 300–*c.* 879 CE). In the many centuries since then, the site has been further expanded and repaired multiple times. The *stupa* (called a *chaitya* in Nepali) adheres to the typical hemispherical shape of *stupas* (see, for example, Fig. 3.3). Four golden, doorway-like projections mark the four cardinal directions; these projections are not actual doorways, but rather small shrines, each associated with a different celestial buddha. The *stupa* is capped by a large golden **spire**, the square base of which is topped by thirteen rings said to signify the thirteen stages of spiritual development in Vajrayana Buddhism. The tip of a 72-foot-long (22 meters-long) wooden pole marking the *stupa*'s central axis is visible at the apex of the spire (the pole runs from the *stupa*'s base to the spire's top). As is common in Nepal, each side of the spire's base is adorned with what looks like a face. The eyes represent the all-seeing gaze of the

spire a tall, slender pointed structure on the top of a building.

5.18 Swayambhu *stupa*, Kathmandu Valley, Nepal, founded in the fifth century CE, renovated and restored thereafter.

Buddha and the wisdom and compassion accompanying it. In between the eyes, what appears to be a nose is the number one written in Devanagari script (the script used for Sanskrit and Nepali, among other languages). It represents the unity of all things—a key aspect of Vajrayana Buddhism.

In addition to the *stupa*, the Swayambhu complex contains a variety of smaller shrines, as well as numerous other structures, and continues to be expanded and venerated by the local Newar community, both Buddhist and Hindu, to the present day. Indeed, it is important to note that Hinduism also has a long history in Nepal, and in fact is today the dominant religion in the region (for an example of Hindu art from Nepal, see Fig. 0.3). Buddhist sites like Swayambu also were (and are) meaningful to local Hindus for two reasons. First, the divide between Vajrayana Buddhism and Hinduism as practiced in Nepal is porous—the two share many rituals, beliefs, and even deities. Second, sites like Swayambhu are meaningful to

5.19 **Portrait of the Indian monk Atisha,** Tibet, early–mid twelfth century CE. Distemper on cloth, 19½ × 14 in. (49.5 × 35.4 cm). Metropolitan Museum of Art, New York.

Newaris' regional identity, regardless of their religious affiliation. Yet, as noted, Swayambhu is also a key site to Vajrayana Buddhists from beyond the Kathmandu Valley, adding to its sacred status. In particular, Tibetan monks and teachers funded many of the additions made over the centuries to the complex.

The links between Tibet and Nepal were particularly strong during the Licchavi dynasty. In the seventh century, the Tibetan king Songtsen Gampo married a Licchavi princess, Bhrikuti. She brought Newari artists and artworks with her to Tibet that influenced artistic styles there. These close connections also helped spread Buddhism. However, although Buddhism was introduced to Tibet during the seventh century, it was not widely practiced in the region until the eleventh century, after what is often called the "second diffusion," when Tibetan monks traveled to study at monasteries like Nalanda in the Pala kingdom and Indian monks were invited to Tibet—with Nepal as a stop along the way. As the *Book of the Perfection of Wisdom in Eight Thousand Lines* manuscript (**Fig. 15.17**) from the Pala dynasty demonstrates, artworks moved alongside these exchanges. As a result, Pala artistic traditions were a major source for both Nepalese and Tibetan art from the eighth through the fifteenth centuries.

At the same time, Nepalese and **Tibetan Buddhist** art of the period differed from that of other regions because Vajrayana Buddhism was highly localized, taking different forms in different locations. For example, in Tibet, spiritual teachers (called *lamas* in Tibetan) occupy even greater importance than they do elsewhere, and their lineage (from master to disciple) is carefully traced. Some *lamas* are considered reincarnations of their predecessors and some even of *bodhisattvas*. Thus, as Tibetan art developed, portraits of eminent spiritual teachers from previous centuries became increasingly significant. This twelfth-century Tibetan painting of the Indian monk-scholar Atisha (**Fig. 5.19**) demonstrates both the importance of such portraits in Tibet and the close connection between Tibet, Nepal, and northeastern India during the period.

Atisha (982–1054) was the abbot (head monk) of a monastery in north India; in this portrait, his elevated status is indicated by his yellow hat. He is revered in Buddhist traditions for his impressive lineage, said to trace all the way back to Shakyamuni, as well as for his understanding of the Perfection of Wisdom *sutras*, like the *Ashtasahashrika Prajnaparamita*, and for the crucial role he played in the second diffusion of Buddhism in Tibet. Around 1042 Atisha left India, traveling to the Kathmandu Valley, where he remained for two years before heading on to western Tibet. While in Kathmandu, Atisha founded a monastery, Tham Bahi, that is still active today. During his time in Kathmandu, he also received several tantric initiations (most likely at Swayambhu) and teachings regarding the Perfection of Wisdom *sutras*, which he then went on to develop further and disseminate in Tibet.

This painting is one of the oldest portraits of Atisha (made about a century after his death). It is also amongst the oldest surviving Tibetan **thangkas**. A *thangka* is the Tibetan term for a painting on either cotton or silk

cloth that can be rolled up like a scroll (the same type of hanging scroll painting is called a *paubha* in Nepal). It typically has a wooden dowel for hanging on a wall, and often has a cloth flap to cover the image when not being actively worshiped. Like most *thangkas* and *paubhas*, the composition consists of a large central figure flanked by smaller ones. The painting is not symmetrical, but it does have a strong central axis and overall sense of stability due to the dominance of triangular and circular forms in the image. Note, for example, the large triangle formed by Atisha's head and body. The monk is shown as an enlightened being: he has a halo, sits on a throne, and holds a palm-leaf manuscript in his left hand. Buddhist hanging-scroll paintings often have inscriptions on the back that add to their sacredness and sometimes provide information about their production

and use. In this case, the inscriptions allow us to date the painting to the twelfth century and indicate that it was used in a monk's residence, where it functioned as a "house-god," underscoring the spiritual importance of such portraits.

Thus, through its subject, visual properties, and symbolic importance, the Tibetan *thangka* portrait of the Indian monk Atisha demonstrates both the transcultural connections and regional variations that mark the development of Vajrayana Buddhist art. Likewise, rock-cut sites such as Bamiyan and sculptures such as the Cambodian Harihara image speak simultaneously to the spread of Buddhist and Hindu art between the sixth and twelfth centuries and the immense diversity of forms, styles, and social and political significance that the art took from location to location.

Tibetan Buddhism centered in Tibetan regions, a branch of Esoteric (also Vajrayana or Tantric) Buddhism, which features secret teachings, requiring the assistance of an advanced instructor to access and understand, as well as the institution of reincarnated spiritual teachers, or *lamas*.

thangka a Tibetan term for a painting on either cotton or silk cloth that can be rolled up like a scroll (in Nepali the same type of painting is called *paubha*); typical subjects include mandalas, portraits of revered teachers, and religious icons.

Discussion Questions

1. How does art and architecture help to disseminate religion?
2. Buddhist art from four distinct geographic areas is discussed in this chapter. Choose two works from different regions and compare them in terms of style, medium, use, and the Buddhist beliefs that they represent.
3. What are some of the questions that the rock-cut art at Mamallapuram raises, and what are some of the theories that have been put forward to explain them?
4. Research question: in addition to the sites discussed in this chapter, another important location of cave architecture in South Asia is Ellora in the state of Maharashtra. Ellora, a UNESCO World Heritage site, contains Buddhist, Hindu, and Jain rock-cut structures carved between the sixth and tenth centuries CE. Research Ellora's cave architecture and compare it to that of Elephanta or Ajanta.

Further Reading

- Byron, Robert. *The Road to Oxiana*. New York: Macmillan & Co., Ltd., 1937.
- Guy, John, ed. *Lost Kingdoms: Hindu–Buddhist Sculpture of Early Southeast Asia*. New York: The Metropolitan Museum of Art, 2014.
- Kaimal, Padma. "Playful Ambiguity and Political Authority at the Large Relief at Mamallapuram." In Rebecca M. Brown and Deborah S. Hutton (eds.). *Asian Art* (*Blackwell Anthologies in Art History*). Malden, MA: Blackwell Publishing, 2006, pp. 43–56.
- Kim, Jinah and Lewis, Todd. *Dharma and Punya: Buddhist Ritual Art of Nepal*. Leiden, The Netherlands and Boston, MA: Hotei Publishing, 2019.
- Leidy, Denise Patry. *The Art of Buddhism: An Introduction to Its History and Meaning*. Boston, MA and London: Shambhala, 2008.

Chronology

377 BCE–1017 CE	The Anuradhapura kingdom rules Sri Lanka	**7th century**	Widespread Buddhist and Hindu art production begins in Southeast Asia; *Dharmachakra* (Buddhist Wheel of Law) sculptures are made by the Dvaravati culture in central Thailand; the Ganesha statue is made by the Champa culture, central Vietnam
c. **300–600 CE**	Buddhism and Hinduism spread throughout Southeast Asia		
c. **300–879**	The Licchavi dynasty rules the Kathmandu Valley, Nepal	**7th century**	Buddhism is introduced to Tibet
early 4th–late 9th centuries	The Pallava dynasty rules in south India	**early 7th century**	The second of two colossal, rock-cut buddha sculptures is carved and painted at Bamiyan
c. **460–500**	Buddhist caves are carved and painted at Ajanta under the patronage of the Vakataka dynasty	**late 7th–early 8th centuries**	Rock-cut monuments are constructed at Mamallapuram
5th century	The Swayambhu *stupa* is established in the Kathmandu Valley, Nepal	**8th–12th centuries**	The Pala dynasty rules in eastern India
c. **550–75**	The rule of Krishnaraja I, who commissions the Shiva cave temple on Elephanta Island, Mumbai	*c.* **1042**	The Indian Buddhist teacher Atisha (982–1054) visits Tibet and revitalizes Buddhist practices there
c. **575–728**	The main period of Pallava dynasty rule in south India	**1056–1235**	The Polonnaruva period in Sri Lanka

Art of the Silk Road

The name "Silk Road" may conjure up images of silk and spice merchants in camel caravans, selling in the bazaars of bustling cities from East Asia to the Mediterranean. In fact, the Silk Road was not a single road, nor was it solely focused on the trade of one commodity. Rather, it was a network of land and sea routes that distributed locally manufactured goods into dispersed but interconnected marketplaces (**Map 1**). The Silk Road also connected people, ideas, languages, religion, technology, and art, often leading to cultural enrichment alongside economic prosperity. Although the Han dynasty in China formalized the use of the Silk Road for trade with entities to its west around 130 BCE, exchange across Asia, Europe, and North Africa can be traced to prehistoric times and was certainly well established by the fourth century BCE.

Artworks provide tangible evidence of the nature and depth of Silk Road contacts and

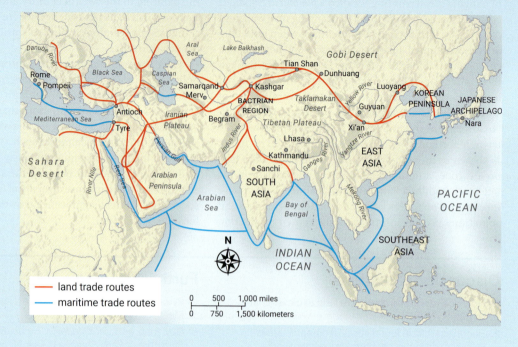

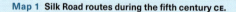

Map 1 Silk Road routes during the fifth century CE.

exchanges throughout its long history. In the sealed palace rooms at Begram, located in present-day Afghanistan near the confluence of Silk Road trade routes, a hoard of eclectic objects demonstrates how the Silk Road connected distant regions. Ranging in date from the first to the third century CE, the Begram palace objects include Roman glass and bronzes, lacquer from China, and South Asian-style ivory and bone sculptures. Most of the ivories take the form of decorative plaques

1 FAR LEFT Plaque with women standing under gateways, from the Palace at Begram, Room 13, Afghanistan, first century CE. Ivory, 6⅜ × 5¼ in. (16 × 13.3 cm). Musée national des arts asiatiques Guimet, Paris. **SOUTH ASIA**

2 LEFT Statuette excavated in Pompeii, Italy, first century CE. Ivory, height 9½ in. (24 cm). Museo Nazionale, Naples, Italy. **SOUTH ASIA**

on wooden furniture. In this example (**Fig. 1**), the woman on the right, standing beneath a gateway, brings to mind the *torana* (gateway) and female figural sculptures at the Great Stupa at Sanchi in central India (see Fig. 3.4). This voluptuous woman is bedecked in jewelry and holds onto a fruit tree, linking earth's bounty with her fertility. Lively debate surrounds the origins of the Begram ivories. Stylistic comparison to sculptures such as those found at Sanchi suggest that they may have been carved in central or north India. However, the discovery of three unworked pieces of ivory at Begram implies the presence of an ivory workshop there—one that may have employed itinerant artists trained in other regional traditions.

Another intriguing example is the Indian-style ivory statuette (**Fig. 2**) discovered around 3,500 miles (around 5,600 km) from Begram in the ruins of a house in Pompeii, which was destroyed in 79 CE. Notice the similarities in stance and dress to the Begram figures. The presence of similarly styled objects in ancient sites as far apart as Afghanistan and the Italian peninsula suggests a remarkable degree of international connection at this time.

The eclectic shape and ornament of this jug, or ewer (**Fig. 3**) attests to the cosmopolitan tastes in Chinese regions throughout the centuries between the Han (206 BCE–220 CE) and Tang (618–906 CE) dynasties. Its overall shape recalls models produced in the Sasanian Empire (224–651 CE) centered in present-day Iran (West Asia), while the figures are inspired by Greek myth, possibly episodes from the Trojan War, or, more generally, the image of a woman seeing her beloved off to war. Such details as the man's head atop the handle, and the camels' heads at either end of it, may indicate Sogdian influence. Sogdian merchants (from regions in West and Central Asia) played a pivotal role in Silk Road trade, and the Sogdian city of Samarqand, in present-day Uzbekistan, was an important trade hub. The combination of Greco-Roman imagery with the resemblance of the female body's shape to South Asian precedents suggests the work of Bactrian artists from Central Asia who learned silversmithing from the West Asian Sasanians, and who were familiar with Greco-Roman mythology, South Asian styles, and Sogdian decoration. Excavated from the tomb of a military general and government official in China, this ewer is evidence of a cosmopolitan taste that was both stimulated and satisfied by Silk Road trade.

Cultural encounters made possible by the Silk Road continued for centuries. By the eighth century CE, Silk Road trade brought goods as far east as Japan. This *biwa* lute (**Fig. 4**) was

3 Ewer from the tomb (dated 569 CE) of Li Xian and his wife, fifth–sixth century. Gilt silver, height 14¾ in. (37.5 cm). Guyuan Museum, Ningxia Autonomous Region, China. **EAST ASIA**

possibly made in China, but it was influenced by musical instruments from West Asia, and it was owned by the Japanese Empress Kōmyō (701–760 CE). The image painted on the plectrum guard reflects West Asian and Central Asian influences. Four entertainers perform atop a decorated white elephant—an animal found on the Asian continent but not in Japan. The bearded drummer and dancing singer both wear hats identifying them as Sogdian. Two flutists, a boy and a girl, provide melodies as the quartet journey through a mountainous landscape.

The diversity of art objects found along the Silk Road, and their often culturally eclectic nature and discovery together with disparate items, sometimes from three continents, speaks to the long history of the global economy in which we participate today and the cultural richness that it fosters.

4 *Biwa* lute, eighth century. Maple wood and bamboo with mother-of-pearl inlay and painted leather guard, length 38¼ in. (97 cm). Shōsōin, Imperial Household Agency, Nara, Japan. LEFT overview of lute; RIGHT detail of painted plectrum guard rotated 90 degrees clockwise. **EAST ASIA**

Discussion Questions

1. What can artworks tell us about the extent of cultural and economic contact along the Silk Road?
2. What might have been the value of objects or artworks from distant lands to those who acquired them?
3. How do the contact and exchange of today's global societies compare to that of the time of the Silk Road?

Further Reading

- Hiebert, Fredrik and Cambron, Pierre (eds.). *Afghanistan: Hidden Treasures from the National Museum, Kabul.* Washington, D.C.: National Geographic Society, 2008.
- Millward, James A. *The Silk Road: A Very Short Introduction.* Oxford, U.K: Oxford University Press, 2013.
- Ten Grotenhuis, Elizabeth. *Along the Silk Road.* Washington, D.C.: Smithsonian Institution, 2002.
- Tucker, Jonathan. *The Silk Road: Art and History.* Chicago, IL: Art Media Resources, 2003.

6

The Dissemination of Buddhism and East Asian Art

600–1200

6.0 Detail of the *Womb World Mandala*, Tōji, Kyoto, Japan.

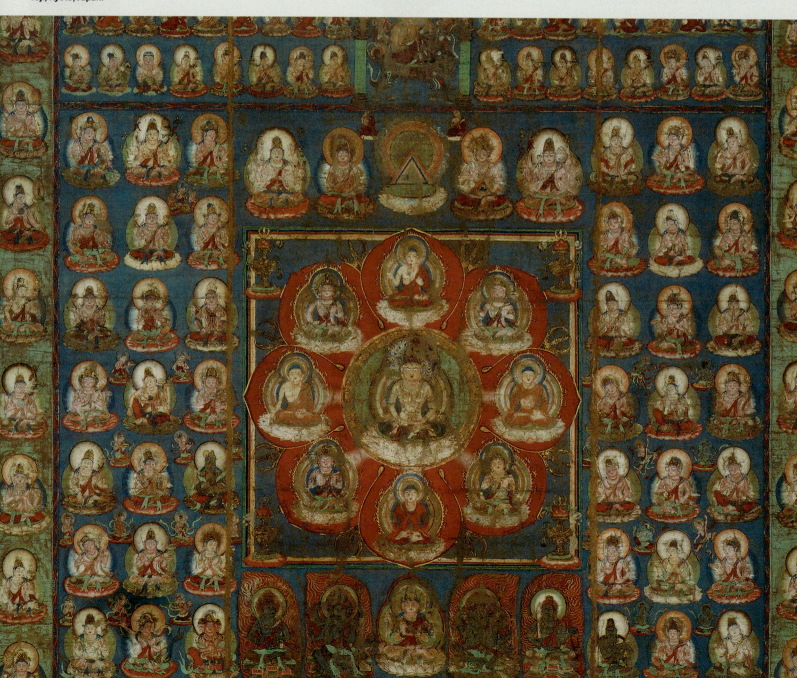

Introduction

During the medieval era, Buddhism spread from South Asia to East Asia (Map 6.1), where it encountered indigenous religions and philosophies (see Chapter 5 and Map 5.1). Rulers and powerful clans did not always welcome this foreign religion, and their policies sometimes forced monks and nuns to return to lay life when governments closed temples, seized valuables, and put previously tax-exempt temple properties to revenue-generating uses. At other times, courts and commoners alike embraced Buddhism, and their donations—extravagant or modest—provided funding to create Buddhist architecture, sculpture, and painting.

Buddhism arrived on the Korean peninsula in the fourth century CE during a time of political division called the Three Kingdoms period (c. 200–668 CE). Shamanism and local religious practices persisted, but Buddhism gained favor at the courts of the kingdoms of Goguryeo in 372, Baekje in 384, and Silla around 528. These rulers saw in this new, foreign religion a mixture of art, architecture, and religious practices that bound Buddhist faith with power and prestige.

Religious transmission continued eastward across the sea after a diplomatic mission from Baekje approached the court of Japan's most powerful clan, Yamato, in the mid-sixth century. Hoping to form an alliance, the mission brought a Buddhist icon and Buddhist texts, or *sutras*, which were believed to be potent protectors of the state. In the ensuing Asuka (538–710) and Nara (710–94) periods, the Yamato clan established its supremacy, and during that time imperial and aristocratic Japanese families commissioned Buddhist temples, shrines, icons, and paintings.

During the Period of Division (220–581; see Chapter 4) in northern Chinese regions, various rulers promoted Buddhism, and during the Tang dynasty (618–906) this foreign faith grew even more prominent and popular. At that time, vigorous trade across the transcontinental Silk Road fed a cosmopolitan culture in the Tang capital, Chang'an. Diplomatic missions from throughout Asia came to Chang'an and subsequently disseminated images, ideas, and technologies to their home regions.

Across East Asia, the medieval period was one of cultural transmission, encounter, negotiation, and adaptation. From the regions of China to Korea to Japan, artworks reflected not only imperial and elite patronage but also shifting religious beliefs and practices, as rulers demonstrated political authority and supported Buddhism by building temples and pagodas and sponsoring other types of Buddhist art.

Early Buddhist Art in Korea and Japan

Beliefs and practices associated with Mahayana Buddhism reached the Korean peninsula and Japanese archipelago in the fourth and sixth centuries, respectively. Mahayana is one of the major strands within Buddhism and is itself divided into a number of different schools. In Mahayana Buddhism, the goal is the liberation of all beings, and *bodhisattvas* who vow to aid all beings toward that goal become the focus of prayers (see Fig. 6.1, p. 120). (For Buddhism and early Buddhist

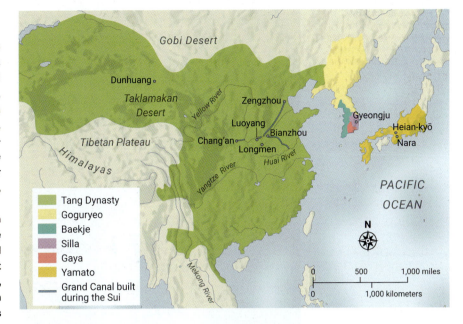

Map 6.1 East Asia, c. 625.

art, see Chapter 3.) Even as older indigenous beliefs persisted in the region, Buddhism gained followers. In the sixth and seventh centuries, Buddhists in East Asia believed that Buddhism had protective and beneficent powers. These beliefs fused with artistic sensibilities and well-developed technologies of bronze manufacture as artists created Buddhist **icons**. New architectural forms provided places for Buddhist worship, and Buddhist stories found expression in painting. As rulers and ministers of state embraced the religion, the visible manifestations of Buddhist belief—icons, temples, and painting—advanced state interests.

On the Korean peninsula, the kingdoms of Goguryeo, Baekje, and Silla are the basis for naming the Three Kingdoms period (c. 200–668 CE). A fourth political entity, the Gaya Confederacy of city-states, was absorbed in 532 by neighboring Silla, which would later conquer the other two kingdoms, ushering the period named for the new political entity, Unified Silla (668–935). The political history of these kingdoms is connected to other societies, too; for example, Goguryeo destroyed the Han Chinese administrative district of Lelang in 313, thereby expanding its own territory. The dynamic political situation, especially as the competing kingdoms sought alliances with governments on the East Asian mainland and the Japanese archipelago, propelled cultural contact. Cultural dissemination across Eurasia is evident in the dazzling gold crowns of the Silla kingdom (see Seeing Connections: Gold Crowns across Asia, p. 76). Traces of political history and cultural contact are also seen in Buddhist ritual implements (see Fig. 4.10) and icons of this period.

This gilt bronze icon of a *bodhisattva* dates to the Three Kingdoms period and is probably from the Silla kingdom (Fig. 6.1). The figure sits with the right leg crossed over the left thigh. His left foot rests on a lotus, a plant that produces an unblemished flower despite its habitat of muddy waters, and therefore provides an apt metaphor for the **Buddha**, who became enlightened in an imperfect world. The *bodhisattva*'s left hand grasps his lower leg, and the fingers of his right gently touch his cheek.

bodhisattva in early Buddhism and Theravada Buddhism, a being with the potential to become a buddha; in Mahayana Buddhism, an enlightened being who vows to remain in this world in order to aid all sentient beings toward enlightenment.

icon an image of a religious subject used for contemplation and veneration.

buddha; Buddha, the a buddha is a being who has achieved the state of perfect enlightenment called Buddhahood; the Buddha is, literally, the "Enlightened One"; generally refers to the historical Buddha, Siddhartha Gautama, also called Shakyamuni and Shakyasimha.

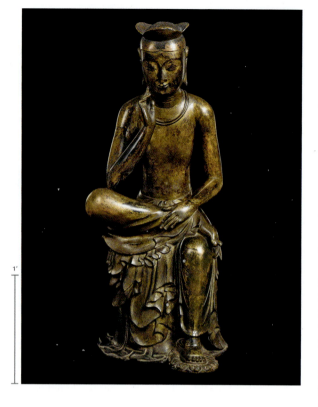

6.1 *Pensive Bodhisattva,* **probably Maitreya** (Korean Mireuk), Three Kingdoms period, early seventh century. Gilt bronze, height 36⅞ in. (93.5 cm). National Museum of Korea, Seoul.

iconography images or symbols used to convey specific meanings in an artwork.

sutra in Buddhism, a scripture containing the teachings of the Buddha; more generally, a collection of teachings in Sanskrit, relating to some aspect of the conduct of life.

cloister a covered walkway, lined with a colonnade, walled on the outside and open to a courtyard; usually found in religious buildings.

pagoda in East Asia, the *stupa* form: a tall structure that houses Buddhist reliquaries.

kondō literally, "golden hall"; the main hall of a Japanese Buddhist temple.

post-and-lintel a form of construction in which two upright posts support a horizontal beam (lintel).

cantilever a horizontal beam, slab, or other projecting structural member that is anchored at only one end.

brackets wooden supports that channel the weight of the roof to the supporting lintels and posts.

With downcast eyes and slight smile, he seems immersed in thought. The triple-lobed lotus crown points to the sculpture's origin, and the expensive gilt bronze and exceptional artistry suggest royal patronage. The Silla kingdom origin of this bronze icon is further suggested by a sculpture carved of red pine and nearly identical in form to **Fig. 6.1**, which is now in the collection of Kōryūji Temple in Kyoto, Japan. A ninth-century list in the temple's records indicates a gift of two *bodhisattva* sculptures from the Silla kingdom in the seventh century.

The statue's posture traces back to images of the historical Buddha, Prince Siddhartha, contemplating life's sorrows and misery. Its creation in Korea during the Three Kingdoms period, a high point in the devotion to the *bodhisattva* Maitreya, suggests that the icon depicts Maitreya, or Mireuk, as he is known in Korean. Maitreya will be the Buddha of the future epoch (just as Siddhartha became the Buddha of the present epoch), and the posture in this sculpture conveys a state of contemplative anticipation.

Aspects of the sculpture, including the medium, **iconography**, and treatment of the body, face, and drapery, are reminiscent of earlier Buddhist icons. (For a review of iconography in Buddhist art, see Fig. 3.11.) For example, a seated Buddha made in the fourth century (see Fig. 4.17) is also made of gilt bronze, and both figures have elongated earlobes and idealized faces with downcast eyes and slight smiles. However, unlike the earlier seated Buddha, the *Pensive Bodhisattva* has a supple, slender upper body, and the drapery creates elegant patterns at the hem. These refinements attest to developments in the art of bronze sculpture as well as to shifting aesthetic preferences.

By the time the *Pensive Bodhisattva* was cast, Buddhism was practiced not only throughout the Three Kingdoms

of Korea but also among emigrant communities in areas of Japan. Emigrées brought Buddhism to the Japanese archipelago before the sixth century: official histories and temple records from the late seventh and early eighth centuries emphasize the role played by a diplomatic mission from the Baekje kingdom in 538 (or 552) CE, which brought Buddhism to the attention of the Yamato court, centered in the Asuka region of Japan. There, Buddhism encountered an indigenous religion, Shintō (literally "the way of the *kami*, or spirits"). Comprising diverse beliefs, ranging from myths that explained the origins of the world to the worship of *kami*, or spirits of natural forces, landscape elements, and revered ancestors, Shintō prescribed ritual practices to ensure victory in war, a successful harvest, and the general well-being of individuals and communities. One major Shintō ritual is the periodic rebuilding of the Inner Shrine at Ise, the sanctuary of Amaterasu, who, according to Shintō belief, is the Sun Goddess and divine progenitor of the imperial family. Initial construction of the Inner Shrine is thought to date to the first century CE; the first rebuilding occurred in 690 CE (see Seeing Connections: Art and Ritual, p. 159).

The diplomatic gifts from Baekje to Yamato, which included one or more Buddhist icons and ***sutras***, according to historical records, led to a mixed reception at court. When the emperor raised the question of whether to adopt this new religion, some aristocratic clans—notably the Korean-emigrée Soga clan—expressed support, while others voiced opposition. The *kami* were said to be displeased, and the court split into factions. Buddhism began to take root only after the Soga clan—who embraced Buddhism unequivocally—vanquished their rivals at court. With familial ties to the Korean peninsula and spouses from the imperial family, the Soga bridged cultures. They built a great temple, Asukadera, in 588; they supported monks, nuns, and artisans; and Buddhism grew in prominence during the Asuka period (538–710), so named for the location of the Yamato court.

Ultimately, the Soga patronage of Buddhism set an example. Among the first of the Yamato court to follow that example were Empress Suiko (554–628) and her nephew and heir apparent, Prince Umayado, who is better known as Prince Shōtoku (574–622). The latter was the patron of Hōryūji, founded in 607. *Ji* means "temple," and Hōryūji may be translated as the "Temple of the Flourishing Law," with "law" referring to Buddhist teachings. Unfortunately, much of the original temple building (**Fig. 6.2a**, right) was destroyed by fire in 670, but it was rebuilt by about 711, and remains one of the oldest surviving temples in Japan. Indeed, Hōryūji is the site of some of the oldest wooden structures in the world, and it preserves the kind of materials, structures, and forms of architecture that did not survive on the Korean peninsula or the East Asian mainland.

In the aerial photograph of Hōryūji (**Fig. 6.2**), the architectural plan is clearly seen (**Fig. 6.2a**, left). Pierced by a central gate at the south and a lecture hall at the north, the **cloister** creates an enclosed space, carving a sacred precinct out of the secular world, an architectural strategy shared by Greco-Roman and Abrahamic religions. Within the cloister, balance prevails over symmetry.

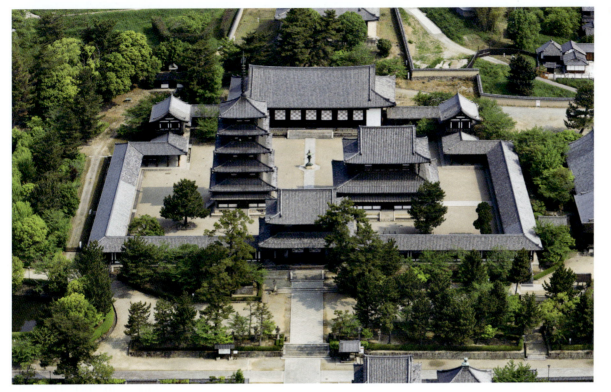

Hōryūji, Nara prefecture, Japan, Asuka period, seventh century.

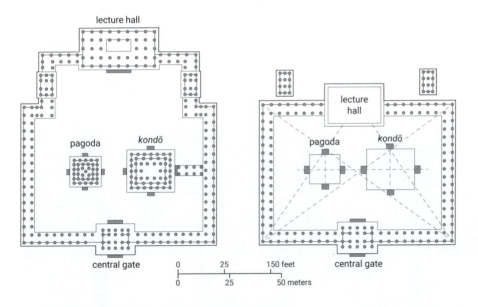

lecture hall

pagoda *kondō*

central gate

0 25 150 feet

0 25 50 meters

lecture hall

pagoda *kondō*

central gate

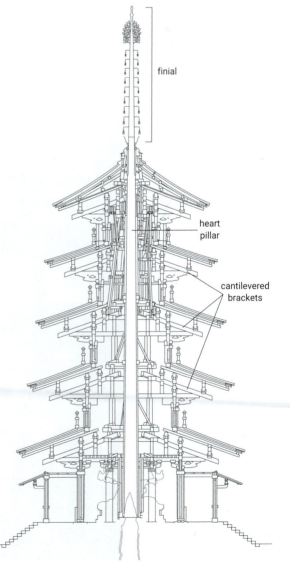

finial

heart pillar

cantilevered brackets

There, a five-story **pagoda** is matched by the shorter, but broader *kondō*, or sanctuary hall. The pagoda and *kondō* are both made of wood, using a **post-and-lintel** system with **cantilevered brackets** to support tiled roofs that extend far beyond the timber frame.

The pagoda's height draws the viewer's attention. Its elegant profile, created by the diminishing size of each story and the buoyant rooflines, directs the viewer's gaze skyward (**Fig. 6.2b**). Several aspects of construction make the pagoda a marvel of structural engineering, giving it the flexibility and strength to withstand earthquakes. First, the post-and-lintel system does not use nails, reducing rigidity. Second, the central timber, or heart pillar, bears most of the pagoda's weight. Third, the primary material—wood—has a natural pliability compared to stone or brick.

6.2a ABOVE **Plan of Hōryūji.** Original plan, early seventh century (right) and plan of the reconstruction, *c.* 711 (left).

6.2b RIGHT **Hōryūji pagoda (cross-sectional drawing).**

Early Buddhist Art in Korea and Japan **121**

Although the pagoda does not resemble its South Asian prototype in shape or material, it is essentially a *stupa* (see Fig. 3.3). The bronze **finial** connects to the single timber at the heart of the structure, marking the central location of **relics** hidden in a crypt beneath the structure. Bodily remains within a *stupa* are not meant to be seen, and similarly a pagoda is not designed to display relics. Instead, both structures are designed primarily for *pradakshina*.

In addition, Hōryūji's pagoda features four sculpted **tableaux** of Buddhist narratives viewable from each of the four doorways (not pictured). One tableau depicts the debate between Manjushri, the *bodhisattva* of wisdom, and the layman Vimakalakirti. Another depicts the *parinirvana*. The pagoda functions simultaneously as a reliquary site for *pradakshina*, a source for disseminating important Buddhist stories, and (from afar) a visual signpost to guide Buddhist visitors to Hōryūji.

Occupying the central position among numerous sculptures within the *kondō* at Hōryūji is an icon of the historical Buddha Shakyamuni with attendants, known as the *Shaka Triad* (**Fig. 6.3**). The historical Buddha, known in Japanese as Shaka, sits in meditative posture on a raised dais over which the drapery of his shawl cascades. He smiles gently, raising his right hand in a *mudra* signaling viewers not to fear, and lowering his left hand in a variation of the *mudra* of beneficence. An elaborate **halo** radiates around Shaka's head, and a flaming **mandorla** featuring seven, small seated buddhas nearly encompasses two smaller attendants standing at his sides. With haloes of their own and wearing crowns

and sashes, these figures appear to be *bodhisattvas*. The sculptors' delight in line and pattern, readily apparent in the flowing drapery and swaying sashes, is fully realized in the exuberant haloes and crowns, which feature dazzling patterns of swirling flames, scrolling vines, beaded pearls, and lotus petals.

The *Shaka Triad* bears some stylistic resemblance to the Silla *Pensive Bodhisattva* (see **Fig. 6.1**), which was made at approximately the same time or slightly earlier. Shawls and sashes drape elegantly over lithe bodies; haloes frame elongated faces. Like shared iconography, stylistic resemblance among sculptures reveals paths of cultural transmission. In the case of the *Shaka Triad*, genealogy and migration may be factors, too. The *Shaka Triad* is attributed to Tori Busshi (meaning "Tori the maker of Buddhist icons"), whose grandfather emigrated from the East Asian mainland. More generally, seventh-century Buddhist artworks from areas of both the Korean peninsula and the Japanese archipelago are stylistically related to Northern Wei prototypes (see "Period of Division in China: Buddhist Art in the North, 220–581 CE," Chapter 4, p. 92).

The sumptuous medium of the *Shaka Triad*, gilt bronze, points not only to metallurgical skill but also to royal patronage. An inscription on the back of the mandorla suggests that members of the Kashiwade family, close relatives by marriage to Prince Shōtoku, were the primary patrons. They commissioned this icon in 621. During that year Prince Shōtoku fell ill not long after his wife, the Princess of Kashiwade, died. The *Shaka Triad* expressed the family's hope for his recovery or his rebirth

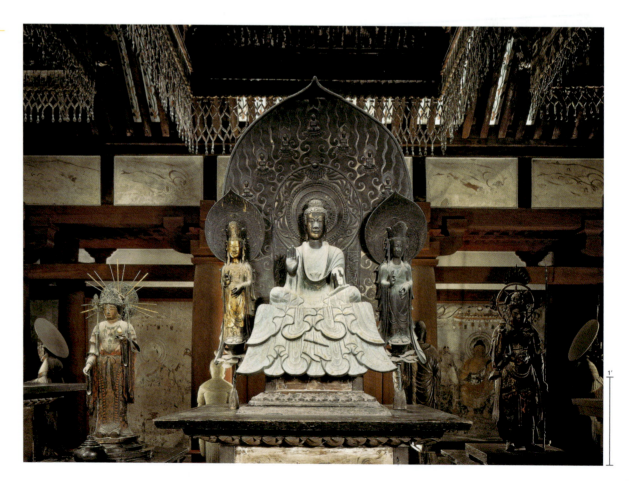

6.3 Tori Busshi, *Shaka (Shakyamuni) Triad*, Hōryūji, Nara prefecture, Japan, Asuka period, dated to 623. Gilt bronze, height 46 in. (1.17 m).

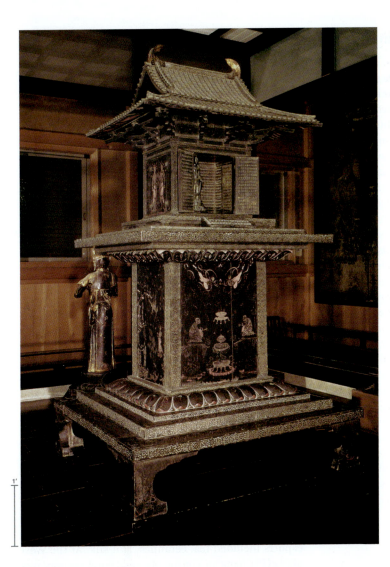

in a Buddhist pure land. The inscription also records the Prince's death in 623, and it attributes the icon to Tori. As the radiant icon captured viewers' attention and turned their thoughts toward Buddhist teachings, those involved in its making and to whom it was dedicated accrued religious merit, or karma, the sum of a person's actions that determines his or her future existences. At the same time, the sculpture demonstrated political allegiance by sealing the bond between the Kashiwade clan and Prince Shōtoku.

The *Shaka Triad* at Hōryūji's *kondō* demonstrates the relationship between icons and architecture: icons serve as the focus of rituals, while architecture provides sacred spaces to house the former and facilitate the latter. We see this relationship in miniature form in the Tamamushi Shrine, a semi-portable **votive** shrine that resembles the *kondō* at Hōryūji (**Fig. 6.4**). *Tamamushi* is the Japanese term for a jewel beetle with iridescent wings, and the shrine is named after the beetle because its wings—now decayed—provided the color behind the shrine's **filigree** metalwork frames.

The Tamamushi Shrine features an icon housed inside a sanctuary hall elevated by an elaborate pedestal. The four sides of the pedestal are decorated with **lacquer** paintings of *bodhisattvas*, the Four Heavenly Kings, and *jatakas* on wood panels. One painting illustrates the Mahasattva *jataka*, popularly known as the "Tale of the Hungry Tigress," which tells the story of Siddhartha's past lifetime as Prince Mahasattva (see Fig. 4.20). This painting depicts three distinct moments simultaneously, but the narrative unfolds spatially against a plain black lacquer background (**Fig. 6.5**). At the top of the cliff the slender figure of Prince Mahasattva disrobes; to the (viewer's) right he plunges through the air; and below on the ground the mother tiger and her cubs devour his body.

The *jataka* has distressing and gruesome aspects, and yet the image is not repulsive. Elegant curves substitute for rocky terrain, and a fine tree receives the prince's clothing. Without hesitation or heaviness, his supple body falls as if performing a swan dive. Lotus buds in the air add sweetness and delicacy to his selfless act. A natural screen of bamboo softens the final scene, inspiring in viewers feelings of admiration, not horror. The *jataka* ends with the prince's act of selfless sacrifice, but the vermilion colors and swooping lines of the cliff lead viewers back to the start, imparting a cyclical aspect to this Buddhist lesson. The style of the Tamamushi Shrine's paintings—featuring elongated bodies, elegant postures, and curvilinear forms—also connects to the visual culture of the Period of Division in Chinese regions and to the Three Kingdoms period on the Korean peninsula.

6.4 ABOVE LEFT **Tamamushi Shrine**, Hōryūji, Nara prefecture, Japan, Asuka period, *c.* 650. Cypress and camphor wood, with lacquer, height 7 ft. 7½ in. (2.32 m). Gallery of Temple Treasures, Hōryūji.

6.5 ABOVE RIGHT **Mahasattva** *jataka*, detail of the Tamamushi Shrine, Hōryūji, Nara prefecture, Japan, Asuka period, *c.* 650. Lacquer painting on wood. Gallery of Temple Treasures, Hōryūji.

votive an image or object created as a devotional offering to a deity.

filigree a type of decoration, typically on gold or silver, characterized by ornate tracery.

lacquer a liquid substance derived from the sap of the lacquer tree; used to varnish wood and other materials, producing a shiny, water-resistant coating.

jatakas stories of the Buddha's past lives.

earthenware pottery fired to a temperature below 1,200 degrees Celsius; also called terra-cotta.

naturalism representing people or nature in a detailed and accurate manner; the realistic depiction of objects in a natural setting.

The Tang Dynasty (618–906) and Buddhist Art in China

Although Buddhism was known on the Chinese mainland during the Han dynasty, not until the Period of Division did the faith garner widespread support, which continued in the Tang dynasty (618–906). Buddhism was not the only religion practiced during that time, however. The Tang capital city Chang'an (present-day Xi'an) was home not only to Buddhist and Daoist monasteries, but also to temples of the Manichean, Nestorian Christian, and Mazdean faiths (**Fig. 6.6**). Jews and Muslims (by the mid-seventh century) were present in the Tang Empire, too, but there is no evidence as yet for temples or mosques in Chang'an. In addition, Confucian rituals took place at court as well as at ancestral shrines both inside and outside the city (for more on Confucianism, see Chapter 4).

Such religious tolerance and, more generally, cosmopolitanism arguably contributed to the dynasty's stability and wealth, but the Tang also benefited from the unification of the realm, which occurred earlier, during the short-lived Sui dynasty (581–618). The Sui rulers may not have been as ruthless as the First Emperor of Qin (see Chapter 2), but nevertheless their combination of military campaigns, including those waged unsuccessfully against the Goguryeo kingdom in Korea, and major infrastructure projects, such as the Grand Canal connecting the northern and southern regions of the empire (see **Map 6.1**), exacted a heavy toll. Opposition turned to outright rebellion. The Sui emperor was assassinated, and a new dynasty—the Tang—was founded.

6.6 Plan of the Tang capital, Chang'an, China, Tang dynasty (618–906).

The Tang quickly occupied the former Sui capital, renaming it Chang'an, or "everlasting peace." The optimistic attitude expressed in the city's name is also evident in its very form, set by the Sui, and inherited by the Tang. The north–south axis, the uniform street grid, the east–west symmetry, and the privileged, north-central position of imperial and administrative precincts were all dictated by centuries-old beliefs that proper alignment of human activities to cosmological patterns ensured society's well-being (**Fig. 6.6**). These beliefs led to a system of practices, called geomancy or *fengshui*, that also include siting and orientation in accordance with topography, natural light, meteorological patterns, watersheds, and seasonal changes.

Chang'an was one of the three largest cities in the world during the ninth century. (The other two were Constantinople—now Istanbul—and Baghdad.) The city plan embodies geomantic principles, but it also reveals a concern for controlling residents and visitors. For example, eighteen-foot-high (5.5 m) outer walls not only served to protect the city's approximately one million inhabitants, but also facilitated close monitoring of traffic in and out of the city's gates. Order and surveillance within the city were aided by additional walls and gates for each of its 108 wards.

Chang'an owed its size and wealth in part to trade, and the Tang dynasty extended its control westward to include towns and garrisons along the Silk Road, which connected Chinese regions to Central Asia and points further west, including Constantinople and Baghdad. The trade routes continued further east, too, carrying exotic goods to cities on the Korean peninsula and Japanese archipelago (see Seeing Connections: Art of the Silk Road, p. 116). Tang exports included tea, ceramics, and silk. At the West Market in Chang'an, consumers could purchase imported dates, figs, sugar, cotton, and other foreign goods.

The Tang taste for the exotic found its way into locally made goods such as this **earthenware** sculpture depicting a camel—the primary means of transport across the desert Silk Road—carrying a troupe of five musicians, some of whom are recognizably foreign (**Fig. 6.7**). Two figures could be Han Chinese, but the other three have deep-set eyes, high-bridged noses, and thick beards, indicating their Central Asian heritage. One man holds a pear-shaped-lute, an instrument from Central Asia that Tang dynasty music-lovers called a *pipa* (in Japanese, *biwa*; for an example of this instrument, see Fig. 4, Seeing Connections: The Art of the Silk Road).

The camel's proud bearing and the troupe's dynamic postures testify to the artist's skill in modeling lifelike sculptures. When compared to the accurate, albeit stiff, soldiers of the First Emperor's terra-cotta army (see Fig. 2.0), this artwork suggests the Tang preference for **naturalism** had further developed by 723 CE, when the sculpture was interred as a grave good to accompany the deceased. The use of glazes, which produce a watertight seal, adds color that further enlivens the sculpture.

The work is typical of Tang dynasty ceramics called *sancai*, literally three-color ware, though not all of them include precisely three colors. Rather, the term is used loosely to refer to multicolored glazes. During the Tang

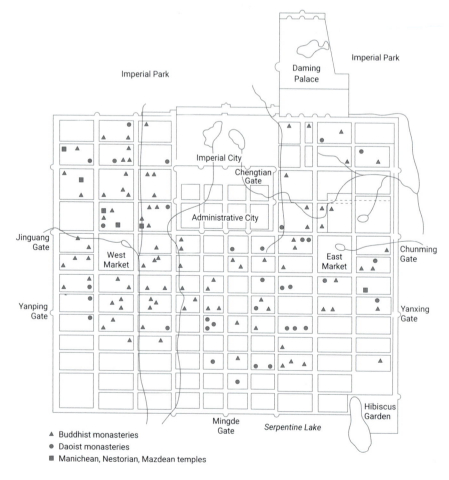

Imperial Park

Imperial Park

Daming Palace

Imperial City

Chengtian Gate

Administrative City

Jinguang Gate

West Market

East Market

Chunming Gate

Yanping Gate

Yanxing Gate

Mingde Gate

Serpentine Lake

Hibiscus Garden

▲ Buddhist monasteries
● Daoist monasteries
■ Manichean, Nestorian, Mazdean temples

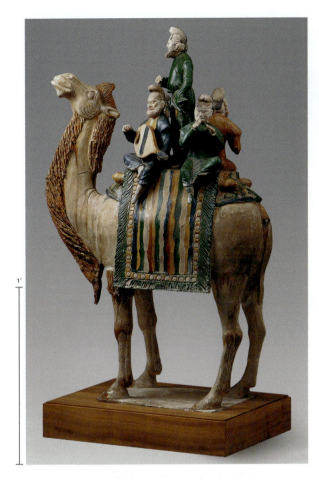

6.7 FAR LEFT **Camel carrying musicians,** excavated in 1957 from the tomb of Xianyu Tinghui, Xi'an, Shaanxi province, China, dated to 723. Earthenware with three-color (*sancai*) glaze, height 26 in. (66 cm). National Museum of China, Beijing.

dynasty, brightly colored earthenware came in an astounding variety of forms, from dishes for household use to fantastic guardian figures to protect the dead. The need to furnish tombs, in particular, resulted in the creation and preservation of many earthenware versions of the animals, servants, officials, athletes, and entertainers of the Tang world. The figure of a polo player, for example, attests to the appreciation for horses (the breed from the Ferghana Valley of present-day Uzbekistan was an especially valuable Silk Road import) and an athletic pastime enjoyed by men and women alike (see Fig. 0.14).

Although Tang society was worldly, religion was not far from the minds of its people. Buddhism gained new prominence and popularity throughout the empire, often drawing support from the imperial court but also nourished by the trade routes, which brought the religion to areas of East Asia. Those same routes accommodated Buddhist pilgrims, such as the monk Xuanzang (602–664), who left a detailed account of his seventeen-year journey to major sites such as Bamiyan and places associated with the life of the historical Buddha (see Going to the Source: A Tang Dynasty Account of Bamiyan, p. 101). After returning in 645 with hundreds of sacred texts, Xuanzang declined imperial offers of government positions in order to devote himself to another religious activity: translating *sutras* from Indic language to Chinese. This monumental undertaking made Chang'an a seat of Buddhist learning in East Asia, drawing eminent monks such as Ennin (794–864) from Japan. In the diary of his pilgrimage to China, Ennin counted more than 300 Buddhist temples

in Chang'an (see Fig. 6.6). Ennin survived the 842–845 government proscription of Buddhism (as well as other foreign religions), when temples were closed, their properties seized, and monks and nuns returned to lay life. That persecution, as well as the intervening centuries, has left few temple buildings dated to the Tang dynasty, but the Great Wild Goose Pagoda (not illustrated) still stands, a remnant of the monastery that once housed Xuanzang's library.

Further from the capital, Buddhist institutions and artwork were more likely to escape destruction, and so vivid expressions of Buddhist devotion survive. Some examples attest to a satisfactory resolution of Confucian views with Buddhist practices. Many worshipers expressed the Confucian virtue of filial piety by dedicating Buddhist services, icons, and temples to their parents and ancestors. Such dedication took monumental form at the **rock-cut** "Temple of Honoring Ancestors," or Cave 19 (although it is not a naturally created cave) as enumerated by archaeologists and art historians, at Longmen (Fig. 6.8, p. 126).

Since the late fifth century, the cliffs at Longmen, or Dragon Gate, had attracted royal patrons of Buddhism (see Fig. 4.19). Conveniently located near Luoyang, the eastern capital of the Tang dynasty, the rock-cut cave-temples and smaller sculptural niches at Longmen continued to receive support from ardent Buddhists both within and outside the court. In 660, workers began excavations for a sculptural group on a massive scale. Completed in 676, the *Colossal Vairochana and Attendants* surpassed all other icons at Longmen in scale and magnificence.

Vairochana Buddha is the cosmic Buddha, who transcends space and time. He is, furthermore, the primordial and unchanging form of other, temporary buddhas, such as the historical Buddha Shakyamuni. As with other Buddhist icons, iconographical markers —including the halo, the **ushnisha**, and the elongated earlobes—help with identification. The sculpture has suffered significant damage, but remnants of a lotus throne suggest a seated position and preserve an inscription that identifies the central figure as Vairochana. Because the lower arms and hands are gone, Vairochana's *mudra* cannot be determined. Two monks immediately flank Vairochana: the young monk Ananda to the viewer's left, and the old monk Kashyapa to the viewer's right. Paired *bodhisattvas*, and, on the sides of the niche, paired guardian kings and *dvarapalas* (protectors of gateways), complete the composition.

The architectural edifice of wood and other perishable material that once covered the sculpture is gone, and with it, protection from natural erosion and human activity. The latter includes the distracting, though devout, pre-modern additions of numerous smaller niches containing Buddhist figures. Nevertheless, slight traces of pigment survive, indicating that the sculptures of Cave 19 were originally painted. The softly modeled faces with sharply defined features and fuller, rounded bodies demonstrate a shift away from the elongated figure styles of early sculptures. The group's sheer size and the level of artistic skill, evident in the drapery that falls so naturalistically and the exquisite patterns in the jewelry and haloes, indicate imperial patronage. Historical records

rock-cut carved from solid stone, where it naturally occurs.

ushnisha one of the thirty-two markers of a buddha or a *bodhisattva*: a protuberance from the head, usually a topknot of hair.

6.8 *Colossal Vairochana and Attendants*, Fengxian si ("Temple of Honoring Ancestors"), Longmen Caves (Cave 19), Henan province, China, Tang dynasty, 660–76. Limestone, height of tallest figure 56 ft. (17.07 m).

name both the third Tang emperor Gaozong (ruled 649–683) and his wife, Empress Wu (624–705), as the patrons. When her husband's health was declining, Empress Wu brought Cave 19 to completion.

The imperial couple was unusual in its joint participation in court rituals, and the *Colossal Vairochana* group expresses the couple's shared faith in Buddhism. Incidentally, Gaozong and Empress Wu were also responsible for the temple that housed Xuanzang's library. As in other instances of royal patronage since the time of Ashoka (see Chapter 3), religious expression cannot be separated from politics. The Buddhist idea of a ***chakravartin*** ruler provided a potent form of political legitimacy that would prove attractive elsewhere in East Asia, too. At Cave 19, the cosmic Vairochana calls to mind the image of a universal ruler—a position to which both Emperor Gaozong and Empress Wu, who later became the only woman ever to reign outright as Emperor of China, aspired. At the same time, by dedicating Cave 19 as Fengxian si, or the "Temple of Honoring Ancestors," the imperial couple performed within a Buddhist context the core Confucian virtue of duty to elders.

Far west of Chang'an, a vast quantity of Buddhist sculptures and **murals** survive in hundreds of rock-cut cave temples near the oasis city of Dunhuang, which flourished with the Silk Road. Between the fourth and fourteenth centuries CE, courts, local governors, merchants, and travelers directed some of their wealth to building and furnishing Buddhist temples hewn from the sandstone cliff. Together, these are known as the Mogao ("Peerless") Cave temples.

Built in the eighth century, Cave 217 features on its south wall an image of the Buddha Amitabha presiding over his Western Pure Land (**Fig. 6.9**). Within Mahayana Buddhist traditions, belief in Amitabha proposes the concept of rebirth in a Pure Land as an intermediary step towards release from *samsara*, the endless cycle of death and rebirth. For some, the corrupt age—called

mofa (Japanese: *mappō*), literally meaning "latter days of the law"—was a time so far removed from the life of the historical Buddha that it presented an insurmountable obstacle to reaching enlightenment. But by chanting Amitabha's name and visualizing his Pure Land (thought to lie in the west, where Buddhism originated), Buddhists believed they could be reborn there.

The mural in Cave 217 represents Amitabha's Western Pure Land in spectacular fashion. In the foreground, celestial musicians and dancers provide joyous entertainments. Modeled with light and shadow, the bodies appear three-dimensional. The diagonal lines of **balustrades** and the relatively smaller sizes of buildings and figures in the distance suggest spatial recession. At the center, a retinue of *bodhisattvas* attends Amitabha, who sits on an elaborate lotus throne. The bejeweled canopy above Amitabha is a sign of reverence and distinguishes him from other buddhas, who share common iconographical features. Behind him rises a magnificent palace with watchtowers to the sides, placing Amitabha within what would have been a contemporary architectural space, and preserving for us the appearance of now long-gone Tang architecture. The fluttering scarves of flying spirits (called *apsaras*) fill the sky. Amid the festivity, the pond where Pure Land adherents are reborn in individual lotus flowers almost disappears. Looking more like a canal, the pond cuts a rectangular course around platforms teeming with musicians, dancers, and *bodhisattvas*.

Consistent with Buddhist visualization practices, which prescribe rigorous picturing in one's mind as a means of religious transformation, this ornate and colorful mural seeks to induce an overwhelming and palpable experience of the Amitabha's Pure Land. It is both extravagant and **illusionistic**, and it required the combined efforts of a workshop. Some artisans prepared the walls with layers of plaster, while others transferred preparatory drawings to the wall. Senior artists painted the outlines; apprentices filled in the colors.

chakravartin literally, "wheel-turner," a Sanskrit title used to refer to an ideal, just ruler, often in relationship to the dharmic faiths of Buddhism, Hinduism, and Jainism.

mural a painting made directly on the surface of a wall.

balustrade a decorative railing, especially on a balcony, bridge, or terrace.

illusionism, illusionistic making objects and space in two dimensions appear real; achieved using such techniques as foreshortening, shading, and perspective.

6.9 *Amitabha Buddha Presiding over the Western Pure Land,* detail of mural on north wall of Cave 217, Mogao Cave temples, Dunhuang, Gansu province, China, Tang dynasty, *c.* 713–66.

The vast majority of the rock-cut caves at Dunhuang are celebrated for their murals and sculpture; by contrast, Cave 17 is famous for being a hidden repository of texts and paintings. This cave, a chamber off the north wall of Cave 16, was sealed sometime before 1006 as a precautionary measure after the nearby Buddhist state of Khotan had fallen to Islamic conquerors from Kashgar. Subsequently, the cave's contents remained unknown until 1900, when a self-appointed Daoist caretaker, WANG Yuanlu (1849–1931), discovered the cave. Seven years later, the Hungarian-British archaeologist Sir Marc Aurel Stein (1862–1943) came to Dunhuang, won Wang's trust, and acquired some twenty-four cases of manuscripts, which were later divided among several institutions, including the British Museum and the British Library. Among the most prized artifacts is a copy of *The Diamond Sutra* (**Fig. 6.10**). With a dedication of 868 CE, this text is the world's earliest complete and dated, printed book.

6.10 *The Diamond Sutra,* Tang dynasty, 868. Woodblock print, ink on paper, height 10½ in. (26.7 cm). British Library, London.

Near the southeast coast of the Korean peninsula at Mount Toham, the Seokguram Grotto houses an extraordinary granite sculpture of the Buddha (**Fig. 6.11**). Commissioned by KIM Daeseong (701–774), a government minister of the Unified Silla government, Seokguram Grotto was completed between 751 and 774. Its granite masonry construction makes it unique among Buddhist cave temples, most of which were rock cut. The "earth-touching" *mudra* suggests the icon is the historical Buddha at the moment of enlightenment, but given the prominent role of the *Avatamsaka sutra* (also known as the "Flower Garland" *sutra*, a Mahayana text important in East Asia), the figure in Seokguram Grotto may also be Vairochana, the cosmic Buddha from which all other buddhas emanate.

In trying to analyze and understand Seokguram Grotto and its Buddha, art historians might look for the influence of earlier works. They might, for example, ask if the Tang dynasty *Colossal Vairochana* (see **Fig. 6.8**) influenced the Seokguram Buddha. However, the search for influence often reflects an implicit bias, in that it implies a preferred model acting on a supposedly lesser follower. Such thinking can help establish chronological relationships, but it can overlook local circumstances and inventions.

The concepts of appropriation and adaptation are useful alternatives to thinking in terms of influence. Both recognize that artists and cultures make choices rather than strictly adhering to established forms, styles, subject matter, or conventions. Note that appropriation here means the borrowing of preexisting

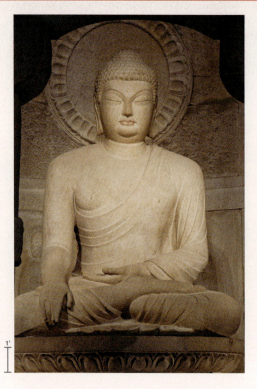

6.11 *Seated Buddha* at Seokguram Grotto, North Gyeongsang province, South Korea, Unified Silla period, *c.* 751–74. Granite, height of Buddha 11 ft. 2 in. (3.42 m).

images, objects, or ideas, but it does not have the negative connotation of taking unjustly, as often implied in popular usage. In the context of East Asia during this period, appropriation considers (among other things) how sculptors, architects, and patrons on the Korean peninsula

and Japanese archipelago chose to adopt (or not to adopt) aspects of Tang dynasty art to suit their goals, just as their counterparts in the Tang dynasty did or did not choose to adopt aspects of the Buddhist art and architecture of South Asia. Adaptation further emphasizes the introduction of local alterations and adjustments, such as when Hindu epics come to adorn Buddhist temples in Southeast Asia (see Chapter 15).

Appropriation and adaptation suggest that mimicry of earlier models cannot be explained as a lack of creativity by later artists. Rather, local conditions determine whether the appropriation and adaptation of foreign styles are religiously effective, politically expedient, or culturally prestigious. Recognizing an artistic source thus becomes less an answer ("Aha, it looks like the *Colossal Vairochana*!") and more an inquiry ("How and why did the artists at Seokguram adapt the practice of building Buddhist cave temples?").

Discussion Questions

1. Identify another instance of appropriation and/or adaptation of Buddhist art in this chapter. Discuss how the later artwork is similar to and different from the earlier source(s).
2. Look at the Tang dynasty palace architecture represented in Amitabha's Western Pure Land (**Fig. 6.9**). How would you describe the relationship between Tang dynasty palace architecture and the Phoenix Hall at Byōdō-in (**Fig. 6.17**)? Explain.

The book is in the format of a handscroll, opening with an image of the Buddha accompanied by monks, *bodhisattvas*, heavenly kings, and guardians. With a jeweled canopy and *apsaras* floating amid clouds above, and an altar table flanked by lion-like creatures before him, the Buddha acknowledges the devotional attention from a monk kneeling at the (viewer's) lower left. Besides conventional iconographical markers, this image of the Buddha has a *svastika*—an **auspicious** sign with a history traceable to 500 BCE, or roughly the lifetime of the historical Buddha—on his chest. In East Asia, this symbol also stands for "ten thousand," suggesting abundance.

The image of an exchange between the Buddha and his follower provides an apt introduction to Buddhist teachings recorded in *The Diamond Sutra*. "Diamond"— translated from the Sanskrit "vajra," which may also be rendered as "thunderbolt"— refers to the *sutra*'s instructive power to cut, like a diamond blade, through worldly illusions to reveal truth. In addition to the *sutra* text, this printed copy preserves a dedication demonstrating both Buddhist motivations and Confucian respect for

elders, "Reverently made for universal free distribution by WANG Jie on behalf of his parents on the fifteenth day of the fourth month of [the year 868]." Taking advantage of **woodblock print** technology, Wang commissions not one but multiple copies of the Buddha's teaching, an efficient means of accruing merit on the karmic records of Wang as well as his parents.

Buddhist Art and Themes in Japan's Nara (710–94) and Heian (794–1185) Periods

During Japan's Nara period (710–94), major projects of Buddhist art and architecture demonstrate a close relationship between religion and politics. The growing power of Buddhist temples during the Nara period led, in part, to policies to limit their physical presence when the government relocated the capital in 794 to Heian-kyō (present-day Kyoto). Still, new schools of Buddhism grew and Buddhist attitudes pervaded the culture of the Heian period (794–1185).

auspicious signaling prosperity, good fortune, and a favorable future.

woodblock printing a relief printing process where the image is carved into a block of wood; the raised areas are inked. (For color printing, multiple blocks are used, each carrying a separate color.)

The different period names of the Asuka to Nara to Heian periods may imply changes in government leadership, but on the contrary, throughout these centuries the imperial family and powerful aristocratic clans that together constituted the Yamato court maintained and extended power. During much of this time, too, the Tang dynasty served as a useful model. Government reforms launched in Japan during the Asuka period in 645, for example, adapted the Tang system of a centralized bureaucracy as a means to consolidate power. The emulation of the Tang model to suit local purposes informed the court's decision to break with the longstanding tradition of establishing new capitals upon the emperor's death and instead to found a permanent capital, Heijō-kyo, now known as Nara, which gives its name to the Nara period. The city's very form—the symmetrical, south-facing grid—echoes that of Chang'an, demonstrating the local prestige accorded to Tang culture. Adopting the written language of Chinese as well as the Chinese habit of writing histories, Japan's earliest histories—*Record of Ancient Matter* (*Kojiki*) and *The Chronicles of Japan* (*Nihon Shoki*)—date to the Nara period.

Not surprisingly, Tang styles of Buddhist art and architecture were primary models for neighboring states. At Tōdaiji, the central temple of the state in Nara, two related Buddhist projects—the casting of a monumental bronze Buddha and the construction of one of the world's largest wooden buildings to house it—reveal the continued fusion of politics and religion at court.

Believing that religious piety could bring Buddha's protection to the nation, Emperor Shōmu (ruled 724–749) commissioned in 743 a monumental sculpture of Vairochana Buddha (Japanese: Birushana), the primordial Buddha (**Fig. 6.12**). Under the management of Kuninaka no Muraji Kimimaro (d. 774), whose grandfather emigrated from Baekje, nearly a decade of work culminated in the icon's ritual consecration by the Indian monk Bodhisena in 752. Attended by heads of state, the aristocracy, and the clergy, the consecration, or "eye-opening" ceremony, transformed the statue into a potent religious icon. In the centuries since the consecration, the Buddha hall and the statue of Vairochana have been destroyed or partially destroyed by fire, but each time, both were restored. As a result, the present 53-foot-high statue of Vairochana comprises original portions with areas of restoration dating to the thirteenth and seventeenth centuries.

The stylistic preferences of several periods co-exist in the statue's body, but much of the lotus pedestal is original. Engraved petals of that pedestal have preserved a Nara period image of the historical Buddha with iconographical markers that are not always visible or present on other representations, such as the wheels on the palms of his hand or the *svastika* on his chest (**Fig. 6.12a**,

6.12 Vairochana Buddha, Daibutsu-den, Tōdaiji, Nara prefecture, Japan, original: Nara period, 743–52; reconstruction: seventeenth century. Bronze, height 53 ft. (16.15 m).

6.12a Drawing based on engraved image on Nara period bronze lotus petal base of Vairochana Buddha, Nara period.

facade any exterior vertical face of a building, usually the front.

bay a space between columns, or a niche in a wall, that is created by defined structures.

hip roof a roof that slopes upward from all four sides of a building.

6.13 BELOW **Great Buddha Hall (Daibutsu-den),** Tōdaiji, Nara prefecture, Japan, original structure completed in 752; destroyed in 1180; reconstruction completed in 1707, with restorations in 1906–13.

see also **Fig. 6.10**). Stylistic qualities of this Buddha, such as the relaxed, full-bodied figure, a rounded face, and flowing drapery, are shared by the *Colossal Vairochana* in Longmen Cave 19 in China and the *Seated Buddha* at Seokguram Cave temple in Korea. All three are examples of the Tang International Style, which succeeded the earlier style of elongated figures seen throughout East Asia, including that of the *Shaka Triad* (see **Fig. 6.3**).

Owing to its large size, this sculpture of Vairochana Buddha is also known as Daibutsu, meaning "great Buddha." Thus, the structure that houses it is the Daibutsu-den, or Great Buddha Hall (**Fig. 6.13**). With a **facade** measuring 187 feet (57 m) across, the Great Buddha Hall has immense proportions, requiring not merely additional **bays** (seven compared to the five of Hōryū-ji's *kondō*) but also significantly larger posts and lintels. The current building is only two-thirds the size of the original, which was set afire and destroyed in the civil war at the end of the Heian period, but it unmistakably shares the language of Tang palatial architecture (see the buildings depicted in **Fig. 6.9**). The sweeping, double-eave **hip roof**—one eave extending over all seven bays, a hip roof above—and the complex array of brackets announce unambiguously the alliance of politics and religion, of material resources and spiritual matters.

Fittingly, it was at Tōdaiji in 754 that Emperor Shōmu (having abdicated the throne to his daughter in 749) and his wife, Empress Kōmyō, received Buddhist ordination, thus joining officially the Buddhist order of

priests, monks, and nuns. Presiding over their vows was the Chinese monk Jianzhen, or better known in Japanese, Ganjin (688–763). Having attempted five times to reach Nara, Ganjin succeeded on his sixth try in 754. In his sixties and blind, he arrived too late to attend the eye-opening ceremony of Vairochana Buddha. Still, he was welcomed enthusiastically and appointed to Tōdaiji. Five years later, he founded the temple Tōshōdaiji, where he offered religious instruction until his death. Enshrined in the Founder's Hall of Tōshōdaiji, a **dry lacquer** sculpture portrays Ganjin seated in meditative repose (**Fig. 6.14**). The sculpture is a true portrait, capturing the specific features of an individual within the constraints of convention. The statue is naturalistic in style: the proportions of the body conform to viewers' expectations, the contours of his face and torso are softly modeled, and the drapery falls according to the shape formed by the arms and the roundness of knees. The sculpture has been painted, too, to heighten the resemblance. Even though the burning of incense has added a layer of soot, nevertheless the sculpture vividly conveys a powerful sense of Ganjin's inner vision. Reverence for Ganjin continues annually when the Founder's Hall is opened for several days coinciding with the anniversary of his death.

From the Asuka to the Nara periods, the Yamato court promoted Buddhism and its accompanying artistic forms. Buddhism grew in popularity, and temples accrued wealth and power. With constituencies and wealth of their own, temples were seen as rivals rather than as partners to the court, and the erosion of the mutually beneficial relationship between politics and religion brought about the end of the Nara period in 794 (incidentally, about fifty years later, the Tang government would mount a proscription of Buddhist temples for the same reason). In part to curb the power of numerous Buddhist temples located within Nara, the court decided to move the capital. After a failed attempt to construct a capital at Nagaoka, the imperial house succeeded with Heian-kyō, present-day Kyoto, which gives its name to the Heian period (794–1185). Like Nara, Heian-kyō took the Tang capital of Chang'an as a model, but the new city strictly limited the number of Buddhist temples within its boundaries. As Heian society and culture developed, the role of the Tang dynasty as a model diminished. Internal rebellion shook the power of the Tang. The last Heian diplomatic mission to the Tang court occurred in 839, and, not surprisingly, later Heian art and architecture are less engaged with Tang models.

The relocation of the imperial capital led to the shift of power and patronage away from Buddhist institutions in Nara, which affected the later development of Buddhism. Monks returning from studies on the East Asian continent introduced schools of Esoteric Buddhism (in other regions of Asia, these schools may be referred to as Vajrayana or Tantric, see Chapter 5), including Tendai and Shingon. Centered on *The Lotus Sutra*, Tendai maintains that all human beings possess the Buddha nature and, therefore, can become enlightened by realizing this nature within themselves. Based on texts transmitted by founding monk Kūkai (774–835), Shingon recognizes two aspects of the Buddha—a temporal body, as manifested in the historical Buddha, and a transcendental body,

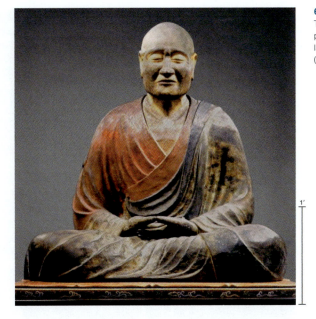

6.14 *Ganjin (Jianzhen)*, Tōshōdaiji, Nara, Japan, Nara period, mid-eighth century. Dry lacquer, painted, height 32 in. (81.3 cm).

represented by the primordial Vairochana Buddha—but upholds a doctrine of non-duality in which these bodies are not separate but belong to a common absolute. Enlightenment, for Shingon followers, is the realization of the absolute, or ultimate Buddhist truth of non-duality, and that the self, too, is not separate.

Like earlier Buddhist schools, Tendai and Shingon built temples and created icons, but they also required new images to serve new purposes. In Shingon, the full realization of the ultimate Buddhist truth and of enlightenment is impossible without images. Kūkai explained, "With a single glance [at drawings and paintings] one becomes a Buddha. The secrets of the *sutras* and commentaries are depicted in a general way in diagrams and illustrations, and the essentials of the Esoteric teachings are actually set forth therein." **Mandalas**—and in particular the "mandalas of the two worlds" (Japanese: *ryōkai mandala*)—attest to Shingon belief in the temporary, or phenomenal and the transcendent realms, and they may have helped with visualization practices as suggested by Kūkai. Mandala is the Sanskrit word for "circle," and a Buddhist mandala takes the form of a cosmic map of a sacred enclosure, arranging buddhas, *bodhisattvas*, and other deities systematically and hierarchically.

For example, in the *Womb World Mandala*—"womb" referring to the womb of great compassion—Vairochana Buddha presides at the composition's conceptual pinnacle, the central square (**Fig. 6.15**). From the center, the universe expands outward like a mountain viewed from above (see Fig. 7.1). In the *Womb World Mandala*, that spatial expansion is expressed as nested squares. Vairochana Buddha occupies a position higher than the historical Buddha, who is placed in the third **register** from the top (**Fig. 6.15a**). Still, the historical Buddha sits at the center of a "court" of thirty-four half-sized disciples and personifications of virtue.

The mandala does not tell a story (see **Fig. 6.5**), nor does it attempt an illusionistic representation (see **Fig. 6.9**). Instead, it uses contrasting colors, **hierarchical scale**, iconography, and symmetrical patterns to give visual

dry lacquer a technique of making sculpture or vessels in which pieces of hemp cloth are soaked in lacquer and then layered over a core of wood and clay. Each layer of lacquer-soaked cloth must dry completely before adding the next.

mandala typically comprised of concentric circles and squares, a spiritual diagram of the cosmos used in Hinduism, Buddhism, and other Asian religions.

register a horizontal section of a work, usually a clearly defined band or line.

hierarchical scale the use of size to denote the relative importance of subjects in an artwork.

6.15 *Womb World Mandala*,
Tōji, Kyoto, Japan, Heian period,
late ninth century. Hanging scroll,
color on silk, 6 ft. × 5 ft. 1½ in.
(1.83 × 1.56 m).

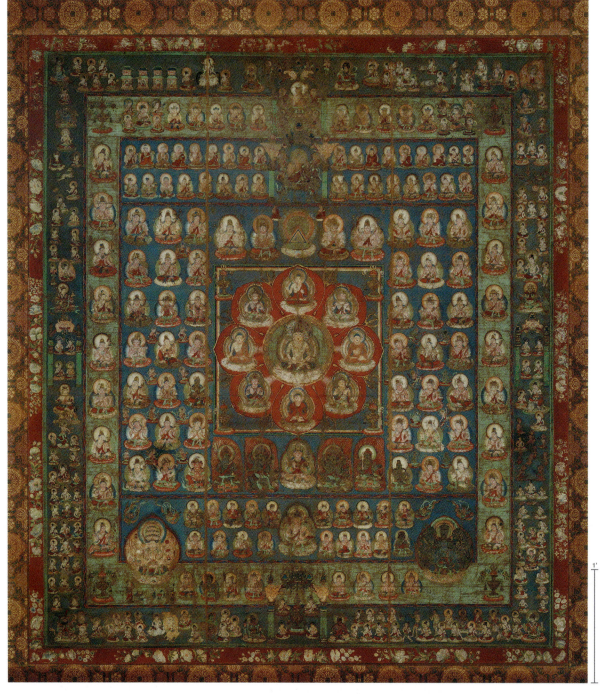

1'

6.15a BELOW **Diagram of the**
***Womb World Mandala**.*

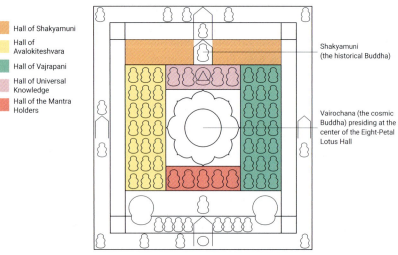

- ■ Hall of Shakyamuni (orange)
- ■ Hall of Avalokiteshvara (yellow)
- ■ Hall of Vajrapani (green)
- ■ Hall of Universal Knowledge (pink)
- ■ Hall of the Mantra Holders (red)

Shakyamuni
(the historical Buddha)

Vairochana (the cosmic
Buddha) presiding at the
center of the Eight-Petal
Lotus Hall

form to abstract, Buddhist concepts. In Shingon belief
and practice, the *Womb World Mandala* is paired with the
transcendental *Diamond World Mandala*, not illustrated
here. Displayed in initiation halls or revealed only on
special occasions, the mandalas were also used in initi-
ation rites to determine a personal deity among those
represented in the mandalas. Thereafter, initiates could
welcome and invoke their personal deities to empower
their images in the mandala.

Both the Shingon school and followers of Amitabha
Buddha (Japanese: Amida Buddha) practiced visualiza-
tion. But whereas the former advocated visualization
as a means to enlightenment, followers of Amitabha
Buddha practiced a series of visualizations in order to
be reborn into Amitabha's Pure Land. Interest in Pure

Land emerged from Tendai practices and gained popularity in the late Heian period, a time that (for Heian Buddhist followers) coincided with *mappō,* or the "latter days of the law," that corrupt age when there was little chance for enlightenment and so rebirth in Amitabha's Pure Land provided an interim step.

Late Heian belief in *mappō* finds vivid expression in the art and architecture of Byōdōin. The site was formerly the suburban villa of a powerful aristocratic family, the Fujiwara. In 1052, with the consecration of a main hall, the villa was named Byōdōin, or "Temple of Equanimity." The following year, coinciding with the onset of *mappō,* saw the completion of the Amida Hall, now commonly known as the Phoenix Hall, which houses the gilt wood icon of Amitabha Buddha, or in Japanese Amida Buddha, by the renowned sculptor Jōchō (d. 1057) (**Fig. 6.16**).

Jōchō perfected a new technique for making wood sculptures. Rather than shaping a single block of wood, he joined together multiple pieces, a process called *yosegi zukuri.* With this method, sculptors could simultaneously shape different parts of the icon, which were subsequently fitted together and finished. Thus, the efficiency of Jōchō's workshop increased, partly in response to a growing demand and competitive market for Buddhist icons.

At Phoenix Hall, Amitabha sits in meditative position upon a raised lotus throne. Depicted as awe-inspiring and splendid, he wears a serene expression. Below Amitabha's broad forehead, Jōchō has carved elegantly elongated brows, half-closed eyelids, and utterly relaxed and perhaps slightly parted lips. The snail-shell curls that stud Amitabha's head and *ushnisha* may be traced back to Nara period precedents in Japan, and ultimately to the Gupta period in South Asia (see Chapter 5). Like other images of the Buddha, Amitabha has an **urna** and elongated earlobes. His clothing falls in shallow folds, and his hands form the *mudra* of concentration.

Above Amitabha hangs an elaborate, gilded canopy with an abundance of floral scrolls and large, stylized lotus petals framing a bronze mirror for reflecting light onto the sculpture. An ornate halo and openwork mandorla—replete with curling clouds and ascending flames—offer a contrasting frame for Amitabha's calm expression and plain appearance. *Apsaras* in the form of tiny attendants, dancers, and musicians float in the mandorla and on the walls. They constitute the heavenly contingent that accompanies Amitabha as he descends from his Pure Land in answer to prayers. The purpose of this *raigō,* or "welcoming descent," is to convey the faithful to their rebirth into Amitabha's Pure Land. The splendor of the *raigō* is described by Tendai priest Genshin (942–1017):

The great vow of Amida...is that he comes with twenty-five *bodhisattvas* and a host of a hundred thousand monks. In the western skies, purple clouds will be floating, flowers will rain down and strange perfumes will fill the air in all directions. The sound of music is continually heard and golden rays of light stream forth. In brilliant rays that dazzle the eyes, he will appear.

What does Amitabha's Pure Land look like? Whereas the mural at Dunhuang offers a two-dimensional image

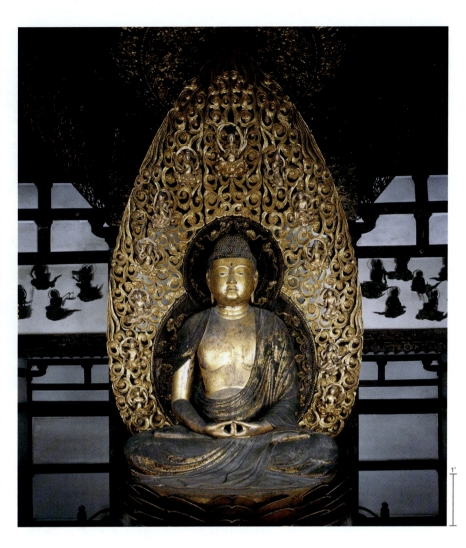

6.16 Jōchō, *Amitabha Buddha,* Phoenix Hall, Byōdōin, Uji, Kyoto prefecture, Japan, *c.* 1053. Gold leaf and lacquer on wood, height 9 ft. 8 in. (2.95 m).

(see **Fig. 6.9**), Phoenix Hall and its setting provide a three-dimensional representation (**Fig. 6.17**). From his elevated lotus throne at the center of Phoenix Hall, Amitabha presides over an artificially formed pond, which represents the place where faithful followers will be reborn in individual lotus flowers. Amitabha's palace has covered galleries stretching to either side, and imitation watchtowers rise from false second stories at the corners where the corridors turn toward the pond. Behind the central hall, another **gallery** stretches backward like a tail (**Fig. 6.17a**).

The plan of Phoenix Hall, with its corridor "wings" and "tail," along with the mythical bronze birds that crown the **hip-and-gabled** roof, give the building its avian nickname. During the Heian period, it was called an Amida Hall, and as materialization of the Pure Land, it facilitated the visualization practices central to Pure Land Buddhism. It was believed that the very act of envisioning the Pure Land and deliverance to that paradise would bring about *raigō* and rebirth there.

As a variety of schools, or sects, of Buddhism developed during the Heian period, Buddhist beliefs and practices also colored secular life. With the onset of *mappō,* the sense of belatedness felt by late Heian Buddhists fueled an aesthetic principle in literary practice called *mono no aware,* which may be described as a keen, bittersweet awareness of the transience of things.

urna one of the thirty-two markers of a buddha or a *bodhisattva*: a tuft of hair or small dot between the eyebrows that symbolizes a third eye.

gallery an interior passageway or other long, narrow space within a building.

hip-and-gabled roof a composite roof design that combines a hip roof in the lower portion, and in the upper portion, one that slopes from two opposite sides with two gables (vertical triangular shapes) at the ends.

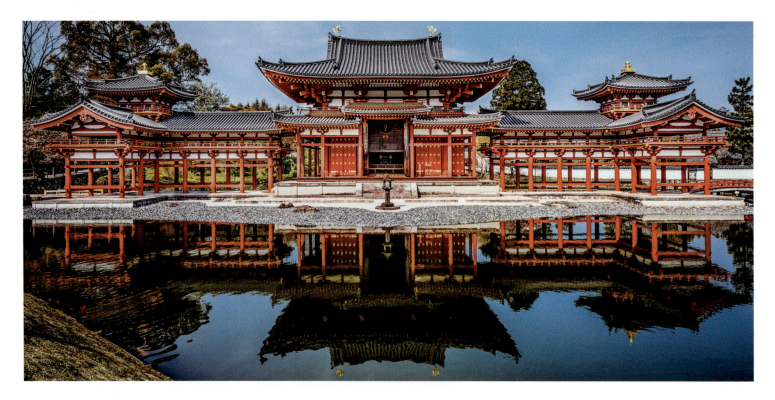

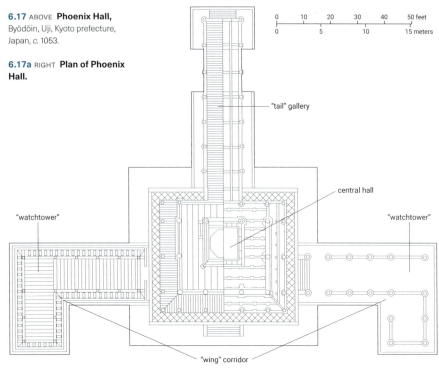

6.17 ABOVE **Phoenix Hall,** Byōdōin, Uji, Kyoto prefecture, Japan, c. 1053.

6.17a RIGHT **Plan of Phoenix Hall.**

"tail" gallery

central hall

"watchtower"

"watchtower"

"wing" corridor

The aesthetic of *mono no aware*, along with Buddhist concepts such as karmic retribution, pervades *The Tale of Genji*, written by Murasaki Shikibu (973 or 978–c. 1014 or 1031), an eleventh-century lady-in-waiting to an imperial princess. Hailed as the world's first novel, *The Tale of Genji* follows the loves and regrets of Genji, the son of the emperor and a secondary consort. Throughout the story, Murasaki describes the intrigues of courtly romances and the complexities of the human heart. The recurring theme of the ephemeral nature of life resonated with Buddhist attitudes toward life as illusory, and it

underlies the novel's extreme sensitivity to the fading of beauty. Though *The Tale of Genji* is fiction, Murasaki's meticulous observations offer a glimpse into the culture of the Heian court.

The Tale of Genji inspired artistic competitions among courtiers and ladies. A set of illustrated **handscrolls** (Japanese: *emakimono*) from the late Heian period combined the skills of papermaking, **calligraphy** (see Seeing Connections: The Art of Writing, p. 138), and painting to capture the novel's elegance and pathos. Of the original set of ten to twelve scrolls that would have included more than one hundred excerpts and paintings, twenty-nine excerpts and twenty paintings survive. Here, we discuss two paintings related to the "Oak Tree (Kashiwagi)" chapter. That chapter recounts how Genji's nephew, Kashiwagi (whose name literally means "oak tree") pursued the Third Princess, one of Genji's wives. That affair produced a child whose birth was followed by the Third Princess's decision to join a Buddhist convent and by Kashiwagi's untimely death.

Preceded by an excerpt from the chapter written in fine calligraphy on decorated paper (not illustrated here), the first scene from the "Oak Tree" chapter takes place in the private chambers of the Third Princess (**Fig. 6.18**). At the far left (as the viewer looks at it), she is identifiable by her long black hair. Her father—the retired emperor, whose shaved head indicates his status as a Buddhist monk—faces her. Genji, wearing the customary black hat of the Heian courtier, sits below him. Each is deeply troubled, but feelings are not excessively displayed in facial expressions or physical gestures. Each yearns to connect emotionally with the others, but they do not make eye contact. Moreover, the moveable curtains and the boundaries of the bright green *tatami* mats emphasize their isolation from one another. The **ground plane** tilts up sharply, and no horizon line offers

6.18 Scene 1 from the "Oak Tree (Kashiwagi)" chapter of *The Tale of Genji,* late Heian period, *c.* 1120–50. Handscroll, ink and color on paper, height 8⅝ in. (21.9 cm). Tokugawa Art Museum, Nagoya, Japan.

spatial relief or counterbalances the diagonal lines of floor and furnishings.

Because Heian culture judged outward displays of emotion to be vulgar, painters supplemented conventionally represented faces and restrained facial expressions with indirect cues in the composition. For example, the tight positioning of **motifs** such as furniture produces a sense of psychological pressure, and the steep angle of the ground plane in combination with diagonally placed screens conveys emotional instability and disarray. Such strategies of representation became conventions that were readily understood by both artists and audiences. Another convention used in the illustrations of *The Tale of Genji* is the point of view: a high vantage unimpeded by ceiling or rooftop, which is called *fukinuki yatai,* literally, "blown-off roof." Thus, viewers gain a privileged glimpse into emotionally charged family matters.

The breach of privacy is underscored by the presence on the (viewer's) right of court ladies, who wait anxiously at the periphery. They are, like the viewers of the painting, unable to alleviate the sorrows of the Third

Princess, her father, or her husband. Instead, the onlookers bear witness to a scene of karmic consequences. Deeply lamenting her fate, the young Third Princess determines to take Buddhist vows, and her father, unsuccessful in his entreaties, resigns himself to her decision. Genji's fate is especially poignant. In his own youth, Genji had an affair with his father's consort, and an illegitimate son was born of that liaison. Now, Genji is wounded by his wife's infidelity, and he must silently bear the shame.

Genji's shame is on display, but, in accordance with Heian etiquette, indirectly, in the third scene from the "Oak Tree" chapter (**Fig. 6.19**). Wearing patterned purple robes, Genji cradles the newborn baby (the child of Kashiwagi) as if it were his own. The excerpt states that Genji's face did not betray his ambivalent and changing attitudes toward the infant, but his awkward and uncomfortable placement near the composition's upper edge reveals the pressure of his situation. As with the first scene of the "Oak Tree" chapter, the boundaries created by architectural structures, sharp diagonal lines, and the steeply pitched ground plane convey emotional isolation

handscroll a format of East Asian painting that is much longer than it is high; it is typically viewed intimately and in sections, as the viewer unrolls it from right to left.

calligraphy the art of expressive, decorative, or carefully descriptive hand lettering or handwriting.

ground plane (referring to the ground represented in two-dimensional artwork): in linear perspective, the ground plane appears to recede to the horizon line; in a picture with a sharply uptilted ground plane, no horizon appears within the picture.

motif a distinctive subject or visual element, the recurrence of which is often characteristic of an artist's work.

6.19 Scene 3 from the "Oak Tree (Kashiwagi)" chapter of *The Tale of Genji,* late Heian period, *c.* 1120–50. Handscroll, ink and color on paper, height 8⅝ in. (21.9 cm). Tokugawa Art Museum, Nagoya, Japan.

1"

isometric a strategy of representing three-dimensional objects and/or space on a two-dimensional surface in which oblique sides are rendered as diagonal, parallel lines, and sides that are parallel to the picture plane are presented frontally.

monochrome made from shades of a single color.

onna-e literally, "women's painting," the category of Japanese painting characterized by heavy pigments, indirect expression of emotional content, and themes of pathos.

otoko-e literally, "men's painting," the category of Japanese painting characterized by ink monochrome and/or light colors, facial expressions, physical gestures, and themes of humor and action.

and instability. The long, layered robes worn by one of the court ladies appear unkempt as they emerge from beneath the agitated draperies onto the veranda, hinting, even before Genji is seen by viewers unrolling the handscroll from right to left, that something is awry.

In both scenes, pigments have flaked off, colors have faded, and fine details are no longer clear or crisp. Even though the centuries-old paintings are worn, the artistry of the scenes—the fine depiction of the opulent robes of the ladies, the bright colors of the furnishings—persist, heightening the poignancy of the tragedy and imparting a sense of *mono no aware*.

Although feelings of melancholy are pervasive in the late Heian period, it was also a time of razor-sharp wit. In the realm of literature, the court lady Sei Shōnagon (c. 966–1017 or 1025, a contemporary of Murasaki Shikibu) recorded in her *Pillow Book* all manner of unsparing critiques of daily irritations and doltish lovers. In art, there is the four-scroll set of the *Scrolls of Frolicking Animals*.

The *Scrolls of Frolicking Animals* depict both humans and anthropomorphic animals engaged in a variety of leisure activities and sacred rituals. In this detail from one of the two scrolls thought to date to the Heian period (**Fig. 6.20**), a monkey abbot kneels before a Buddhist altar. Seated in a meditative position upon a lotus leaf and backed by a plantain-leaf mandorla, the frog icon raises a webbed hand in the *mudra* signaling not to fear. Hares, foxes, and a monkey observe the religious ritual in what may be a cheeky parody of Buddhism.

Compared to the *Tale of Genji* paintings, *Frolicking Animals* resembles a sketch. Indeed, the handling of brush and ink suggests swift and spontaneous execution. It would be a mistake to describe the painting as simplistic or elementary, however. The medium, ink on paper, is unforgiving. Errors cannot be corrected, and thus it takes years of practice and experience to produce the sure and nuanced lines that describe knotted branches, wispy breath, and perky ears. Careful control of ink tonality must substitute for a rainbow of colors. The artist's

understanding of spatial relationships creates order and hierarchy among the motifs, so that even though the monkey abbot is closest to the middle of the composition, the frog icon occupies the center of attention. In addition, the painter has made use of several techniques to create space and mass on a two-dimensional surface. These include the **isometric** representation of tables and pedestals, overlapping objects, attention to physical scale, and use of three-quarter views (in which the subjects are presented midway between a front and a side view).

Unlike the illustrations to *The Tale of Genji*, *Frolicking Animals* seems to oppose all the conventions of painting: ink **monochrome** instead of heavy pigments, dynamic brushwork as opposed to meticulous outlines, vivid expressions and gestures instead of indirect means to express emotions, and the substitution of humorous antics for profound human themes. These two paintings belong to categories called ***onna-e*** and ***otoko-e***, literally "women's painting" and "men's painting," respectively. Although the use of gendered terms for painting categories might suggest underlying beliefs about gender, they do not mean that audiences were composed exclusively or primarily of women or of men. Nor are the terms evidence that women painted in one manner and men in another. Instead they attest to the emergence and recognition of two distinct painting modes that were thought to be appropriate for particular kinds of social interaction at court. *Onna-e* typically depicted figural groups related to poetry and courtly fiction, and they evolved to have a palette of bright colors including mineral pigments. By contrast, physical actions and adventures ranging from the miraculous to the historical to the satirical dominate the subject matter of *otoko-e*. In terms of style, *Otoko-e* may be monochromatic or use paler colors derived from vegetable matter, and the calligraphic quality of the brushwork is more apparent.

Although neither the *Tale of Genji* paintings nor the *Scrolls of Frolicking Animals* would be described as typical or canonical works of Buddhist art, they do reveal how

Buddhism had become an inextricable part of late Heian culture. More generally, the history of Buddhist art and culture in East Asia—from the seventh-century gilt bronze *Pensive Bodhisattva* icon (see **Fig. 6.1**) to the twelfth-century ink paintings of *Frolicking Animals*—is one of cultural transmission and adaptation. Encounters with the unfamiliar generated both opposition and opportunities as Buddhism challenged deeply held religious beliefs and practices stemming from Confucianism, shamanism, and Shintō. Yet it promised power and authority, enlightenment and rebirth in a Pure Land. Temples and icons attest to the dissemination and robust growth of Buddhism throughout East Asia. Buddhism changed the cultures and art of East Asia, but East Asia also changed Buddhism.

In the ensuing centuries, Buddhism would continue to be a source of creative inspiration, generating deceptively simple images as well as manifestly complicated forms. At the same time, interest in secular subjects drawn from both the natural world and urban experience would grow. In the centuries to come, the artistic record of East Asia would include landscapes of monumental proportions, startlingly realistic portraits, and the invention of a most wondrous and coveted material—porcelain.

Discussion Questions

1. Understanding iconography and style can help in identifying and differentiating one Buddhist icon from another. Choose two Buddhist icons in this chapter to explain the difference between iconography and style.

2. Words and images convey stories differently. Choose a narrative image from this chapter and discuss the visual strategies that the image uses to tell the story.

3. Architecture transforms space into meaningful places of human activity. Describe and analyze how architecture facilitates Buddhist practice. Refer to a temple or building in this chapter.

4. Further research: many of the artworks are related to a specific patron, site or temple, or ritual. Choose one and do some research to deepen your understanding of the nature of that relationship. Here are some questions to get you thinking: Did challenging circumstances motivate the patron? Was the artwork in question merely part of a greater artistic program? How does the ritual context change a particular artwork's meaning?

Further Reading

- Leidy, Denise Patry. *The Art of Buddhism: An Introduction to Its History and Meaning.* Boston, MA and London: Shambhala, 2008.

- Lippit, Yukio. "Figure and Facture in the *Genji Scrolls*." In Haruo Shirane, ed. *Envisioning* The Tale of Genji: *Media, Gender, and Cultural Production.* New York: Columbia University Press, 2008, pp. 49–80.

- Washizuka, Hiromitsu, Park, Youngbok, and Kang, Woo-bang. *Transmitting the Forms of Divinity: Early Buddhist Art from Korea and Japan.* New York: Japan Society, 2003.

- Watanabe, Masako. *Storytelling in Japanese Painting.* New York: The Metropolitan Museum of Art, 2011.

- Whitfield, Roderick, Whitfield, Susan, and Agnew, Neville. *Cave Temples of Mogao at Dunhuang: Art and History on the Silk Road.* Los Angeles, CA: Getty Conservation Institute and the J. Paul Getty Museum, 2000.

Chronology

CHINA		
581–618	The Sui dynasty	
618–906	The Tang dynasty	
645	The monk Xuanzang returns with hundreds of Buddhist texts after a 17-year pilgrimage to India	
676	*Colossal Vairochana and Attendants*, commissioned by Emperor Gaozong and Empress Wu, is completed	
723	The sculpture *Camel Carrying Musicians* is buried as a tomb furnishing	
868	The *Diamond Sutra* is printed	
KOREA		
c. **200–668**	The Three Kingdoms period	
538 or 552	Diplomatic gifts from Baekje to Yamato include a Buddhist icon	
early 7th century	*Pensive Bodhisattva* is sculpted	
668–935	The Unified Silla period	
751–74	*Seated Buddha* is sculpted at Seokguram Grotto	
JAPAN		
538–710	The Asuka period	
607	Hōryūji is founded	
623	Tori Busshi's workshop sculpts *Shaka (Shakyamuni) Triad*	
710–94	The Nara period	
752	The First Great Buddha Hall is constructed at Tōdaiji; the *Vairochana (Birushana) Buddha* icon is consecrated	
754	The Buddhist monk Ganjin (Jianzhen) arrives in Nara	
794–1185	The Heian period	
c. **1053**	The Phoenix Hall at Byōdōin is built; Jōchō sculpts the *Amitabha Buddha*	
12th century	The earliest illustrated handscrolls of Murasaki Shikibu's *The Tale of Genji* are made	

The Art of Writing

Words that are written down last longer than those that are spoken. Yet the human desire to read these words often causes readers to forget that the act of writing is itself a visual practice: it is a process of inscribing conventional marks in an orderly fashion on a smooth surface. By extension, reading involves interpreting what is seen, and knowing how to decipher particular symbols, such as numbers and letters, and comprehending their relationships.

In some cases, the visual characteristics of written words exceed the demands of legibility and reach into the realm of art; in other cases, ornament draws greater attention to the significance of some words over others. In Chinese, this practice is called *shufa*, meaning "brush method". But such writing practices are present in many cultures around the world, and art history employs the more general term calligraphy (from the Greek for "beautiful writing") to refer to artistic writing. Several examples from the medieval era—within and outside Asia—suggest how calligraphy served a variety of functions.

In the late Heian period in Japan, writing combined with the arts of poetry and papermaking (**Fig. 1**). Using a flexible brush, the unknown calligrapher wrote fluid columns of text beginning at top right and ending at bottom left. The animated lines are at times dark and thick, then turning pale, dry, or attenuated. In places, the brush changed direction rapidly, producing sharp angles and tight circles; in others, it traced wider, smooth arcs. The calligrapher's visual rhythms interact with the papermaker's art. Against a background of peacocks and flowers printed with a subtly sparkling ground-mica ink, small birds are flying amid leaves and wind-tossed silver branches.

The text, composed by Lady Ise (died *c.* 939), suggests a romantic exchange:

The man came and stood at her gate; hearing a cuckoo singing in a flowering orange tree, he composed the following verse and sent it to the lady:

Standing at your gate
Forlorn am I as the mournful
Cuckoo that sings
My sadness from his perch among
The branches of your blossoming
orange tree.

To this she replied:

Hardly can he know
What errand brings you here
The cuckoo in my tree
Is it not his tuneful nature
Thus to come and sing?

Lady Ise wrote poetry during a pivotal, cultural moment, and here the *kana* system of writing (a system of Japanese script), the thirty-one-syllable *waka* (a form of classical Japanese poetry), the decorated paper, and the calligraphic style all testify to a new approach to transforming writing into art (compare to Fig. 4.12).

Calligraphy is the most esteemed form of art in Islamic culture. Its status stems not only from the importance of writing within Islam, as articulated

1 LEFT **Page from the "Lady Ise Collection" (*Ise shū*),** from the Nishi-Honganji edition of the *Thirty-Six Poetic Immortals* (*Nishi-Honganji-bon Sanjūrokuninshū*), late Heian period, *c.* 900–1185. Mounted as a hanging scroll: ink on decorated paper, 8 × 6¼ in. (20.3 × 15.9 cm). Metropolitan Museum of Art, New York. **EAST ASIA**

2 ABOVE **Bowl,** Nishapur, Iran, Samanid period, tenth century. Earthenware; white slip with black-slip decoration under transparent glaze, height 7 in. (17.8 cm), diameter 18 in. (45.7 cm). Metropolitan Museum of Art, New York. **WEST ASIA**

3 Page from the *Lindisfarne Gospels*, folio 27r, Northumberland, England, *c.* 715–20. Ink and tempera on vellum, 13⅜ × 9½ in. (34 × 24.1 cm). British Library, London.
EUROPE

in the Qur'an, the holy book of Islam, but also from the adaptability of the Arabic script (Arabic is both the name of a language and a script). Beginning in the seventh century CE, across North Africa, West Asia, and Central Asia, and eventually in South Asia and Southeast Asia, as Islam spread to those regions (see Chapter 10), artists adorned a variety of media, from architecture to jewelry, with Arabic calligraphy. The chosen passages represent a range of literary genres, from love to poems to proverbs. The ceramic bowl illustrated here, from tenth-century Iran, expresses the adage "planning before work protects you from regret" and also wishes "good luck and well-being" to the viewer (**Fig. 2**).

In its original context, the bowl signaled its owner's wealth, refinement, and hospitality. It also exemplifies Arabic's ability to provide bold, simple, and beautiful ornamentation. The brown-black glaze of the letters—written in a visually striking script called "new style Kufic"—contrasts with the vessel's smooth white-slip surface. The artist has carefully arranged the writing so that it fits perfectly around the bowl's edge, and has played with the letters, elongating some and compressing others, to create a rhythmic, almost abstract, patterning. The letters' elegantly rendered vertical shafts draw the viewer's eye to the bowl's center, where a single dot, functioning as both a displaced diacritical mark and focal point, resides.

Richly ornamented calligraphic script is an important visual feature of the *Lindisfarne Gospels*, a book named after the island near the northeast coast of England where it was

probably made. For instance, on the page showing the first chapter of the Book of Matthew, the Latin text—which translates as "The book of the generation of Jesus Christ, son of David, son of Abraham," is difficult to read due to the extensive use of abbreviated text and dense ornament (**Fig. 3**). Words are rendered in extraordinary visual detail, with the aid of a straight edge and compass. The intricate patterning closely resembles that found in contemporaneous jewelry, calling attention to the precious quality of the sacred text. The dynamic complexity of the linear design, the use of multiple colors (including pigments imported from the area of present-day Afghanistan), and the labor and expense of making calligraphic imagery indicate the book's material and spiritual value.

Although the *Gospels* can be read, that was not its primary function. In the same manner as a sacred relic, the book was placed on the altar and carried in religious processions; it was used to evoke the presence of Christ, whom Christians consider to be the Word (of God) made Flesh. Only on special occasions was the book opened to particular pages, revealing its splendid calligraphy. Throughout the medieval world, calligraphy was often reserved for books of high esteem, such as sacred and devotional writings, to heighten their significance relative to other texts.

Discussion Questions

1. How was calligraphy used in other cultural contexts, such as by emperors and empresses in Song dynasty China, scholars in Joseon Korea, or scribes in Mughal India?
2. Calligraphy continues to be used today. Find a contemporary example in this textbook and compare it to one here.

Further Reading

- Brown, Michelle P. *The Lindisfarne Gospels: Society, Spirituality, and the Scribe*. Toronto, Canada: University of Toronto Press, 2003.
- Ekhtiar, Maryam D. *How to Read Islamic Calligraphy* (Metropolitan Museum of Art—How to Read series). New York: The Metropolitan Museum of Art, 2018.
- McKendrick, Scot and Doyle, Kathleen. *The Art of the Bible: Illuminated Manuscripts from the Medieval World*. London: Thames & Hudson, 2016.
- Shimizu, Yoshiaki, Rosenfield, John M., and Richard, Naomi Noble. *Masters of Japanese Calligraphy: 8th–19th Century*. New York: Asia Society Galleries: Japan House Gallery, 1984.

7

Monumental Art in South Asia and Southeast Asia

800–1300

7.0 Detail of the Churning of the Sea of Milk, Angkor Wat, Cambodia.

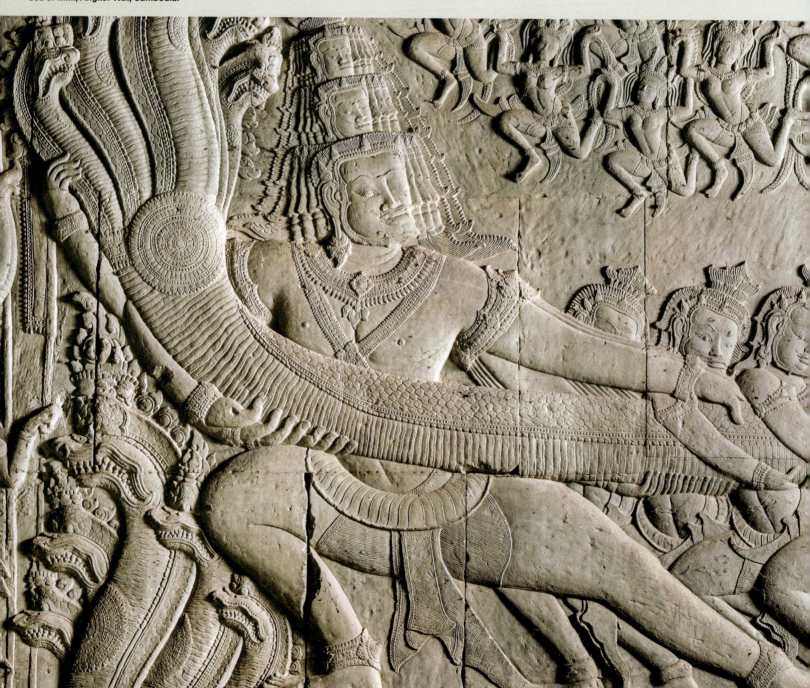

Introduction

Many of the major Hindu, Jain, and Buddhist monuments located in South and Southeast Asia date to the period between 800 and 1300 CE (see **Map 7.1**). These medieval-era monuments include Indonesia's Borobudur, the world's largest Buddhist monument, and Cambodia's Angkor Wat, considered the world's largest pre-modern Hindu temple. During these five centuries, an array of local kingdoms as well as a few expansive empires (the Cambodia-based Khmer, for example) rose and fell from power. The specific political, economic, and social history of each one differed greatly, and artistic styles varied from region to region. Within this diversity, one overarching trend appears: many of the rulers constructed imposing sacred centers as a way to connect earthly and spiritual power. These centers are at once architecturally impressive as well as spiritually and visually complex. Their multifaceted natures speak to the complexity of the societies that built them. Understanding them requires more than one analytical approach, thereby demonstrating the wide-ranging nature of art history.

For example, a single Hindu temple might be adorned with dozens of sculptural forms, each of which may shed light on contemporaneous religious beliefs, political priorities, or even water-management practices. At the same time, just as the perception of an individual painting is affected by the overall experience of visiting a museum, from entering the lobby to reading an informational wall label, so too the original context of the temple, from gateways marking the sacred precincts to the height of its walls, shapes how the pilgrim would see and understand a specific sculpture.

Often a monument's builders designed individual parts to work together to convey a coherent iconographic program. In other cases, the significance was left ambiguous. Meanings might be layered to appeal to a broader audience, to heighten the religious experience, or to link piety with displays of status. In some instances, the meaning of a specific element may have shifted over time. In others, the physical form itself was altered by later rulers and builders. When considered holistically, many of these monuments call into question conventional categories (such as sacred and profane); they challenge contemporary viewers to think in different ways. This chapter focuses on just eight artworks—seven architectural monuments and one bronze sculpture—in order to explore such nuances.

Monumental Java: Borobudur and Prambanan

Throughout the eighth and ninth centuries, maritime trade routes across the Indian Ocean, Java Sea, and various other seas south of China—the same pathways that helped spread Buddhism and Hinduism in the fifth century—continued to grow in importance. Because the Strait of Malacca (**Map 7.1**) was the main waterway between India and China, the Indonesian islands south of the strait benefited from increased trade. In this environment the Shailendra and Sanjaya dynasties came to power in central Java. The rulers displayed their newfound

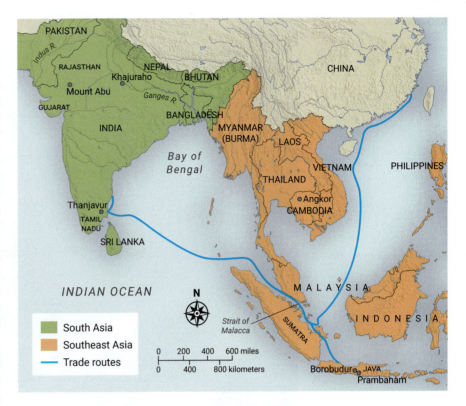

Map 7.1 **South Asia and Southeast Asia,** showing major early trade routes and current nation states.

wealth and political might through the construction of, among other things, two massive monuments located only 20 miles (around 32 km) apart from each other: the Buddhist monument of Borobudur and the Hindu temple complex of Prambanan.

Measuring 387 feet (117.96 m) per side and featuring more than 1½ miles (over 2.4 km) of **relief** carvings, Borobudur is the largest Buddhist monument in the world (**Fig. 7.1**, p. 142). Although scholars do not agree on the exact dating of Borobudur, it was clearly the product of Shailendra royal patronage and most likely was constructed during the early ninth century. It would have taken years, if not decades, to build. Borobudur's unique form raises many questions, foremost among them its original function. Did its builders intend it as an elaborate ***stupa***, a three-dimensional **mandala**, an experiential embodiment of the three realms of Buddhist existence, or a representation of Mount Meru, the sacred mountain at the center of the universe in both Buddhist and Hindu cosmology? Or is it, as most scholars currently believe, multivalent—that is, some combination of all these things and more?

Borobudur is an open-air structure (there is no interior) built on a natural hill. Constructed from slabs of volcanic stone, it is comprised of a base and eight upper levels—five square terraces and three round ones—capped by a large *stupa*. A central staircase on each of the four sides allows pilgrims to ascend, descend, and perform ***pradakshina*** around each level. From above, Borobudur takes the shape of a mandala. From the side, it resembles a stone mountain, with 432 statues of **buddhas** looking outward from niches on the **balustrades**. The Shailendras, whose name means Lords of the Mountain, built Borobudur in south central Java between two pairs of volcanoes. Perhaps the five peaks—four natural and

relief raised forms that project from a flat background.

stupa a mound-like or hemispherical structure containing Buddhist relics.

mandala typically comprised of concentric circles and squares, a spiritual diagram of the cosmos used in Hinduism, Buddhism, and other Asian religions.

pradakshina in Hindu, Buddhist, and Jain practice, the ritual of walking around (circumambulating) a sacred place or object.

buddha a buddha is a being who has achieved the state of perfect enlightenment called Buddhahood; the Buddha is, literally, the "Enlightened One"; generally refers to the historical Buddha, Siddhartha Gautama, also called Shakyamuni and Shakyasimha.

balustrade a decorative railing, especially on a balcony, bridge, or terrace.

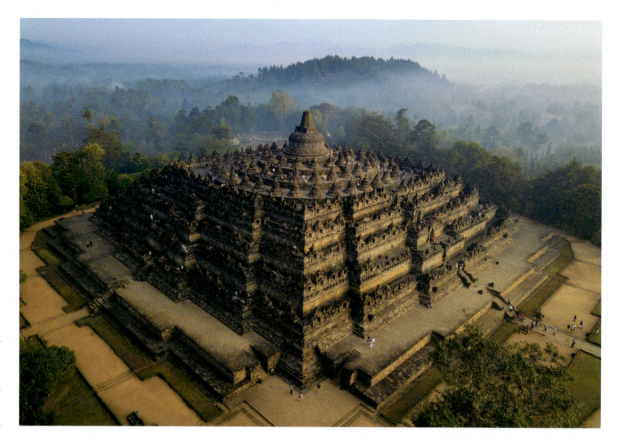

7.1 Borobudur, Java, Indonesia, Shailendra dynasty, early ninth century.

auspicious signaling prosperity, good fortune, and a favorable future.

jatakas stories of the Buddha's past lives.

7.2 Cross-sectional diagram of Borobudur.

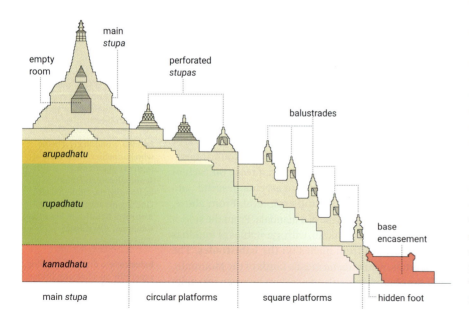

the one constructed at Borobudur—refer to the five peaks of Mount Meru, with the sea around Java representing the cosmic ocean surrounding the sacred mountain. If so, then the monument would equate the Shailendras' kingdom with the cosmos and align the earthly and spiritual realms.

Adding to the monument's spiritual import, numerology seems to have played a key role in Borobudur's design. Eight, representing infinity, is one of the most sacred of numbers in Hindu-Buddhist belief systems, and 108 (or 1,008) is a longstanding **auspicious** number. Its significance can be traced back to ancient Indian Vedic traditions. One belief is that the number symbolizes

victory, or *jaya* in Sanskrit, because the syllable "ja" has a numerological value of 1 and "ya" has a value of 8. Multiples of the numbers 8 and 108 recur throughout Borobudur, sometimes in visible ways and sometimes in subtle ways or even in ways a visitor cannot readily discern, a reminder that an artwork's meaning, particularly in Southeast Asian culture, often goes beyond the visible. For example, seventy-two perforated *stupas* containing images of buddhas seated in meditation are arranged on the three circular terraces; adding them to the 432 buddha sculptures on the balustrades yields 504 buddha statues in total. A pilgrim who makes the journey to the central *stupa* at the top and then back down would thus walk past 1,008 buddhas.

Borobudur's design may also represent the three realms of Buddhist existence (**Fig. 7.2**). The base corresponds with the realm of desire (*kamadhatu*), the state that precedes the spiritual journey. It features 160 relief carvings (another multiple of 8) displaying karmic laws of cause and effect such as "speaking ill of others leads to ugliness." At some time shortly after construction, the reliefs were covered from view by a second wall (labeled in **Fig. 7.2** as the "base encasement"), perhaps for religious symbolism, but more probably for structural reasons.

The five square levels in the middle parallel the realm of form (*rupadhatu*), in which one is no longer guided by desire, but the world is still shaped by form. The high walls on either side of the path obstruct the view outward, encouraging devotees to focus on the walls' reliefs. The outer wall panels depict *jatakas*, while the inner walls recount the life of the historical Buddha, Shakyamuni, as well as the adventures of virtuous people as they search for spiritual awakening. One narrative is depicted along

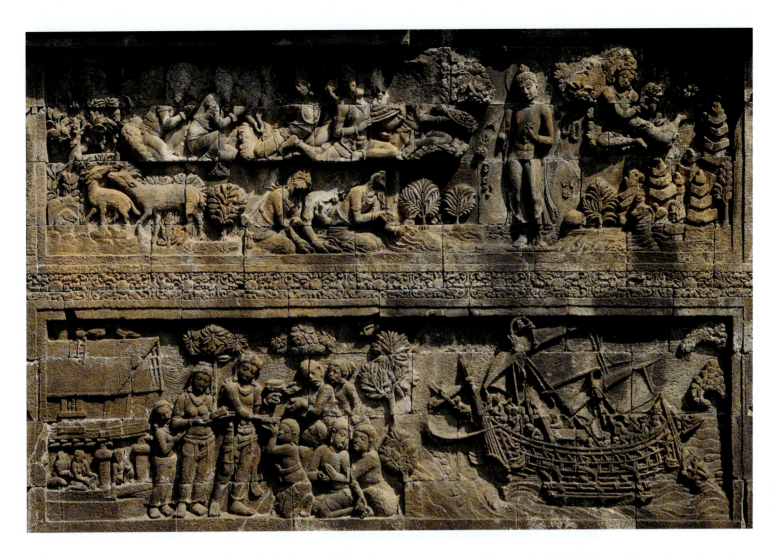

the inner walls' upper **register**, and another is illustrated below, so that two separate stories run concurrently. In the segment illustrated here (**Fig. 7.3**), the top register shows Shakyamuni (identifiable by his halo and ***ushnisha***) bathing in a river and being attended to by gods. In the bottom scene, two virtuous ministers, Hiru and Bhiru, arrive by boat at the country of Hiruka and are greeted by locals. The scenes are carved in a detailed and highly animated fashion, with figures crowded together. Note, for example, in the lower register, the lively interaction between the locals and the two ministers. Even the ship on which the ministers arrived—shown at right—is depicted at an angle to convey movement.

The complexity and density of the carvings on these middle levels contrast with the sense of spaciousness on the final three circular terraces, which denote the realm of formlessness (*arupadhatu*). Here, the pilgrim, with a sweeping view over the surrounding landscape, encounters the seventy-two perforated *stupas*, each containing a statue of a buddha sitting in meditation (**Fig. 7.4**). Originally, only glimpses of the buddhas were visible through the square or diamond-shaped openings. (When Borobudur was restored, several *stupas* were left uncovered so that modern visitors could admire the buddha sculptures in full.) The final, large central *stupa* is solid, except for a small empty chamber in the middle. Whether that chamber originally held a sculpture or was empty is

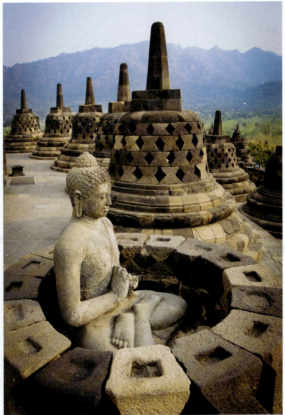

7.3 ABOVE **First gallery wall, Borobudur,** north side, east end, Java, Indonesia, Shailendra dynasty, early ninth century.

7.4 LEFT **Exposed buddha statue with perforated *stupas* in the background,** Borobudur, Java, Indonesia, Shailendra dynasty, early ninth century.

register a horizontal section of a work, usually a clearly defined band or line.

ushnisha one of the thirty-two markers of a buddha or a *bodhisattva*; a protuberance from the head, usually a topknot of hair.

unclear. Regardless, the final *stupa*'s lack of any visible sculpture (not even a glimpse) suggests that it represents the Buddha's ultimate release from human form.

Although Borobudur's primary concerns seem to be spiritual, aspects of the monument's reliefs also reflect life in ninth-century Java. Particular trees and animals included throughout the scenes provide the narratives with a specifically Javanese setting. Clothing, architecture, and ships, too, are particular to Javanese **material culture** of the period. For example, in the scene of Hiru and Bhiru arriving at Hiruka (see **Fig. 7.3**), the ministers' ship is meticulously depicted with masts, outriggers, crew, and passengers. In total, eleven seagoing vessels are depicted at Borobudur, reflecting the importance of maritime trade to the Shailendra dynasty and providing a wealth of information for maritime historians. The detail and technical accuracy are such that in 2003 these images were the basis for an international team's replica of an early Javanese ship that sailed from Java across the Indian Ocean and around the Cape of Good Hope to Ghana. In many respects, Borobudur's significance to contemporary scholars in the fields of art, religion, and shipbuilding remains as multivalent as it was for ninth-century pilgrims.

In 832, a prince of the Sanjaya dynasty usurped the Shailendra throne. Because the two dynasties were linked by marriage, some scholars consider them branches of the same royal line. Certainly, there were many similarities between the two Javanese powers. Like the Shailendras, Sanjaya rulers used monumental religious architecture to display their power and to connect the earthly and spiritual realms. They built a series of Hindu temples (called *chandis* in Indonesia), the most impressive of

which was the Prambanan complex, datable by inscription to 856 CE. A mere 20 miles (around 32 km) from Borobudur, Prambanan employs the same hard, volcanic stone that was used for the earlier Shailendra monument. The complex, which—like Borobudur—is no longer used for worship, originally consisted of eight temples on a central raised platform surrounded by 224 smaller shrines arranged in rows (**Fig. 7.5**). The raised platform and surrounding smaller shrines were set within a walled enclosure marked by four gateways. That enclosure was

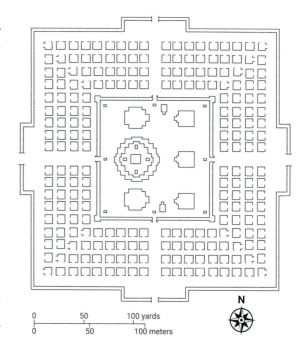

0 | 50 | 100 yards
0 | 50 | 100 meters

N

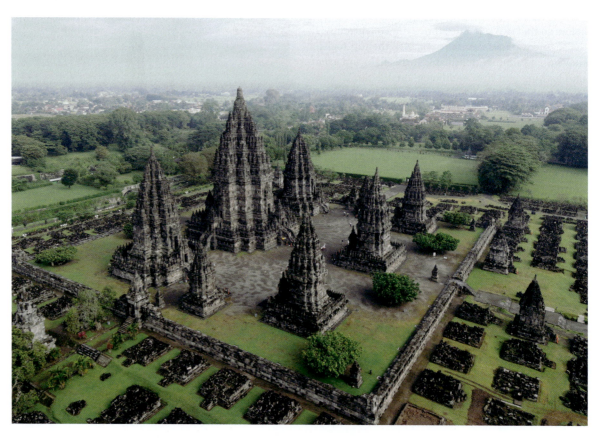

7.5 ABOVE RIGHT **Plan of Prambanan temple complex,** Java, Indonesia, Sanjaya dynasty, *c.* 856 CE.

7.6 RIGHT **Prambanan temple complex,** Java, Indonesia, Sanjaya dynasty, *c.* 856 CE. The Shiva temple is in the center.

itself set within another larger walled enclosure, now mostly gone, which must have contained buildings made of more perishable materials.

Among the eight temples on the central raised platform, the three main ones, arranged in a row facing east, are dedicated to the Hindu gods Brahma, Vishnu, and Shiva. Together these three male deities form the *trimurti*, or triple supreme divinity, representing creation (Brahma), preservation (Vishnu), and destruction (Shiva). In Javanese Hinduism of the period, Shiva was the most powerful of the three; thus, his temple is the tallest and located in the middle (**Fig. 7.6**). Directly across from each temple is a smaller shrine to the deity's sacred mount, or animal vehicle. Today these smaller shrines are partially in ruins; only the statue to Shiva's sacred mount, the bull Nandi, survives.

Javanese Hindu temples functioned similarly to early South Asian Hindu temples (see Figs. 3.17–3.19): they served as homes of the gods, symbols of Mount Meru, and places for devotees to receive **darshan**. Thus, the temples share many of the same architectural features. The small central room housing the main devotional image of the deity (the **garbhagriha**) is topped by a steep tower resembling a mountain peak. Each temple sits on a **plinth** and features relief carving on the exterior. Notably, the staircases leading up to the plinths feature high first steps and railings with carvings of auspicious sea-creatures called *makara*. These two details, along with the remains of irrigation channels at the site, have led some archaeologists to speculate that the central platform may have been deliberately flooded with water during special occasions so that the temples would appear as mountain peaks floating on the cosmic ocean. This use

of water to amplify the affective power and sacredness of the monument recalls its use at other sites throughout South and Southeast Asia, including Mamallapuram (Fig. 5.11) and Udayagiri (Fig. 3.16).

Each Prambanan temple is encircled by balustrades, and the inner walls of the balustrades are decorated with extensive relief carvings, which devotees would view while circumambulating the structure. On the Shiva and Brahma temples, these carvings depict scenes from the *Ramayana*, the Hindu epic about the god Rama's quest, with the help of his loyal brother and an army of monkeys, to rescue his wife Sita from the demon Ravana. Rama is the seventh *avatar*, or incarnation, of Vishnu, and was born a prince of the kingdom of Ayodhya. The *Ramayana*, which begins with prince Rama's exile from home and ends with his triumphant return to become king, is one of the most commonly illustrated stories in the art of both South Asia and Southeast Asia (see Figs. 11.16, 14.0 and 14.8). The Prambanan relief sequence provides an important early example. In the scene reproduced here (**Fig. 7.7**), Ravana, recognizable by his multiple heads and arms, abducts Sita. The bird Jatayu (at left) valiantly tries to stop Ravana, but he is mortally wounded by the antagonist's spear. Note the stylistic similarities between these images and the earlier reliefs at Borobudur (see **Fig. 7.3**): in both, the figures are expressive and animated, and plants and animals create a Javanese setting for the story.

Prambanan seems to have been abandoned in the mid- to late tenth century, when the Sanjaya dynasty moved its capital to eastern Java. The structures fell into disrepair in the centuries thereafter, while new temples arose in east Java. By contrast, the *Ramayana* remained popular

darshan the auspicious devotional act of seeing and being seen by a deity, holy person, or sacred object in Hinduism.

garbhagriha a Hindu temple's inner sanctum, typically a small, dark space, where the main icon of a deity is housed.

plinth a base or platform upon which a structure rests.

7.7 Scene from the *Ramayana*, Ravana abducting Sita while Jatayu unsuccessfully tries to save her, relief carving on the balustrade of the temple dedicated to Shiva, Prambanan temple complex, Java, Indonesia, Sanjaya dynasty, *c.* 856 CE. Photograph by W. G. N. van der Sleen, 1929.

in Javanese culture long after the Sanjaya dynasty ended and even after Hinduism stopped being widely practiced on the island. The epic is still, for example, a beloved subject of Javanese shadow puppet theater.

Art of the Chola Empire, 848–1279

At roughly the same time that the Sanjaya dynasty was constructing Prambanan, the Chola dynasty (848–1279) was coming to power in the Tamil Nadu region of southern India (see **Map 7.1**). The Cholas reached their height during the reign of Rajaraja I (ruled 985–1014). As soon as he ascended the throne, Rajaraja began expanding his empire, conquering more of south India as well as Sri Lanka (see Chapter 5) and the Maldives, and sending a diplomatic mission to Java. In 1003–4, the same year he took the title Rajaraja ("King of Kings") in honor of his military victories, he initiated construction of the Rajarajeshwara temple (also spelled as Rajarajeshvara, **Fig. 7.8**). The temple, dedicated to the god Shiva, is located in Rajaraja's capital, Thanjavur. At 100 feet (30.48 m) per side and 216 feet (65.84 m) high, the Rajarajeshwara temple, today also called the Brihadeshwara temple, was nearly five times bigger than any previous south Indian temple. It was the tallest structure of its day in the region and provided visible proof of Rajaraja's power.

7.8 Rajarajeshwara temple, Thanjavur, India, Chola dynasty, c. 1003/4–1010.

To appreciate the significance of the Rajarajeshwara temple, it helps to understand the development of Hindu temple architecture in South Asia. Regardless of where or when they are made, temples conform to certain religious specifications and principles. Ancient and medieval Hindu texts lay out the specific **iconography** of gods and goddesses, the ideal proportions of buildings, and the rules for selecting a temple site, among other requirements. At the same time, local conditions—from available materials to prevailing stylistic norms—affect designs. Within South Asia, temples had developed distinct regional styles by the eighth century. Contemporaneous texts labeled these styles Northern (Nagara), Southern (Dravida), and Mixed (Vesantara). Like all such classification structures, these categorizations are imperfect. They obscure other regional variations, and in the past, particularly during the British colonial period, they were conflated with racial classifications (Aryan and Dravidian) that are now recognized as deeply problematic. Nonetheless, the Nagara and Dravida categories, through their distinct plans and **elevations**, provide a useful introduction to the visual vocabulary of Hindu temples in South Asia (see **Fig. 7.9**). The Nagara and Dravida styles are commonly viewed as having reached their height of architectural

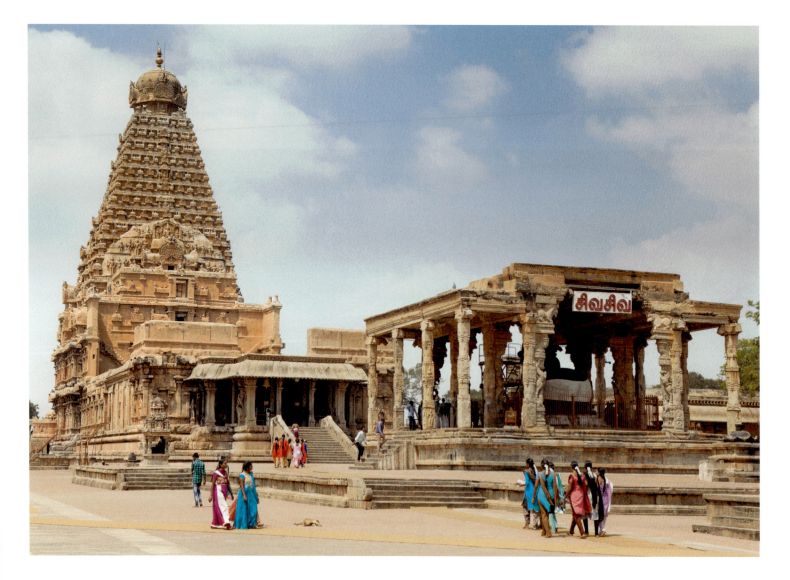

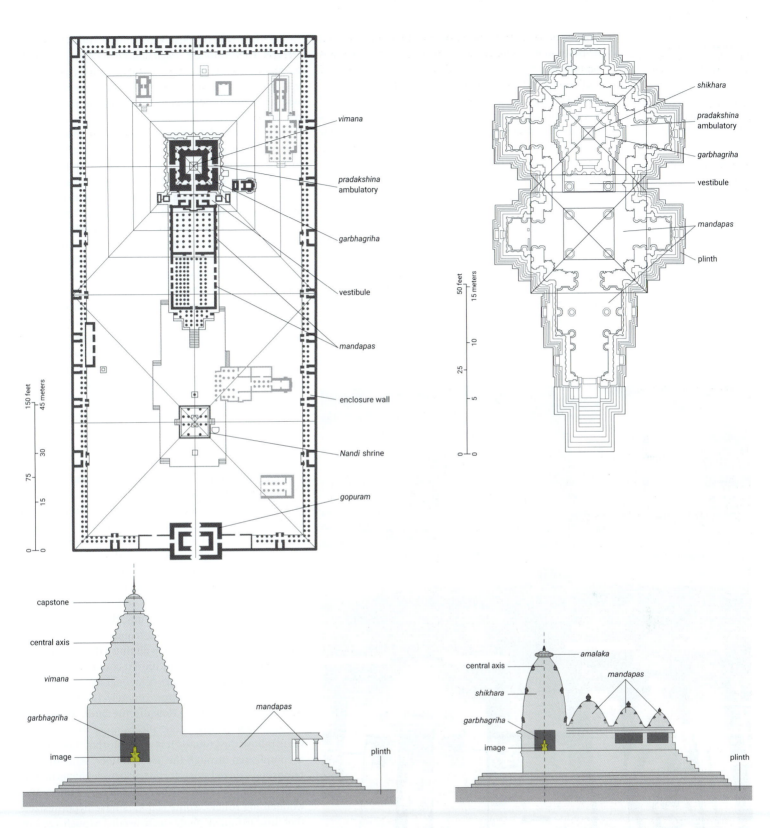

vimana

pradakshina
ambulatory

garbhagriha

vestibule

mandapas

enclosure wall

Nandi shrine

gopuram

shikhara

pradakshina
ambulatory

garbhagriha

vestibule

mandapas

plinth

capstone

central axis

vimana

garbhagriha

image

mandapas

plinth

central axis

shikhara

garbhagriha

image

amalaka

mandapas

plinth

accomplishment around the year 1000, corresponding with the Rajarajeshwara temple's construction in southern India and the Chandela dynasty temples at Khajuraho in northern India (see **Figs. 7.13** and **7.14**). Thus, in addition to its impressive size, the Rajarajeshwara temple is widely viewed as exemplifying Dravida temple design.

In common with other south Indian Hindu temples, Rajaraja's temple is enclosed in a large walled compound. Originally surrounded by a 45-foot-wide (13.72 m) moat, the complex has an east-facing gateway topped by a tower (called a **gopuram**; see the temple plan, top left of **Fig. 7.9**). Precisely laid out, its courtyard is twice as long as it is wide. If divided into two equal squares, the pavilion housing the god Shiva's sacred mount, the bull Nandi, is located in the middle of the front square, and the temple's inner sanctum (*garbhagriha*) marks the center of the other.

Rajarajeshwara's main temple structure is elevated on a 15-foot (4.57 m) high plinth, and the walls rise up another 45 feet (13.72 m), punctuated by over-life-sized

7.9 Comparison of north and south Indian Hindu temples.

TOP LEFT Plan of Rajarajeshwara temple, Thanjavur, south India, Chola dynasty, c. 1003/4–1010. Lighter gray areas are ancillary structures, many of which are later additions to the complex. BOTTOM LEFT Elevation of Rajarajeshwara temple. TOP RIGHT Plan of the Kandariya temple, Khajuraho, north India, Chandela dynasty, c. 1035. BOTTOM RIGHT Elevation of Kandariya temple.

mandapa a porch or hall located before the inner sanctum of a Hindu temple.

vimana the tower above the inner sanctum of a Hindu temple in south India.

stupi the finial, often shaped like a bulbous pot, situated at the high point of a Hindu temple.

7.10 Exterior wall, Rajarajeshwara temple, Thanjavur, India, showing the Hindu god Shiva in his beautiful form in the lower niche and Shiva as Tripurantaka in the above niche; a large door guardian is visible on the left. Chola dynasty, c. 1003/4–1010.

images of Shiva in his various manifestations as well as other deities and guardian figures. Several porches (**mandapas**) lead to the *garbhagriha*, which is topped by a tall tower (called a **vimana** in south India). In general, Dravida temples emphasize geometry, with flat walls and a tower made up of clearly delineated horizontal tiers topped by a dome-shaped capstone (called a **stupi**). At Rajarajeshwara, the 216-foot (66-m) tall *vimana* is comprised of thirteen tiers. Dravida *mandapas* tend to be long, pillared halls capped with flat roofs, and the exterior figural sculptures tend to be frontally oriented and housed in their own niches, as is the case here. (By contrast, Nagara temples appear organic, with undulating walls covered in sculpture and gently curving, vertically oriented towers, such as in **Fig. 7.13**.)

The Rajarajeshwara temple has an enclosed ambulatory for circumambulation around its sanctum. This inner pathway is divided into **bays** adorned with **fresco** painting. Its *garbhagriha* is just 24 square feet. No matter how grand the structure, Hindu sanctums traditionally are not designed to accommodate congregations of people;

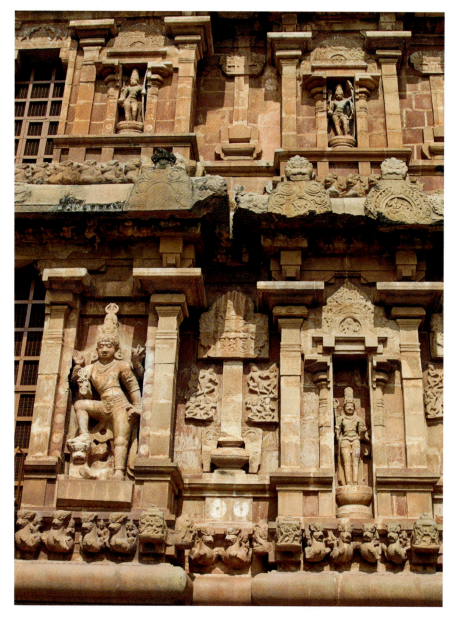

rather, their sole purpose is to hold the main image of the god. The monolithic **linga** housed in Rajarajeshwara's *garbhagriha* is 12 feet (3.66 m) high, so tall that priests stand on a second-story gallery to anoint it ceremonially with milk and other sacred substances in preparation for *darshan*.

Every aspect of the temple, beginning with its impressive size, was designed to fuse Rajaraja's power with Shiva's. A large, outer, walled enclosure originally held both Rajaraja's palace compound and Shiva's temple compound, thus equating the king's home with the god's. While the first level of sculptural niches on the exterior walls contains a variety of forms of the god alone or with his consort (bottom of **Fig. 7.10**), those on the upper level repeatedly portray Shiva as Tripurantaka ("Destroyer of Three Cities"), making a connection to Rajaraja's military prowess (top of **Fig. 7.10**).

The Rajarajeshwara temple represented Rajaraja's sovereignty more than just symbolically. The technical know-how, labor, and material resources necessary for its construction were tangible markers of his power. Indeed, so remarkable was the temple's construction that a play, the *Rajarajeshwara Natakam*, was written about it and performed at court. Unfortunately, the play's text does not survive, but by drawing from a variety of other sources, including physical evidence, Chola-era inscriptions, and later temple construction methods, we can re-create the general steps of this temple's construction.

The huge temple was constructed of granite, quarried and transported from more than 30 miles (nearly 50 km) away. At the site, stonemasons carefully shaped the blocks. As in the construction of most pre-modern Indian temples, no mortar was used. Instead, the blocks were secured through precise fit and the downward transfer of weight as they were placed on top of one another. Occasionally, iron clamps and beams further secured the pieces. Medieval Hindu temple architecture employed **post-and-lintel** construction. Thus, the construction of the temple's tall, tapering tower required very thick walls, and **corbeling** was employed to diminish the hollow space between the walls gradually until it could be covered by a capstone. Rajarajeshwara's octagonal *stupi*, comprised of four slabs weighing approximately 20 tons each, is particularly impressive. How did the builders manage to raise such massive stone pieces more than 200 feet (60 m) above the ground? It is probable that this feat was accomplished through the use of timber, sand, or mud ramps constructed at low inclines. Then elephants moved the slabs up the ramps with the aid of rope pulleys and wooden log rollers. Some scholars have hypothesized that three to four elephants were needed to push a 20-ton rock up a ramp of reasonable incline.

The temple's importance went beyond religion and politics. It was also an economic and cultural institution with more than 800 employees, including dancing girls, musicians, priests, watchmen, accountants, astrologers, and jewel appraisers. Rajaraja required all villages, including those in newly conquered Sri Lanka, to give a percentage of their income to support the temple. In addition, he and his nobles gifted land grants, war booty, and gold and jewels to the temple, which was the city's

main banking institution, granting loans at a 12.5 percent interest rate. We know these details because, like most Chola temples, its walls bear lengthy inscriptions detailing administrative and financial procedures. Indeed, the records are so specific that they provide the name and address of each temple dancer.

Rajarajeshwara's inscriptions also record the gifting of sixty metal images to the temple, twenty-two donated by Rajaraja himself, and the rest by his family and nobles. Most were bronze icons of Hindu deities. The use of such images at south Indian temples began during the late Pallava dynasty (ninth century), but bronze statuary did not become a major art form until the Chola dynasty (848–1279). Under the patronage of Chola rulers, particularly Queen Sembiyan Mahadevi (c. 941–1001), artists produced magnificently detailed 2- to 3-foot-high (around 60 to 90 cm) bronze sculptures using the **lost-wax casting** technique. Intended as mobile forms of deities, these sculptures were ceremonially bathed, anointed with sacred substances, richly clothed, and adorned with jewelry and garlands before being viewed. While the main image in the temple's inner sanctum is large and immobile, these smaller bronze images could be carried on palanquins (an enclosed litter carried on poles) or pulled in wooden chariots. Accompanied by a retinue of people, they were processed around the city during festivals and moved to different parts of the temple complex for ceremonies. Their popularity grew alongside changes to south Indian temple compounds, the scope of which increased from the Chola period onward. Eventually reaching the size of small towns, complexes might include multiple smaller shrines, halls, and water tanks in addition to the main temple (see Figs. 10.15–10.18).

The most iconic Chola bronze form is that of Shiva Nataraja, or Shiva as the Lord of Dance. In his manifestation as Nataraja, Shiva simultaneously creates and destroys the universe, embodying the union of opposites represented by the four-armed god. After this visual form of the god Shiva developed during the tenth century, it became—and remains—an extraordinarily popular way to depict him. This example (**Fig. 7.11**) dates to the eleventh or twelfth century and is typical of Shiva Nataraja bronzes from the Chola period. In it, Shiva's left hand holds the fire of destruction, while his right hand holds the drum of creation. With his other two hands he makes the fear-not *mudra* (see Fig. 3.11) and points to his upraised foot, under which the worshiper may seek refuge. While he dances, he tramples on a demon who embodies the ignorance that stops one from gaining liberation. Shiva's dreadlocks splay out, showing his movement, but his face remains calm, representing his tranquility. The circle of flames around him indicates the boundaries of the cosmos and also symbolizes *samsara*, the cycle of birth, death, and reincarnation.

The sculpture is balanced visually as well as spiritually: the circle of flames provides a stabilizing, containing frame for Shiva's dynamic, open form. Yet, as harmoniously as the sculpture's meaning and form seem to come together, scholars cannot prove that the current understanding of the iconography dates back further than the thirteenth century. The sculptural form may have had a

7.11 **Shiva Nataraja,** south India, Chola period, eleventh–twelfth century. Bronze, height 32⅜ in. (82.3 cm). Museum Rietberg, Zurich.

different religious meaning when it was first developed. However, once the accepted iconography fell into place, it clearly stuck. Chola bronzes remind us that just as religion shapes art, art also shapes religion.

North Indian Temples

In the same period that the Chola Empire in southern India was reaching its height, a regional north Indian power, the Chandela dynasty (831–1308) was building a series of temples at its capital, Khajuraho. During the early tenth century, the ruler Yashovarman Chandela (ruled c. 925–950) stole a monumental stone statue of Vishnu from his regional overlord, brought it back to Khajuraho, and founded a temple to house the image of the deity. With this extraordinary act of defiance, Yashovarman made it clear that he was the new king, established a home for Vishnu in his realm, and also set in motion a pattern of temple construction at Khajuraho. Over the century that followed, royal Chandela patronage of such construction

bay a space between columns, or a niche in a wall, that is created by defined structures.

fresco a wall or ceiling painting on wet plaster (also called true fresco or *buon fresco*); wet pigment merges with the plaster, and once hardened the painting becomes an integral part of the wall; painting on dry plaster is called *fresco secco*.

linga an abstract representation of the Hindu god Shiva that denotes his divine generative energy.

post-and-lintel a form of construction in which two upright posts support a horizontal beam (lintel).

corbeling an overlapping arrangement of wood, stone, or brick wall projections positioned so that each course extends farther from the wall than the course below.

lost-wax casting a method of creating metal sculpture in which a clay mold surrounds a wax model and is then fired; when the wax melts away, molten metal is poured in to fill the space.

mudra a symbolic gesture in Hinduism and Buddhism, usually involving the hand and fingers.

shikhara literally, "mountain peak," the tower above the inner sanctum of a Hindu temple, used specifically for north Indian temples.

amalaka a stone disk shaped liked the amala (a lobed fruit said to have purifying medicinal powers), that sits atop the *shikhara* of a north Indian Hindu temple.

molding a decorative architectural feature that covers the transition between two surfaces, such as the dividing line from one story, portal, or window framing, to another, or to the roofline of a building.

ambulatory a place for walking, especially an aisle around a sacred part of a religious space.

aniconic the indirect visual representation of divine beings through symbols or abstract images.

7.12 Kandariya temple,
Khajuraho, India, Chandela dynasty, c. 1035.

activity flourished, with reportedly eighty-five Hindu and Jain temples built there. Twenty-five remain, with fragments of another twenty-five visible. The Kandariya temple, also called the Kandariya Mahadeva temple, was built by Vidyahara (ruled *c.* 1003–35) and is dedicated to the god Shiva. It is the largest temple at the site and is considered by many art historians to mark the high point of Nagara temple design. Its construction, which probably took over a decade, was completed around 1035.

Like other Nagara temples, Kandariya (**Fig. 7.12**) is a freestanding structure elevated on a high plinth and composed of several *mandapas* leading to the *garbhagriha*. The tower (called a **shikhara** in north India) rises directly above the sanctum, the two together acting as an axis connecting the earth and heavens. The tower is slightly curved and topped by a fluted, fruit-shaped **amalaka**. At Kandariya, the 98-foot-tall (29.87 m) *shikhara* is composed of eighty-four smaller towers of the same curved shape but at different scales and clustered together. The repetition of shapes and patterns at various scales also appears in nature, and it gives an organic appearance and sense of verticality to the mountain-like tower. Indeed, successively higher pyramidal roofs cap the porch and halls, resembling an entire mountain range in miniature, leading up to the *shikhara*, the temple's tallest peak.

Unlike Dravida temples, which tend to emphasize geometry and the clear delineation of individual elements, Nagara temples stress movement and the interconnection of elements (see Fig. 7.9 for a comparison of the two

styles). The temple's exterior walls alternately project and recess, creating spaces for numerous sculpted images, adding to the structure's organic feel, and representing the divine energy emanating from the sanctum. The walls below the roofs are comprised of two main horizontal zones. A high base decorated with rows of **moldings** reaches 13 feet (3.96 m) above the plinth. The section above this base, pierced by projecting balconies, features three horizontal bands of sculpted figures. Devotees visiting the temple would, at some point, circumambulate the exterior to take in these sculptures. Ascending the stairs, they would also move through the porches and halls, to circumambulate in the interior through the enclosed **ambulatory**. When standing at the vestibule to the *garbhagriha*, the devotee would receive *darshan* from the main representation of the deity (see **Fig. 7.13**). At Kandariya, which is dedicated to Shiva, that central devotional image is a *linga*, Shiva's **aniconic** and most powerful form.

Khajuraho's temples are renowned for their figural sculptures carved in **high relief**, which include images of deities, *apsaras*, *mithunas*, and erotic groups. On Kandariya's exterior walls, there are 646 figures in total, each about half life-size (another 226 figures decorate the interior). On the sculptural bands adorning the undulating exterior walls, front-facing gods mark the outward-most projections and are flanked by *apsaras*, many in complicated twisting postures (at the left and right edges of **Fig. 7.14**). The female celestial figures, with

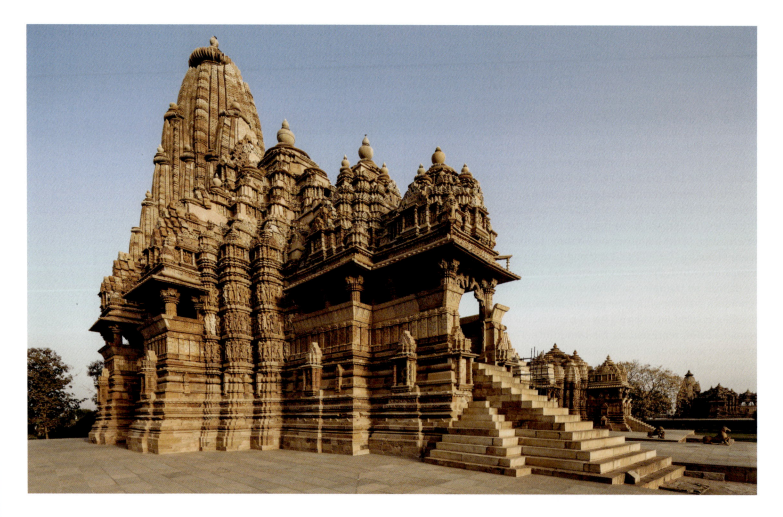

their sheer clothing, curvaceous forms, elongated eyes, and arched eyebrows, highlight the medieval Indian sculptors' skills as well as testifying to the importance of beauty in the culture. In ancient and medieval South Asia, female beauty was defined by large, lotus-petal-shaped eyes, graceful limbs, a slim waist, and full hips and breasts. Beautiful women were seen as auspicious and thus central to successful art and architecture. As one medieval text explains, "As a house without a wife, as a frolic without a woman, so without a figure of a woman the monument will be of inferior quality and bear no fruit." The text then describes sixteen different types of women that should be represented on a monument, from a mother with her child to a woman looking into a mirror. Among the various female types that grace the temples' walls, the latter seems to have been a favorite of Khajuraho's stone carvers, although no two *apsaras* are exactly the same.

Even though they account for only a small fraction (less than ten percent) of the total sculptures, the erotic scenes (center of **Fig. 7.14**) found on Khajuraho's temples have received abundant attention. Various theories attempt to explain them: they may relate to esoteric religious practices; they may represent the intense desire of a devotee's love for the divine; they may symbolize generative energy; or they may be an architectural pun showing the builders' knowledge of Sanskrit texts that describe how temple joins should come together as beautifully as a man and woman on their wedding night. The strong link between fertility, sexuality, and auspiciousness

means that similar, but less explicit, imagery appears on many Indian monuments and was an accepted and valued part of visual culture during this period in South Asian history. In fact, according to ancient Indian aesthetic theory, love—including eroticism—ranks first among the nine aesthetic emotions (*rasas*) that the arts should evoke. Humor, another one of the nine, is also represented on Khajuraho's temples. In one sculptural detail, for example, a monkey playfully pulls at a staff held by a male *mithuna* figure.

Khajuraho's erotic scenes differ depending on their placement on the temples. For example, a **frieze** on one temple's plinth depicts a scene of bestiality between two men and a horse. That scene almost certainly had a meaning quite distinct from the elegant loving couples on the upper part of the temples. Some of the erotic sculptural groups (such as those on the lower center of **Fig. 7.14**) seem to take the form of *yantras* (geometric diagrams, often triangular or circular in form, used as an aid to meditation), suggesting they had a specific religious or protective function. Most likely, no single explanation can account for all of the sexually suggestive imagery, nor would all worshipers have interpreted it in the same way. Once again, like Borobudur (see **Fig. 7.1**) or the Great Relief at Mamallapuram (see Fig. 5.11), the multivalence of the imagery was probably intentional, with the ambiguity and layers of meaning serving to heighten the worshipers' experiences. In addition, the aesthetic and religious experiences provided by Khajuraho's temples reflected the status of their royal patrons. Complex

7.13 ABOVE LEFT **Interior view looking toward the *garbhagriha* and *linga*,** Kandariya temple, Khajuraho, India, Chandela dynasty, *c.* 1035.

7.14 ABOVE RIGHT **Figural sculpture from the exterior wall,** Kandariya temple, Khajuraho, India, Chandela dynasty, *c.* 1035.

high relief raised forms that project far from a flat background.

apsara a celestial maiden.

mithuna in South Asian cultures, an amorous couple, representing fertility, and considered auspicious.

frieze any sculpture or painting in a long, horizontal format.

religious monuments served not only to reinforce the Chandela kings' piety and close links to the gods, but also to establish the rulers as connoisseurs who appreciated the intricacies of the visual arts and Sanskrit literature as embodied in the temple's design.

Not all of the religious structures at Khajuraho were Hindu temples patronized by Chandela rulers. During the tenth and eleventh centuries, wealthy Jain members of the kingdom's merchant community commissioned a number of Jain temples (for more on the Jain religion, see Chapter 3, pp. 69–70). The six surviving temples are similar in material, layout, and style to Khajuraho's Hindu temples. The main difference is that the sculptural decoration on the Jain structures avoids explicitly sexual imagery.

The height of medieval Jain temple construction can be found at the site of Mount Abu in the northwest Indian region of Rajasthan (see **Map 7.1**). There, five temples, commonly called the Dilwara temples after a nearby village, were constructed between the eleventh and fourteenth centuries. The earliest and most elaborate of them is the Vimala temple, also called the Vimal Vashi temple (**Fig. 7.15**). It was founded in 1032 by its namesake, Vimala, a high-ranking minister of the Solanki king Bhima I (ruled 1022–63). The Solanki dynasty (mid-tenth to mid-thirteenth century) controlled a number of strategic ports in Gujarat, the region directly south of Rajasthan. These ports facilitated trade with various parts of Asia, which in turn made the Solankis and their ministers wealthy. Vimala used some of his wealth to build a temple at Mount Abu in honor of the first Jina or "Spiritual Conqueror," Rishabhanatha (also called Adinatha). Sources suggest that Vimala's temple was constructed in black stone and relatively plain compared to the elaborately carved white marble temple that currently exists (**Fig. 7.15**). When and how the architectural transformation of the temple happened is debated. Some scholars believe the temple was rebuilt circa 1300 after being destroyed by invading armies, whereas others suggest that it was expanded and renovated over multiple building campaigns, beginning around 1150. There is, however, general agreement that at least some of the layout and design are based on the original 1032 temple.

The Vimala temple is similar to other Nagara temples, such as those at Khajuraho, in several ways: the tower above the inner sanctum has a vertical rather than horizontal emphasis, an abundance of carving provides the temple with a sense of organic exuberance, and sculptural images of *apsaras* as well as female musicians and dancers abound. Nevertheless, it also differs in a few respects.

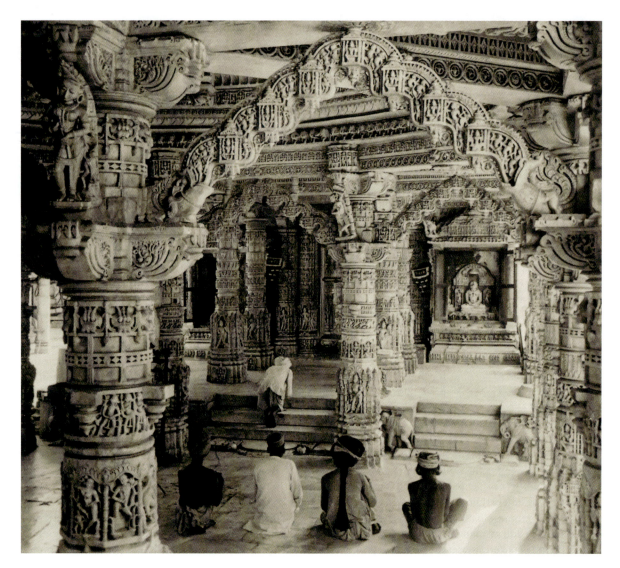

7.15 Interior view, looking toward the central shrine, of the Vimala temple, Mount Abu, Rajasthan, India, Solanki dynasty and later, eleventh–fourteenth centuries. Photograph by Underwood & Underwood, *c.* 1900.

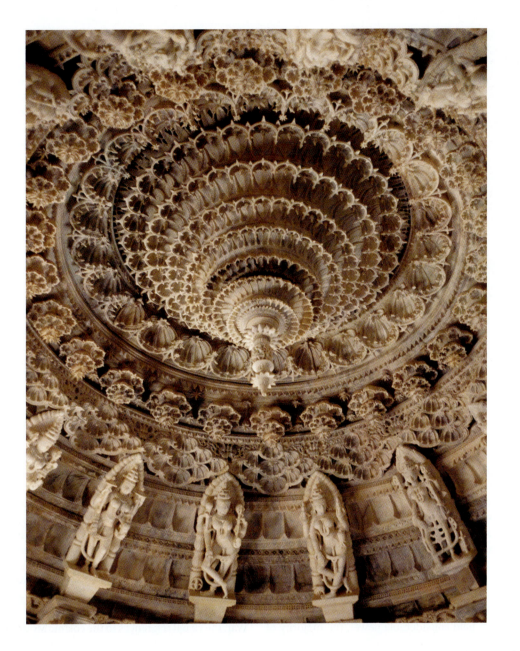

First, the Vimala and other Dilwara temples are located within walled compounds; thus, most of their splendor is invisible from outside. Second, along the wall's interior are fifty-two small shrines, each with a Jina image and a small portico. The main temple, in the middle of the enclosure, has three *mandapas* leading up to the inner sanctum, which houses a sculpture of Rishabhanatha (see **Fig. 7.15**). Third, Jain temples differ from Hindu temples in their religious purpose. Because Jinas are beings who are believed to have reached liberation from existence, they do not inhabit the icons, as Hindu deities are believed to, and temples are not their homes on earth. Instead, the Jina statues' visual presence is a reminder for Jain devotees of the spiritual journey toward liberation, and Jain temples are meant to evoke the overwhelming brilliance and beauty of the celestial realm.

In addition to the intricate carving covering every inch of the temple, the celestial abode is invoked through the visual emphasis on ceilings. The Vimala temple has fifty-five ceilings—three in the main temple and fifty-two in the porches of the small shrines. Each is unique.

Called *vitanas*, meaning canopies of the heavens, the ceilings feature a variety of forms: some are flat, others are vaulted; some contain images of deities, others emphasize geometric and organic ornament. Many feature concentric bands of decoration and elaborate hanging lotus pendants. The temple's octagonal-shaped central hall is capped by a particularly large and ornate vaulted ceiling ringed with sixteen female figures in brackets (**Fig. 7.16**). These women are *vidyadevis*, or goddesses of esoteric knowledge, whose presence adds to the space's auspiciousness as well as its decorative excess. This visual overabundance was intentional—a way of satiating the devotees' senses to help them refrain from overindulging in their day-to-day lives.

Khmer Art of Angkor, 802–1434

Around the time when the Shailendras constructed Borobudur in central Java, the Cambodian Khmer dynasty established its capital, Yasodharapura (City of Glory), on a plain not far from Tonle Sap, the largest freshwater body in Southeast Asia. Yasodharapura,

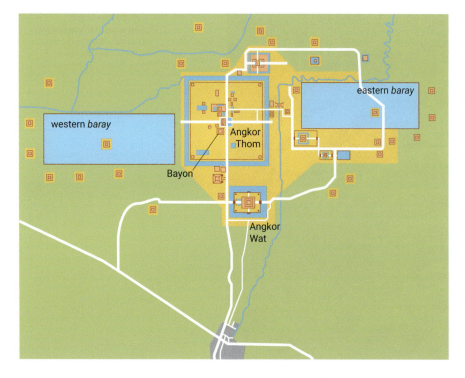

7.17 Plan of Angkor, Cambodia.

bodhisattva in early Buddhism and Theravada Buddhism, a being with the potential to become a buddha; in Mahayana Buddhism, an enlightened being who vows to remain in this world in order to aid all sentient beings toward enlightenment.

7.18 Angkor Wat, Angkor, Cambodia, Khmer dynasty, *c.* 1113–45 or later.

known today as Angkor, served as the capital of the Khmer Empire for six hundred years (*c.* 802–1431). Angkor was among the largest pre-industrial cities in history, with an estimated 750,000 residents, a plethora of temples, and an elaborate water-reservoir system that aided rice production. Rice was the Khmers' largest crop, and agricultural success accounted in part for their longstanding domination of the region. Angkor possessed six huge reservoirs, called *barays*, several of which formed moats around temple complexes (**Fig. 7.17**). These connected to canals, which fed smaller water bodies, thereby ensuring water for farming rice as well as other needs, even during the dry season.

Although the Khmer's ancestors were matrilineal and royal women held considerable power, the majority of Khmer rulers, like those of many societies, were male. Khmer leaders derived power from their status as *deva-rajas* (god-kings). As such, each adopted a title that fused his name with that of a deity: Shiva, Vishnu, or a specific Buddhist *bodhisattva*. Each ruler then commissioned a temple in or around Angkor to that same deity. The temple would often contain an image that served as both a representation of the deity and the king's portrait. The earliest Khmer temples were built of brick. Later, laterite (a reddish soil that combines silt, clay, sands, and gravels and is useful for making compressed bricks) and sandstone became the preferred materials for temple production. The center of the city changed, too, over time. During the twelfth century, it was focused on the temple Angkor Wat (near the bottom center of **Fig. 7.17**). Later, the center shifted to Angkor Thom, just north of Angkor Wat.

Angkor Wat ("City Temple"; **Fig. 7.18**), as it is known today, was built for the Khmer ruler Suryavarman II (ruled *c.* 1113–1145/50). The complex covers 494 acres, an area four times more extensive than Vatican City in Rome. During the twelfth century, when Suryavarman II reigned, the Khmer Empire reached its height, controlling much of what is now Cambodia, Thailand, Vietnam, and Laos. Artistic expression was also at its zenith, as demonstrated by Angkor Wat. Dedicated to the Hindu god Vishnu, protector of the established order, it is not only the largest Khmer temple, but also considered by many art historians to be the finest in design and execution.

Yet, the full scope of the temple's functions remains somewhat unclear. Was it also intended as Suryavarman's funerary memorial? Was it used as an administrative capital? Although we do not know all the temple's functions, we do know that, like South Asian Hindu temples and Borobudur and Prambanan in Java, it worked as a microcosm of the Hindu–Buddhist universe, giving physical form to the temple-mountain concept. At Angkor Wat, the visual references to the cosmic Mount Meru are

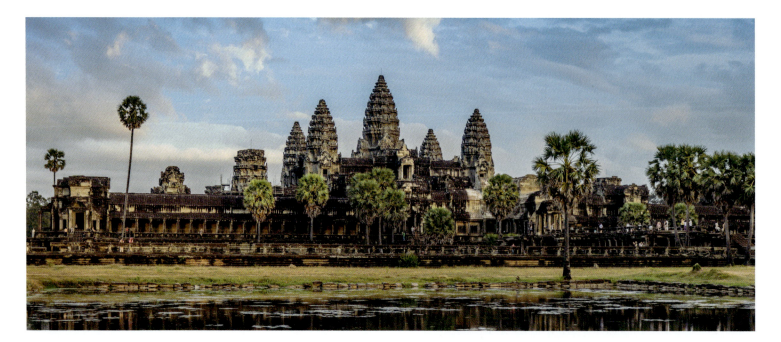

explicit: the temple's central sanctuary is marked by five towers, corresponding with Meru's five peaks, and the complex is enclosed by a three-mile-long (4.8 km) moat or reservoir that represents the cosmic ocean (**Fig. 7.19**).

Visitors today (and presumably in the past as well) first cross the moat by a wide stone causeway edged with balustrades that take the shape of water-divinity snakes (*nagas*). A high wall surrounds the outer edge of the complex, so visitors cannot see the monument until they have passed through the gateway. The causeway with *naga* balustrades continues, spanning a large area that would have been the site of a variety of buildings, but today is mostly empty. Finally, visitors arrive at a monumental entrance guarded by stone lions.

The temple itself comprises three concentric rectangular enclosures, intended for circumambulation, with each enclosure becoming narrower and more elevated as visitors approach the center. The staircases leading up to the final enclosure are at a steeply pitched 70-degree angle, making visitors feel as if they have climbed a mountain of carved stone to reach the inner sanctum. Topped by a tower that is 213 feet (64.92 m) high, the sanctum originally housed a statue of Vishnu.

The long galleries of the third enclosure feature four-and-a-half square miles (about 11.5 square km) of relief carvings depicting Suryavarman II and his armies, as well as scenes from various Hindu epics. The best-known relief illustrates the Churning of the Sea of Milk, a creation myth that thematizes the triumph of good over evil. In the story, the gods (*devas*) convince the antigods (*asuras*) to work with them to obtain the elixir of life, even though both sides know that the release of this immortality potion will cause war. To obtain the elixir, the gods and antigods must churn the cosmic ocean. The churning is done through a sort of tug-of-war, depicted

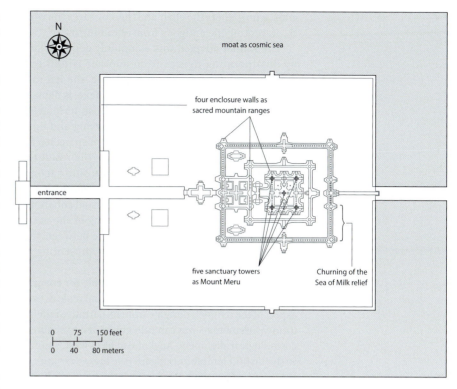

in the relief by a row of repeating figures, with the gods on the right and antigods on the left (**Figs. 7.20** and **7.0**). The five-headed *naga* king agrees to act as the rope, and Mount Mandara (another mythical mountain) is the churn. Vishnu is depicted twice at the center: as his tortoise incarnation Kurma below (not visible in this image), and again in his four-armed human form in front of the mountain, with his back toward the viewer and his head turned to the right. Directly above is Indra, the king of

7.19 Plan of Angkor Wat, Angkor, Cambodia, Khmer dynasty, *c.* 1113–45 or later.

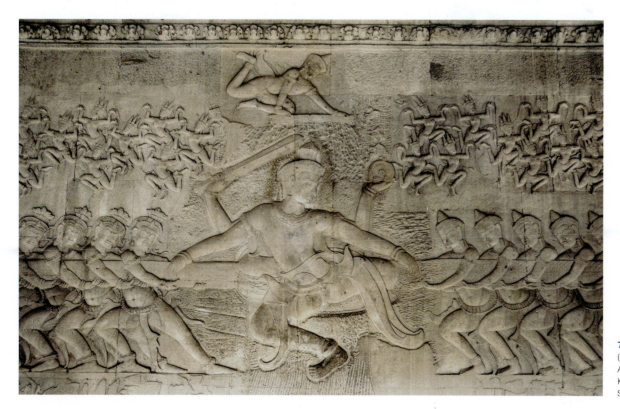

7.20 Churning of Sea of Milk (detail showing Indra and Vishnu), Angkor Wat, Angkor, Cambodia, Khmer dynasty, *c.* 1113–45 or later. Stone relief.

gods, who gathers the elixir and thereby saves the world by preventing the antigods from obtaining it.

The Khmer adapted this commonly depicted story by incorporating figures from another Hindu epic, the *Ramayana* (see **Fig. 7.7**). For example, the left-most antigod, positioned at the head of the snake, is depicted as the multiheaded *Ramayana* antagonist, Ravana (see **Fig. 7.0**). The relief, favoring shallow carving and linear detail, exemplifies Khmer artistic style. It spans 160 feet (48.77 m) along a narrow corridor, with the result that the viewer can never see the whole composition at once. The sculptors cleverly divided the relief compositionally into three horizontal levels to provide visual coherence: the bottom depicts the chaotic churning of the ocean, the middle shows the balanced struggle between good and evil, and the top features *apsaras* representing the creation of life.

Because a Khmer ruler was responsible for ensuring harmony between the earthly and spiritual realms, every aspect of the temple's design—from its narrative reliefs to its measurements—was carefully calibrated to ensure its cosmological alignment. Angkor Wat faces west, similarly to the Vishnu temple at Deogarh (see Figs. 3.17–3.19). On the spring and autumnal equinoxes, the sun rises directly over the central tower. The twelve staircases of the first enclosure represent the twelve months of a year, and some scholars believe that the lengths of the main causeway's various sections correspond with the four ages (*yugas*) in Hindu cosmology. One study of the monument has proposed that the Churning of the Sea of Milk relief acted as a calendar of sorts, with the center representing the equinoxes and each end the summer and winter solstice.

Like the other art of this period, the monument lends itself to multivalent readings.

A century after Suryavarman, the Khmer Empire remained strong, but it faced a formidable opponent: the Champa kingdom of central Vietnam (for more on the Champa state, see Chapter 5, p. 108). Twice—in 1167 and again in 1170—the Khmer defeated Cham attacks. But in 1177 the Cham army was victorious. The Cham defeated the Khmer army, killed the Khmer ruler, and sacked Angkor. However, the victory was short lived. Four years later the Cham were driven out, and Jayavarman VII (ruled *c.* 1181–1218) became Khmer king. He oversaw the rebuilding of the capital city: roads, hospitals, rest houses, universities, monasteries, and temples all were constructed. He also relocated the city's core to Angkor Thom, a large walled district surrounded by a reservoir and containing a new temple named Jayagiri (Victory Mountain), today commonly known as Bayon (see **Figs 7.17, 7.21, 7.22**).

Under Jayavarman VII, the state religion changed from Hinduism to Buddhism. Accordingly, Bayon is a Buddhist monument. Still, the boundaries between the two religions were fluid, and Bayon contains shrines and sculptures to Hindu deities as well as to buddhas and *bodhisattvas*. Its layout is difficult to decipher because the temple was built on the foundations of an earlier structure, altered during construction, and is today badly damaged. However, its plan seems to share many similarities with that of Angkor Wat: both temples invoke Mount Meru through a series of concentric enclosures that culminate in a multitowered central structure.

Two visual elements distinguish Bayon. First, the reliefs carved into the galleries lining the concentric

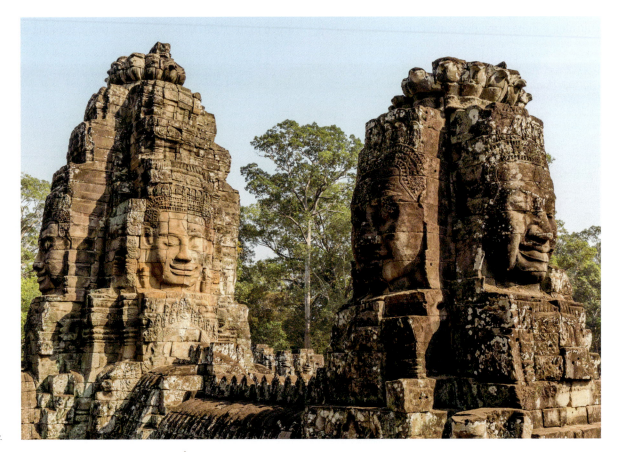

7.21 View of towers with faces, Bayon temple, Angkor Thom, Cambodia, Khmer dynasty, late twelfth–early thirteenth century.

Traditionally, an art historical analysis of a monument focuses on the structure itself: the plan, elevation, dimensions, materials, and decoration that together work to convey meaning and provide the visitor with a particular architectural experience. However, a monument never exists in isolation. Rather, it forms part of a visual environment that includes other buildings, trees, roads, waterways, animals, people from a range of social classes undertaking various activities, and corresponding material culture. This broader context impacts how a monument is perceived.

Thus, in recent years, art historians have begun to expand their analysis to consider the original visual environment in which a monument existed. For example, what did the larger landscape of Angkor look like when Angkor Wat and Bayon were built? What about the people and animals that populated the spaces? Answering such questions can be challenging in relation to monuments from early cultures, particularly those, such as the Khmer, for which few written or pictorial records survive. In the case of Cambodia, thick jungles, a monsoon climate, and a recent period of war and genocide have all had detrimental effects on the surviving heritage and add to the difficulty.

Scholars do have several methods for gathering information. On surviving monuments, reliefs often depict aspects of royal life and dress from the period of their construction. Occasionally, carved details show aspects of everyday life as well. For example, one segment of the reliefs at Bayon depicts a lively community of people preparing food outdoors, beneath a lace-like canopy of trees (**Fig. 7.22**). On the far right, people add branches to a fire, presumably preparing it to roast the pig being brought in from the left. Such representations provide valuable information about people's appearances, activities, and objects, such as pots, that they used.

Recent technological developments provide exciting new ways to learn more about the original landscape and built environment of Angkor. Several Angkor-based organizations have started using a remote sensing method called LiDAR (light detection and ranging). From the air, helicopters equipped with sensors scan an area. LiDAR, which works like radar but uses laser light instead of radio waves, cuts through the dense vegetation to reveal underlying ground patterns, including ancient roads and structural foundations. The resulting picture provides a plan of what Angkor originally looked like beyond the surviving stone temples.

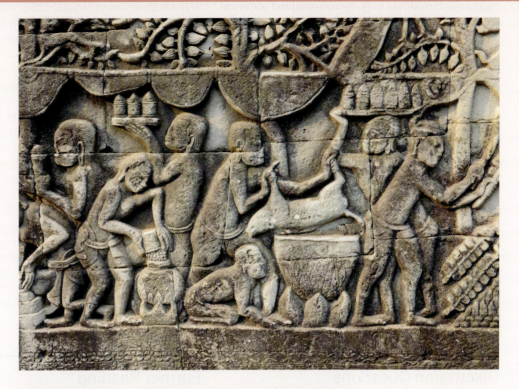

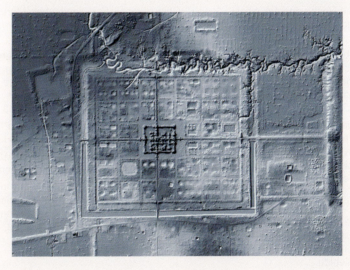

7.22 ABOVE **People cooking and other scenes of daily life, Bayon temple,** Angkor Thom, Cambodia, Khmer dynasty, late twelfth–early thirteenth century. Stone relief.

7.23 LEFT **Aerial LiDAR image showing the outlines of gridded settlements around Beng Mealea,** temple at Angkor, Cambodia, twelfth century.

Specifically, the LiDAR imagery shows gridded settlements outfitted with artificial ponds in the rectangular areas between the temples and their surrounding moats (**Fig. 7.23**). A network of roadways and settlements connected the expansive areas between temple complexes, confirming Angkor as the largest low-density urban center of its age, covering 1,100 square miles (2,849 square km).

Using such information, as well as knowledge gleaned from archaeological excavations and surviving written accounts by foreign visitors to Angkor, an international group of scholars has created a reconstruction of the city and its inhabitants. Their award-winning work is visible at the website www.virtualangkor.com.

Discussion Question

1. Explore the website www.virtualangkor.com. In what ways does considering the larger urban environment of Angkor affect how you understand an individual monument such as Angkor Wat or Bayon?

enclosures include not only mythological and historical scenes, but also scenes from Khmer daily life (see **Fig. 7.22** and Art Historical Thinking: Situating Monuments within Wider Visual Contexts, p. 157). People are shown hunting, cooking, playing games, and taking care of children, among other things. One detail depicts a woman giving birth.

Second, Bayon's towers are carved with large faces (**Fig. 7.21**). The serene, slightly smiling visages look out over the four cardinal directions as if offering benevolence and protection to all around. Exactly whom the faces represent is debated. The most important Buddhist figure during the reign of Jayavarman VII was the Bodhisattva Avalokiteshvara, "the Lord who gazes down with compassion," leading many scholars believe it is he who is represented. Alternatively, others have suggested that the faces may represent the four faces of the god Brahma, or the esoteric god Hevajra, one of the divine guardians of the cardinal directions. Still others have argued that the faces represent Jayavarman himself, or Jayavarman as Avalokiteshvara—conflating the ruler with the *bodhisattva* of compassion and mercy. Whether or not the faces represented the Khmer ruler, clearly the monument, like the others discussed in this chapter, was designed to merge earthly and spiritual power.

In the middle of the fourteenth century, the hydro-engineering systems of Angkor that were so key to the prosperity of Khmer society began to collapse, probably from overuse and environmental degradation as a result of deforestation. Already in a state of decline, the city was besieged and sacked in 1431 by the armies of the Thai kingdom of Ayutthaya (for more on the Ayutthaya kingdom, see Chapter 14), bringing a definitive end to Angkor's six centuries as the capital of the Khmer dynasty. Like the other six monuments discussed in this chapter, the political, military, and economic might that was part and parcel of the Khmer temples' construction eventually declined and disappeared. The monuments themselves, however, have remained, even if only in fragmentary form, and attest to the extraordinary societies that built them.

Discussion Questions

1. Based on the works discussed in this chapter, what are some of the ways in which architecture structures religious experiences?

2. All the works discussed in this chapter are religious, but their significance goes beyond religion. What are some of the other aspects of society and culture that shaped and in turn were shaped by the architectural monuments and sculptures?

3. Compare Khajuraho's Kandariya temple to the Rajarajeshwara temple in Thanjavur. The two monuments exemplify north (Nagara) and south (Dravida) Indian temple design, respectively. What are the main differences between them, and what visual elements do they share?

4. Research question: not all South Asian temples fit neatly into the Nagara and Dravida styles. Choose one of the following temples and research its design: the Durga temple at Aihole, the Sun temple at Konark, or the Hoysaleswara temple at Halebidu.

Further Reading

- Ching, Francis D. K., Jarzombek, Mark, and Prakash, Vikramaditya. *A Global History of Architecture.* 2nd edn. Hoboken, NJ: Wiley, 2011.
- Dehejia, Vidya. "Reading Love Imagery on the Indian Temple." In Karen Sagstetter, ed. *Love in Asian Art & Culture.* Washington, D.C. and Seattle, WA: Arthur M. Sackler Gallery, Smithsonian Institution and University of Washington Press, 1998, pp. 97–113.
- Evans, Damian and Fletcher, Roland. "The landscape of Angkor Wat redefined." *Antiquity* 89 (2015): 1402–19.
- Miksic, John N., *et al. Borobudur: Golden Tales of the Buddhas.* Hong Kong: Periplus Editions, 1996.
- Stein, Emma Natayla. "Sacred Sites in Southeast Asia." Smithsonian Institution, National Museum of Asian Art website. https://asia.si.edu/collections-area/southeast-asian/sacred-sites-in-southeast-asia/

Chronology

c. 750–850	The Shailendra dynasty rules in central Java	*c.* 930–1035	Construction of Hindu and Jain temples at Khajuraho, north India
c. 802–1431	The Khmer dynasty rules greater Cambodia from Angkor	*c.* 1003/4–1010	Construction of the Rajarajeshwara temple in Thanjavur, south India
9th century	Construction of Borobudur in Java		
831–1308	The Chandela dynasty rules in north India	1032	Founding of the Vimala temple at Mount Abu, India
848–1279	The Chola dynasty rules in south India		
c. 856	Construction of the Prambanan complex in Java	*c.* 1113–1145 or later	Construction of Angkor Wat, Cambodia
10th–11th centuries	Bronze images of Hindu deities become popular under Chola royal patronage	12th–13th centuries	Construction of Angkor Thom, Cambodia

Art and Ritual

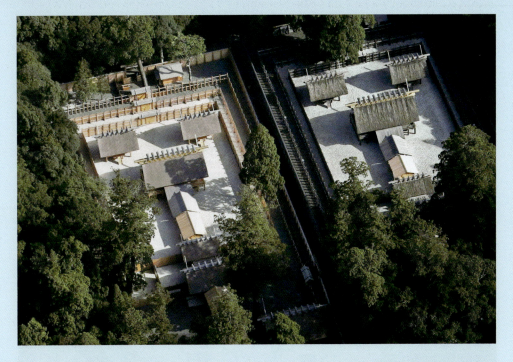

Throughout history, art and architecture have been intimately linked to ritual. Though their particular forms and uses vary in time and space, they may nevertheless share a common function. Across Asia, for example, *stupas* and pagodas mark the site of Buddhist reliquaries where devotees practice circumambulation. More generally, art and architecture provide focus not only for important sacred events, but also secular ones, as with Akbar's Audience Hall in Fatehpur Sikri (see Fig. 11.4). Here, four examples suggest the variety of artworks and related religious rituals in and outside of Asia.

Many buildings provide settings for rituals, but the construction of the Shintō shrine at Ise, Japan, is itself a ritual. The first formalized rebuilding of the Inner Shrine occurred in the late seventh century CE, and since then, the state has assumed responsibility for its periodic reconstruction (now set at every twenty years). This photograph (**Fig. 1**) shows the two adjacent sites of the Inner Shrine with a newly built complex on the left site. The Inner Shrine is home to Amaterasu, the Shintō sun goddess and believed to be an ancestor of the Japanese imperial family. The process of building a new shrine takes eight years and is accompanied by thirty-two ceremonies. When the new shrine is completed, the three sacred treasures of Amaterasu— the sword, the mirror, and the *magatama* jewel—are ritually transferred from the old shrine into the new one. After the transfer, the old one is ritually disassembled. The periodic renewal of the Ise Shrine consumes enormous resources, but it effectively affirms an intrinsic Shintō belief in the natural cycle of growth, decay, death, and renewal.

One visual element common to many religious rituals throughout the world— but not present at Ise—is the icon. Icons may be described as physical and often anthropomorphic likenesses of deities and revered religious teachers. Many thousands of Jain worshipers gather around this monumental icon of Lord Bahubali, which stands on a hilltop in southern India, during the *mahamastakabhisheka*, or head-anointing ceremony (**Fig. 2**). Fifty-seven feet high and carved from a single piece of granite by sculptors during the tenth century, the statue shows Bahubali (also called Gommateshwara) in prolonged meditation. It is said that he stood still for so long, without any clothing for protection, that vines grew up his arms and legs. Revered by Jains for this dedication, every twelve years Bahubali, as manifest in this icon, is ritually anointed with milk, saffron, ghee (clarified butter), and sugarcane juice by priests perched on scaffolding specifically built for the ceremony.

The religious experience facilitated by Buddhist mandalas (**Fig. 3**) involves visualization.

1 Inner Shrine, Ise Jingu, Mie prefecture, Japan. On the left is the new complex; on the right, the old one prior to ritual disassembly. Photograph September 2013. **EAST ASIA**

2 The head-anointing ceremony (*mahamastakabhisheka*) of the Jain statue of Bahubali at Shravanabelagola, Karnataka, India, held every twelve years; this photograph is from the last time it took place, in February 2018. Bahubali sculpture, tenth century. Granite, height 57 ft. (17.4 m). **SOUTH ASIA**

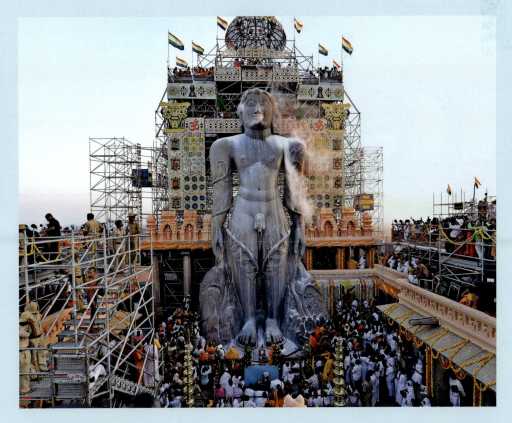

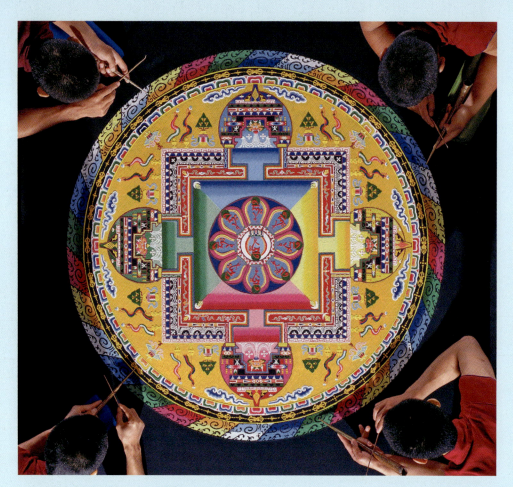

3 Amitayus sand mandala (*Mandala of Amitabha*), made by the Tibetan monks of Drepung Loseling Phukhan Khamtsen, undated. **ASIAN DIASPORA / U.S.**

Mandalas function like maps, but instead of navigating physical locations, devotees visualize the two-dimensional mandala as a three-dimensional universe with a deity or enlightened being residing at center. Here, the enlightened being is Amitabha (also called Amitayus), the buddha who presides over the Western Pure Land (see Figs. 6.9 and 6.16). Through intense identification with Amitabha, devotees realize the central Buddhist tenet of non-duality (the false perception of

separateness). Mandalas made of colored sand, such as this one, offer another religious lesson as well. After painstakingly placing millions of grains of sand, the monks perform a ritual that destroys the mandala. With brushes and working in a prescribed order, they sweep away the sand, reminding viewers—whether at a temple, art museum, or college setting— of the Buddhist belief in the impermanence of the world.

Some of the most familiar icons of Christianity issue from the patronage of the Roman Catholic Church, which employed such artists as Raphael (1483–1520) and Michelangelo (1475–1564), but other denominations promoted widespread use of icons, too. This example from the Eastern Orthodox Catholic Church depicts Mary, the mother of Jesus Christ; and it belongs to a type known as "Sign Mother of God," or Mother of God "Of the Sign" (**Fig. 4**). This composition portrays Mary with her hands uplifted in prayer, while the infant Christ appears in a circular mandorla, or sacred frame, at her bosom. As in the creation of imagery in other religions such as Buddhism, the artist must work according to established iconography, in other words, by using symbols or images that convey specific meanings. For example, Mary wears a blue robe and a veil over her head. The two six-winged fingers to either side of her are seraphim, heavenly creatures that are thought to protect the body and blood of Christ. In Russia, Sign Mother of God icons serve as the focus of a feast day for Mary, whose image is believed to have once shed miraculous tears, which led to a successful defense of the city of Novgorod in 1170. More generally, devotees could direct prayers to this icon, and they could commission gilt and silver revetments (*oklad*), which provided a protective cover that exposed only the faces and hands of the icon.

4 Sign Mother of God, Russia, *c.* 1780. 12 × 10 in. (30.5 × 25.4 cm). The Museum of Russian Icons, Clinton, Massachusetts. **NORTHERN EURASIA**

Discussion Questions

1. Whether in the form of sacred objects like those described here, or items used in secular ceremonies such as political inaugurations and college graduations, ritual remains an integral part of cultural and artistic practices around the world. Discuss an image or object from a ritual at which you participated.

2. Select another artwork in this textbook or find an artwork in a museum near you to extend the discussion in this "Seeing Connections." Identify and explain the way that artwork was linked to ritual.

Further Reading

- Coaldrake, William H. "Ise Jingu." *Architecture and Authority in Japan.* London and New York: Routledge, 1996, pp. 20–42.

- Cort, John E. *Framing the Jina: Narratives of Icons and Idols in Jain History.* New York: Oxford University Press, 2010.

- "Timelapse: Tibetan Sand Mandala Demonstration: The Monks of Drepung Loseling Phukhang Monastery." Asian Art Museum, San Francisco, August 17–19, 2012: https://education.asianart.org/resources/create-your-own-mandala/

8

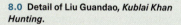

Art during the Song and Yuan Dynasties in China

960–1368

8.0 Detail of Liu Guandao, *Kublai Khan Hunting*.

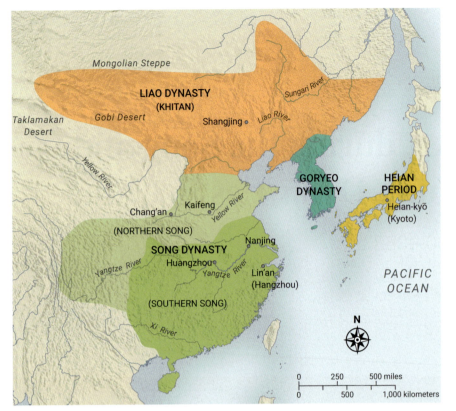

Map 8.1 **East Asia,** *c.* **1000** (in 1127 the Song dynasty is reduced to Southern Song area only).

calligraphy the art of expressive, decorative, or carefully descriptive hand lettering or handwriting.

hanging scroll a format of East Asian painting that is typically taller than it is wide; generally, hanging scrolls are displayed temporarily and may be rolled up and stored easily.

Introduction

Occurring within the medieval era of world history, the Song (960–1279) and Yuan (1271–1368) dynasties may at first appear to be complete opposites. The Song was an indigenous dynasty in which Confucian attitudes, including the cultivation of virtue and adherence to social rituals, dominated matters of government and culture. A robust economy, philosophical and scientific inquiry, and technological innovation all contributed to an era that became much celebrated later. Images of monumental landscapes and thriving urban activity aptly captured the confident ethos. Even though foreign incursions led to a diminished empire during the second half of the dynasty, aspects of Song culture survive and inform our understanding of what is considered typically Chinese art today.

By contrast, the nomadic Mongols lived outside Confucian tradition. After the Mongols established the Yuan dynasty— part of a vast, pan-Asian empire—some Chinese resented their presence. Mongol culture, which was based on pasturing animals and nomadic ways of life, differed from that of the Chinese, who considered them "barbarians" and who sometimes used art to express discontent with Mongol rule. Nonetheless, peace and stability across the Mongol empire increased intercultural contact, providing artistic stimulation that led to the creation of some of the most treasured works in Chinese art.

One overarching theme of this chapter is the relationship between art and politics in which paintings play a central role. In China, landscape became a major vehicle for both promoting imperial views and voicing political dissent. In addition to furnishing courts with paintings, imperial workshops provided a wide variety of artworks, including fans, ceramics, lacquerware, and textiles, demonstrating significant advances in skill and technology. Commercial workshops produced goods for the court as well as the general population, and they supplied merchants who met the demands of eager consumers across land and sea. At the same time, scholar-officials used poetry and calligraphy to emphasize authenticity and individuality.

Sociopolitical changes were not the only drivers of artistic development during the medieval era, however. A previous and severe prohibition against Buddhism (in 845, late in the Tang dynasty) led indirectly to the later prominence of the Buddhist sect of Chan (known in Korean as Seon and in Japanese as Zen), and the Mongol court supported a form of Tibetan Buddhism (a branch of Vajrayana Buddhism, characterized by secret teachings, requiring the assistance of an advanced instructor to access and understand). As Buddhist beliefs and practices changed, new forms emerged in Buddhist art (see Chapters 5 and 6).

Art of the Southern Tang Kingdom, 937–75

After the Tang dynasty collapsed in 906, numerous governments ruled over regional Chinese territories. In the north, five dynasties rose and fell in quick succession. To the west and south, roughly a dozen kingdoms—including one known in retrospect as the Southern Tang (937–975)— held sway. This time of disunion is thus known as the Five Dynasties and Ten Kingdoms period.

Contemporaneous accounts and modern histories often view periods of disunion unfavorably, yet these crises proved to be catalysts for the formation of vital new ideas for government, society, and culture. For example, the regional Southern Tang kingdom drew talented officials and painters to its court in present-day Nanjing (see **Map 8.1**), and in that relatively peaceful kingdom, the arts of music, poetry, **calligraphy**, and painting flourished. The kingdom's last ruler, LI Yu (937–978), was an active patron of art and a talented poet and calligrapher himself, and he provided a model for later emperors (such as Emperor Huizong, see below). Li Yu assembled an art collection, which was later seized by conquering Song forces. This transfer of cultural patrimony symbolized the late capitulation of Southern Tang to the Song government, and greatly enriched Song collections. But it also made Southern Tang painting—especially landscapes—known to artists of the Song dynasty and generations to come.

Among the most important paintings associated with the Southern Tang is *Wintry Groves and Layered Banks*, attributed to the Southern Tang painter DONG Yuan (d. 962) (**Fig. 8.1**). It represents an early stage of Chinese landscape painting. In this **hanging scroll** (see **Fig. 8.2b**), Dong used a moist brush, layers of ink wash, and limited color to construct a marshy landscape with gently sloped mountains, typical of the Yangtze River territory of the Southern Tang. (When initially completed, this landscape would have appeared brighter. As in the case of other early paintings, the silk has darkened over the centuries.)

The composition is divided roughly into three parts. Reeds grow along a sandy spit in the foreground; a bridge at far right leads the eye to the middle ground, where

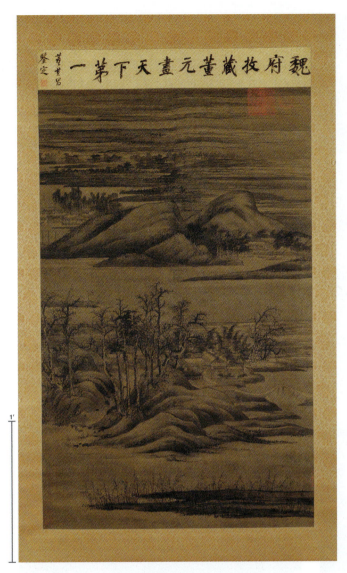

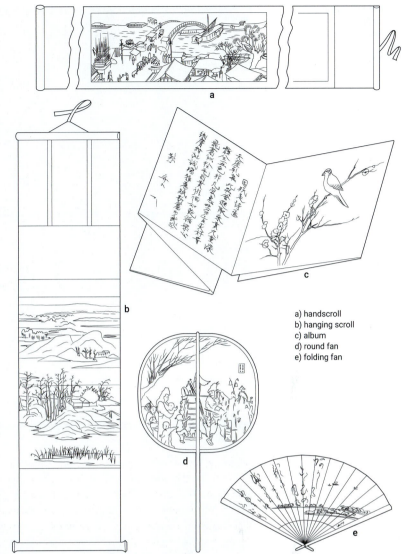

a) handscroll
b) hanging scroll
c) album
d) round fan
e) folding fan

bamboo groves and bare trees surround a rustic dwelling, which brings to mind the image of the noble recluse, or hermit; and in the background, rounded mountains rise from wetlands that recede into the distance.

Although houses and boat masts (visible to the left of the rounded mountains) indicate human presence, Dong's quiet landscape focuses on two main elements, mountains and water. This pairing matches the Chinese term for landscape, *shanshui*, literally "mountain-water." In Chinese philosophy, water is considered feminine, or *yin*, whereas mountains are associated with the masculine, or *yang*. Consequently, by combining physical embodiments of *yin* and *yang*—generative of all matter and phenomena—the landscape **genre** has the character of a microcosm.

Art during the Northern Song Dynasty, 960–1127

The art, culture, and ideas developing in regional kingdoms such as the Southern Tang came together with the reunification brought about in 960 by the Song dynasty. Due to foreign conquest of northern areas of the empire in 1127, the Song dynasty is in retrospect divided into two

periods: the Northern Song of 960–1127 and the Southern Song of 1127–1279 (see **Map 8.1**). The conquest also forced the Song court to relocate its capital from Kaifeng in the north to Lin'an (present-day Hangzhou) in the south.

Believing that the fall of the Tang dynasty was a direct consequence of insufficient central control, Song emperors disarmed potential rivals and promoted a civil bureaucracy based on Confucian principles of governance, encouraging intelligent and ambitious men to focus their energies on preparing for civil-service examinations. Success in the examinations led to prestigious government appointments.

With the support of legions of scholar-officials, the emperor ruled over a stable and flourishing empire. In the Northern Song capital, Kaifeng, highly skilled court artists produced exquisite and elaborate paintings that attested to society's good order and thereby proclaimed the emperor's fitness to rule. They also manufactured extremely refined objects, notably ceramics, for imperial use. Generally, emperors collected and commissioned artwork, but occasionally they themselves painted and practiced calligraphy.

In contrast to Dong Yuan's restrained and watery landscape, *Travelers among Streams and Mountains* by Northern

8.1 ABOVE LEFT **Attributed to Dong Yuan, *Wintry Groves and Layered Banks*,** Southern Tang dynasty, *c.* 950. Hanging scroll: ink and color on silk, 5 ft. 11¼ in. × 45⅝ in. (1.81 × 1.16 m). Kurokawa Institute of Ancient Cultures, Hyogo, Japan.

8.2a–e ABOVE RIGHT **Formats of East Asian paintings:**
a. handscroll; b. hanging scroll; c. album leaf; d. circular fan; e. folding fan.

genre a category of art, determined primarily on the basis of subject matter. In Chinese painting, genres include: figure painting, landscapes, and flower-and-bird, for example.

8.3 Fan Kuan, *Travelers among Streams and Mountains,* Northern Song dynasty, *c.* 1000. Hanging scroll: ink and colors on silk, 6 ft. 9⅛ in. × 40⅝ in. (2.06 × 1.03 m). National Palace Museum, Taipei.

style characteristics that distinguish the artwork of individuals, schools, periods, and/or cultures from that of others.

naturalism, naturalistic representing people or nature in a detailed and accurate manner; the realistic depiction of objects in a natural setting.

illusionism making objects and space in two dimensions appear real; achieved using such techniques as foreshortening, shading, and perspective.

Song painter FAN Kuan (*c.* 950–*c.*1031) overwhelms viewers with a massive mountain that fills nearly the entire space (Fig. 8.3). Sheer cliffs and a steep waterfall emphasize the composition's verticality. The foreground and middle ground occupy a smaller area, and tiny figures at the mountain's base—pack mules and peasants, below the largest tree on the right—provide a sense of scale, magnifying the peak's height. Below the waterfall, elegant rooftops are nearly camouflaged by the dense surrounding woods, but careful observation yields a wealth of details, including a variety of trees, ripples of flowing water, and carefully rendered rocky crevices. Additionally, tucked into the foliage at lower right, Fan Kuan's signature suggests not only pride in this work, but also the rising status of artists more generally.

Fan's painting is a quintessential example of monumental landscape. Its physical dimensions are impressive—at more than six feet high—but more importantly, the scale of the imagery is towering. The rugged terrain in *Travelers,* characteristic of Fan's native Shaanxi province (toward the northwest of China), is rigorously depicted. Declaring that "It is better to have nature as

a teacher," Fan retired to the mountains to study and to paint.

Fan's **style** was continued by painters serving at the Song court, which also acquired the art of fallen kingdoms and former enemies such as the Southern Tang, whose court painters were forcibly moved to the new imperial capital at Kaifeng. With many talented painters and scholar-officials, the Song capital became the center of significant artistic innovations and profound cultural changes. Various regional approaches to landscape, as exemplified by Dong Yuan and Fan Kuan, came together at the Song court, and GUO Xi (*c.* 1001–1090) drew on his predecessors' styles for his *Early Spring* of 1072 (Fig. 8.4). The pervasive presence of water—river, waterfalls, vapors, mists, and clouds— and the receding "deep distance" seen in the valley in the middle ground at the viewer's left, are related to such southern landscapes as Dong's *Wintry Groves and Layered Banks* (see Fig. 8.1). From the northern tradition come the monumental scale and the tall mountains, along with a point of view that Guo described as "high distance" (see Fig. 8.3). In his treatise on landscape painting, Guo identified a third point of view, "level distance," which refers to seeing far from a high vantage point (see Going to the Source: Guo Xi's Writing on Landscape).

Guo's deliberate use of multiple points of view is integrated seamlessly into a single landscape. In *Early Spring*, these perspectives facilitate the close representation of scenes of daily life (the peasant family in the foreground and the temple complex in the right middle ground) while also permitting the view of the serpentine mountain peak and the distant river valley. A single, fixed

8.4 FAR RIGHT **Guo Xi,** *Early Spring,* Northern Song dynasty, 1072. Hanging scroll: ink and color on silk, 5 ft. 2¼ in. × 42½ in. (1.58 × 1.08 m). National Palace Museum, Taipei.

Writing by artists helps to shed light on their intentions and motivations, but in pre-modern eras it was uncommon for artists to write, and the preservation of such writing was not at all ensured. Thus, Guo Xi's surviving treatise on landscape painting, *The Lofty Appeal of Forests and Streams*, is of particular value. Wide-ranging and detailed, Guo's essay not only illuminates the meaning and significance of his own paintings but also provides insight into the artistic culture of his time. *The Lofty Appeal* begins:

> Of what does a gentleman's love of landscape consist? The cultivation of his fundamental nature in rural retreats is his frequent occupation. The carefree abandon of mountain streams is his frequent delight. The secluded freedom of fishermen and woodmen is his frequent enjoyment. The flight of cranes and the calling of apes are his frequent intimacies.

In this ideal landscape, the educated man occupies himself in the activity of self-cultivation:

> The bridles and fetters of the everyday world are what human nature constantly abhors. Transcendents and sages in mist are what human nature constantly longs for and yet is unable to see. ...It is now possible for subtle

hands to reproduce [ideal landscapes] in all their rich splendor. Without leaving the mat in your room, you may sit to your heart's content among streams and valleys.

In addition to characterizing landscape painting as an expression of the Confucian scholar-officials' longing to escape the fetters of government duty in order to pursue self-cultivation, as a Daoist recluse might (see Fig. 4.16), Guo also judged landscapes according to

> those through which you may travel, those in which you may sightsee, those through which you may wander, and those in which you may live. Any paintings attaining these effects are considered excellent, but those suitable for traveling and sightseeing are not as successful an achievement as those suitable for wandering and living. Why is this? If you survey present-day scenery, in a hundred miles of land to be settled, only about one out of three places will be suitable for wandering or living....

In addition, he urged the painter

> to go in person to the countryside.... To discover the overall layout of rivers and valleys in a real landscape, you look at them from a

distance. To discover their individual characteristics, you look at them from nearby.

Yet, for all Guo's attention to natural phenomena, he nevertheless conceived of landscape as a vehicle for expressing social norms. The artifice and symbolism of landscape paintings are apparent when he wrote:

> A great mountain is dominating as chief over the assembled hills, thereby ranking in an ordered arrangement the ridges and peaks, forests and valleys as suzerains of varying degrees and distances. ...A tall pine standing erect is the manifestation of a host of trees. Its outward spreading indicates that it brings order to the vines, creepers, grasses, and trees, like a commander of an army bestirring those who rely on him.

Discussion Questions

1. Choose a single sentence from Guo Xi's writing that deepens your understanding of Guo's painting, *Early Spring*, and explain how it does so.

2. Use Guo Xi's judgements about "excellent" and the most "successful" landscapes to discuss and evaluate landscapes by other painters such as Dong Yuan (see **Fig. 8.1**) or Fan Kuan (see **Fig. 8.3**).

viewpoint would have been limiting, and would not have allowed viewers to experience the landscape painting as if traveling through an actual landscape.

The multiple perspectives underlie a composition that is firm, but—unlike Fan's *Travelers*—also dynamic. No longer are foreground, middle ground, and background separated into discrete parts. Instead, the craggy boulders and ancient pine trees propel viewers into a landscape of circuitous forms and pathways. A sinuously shaped mountain presides over a mist-filled realm that appears to be in constant flux. The moisture in the air and the movement implied by curved forms signal the season of early spring, a time of rebirth.

Guo Xi's **naturalistic** style captures a persuasive image of hopeful, seasonal change. It also aptly conveys a political agenda. In the year 1072, the emperor was embarking on a set of major reforms. *Early Spring* is at once **illusionistic** in its rendering of space, topography, ecology, and atmosphere, and idealized in its balanced composition and orderly arrangement of human activities: peasants in the lower foreground, an official traveling across a bridge in the middle ground, and temple buildings in higher elevations. In combination, these aspects of the landscape deliver a political message: the Song emperor has made the realm orderly, and that order validates his rule.

As the emperor's favorite artist, Guo was put in charge of creating paintings for the newly renovated court buildings in the capital at Kaifeng. *Early Spring* now takes the **format** of a hanging scroll, but its composition also works well as a **screen painting** (see, for example, the screens pictured in Fig. 12.5). It is possible that *Early Spring* was originally mounted as a screen, framing the emperor's throne in the building called the Jade Hall. The Jade Hall housed the prestigious academy of scholar-officials, an important constituency in the context of political change. The harmonious order captured in *Early Spring* would have reflected well on the emperor and appealed to Confucian scholar-officials.

While monumental landscapes featuring precipitous cliffs and plummeting waterfalls could signify imperial legitimacy by picturing a harmonious microcosm, the long **handscroll** painting *Peace Reigns along the River* offers insight into the economic activities underlying dynastic power and wealth. Painted by the otherwise unknown court artist ZHANG Zeduan, *Peace Reigns along the River* begins with rural scenes in the early morning. The painting is designed to be viewed by a single person or a small group seated at a table. At their own pace and with their own hands, viewers unroll the handscroll from right to left. They see a river appear and carve a path

format in East Asia, painting types that include the hanging scroll, handscroll, album leaf, and fan.

screen painting a format of East Asian painting, consisting of one or more panels; functions as a moveable piece of furniture to frame a significant area or subdivide a space.

handscroll a format of East Asian painting that is much longer than it is high; typically viewed intimately and in sections, as the viewer unrolls it from right to left.

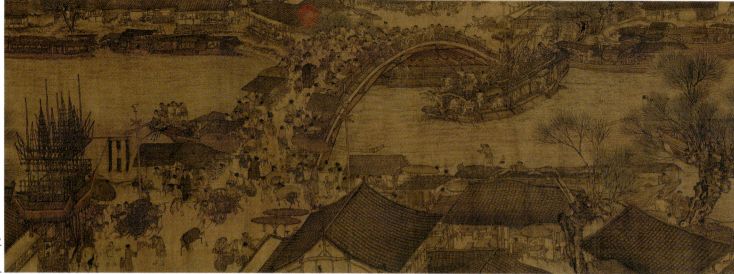

1"

ruled-line painting using rulers and compasses to render architecture and other complex, engineered structures with meticulous care.

isometric perspective a strategy of representing three-dimensional objects and/or space on a two-dimensional surface in which oblique sides are rendered as diagonal, parallel lines, and sides that are parallel to the picture plane are presented frontally.

facade any exterior face of a building, usually the front.

literati painters educated artists, including scholar-officials, who brought literary values into painting, and pursued abstraction and self-expression in their art.

album a format of two-dimensional artwork such as painting, calligraphy, or photography, in which individual leaves, or pages, may be bound together like a book to form an album.

inscription writing added to an artwork, either by the artist or by admirers and later collectors.

toward increasingly populated areas. Taking advantage of the sequential viewing process, Zhang structured his composition as a journey along the river. The anticipation of seeing what is concealed in the scroll reaches a climax in the scene of the rainbow bridge (**Fig. 8.5**). Gathering on the bridge, which is already crowded with vendors, spectators watch a frantic crew trying to lower the mast and safely guide their boat beneath the bridge. Someone has thrown a coiled rope to the crew; many others gawk at the unfolding drama. On the other side of the bridge, the prow of another boat emerges, suggesting a safe outcome. Following the river to the left, viewers eventually encounter a road leading to a city gate and the scroll's conclusion within the bustling city (not pictured here).

Zhang invested tremendous skill and care in his meticulous depiction of watercraft, architectural structures, commercial activities, and street scenes. No detail escaped his eye: not the eddies of the turbulent water, nor the shapes of tiny scissors for sale. Seen in its entirety, *Peace Reigns along the River* documents daily sights and commercial activities across the rural-to-urban spectrum of the Song dynasty, but it does not present an altogether objective view. The Song court that commissioned the handscroll wanted to project a positive image; the artist wanted to meet the patron's expectations. In this case, the court claimed credit for the good governance that facilitates the peaceful, productive activities pictured in *Peace Reigns along the River*, and Zhang ensured his continued status with an image that pleased the rulers.

We can read the painting as evidence of Song culture in other ways, too. Zhang demonstrated skill in a genre or style called **ruled-line painting**. Artists sometimes used a ruler and compass to aid in drawing such exacting representations of architecture, but Zhang appears to have worked freehand. The rendering in **isometric perspective** of the lashed-bamboo structure at the viewer's lower left (the **facade** to a wine shop where patrons may enjoy a drink) demonstrates his skill. More significantly, the impulse to represent things precisely, as evidenced in ruled-line paintings, indicates an empirical approach to measuring and understanding the physical world.

Whereas court painters often demonstrated careful observation and meticulousness in their artworks, scholar-officials who served the government forged an alternate set of aesthetic values in their calligraphy, poetry, and paintings. Among the talented scholar-officials, SU SHI (1039–1101) emerged as a leading voice. Adept in fields as different as hydraulic engineering and poetry, Su Shi parlayed his intellect into a long government career that was both distinguished and checkered. At times he wielded enormous influence, but he was also the victim of political machinations and was three times banished from court.

Banishment was never desirable, but time away from court could spur creativity. Su wrote *Poems Written on the Cold Food Festival* in 1082 during his first political exile in Huangzhou (**Fig. 8.6**). Reading in columns from right to left, the poem begins:

> Since I came to Huangzhou,
> Already three cold-food festivals have come and gone.
> Each year I wish to linger with spring,
> But spring's departure admits no delay.

The melancholy tone continues, and toward the end of the poem Su lamented his isolation from court and kin: "The emperor's gates are nine layers deep, my family's tombs are ten thousand miles away." He wondered, too, if his life would end soon and in so mean a state.

Su's calligraphy does not strive for grace, balance, or moderation. He rejected the polished elegance of Wang Xizhi (see Fig. 4.12), and instead embraced an unvarnished directness. The first line at far right shows the most control, but already in the next line, Su elongated the second character, "year," conveying visually a sense of duration and perhaps also frustration with the passage of his time in exile. In the lines that follow, characters vary markedly in size, and brushstrokes are thick, blunt, and emphatic. Leaving behind inherited standards of beauty, Su's calligraphy proposes that spontaneity and authenticity are the more important values in art.

自我来黄州已過三寒食年、欲惜春、春不容惜今年又苦雨两月秋蕭瑟卧聞海棠花泥汙燕支雪闇中偷負去夜半真有力何殊病少年子病起須已白春江欲入戶雨勢来不已兩小屋如漁舟濛濛水雲裏空庖煮寒菜破竃燒濕葦那知是寒食但見烏

Su's views about calligraphy as an expressive art form the basis for an alternate approach to painting. He criticized artists whose primary concern was "form-likeness," or fidelity to physical appearances. Instead, Su promoted painting as a medium closer to poetry and calligraphy, which aimed to express the artist's thoughts and feelings. Consequently, Chinese **literati painters**—who belonged among the social elite and brought literary values to bear on painting—rejected technical refinement, which they associated with the lesser class of artisans whose abilities were limited to mere mimicry of nature. Instead, they deliberately pursued awkwardness and abstraction, which conveyed a sense of uncalculated authenticity and individuality.

The poetic values that informed Su Shi's artistic attitudes spread beyond literati circles. At the late Northern Song court, for example, Emperor Huizong (ruled 1101–25) is credited with this meticulously painted bird and flowering branch, which accompany a poem written in his distinctive calligraphy (**Fig. 8.7**). This oversized **album** leaf, titled *Five-Colored Parakeet on a Blossoming Apricot Tree*, combines the fine arts of poetry, calligraphy, and painting—the "three perfections"—to attest to the emperor's mastery of the three most celebrated Chinese art forms.

Rendered in profile, a parakeet perches on branches that arc elegantly to left and right. Fine brushes were used to color the soft feathers and outline the delicate petals. The effect is a heightened, almost magical, realism in which the bird has been extracted from its natural environment and artificially posed.

To the viewer's right, the emperor's preface and poem describe how this exotic parakeet, a tribute from a southern region, had been tamed and trained to talk. (Originally, the **inscription** may have been to the left of the painting, but it has been remounted in

8.6 Su Shi, *Poems Written on the Cold Food Festival* (detail), Northern Song dynasty, 1082. Handscroll: ink on paper, 13½ in. × 6 ft. 6½ in. (34.29 cm × 1.99 m). National Palace Museum, Taipei.

8.7 Attributed to Emperor Huizong, *Five-Colored Parakeet on Blossoming Apricot Tree*, Northern Song dynasty, c. 1110. Originally oversize album leaves, now mounted as a handscroll: ink and color on silk, 21 × 49¼ in. (53.3 cm × 1.25 m). Museum of Fine Arts, Boston, Massachusetts.

reverse order.) One spring day, the parakeet alighted atop a blooming apricot tree, and the delightful sight moved the emperor to record it in both word and image. His calligraphy consists of sharp, angular strokes, written confidently and consistently in a tight, invisible grid. Emperor Huizong's writing has been nicknamed "slender-gold," which aptly captures its preciousness.

Five-Colored Parakeet attests to Emperor Huizong's appreciation of poetic values and his artistic skills, yet it also stresses the legitimacy of his reign by recording a marvel of the physical world, proof of heaven's blessing for the emperor's rule. During his reign, Emperor Huizong and his retinue of highly accomplished court painters produced many **auspicious** images documenting similar signs of good fortune.

The exceptional attention that Emperor Huizong directed to painting and calligraphy extended to other artistic media. The simple oblong shape of this narcissus planter, or bowl (**Fig. 8.8**), displays to good advantage the lustrous, pale blue-green glaze characteristic of *ru* ware. A type of **stoneware**, *ru* ware was produced almost exclusively during Emperor Huizong's reign. *Ru* ware forms have restrained, disciplined shapes derived from simple flowers or, as in this case, basic geometry. Thus, any flaws in the application of the glaze or the firing would be immediately apparent. Using tiny grains of clay to prevent the bowl from adhering to the kiln during the firing process, the potter applies glaze to the vessel's entire body, giving the finished *ru* ware a jade-like texture and sheen.

Emperor Huizong is well known for the artistic accomplishments of his time, yet these same accomplishments became the rationale for contemporaries and later historians to denounce him for his failure to prevent the collapse of the Northern Song dynasty. In 1125, armies of the Jurchen tribal peoples from Manchuria invaded the Northern Song, kidnapped the emperor and his immediate family, and established a

Chinese-style dynasty of their own called Jin (1115–1234). Remnants of the Song imperial family and court fled south, and in Lin'an (present-day Hangzhou) they eventually re-established the dynasty, known retrospectively as the Southern Song.

Art at the Southern Song Court, 1127–1279

Once peace and stability had been restored in a new geo-political configuration, the Southern Song (1127–1279) resumed the systems and routines of the Chinese court and bureaucracy. As before, artists belonging to the court painting academy were charged with making artwork on political themes. Cultural continuity can be perceived in images that do not address questions of legitimacy directly, too.

Evidence of cultural continuity is visible in MA Yuan's (active *c.* 1190–1225) *Apricot Blossoms* (**Fig. 8.9**), which bears stylistic similarities to Emperor Huizong's *Five-Colored Parakeet* (see **Fig. 7.7**). Ma's knobby branch emerges asymmetrically from the lower left-hand corner of the album leaf. Fine ink outlines and opaque white and crimson colors describe the blossoms. Against a blank ground, the branch reaches toward to the upper right before splitting, encouraging the viewer's gaze to alight on an inscribed poem.

Ma Yuan did not compose and inscribe the poetic couplet; nor was an emperor the poet and calligrapher, as in the case of Emperor Huizong. Rather, credit goes to the empress YANG Meizi (1162–1232). Numerous examples of her writing survive on paintings by Ma, attesting to their frequent collaboration. On *Apricot Blossoms*, she wrote:

> Receiving the breeze, she presents her unsurpassed beauty;
> Moistened with dew, she reveals her red charms.

auspicious signaling prosperity, good fortune, and a favorable future.

stoneware a type of ceramic that is relatively high-fired and results in a non-porous body (unlike terra-cotta or earthenware).

Empress Yang's lines combine with Ma's painting to personify the apricot blossoms, creating a seductive invitation to the emperor to come enjoy the pleasures of the bedchamber with her. Intelligent and talented, the empress fully understood that her surest means to secure power was to become pregnant and give birth to a male heir. Just as emperors used painting as a vehicle to demonstrate their right to rule, so could others directly enlist art to win imperial favor.

While some court paintings emphasized poetic expression, others featured careful observation of the physical world. A contemporary of Ma Yuan, LI Song (active 1190–1230) cast his perceptive eye on a traveling salesman and the excitable children lured by his merchandise in *Knick-knack Peddler* (**Fig. 8.10**). The **fan-painting** format (see **Fig. 8.2**) also makes a useful object during the warm, humid summer of Lin'an, the Southern Song capital.

Li's painting is a *tour de force*. On the tree, just above and to the right of where the bamboo stalk meets it, Li has written in minute characters, "three hundred items." Enticed by the peddler's racks, which are crowded with tools, medicines, edibles, and toys, one child clambers onto the base the better to extend his reach. His pals are close behind, and even the suckling baby dangles a hand toward the tower of delights. The peddler wears a necklace featuring three round disks decorated with human eyes.

8.9 Ma Yuan, *Apricot Blossoms,* with an inscription by Empress Yang Meizi (1162–1232). Southern Song dynasty, early thirteenth century. Album leaf: ink and colors on silk, 10¼ × 10¾ in. (26 × 27.3 cm). National Palace Museum, Taipei.

fan painting a format of East Asian painting in which the image is painted on an oblong, round, or folded fan.

8.10 FAR LEFT **Li Song, *Knick-knack Peddler,*** Southern Song dynasty, 1210. Fan mounted as an album leaf: ink and colors on silk, 10¼ × 11¾ in. (26 × 29.8 cm). National Palace Museum, Taipei.

8.10a and b LEFT **Details from *Knick-knack Peddler.***

This type of necklace was worn by eye doctors, but in this picture, it signals one of the painting's themes, vision. For the children, vision leads to material desire; seeing boisterous potential customers, the peddler must take action. For the viewer, the sheer abundance of objects in so small a painting becomes an amusing challenge to the limits of vision. At the far right, one stealthy child has eluded the peddler's sight and may sneak away with a modest treasure in hand.

The *Knick-knack Peddler* takes as its subject matter peasants and everyday life, and in this regard may be compared to *Peace Reigns along the River* (see **Fig. 8.5**). Both paintings use fine ink outline as the primary method of representing a physical world characterized by abundance and narrative charm. For imperial audiences, such idealized paintings suggested a world of peace and plenty, made possible by good governance. Thus, the paintings also served to legitimize and validate imperial power and position.

Art during the Yuan Dynasty, 1271–1368

Over the thirteenth century, the Southern Song dynasty weakened until its final collapse in 1279. Its decline is part of a larger history of Mongol conquest, which declared the founding of a new dynasty, the Yuan, eight years earlier in 1271. Under the leadership of Chinggis Khan (also written Genghis, *c.* 1162–1227), the Mongols defeated the Jurchens who had ruled the northern region of Chinese territory under the dynasty called Jin (1124–1234). Led by Chinggis's grandson, Kublai (also written Khubilai, ruled 1260–95), the Mongol army completed the conquest and reunification of all Song-dynasty territory. Ruling as the Yuan dynasty from their capital at Dadu (now Beijing), the Mongols remained in power until 1368. The Yuan emperor concurrently held the title Great Khan, making him superior to the three other khanates in Eurasia. Together the khanates formed the largest contiguous land empire that has ever existed (**Map 8.2**; see also Seeing Connections: *Pax Mongolica*, p. 182).

The Mongol conquest was violent, combining gunpowder technology and siege warfare with a superior cavalry and supply chain, yet their rule did not result in the end of art. Indeed, the foremost female art patron and collector in pre-modern China was Princess Sengge Ragi (1284–1331), sister of Ayurbarwada (1285–1320), who ruled briefly as Emperor Renzong and is pictured in **Fig. 8.20** wearing blue. More generally, the destructive and creative aspects of Mongol rule are apparent in changes to government institutions as well as to art and culture. The Yuan maintained significant parts of the government bureaucracy, which was needed to administer the vast empire, but Mongol rulers gave preference to Mongolians and Central Asian peoples over the Han Chinese. As a result, many Chinese scholar-officials were disenfranchised. Whether motivated by loyalty to the fallen Song dynasty or prevented from pursuing the traditional path to political success, some literati turned to painting to express frustration and dissent. The political conditions of the Yuan dynasty propelled the development, outside of the context of the imperial court, of more abstract styles of landscape painting.

Another change occurred with the dissolution of the robust painting academy formed during the Song dynasty. But painters remained employed at the court, albeit in somewhat lower-status household agencies, and the Mongol regard for excellent craftsmanship introduced different artistic priorities in the Chinese realm. For example, technique was prized above individual style, which benefited painters specializing in the ruled-line technique, such as WANG Zhenpeng (active *c.* 1271–1368). Additionally, portraiture was preferred to landscape, and textiles were considered more prestigious than paintings. These preferences underlie a silk **tapestry mandala** (see **Fig. 8.21**), which because of its religious nature will be discussed in the last section on Buddhist art. Meanwhile, the Yuan dynasty returned a measure of security to the

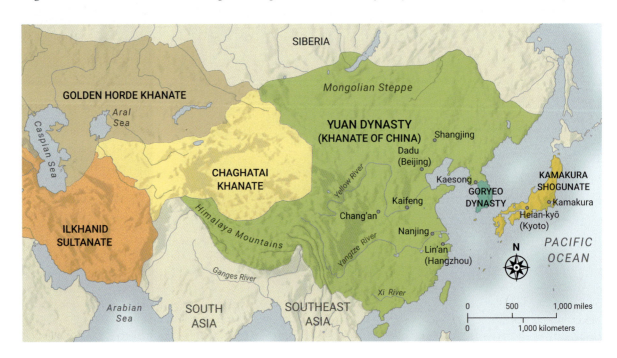

Map 8.2 West, Central, and East Asia, *c.* 1300.

continental trade routes known as the Silk Road, facilitating economic activity and spurring intercultural contact. Finally, the Yuan imperial devotion to **Tibetan Buddhism** (see Chapter 5 and Fig. 5.18), brought new artists to Chinese regions and expanded the diversity of Buddhist art and architecture.

Key aspects of Mongol culture—along with the Mongols' distinctive approach to representing the emperor, foreigners, and landscape—are visible in a painting of *Kublai Khan Hunting* by the court artist LIU Guandao (1258–1336) (**Figs 8.0** and **8.11**). In lieu of soaring mountains or flowing rivers, Liu depicted a nearly featureless landscape as the setting for a hunting party. Layered, slight hills at the painting's upper portion suggest the vast, horizontal spread of the steppes. Emerging from behind the barren slopes, a single rider and four Bactrian camels blend so closely into the environment that they are easily overlooked. The composition focuses on the horses and figures in the ample space of the foreground, especially Kublai Khan dressed in an impressive ermine fur. Beside him, Empress Chabi wears white face make-up and a white-and-gold brocade robe. Around the imperial couple, eight retainers and several trained animals—including a cheetah (sitting, somewhat unexpectedly, behind the rider in the center foreground), an eastern greyhound, and falcons—complete the hunting party.

The primary roles played by horses and hunting—note the archer at far left taking aim at a pair of birds—in Mongol culture are clearly apparent in Liu's painting. So, too, is the multi-ethnic, multi-racial population of the Yuan empire. Using fine outline and color fill, Liu carefully captured the physiognomy and dress of the individual figures. The long, pointed cap and ruddy hair of the man with the cheetah, for example, mark him as someone possibly of Sogdian (Central Asian) or Persian heritage. The Persians gave cheetahs to the Mongol court, and this one along with the trainer may have been gifts from Kublai's brother, Hulagu (ruled 1256–65), who ruled Ilkhanid Iran. The archer, with his shaved pate, may be Khitan or Tangut, people from areas subsumed into the Mongol Empire. The falconers may be Khitan, too, but the man with the hooded white gyrfalcon is more likely Mongol. The two dark-skinned men may trace their family roots to areas of present-day Malaysia, southern India or Africa. These men may enjoy closeness to the khan, yet the figure wearing red robes bears a face tattoo in the form of the character "ya Y," meaning "servant" or "subordinate." Thus, their privileged status—not unlike those of many others in service to the court—is offset by the likelihood of their servitude, which probably began prior to their attachment to Kublai. These men may have been among the many Mamluks, slave soldiers who had converted to Islam or served Muslim rulers of slave origin, scattered and displaced by the Mongol conquest. Notably, none of the figures is Chinese. In contrast to Song dynasty court art, which drew its authority from Confucian principles, *Kublai Khan Hunting* proposes a new model for imperial power, one based on the activity of hunting and the presence of foreign people answering to the emperor's command.

If Mongol conquest forced some people to move, it nevertheless facilitated the elective journey of others, such as merchants. Restored trade led to the invention of a product that has since become ubiquitous throughout the world and is considered quintessentially Chinese: blue-and-white **porcelain** (**Fig. 8.12**, p. 172). While the earliest porcelain wares date to the late Tang period, the distinctive blue-and-white color combination

8.11 Liu Guandao, *Kublai Khan Hunting*, 1280. Hanging scroll: ink and color on silk, 6 ft. × 3 ft. 5 in. (1.83 × 1.04 m). National Palace Museum, Taipei.

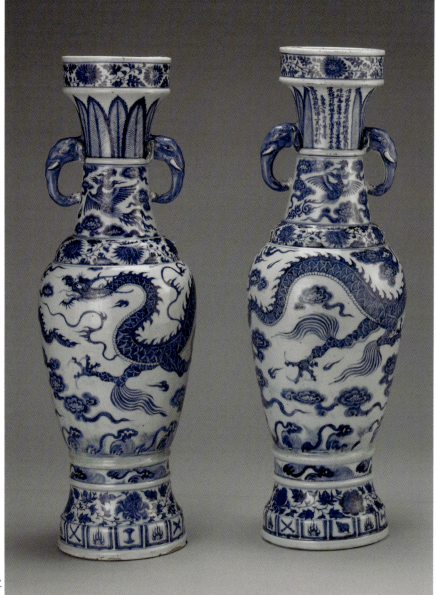

1"

8.12 Altar vases (the David Vases), Yuan dynasty, 1351. Porcelain with underglaze blue design, height 25⅛ in. (63.8 cm), diameter 7¾ in. (19.6 cm). British Museum, London.

register a horizontal section of a work, usually a clearly defined band or line.

Daoism originating in China, a philosophy and religion that advocates pursuit of the Dao (the "Way"), as manifested in the harmonious workings of the natural world and universe; Daoist practice also includes worship of immortals and numerous popular deities.

palette an artist's choice of colors.

begins to gain popularity during the Yuan dynasty (see Seeing Connections: Blue-and-White Porcelain: A Global Commodity, p. 241). At this time, artisans used blue pigment derived from cobalt imported from West Asia to decorate the white bodies of porcelain vessels, producing vivid and appealing objects that circulated throughout and beyond the empire. Around the world, blue-and-white porcelain objects remain to this day collectors' items.

This pair of blue-and-white porcelain altar vases, known by the name of the art collector Percival David, is elaborate in both form and decoration. Between the foot and the mouth, each vase is divided into numerous bands, or **registers**, of different widths and ornament. Further, the registers are of different diameters, with some having a concave or convex shape, resulting in a complicated silhouette, punctuated by elephant-head handles emerging from the neck. Floral scrolls, stylized plantain leaves, and cloud patterns appear throughout the vases, but two supernatural animals, the dragon and the phoenix, are featured on the body and the neck,

respectively. As supernatural animals that are believed to be capable of bringing rain for growing crops, dragons are considered auspicious throughout East Asia. Although such creatures—especially five-clawed dragons—symbolized imperial power, these mythical beasts appear in a variety of contexts. On these vases, the serpentine shapes of four-clawed dragons writhe amid clouds, and, as symbols of *yang* (the active, masculine force), they are matched with phoenixes, symbols of *yin* (the reactive, feminine force). In Chinese philosophical thought, especially **Daoism**, *yin* and *yang* in dynamic combination are the generative principles, or energies, of all phenomena. More generally, Daoism advocated pursuit of the Way, as manifested in the harmonious workings of the natural world and the worship of immortal beings.

The inscription on each vase reinforces a Daoist interpretation by recording its ritual purpose. (Some bronze vessels from the earlier Zhou dynasty have similar inscriptions; see Figs. 2.9 and 2.9a). The donor, ZHANG Wenjin, dedicated these vases and an incense burner to a deified military figure, General HU Jingyi. Seeking blessing upon his family, Zhang gave the vases to a Daoist temple. The inscription gives the precise date of dedication as May 13, 1351.

Even though the Mongol conquest brought peace and new prosperity to the empire, not everyone welcomed the new rulers. The political situation posed a dilemma to the Chinese scholar-officials. That dilemma, along with the expressive possibilities of landscape painting, is demonstrated in the person and artwork of ZHAO Mengfu (1254–1322).

Rather than serve the foreign Mongols, some Song-dynasty loyalists committed suicide, while others withdrew from society to become recluses. Zhao was born to a distant branch of the Song imperial family and might have been expected to take a loyalist stance, but instead he agreed to serve in the Yuan government. He had a long and distinguished career, including positions as secretary of the Board of War and director of the Imperial Academy. His creative talent in both calligraphy and painting was also recognized by Yuan emperors who collected artworks by Zhao as well as by his wife, GUAN Daosheng (see below). In his paintings, Zhao mustered his knowledge of art and history to fashion multivalent messages that could reflect well on both him and the government he served.

For example, in *The Mind Landscape of Xie Youyu* (**Fig. 8.13**), Zhao chose as his subject the Jin dynasty official XIE Youyu (280–322). (For art of the Eastern Jin, see Chapter 4.) Xie professed an affinity for wilderness, yet earned a reputation as an official whose appointment at court did not compromise his integrity. Paradoxically a recluse at court, Xie became Zhao's model.

In terms of style, Zhao rejected the naturalism of such Song-dynasty artists as Guo Xi and Li Song, Instead, *Mind Landscape* features abstract qualities that allude to earlier periods of Chinese history. From art of the period during which Xie Youyu lived (the Period of Division, 220–581), Zhao adopted fancifully shaped trees and discrete spaces between them (see Fig. 4.16). The dominant blue-green **palette** recalls scenes of Buddhist paradises

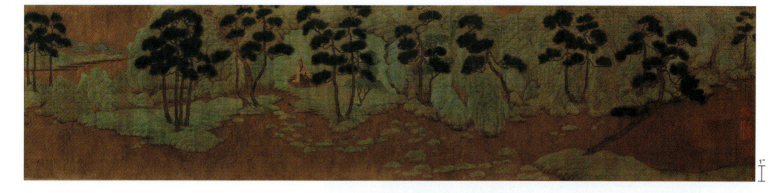

prominent in the Tang dynasty of 618–906 (see Fig. 6.9). In effect, Zhao's innovative and eclectic style is a form of **archaism**, and his audience would have understood *Mind Landscape* as an expression of a widespread belief that a golden age lay somewhere in the past.

Yet it is also the case that Zhao suggested that the moment in which he lived was an auspicious time, too. Several of the pine trees are paired, or double-trunked. This motif would have been seen as "trees of conjoined cosmic pattern," an omen that appeared during Xie's service at the Eastern Jin court and, according to the inscription of the motif at the Wu family shrine (see Chapter 2), is present only during the time when an emperor's virtue spreads throughout his realm. Thus, Zhao's painting implies that Kublai is a virtuous emperor and that the court welcomes officials in the mold of Xie Youyu.

Zhao Mengfu was, like Su Shi, foremost a scholar-official whose education informed his artistic practice, and so he is recognized as a literati painter. But not all literati painters were men. Guan Daosheng (1262–1319) demonstrated her abilities as poet, calligrapher, and painter in *Bamboo Groves in Mist and Rain* (**Fig. 8.14**). Using only ink on paper—the materials associated with the literati arts of poetry and calligraphy—Guan created a quiet scene of bamboo clusters growing at the edge of a river. She used dry, hemp-fiber-textured strokes to depict earth, and she set delicate patterns of leaves against the blank mist. As with *Mind Landscape* by her husband Zhao Mengfu, Guan shifts away from illusionism toward **abstraction**. Her spare style lays bare the work of brush and ink, and her choice of format—the short handscroll—facilitates an intimate aesthetic experience for her intended recipient, the woman named Lady Chuguo in Guan's **colophon** (which follows the painting at the far left).

The meaning and significance of Guan's *Bamboo Groves* derive from art history, mythology, and symbolism. First, the genre of ink bamboo painting was purportedly invented when a woman surnamed Li observed the shadows of bamboo cast upon a window. Second, waterside bamboo is an image of grief; according to a Chinese legend, the tears of the widowed consorts of the mythological king Shun marked a variety of speckled bamboo. Finally, because bamboo has the capacity to bend without breaking, it is a symbol of resilience under adversity. Precisely which of the multiple meanings of bamboo Guan intended Lady Chuguo to recognize is not certain, but the painting surely participates in a sophisticated system of communication.

While Guan's painting is a one-of-a-kind artwork for a specific patron, a developing market in fine crafts met the general needs of many. This seven-lobed **lacquer** tray features the popular imagery of women with children (**Fig. 8.15**, p. 174). Painting offers one way to decorate lacquerwares (see Fig. 2.18); this tray uses another technique: layers of lacquer, colored red with ground cinnabar, create a thick surface, which is then carved. The resulting ornamentation on this example includes both a floral pattern for the border and a figurative scene set within it. Two elegantly attired women, a seated lady and a standing nursemaid, watch as twenty-three boys frolic on a waterside terrace. A willow tree, oddly shaped garden rocks, and a pair of ducks in a lotus pond complete the idyllic setting. Informed by paintings, especially the asymmetrical compositions of the Southern Song dynasty, this idealized image of playful boys would have made the tray a suitable gift for a bride, conveying an auspicious wish for abundant male offspring. The artistic quality evident in this lacquer tray is demonstrated in other media, such as textiles

8.13 Zhao Mengfu, *The Mind Landscape of Xie Youyu*, Yuan dynasty, c. 1287. Handscroll: ink and colors on silk, 10¾ × 46 in. (27.3 cm × 1.17 m). Princeton University Art Museum, Princeton, New Jersey.

archaism the use of forms dating to the past and associated with a golden age.

abstraction artistic styles that transform a recognizable image into shapes and lines.

colophon a statement at the end of a book, which records such information as the date and location of completion, name of calligrapher, and patron. In East Asia, colophons are also written on paintings and calligraphy, and their content may be expressive and wide-ranging.

lacquer a liquid substance derived from the sap of the lacquer tree; used to varnish wood and other materials, producing a shiny, water-resistant coating.

8.14 Guan Daosheng, *Bamboo Groves in Mist and Rain*, Yuan dynasty, 1308. Handscroll: ink on paper, 9 × 44⅞ in. (22.9 cm × 1.14 m). National Palace Museum, Taipei.

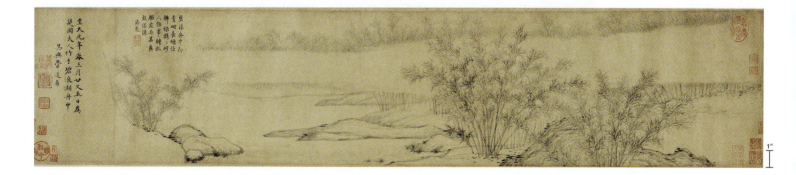

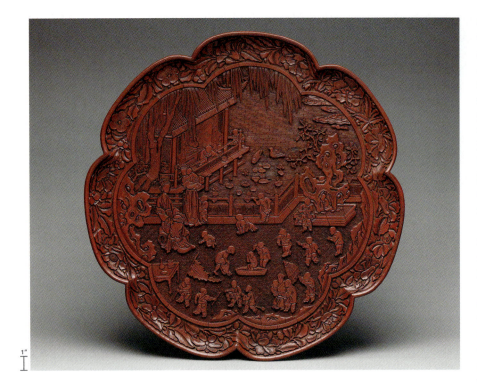

8.15 ABOVE **Tray with women and boys on a garden terrace,** Yuan dynasty, fourteenth century. Carved red lacquer, diameter 21⅞ in. (55.6 cm). Metropolitan Museum of Art, New York.

monochrome made from shades of a single color.

pingdan an aesthetic sensibility promoted by the literati, *pingdan* is reserved in style, mild in taste.

icon an image of a religious subject used for contemplation and veneration.

sutra in Buddhism, a scripture containing the teachings of the Buddha; more generally, a collection of teachings in Sanskrit, relating to some aspect of the conduct of life.

8.16 **Ni Zan,** *The Rongxi Studio,* Ming dynasty, 1372. Hanging scroll: ink on paper, 29 × 13⅞ in. (74.9 × 35.2 cm). National Palace Museum, Taipei.

and metal ware, and more generally may be related to Mongol appreciation for fine craftsmanship as well as to expanding trade throughout East and Southeast Asia. One source of evidence for such trade comes from maritime archaeology, which has recovered the cargo of shipwrecks. For example, in 1975 archaeologists discovered the remains of a Yuan Chinese trade vessel—the Sinan shipwreck—in the waters off Korea. Having departed Ningbo in 1323, the Sinan ship was bound for Japan with a cargo of carved lacquerware, hare's fur ceramics (see below), and great numbers of celadons. Altogether, more than 26,000 objects were recovered during the nine-year excavation.

Just as artisans developed models set by Song painting in their artwork, interest in pre-Song painting and experiments in abstraction during the early Yuan dynasty provided the foundation for further development in landscape. One beneficiary was the literati painter NI Zan (1301–1374). Throughout his life, Ni found inspiration in the work of Dong Yuan (see **Fig. 8.1**) and typically painted in a spare, **monochromatic** style similar to that seen in Guan's *Bamboo Groves* (see **Fig. 8.14**). In *The Rongxi Studio* (**Fig. 8.16**), painted near the end of his life and dating to the early Ming dynasty, Ni further distilled that spare style: no ripples enliven the blank water; no mist softens the stark atmosphere. The addition of a rustic pavilion only emphasizes human absence. Likewise, the withered trees indicate a desolate environment.

The painting deliberately shuns beauty and visual excitement. Instead, Ni's choice of motifs, along with his dry brushwork and grey ink, capture a reserved and mild aesthetic called ***pingdan***. This aesthetic is in keeping with both the artist's anti-Mongol political stance and his personal fastidiousness. Given its subjective, abstract style of representation, *The Rongxi Studio* might arguably (similarly to Zhao Mengfu's work, **Fig. 8.13**), be called a landscape of the mind. The artist's composition, showing a grove of trees in the foreground and low-lying hills beyond a river, appears generic. But Ni retroactively asserted that the landscape represents a real location. In the long inscription at the composition's top center, Ni described how the painting's original recipient returned in 1374 to ask that he rededicate it to a physician whose retreat was modestly called "Rongxi Studio"—literally, the studio just large enough to accommodate one's knees. That place becomes, after the fact and according to the artist himself, the site represented in this artwork.

A landscape screen distilling the quintessential features of a Ni Zan landscape serves as an appropriate backdrop for a portrait of the painter himself (**Fig. 8.17**). Wearing a scholar's robe and wielding brush and paper, Ni sits on a piece of versatile furniture, which might be described as a platform bed or couch. A pair of servants, male and female, each has on hand a fly whisk and water jug and towels, respectively. These objects signal Ni's fastidiousness. Select objects—including a brushrest in the shape of miniature mountains and an antique bronze vessel—displayed on a side table express his erudite taste. The unknown artist captured the artist's tidy appearance, but the material surroundings are more revealing of his

inner proclivities. The manner in which the landscape with its fisherman-recluse frames Ni's head, especially, suggests the workings of his mind.

Even though the date of *The Rongxi Studio* technically places it in the Ming dynasty (1368–1644), Ni Zan lived nearly all of his years under Yuan rule. Also, for him as well as for other literati painters, the conditions of Mongol government—including the curtailment of the civil-service bureaucracy—determined in large measure their decision to take up the brush. To distinguish their art from that of professional court painters, the literati pursued subject matter and styles that conveyed their learning, their individuality, and their point of view.

Buddhist Art during the Song and Yuan Dynasties, 960–1368

Beginning in the Period of Division (220–581) and continuing during the Tang dynasty, Buddhism inspired the creation of magnificent temples and myriad **icons** in areas of present-day China (see Chapters 4 and 6). Illustrated *sutras* helped spread Buddhist teachings across the empire. As Buddhist temples and other religious institutions gained in wealth and power, the Tang court perceived threats to tax receipts and political control. Thus, in 845, temples were targeted in a major proscription. Temple properties were seized, and monks and nuns forced to return to lay life. Still, Buddhism persisted, albeit in changed forms as new sects emerged from the wreckage.

During the Song dynasty, **Chan** Buddhism (a school of Buddhism that emphasized meditation) gained prominence and drew followers among scholar-officials. Literally meaning "meditation," Chan is a school, or sect, of Mahayana Buddhism. (Mahayana is one of the major strands within Buddhism and is itself divided into a number of different schools. In Mahayana Buddhism, the goal is the liberation of all beings, and *bodhisattvas* play prominent roles.) Chan adapted aspects of Daoism, and in doing so, it offered new paths to enlightenment that could be immediate and unorthodox, and it emphasized direct transmission of teachings from master to disciple.

By contrast, the Mongol rulers of the Yuan dynasty espoused Tibetan Buddhism, a form of **Esoteric**, or Vajrayana **Buddhism**. The Buddhist artworks illustrated here—a sculpture, a painting, a *stupa*, a tapestry, and a teabowl—make clear the variety of religious expression, which was not separate from the political arena or social life. Rather, Buddhist art from the Song to the Yuan dynasties was knit into the cultural fabric.

Among *bodhisattvas*, Avalokiteshvara, the *bodhisattva* of infinite compassion and mercy, is the most beloved in East Asia. In Chinese, Avalokiteshvara is commonly called "Guanyin," a condensed form of "Guanshiyin," which means "observing the sounds of the world." Thus, Guanyin is the *bodhisattva* who is particularly responsive to prayers. Such responsiveness fueled Guanyin's widespread popularity and informed the making of this sculpture (**Fig. 8.18**, p. 176), which dates to the Liao dynasty (907–1125) of the Khitan (see **Map 8.1**). The Khitan, whose name is the source of Cathay—an alternate European term for China—were semi-nomadic groups from northeast Asia. They ruled over parts of present-day Mongolia, northeast China, and far eastern Russia, and in the tenth and eleventh centuries, they were powerful neighbors of the Northern Song. In the early twelfth century, both the Liao and the Northern Song would be conquered by the Jurchens. But during their time in power, the Liao were active patrons of Buddhism, sponsoring the construction of temples and the making of such icons as this *Guanyin in Water-Moon Form.*

8.17 *Portrait of Ni Zan,* Yuan dynasty, *c.* 1340. Handscroll: 11⅛ × 24 in. (28.3 × 61 cm). National Palace Museum, Taipei.

Chan literally "meditation," Chan is a school, or sect of Mahayana Buddhism. Adapting aspects of Daoism, Chan emphasizes immediate, sometimes unorthodox realization of enlightenment, and direct transmission of teachings from master to disciple, beginning with the founding master Bodhidharma. Known in Korea as Seon, and in Japan as Zen.

bodhisattva in early Buddhism and Theravada Buddhism, a being with the potential to become a buddha; in Mahayana Buddhism, an enlightened being who vows to remain in this world in order to aid all sentient beings toward enlightenment.

Esoteric Buddhism schools of Mahayana Buddhism involving secret teachings available only to initiates who, with the aid of an advanced instructor, have completed certain rituals or reached certain levels of understanding.

stupa a mound-like or hemispherical structure containing Buddhist relics.

8.18 *Bodhisattva Guanyin (Avalokiteshvara) in Water-Moon Form,* Liao dynasty, eleventh century. Wood with traces of pigment, height 46½ in. (1.18 m). Metropolitan Museum of Art, New York.

also describe landscape walls that combined the arts of painting and sculpture to create a semblance of Mount Potalaka for icons of the Water-Moon Guanyin. In approaching the icon, worshipers echo the actions of the pilgrim boy Sudhana, as described in the *Avatamsaka* ("*Flower-Garland*") *sutra*. In his quest for enlightenment, Sudhana visited fifty-three spiritual teachers, the twenty-eighth being Guanyin.

Other Buddhist texts, among them the *Lotus sutra* and the *Heart sutra*, recount stories of Guanyin rescuing worshipers from calamities, or emphasize his meditative practice. These different conceptualizations underlie a variety of forms that this shape-shifting *bodhisattva* assumes in art. For example, *White-Robed Guanyin, Gibbons, and Crane,* a **triptych** of hanging scrolls by the Chan monk and painter Fachang Muqi ("Fachang" is the artist's monastic name, "Muqi" is the name by which he is known in art, *c.* 1200–after 1279), shows a form that is similar to, yet distinct from, the Water-Moon Guanyin (see Fig. 8.19). As in the earlier sculpture, Guanyin wears a crown featuring Amitabha Buddha. The landscape setting, which includes a rocky outcrop and lapping waters, evokes Guanyin's Pure Land of Mount Potalaka. Near Guanyin is a vase containing pure water and a willow branch, items that could be used in rituals and healing. The *bodhisattva*'s distinctive plain-white robe suggests that this is the salvific, or rescuing, White-Robed Guanyin and not the instructive Water-Moon Guanyin.

Muqi's *White-Robed Guanyin* is further distinguished in terms of style. The evident naturalism in the representation of facial expression, robes that plausibly drape over a physical body, and the moisture in the air and texture of the rocks, indicate a high degree of technical proficiency. In addition, Muqi's Guanyin does not sit confidently upright in the posture of royal ease but slumps slightly forward, suggesting interiority. The *bodhisattva*'s bearing seems more human, making him an exemplar for Chan practitioners and especially appealing to laymen of the scholar-official class. Finally, unlike many Buddhist and other religious painters, Muqi rejected the use of rich colors in favor of ink alone. In this regard, his monochrome composition attests to the spread of the literati aesthetic, with its emphasis on expressive brushwork.

Guanyin is flanked by a mother gibbon clutching her baby and by a calling crane. Capturing their physical shape and attentive to feathers and fur alike, Muqi imbued these creatures with vitality. Their religious meaning is not immediately apparent, however. Without an iconographical source in Buddhist *sutras*, the triptych has elicited lively discussion. The fact that the paintings were transmitted to Japan, where continuous esteem ensured the preservation of Muqi's artwork, raises the possibility that approaches to display in Muromachi period (1336–1573) Japan brought the three paintings together on the basis of aesthetic sensibility or thematic similarity. Recent research, however, has brought to light writing by Muqi's Chan master, the abbot Wuzhun Shifan (1178–1249). In a poetic inscription to a now-lost painting of Guanyin, the abbot yoked together the melancholy sounds of the cries of a solitary monkey and a crane

There is a standard **iconography** that allows viewers to identify forms of the Buddha and *bodhisattvas* (see Chapter 3). All *bodhisattvas* wear jewelry, but the tiny Amitabha Buddha figure in the crown identifies this figure specifically as Guanyin. Formed of multiple pieces of willow wood, the figure of Guanyin assumes a relaxed posture of royal ease, seated with its right arm resting on a raised knee. This pose further indicates a particular manifestation, the Water-Moon Guanyin, who presides over an island Pure Land, Mount Potalaka. (Compare to Amitabha Buddha who presides over the Western Pure Land, see Figs. 6.9 and 6.16). Naturalism in the representation of Guanyin's face, body, and drapery continues the direction of Tang International Style (see Fig. 6.8). Traces of pigment indicate that the sculpture was at one time fully painted. Resplendent in its original color, and regal in form, the figure of Guanyin would have appeared simultaneously otherworldly and immediately tangible. These formal qualities underscore Guanyin's capacity to comfort Buddhists seeking relief from suffering, and religious rituals would have transformed the sculpture, for believers, from mere **effigy** into efficacious icon.

Now in a museum collection, the statue of Guanyin may originally have been housed in one of the many temples built by the Khitan, who were prodigious sponsors of timber architecture. Contemporaneous records

iconography images or symbols used to convey specific meanings in an artwork.

effigy a sculpture or model, usually created for its symbolic and/or material value in relation to the thing it represents.

triptych a three-part work of art, often three panels attached together.

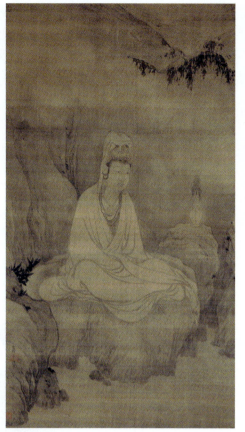
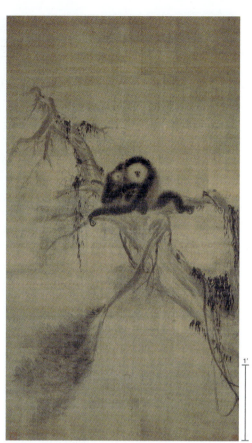

atop a wintry pine with the image of Guanyin. These two creatures' sounds had a prior history in Chinese literature of startling human listeners into awareness, or insight, a history that Guo Xi also drew on (see Going to the Source: Guo Xi's Writing on Landscape, p. 165). In this case, Wuzhun Shifan emphasized the role of sound followed by silence as a mechanism for Chan enlightenment. Following his master's idea, Muqi may have in fact originally intended these three paintings to be arranged together.

A prolific artist, Muqi belonged to one of the five major Chan temples located in the Southern Song capital. These temples not only supported religious practice but also nourished intellectual exchange with scholar-officials and with monks from outside the Southern Song borders. This context proved advantageous for Muqi and his art. Scholar-officials provided the model of monochrome ink painting that Muqi would adapt, and monks hailing from the Japanese archipelago returned home with not only a new school of Buddhism known in Japanese as Zen (see Chapter 9) but also many paintings by Muqi. This triptych is now in the collection of Daitokuji, a prominent Zen temple in Kyoto, Japan.

While Chan originated in Chinese regions, the Mongols brought to their Chinese empire another Buddhist sect named for its regional roots, Tibetan Buddhism. In East Asia, Buddhism was generally believed to have the power to protect the nation (see Chapter 6), and it provided a means of political legitimacy in the concept of the *chakravartin*. Tibetan Buddhism appealed to Mongol rulers who saw in it potent forms of religious ritual that could ensure victory on the battlefield.

The *chakravartin* ideal is demonstrated when devout rulers established Buddhist temples and otherwise spread Buddhist teachings. This ideal lies behind the White Stupa (**Figs. 8.20** and **8.20a, b**, p. 178). In 1271, Kublai Khan and Empress Chabi went to view Buddhist relics that were said to emit a supernatural light at the site of a ruined Liao dynasty *stupa*. When the iron **reliquary** was opened, golden-colored relics were discovered, along with Buddhist texts. Determined to erect a new *stupa* to enshrine the relics, Kublai commissioned the Nepalese artist Anige (also Arniko, 1245–1306). Born to Nepalese royalty of the Kathmandu Valley (see Chapter 5), Anige was a gifted painter and sculptor. In 1261, he traveled to Tibet to assist in the construction of a golden *stupa* at Kublai's behest. Anige distinguished himself in this project and consequently was summoned to court, where he rose to the position of supervisor-in-chief of court artisans.

For the White Stupa, Anige combined South Asian architectural features with Nepalese and Chinese ones, creating an apt monument completed in the same year that Kublai conquered Southern Song territory, thereby uniting the realm. The White Stupa is centered on a **plinth** with a narrower projection to the south for a front hall (**Fig. 8.20a**). Four small shrines, built in a Chinese style, occupy the corners of the plinth. The *stupa* itself is comprised of three parts. First, a two-tiered square base with progressively smaller projecting **bays** in each wall recalls a compositional strategy standard in South Asian temple architecture. Next, the *stupa* mound expands upward from a ring of stylized lotus petals, ending in a flat top, a shape characteristic of the Nepalese approach. Finally, at

8.19 Fachang Muqi, *White-Robed Guanyin, Gibbons, and Crane,* Southern Song dynasty, thirteenth century. Set of three hanging scrolls, ink and colors on silk; each approx. 5 ft. 7 in. × 38⅞ in. (1.7 m × 98.7 cm). Daitokuji, Kyoto, Japan.

chakravartin literally, "wheel-turner," a Sanskrit title used to refer to an ideal, just ruler, often in relationship to the dharmic faiths of Buddhism, Hinduism, and Jainism.

reliquary a container for relics (items associated with a deceased sacred individual), which is often elaborately decorated.

plinth a base or platform upon which a structure rests.

bay a space between columns, or a niche in a wall, that is created by defined structures.

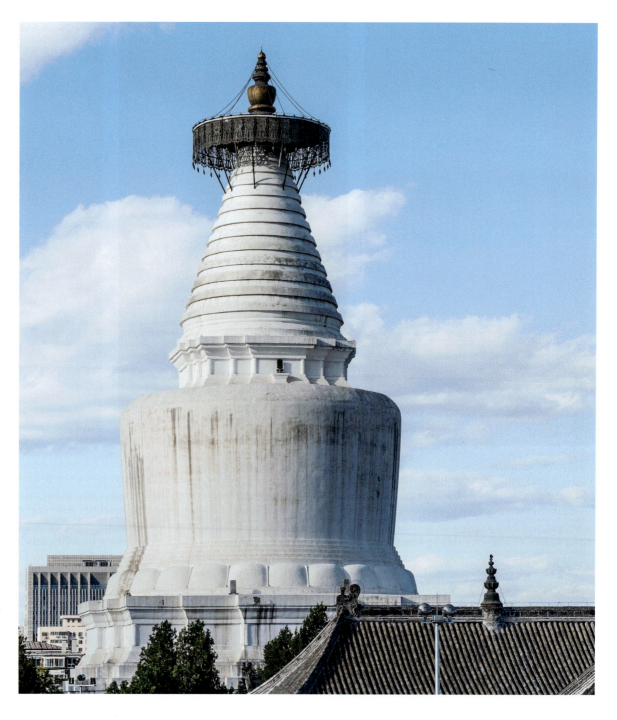

8.20 RIGHT **Anige, White Stupa,** Miaoying Temple, Beijing, Yuan dynasty, 1279. Stone with stucco and bronze, height 167 ft. (50.9 m).

8.20a BELOW **Anige, White Stupa, elevation and 8.20b plan,** Yuan dynasty, 1279.

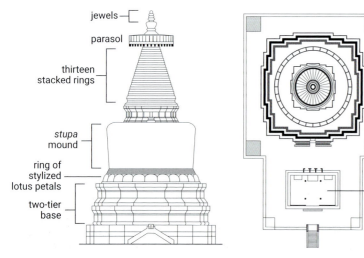

jewels

parasol

thirteen stacked rings

stupa mound

ring of stylized lotus petals

two-tier base

plinth

one of four shrines

front hall

the top, thirteen stacked rings—referring to the thirteen stages of Vajrayana Buddhism (see Fig. 5.18)—culminate in a parasol and jewels, the latter referring to the Three Jewels of Buddhism: the Buddha, the *dharma* (Buddhist teachings), and the *sangha* (the monastic community).

At the ceremony celebrating the *stupa*'s completion, Kublai shot four arrows from the four sides of the *stupa* to mark the boundaries (an area of about 40 acres, or 16 hectares) for a Buddhist temple. Modeled after the imperial palace, this temple eventually housed imperial portraits designed by Anige. In 1368, fire caused by a thunderstorm burned down most of this grand temple, but the White Stupa still stands.

Imperial Mongol patronage of Buddhism continued in later generations, and is evident in this mandala (**Fig. 8.21**, and see, for comparison, Fig. 6.15). Esoteric

schools of Buddhism advocated visualization practices and identification with personal deities, and such rituals were facilitated by the use of a mandala. Dating to the Yuan dynasty, this mandala imagines a religious cosmos with the deity Vajrabhairava, the wrathful manifestation of the *bodhisattva* of wisdom, at its center. With a grimacing expression and horned bull's head, the multi-limbed Vajrabhairava seems to resemble images of evil as pictured in other artistic traditions. This wrathful *bodhisattva*'s superhuman physical power, however, is directed at literally stomping out

impediments—represented by tiny human and animal figure—to liberation and enlightenment.

Vajrabhairava presides within a palatial structure with elaborate gates located in the four cardinal directions. Completing the kaleidoscopic composition are lesser deities who occupy—in rank order—the positions around Vajrabhairava. Some inhabit the central square court; others fill the corner spaces. Registers at top and bottom accommodate some human figures. For example, numerous monks, identifiable by their patchwork robes, occupy bright-orange, lotus-petal-shaped niches. The

8.21 *Mandala of Vajrabhairava,* c. 1330–32. Silk tapestry (*kesi*), 8 ft. ⅝ in. × 6 ft. 10⅜ in. (2.45 × 2.09 m). Metropolitan Museum of Art, New York.

bottom corners feature donor portraits. At (the viewer's) left are the Yuan emperor Tugh Temür (known as Wenzong, ruled 1328–1332) wearing a white robe and his elder brother wearing blue; their consorts appear in the opposite corner. The imagery of the mandala attests to Mongol patronage of Buddhism and, more generally, to the close relationship between politics and religion during the Yuan dynasty.

The mandala's medium—silk tapestry (Chinese: *kesi*) with gilded paper representing jewelry—speaks to the encounter of cultures. The Mongol esteem for textiles led to the preference for tapestry over painting for important imperial commissions. Thus, the mandala image employs the most sophisticated technologies of Chinese silk manufacture.

In contrast to icons and *stupas* that directly express Buddhist beliefs, this stoneware teabowl (**Fig. 8.22**) dated to the Southern Song period may not immediately bring to mind religious practices. It features neither sacred imagery nor a dedicatory inscription (compare to **Fig. 8.12**). Instead, its deliberately subdued, understated appearance as well as its physical thickness complement its usage: drinking powdered, whisked tea as a stimulant for sustaining lengthy periods of meditation or other rituals. In a Song dynasty book about tea, the scholar CAI Xiang (1012–67) wrote:

> Tea is of light color and looks best in black cups. The cups made at Jian'an [present-day Fujian province] are bluish-black in color, marked like the fur of a hare. Being of rather thick fabric they retain the heat, so that when

once warmed through they cool very slowly, and they are additionally valued on this account.

Although this particular teabowl is brownish-black rather than bluish-black in color, the glaze does produce a pattern bearing some resemblance to hare's fur. As Cai Xiang remarked, it would have provided an attractive, contrasting frame for frothy, bright-green tea.

Cai's remarks also demonstrate that appreciation for hare's fur ceramics was not limited to Chan Buddhist contexts. The cargo of the Sinan shipwreck of 1323 included black-glazed ceramics, and Emperor Huizong (during whose reign the celebrated celadon *ru* ware was made, see **Fig. 8.8**) opined that among black teabowls, those with hare's-fur markings were superior. Still, the most enthusiasm for black wares is to be found in the history of Japanese pottery, where it is called *tenmoku*, which refers to the mountain location of Chan monasteries where Japanese monks had studied during the Southern Song dynasty. The ritual of making whisked green tea would continue to bear on pottery in Japanese regions for centuries to come; in China, that form of tea was displaced by steeping tea leaves and different types of tea cups and teapots replaced black teabowls.

During the Song dynasty, quintessential features of Chinese culture took shape. At the Song courts, idealized landscapes and refined images demonstrated artistic excellence, but also proclaimed political legitimacy. In contrast to courtly standards, scholar-officials developed alternative aesthetic values based on the traditions of

8.22 **Tea Bowl with hare's-fur glaze,** Southern Song dynasty. Stoneware with iron glaze, height 2¾ in. (7 cm); diameter 5 in. (12.7 cm). Metropolitan Museum of Art, New York.

poetry and calligraphy, which emphasized subjectivity. Their aesthetic preferences informed art at court and in temples, too, which led to their transmission beyond Chinese lands. Foreign invasions caused violence and destruction, but the Khitan Liao and the Mongol Yuan also spurred new developments in art. Whereas antipathy toward Mongol governance indirectly nourished literati painting, Mongol rule led positively to artistic developments, too, notably in ceramics and textiles.

Between the tenth and fourteenth centuries, cultural contact generated tremendous wealth and played a prominent role in art in China. After journeying to the Yuan capital of Dadu, one eyewitness to the riches of the Mongol Yuan Empire wrote, "The quantity of merchandise sold there exceeds also the traffic of any other place; for no fewer than a thousand carriages and pack-horses, loaded with raw silk, make their daily entry; and gold tissues and silks of various kinds are manufactured to an immense extent." The eyewitness was the Venetian Marco Polo, and his descriptions of the fabulously affluent and highly cultured empire at this end of the Eurasian continent would fuel European imaginations. The increasing volume of cross-cultural encounters in the centuries to come would shape Early Modern societies across much of the world including Late Imperial China.

Discussion Questions

1. Following Su Shi's ideas on painting, literati artists preferred abstraction to naturalism, or illusionism. Why? Explain by referring to paintings in this chapter.

2. The courts of the Song dynasty and the Yuan dynasty were major patrons of art. Identify the stylistic characteristics of court-sponsored artworks and explain how style relates to subject or content.

3. The Buddhist artworks in this chapter demonstrate a great deal of variety. How can such strikingly different artworks nevertheless be understood as Buddhist? Refer to artworks in your explanation.

4. Further research: compared to earlier eras, the names of more artists and patrons are known. Choose an artist or patron who interests you. What other artworks are associated with that person? Compare those with the one discussed in this chapter.

Further Reading

- Foong, Leong Ping. *The Efficacious Landscape: On the Authorities of Painting at the Northern Song Court.* Harvard East Asian Monographs 372. Cambridge, MA: Harvard University Asia Center, 2015.

- Lee, Hui-shu. *Empresses, Art and Agency in Song Dynasty China.* Seattle, WA: University of Washington Press, 2010.

- Lippit, Yukio. "Seer of Sounds: The Muqi Triptych." In Gregory P. A. Levine, Andrew M. Watsky, and Gennifer Weisenfeld (eds.). *Crossing the Sea: Essays on East Asian Art in Honor of Professor Yoshiaki Shimizu.* Princeton, NJ: Princeton University Press, 2012, pp. 243–66.

- McCausland, Shane. *The Mongol Century: Visual Cultures of Yuan China, 1271–1368.* Honolulu, HI: University of Hawai'i Press, 2015.

Chronology

907–1125	The Liao (Khitan) dynasty; *Bodhisattva Guanyin (Avalokiteshvara) in Water-Moon Form* is sculpted		13th century	Chan monk-artist Fachang Muqi paints *White-Robed Guanyin, Gibbons, and Crane*
937–75	The Southern Tang kingdom; Dong Yuan paints *Wintry Groves and Layered Banks*, c. 950		1271–1368	The Yuan (Mongol) dynasty; blue-and-white porcelain is first manufactured
960–1279	The Song dynasty; the Jurchen conquest of areas of this empire in 1127 results in historical divisions: Northern Song and Southern Song		1279	Designed by Nepalese artist Anige, the White Stupa is built
			c. 1287	Zhao Mengfu paints *The Mind Landscape of Xie Youyu*
960–1127	The Northern Song dynasty			
1072	Guo Xi paints *Early Spring*		1323	Now known as the Sinan shipwreck, a Yuan trading vessel loaded with lacquerware and black teabowls in its cargo sinks near the Sinan islands of present-day South Korea
1082	Su Shi writes a poem on the Cold Food Festival			
1101–25	The rule of Emperor Huizong; *ru* ware is made for the court		1330–32	*Mandala of Vajrabhairava* includes portraits of its imperial Mongol patrons
1115–1234	The Jin (Jurchen) dynasty		c. 1340	The artist Ni Zan is portrayed seated before a screen painted with a landscape in his characteristic style
1127–1279	The Southern Song dynasty			
early 13th century	Empress Yang inscribes a poetic couplet onto *Apricot Blossoms* by court painter Ma Yuan		1351	Altar vases (the David Vases) are made and dedicated

Pax Mongolica

Military invasions and conquests typically result in the destruction of art: cities sacked, monuments damaged, artisans killed, and economies and patronage systems disrupted. Paradoxically, war also can foster new cross-cultural connections, which in turn spur economic development and artistic creativity. The period of Mongol rule in Eurasia during the thirteenth and fourteenth centuries clearly illustrates both sides of this equation, with cultural destruction and development as enmeshed byproducts.

Under the leadership of Chinggis Khan (also spelled Genghis; *c.* 1162–1227) and his descendants, the Mongol armies swept across the Central Asian steppe, moving east and west, to create the largest land-based empire in world history. They achieved this feat through unprecedented devastation and killing, but also through military superiority: fast horses, expert archers, and smart strategic planning. Decades of brutal military confrontation yielded to a period of relative stability, often referred to by historians as *Pax Mongolica* (Latin for "Mongolian Peace"). This peace facilitated active overland trade and led to artistic cross-fertilization.

Under Chinggis Khan's grandsons, the empire was divided into four parts, called khanates: the Yuan in present-day China (the most powerful of the four, see Chapter 8); the Chaghatay in Central Asia; the Ilkhanids in the Iranian plateau region; and the Golden Horde in the area of present-day southern Russia and eastern Europe. In each region, Mongol elite employed local administrators, and combined aspects of their nomadic culture with local traditions. For example, in Ilkhanid Iran, they converted to Islam, spoke Persian, and set up royal workshops to produce illustrated manuscripts and paintings on paper.

The Mongols' predilection for recording history and their own accomplishments can be seen in artwork such as this fourteenth-century painting, commemorating the taking of Baghdad in 1258 (**Fig. 1**). This victory, during which the Mongols killed the Muslim caliph—officially ending the five-hundred-year-old 'Abbasid Caliphate—was a crucial one, and the painting carefully records the siege techniques used to achieve it.

The many strands in Mongol culture are perhaps most evident through the dress and accessories they wore. Clothing may conceal the body, but it reveals the person and the culture. For example, the cut of this robe (**Fig. 2**), or tunic—with its long, fitted sleeves, overlapping collar, and flared skirt—makes it suitable for horseback riding. A wide waistband culminates in numerous ribbons for fastening the garment securely. The tunic was excavated in 1978 at an Onggut tomb site in Inner Mongolia. The Onggut (also spelled Ongud) were Turkic-speaking, Christian people who lived in Mongolia during the time of Chinggis Khan. In the early thirteenth century, they allied themselves to the Mongols, and marital unions, including that between Chinggis's daughter and the son of an Ongud chief, ensued.

The robe's fabric itself merges diverse visual cultures, too. By the time of *Pax Mongolica*, silk manufacturing had spread well beyond its origins in fourth-millennium BCE Neolithic cultures in China. Nevertheless, Chinese silks remained among the most prized commodities, and this tunic was made from a luxurious silk woven with a figural pattern. The lining of gold brocade features stylized, winged lions wearing crowns and paired inside roundels (**Fig. 2a**). Such patterns may be traced to Persian Sasanian culture (*c.* 224–651 CE) inherited by

1 The Mongol Conquest of Baghdad, illustration from the *Diez Albums*, Iran, Ilkhanid dynasty, fourteenth century. Ink and colors on paper, 15⅛ × 11⅞ in. (38.3 × 30.3 cm). Staatsbibliothek zu Berlin Preussischer Kulturbesitz, Orientabteilung. **WEST ASIA**

2 ABOVE **Robe or tunic,** found at the Onggut tomb site, Mongolia, thirteenth–fourteenth century. Silk with gold brocade, 56 in. × 8 ft. ⅞ in. (1.42 × 2.46 m). Inner Mongolia Museum of the People's Republic of China, Hohhot, China. **EAST ASIA**

2a ABOVE RIGHT **Motif from the robe lining (detail).**

the Ilkhanids, further illustrating the multicultural nature of the Mongol Empire.

Another example of the blending of Chinese, Persian, and Mongolian material traditions is this shallow cup, or "dipper" from the Tobolsk region of Russia (**Fig. 3**). A member of the Golden Horde would have tied the object to his belt through the loop hanging from the dragon's mouth on the handle, thus making the cup readily accessible and a visible marker of his status. Scholars believe that this type of vessel originated in northern China during the Liao dynasty (907–1125) of the semi-nomadic Khitan tribes who ruled over the eastern steppe of Eurasia. The Golden Horde continued the tradition as a show of wealth, with cups made of gold or silver. Chinggis Khan adopted the Chinese dragon motif as a sign of power, and its inclusion on the dipper marks its owner as a high-status member of Mongol society. Notably, the other prominent decoration on the cup, around the lip, is an abstract band of ornamentation that looks like Arabic calligraphy, but does not actually form any letters or words. Objects such as this one embody both the rich artistic output fostered by the *Pax Mongolica* and the Mongol military culture, which enabled the conquest of so many people and so much land.

3 **Dipper, Golden Horde,** Tobolsk region, Russia, thirteenth–fourteenth century. Silver, 1¾ in. (4.4 cm), diameter 4⅜ in. (11.1 cm). State Hermitage Museum, St. Petersburg, Russia. **NORTHERN EURASIA**

Discussion Questions

1. Art during the Yuan dynasty is also discussed in Chapter 8. Choose a Yuan dynasty artwork to compare to examples discussed here. What common traits or themes do you see?

2. How might any of the artwork here be connected to art by later Mongolian artists, such as Zanabazar (Fig. 12.17) or Nyam-Osoryn Tsultem (Fig. 0.6)?

Further Reading

- Carboni, Stefano and Komaroff, Linda (eds.). *The Legacy of Chinggis Khan: Courtly Art and Culture in Western Asia, 1256–1353.* New York: The Metropolitan Museum of Art, 2002.

- McCausland, Shane. *The Mongol Century: Visual Cultures of Yuan China, 1271–1368.* Honolulu, HI: University of Hawai'i Press, 2015.

9.0 Detail of Seo Gubang, *Water-Moon
Gwaneum Bosal.*

9

Transformative Eras and
Art in Korea and Japan

1200–1600

Introduction

Arts of the Korean peninsula and those of the Japanese archipelago are often discussed separately, but areas of these two regions form a zone of political, social, and cultural interaction (Map 9.1). Sometimes the histories of these areas unfolded independently, but at other times, migration, trade, diplomacy, and war created an intertwined history. From the thirteenth to the end of the sixteenth century, a period when the late medieval yields to the Early Modern, such interactions—both peaceful and violent—were transformative in terms of artistic development.

Studying both regions together reveals how shared sources, such as Buddhism or the culture of scholar-officials on the Chinese mainland, inspired distinct artforms. This approach also facilitates analysis of the dynamic interaction of geopolitics and art. Notably, late sixteenth-century invasions of the Korean peninsula led by the Japanese warlord Hideyoshi directly resulted in the abduction of ceramic artisans and the transfer of ceramic technology and styles from Korea to Japan.

Between around 1200 and 1600, art from the Korean peninsula reveals a shift in emphasis from Buddhist to Confucian beliefs. The Goryeo dynasty (918–1392), the source of the word "Korea," drew political legitimacy from Buddhism. Consequently, no expense was spared in royal and aristocratic patronage of Buddhist art. Buddhism continued to be practiced during the following Joseon dynasty (1392–1910), but its prominence gave way to Confucian ideas, espoused by the founding Joseon king and his supporters. Thus, arts of the early Joseon demonstrate heightened attention to subjects and styles with Confucian significance.

On the Japanese archipelago, these same centuries saw dramatic changes in art, as civil war and military rivalry swept the country. At the same time, courtly taste and earlier styles continued to be sources of cultural prestige, even in images of important battles. Change and continuity co-existed in Buddhist art in this region, too, particularly in the icons, paintings, and gardens associated with Zen (Chinese: Chan, Korean: Seon). By the late sixteenth century, coinciding with the start of the Early Modern era, such continuity was less visible, as mighty castles, rustic teahouses, and splendid screens featuring Portuguese missionaries and exotic animals attest to a much-changed landscape of architecture and art.

Buddhism and Art of Goryeo Korea, 918–1392

Introduced to the Korean peninsula in the fourth century CE, Buddhism initially found favor with the ruling aristocracies of regional kingdoms and then gained popularity among the general populations (see Map 6.1 and Chapter 6). Buddhism's broad appeal grew during the Unified Silla period (668–935) and persisted during the Goryeo dynasty (918–1392).

WANG Geon (also known as Taejo, 877–943) founded the Goryeo dynasty, establishing Songdo as the capital. Acknowledging that "the success of the great enterprise of founding our dynasty [Goryeo] is entirely owing to

Map 9.1 **Korea and Japan,** highlighting key sites, c. 1200–1600.

the protective powers of the many Buddhas," Wang declared Buddhism the state religion. Subsequently, the court became a major sponsor of Buddhist temples and patron of Buddhist art. The magnitude of state support is demonstrated by its commissioning **woodblock** editions of the complete Buddhist canon, known as the *Goryeo Tripitaka* ("Goryeo" referring to the sponsorship and "Tripitaka" referring to the Buddhist *sutras*). Astoundingly, this monumental project—about 80,000 wooden panels were carved for printing 6,568 volumes—was undertaken to protect the state from foreign enemies not once, but twice. The first printing was undertaken in the eleventh century partly as a prayer for protection against the Khitan, who tried to expand the territory of their Liao dynasty (906–1125; see Chapter 8) into the Korean peninsula. Goryeo forces succeeded in repelling the third and last invasion in 1118, after which they built a "thousand-mile" Long Wall for defense. But in the thirteenth century, neither the wall nor the first *Tripitaka* stopped the Mongol attack. The Goryeo court fled the capital, and the *Tripitaka* was destroyed in the fighting. After the Goryeo court reestablished at Ganghwa Island, west of Hanseong (Seoul), it initiated a second *Tripitaka*. This set of 80,000 woodblocks, now housed at Hae'in monastery in South Korea, was completed in 1251.

The *Goryeo Tripitaka* has few rivals in terms of scope and quality, but the practice of commissioning Buddhist texts was not new. For centuries, devotees sponsored handwritten, illustrated, and/or printed Buddhist texts as a means of gaining karmic merit. Commissioned by a high-ranking official, this lavish example of the *Avatamsaka* (*Flower Garland*) *sutra* demonstrates the extraordinary skill of monks specially trained in calligraphy and painting for the express purpose of making

woodblock printing a relief printing process where the image is carved into a block of wood; the raised areas are inked. (For color printing, multiple blocks are used, each carrying a separate color.)

sutra in Buddhism, a scripture containing the teachings of the Buddha; more generally, a collection of teachings in Sanskrit, relating to some aspect of the conduct of life.

9.1 *Avatamsaka (Flower Garland) sutra* (Korean: Hwaeomgyeong), Vol. 78, illustrated frontispiece. Goryeo dynasty, thirteenth to fourteenth century. Gold and silver on paper. 8⅛ × 17⅛ in. (20.6 × 43.5 cm). Page: 8⅛ × 4⅜ in. (20.6 × 11.11 cm). Cleveland Museum of Art, Ohio.

bodhisattva in early Buddhism and Theravada Buddhism, a being with the potential to become a buddha; in Mahayana Buddhism, an enlightened being who vows to remain in this world in order to aid all sentient beings toward enlightenment.

icon an image of a religious subject, used for contemplation and veneration.

halo a circle of light depicted around the head of a holy figure to signify his or her divinity.

vajra a term meaning thunderbolt or diamond; in Hinduism and Buddhism, a ritual weapon with the properties of a diamond (indestructibility) and a thunderbolt (irresistible force) to cut through illusions that obstruct enlightenment.

sutras of splendid appearance (**Fig. 9.1**). Typical of its kind, this *sutra* uses silver and gold ink on paper that has been dyed a deep indigo blue. Such precious materials attest to the value accorded the text, but they also produce a visually striking effect. The *sutra* takes the form of an accordion-fold book, and as the viewer unfolds it to the left, an illustrated frontispiece precedes the text.

At the right edge of the frontispiece, the larger cartouche identifies this *sutra* as volume 78 of the multi-volume *Avatamsaka sutra*, and the smaller cartouche beside it further specifies the content as part of the story of the pilgrim Sudhana. On his quest for ultimate truth, Sudhana encounters fifty-three teachers, including several *bodhisattvas*. This illustration begins with a temple courtyard rendered in extremely fine gold lines. Doors and windows to two of the resplendent buildings have been opened, allowing viewers to see unoccupied pedestals. Wavy lines around the pedestals indicate the aura of absent Buddhist **icons**. In the second half of the illustration, the pilgrim Sudhana turns toward an assemblage of **haloed** figures, the first and largest of which is the *bodhisattva* Maitreya. The picture suggests that the icon of Maitreya has miraculously become animated, and now Maitreya offers Sudhana instruction outside the temple building. The nearby cartouche confirms Maitreya's identity. Around the entire image, a fine border repeats a pattern of double *vajras*, indicating the *sutra's* power to cut through illusions to reveal truth.

In the course of his pilgrimage, Sudhana also visits Avalokitesvara. Throughout East Asia, Avalokiteshvara is one of the most beloved Buddhist deities, known for the capacity for compassion and mercy. Reflecting this, the local name for this *bodhisattva* (Korean: *bosal*), literally

means "to see the sounds of the world." In Chinese, the name is Guanyin, abbreviated from Guanshiyin (see Chapter 8). The corresponding Korean names are Gwaneum and Gwanse-eum.

In this painting dating from 1323 by SEO Gubang (active *c.* 1323), Gwaneum appears resplendent in a particular manifestation called "Water-Moon" (**Figs. 9.0** and **9.2**). Time has darkened the silk on which Seo painted the image, but its exquisite details are nevertheless visible. Gwaneum is framed by a gold halo and **mandorla**, both round like the full moon. He wears a diaphanous scarf and abundant jewelry, including a crown featuring a tiny Amitabha Buddha, a **buddha** whose image is used as an **iconographic** marker for Gwaneum.

A rocky outcrop that emerges from the right not only provides a natural throne but also identifies the location as the *bodhisattva's* island realm, Mount Potalaka. At the lower right, water pours through the rocky crags into the foreground, where corals and flowers adorn the shoreline. Seated in a posture called "royal ease," Gwaneum rests his foot on an ornate lotus, a common Buddhist symbol of purity. The *bodhisattva's* gaze, his right arm, and the crystal prayer beads dangling from his hand direct attention to the pilgrim Sudhana, the small figure kneeling in the lower-left corner.

Juxtaposed with earlier Avalokiteshvara icons from areas of present-day China (see Figs. 8.18 and 8.19), Seo's painting testifies to the transmission and transformation of this revered *bodhisattva*. The iconographic marker of the crown set with Amitabha Buddha is consistent across all representations. Other features are new, such as the diaphanous quality of and embroidery on Gwaneum's

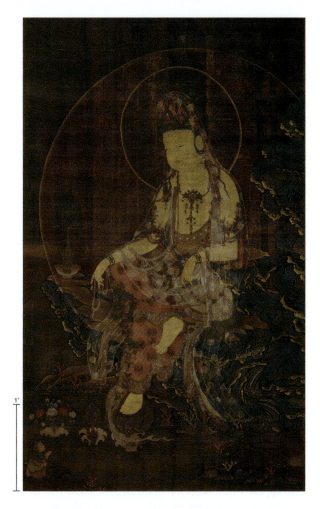

sources, so does this water-sprinkler, or *kundika*, which has developed from a South Asian form (**Fig. 9.3**). The curved mouth at the side is for filling, while the narrow spout at top is for sprinkling. Used in Buddhist purification rituals, some Goryeo *kundika* are made of bronze with inlaid silver wire, while others, like this one, are made of ceramic, and commonly called **celadon**.

"Celadon" refers to a wide range of ceramics from Asia (see Fig. 8.8). Regardless of whether they are low-fired **earthenware**, higher-fired **stoneware**, or **porcelain**, celadons share a predominant greenish color of glaze and are therefore also known as green ware (Korean: *cheongja*). For local audiences as well as contemporaneous collectors in Song dynasty China, the luster and hue of the glaze sometimes resembled jade, a highly regarded material. For Early Modern Europeans, the color called to mind the green costume of a character from French literature and drama, Céladon. Despite the term celadon being neither technical nor East Asian in origin, it continues to be used.

Made for both secular and sacred purposes, celadons of the Goryeo period demonstrate an exceedingly high standard. They come in an extraordinary variety of shapes, including imitation gourds and lively animals, and Goryeo potters experimented with techniques such as **openwork**. To create this *kundika*, the potter adapted a widely used metalworking technique, inlay.

white veil, which may allude to the net of light with which the suffering of sentient beings is removed. In terms of artistic medium, Goryeo Buddhist icons are also distinguished by their use of gold ink, notably as visual accents on rocks.

A gold-ink inscription along the painting's lower left records the artist's name, Seo Gubang, and a date equivalent to 1323. The inscription, which includes a reference to Seo's position as a court artist, also attests to royal sponsorship. Nothing else is known about Seo, and because inscriptions are extremely rare, *Water-Moon Gwaneum Bosal* functions as a landmark for other Goryeo Buddhist paintings. Such paintings would have demonstrated religious devotion among Goryeo aristocracy and would probably have been displayed in **votive** chapels, whether in private temples or homes. However, the painting's current location is Japan. Centuries ago, Goryeo Buddhist paintings that depicted Buddhist icons were transferred by pilgrims, pirates, or as plunder from war to collectors and temples in the Japanese archipelago. Their origins forgotten, such paintings were subsequently misidentified as the work of anonymous Chinese artists of the Song or Yuan dynasties. Over the course of the twentieth century, however, Goryeo artists, such as Seo Gubang, and Goryeo Buddhist paintings—of which only about 140 are known to have survived—have become properly recognized.

Just as Seo's painting of Gwaneum demonstrates both a connection to and independence from earlier

9.2 FAR LEFT **Seo Gubang, Water-Moon Gwaneum Bosal,** Goryeo dynasty, 1323. Color and gold on silk, 5 ft. 4¾ in. × 40 in. (1.65 × 1.02 m). Sen-oku Hakukokan Museum, Sumitomo Collection, Kyoto, Japan.

mandorla (in religious art) a halo or frame that surrounds the entire body.

buddha; Buddha, the a buddha is a being who has achieved the state of perfect enlightenment called Buddhahood; the Buddha is, literally, the "Enlightened One"; generally refers to the historical Buddha, Siddhartha Gautama, also called Shakyamuni and Shakyasimha.

iconography images or symbols used to convey specific meanings in an artwork.

votive an image or object created as a devotional offering to a deity.

celadon (also known as green ware): a wide range of ceramics with a common greenish hue.

earthenware pottery fired to a temperature below 1,200 degrees Celsius; also called terra-cotta.

stoneware a type of ceramic that is relatively high-fired and results in a non-porous body (unlike terra-cotta or earthenware).

porcelain a smooth, translucent ceramic made from kaolin clay fired at very high temperatures.

openwork decoration created by holes that pierce through an object.

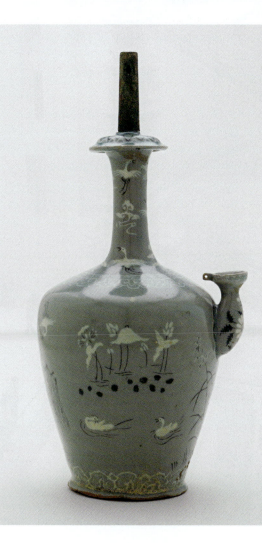

9.3 *Kundika*, Goryeo dynasty, *c.* late twelfth–early thirteenth century. Stoneware with inlays under celadon glaze; bronze repair, height 12¼ in. (31.1 cm). Freer Gallery of Art, Smithsonian Institution, Washington, D.C.

This technique involved carving or **incising** the leather-hard clay body and filling the shallow cavities with white or red **slip** before firing the vessel. The entire vessel then received a greenish glaze and was fired a second time. For the *kundika* pictured here, white slip was used for waterfowl and lotus, and red slip (which turns black when fired) gives form to the stems and duckweeds. Other inlaid decorations include a chrysanthemum on the curved mouth, cranes and stylized clouds on the long neck, and cranes and a willow tree on the side opposite the mouth (not seen in the view illustrated here). The motifs are both decorative and symbolic. The lotus symbolizes purity, and the willow tree, which is the source of healing substances similar to aspirin, alludes to the *kundika*'s purpose as a container of purified water. (Note that the wood used for the Liao dynasty icon was willow wood, Fig. 8.18.)

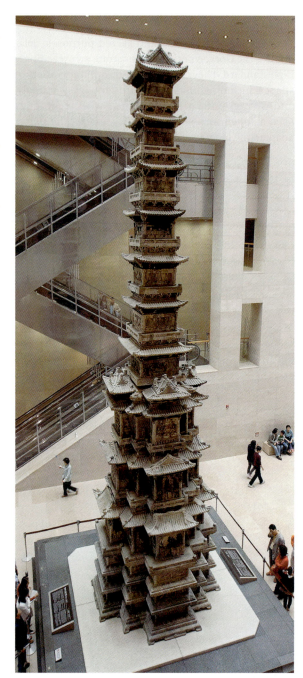

9.4 Ten-story pagoda from the site of Gyeongcheon Temple, late Goryeo dynasty, fourteenth century; inscription dated to 1348. Marble, height 44 ft. 3½ in. (13.5 m). National Museum of Korea, Seoul.

While Buddhist implements, paintings, and texts survive from the Goryeo period, the wooden architecture of the many Buddhist temples founded during that time has perished. Some sense of their lost splendor may be gleaned from their depiction in paintings (see **Fig. 9.1**) and from stone **pagodas**, a form of sculpture informed by architecture. Some stone, or masonry, pagodas are quite small and simple, consisting of a base or **plinth**, a sculpted block resembling a **post-and-lintel** architectural **bay**, and a roof with or without a **finial**. But other stone pagodas may be large and elaborate, such as this ten-story pagoda of Gyeongcheon Temple (**Fig. 9.4**). Dated to 1348, this pagoda offers evidence of new forms of Buddhism—as well as a new geo-political relationship between Goryeo and the Mongol Yuan dynasty—in the late Goryeo period.

The forty-four-foot high pagoda has a three-tiered base. Rising atop the base, the ten stories may be divided into two sections: the lower three stories echoing the base's cross-shape, and the upper seven stories being square. Separating the lower and upper stories is an especially elaborate double-eave, **hip-and-gabled roof**. The roof at the top of the pagoda is similar in style. Whereas carved architectural features such as roofs and brackets derive from East Asian architecture, the square-shaped base with protruding walls on the side may be traced to the Yuan dynasty Mongol adoption of Tibetan Buddhism (see Figs. 8.20 and 8.20a).

The surface of this ten-story pagoda is filled with relief sculpture. On the lower four stories, Buddhist assemblies dominate; on the upper six stories, buddhas in meditation appear. The middle tier of the pagoda's base features twenty scenes representing the popular Chinese epic *Journey to the West*, which fictionalizes the pilgrimage of the Tang dynasty monk Xuanzang (d. 664). Ten scenes picture Xuanzang's outbound journey to Buddhist holy sites; the other ten scenes show his return home with thousands of *sutras* (see Going to the Source: A Tang Dynasty Account of Bamiyan, p. 101). In *Journey to the West*, Xuanzang is accompanied by three companions, the most famous of whom is Sun Wukong, popularly known as the trickster Monkey King. Thus, the pagoda not only depicts the story of transmitting Buddhist **relics** (in East Asia, *sutras* are often considered relics) but it also houses relics, which would have been buried in a crypt beneath it.

Just as the pagoda's form and decorative program offer a history of cultural contact, so too the circumstances of its patrons demonstrate changing geo-political relationships. Two of the patrons (one of whom married his daughter to a high-ranking Yuan minister) had close ties to the Mongol Yuan court. (At the highest level of government, the close political relationship is evident in the Yuan insistence that Goryeo kings marry Mongol princesses and that Goryeo princes live in the Yuan capital.) Accordingly, the pagoda is dedicated to the welfare of the Yuan dynasty, the Goryeo state, and the Buddhist faith. The later history of the pagoda includes a case of illegal smuggling to Japan, repatriation to Korea, and temporary installation in the Gyeongbok Palace of the Joseon dynasty. Now, after conservation, the pagoda is on display in the National Museum of Korea.

Confucianism and Art of Joseon Korea in the Fifteenth Century

Although Buddhism permeated Goryeo society, the state also established a Confucian system of scholar-officials such as that created in Song dynasty China. Having studied Confucian classic texts and passed government-sponsored examinations, scholars could qualify for appointments to official positions in civil administration. As a social force, scholar-officials exerted less influence during Goryeo, but they gained more power in the subsequent Joseon dynasty (1392–1910), when the government replaced Buddhism with a new state ideology, **Neo-Confucianism**. This philosophy, which originated in Song dynasty China and endures in areas of East and Southeast Asia, draws on Confucianism, Daoism, and Buddhism to provide a system of beliefs aimed at establishing harmony in state and society. Two paintings—a portrait and a landscape—from the part of the Joseon period that overlaps with the medieval era of world history demonstrate the taste and values of scholar-officials.

By definition, portraits represent their sitters. But how closely do representations correspond to physical appearance? The images of powerful individuals vary according to portrait conventions and cultural standards relating to **physiognomy**. Rather than being straightforward records of physical appearance, portraits of important individuals are designed to convey certain ideas to the viewer. Portraits of powerful people often use visual strategies to assert authority and legitimacy.

This painting of the scholar-official SIN Sukju (1417–1475) combines generic conventions of formal portraiture with an individualized face (**Fig. 9.5**). Seated with feet resting on an ornately carved footstool, Sin wears a black hat with starched wings and a green robe, which features a gold-embroidered badge, including a pair of peacocks, to indicate his official rank in the bureaucratic hierarchy. (Each rank was assigned a different motif.) The costume, furnishings, unpainted background, and posture are formulaic, but Sin's face is particularized. His straight eyebrows, steady gaze, rounded jaw, mustache, and whiskers are probably the work of a portrait specialist.

Produced at court, which was at the capital Hanseong (present-day Seoul), formal portraits of officials such as Sin demonstrate the Confucian ideal of a reciprocal relationship between emperor and members of the civil service. Officials served the emperor not only by administering the realm but also by lending legitimacy to his rule. In return, the emperor provided officials with employment, rank, and recognition. By demonstrating the subject's merit, this portrait brought honor to Sin's family and may have been the focus of rituals of venerating ancestors. As Neo-Confucianism gained favor over Buddhism, ancestral rituals became increasingly important.

In East Asia, government officials were also poets, artists, and scholars of history, religion, literature, and art. Sin Sukju, for example, was especially skilled in linguistics and, together with other officials and the king himself, played a role in inventing Hangeul, the system for writing Korean, which is used to this day. Sin was also knowledgeable about art, as demonstrated

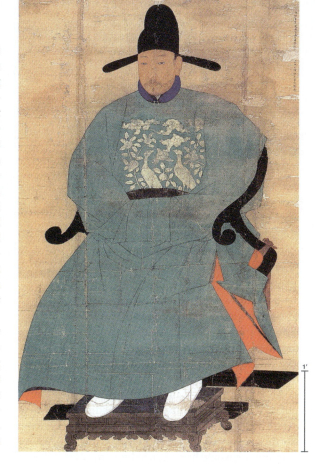

9.5 **Portrait of Sin Sukju**, Joseon dynasty, second half of the fifteenth century. Hanging scroll: ink and colors on silk, 5 ft. 5¾ in. × 43 in. (1.67 × 1.09 m). Goryeong Sin Family Collection, Cheongwon, South Korea.

in his *Record on Painting*, written in 1445 (see Going to the Source: Sin Sukju's *Record on Painting*, p. 191). Sin's *Record* documents 222 paintings and **calligraphies** in the collection of his patron, Prince Anpyeong (1418–1453). Many of the artworks dated to the Song and Yuan dynasties, attesting to the prince's antiquarian taste in Chinese paintings. But the prince also owned thirty-six paintings by the Joseon court painter An Gyeon (active *c.* 1440–1470). Two years after the *Record of Painting* was finished, the prince commissioned yet another artwork from An, *Dream Journey to Peach-Blossom Land* (**Fig. 9.6**, p. 190).

Painted on silk that has darkened over time, the dramatic landscape opens at right with a few modest buildings overlooking a mist-filled grove of flowering peach trees. Strangely shaped, unevenly eroded peaks enclose the grove. Next, visible at interludes from the center to the left of the scroll, water flows through a narrow gorge to the foreground. A winding path nearby suggests the tenuous connection between the dreamlike peach grove at right and the more restrained, mundane world to the left, which ends the composition.

The landscape's structure reverses typical compositions on the subject of the peach-blossom spring (see Fig. 16.15), a utopia described by the Chinese recluse and poet TAO Qian (365–427). Generally, viewers would follow the fisherman-narrator's journey on a stream that winds through grove and grotto into paradise. Instead, An's painting begins with the paradise of peach trees and then leaves it behind, as if returning from a reverie.

Neo-Confucianism drawing on Confucianism, Daoism, and Buddhism, a philosophy originating in China that provides a system of beliefs that undergird governance, especially civil service examinations (flourishes after 1000 CE in China, Korea, Japan, and Southeast Asia).

physiognomy the shape, proportion, and composition of facial features.

calligraphy the art of expressive, decorative, or carefully descriptive hand lettering or handwriting.

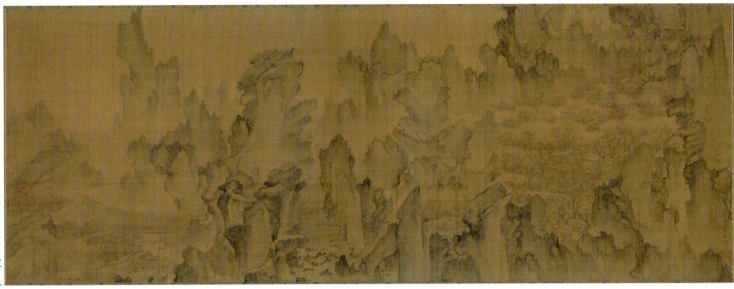

9.6 An Gyeon, *Dream Journey to Peach-Blossom Land,* Joseon dynasty, 1447. Handscroll: ink and light colors on silk, 15¼ × 41¾ in. (38.7 × 106 cm). Important Cultural Property of Japan, Tenri Central Library, Tenri University, Nara, Japan.

colophon a statement at the end of a book, which records such information as the date and location of completion, name of calligrapher, and patron. In East Asia, colophons are also written on paintings and calligraphy, and their content may be expressive and wide-ranging.

contour line the outline that defines a form.

This scroll's inverted structure adheres to the experience of its patron, Prince Anpyeong, who had woken from a dream in which he found himself in the fabled land. The **colophon** at the end of the handscroll records his dream (not pictured).

An Gyeon's style—watery passages, fog-filled atmosphere, irregular **contours**, careful shading, and finely detailed trees and buildings—draws inspiration from the Northern Song court painter Guo Xi (see Fig. 8.4), whose paintings An would have seen in his patron's collection.

An adapted those techniques to respond directly to Prince Anpyeong's experience by creating an innovative composition imbued with the mysterious immediacy of a dream.

The Neo-Confucian impact on Joseon culture supported some kinds of painting, such as the portraits of meritorious officials, but it also stifled other kinds of painting, chief among them the work of women artists. In this regard, the most famous case is that of SIN Saimdang (known as Saimdang, 1504–51). At a time when Neo-Confucian attitudes increasingly restricted the

9.7 Ojukheon ("Black Bamboo Studio"), Gangneung, Gangwon province, South Korea, Joseon dynasty, fifteenth century.

Art historical writing in East Asia has a long history. Tang dynasty author ZHANG Yanyuan wrote his *Record of Famous Painters of All Periods* in 847 CE. Another early example of art historical writing is Sin Sukju's 1445 inventory of Prince Anpyeong's collection, *Record on Painting*. Following are several excerpts.

> [Prince Anpyeong] loved calligraphy and painting. [Whenever] he heard that someone owned a fragment [of calligraphy or painting] on paper or silk he definitely purchased it, paying generously. Selecting the good pieces, he had them mounted and preserved them in his collection.

> One day he took them all out, showed them to me, [Sin] Sukju, and said, "I am fond of this by nature; it is also an obsession. After exploring exhaustively and searching widely for more than ten years, I finally gained [all] this. Alas! There are times for the completion and for the destruction of things, and it is [their] fate to be gathered and dispersed. How can we know that what has been built today will [not] be destroyed again in the future? Thus, we cannot be certain about a [collection's] gathering and dispersal. ... Please, write such a record for me."

Sin organized his *Record* chronologically, beginning with Gu Kaizhi (see Chapter 4) who is followed by artists such as Su Shi, Guo Xi, Ma Yuan, and Zhao Mengfu (see Chapter 8). An Gyeon is the only contemporary Joseon artist discussed.

> Of [our Joseon] dynasty there is one master, An Gyeon. ...He is bright by nature, profound and erudite. Having viewed many ancient paintings, he was able to grasp their essence, combine the strengths of various masters, and digest them. There is nothing he did not master, with landscape [painting] being his greatest strength. Even searching in antiquity, one can hardly find anybody who can compare with him.

Sin then listed the titles of An's paintings and several artworks by unknown artists, before concluding:

> Altogether [the collection represents] five dynasties and 35 masters [and comprises] 84 landscapes; 76 paintings of birds, animals, plants, and trees; 29 of architecture and figures; and also 33 pieces of calligraphy. Altogether there are 222 scrolls.

> Alas! If one did not love it so dearly, how could one [collect] as many [artworks] as these? I, Sukju, have not devoted myself to detailed research but have rather learned what people have said: When it comes to painting, one has to exhaust the transformations of Heaven and Earth and to examine the movements of *yin* and *yang*, the sentiments of ten thousand things, and the changes of events. After taking such extensive [experience] into his chest, [the painter] wields the brush and realizes [what he has absorbed] on white silk; he concentrates and mysteriously communicates [with nature]. If he wishes [to paint] a mountain, he sees a mountain, if he wishes [to paint] water, he sees water. Whatever he desires he sees without fail, and it emerges from his energetic brush. Therefore, he can capture the truth on the basis of illusion: this is the method of the painter. What has been accomplished in his mind emerges through his hand accordingly. Mind and hand forget each other; the body and the object transform as if in trance. Just as in Creation itself no traces can be sought, but [nature] has manifested itself beyond the pigments. Having observed this [process of transformation and creation in the paintings of Prince Anpyeong's collection], if one can delight one's nature through the modest and simple, yet noble and elegant, if one can nourish one's spirit through the heroic and vigorous, yet edifying and stern, is this not more than a small aid? For investigating the principle of things, becoming erudite and widely knowledgeable, [painting] indeed has the same merits as poetry! Nevertheless, I do not know people of this world—has anyone attained this yet? Respectfully written...by Sin Sukju....

Discussion Questions

1. How does Sin's *Record* deepen our understanding of An Gyeon's *Dream Journey to Peach-Blossom Land* (Fig. 9.6)?
2. Compare and contrast how Sin and Guo Xi describe the painter's creative process (see Going to the Source: Guo Xi's Writing on Landscape, p. 165).

movement, wealth, and self-determination of upper-class (*yangban*) women, a sliver of Goryeo dynasty norms—when women could marry, divorce, become heads of households, and inherit wealth—still held in Saimdang's experience. On the one hand, Saimdang did become the sagacious mother that Neo-Confucianism demanded of model women; on the other hand, she inherited a portion of her mother's property and earned a reputation for poetry, calligraphy, and painting.

At various times over the centuries since her death, Saimdang was said to paint landscapes and grapes, then orchids, later plants and insects, and still later plum blossoms. Her shifting reputation reveals the limits of what Neo-Confucian ideals would tolerate from a talented woman, and unfortunately a surfeit of attributed paintings, especially in the plant-and-insect genre, substitute for any unequivocally authentic work by her (as a result, this book does not show any of the works attributed to Saimdang). For the history of art, the loss is keenly felt.

Remarkably, the home where Saimdang grew up—her mother's family residence—still stands and offers an example of domestic architecture (Fig. 9.7). Named for the locally abundant black bamboo, Ojukheon is one of Korea's oldest extant wooden buildings. Slightly elevated on a stone plinth, deliberately plain timbers support a hip-and-gabled roof of gray tile. The three-by-two bay building does not require solid supporting walls, and so doors and large windows provide abundant light and fresh air. The architecture is practical and restrained. The only embellishments are plaques with inscribed calligraphy. The one over the central bay and entrance reads, "Black Bamboo Studio"; the smaller plaque outside the room to the (visitor's) right when facing the entrance refers to the "Dragon Dream Chamber." The dreamer in question is Saimdang, who dreamt of a dragon the night before giving birth to her third son, YI Yulgok (1536–84), at Ojukheon. The dream was an **auspicious** omen that an unusually gifted child would be born, and indeed Yi would later

auspicious signaling prosperity, good fortune, and a favorable future.

buncheong a variety of Korean stoneware created with white slip.

underglaze a color or design applied to pottery before it is glazed and fired.

wabi-cha rustic style of *chanoyū*, promoted by tea master Sen no Rikyū.

shogun a title granted by the Japanese emperor to the military leader and de facto ruler during the Kamakura, Muromachi, Momoyama, and Edo periods.

emaki (also **emakimono**) a Japanese term for a handscroll painting typically viewed in sections, from right to left. It is wider than it is tall, and when rolled up, it is easily stored and portable.

become a minister of state and Neo-Confucian scholar of great renown. Demonstrating filial piety, Yi paid tribute to his mother in a biography, writing, "When [Saimdang] was young, she mastered the Chinese classics. She had talent in writing and in the use of the brush. In sewing and embroidery, she displayed exquisite skills.... From the age of seven, she painted landscapes after An Gyeon, and also painted ink grapes."

At Ojukheon, Saimdang had the good fortune of being sheltered among highly educated family members. There, she learned to read Confucian classics from her mother, father, and grandfather. Even after marrying, Saimdang continued to live at Ojukheon until the birth of her first son, and thereafter returned with some frequency. Although Ojukheon's most famous son is Yi, it is a testimony to matriarchs, too.

The scholar-official culture of Joseon informed not only painting but also ceramics, fueling interest in austere, plain-white porcelain. From the Confucian point of view, plain porcelain vessels suggested values of restraint, moderation, and integrity, in contrast to finely polished or ornate pieces, which were seen as superficial or merely decorative. First invented in China, porcelain came into wide use after the Joseon court established official kilns, called *bunwon*, in the 1460s. These kilns produced hundreds of white porcelain wares for Confucian rituals. At about the same time, a new type of stoneware emerged from the celadon tradition. This new type, **buncheong**, involved adapting some celadon techniques for decoration, such as inlay and incision, but it used coarser clay and relied more heavily on white slip.

Buncheong ware was appreciated and used in court and by the royal family, but potters creating such artworks experimented with bold, even witty designs that had a broader appeal. Some *buncheong* imitate plain-white porcelain, while others are painted with iron-oxide patterns. Still others—such as this flask (**Fig. 9.8**)—feature a touch of humor in the **underglaze** incised decoration. With white slip covering all but the foot and the mouth,

this flask could have been an economical alternative to porcelain. But the carved shapes of a half-dozen fish transform what would have been an unadorned, austere vessel into a whimsical one. A single upside-down fish, which swims in a direction opposite its mates, has been cleverly squeezed into the negative space formed by its immediate neighbors. Variation among the fish forms, too, suggests artistic inventiveness. Thus, the flask may have once provided both a delightful image and delicious drink to accompany a meal of fish.

The unpretentious, imperfect qualities of *buncheong* also found favor among aficionados overseas. **Wabi-cha** (Japanese: *chanoyū*) fueled an interest in Japan for collecting *buncheong*. In the late sixteenth century, the warlord TOYOTOMI Hideyoshi (known as Hideyoshi, 1537–1598) launched a series of invasions into the Korean peninsula as the first step toward his goal of conquering the Ming dynasty. The invasions failed, but Hideyoshi and other warlords captured and forcibly moved thousands of Korean potters to their own domains. There, the potters founded or improved the technology of local kilns, which would become major centers of Japanese ceramics. In Korea, few kilns would continue to produce *buncheong* ware, but even before the invasions, demand was shifting to porcelain. Hideyoshi's invasions, known as the Imjin Wars (1592–98), also mark the end of the early Joseon period.

Civil War and Art of Kamakura Period Japan, 1185–1333

Over the course of the late Heian period (794–1185) in Japan (see Chapter 6), the power of the emperor and nobility in Kyoto declined as military landowners in the provinces forged alliances with ambitious leaders of competing clans at court. Rivalries led to civil wars. These wars ended in 1185 when MINAMOTO no Yoritomo (known as Yoritomo, ruled 1192–99) vanquished his enemies. In 1192, the emperor bestowed on him the title of *Sei-i Taishogun* (commonly known as Shogun), and Yoritomo established a new form of government, the *bakufu*. Also known as the shogunate, the *bakufu* is a form of military government that preserves the emperor as a figurehead while the real power is exercised by a **shogun**. While the emperor continued to occupy the throne in Kyoto, Yoritomo located his government headquarters in Kamakura. Not surprisingly, the Kamakura period (1185–1333) brought not only military themes to art, but also a pressing need to rebuild devastated structures, resulting in fusions of old and new.

Long-standing artistic conventions and terrifying experiences of civil war come together in several extant handscroll paintings, called **emaki** in Japanese. Some examples portray in gruesome detail the tortures of Buddhist hells; others depict legends and historical events, such as the Heiji rebellion (1159–60), a conflict between the Taira and Minamoto clans. One such scroll, *Night Attack on the Sanjō Palace*, depicts the dramatic kidnapping of the retired emperor Go-Shirakawa, the slaying of his military supporters, and the burning of his palace by Minamoto forces in 1159. In this detail, smoke

9.8 Flask with Fish, Buncheong ware, 1400–99, Joseon dynasty. Stoneware with underglaze carved decoration, 8¾ × 7⅞ × 5⅛ in. (22.2 × 20 × 13 cm). Art Institute of Chicago, Illinois.

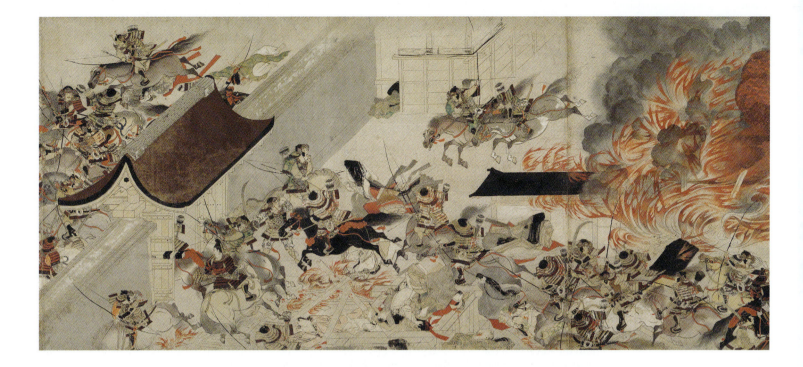

billows from a dazzling and destructive inferno engulfing the Sanjō Palace (**Fig. 9.9**). The actions portrayed in this scene may be compared to a textual record:

> The situation at the Sanjō Palace was beyond description. ...Wild flames filled the heavens, and a tempestuous wind swept up clouds of smoke. The nobles, courtiers and even the ladies-in-waiting of the women's quarters were shot down or slashed to death.... When they rushed out, so as not to be burned by the fire, they met with arrows. When they turned back, so that they would not be struck by arrows, they were consumed by the flames. Those who were afraid of the arrows and terrified by the flames even jumped into the wells in large numbers, and of these, too, the bottom ones in a short time had drowned, those in the middle had been crushed to death by their fellows, and those on top had been burned up by the flames themselves.

The text calls the situation "beyond description," but the painting depicts the actions and physical items— architecture, armor, weaponry—in exceptional detail, providing a wealth of information about **material culture** of the time. For example, the foot soldier standing just inside the gate wears under-armor clothing with a comma-like swirl pattern called *tomoe* (**Fig. 9.9a**). Elsewhere in the handscroll, MINAMOTO no Yoshitomo (father to Yoritomo) appears, wearing a distinctive, horned helmet. In and near the well (center bottom edge of the scene), disheveled and dying women may be recognized by their long hair and layered robes, characteristics seen previously in Heian period paintings (see Figs. 6.18 and 6.19).

The composition of *Night Attack* takes advantage of the handscroll format, which requires the viewer to unroll portions of the image from right to left, intensifying the narrative suspense. Warriors and horses rush from the right to the left, stimulating viewers' curiosity as to

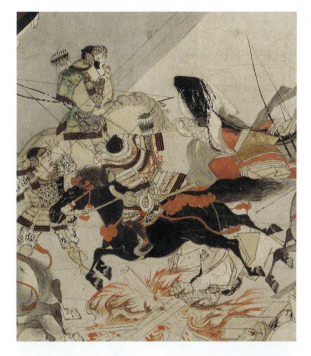

what will be unrolled next. Events unfold in chronological order, too. The scroll begins with foot soldiers, carts, and cavalry converging at the palace, and it ends with triumphant forces guarding the cart imprisoning Go-Shirakawa. In the middle, the detail illustrated here, the conflagration marks the composition's climax. The way that handscrolls such as these shape stories seems to prefigure cinematic structures and techniques.

The civil wars damaged not only imperial palaces, but also religious institutions. For example, after the Buddhist temple Tōdaiji sided with the Minamoto, the Taira set it afire in 1180. The blaze destroyed more than half of the complex, including the colossal bronze sculpture of Vairochana Buddha and the Great Buddha Hall

9.9 and 9.9a *Night Attack on the Sanjō Palace* (details), from the *Illustrated Scrolls of the Events of the Heiji Era* (*Heiji monogatari emaki*), Kamakura period, second half of thirteenth century. Handscroll: ink and colors on paper, 16¼ × 22 ft. 11¾ in. (41.3 cm × 7 m). Museum of Fine Arts, Boston, Massachusetts.

material culture the materials, objects, and technologies that accompany everyday life.

Niō (also known as *kongo rikishi*) paired guardian statues often found at Buddhist temples in Japan.

yosegi-zukuri a Japanese technique for making wood sculpture by joining multiple blocks together.

Zen Buddhism literally meaning "meditation," a Japanese school of Mahayana Buddhism that traces its founding to Bodhidharma.

chinsō commemorative portraits of revered Zen teachers.

(Daibutsu-den) (for reconstructions of both, see Figs. 6.12 and 6.13). The priest Shunjōbō Chōgen (known as Chōgen, 1121–1206) took charge of repair and reconstruction, commissioning numerous sculptors to repair and replace icons made some 450 years earlier during the Nara period. Master sculpture Kōkei (active *c.* 1175–1200), along with his assistants and students—together known as the Kei school—undertook much of this work. Their close engagement with Nara period sculpture informed a new style, marked by unflinching realism and, when called for, deepened pathos or robust drama.

In 1203, the sculptors Unkei (d. 1223) and Kaikei (d. before 1227) led a collaborative team to create a pair of guardian deities, Agyō and Ungyō (**Fig. 9.10**). Together these guardians form the monumental *Niō* that flank the new Great South Gate to the rebuilt Daibutsuden at Tōdaiji. Remarkably, these more-than-27-foot-tall sculptures were completed in just seventy-two days. With two other master sculptors and sixteen assistants, Unkei and Kaikei made efficient use of the *yosegi-zukuri* technique pioneered in the late Heian period by Jōchō, the sculptor to whom the Kei school traces its lineage (see Fig. 6.16).

Installed in the outer bays of the Great South Gate, the *Niō* face the central walkway, and visitors must turn to see one and then the other. Look closely at their mouths. To visitors' left, the statue of Agyō's open mouth suggests the sound "ahh." To the right, the statue of Ungyō has closed lips, which imply the sound "hmm." These open and closed Sanskrit syllables give the *Niō* their names. Agyō wields a *vajra*, or thunderbolt mallet. Ungyō holds a sword (the edge and tip are obscured by his body). Massive and mighty, both figures take powerful, active stances. Their state of readiness is also visible in their furrowed eyebrows, flaring nostrils, flexed fingers, tensed muscles, and swollen veins. Such detailed attention to the mechanical operations of the body demonstrates the sculptors' familiarity with realism, but these bodies— bones, flesh, sinews—are exaggerated into a kind of hyper-realism, as befitting guardian deities. Draperies, too, swirl dramatically to suggest supernatural energy. Thus, Unkei and Kaikei infused the *Niō* with a sense of religious ferocity.

Even as great energy poured into the rebuilding of such major temples as Tōdaiji, new Buddhist institutions and sects took root in Japan. Prominent among these is **Zen Buddhism**, which recognizes the Indian monk Bodhidharma as its patriarch and traces its beginnings to Tang dynasty China, where it is called Chan (see Chapter 8). Zen (as well as the Chinese and Korean equivalents, Chan and Seon) literally means "meditation," and over the centuries an association between Zen and meditation became prevalent. Zen Buddhism includes widely shared Buddhist traditions, too, such as the creation and worship of icons. One type of icon with special importance in Zen Buddhism is known as *chinsō*.

9.10 Unkei and Kaikei, *Niō: Agyō* LEFT **and** *Ungyō* RIGHT, outermost bays of Nandaimon (Great South Gate), Tōdaiji, Nara, Japan, Kamakura period, 1203. Wood with paint, respective heights 27 ft. 4¾ in. (8.35 m) and 27 ft. 7¼ in. (8.41 m).

9.11 FAR LEFT **Portrait (*chinsō*) of Mugai Nyodai,** modern replica of the Kamakura period original, thirteenth century. Wood, height 28⅞ in. (73.2 cm). Kanazawa Bunko, Japan.

responded to the rigid shape of the chair with Mugai's formal posture of meditation.

The story of Mugai Nyodai's enlightenment describes a mundane event: Mugai carrying a bucket of water. When the bucket's bottom fell out, the water and the moon's reflection drained away, and Mugai realized reality was like the moon's false reflections held in a bucket of her own delusions. This story captures one aspect of Zen: its novel proposition that enlightenment may be experienced suddenly and in the course of everyday activities. By contrast, the portrait sculpture demonstrates continuity in the sect's espousal of making icons. Additionally, Mugai's *chinsō* reveals a penchant for discipline and hierarchy; it is a serious expression of reverence to an important religious teacher. The characteristics of novelty, tradition, and strictness resonated in the Kamakura warrior culture, and in subsequent periods Zen found support among shogun and samurai families.

Art of Japan's Nanboku-chō (1333–92) and Muromachi (1392–1573) Periods

Foreign invasions and domestic rivalry marked the late Kamakura period. From the Korean peninsula, the Mongols launched (unsuccessful) invasions of Japan in 1274 and 1281. Memory of the attempted invasions survives in histories, handscroll paintings, and the word *kamikaze,* or the "divine winds" that helped repel the Mongol Goryeo fleet. Although fruitless, these invasions tested Kamakura military capability and political strength.

Ultimately, it was not foreign invasion but domestic rivalry that upended the Kamakura *bakufu.* In 1333, the emperor Go-Daigo (1288–1339) and his supporters mounted a return to imperial power, and though the Kamakura regime fell, the restoration was shaky. Three years later, a descendant of a branch line of the Minamoto family, ASHIKAGA Takauji (known as Takauji, 1305–1358) usurped power, put an alternate royal on the throne, and drove Go-Daigo from Kyoto. While Takauji held Kyoto, Go-Daigo reestablished a competing government some 50 miles (80 km) south in Yoshino, ushering in nearly six decades of rivalry known as the Nanboku-chō (literally, "South and North Courts," 1336–92).

During this pivotal and factious fourteenth century, this suit of armor purportedly belonged to Takauji (**Fig. 9.12**, p. 196). Made of **lacquered** iron and leather laced together with silk, this armor features a stenciled image of a Buddhist deity, Fudō Myōō, on the breastplate. The "Immovable" King of Brightness, Fudō Myōō is an emanation of Vairochana, the primordial Buddha (see Fig. 6.12). Grimacing fiercely, Fudō Myōō wields a sword to cut through ignorance and a lasso to reign in those who would obstruct the path to enlightenment. Generally worn by cavalry, this armor has a four-sided skirt that telescopes upward when the wearer is seated on horseback (see **Fig. 9.9**). Helmets protected heads, but could also be used to intimidate enemies or communicate identity and rank by means of embellishments, such as the horn-shaped ornament seen in the helmet accompanying this armor (**Fig. 9.12**). Although this helmet is contemporaneous, it is not original to the armor. This armor was

Used for ritual purposes and memorial services, painted *chinsō* provided evidence of religious lineage when teachers bestowed such images on their disciples. As sacred objects of devotional worship, sculpted *chinsō* preserve for followers the spiritual essence of important clergy, both male and female.

This replica of a *chinsō* sculpture captures the likeness of the first female Zen master, Mugai Nyodai (1223–1298) (**Fig. 9.11**). In the Kamakura period, Mugai founded the head temple of the Five-Mountain Convents Association (a parallel Five-Mountain Monasteries system existed for Zen monks). In this portrait sculpture, the elderly abbess sits in a meditative position, bringing her hands together and gazing steadily. Mugai's expression suggests she is neither agitated nor relaxed, but quietly alert, bearing some similarity to the Nara period portrait of Ganjin (see Fig. 6.14). In keeping with her religious position, Mugai has a shaved head and wears priestly garb. The original *chinsō* featured a high-backed chair (a type of furniture foreign to Japan and, at this time, adapted for use by Zen clergy, see **Fig. 9.5**), and Mugai's clothing draped over the seat.

Zen portraits, or *chinsō,* whether paintings or sculptures, combine realism and convention to commemorate revered clergy. Informed by the Kei school style, the unknown sculptor has captured the particular shape of Mugai's facial features and has set crystals into her eyes, enhancing the statue's lifelike quality. At the same time, the costume and composition adhere to formulas common to *chinsō.* The costume includes Mugai's monastic robe and the clasp and ribbon, which are meant to fasten the robe, on her left shoulder; the composition

lacquer a liquid substance derived from the sap of the lacquer tree; used to varnish wood and other materials, producing a shiny, water-resistant coating.

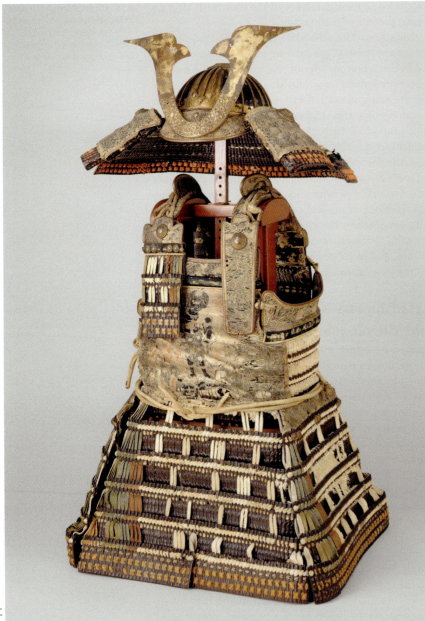

9.12 *Yoroi* (suit of armor), early fourteenth century. Lacquered iron and leather, silk, stenciled doeskin, and gilt copper, height 37½ in. (95.3 cm). Metropolitan Museum of Art, New York.

purportedly given by Takauji to a shrine to Hachiman, the Shinto god of war. Hachiman is also regarded as a *bodhisattva* and protector of Buddhism. Furthermore, Hachiman is closely associated with nation building. This last association seems especially apt as Takauji was the founder of the Ashikaga shogunate.

Takauji established the Ashikaga *bakufu* before 1392, but only in that year did the third Ashikaga shogun, Yoshimitsu (1358–1408), reunify the Southern and Northern Courts. Thereafter, the Northern Court prevailed in questions of imperial succession, and so began the Ashikaga, or Muromachi, period (1392–1573), when the seat of power moved to the Ashikaga headquarters in Kyoto's Muromachi district.

Once again, Kyoto became a major center for art and culture, as Ashikaga shoguns built private gardens and exquisite pavilions, and in direct competition with the imperial court, collected and commissioned paintings, too. Diplomatic relations with the Ming dynasty in China

resumed, leading to travel and trade. In the realm of artistic merchandise, Ming subjects now cooled themselves with folding fans (invented in Japan), while Japanese collected and displayed porcelain vessels. The Muromachi period was an especially vibrant time for Zen Buddhism, with the shoguns among the leading patrons of the numerous temples in Kyoto. Yoshimitsu, for example, founded Shōkokuji. One of the prestigious and powerful Five Mountain Zen temples, Shōkokuji was dedicated in 1392, the first year of the Muromachi period.

Many strands of Muromachi culture come together in a painting by a monk-artist of Shōkokuji, Josetsu (active c. 1405–23). Josetsu depicts a curious and impossible activity: trying to pin down a catfish with a gourd (**Fig. 9.13**). With ink and light colors on paper, the artist represents a coarse-looking man awkwardly grasping a gourd. While the man struggles rather clumsily, his would-be prize, the catfish, glides gracefully away. Visually, the gently undulating curve of the riverbank—more like a stroke of calligraphy than an attempt to represent the meeting of earth and water—echoes the fish's lithe body. By contrast, the mulish fellow shares with the heavy rocks both angular shape and dark accents of ink, suggesting a rough-hewn quality. Josetsu sets this strange drama in an idyllic landscape featuring an asymmetrical composition, and he uses bamboo stalks as a device to frame the figure and to bridge the misty distance to the pale mountains in the background. Such stylistic traits demonstrate awareness of Southern Song styles as exemplified in the work of artists such as MA Yuan, LI Song, and Fachang Muqi (see Chapter 8). Muqi, known as Mokkei in Japanese, was especially popular in the Ashikaga period. A fifteenth-century inventory of one shogun's painting collection documents 101 scrolls by him, and his triptych of the *White-Robed Guanyin, Gibbons, and Crane* bears a seal of Yoshimitsu (see Fig. 8.19). Recall that in the fifteenth century, too, as we saw earlier in this chapter, the Korean scholar-official Sin Sukju catalogued Prince Anpyeong's painting and calligraphy collection, which demonstrated a comparable interest in Song dynasty paintings.

Josetsu's painting was made for the fourth Ashikaga shogun and Yoshimitsu's son Yoshimochi (r. 1386–1428). Currently in the form of a **hanging scroll**, *The Gourd and the Catfish* positions calligraphy and poetry above Josetsu's painting, but originally the two halves were mounted side-by-side as a small screen. The inscriptions begin at the (viewer's) upper right with a preface in which Yoshimochi's religious advisor, the monk Daigaku, poses a question: "...how, in the muddy expanse, is one to pin down a catfish, smooth and covered with slime, using an empty capacious gourd, slippery and rotund?" In a series of linked poems (*renga*), thirty-one monks, including Daigaku himself, respond, thereby transforming a subject that otherwise had no presence in Buddhism into a particular type of religious lesson, known in Zen practice as a *koan*. The most famous *koan* asks in characteristically illogical fashion, "What is the sound of one hand clapping?" Leveraging riddles and paradoxes, *koan* aim to dislodge conventional thinking, to measure religious progress, and ultimately to demonstrate the

9.13 Josetsu, *The Gourd and the Catfish*, Muromachi period, c. 1413. Hanging scroll: ink and light colors on paper, 43⅞ × 29⅞ in. (1.11 m × 75.9 cm). Taizō-in Temple, Kyoto, Japan.

fundamental Buddhist truth of the illusory nature of things. In this regard, *The Gourd and the Catfish* invites viewers to join the seriously playful discussion of the impossibility of "pinning down a catfish with a gourd," or, in a metaphorical sense, of grasping one's mind with one's mind. Placed in Yoshimochi's private quarters in a newly built palace, this artful furnishing proclaimed the shogun's up-to-date taste as well as his impressive religious affiliations.

Prior to Josetsu, monk-painters had little status; but with him begins a distinguished line of them. His student, Shūbun (active c. 1423–54) served as a painter-in-attendance to the Ashikaga shoguns; Shūbun's disciple, Sesshū Tōyō (known as Sesshū, 1420–1506) is perhaps the

most famous and versatile painter of the Muromachi period. Evidence of Sesshū's artistic virtuosity, as well has his concern for lineage, appears in his *Splashed Ink Landscape* (**Fig. 9.14**, p. 198).

Splashed Ink Landscape hovers at the edge of legibility. In some areas, patches of moist ink form pale irregular pools that disappear, absorbed into the paper. In other places, spiky gray lines punctuate the empty space and dark black marks bleed more or less with seemingly still-damp spots. From these painterly oddments, a coherent landscape emerges: two figures in a boat at the far right, a fence and modest buildings, woods atop a cliff, and mountains in the distance. Sesshū has deftly used the motifs and materials of landscape painting with the

Imperial Painting Academy of the Ming dynasty. *Splashed Ink Landscape* may appear to be spontaneously executed, yet it is the outcome of years of practice on the part of the septuagenarian Sesshū. He adapts the particular manner of the Southern Song dynasty monk-painter Ruofen Yujian (n.d.), whose abbreviated monochrome landscapes relied on areas of indistinct ink wash. Among the favored modes of the Ashikaga shoguns, Yujian's style would have been immediately recognizable to Sesshū's audience. They included his student Josui Sōen (known as Sōen, active *c.* 1470–1505?) for whom *Splashed Ink Landscape* was made, as well as the six Kyoto abbots who added poems (probably at Sōen's request), making this artwork into an example of a poem-painting scroll (Japanese: *shigajiku*). Besides the six poems (at the top of the scroll, **Fig. 9.14**), *Splashed Ink Landscape* bears a dedicatory inscription (immediately above the image) by Sesshū to Sōen, which reads in part:

> [Sōen] has spent several years studying painting with me. His skill with the brush has matured, and he has devoted his heart and mind to the Way of Painting. His inspired work ethic has been remarkable. This spring Sōen announced to me that he would be returning home, and asked that I brush a painting that he could take with him....

With this inscription, Sesshū transforms the painting into a document of artistic transmission from teacher to disciple, in a manner that imitates the use of *chinsō* paintings in Zen Buddhism. Whereas *chinsō* sculptural icons could be installed in temples to be revered by many, portraits of venerated masters were bestowed on individual students, testifying to the transmission of Buddhist teachings, stretching back to Bodhidharma. With *Splashed Ink Landscape*, Sesshū confers artistic legitimacy upon Sōen. For the six abbots who inscribed poems, the poem-painting scroll offered a vehicle for strengthening their relationships as members of a powerful coterie of the Five Mountain Zen temples of Kyoto, and for demonstrating their cultural savoir-faire. Their poems not only confirm the use of *Splashed Ink Landscape* as a document of transmission and recognize the adoption of Yujian's style, but also invoke the Confucian ideal of the noble recluse as an interpretation of Sesshū's painting. Such paintings by Josetsu, Sesshū, and others show that Zen Buddhism, however iconoclastic its rhetoric, nevertheless made effective use of conventions, drawing on prestigious traditions—Chinese landscape painting, Confucian ideals, and such literati practices as poetry—to attract followers and foster relationships among its various constituents.

The variety of artforms and styles associated with Zen Buddhism is suggested by Sesshū's oeuvre alone, which included not only landscapes in the manner of several Song dynasty masters, but also portraits, flower-and-bird paintings, pictures of gibbons, and images of Bodhidharma. He also once painted a detailed representation of the Tōfukuji temple, replete with all of its temples, sub-temples, walls, gates, bridges, and pagoda (not illustrated). Zen Buddhism modified and introduced features

utmost economy, resulting in a composition that constantly oscillates between abstraction and representation.

Sesshū developed such artistic skill in part from Josetsu and Shūbun, but he also traveled to China where he pursued his religious studies, purchased paintings for his patrons, and studied painting, including at the

of temple architecture, notably dry landscape gardens, or *karesansui*. This view looks northeast from the veranda of the abbot's quarters at Daisen-in, a sub-temple of Daitokuji, another one of the Five Mountain Zen temples of Kyoto (**Fig. 9.15**). Several gray boulders have been placed vertically so that their white striations resemble waterfalls. Carefully raked gravel "spills" from one pool to another in a succession of tiers before "flowing" beneath a long, flat rock that imitates a bridge. Other rocks become a boat, a fish, or a turtle in the gravel "river." Artfully pruned trees and clumps of moss provide greenery for this miniature landscape.

Gardens such as this one at Daisen-in shun showy flowers, lush plantings, and generous expanses. They were not for wandering or for hosting social gatherings (see Figs. 12.3 and 12.5). Rather, they consciously invoked the tradition of Chinese landscape painting, and they rewarded viewers who recalled the compositions of Guo Xi, who exhorted painters to create the illusion of vast distance within the limits of few feet of silk (see Chapter 8). Note that the arrangement at Daisen-in comprises a bridge in the foreground, waterfalls in the middle ground, and mountain peaks in the distance. The *karesansui* at Daisen-in may or may not have encouraged the abbot and his guests to empty their minds in a meditative fashion. More certain, the garden was part of the Muromachi artistic economy that recognized the currency of Chinese models, adapting them for Zen Buddhist and Ashikaga *bakufu* contexts.

Hideyoshi, Warlord and Patron in Momoyama Period Japan, 1573–1615

After Ashikaga power collapsed in 1573, a forty-year struggle for control ensued. That period, the Momoyama (1573–1615), is named for the "Peach Hill" location outside Kyoto where the warlord TOYOTOMI Hideyoshi (known as Hideyoshi) built his Fushimi Castle. Hideyoshi played

a pivotal role in Momoyama history. Along with ODA Nobunaga (known as Nobunaga, 1534–1582) who preceded him and TOKUGAWA Ieyasu (known as Ieyasu, 1543–1616) who came afterward, Hideyoshi pursued military actions and political reforms that eventually reunified the country. In the course of his conquests, Hideyoshi also affected art and culture, building and renovating castles, commissioning paintings, collecting art objects, and demonstrating avid interest in tea ceremony, which was a complex secular ritual that effectively cemented social and political relationships. While drinking tea was, understandably, an important component of the ceremony, participants would also engage in aesthetic appreciation. Just as Ashikaga shoguns previously collected art, fashioned gardens, and practiced tea, likewise, Hideyoshi connected art to authority.

In turbulent times, especially after Portuguese traders arrived in Japan in the mid-sixteenth century and introduced firearms to the archipelago (see Looking More Closely: *Namban Byōbu*, p. 201), castles served as protective fortresses. As highly visible structures, castles also functioned symbolically, communicating power to vast audiences. The lords of large estates, *daimyō*—literally meaning "great name"—were the primary retainers of the shogun during the *bakufu* governments. They chose strategic hilltop locations on which to build magnificent residences to mark their authority and to intimidate one another.

Among the castles that have survived fire and enemy onslaught is Himeji Castle, located about 60 miles (100 km) west of Osaka (**Fig. 9.16**, p. 200). The history of Himeji Castle begins before the Momoyama period, but Hideyoshi renovated it in 1581. After a decisive battle that signaled the waning of Toyotomi power in 1600, the future shogun Tokugawa Ieyasu awarded the castle to his son-in-law and supporter IKEDA Terumasu (known as Terumasu, 1565–1613), who rebuilt Himeji, adding three moats and greatly expanding it.

karesansui a Japanese dry landscape garden; commonly known as a Japanese rock garden.

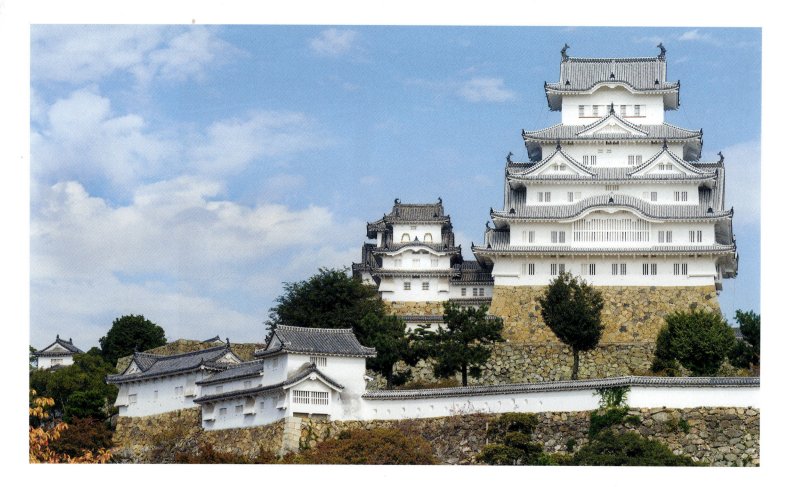

9.16a FAR RIGHT **Plan of Himeji Castle,** noting the main keep (fortified tower), moats, baileys (castle courtyards), and front gate.

tenshu the keep of a Japanese castle.

gable the roughly triangular upper section of an exterior wall created by a roof with two sloping sides.

bailey in castle architecture, a high-walled courtyard that exposes attackers.

Resplendent in white plastered walls and silver-gray tiles, Himeji Castle (nicknamed "White Heron Castle") rises from a masonry foundation atop a hill. The castle complex comprises around eighty buildings, including storehouses, gates, and corridors. The six-story *tenshu*, or keep, dwarfs everything in its vicinity. Elegantly curved roofs and pointed **gables** give the *tenshu* a graceful, buoyant character, which belies its impregnable quality. For defensive purposes, the castle plan uses high-walled, narrow corridors that connect in circuitous fashion to **baileys**, or open courtyards (**Fig. 9.16a**). Enemies who managed to cross the moat would find themselves slowed by the former and made vulnerable by the latter.

In his rise to power, Hideyoshi not only constructed opulent castles but also commissioned a rather unassuming teahouse from his tea master SEN no Rikyū (known as Rikyū, 1522–1591). The Taian teahouse is modest in size, measuring just nine feet on each side (**Figs. 9.18** and **9.18a**, p. 202). Its rustic style—neutral colors, minimally treated timber and bamboo, and wood shingles—derives from Rikyū's aesthetic vision. Rikyū, who previously served as tea master to Oda Nobunaga, assisted Hideyoshi in performing rituals of *chanoyu* (literally, "hot water for tea," commonly translated as "tea ceremony") for the emperor, as well as at the Grand Kitano Tea Ceremony in 1587, to which Hideyoshi invited the entire population of Kyoto. Notwithstanding splendid occasions, Rikyū advocated the humble character of *wabi-cha*, or "austere" tea, for which the Taian teahouse creates an ideal setting.

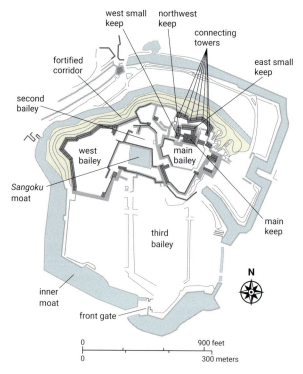

Guests would have arrived via a meandering garden path and left their swords outside the tearoom, thereby symbolically casting aside social status. After crawling through a confined entry, they would have sat opposite the host, all on *tatami* mats. In combination, the setting and the prescribed actions created a fictional world of

In Muromachi period Japan, scenes of everyday life gained new visibility in the painting formats of *fusuma* (sliding door or wall panels) and *byōbu* (screens). On these sizable surfaces, painters depicted teeming cities, seasonal activities, theatrical performances, and private entertainments inside brothels. Other subjects of choice were the curious appearances and activities of foreigners. These were featured in *namban byōbu*, or "southern barbarian screens."

In Japan, "southern barbarian" refers to foreigners in general, but *namban byōbu* are especially associated with the Portuguese, the first Europeans to reach Japan. Portuguese merchant ships arrived in the Japanese archipelago in 1543, and the Portuguese Jesuit missionary Francis Xavier came in 1549. While merchants were keen to profit from trade, missionaries hoped to spread Christianity. The Japanese eagerly purchased Chinese goods and European firearms brought by the Portuguese, and some Japanese converted to Catholicism. But relations could be strained, as when the Portuguese expanded their trade in enslaved people to include Japanese, and when Hideyoshi, wary of foreign influence, banned Christianity and ordered the arrest and execution of twenty-six Christians. Still, like many during the Momoyama period, Hideyoshi was both intrigued by and apprehensive of the foreigners.

This early example of *namban byōbu*, by KANŌ Naizen (known as Naizen, 1570–1616) of the distinguished Kanō school of painting, depicts Portuguese vessels departing from a colony, possibly Macao on the south coast of China, on the left and arriving on Japanese shores on the right. As artifacts born of cultural encounter, Naizen's paintings offer a glimpse into how Europeans were depicted as the exotic "Other." In both screens, the generous use of gold leaf (which may appear tan-colored in photographs) for clouds and ground is typical and conveys a sense of luxury and splendor in keeping with the high social status of Naizen's patrons, including Hideyoshi.

9.17 Kanō Naizen, *Namban Byōbu,* Momoyama period, 1593. Pair of six-fold screens: colors and gold leaf on paper, 5 ft. 1 in. × 11 ft. 10⅞ in. (1.5 × 3.63 m). Kobe City Museum, Japan.

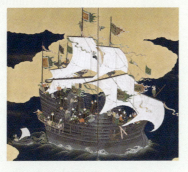
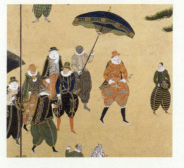

A Colorful and ostentatious buildings at the upper left of the left-hand screen suggest Chinese styles and Buddhist structures. However, the ornaments enclosed in the bell-shaped alcove atop the temple-like building and directly atop the *stupa*-like building are cross-shaped, thus identifying the buildings as Christian ones built by the Portuguese in their Indian, Chinese, or Southeast Asian colonies, as imagined by Naizen and his Japanese audience.

B For dramatic contrast, Naizen places two ships where the compositions of the left- and right-hand screens meet. On the left (pictured here), strong winds fill the sails of the departing ship, the crew take positions among the masts and rigging, and people ashore run, frenzied, and gesture wildly. To the right, a second ship is anchored in calm waters.

C The prominent figure wearing red is the *Capitão-mor* ("Captain-major"), a nobleman appointed by the Portuguese king to oversee trade in East Asia. He leads an exotic procession of people and animals. Gold-embroidered capes and hats identify the Europeans, whereas the figure holding the parasol and the horse groom dress in stripes or plaid. They may be servants or enslaved people from Africa, India, or Malaysia. Further to the left (not pictured here), porters carry a caged tiger.

D Mirroring the architecture on the opposite screen, in the upper-right corner of the right-hand screen, a rooftop cross identifies this Japanese-style building as a *namban* temple, or church. Inside, five worshipers—both Europeans and Japanese—gather at an altar set before a painting of a figure bearing a cross.

noble recluses (see Figs. 12.1 and 12.3). Long revered from both Confucian and Daoist perspectives, hermits were individuals who renounced worldly values and therefore were virtuous and incorruptible. By enacting the role of the hermit, or recluse, *wabi-cha* participants proposed themselves as ideal candidates for powerful political positions. While the host prepared tea near the sunken hearth, the guests would have examined artwork displayed in the **tokonoma**. In discussing the calligraphy or painting, as well as in drinking tea together, participants would have demonstrated mutual admiration and further solidified their relationships.

tokonoma an indoor alcove used to display artwork and seasonal plant cuttings.

9.18 RIGHT **Sen no Rikyū, Taian teahouse,** interior view, Myōkian temple, Kyoto prefecture, Japan, Momoyama period, 1582–83.

9.18a BELOW RIGHT **Taian teahouse (cross-sectional drawing).**

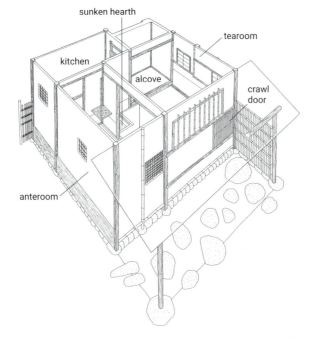

sunken hearth

tearoom

kitchen

alcove

crawl door

anteroom

9.19 FAR RIGHT **Chōjirō, *Muichibutsu* (*Holding Nothing*)**, Momoyama period, late sixteenth century. *Raku* ware: earthenware with transparent glaze, height 3⅜ in. (8.6 cm). Hyogo Prefectural Museum of Art, Japan.

A similar sense of rustic intimacy to that created in the Taian teahouse informed ceramic wares for *wabi-cha*, including water jars, tea caddies, flower vases, and such teabowls as this one by Chōjirō (1516–1592, **Fig. 9.19**). Chōjirō's modestly named *Muichibutsu*, or "Holding Nothing," is less than four inches high, yet it possesses a strong sculptural quality. Its irregular contours and rough surface complement the natural, earthy colors of the fired clay.

Muichibutsu is an example of *Raku* ware. The unfussy aesthetic quality of *Raku* ware developed within the context of *wabi-cha*. *Wabi* means austere, and *Muichibutsu* favors rustic understatement over obvious refinement. To appreciate the teabowl's restrained beauty, viewers shifted their aesthetic expectations and slowed their habits of eye, mind, and body. Such adjustments were effected in *wabi-cha* when host and guests engaged in measured motions of preparation, appreciation, and drink. The

host used a bamboo whisk to whip the frothy, powdered green tea—a bright contrast in color and texture to the simple bowl—before carefully presenting the bowl to the guest. The guest reciprocated with unhurried gratitude.

To generate the *wabi* qualities of earthenware teabowls such as *Muichibutsu*, potters combined old techniques, such as handbuilding (in contrast to throwing on a wheel) with new experimentation. By plucking teabowls from the kiln while still hot and then plunging them into water or placing them on beds of straw that ignited upon contact, potters relinquished a degree of control. The resulting natural accidents became part and parcel of *Raku* ware. The transformation from ordinary object to cherished teabowl is brought to completion with the bestowal of a name. Naming practices were canonized in *chanoyu* writings, the most important of which was the *Records*, written in the 1580s by Yamanoue no Sōji, a student of Sen no Rikyū. Names for teabowls and other tea accessories could allude to poetry, refer to famous places, or invoke profound and paradoxical ideas, such as "holding nothing." Alternatively translated as "empti-ness," *Muichibutsu* invokes more apparently the quality, or reality, that Zen Buddhist teachings ascribe to the world of human experience.

The very name *Raku* also has layered meanings, which bind together power and art. Literally meaning "pleasure," the word *raku* is embedded in the name of Hideyoshi's palace in Kyoto, Jurakudai. *Raku* has been used for later generations of potters who, maintaining that Hideyoshi bestowed upon Chōjirō a seal inscribed with that word, adopted it as a family name and proclaimed to the present an unbroken and direct lineage to their famous founder. Whether Hideyoshi actually did present such a seal to Chōjirō, his role as a patron in the development of *wabi-cha* and the taste for *Raku* ware is certain.

But Hideyoshi's patronage, his quest for famous objects related to *chanoyu*, and his zeal for certain types of ceramics had negative consequences, too. For example, in 1591 Hideyoshi ordered Rikyū to commit suicide, and Rikyū's family were forced into hiding. The circum-stances around the suicide are not entirely clear, but they may relate to Rikyū's misjudgment in including a por-trait sculpture of himself in the restoration of the main gate at Daitokuji temple. Violence and tragedy on a far greater scale would result from Hideyoshi's unsuccessful

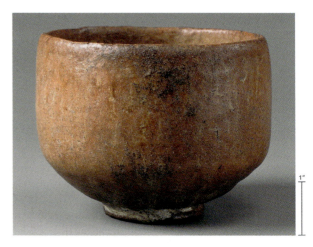

campaigns, which were launched the following year, to conquer Joseon Korea and Ming China.

These Imjin Wars of 1592–98 deeply affected both Japan and Korea. Aided by reinforcements from Ming China, Joseon beat back Hideyoshi's forces, and although Japan's culture benefited from the infusion of Korean captives skilled in ceramics, as well as in textiles and Chinese literature, generations afterward had less appetite for military adventures abroad. After establishing the Tokugawa *bakufu* in 1603, Ieyasu aimed for stability by adopting laws that strictly controlled trade and regulated society. The Joseon court, in the aftermath of invasions by Hideyoshi and later by the Manchu military (who eventually ended the Ming dynasty), also approached foreign contact cautiously, limiting and carefully managing its diplomatic ties to Qing China and Edo Japan. Even so, cultural encounters within East Asia would continue to inspire artists and patrons on the Korean peninsula and Japanese archipelago. Woodblock-printed books on subjects from Chinese landscape painting to European natural history enlarged the scope of knowledge and brought it to readers in Korea and Japan. Policies in the ensuing centuries aimed for more closely regulated contacts with foreigners, but signs of cultural contact appeared nevertheless in art. At the same time, new conditions provided for vigorous exploration of domestic places and pleasures.

Discussion Questions

1. This chapter discusses several different types of ceramics. How do underlying socio-political contexts in East Asia inform innovations in ceramic styles and techniques?

2. Different kinds of power—military, political, religious, and cultural—may be projected in portraits, icons, architecture, or narrative painting. Compare two artworks from this chapter and the different ways they project power.

3. Cultural contact can occur under peaceful exchange, as when Sesshū traveled to China, or under terrible violence, as when Hideyoshi invaded Korea. Explain the effects on artwork resulting from these instances of cultural contact.

4. Further research: compared to earlier eras, the names of more artists and patrons are known. Choose an artist or patron who interests you. What other artworks are associated with that person? Compare those with the one discussed in this chapter.

Further Reading

- Brown, Kendall H. *The Politics of Reclusion: Painting and Power in Momoyama Japan*. Honolulu, HI: University of Hawai'i Press, 1997.

- Jungmann, Burglind. *Pathways to Korean Culture: Paintings of the Joseon Dynasty, 1392–1910*. London: Reaktion Books, 2014.

- Levine, Gregory. "Critical Zen Art History." *Journal of Art Historiography* 15 (2016): 1–30.

- Lippit, Yukio. *Painting the Realm: The Kano House of Painters in Seventeenth-century Japan*. Seattle, WA: University of Washington Press, 2012.

- Seo, Yoonjung. "The Art of Salvation: New Approaches to Koryŏ Buddhist Painting." In J. P. Park *et al* (eds.). *A Companion to Korean Art*. Hoboken, NJ: Wiley-Blackwell, 2020.

Chronology

	KOREA		JAPAN
918–1392	The Goryeo dynasty; exceptionally high-quality celadon wares are made	1185–1333	The Kamakura period; Minamoto no Yoritomo becomes the first shogun
1251	The second *Goryeo Tripitaka* of 80,000 woodblocks is completed	1203	Unkei and Kaikei sculpt *Agyō* and *Ungyō*
1323	Seo Gubang paints *Water-Moon Gwaneum Bosal*	c. 1298	The *chinsō* of Abbess Mugai Nyodai is made
		1392–1573	The Muromachi (Ashikaga) period
1392–1910	The Joseon dynasty; *buncheong* wares are developed	1495	The monk-painter Sesshū Tōyō paints *Splashed Ink Landscape*
1445	Sin Sukju writes *Record on Painting*	1543	The Portuguese arrive in Japan
1447	An Gyeon paints *Dream Journey to Peach-Blossom Land*	1573–1615	The Momoyama period
		1581	Hideyoshi's expansion and renovation of Himeji Castle is completed
1536	Sin Saimdang dreams of a dragon the evening before she gives birth to a gifted son at her family home, Ojukheon	1582–83	The Taian Teahouse, designed by Sen no Rikyū, is built
1592–98	The Imjin Wars, instigated by Hideyoshi's invasions of the Korean peninsula, mark the end of the Early Joseon period	16th century	Chōjiō makes *Raku* ware teabowls
		1593	Kanō Naizen paints *Namban Byōbu*

10

Art, Trade, and Religious Developments in South Asia and Southeast Asia

1100–1550

10.0 Detail from a folio of the *Ni'matnama,*
showing Ghiyas al-Din having a betel chew,
Malwa, India.

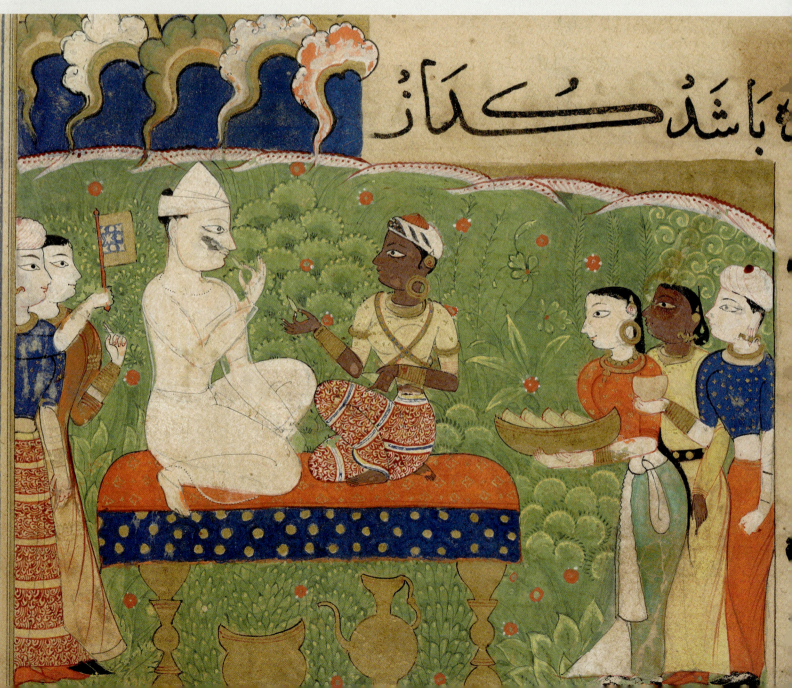

Introduction

Global historians often classify the millennium spanning roughly 500 CE to 1500 CE—the period between the empires of the ancient world and the advent of ocean routes connecting the Americas to Africa, Europe, and Asia—as the medieval era. In South Asia and Southeast Asia, the medieval era might be seen as beginning with the spread of Hindu and Buddhist art beyond the Indian subcontinent to both island and mainland Southeast Asia as well as the Himalayan region (see Chapter 5). It also encompasses the construction of many major Hindu, Buddhist, and Jain monuments: sacred centers intended to connect earthly and spiritual power (see Chapter 7). The last few centuries of the period—the focus of this chapter—are marked by two interrelated developments affecting the visual cultures of South and Southeast Asia.

One is the spread of Islam and the corresponding development of Islamic art in the regions. The monotheistic religion of Islam, which began in Arabia, reached the edges of South Asia in the seventh century, soon after Islam had been founded. However, Islamic art and architecture did not significantly affect visual culture on the Indian subcontinent until the late twelfth century, when a substantial Muslim state was firmly established there. The new rulers, originally from a region that is today part of Afghanistan, made Delhi their capital and began constructing monumental architecture, including mosques, in a mixture of styles. In Southeast Asia, the development of Islamic art and architecture happened even later, when the ruler of Melaka in the Malay peninsula converted to Islam during the fifteenth century and the faith became widely adopted in what are today Indonesia, Malaysia, and Brunei.

The other development of the late medieval era in South and Southeast Asia was a noticeable increase in trade, especially the volume of maritime trade across the Indian Ocean and the sea east of Southeast Asia, beginning in the fourteenth century. This surge in trade correlated with an increase in the production and consumption of portable art objects, including ceramics, textiles, and illustrated books. It also led to more cross-cultural contact and the adoption of cosmopolitan identities amongst the ruling elite, as is evident, for example, in architecture of the south Indian capital city of Vijayanagara. The Hindu rulers adopted aspects of Islamic architecture for their secular buildings, at the same time that they built expansive Hindu temple complexes in local styles. These temple complexes would continue to increase in size and complexity during the reign of the original rulers' Nayaka successors in south India.

Early Islamic Architecture in South Asia and Southeast Asia, *c.* 1100–1500

Unlike the dharmic belief systems of Hinduism, Buddhism, and Jainism, all of which began in South Asia and hold as the ultimate goal release from *samsara*, or the cycle of death and rebirth, Islam began in Arabia (see **Map 10.2**, p. 206) and is based on the belief in paradise awaiting the faithful after death. Despite these differences, Islamic traditions are today intrinsic parts of South and Southeast Asian cultures. Many people mistakenly conflate "Muslim" with "Middle Eastern," but in fact, the Asia-Pacific region currently contains the highest number of Muslims in the world. Indonesia, Bangladesh, India,

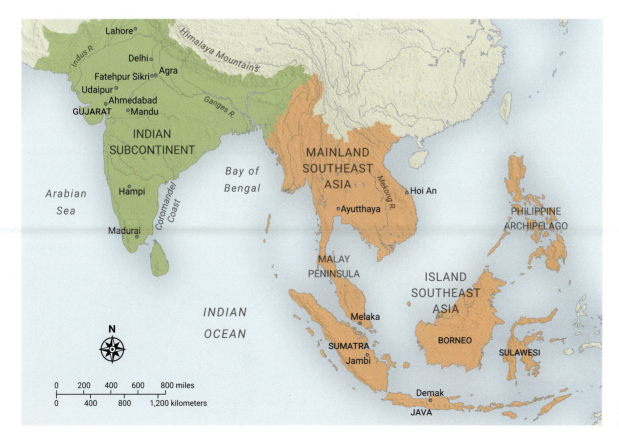

Map 10.1 South Asia (in green) and Southeast Asia (in orange), *c.* 1100–1600.

and Pakistan—just four countries—are home to more than 40 percent of the world's Muslims. Therefore, to understand fully the history of South Asian and Southeast Asian art, it is necessary to understand the development of Islam and Islamic art.

INTRODUCTION TO ISLAM

Islam is a monotheistic Abrahamic faith, meaning that it is closely related to Judaism and Christianity; all three regard Abraham, who according to tradition is the father of the Jewish people, as the first monotheist. In Muslim tradition, God (or *Allah* in Arabic) revealed himself multiple times to prophets, including Moses and Jesus, with Muhammad (c. 570–632) being the final prophet and the founder of Islam.

The Prophet Muhammad was born in Mecca, an important trading and pilgrimage city in western Arabia and home to a polytheistic, tribal society. Orphaned at an early age, Muhammad was raised by his uncle, a long-distance trader, and like him, became a merchant, developing a reputation for fairness. He married a wealthy widow named Khadija (died 619) and led her trading caravans, meeting people of various religions during his travels. According to tradition, in 610, at the age of forty, Muhammad began receiving divine messages instructing him to preach a new monotheistic faith. This new religion, which became known as Islam, meaning "submission to God's will," focused on the ideas of one God and a single community of believers—radical concepts within the polytheistic and tribal society of Arabia. Those new believers became known as Muslims, "ones who submit to God's will." In 622, responding to an invitation to mediate between disputing communities in the city of Yathrib (later renamed Medina), Muhammad, along with the fledgling Muslim community, left Mecca to migrate northward. For Muslims, this event, called the *hijra* (migration), marks the official beginning of Islam and year 1 of the Islamic calendar. Islam's message appealed to many people of the era, and the faith quickly spread (**Map 10.2**).

The divine revelations received by Muhammad between 610 and his death in 632 became the Qur'an, the holy book of Islam. It is believed that the Qur'an was codified in the form that it exists today, with its 114 chapters organized by length, within a few decades of Muhammad's death. Among other things, the Qur'an lays out the Five Pillars of Islam, the defining practices central to devout Muslims. They are: the profession of faith ("There is no God but God and Muhammad is his messenger"); prayer five times each day in the direction of the Ka'ba, the most holy shrine in the Islamic faith, located in Mecca; giving a percentage (usually a fortieth) of one's income to charity; fasting from sunrise to sunset during Ramadan, the ninth month of the Muslim calendar; and, if able, at least once in one's life, performing the pilgrimage to Mecca. The pilgrimage, called the *hajj*, is undertaken during Dhu'l-Hijja, the last month of the Muslim calendar, and is based on rituals, believed to have been related to Abraham, as performed by Muhammad. These Five Pillars provide a sense of community to Muslims spread across diverse geographic regions.

Because the Qur'an is believed to be the direct word of God, it is always written in Arabic. Thus, even an early fourteenth-century copy of the Qur'an made in western India (**Fig. 10.1**), where the local language was not Arabic, is still written in Arabic. In turn, because historically many devout Muslims learned Arabic to read the Qur'an, knowledge of the language—like the Five Pillars—fostered a Muslim community that crossed geographic borders. From an economic perspective, it also facilitated trade. In fact, from the very beginning,

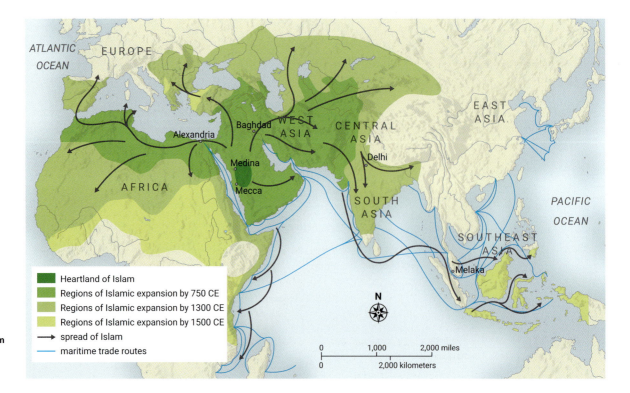

Map 10.2 The spread of Islam and maritime trade routes across Asia during the medieval and Early Modern periods.

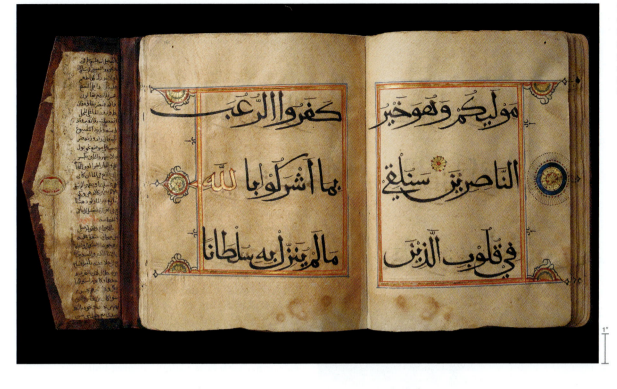

10.1 Copy of the Qur'an,
written in *muhaqqaq*, with later
leather binding, western India
(with an inscription that it was
gifted to a Mamluk ruler of Egypt),
c. 1300. Each leaf: 10⅛ × 7½ in.
(25.5 × 19 cm). David Collection,
Copenhagen.

as Muhammad's biography attests, Islam and trade were closely intertwined. This connection is demonstrated in the Qur'an illustrated here (**Fig. 10.1**): made in western India, an important region for the textile trade (see **Fig. 10.9** and Seeing Connections: Matters of Cloth, p. 57), the Qur'an was gifted to the Egyptian Mamluk ruler Sultan Nasir al-Din Muhammad (ruled 1293–94; 1299–1309; and 1310–41). South Asian textiles and other goods destined for Europe traveled through Nasir al-Din's lands, and he helped promote this trade by having a canal dug from the Red Sea to the city of Alexandria on the Mediterranean coast. The gifting of a lavish Qur'an to him, whether by an Indian ruler or a wealthy merchant, would have shown gratitude and helped cement a key relationship.

This particular Qur'an is considered lavish because of its size and the quality of its **calligraphy**. Arabic script (Arabic is both the name of a language and the name of a script) is written from right to left and is adaptable to a wide range of calligraphic styles (see Seeing Connections: Art of Writing, p. 138). For this Qur'an, the Indian calligrapher used a visually bold and powerful style of Arabic script called *muhaqqaq*. Although each page, at roughly 10 by 7 inches, is ordinary in size, because there are only three lines of text per page, a copy of the entire Qur'an required multiple volumes—all made with expensive paper, gold-leaf **illumination**, and leather bindings.

This Qur'an dates to a period, around 1300, when Islamic art and culture were well established on the subcontinent. However, the history of Islam in South Asia goes back further—to the seventh and eighth centuries. The earliest Muslims in the region were traders who settled along the coasts of southeast India and Sri Lanka, as well as Arabs from the Umayyad caliphate (661–750 CE; a caliphate is an area ruled by a Muslim religious and political leader called a caliph), who conquered the Sindh region along the Indus River. Material evidence from these communities survives, but the production of major works of Islamic art and architecture only began in the late twelfth century, when a significant and extensive Muslim state was inaugurated in the northern part of the subcontinent.

EARLY MOSQUE ARCHITECTURE IN NORTHERN INDIA

In the early 1190s, the armies of the Ghurid dynasty (*c.* 879–1215; from a region that is today part of Afghanistan), under the command of the general Qutb al-Din Aybak, defeated a local Hindu king and seized Delhi. In 1206, after the death of the Ghurid ruler, Aybak declared his independence and made Delhi his capital. His successor, Iltutmish (ruled 1210–36), was proclaimed sultan (king) by the Muslim caliph in Baghdad. For the next three hundred years the Sultanate of Delhi (1206–1556), under the rule of five different Muslim dynasties, controlled north India and sometimes much of south India as well. The sultans of Delhi, most of whom were Persian-speaking Central Asian Turks, were keen patrons of the arts, sponsoring poets and painters and overseeing the transformation of Delhi from a regional center into an imperial metropolis. They built fortifications, palaces, water reservoirs, and numerous religious structures, but the heart of their capital from the start was the Qutb Mosque complex.

The Qutb Mosque complex (also called Quwwat al-Islam, "Might of Islam," although this is not the structure's original name) in Delhi is an **architectural palimpsest**, with three main phases to its development (**Fig. 10.2**, p. 208). These phases provide insights into the beginnings of South Asian Islamic architecture. The Qutb Mosque's builders creatively combined visual traditions to construct something both familiar and innovative.

calligraphy the art of expressive, decorative, or carefully descriptive hand lettering or handwriting.

illumination decorative designs, handwritten on a page or document.

architectural palimpsest a structure that has been changed over time and shows evidence of that change.

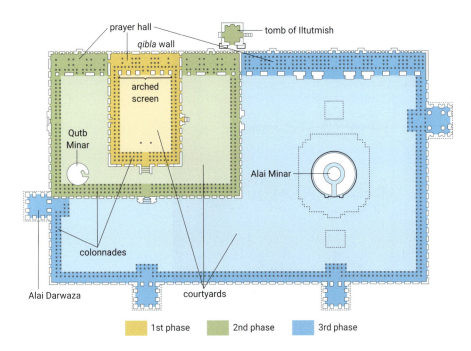

prayer hall
qibla wall
tomb of Iltutmish
arched screen
Qutb Minar
Alai Minar
colonnades
Alai Darwaza
courtyards

1st phase 2nd phase 3rd phase

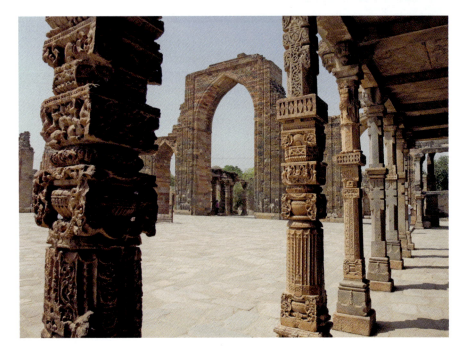

10.2 TOP **Qutb Mosque complex (plan drawing),** showing its three phases of construction. Sultanate of Delhi, India, *c.* 1192–1311.

10.3 ABOVE **Interior of Qutb Mosque complex,** view from the side of the prayer hall toward the *qibla* wall and five-arched screen, Sultanate of Delhi, India, *c.* 1192–98.

congregational mosque also called a Friday mosque, or *jama masjid* in Arabic, the main mosque in a city or town and the location of Friday prayers, when the entire community comes together.

hypostyle hall a large room with rows of columns or pillars supporting the roof.

colonnade a long series of columns at regular intervals that supports a roof or other structure.

qibla wall the wall in a mosque that indicates the direction toward which Muslims face to pray, usually indicated by the presence of a *mihrab*.

spolia building materials or reliefs salvaged from other works and reused in a different structure.

anthropomorphic described or depicted with human characteristics (in art: images of people).

corbel a wood, stone, or brick wall projection, such as a bracket, that supports a structure above it.

keystone a central stone, wider at the top than the bottom, placed at the summit of an arch to transfer the weight downward.

While still a Ghurid general, Aybak initiated construction of this **congregational mosque**. Inscriptions on the mosque give the date of 1191–92, but more likely it was begun about 1193. Mosques are places of communal prayer (see Seeing Connections: Mosque Architecture around the World, p. 221); however, they can also be important markers of political authority. In Islamic tradition, having a leader's name recited at Friday prayer legitimized the political power, and so building a mosque in a newly conquered area was a priority. Construction typically began in the first months of rule, and the structure needed to be large enough to accommodate the community's entire Muslim male population (during the Prophet Muhammad's lifetime, women did pray alongside men at mosques, but by the twelfth-century women generally did not attend public prayer for reasons related to modesty). Aybak's mosque adapts a rectangular **hypostyle hall** plan (first phase in **Fig. 10.2**). An open-air courtyard is surrounded on three sides by covered **colonnades**, while the fourth side—the *qibla* **wall**—originally held the pillared prayer hall. The hall no longer survives; the complex is partially in ruins today. As is typical in many warm climates, the courtyard takes up the majority of the 214 × 149-foot plan (around 65 × 45 m), with only a small, pillared hall.

Notably, the structure makes use of **spolia**, primarily columns, from twenty-seven Hindu and Jain temples, stacked two high to achieve the necessary height for the colonnades' roofs (**Fig. 10.3**). The spolia's significance is a debated issue. Was it used for expediency, to embody the Ghurids' military conquest, out of appreciation for local artistic practices, or some combination of these or other reasons? Reused materials were often employed in early mosques for pragmatic purposes; here, however, with inscriptions noting exactly how many temples were plundered for materials, the spolia also appears to be a victory statement. During this period, South Asian rulers from a variety of religious traditions often deliberately made use of spolia and seized statues to display power; as we saw, the Hindu Chandela ruler Yashovarman, in order to demonstrate his growing power, built a temple at Khajuraho to display the Vishnu statue he had stolen from his overlord (see Chapter 7). The way in which the spolia was modified in the Qutb Mosque also suggests an appreciation for the Indian stone-carvers' skills. **Anthropomorphic** imagery, central to Hindu art, was not acceptable in a Muslim religious context, so any human or animal form had to be disfigured or disguised in some way. In many of the Qutb's Mosque's pillars, the nose or eyes of a figure were carefully removed to leave the rest of the carving intact.

In 1198 Aybak had a sandstone screen (a partition wall) pierced by five monumental arches built in front of the prayer chamber (**Figs. 10.3** and **10.4**). The arched screen reveals the interaction between patron and artisans as they worked out the transfer of traditions. For example, the local craftspeople, following their training, built the arches using **corbels** rather than a **keystone**, the typical method in Islamic architecture. Visually, however, the arches resemble the typical Islamic pointed arches found in Aybak's Central Asian homeland. Indeed, the screen was probably intended to make the building look more

In 1303, after a key victory against the Mongols, the sultan 'Ala' al-Din Khalji (ruled 1296–1316) attempted to double the mosque's size again (third phase in **Fig. 10.2**). Not all of his additions were completed or have survived the centuries. For example, he ordered the construction of a minaret, the Alai Minar. It was intended to eclipse the Qutb Minar, with a base twice the size. Its final height would have reached 475 feet (145 m), equivalent to a modern 40-story building, but the tower made it only to 80 feet (24 m) before construction was abandoned. Of the surviving elements, most notable is the Alai Darwaza, a ceremonial gateway near the Qutb Minar (on the right in **Fig. 10.5**). A square, domed structure completed in 1311, it shows the final stage of development at the site. Its four arched entrances make use of keystones, by this point part of the Indian subcontinent's architectural vocabulary. Featuring **architectural polychromy**, the red sandstone is creatively offset with white marble trim, an innovation adopted by the later Mughal dynasty (see Chapter 11). The structure features copious calligraphy, and its

10.4 FAR LEFT **Arched screen in front of the *qibla* wall (detail)**, Qutb Mosque complex, Sultanate of Delhi, India. Screen constructed in 1198.

minaret a tower at a mosque or Islamic tomb; can be used to give the call to prayer and also functions as a visible marker of the mosque on the skyline.

architectural polychromy using different-colored materials to create decorative patterns in architecture.

10.5 **Qutb Minar** (minaret, built *c.* 1199–1220) and RIGHT **Alai Darwaza** (ceremonial gateway, completed in 1311), Qutb Mosque complex, Sultanate of Delhi, India.

like contemporaneous mosques from Central Asia, which often featured grand arched openings (for example, see Seeing Connections: Mosque Architecture around the World, Fig. 1, p. 221). Likewise, inscriptions on earlier Ghurid dynasty architecture feature distinctive undulating vines behind the Arabic calligraphy. The Indian artisans emulated that tradition on the Qutb screen, but they turned the vine into a (locally prized) lotus creeper and endowed the carving with organic exuberance (**Fig. 10.4**).

In 1199, Aybak began construction on a **minaret** called the Qutb Minar. Its base alternates round and wedge shapes, a plan found in earlier minarets in the Afghan region that was the Ghurid's homeland. Aybak's successor Iltutmish initiated another round of construction to the Qutb Minar. He added three stories separated by balconies (on the left in **Fig. 10.5**), making the Qutb Minar the tallest minaret of its age and a symbol of Delhi's status as a center of Islamic authority. It remains the tallest masonry minaret in the world. Iltutmish expanded the complex in other ways as well. He had his tomb constructed at the site, and he doubled the mosque's size by building courtyards and colonnades on three sides and extending the *qibla* screen (second phase in **Fig. 10.2**). Completed by 1229, these additions featured decoration that was more geometric than organic, emphasizing Persian rather than Indic forms. While this work was ongoing, Delhi's Muslim population was rapidly increasing as a result of repeated Mongol incursions across much of Eurasia (see Seeing Connections: *Pax Mongolica*, p. 182). These new groups of war-fleeing émigrés most likely included artisans who helped to shape Delhi's visual environment.

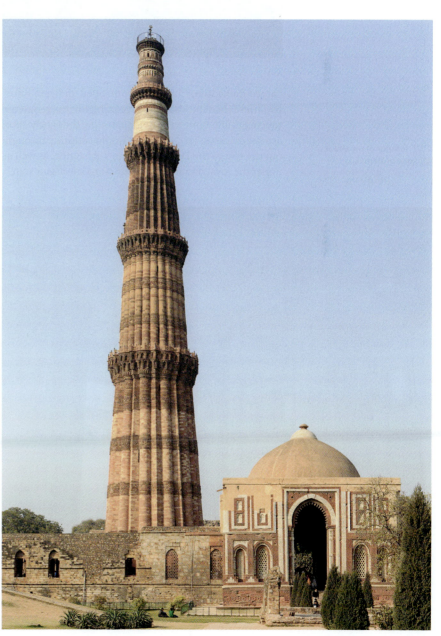

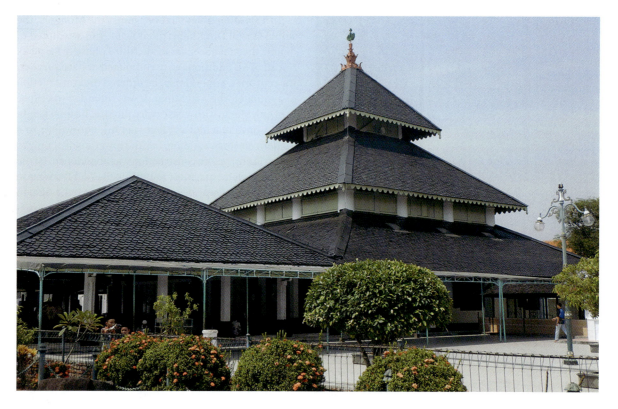

10.6 Great Mosque of Demak, *c.* 1507 and later, Demak, Indonesia.

10.7 Interior of the Great Mosque of Demak, *c.* 1507 and later, Demak, Indonesia.

carved decoration, including controlled, delicate lotus-bud friezes and intricate *jali* screens, highlights geometric repetition and symmetry, demonstrating the synthesis of artistic cultures. That synthesis would continue throughout the rest of the Delhi Sultanate's existence, as well as under the royal patronage of their many successor states.

EARLY MOSQUE ARCHITECTURE IN JAVA

In historical circumstances surrounding the spread of Islam in Southeast Asia differed from those in South Asia, as did the pre-existing artistic and cultural traditions into which the religion was merging. Those differences are clearly visible when we compare the Qutb Mosque complex to an early Indonesian mosque, such as the Great Mosque of Demak (**Fig 10.6**).

Although Islam had been present in Southeast Asia, particularly northern Sumatra, for about two hundred years, it was not until the ruler of Melaka converted to Islam during the fifteenth century that the faith became widely adopted in the region (see **Map 10.2**). Islam's expansion in island Southeast Asia (chiefly the present-day countries of Malaysia, Indonesia, and Brunei) was closely linked with trade, spreading from Melaka to port towns on the coast of Java, and from there inland. Islam, along with the Malay language, became a unifying factor at a time when political authority was fractured. By joining a pan-regional religious community, rulers gained political clout and consolidated trade alliances. Additionally, Sufism, the mystical branch of Islam, was prevalent at the time. Sufism helped popularize Islam because its flexibility and openness were accommodating to older local practices related to Hinduism, Buddhism, and ancestor worship. A Javanese legend states that nine Sufi saints spread the religion throughout the island and, through miraculous means, also helped construct some of its first mosques.

The earliest Javanese mosques, dating from the late fifteenth to the early sixteenth centuries, provide evidence of Islam's growth and its fusion with local traditions. The Great Mosque of Demak is one of the oldest extant prayer halls. At the turn of the sixteenth century, Demak, located on Java's north coast, was the strongest of the island's Muslim port-states. Historical sources suggest

that the mosque was either built or rebuilt in 1507 by the ruler at the time, who was a direct descendant of Demak's Chinese-Malay Muslim merchant founder.

As with many early Indonesian mosques, the building has an uncertain early history and has been renovated multiple times over the centuries; nonetheless, it illustrates the principal early Southeast Asian mosque type. While a **mihrab** marks the *qibla* wall and an open space is provided for communal prayer, as per religious requirements, the fundamental elements that make up mosque architecture in North Africa, West Asia, and Central Asia—and that are used in the Qutb Mosque complex— are notably absent here. These elements include arches, domes, calligraphy, and geometric ornamentation. Indeed, no Indonesian mosques with domes were constructed until the nineteenth century (see Fig. 14.11).

Instead, mosque design took inspiration from local palace halls and village meeting houses. These wooden, pavilion-like structures were typically square in plan, as Demak's mosque was initially (the rectangular side hall was added later), and topped by a tall, multi-tiered roof that allowed for ventilation and gave the building a vertical emphasis. Four to six massive pillars, called the *saka guru* (master columns), support the heaviest central portion of these distinctive roofs (**Fig. 10.7**). Typically, each column was hewn from a tree trunk for stability; however, at Demak, only three of the four 72-foot-high (22-meters-high) pillars are constructed in this manner. The last had to be made from multiple pieces of wood laminated together, and, interestingly, has become an object of veneration for that reason. As with most of the region's early mosques, the Great Mosque of Demak's orientation toward Mecca is approximate.

Mosque architecture—and Islamic art and architecture, more generally—is flexible. Materials, design, and ornament: all of these things are able to shift and bend to accommodate local traditions, political ambitions, and varying historical circumstances. The coming of Islam unquestionably altered the visual cultures of South Asia and Southeast Asia, but at the same time, the diverse cultures of these regions changed the religion and its art. The increase in trade that occurred from around 1300 onward, bringing with it more intercultural contact, further affected art and architecture.

Portable Objects and Trade, c. 1300–1500

The geography of South Asia and Southeast Asia made these regions beacons for traders (see **Map 10.2**). The busiest east–west maritime routes crossed Southeast Asia, the biodiverse forests of which were home to desirable products (particularly spices and aromatic woods) not found elsewhere. The coasts of South Asia, midway between the markets of West Asia and those of Southeast Asia and East Asia, provided a convenient stopping point for ships, while the subcontinent's agricultural production included cotton and indigo, from which craftspeople manufactured large amounts of highly tradable textiles. Trade had long formed a key piece of the regions' economies and influenced visual culture (see, for example,

Fig. 7.3), but beginning in the late fourteenth century, the volume of trade increased. As a result, its impact on visual culture was greater. Also, because more objects were traded, more of them survive for us to study today.

CERAMICS AND TEXTILES

Much of our knowledge of the ceramics trade in the 1300s–1500s comes from the cargo of numerous shipwrecks found throughout Southeast Asia's seas. For example, in the early 1990s, fishermen working off the coast of central Vietnam, near the city of Hoi An, began finding small dishes, jars, and bowls in their nets. Realizing that the objects came from a shipwreck hundreds of years old, the Vietnamese government teamed up with a for-profit salvage company to excavate the underwater site, and succeeded in recovering a remarkable 244,000 pottery artifacts, 150,000 of which were still intact. The objects, primarily Vietnamese blue-and-white ware (**Fig. 10.8**) from the Red River Delta region, range from simple, everyday items to finely decorated luxury pieces, and are datable from the late fifteenth to the early sixteenth centuries. The sunken ship, probably of Thai or Chinese origin, may have been headed toward one or more Indonesian or Philippine islands. The Hoi An hoard, as the trove is commonly called, reveals much about Vietnamese ceramic production, the scale of maritime trade, and the links between Chinese and Vietnamese cultures.

Chinese imperial forces invaded and occupied Vietnam four times between 111 BCE and 1428 CE. In each instance, the Vietnamese eventually drove the foreign conquerors out, but not before acquiring aspects of Chinese culture, such as its writing system. During the two-decade Ming

mihrab prayer niche, usually concave in shape with an arched top, located in the *qibla* wall of a mosque and indicating the direction of Mecca.

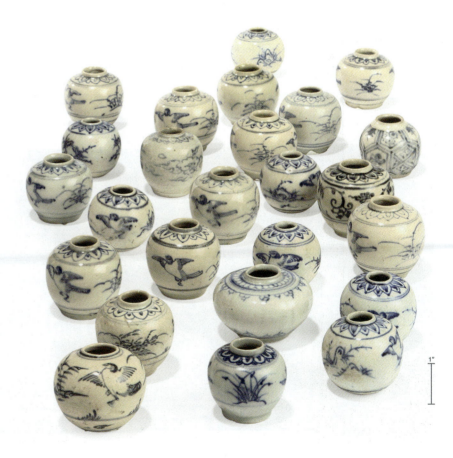

10.8 Ceramics from the Hoi An hoard, Vietnam, late fifteenth to early sixteenth centuries. Width of largest jar: 2½ in. (6.4 cm).

dynasty occupation of Vietnam (1407–28), Chinese officials taught local artisans how to manufacture **porcelain** in styles popular for export (see Seeing Connections: Blue-and-White Porcelain around the World, p. 241). Shortly thereafter, the Ming government, preoccupied with internal conflicts, banned exports of blue-and-white ware from the Jingdezhen imperial kilns. Scholars sometimes refer to the period of the ban, which lasted for about thirty years, as the "Ceramic Interregnum" or "Ming Gap." The Vietnamese, along with Thai and other Southeast Asian ceramic producers, took the opportunity to increase their production levels to meet existing West Asian and Southeast Asian needs. The Hoi An hoard represents the tail end of that augmented output. Because Chinese porcelain was so universally esteemed, Vietnamese manufacture largely conforms to Chinese styles, but the local artisans also found ways to make it their own. For example, the Hoi An hoard objects, such as a group of small jars painted with images of flying birds and flowering branches (**Fig. 10.8**), display a distinctive sense of spontaneity and swiftness of execution in the brush-strokes used to apply the decorative designs.

Textiles—portable, adaptable, and functional—were also traded at high volume across the Indian Ocean and the sea east of Southeast Asia. Unlike ceramics, however, cloth does not survive prolonged periods submerged in water, and thus, we have no shiploads of sunken cargo to analyze. Instead, what we know about the textile trade in South and Southeast Asia during this period comes chiefly from a select number of carefully preserved items. One of the most remarkable pieces is a 650-year-old Indian textile (a portion of which is shown in **Fig. 10.9**), preserved for most of those centuries in a Toraja village on the eastern Indonesian island of Sulawesi.

Despite the tropical environment, the 5-yard-long **woodblock-printed** and **resist-dyed** cotton cloth survived because of its status as *pusaka* (an Indonesian term for a sacred heirloom believed to be imbued with spiritual power). In various premodern Indonesian cultures, textiles, particularly those imported from South Asia, served as forms of wealth, symbols of societal status, and objects for use in religious rituals. Within the Toraja ethnic group of central highland Sulawesi, treasured textiles, called "cloths of the ancestors," played vital roles in ceremonies relating to fertility, agriculture, and funeral rites. The banner-like lengths of cloth were hung from bamboo poles during the events, and carefully preserved in village clan houses the rest of the time.

This particular piece, **radiocarbon-dated** to *c.* 1340, was made in Gujarat, on the Indian subcontinent's west coast. A closely related cloth fragment, as well as a series of other cotton cloth pieces in different designs all made in Gujarat *c.* 1340, were discovered in a Mamluk-era archaeological site outside of Cairo, Egypt. In addition to indicating the close relationship between Mamluk Egypt and western India (see **Fig. 10.1**), these pieces reveal the extent of the Indian textile trade at the time, spanning from the furthest islands of Indonesia to the Mediterranean and beyond.

Textiles were South Asia's principal export commodity at the time, and Indian cottons in particular were in wide demand because of their fine weaves, rich variety of designs, and fastness of dye colors (for more on cotton textiles, see Seeing Connections: Matters of Cloth, p. 57). Because of cotton's molecular composition, dyes made from plants and other organic materials will not properly affix to the material if it is not first treated with a mordant (a metallic oxide, such as alum, copper, or iron). Indian artisans used this aspect of cotton to "paint" designs onto the cloth. Using a brush, they applied mordant to the areas where they wanted color, and wax or mud to the areas they wanted to remain color-free (that is, resist the color). They then dyed the fabric, repeating these steps for each additional color. Resist-dyed cotton cloth was produced in two main regions of the Indian subcontinent: Gujarat and the Coromandel Coast (see **Map 10.1**). Gujarati artisans also decorated fabric using woodblock printing: mordant and dye were applied to specially carved blocks, which would be stamped onto the fabric. The example here features both block-printing

10.9 Ceremonial banner (detail), Gujarat, India, radiocarbon-dated *c.* 1340 (plus or minus forty years). Cotton block-printed and resist-dyed, 37 in. × 16 ft. 4 in. (94 cm × 4.98). Victoria and Albert Museum, London.

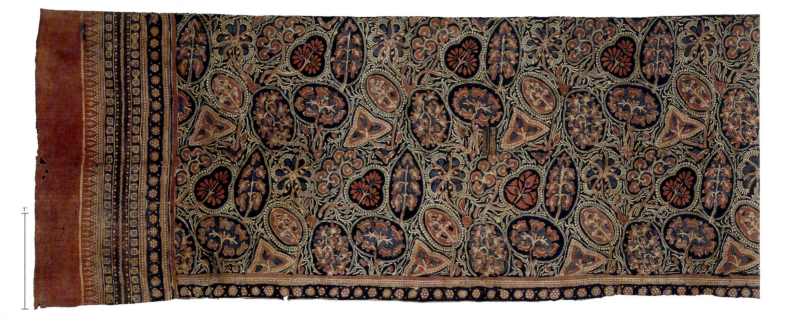

and resist-dyeing. Its dominant colors, indigo blue and madder red, are typical of the region, as is the outlining of the decorative forms in white (the undyed cloth). Here, the design features a complex pattern of interlocking trees and leaves.

ARTS OF THE BOOK

In 1407, the Sultanate of Gujarat, a Muslim state with a diverse population that included Hindus and Jains, established its independence from the Delhi Sultanate. A few years later, the newly independent state made Ahmedabad its capital, refurbished Gujarat's ports, and built up its naval force. These actions increased Gujarat's importance to the manufacture and trade of textiles, in turn bringing more wealth and prosperity to the region. Jains particularly benefited from these changes, with many playing central roles in the textile trade. Because a crucial practice of the Jain faith is to avoid causing injury to living creatures (see Chapter 3 for more about the religion), Jains shunned such professions as farming (where one might harm an insect while cultivating the fields), becoming bankers and merchants instead. Thus, as a community, Jains tended to be both prosperous and literate, and many of the wealthiest became important patrons of illustrated religious **manuscripts**. Because the patrons often gifted these manuscripts to temple libraries as a way of gaining spiritual merit, many survive in good condition and help trace the development of Indian manuscript painting.

Although illustrated manuscripts probably have a much longer history in South Asia, the earliest surviving examples, such as *The Book of the Perfection of Wisdom in Eight Thousand Lines* (*Ashtasahashrika Prajnaparamita Sutra*) made at Nalanda monastery (see Fig. 5.17), date to *c.* 1000 CE. Like *The Book of the Perfection of Wisdom*, most early examples are Buddhist and Jain texts with only a few small paintings. Because they were made from palm leaves, these manuscripts have elongated horizontal formats. In the mid-fourteenth century, paper, introduced from West and Central Asia, began to be used, increasing both the number and size of manuscripts; however, the horizontal orientation of the earlier palm-leaf books was often maintained, particularly for Jain manuscripts. In the fifteenth century, concurrent with the political and economic changes described above, Jain manuscripts from western India became more lavish, using expensive pigments, such as gold and ultramarine blue. For example, in **Fig. 10.10** (*verso* page), the central text and

manuscript a handwritten book or document.

10.10 Folio from the *Devasano Pada Kalpasutra manuscript,* ABOVE (front or *verso*) at left, "Sthulabhadra and His Sisters"; at right, "The dancing courtesan Kosha and the king's charioteer," flanked by female figures. BELOW (back or *recto*) text page with female figures. *c.* 1475–1500. Gujarat, possibly Patan, India. Opaque watercolor, ink, silver, and gold on paper, sheet only: 4½ × 10¼ in. (11.2 × 26 cm); matted: 15 × 20 in. (38.1 × 50.8 cm). Cleveland Museum of Art, Ohio, On Loan from the Catherine and Ralph Benkaim Collection.

folio one leaf of a book.

figures are painted gold with blue backgrounds. The pages, while still horizontally orientated, became taller, allowing more room for the illustrations.

The two major Jain texts, one often appended to the other, are the *Kalpasutra*, which recounts the lives of the twenty-four Jinas, "victors" who obtained spiritual liberation, and the *Kalakacharyakatha*, which tells the story of a Jain monk named Kalaka. The images illustrating these texts, such as those adorning this late fifteenth-century **folio** (Fig. 10.10), display a distinctive style featuring flat areas of saturated color and sharp, angular figures outlined in black. The figures, in lively poses conveying movement, have pointed noses and chins. Their faces are depicted in a three-quarter view with one projecting eye, a hallmark of the style. These paintings also underscore the connections between textile and manuscript production. The way in which the painted forms are accentuated with white highlights clearly derives from the aesthetics of resist-dyeing and block-printing. Moreover, in scenes that otherwise were repeated with little differentiation between manuscripts, the artists lavished individualized attention on the figures' dress, signifying the importance of textiles within society. Indeed, many of the cloth patterns featured in Jain paintings can be matched with those found on surviving textile fragments.

The developments in South Asian illustrated manuscript production that occurred from the fourteenth century onward resulted from increases in wealth within certain communities, but also from the significance of book culture at the courts of Muslim rulers. In addition to the Qur'an, all types of writing—romantic literature, Sufi mystical poetry, scientific treatises, astrological studies—were valued within Islamic society, especially within Persian courtly culture. People, including princes, soldiers, scholars, and artists, were constantly emigrating from the Persianate realm—what is today Iran, Afghanistan, and Uzbekistan—to the sultanate courts in India. The vibrancy of the resulting compound cultures is visible in the illustrated manuscripts produced in the royal workshops at these courts. One of the most charming of such manuscripts may be the *Ni'matnama* (*Book of Delights*), a recipe book written for the sultan of Malwa, Ghiyas al-Din Khalji (ruled 1469–1500) and completed during the reign of his son Nasir al-Din Shah (ruled 1500–10).

Malwa was a small state in central India, and its capital was the city of Mandu (see Map 10.1). Sultan Ghiyas al-Din

10.11 *Ni'matnama* (*Book of Delights*), Malwa, India, *c.* 1490–1510. Recipes for samosas with illustrations showing cows being milked (below right) and Sultan Ghiyas al-Din seated on his throne (below left) attended by servants. British Library, London.

Illustrated manuscripts combine visual and written content. To analyze them, therefore, art historians need to consider both the images and the text closely. In the case of the *Ni'matnama* or *Book of Delights*, the text is composed of a series of recipes. Below is a translation of the text accompanying the illustration on the right side of Fig. 10.11. Note that the recipe begins not with the making of the dish, but rather with the feeding of the cows that will produce the milk to be used.

"Another method [recipe]: buy a yellow cow or a black cow, feed it on sugarcane, green grass, cotton seeds and date sugar and also coconut, nutmeg, cinnamon, pulses, partridge eggs and bamboo leaves, or else use a sheep or a cow buffalo. Take the milk from it, boil it and skim off the cream that rises to the top. Drink the milk lukewarm. Strain the cream in a cloth and, having added wheat flour to it, prepare *kashk* [a very thick, almost solid mixture made of milk and flour]. Fry it in *ghee* [clarified butter] and add a quantity of camphor, cardamoms, cloves, date sugar and round peppers. It is very tasty."

The book contains multiple recipes for samosas, a savory pastry treat still popularly eaten today. One such recipe is given on the left side of Fig. 10.11 in the text surrounding the illustration:

"Another of Ghiyas Shahi's samosas: mix together well-cooked mince with the same amount of minced onion and chopped dried ginger, a quarter of those, and half a *tulcha* [a weight of measurement] of ground garlic and, having ground three *tulchas* of saffron in rosewater, mix it with the mince together with aubergine [eggplant] pulp. Stuff the samosas and fry (*them*) in ghee. Whether made from thin coarse flour bread or from fine flour bread or from uncooked dough, any of the three (*can be used*) for cooking samosas, they are delicious."

This recipe combining minced meat with spices is typical of Ghiyas al-Din's samosa recipes, which most likely have their roots in Central Asia. Notably, none of the recipes makes use of potatoes, the most common ingredient in samosas today—because potatoes, which originate in the Americas, were not yet known in South Asia. In this regard, the manuscript captures a particular moment in time: one marked by the increased coming together of diverse traditions during the late medieval era but before the global exchange of commodities that marks the Early Modern and modern eras.

Discussion Questions

1. Compare the text and illustrations: What aspects of the text are illustrated? What aspects are not illustrated?
2. What are the various ways in which the manuscript embodies the coming together of diverse traditions during the late medieval era?

seems to have been a connoisseur who liked to spend his time pursuing epicurean interests in Mandu's royal palace. The *Ni'matnama*, written specifically for Ghiyas al-Din, contains his favorite recipes, not just for food and drink, but also for perfumes, aphrodisiacs, and medical remedies. The illustrations, set within palace or garden environs, tend to feature the sultan, recognizable by his jaunty moustache (in the center on the left folio of 10.11), supervising the production of the items described in the text. One illustration (Fig. 10.0) depicts him about to chew on *paan*, a South Asian betel-nut-leaf mixture that acted as a mild stimulant, given to him by a female companion. More female attendants flank the sultan.

The text is written in a mixture of Persian and early Urdu (both languages use the Arabic script). Urdu was a new language that developed during this period as a blend of north Indian languages, Persian, and select words from Arabic. Like the language in which the book is written, the illustrations combine local Indian stylistic elements with Persian ones. For example, in the small painting of an attendant milking a cow (right folio of Fig. 10.11), the horizon line is curved and placed near the top of composition, leaving just a little sliver of golden sky. That detail is characteristic of painting from the Iranian city of Shiraz, suggesting that at least one of the artists employed at Mandu's court was from Shiraz or trained in a Shirazi painting style. Likewise, in the image on the left page of Fig. 10.11, the scene is shown from a variety of perspectives, making the architecture and figures appear flattened, like a paper-doll stage set that has been dismantled. That, again, is characteristic of Persian painting of the period. Other details, particularly with regard to the depictions of women, incorporate localized western Indian visual elements. Note, for example, the slender waist, colorful dress, and large earrings of the sultan's companion in Fig. 10.0, all common visual elements found in western Indian painting.

Artistic Developments in South India from the 1330s onward

When Sultan 'Ala' al-Din Khalji (ruled 1296–1316) came to power in Delhi (see p. 209) , he initiated a series of destructive raids to the far south of the Indian subcontinent that continued under the armies of his successors. Local forces able to defend the region eventually rose to power, and many of these ruling dynasties became important patrons of art and architecture. Thus, art in southern India from the 1330s onward developed in distinctive ways, ones that both drew on earlier local artistic practices and selectively incorporated cross-cultural elements.

VIJAYANAGARA

One such defending force against the northern armies included members of the Sangama dynasty, who, in 1336, founded the Vijayanagara Empire. That empire lasted for 230 years under the rule of four different Hindu dynasties, and at its height controlled almost the whole of peninsular southern India. Its rulers were able to dominate in part because they adopted new military strategies, including the use of cannons and cavalry.

Before Muslim forces arrived in South Asia in the eleventh and twelfth centuries, horses were not used in battle, but by the fifteenth century, cavalry divisions formed a crucial component of successful armies throughout the subcontinent. Vijayanagara's Hindu rulers not only

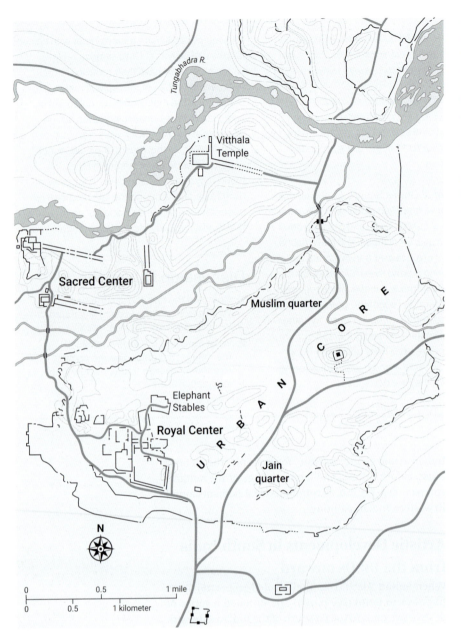

imported large numbers of horses from West and Central Asia for their military, but they also adopted other aspects of Islamic culture, including dress and royal titles, that would be widely recognized symbols of power within the Indian Ocean world. At the same time, they assiduously linked their rule to Hindu deities and belief systems that would demonstrate their legitimacy within local contexts. Such purposeful and selective appropriation marks the Vijayanagara rulers as cosmopolitan.

Their cosmopolitan approach is visible in the architectural remains of their capital city, also named Vijayanagara (today the city is commonly referred to as Hampi). By the early sixteenth century, Vijayanagara was one of the most populous and wealthy cities in South Asia. Accounts by Persian, Italian, and Portuguese visitors all describe the capital's splendor. In 1565, however, Vijayanagara was sacked and burnt by the victorious armies of its rivals, the Muslim sultans who ruled a series of kingdoms 200 miles (320 km) to the north in the Deccan plateau (see Chapter 11). After that event, the city was largely abandoned. Today it is a major archaeological site, with some surviving structures as well as ruins covering 10 square miles (26 square km).

The city was located along the Tungabhadra River in a rocky granite landscape (see **Fig. 10.14**). Based on archaeological evidence, it appears to have been divided into two zones: one was a sacred center, where the major Hindu temples were located, and the other was a walled residential and commercial area where most of the city's population lived (**Fig. 10.12**). An irrigated valley used for agriculture connected the two zones. At the heart of the urban core was the Royal Center, a smaller walled area that seems, again, to have been divided into two parts: a more public area that archaeologists refer to as the zone of royal performance and a private one, the zone of royal residence. Outside the Royal Center, the urban core had several distinct neighborhoods, including a Jain quarter with temples and a Muslim quarter with at least one mosque.

Notably, different styles of architecture were used in the Royal Center and in the Sacred Center. In the Royal Center, builders used rubble masonry covered with fine plaster to construct the monuments. Structures feature

10.12 ABOVE **Plan of Vijayanagara capital city (Hampi),** south India, 1336–1565.

10.13 BELOW **Elephant stables,** Vijayanagara, south India, fifteenth century.

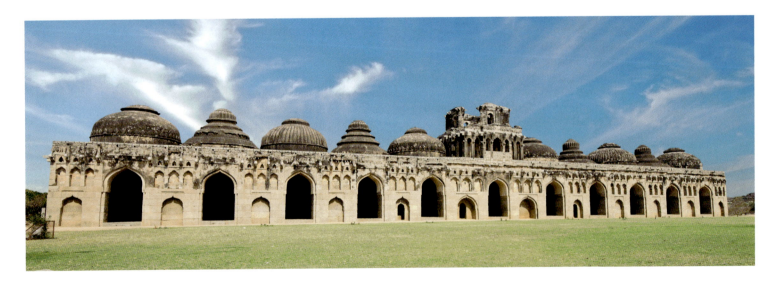

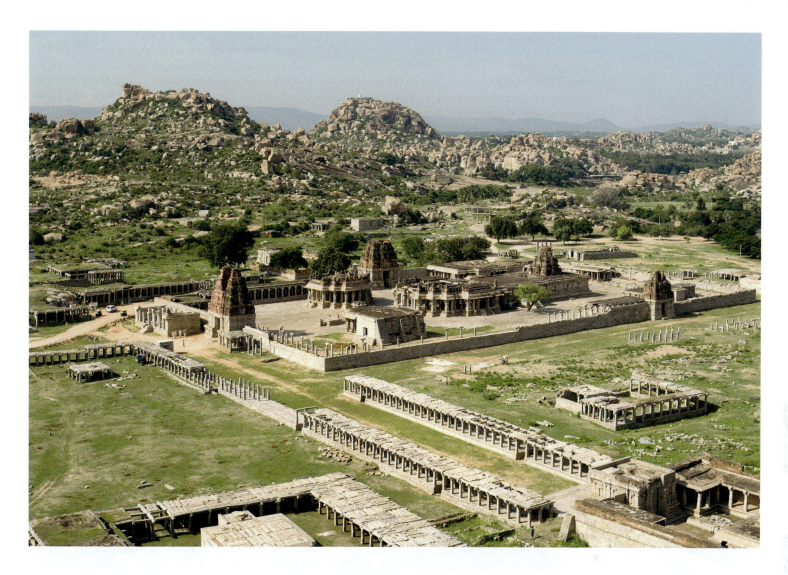

square or octagonal-shaped plans, pointed arches, domes, and vaults—all elements found in the monuments of the contemporaneous Bahmani sultanate (1347–1518) in the Deccan plateau. In other words, for their secular, courtly buildings, the Vijayanagara kings appropriated what we today would classify as Islamic architectural styles. For example, the stables built to house the royal elephants (Fig. 10.13) are comprised of eleven spacious square chambers laid out in a line, each with a grand, pointed-arch doorway. The central chamber is topped by a tower (now in disrepair); the rest are capped by prominent domes in a variety of shapes arranged symmetrically. Much of the plaster decoration is gone, but the smaller recessed arches animating the **facade** remain.

The religious buildings of the Sacred Center, by contrast, are constructed primarily of solid granite, using post-and-lintel construction (in which vertical posts support horizontal lintels). They largely conform to the design of earlier south Indian Hindu temples, such as the Chola Rajarajeshwara Temple (Figs. 7.8–7.11), meaning that the *garbhagriha* is capped by a *vimana* with clear horizontal levels, and the temple is enclosed in a large walled compound. There are, however, noticeable developments compared to earlier south Indian temples as well. In addition to incorporating local stylistic elements in column design and figural carving, overall, the temple complexes expanded to include spaces unnecessary for day-to-day worship but required for the periodic religious festivals that were growing in importance.

The Vitthala temple (Fig. 10.14), the most important of Vijayanagara's sacred sites during the sixteenth century, exemplifies the changes taking place. During the reign of Krishnadevaraya (ruled 1509–30), the temple was extensively renovated to hold an icon of the deity Vitthala, a form of the Hindu god Vishnu. The icon, which no longer survives at the temple, was probably acquired by force during a military campaign to the Maharashtra region, and therefore, in addition to its religious import, would have signified the empire's power. Krishnadevaraya, his queens, and a local chieftain all sponsored additions to the complex, including a 100-columned *mandapa* used for festival rituals and three stately *gopurams* marking the compound entrances. The tallest *gopuram* indicates the complex's main entrance, which was part of the ceremonial route that the deity, as manifest in a portable bronze icon, took during festival processions. The deity was carried in a wooden chariot, several of which were also made for the temple. Two long stone colonnades, also built during the sixteenth century and visible in the foreground of Fig. 10.14, demarcate the sacred route, which stretched the temple precinct far beyond the main shrine itself.

10.14 Vitthala temple, Vijayanagara, south India, overview of the complex showing its architecture and landscape, fifteenth–sixteenth centuries, renovated largely c. 1509–30.

facade any exterior face of a building, usually the front.

garbhagriha literally translating as "womb-chamber," a Hindu temple's inner sanctum, typically a small, dark, protective space, where the main icon of a deity is housed.

vimana the tower above the inner sanctum of a Hindu temple in south India.

mandapa a porch or hall located before the inner sanctum of a Hindu temple.

gopuram a monumental tower at the entrance of a Hindu temple complex, especially in south India.

MADURAI

Under Vijayanagara's successors, the expansion in both size and complexity of south Indian temple complexes continued until they became almost small cities unto themselves, as exemplified by the Minakshi temple in Madurai (Fig. 10.15). Similar to the Qutb Mosque (Figs. 10.2–10.5), the Minakshi temple is an architectural palimpsest. It was built, added onto, and renovated over a long period of time—and, in fact, modifications continue today. Some textual sources suggest that the original shrine dates back to the sixth century. The temple was attacked during the Delhi Sultanate's incursions into south India and thereafter had to be rebuilt. Reconstruction began during the Vijayanagara era, but the most concentrated period of building took place under the patronage of the Nayakas of Madurai (1529–1736), specifically the century between

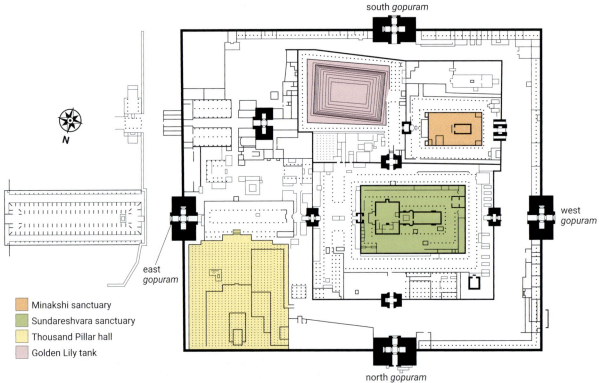

10.15 ABOVE **Minakshi temple,** Madurai, Tamil Nadu, south India, sixth–twenty-first centuries, mainly *c.* 1336–1736.

10.16 RIGHT **Plan of Minakshi temple complex,** Madurai, Tamil Nadu, south India, mainly 1336–1736.

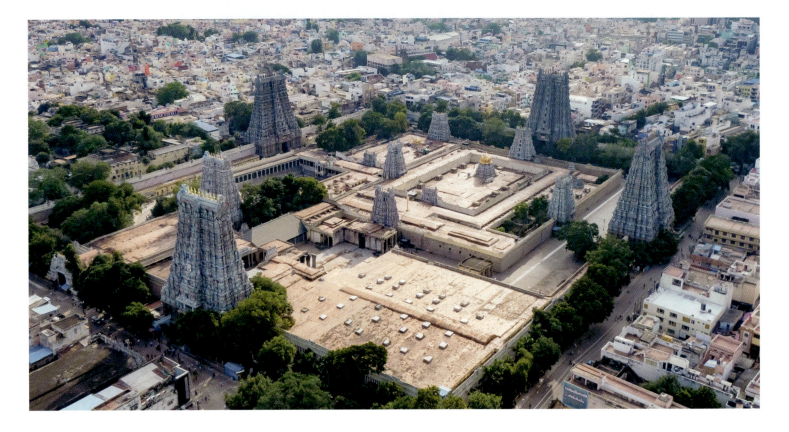

south *gopuram*

west *gopuram*

east *gopuram*

north *gopuram*

N

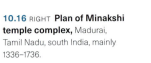

- Minakshi sanctuary
- Sundareshvara sanctuary
- Thousand Pillar hall
- Golden Lily tank

roughly 1530 and 1630. Nayaka is not a dynastic name, but rather a title meaning "leader." It was adopted by the regional rulers who came to power as the Vijayanagara Empire began to decline in the 1530s. These rulers patronized Hindu temple complexes like Minakshi as a way of asserting power at a time of political uncertainty.

Because the Minakshi temple complex, and others like it, grew gradually from the center outward, their plans often are complicated. The Minakshi temple plan is particularly involved because Hindu devotion at the site actually centers on not one shrine, but two (**Fig. 10.16**). The complex encompasses a pair of sanctuaries, one to Minakshi, a local form of the goddess Devi, and the other to her consort, Sundareshvara, a local form of the god Shiva. Each sanctuary sits in its own walled compound, which are located side by side with a gateway connecting them. Each deity's compound contains *mandapas* and columned corridors leading up to the shrine. Additionally, Minakshi's sanctuary is fronted by a large sunken tank (the Golden Lily tank on **Fig. 10.16**). These walled sanctuaries are located within a much larger walled complex, which contains more corridors and *mandapas*, including the impressive Thousand Pillar hall in the northeast corner.

The whole complex is punctuated by multiple soaring *gopurams*. These gateways are comprised of stone bases supporting brick towers covered in densely packed, painted plaster sculptures of gods and antigods. Because the *gopurams* marking the outermost enclosure were built later, they rise above the inner towers. The south gateway (built in 1599), which is the tallest of the *gopurams* at Minakshi, rises 197 feet (60 meters) high and includes more than 1,500 figures. Every twelve years, the *gopurams*' plaster sculpture is restored and repainted.

On the one hand, Sundareshvara's shrine is clearly the focus of the complex's layout. It is located at the juncture of the axes created by the east and west *gopurams* and the north and south *gopurams*. It is also significantly larger than Minakshi's shrine. On the other hand, the goddess, who is the guardian of the city of Madurai, is clearly the focus of daily religious devotion at the site. The most important event at the temple is the annual celebration held in April or May of the god and goddess's marriage, which symbolizes the union between the two. A larger-than-life-size rendering of their marriage is depicted on a sculpted granite pier in front of Sundareshvara's shrine (**Fig. 10.17**). Vishnu appears on the viewer's left and acts as the brother of the bride. He holds a ritual water pot in one hand. Minakshi, with her eyes downcast as a bashful bride supposedly should, is in the middle, and Sundareshvara on the right.

The skill required to create such a work—detailed, intertwined, three-dimensional figures emerging from the pier, all carved from a single piece of granite—speaks to the sculptors' abilities. Those skills, likewise, are on display in the many composite columns adorning the temple's *mandapas*. A composite column, always carved from a single stone block, incorporates a figure, whether

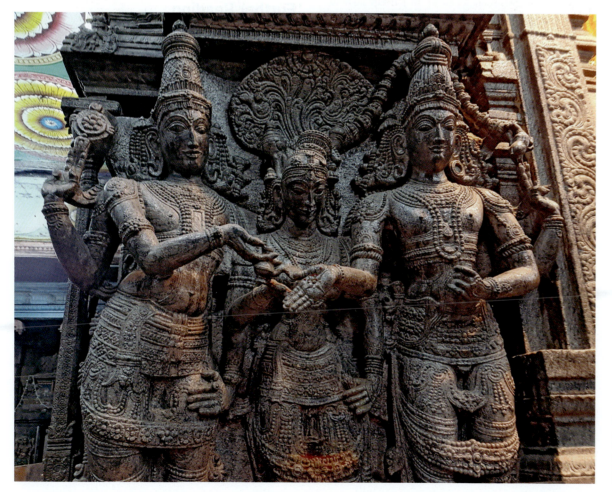

10.17 Sculptural relief showing the marriage of Sundareshvara and Minakshi, witnessed by Vishnu (at left), Minakshi temple, Madurai, Tamil Nadu, south India, 1572–95.

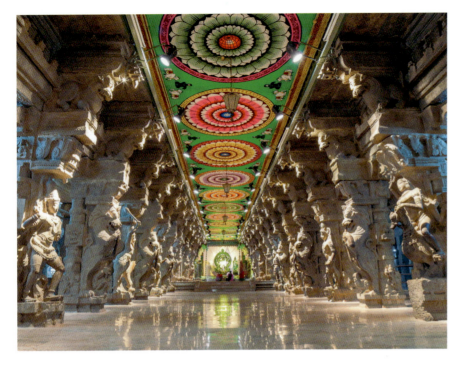

a depiction of a mythical animal, god, goddess, or even a Nayaka ruler, into a structural, freestanding pillar. The figure, even when shown twisting or turning or riding her sacred mount (as at left, **Fig. 10.18**), is not a separate addition, but rather is an integral part of the column, making it both an architectural element and a monumental artwork. Two rows of such composite columns face each other along the main aisle of the Minakshi temple's massive so-called Thousand Pillar hall, constructed between 1572 and 1595.

The Minakshi temple, with its multiple phases of construction, bridges the medieval era (*c.* 500–1500) and the Early Modern era (*c.* 1500–1800, see Chapter 11) that followed. Of course, historical periodization is not an exact science, and artists working at a particular time or place certainly would not have classified themselves or their artworks in many of the myriad ways we do today. Yet it is possible to see in the artistic developments of the later medieval era changes resulting from increasing cosmopolitanism, wealth, and movement of both people and goods—trends that continued, and indeed intensified, in the centuries to come.

10.18 Interior of the Thousand Pillar hall, Minakshi temple, Madurai, Tamil Nadu, south India, 1572–95.

Discussion Questions

1. This chapter discussed Vijayanagara's royal architecture in terms of the concept of cosmopolitanism. Choose another example—an artwork or building—discussed in this chapter that you think also displays cosmopolitanism and explain how.

2. The changes to south Indian Hindu temple complexes discussed in this chapter actually began during the Chola dynasty, covered in Chapter 7. Using the Chola temple featured there, and the examples in this chapter, trace the development of south Indian Hindu temple architecture.

3. Although more portable objects—things such as ceramics, textiles, and books—survive from the fourteenth century onward, these are still only a small fraction of what was originally produced. What are the circumstances by which some objects survive and others do not, and how does that shape what we know?

4. Research prompt: there are many additional examples of early Islamic architecture from South Asia and Southeast Asia to study, such as that produced by the sultans of Gujarat for their capital in Ahmedabad. Research one monument, which pre-dates 1600, and compare it to an example of early Islamic architecture discussed in this chapter.

Further Reading

- Asher, Catherine B. *Delhi's Qutb Complex: The Minar, Mosque and Mehrauli*. Mumbai: Marg, 2017.
- Bloom, Jonathan and Blair, Sheila. *Islamic Arts*. London: Phaidon Press, 1997.
- Branfoot, Crispin. *Gods on the Move: Architecture and Ritual in the South Indian Temple*. London: The Society for South Asian Studies, The British Academy, 2007.
- Fritz, John M. and Michell, George (eds.). *New Light on Hampi: Recent Research at Vijayanagara*. Mumbai: Marg, 2001.

Chronology

c. 570–632	The life of the Prophet Muhammad	1407–1535	The Gujarat Sultanate rules in western India
622	The founding Islam and Year 1 of the Islamic calendar	1407–28	The Ming occupy Vietnam, during which Chinese artisans teach Vietnamese ceramicists how to produce porcelain
c. 879–1215	The Ghurid dynasty rules in Afghanistan		
c. 1192–1311	The Qutb Mosque complex is constructed in Delhi, India	1469–1500	The rule of Sultan Ghiyas al-Din Khalji of Malwa
1206–1556	The Delhi Sultanate rules north India	*c.* 1507 and later	The Great Mosque of Demak is constructed in Indonesia
1336–1565	The Vijayanagara Empire		
1400s–1500s	Islam spreads throughout much of island Southeast Asia	1529–1736	The Nayakas rule over Madurai and make significant additions to the Minakshi temple complex

Mosque Architecture around the World

Muslim prayer is a physical and spiritual act in which one kneels and touches one's forehead to the ground while reciting certain verses. For Friday noon prayer, a local Muslim community comes together to pray, with members standing shoulder-to-shoulder and facing in the direction of the Arabian city of Mecca, home to the Ka'ba, the holiest shrine in Islam. The structure in which this communal prayer is practiced is called a mosque or, in Arabic, *masjid* ("a place of prostration"). The Prophet Muhammad's house, a simple mudbrick building constructed in around 622 CE in Medina, Arabia, served as the first mosque and set the model for subsequent mosques. Compared to other religions, Islam has few liturgical needs. A mosque need fulfill only three functions: provide space for communal prayer, give shelter from the elements, and visually indicate the direction of prayer, called the *qibla*. Because of this, mosque architecture, while maintaining some unifying aspects across regions and time periods, is adaptable and diverse.

As Islamic architecture developed between the seventh and twelfth centuries, certain elements—while not necessary—became standard in mosques across much of North Africa, West Asia, Central Asia, and South Asia. Typically, *mihrabs* (prayer niches) adorn *qibla* walls to indicate the direction of prayer, fountains for ritual ablutions punctuate courtyards, and small towers called minarets mark the skyline. Additionally, arches and domes are common architectural components, and ornamentation primarily consists of calligraphy, geometric

designs, and floral motifs. We see these characteristics at the Great Mosque of Herat, first built in the fifteenth century and renovated in the twentieth century (**Fig. 1**). There, a pair of minarets flank the prayer hall, arches repeat around the facades, and colorful geometric patterning covers much of the mosque's exterior.

Alongside these shared characteristics, regional variations developed in response to local climate, materials, and architectural traditions. For example, most mosques made before the twentieth century in the greater Persianate region (roughly present-day Iran and neighboring countries) used baked brick sheathed in multicolor tiles (as in **Fig. 1**). Likewise, beginning in about the twelfth century, many Persian mosques began to follow a plan in which large *iwans* (vaulted halls with walls on three sides and an opened fourth) faced onto a central courtyard, as they do at the Great Mosque of Herat.

As Islam spread to Southeast Asia, East Asia, and sub-Saharan Africa, mosque architecture continued to respond to local conditions; in some cases, the resulting structures differed markedly in appearance from what one might

expect of Islamic architecture. For example, the Great Mosque of Xi'an (also called Huajuexiangsi) conforms to Chinese imperial architectural traditions in which space is organized horizontally along a central axis, with the most important structure located at the end. Thus, at this mosque complex built largely in the Ming and Qing dynasties, the prayer hall anchors a long, walled enclosure consisting of five courtyards that are punctuated by gateways (**Fig. 2**). Sitting in the third courtyard, an octagonal two-storied structure with a double hipped roof may have functioned, although this is unconfirmed, as the mosque's minaret

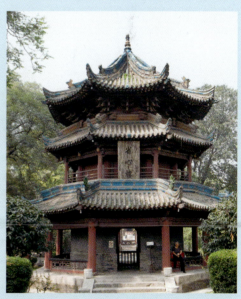

2 LEFT **Drawing of the Great Mosque of Xi'an,** also called Huajuexiangsi, Xi'an, China, largely built during Ming and Qing dynasties. **EAST ASIA**

3 ABOVE **Shengxinlou (Examining the Heart Tower),** third courtyard, Great Mosque of Xi'an (also called Huajuexiangsi), Xi'an, China, largely built during Ming and Qing dynasties. **EAST ASIA**

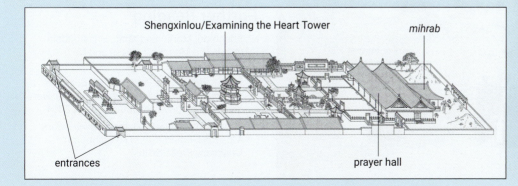

Shengxinlou/Examining the Heart Tower

mihrab

entrances

prayer hall

4 Calligraphy on the pillars of the prayer hall,
Great Mosque of Xi'an (also called Huajuexiangsi), Xi'an, China, largely built during Ming and Qing dynasties. **EAST ASIA**

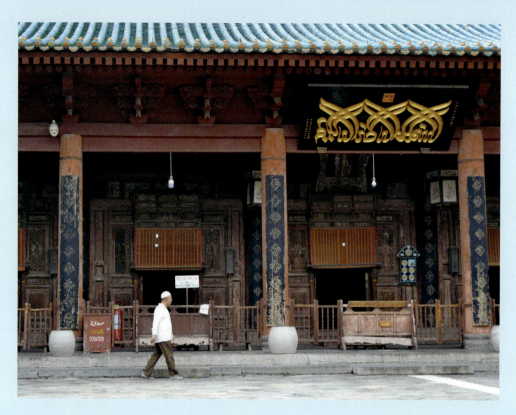

(**Fig. 3**). Its name, Examining the Heart Tower, which appears on a plaque on its second story, suggests it also was intended to encourage spiritual contemplation. Its form mimics that of a Buddhist pagoda, and, like the other structures in the complex, consists of a timber frame supporting prominent ceramic tiled eaved-roofs, typical of East Asian architecture. Even the Arabic calligraphy adorning the columns of the prayer hall (**Fig. 4**) has been fashioned so that the words resemble Chinese characters. In all these ways, Xi'an's Great Mosque simultaneously blends Islamic artistic traditions with local visual culture.

Likewise following regional practice, West African mosques are built of timber and mud brick, with thick, sculptural walls and minimal ornament. Timbuktu's Sankore Mosque, originally constructed during the fourteenth to sixteenth centuries, when the Malian city was a center for commerce and learning, features a large walled courtyard, pillared prayer hall, and prominent trapezoidal-shaped minaret (**Fig. 5**). The minaret's chief adornments are rows of wooden pegs, which also function as footholds to facilitate the annual upkeep that

5 Sankore Mosque, Timbuktu, Mali, fourteenth–sixteenth centuries, with nineteenth-century additions. **AFRICA**

mudbrick architecture requires. Lacking arches, domes, Arabic calligraphy, or any of the other elements commonly associated with Islamic architecture, the mosque may appear far removed from Muslim traditions, and yet, that is not the case. Not only does it meet the basic functions a mosque must fulfill, but also, in fact,

the courtyard's interior measurement is based on the perimeter of the Ka'ba. The monument thereby provides a direct connection between Islam's holiest shrine and the inner courtyard, a space considered in West African architectural traditions the conceptual center of the universe—again, integrating Islamic and local visual culture.

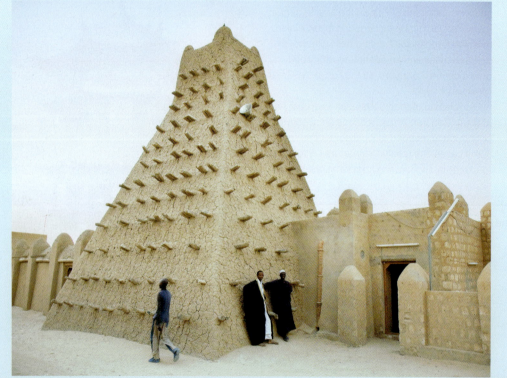

Discussion Questions

1. Islamic architecture is also discussed in Chapters 10 and 11. Choose one of the Muslim religious buildings (mosque or tomb) discussed in those chapters and compare its architectural form to that of a building discussed here.

2. Compare the layouts of the Great Mosque of Xi'an and the imperial palace in Beijing. What do their similarities tell us about the relationship between architecture, culture, and religion?

Further Reading

- Frishman, Martin and Khan, Hasan-uddin (eds.). *The Mosque*. London and New York: Thames & Hudson, 1994.

- Morris, James and Preston Blier, Suzanne. *Butabu: Adobe Buildings of West Africa*. New York: Princeton Architectural Press, 2004.

- Steinhardt, Nancy Shatzman. *China's Early Mosques*. Edinburgh, U.K.: Edinburgh University Press, 2015.

11

Art in Early Modern South Asia

1550–1800

11.0 Detail showing inlaid relief carving on the lower portion of the exterior wall of the Taj Mahal, Agra, India.

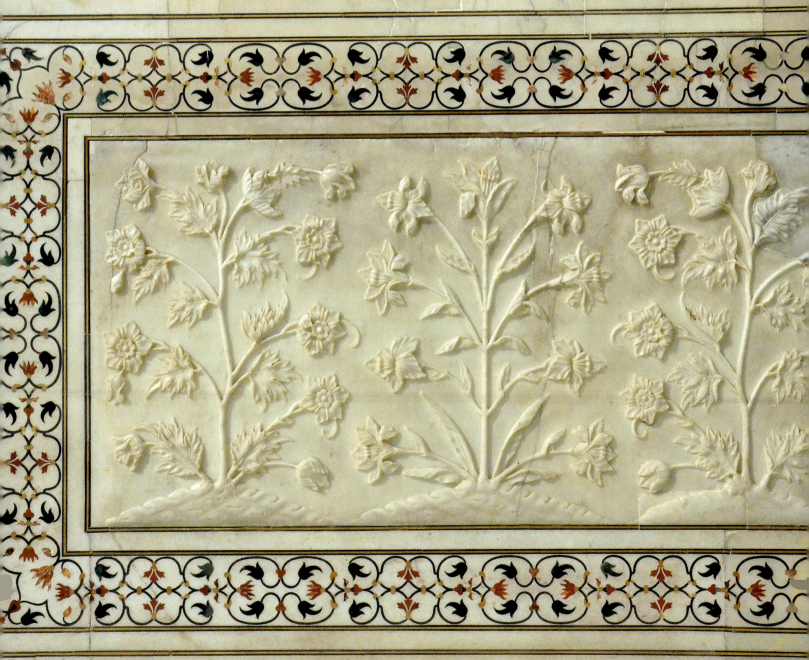

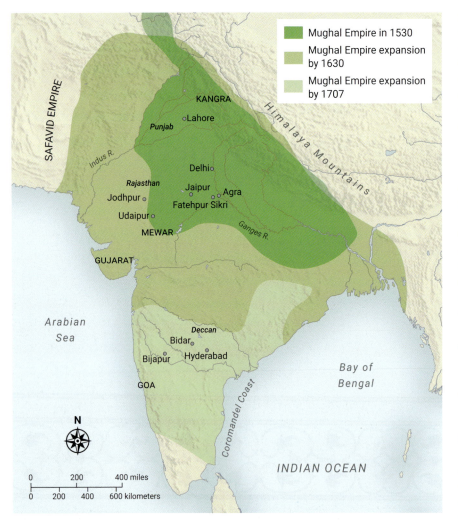

Map 11.1 The Mughal Empire, showing its borders in 1530 at the end of Babur's rule; its much-increased area in 1605 at the end of Akbar's rule; and its expansion by 1707, at the end of Aurangzeb's rule, when the empire was at its largest size.

Map legend:
- Mughal Empire in 1530
- Mughal Empire expansion by 1630
- Mughal Empire expansion by 1707

Introduction

Global historians often classify the period 1500–1800 as the Early Modern era. It was marked by significant trans-regional developments, from population growth to the establishment of worldwide sea routes. Much of South Asian art production during the era can be understood in terms of these phenomena, which also included the centralization of power in large states supported by a bureaucratic, elite class; the growth of urban centers; the amplification of cross-cultural contact; and the expansion of trade.

The largest state in South Asia during this period was without a doubt the Mughal Empire (1526–1857), based in north India, but at its height controlling most of the Indian subcontinent (Map 11.1). The Mughals were enthusiastic patrons of the arts, overseeing the construction of monumental works of architecture as well as the production of lavishly illustrated manuscripts and albums of paintings. Their visual environments were enhanced by a variety of luxury items—textiles, jewelry, metalwork, and jade. Mughal court artists synthesized various traditions to create a unique visual idiom that enhanced the majesty of their royal patrons.

As the Mughal Empire expanded throughout the sixteenth and seventeenth centuries, it conquered smaller regional Muslim and Hindu states in northern and central India (see Map 11.1), in some cases, swallowing them completely. In other instances, local rulers who agreed to serve the empire were left in place. Additionally, certain other areas, particularly in far southern India, were never conquered, and local powers continued to govern autonomously (see Figs. 10.15–10.18). Because much of the art was made to glorify divinely ordained rulers, certain artistic types predominated: royal portraiture, religious works, palatial architecture, and decorative arts showcasing courtly splendor. At the same time, each kingdom maintained a distinctive visual identity, endowing South Asian art from this period with rich diversity.

In the sixteenth and seventeenth centuries, for example, a number of small states in the Deccan region became artistic centers. In many ways, the Deccan, which contained the Portuguese port of Goa and hosted a wealth of foreign traders and émigrés, embodied the cosmopolitanism of the era. As the Mughal Empire weakened in the eighteenth and nineteenth centuries, although art continued to be produced at its capital, Delhi, both political power and artistic patronage became increasingly decentralized. As a result, artistic production thrived at a number of courtly centers, including those in the regions of Rajasthan and the Punjab Hills.

Art of the Mughal Empire, 1526–1857

The Mughal Empire's founder, Babur (ruled 1526–30), was a Central Asian prince who traced his lineage to both the legendary Mongol leader Chinggis (also spelled Genghis) Khan (ruled 1206–1227; see Seeing Connections: *Pax Mongolica*, p. 182), and Timur (ruled 1370–1405) who established the Timurid Empire. As the remnants of that empire collapsed in the early years of the sixteenth century, due to internal fighting and conquests by the Persian Safavid Empire (1501–1736), Babur made his way from what is now Uzbekistan and Afghanistan to the plains of north India. In 1526, he and his army defeated the Lodi dynasty (1451–1526) of the greatly reduced Delhi Sultanate. The kingdom Babur established became the great Mughal Empire, the wealth and power of which was such that in English the word "mogul" (a variant spelling of Mughal) has come to mean an important, powerful person (for example, "movie mogul"). Unsurprisingly, during the 332 years that the Mughals ruled over much of South Asia, they profoundly impacted its art and culture.

Muslim rulers commanded north India since the twelfth century (see Chapter 10), so Islam, the religion of the Mughals, was not new to the region, but their Timurid Turkic-Mongol heritage was. The Mughals inherited their ancestors' emphasis on recording history, building monumental architecture, and cultivating the royal library-and-workshop, called the *kitabkhana* (book-house) or *karkhana* (work-house) in Persian, the language of the Mughals. Similarly to the rulers of the Ming and other Early Modern empires, the Mughal monarch developed almost absolute power, and created a centralized bureaucracy to support the efficient running of the state. But the Mughals, who ruled over a majority Hindu population, also fostered a unique, syncretic culture. In their art, they combined elements from a variety of visual traditions—Central Asian, Persian, north Indian, and even European—to create a distinctly Mughal visual idiom.

Many of these developments occurred during the reign (1556–1605) of Akbar, who was the grandson of the Mughal dynasty's founder, Babur, and widely considered a highly adept ruler. After expanding the state through military victories and overseeing administrative reforms, he set out to bind the empire more closely to local Indian cultural practices and structures as well as to promote the idea of divine kingship. He introduced a doctrine of religious tolerance, married a Hindu princess, and propagated Din-i Ilahi, a discipleship order incorporating aspects of various religions, in which his nobles swore allegiance to him. He also created a new capital, Fatehpur Sikri (City of Victory), embodying his ruling ideology.

As in other Muslim cultures during this period, Sufic (Islamic mystical) orders played prominent roles in society. Akbar himself was a follower of the Sufi shaykh Salim Chishti (1478–1572). After Chishti correctly predicted the birth of Akbar's sons, Akbar as a show of gratitude founded Fatehpur Sikri at the site of the shaykh's spiritual retreat, on a rocky ridge 23 miles (37 km) from Agra. The fortified imperial center was divided into two parts: one featuring a large **congregational mosque** and (after the shaykh's death in 1572) the shaykh's tomb, and the other containing the royal residence and administrative buildings (**Fig. 11.1**). Surrounding these walled portions were nobles' mansions, gardens, shops, workers' homes, and various utilitarian structures. Fatehpur Sikri was occupied for only about fifteen years, c. 1570–85, before Akbar moved the capital to Lahore. Because it was used for such a short time, but yet is fairly well preserved, Fatehpur Sikri

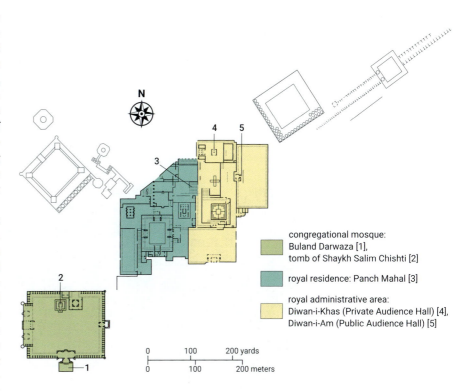

congregational mosque:
Buland Darwaza [1],
tomb of Shaykh Salim Chishti [2]

royal residence: Panch Mahal [3]

royal administrative area:
Diwan-i-Khas (Private Audience Hall) [4],
Diwan-i-Am (Public Audience Hall) [5]

provides compelling evidence of how Akbar employed architecture to advance his imperial vision, using a deliberate mixture of styles.

A prime example of this distinctly Mughal amalgam of architectural styles is the Buland Darwaza (**Fig. 11.2**), a

11.1 Plan of Fatehpur Sikri, India.

congregational mosque also called a Friday mosque, or *jama masjid* in Arabic, the main mosque in a city or town and the location of Friday prayers, when the community comes together.

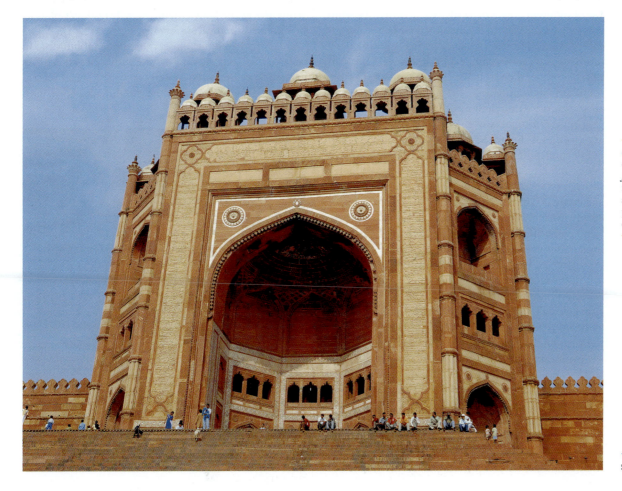

11.2 Buland Darwaza, Fatehpur Sikri, India, Mughal, c. 1570–85.

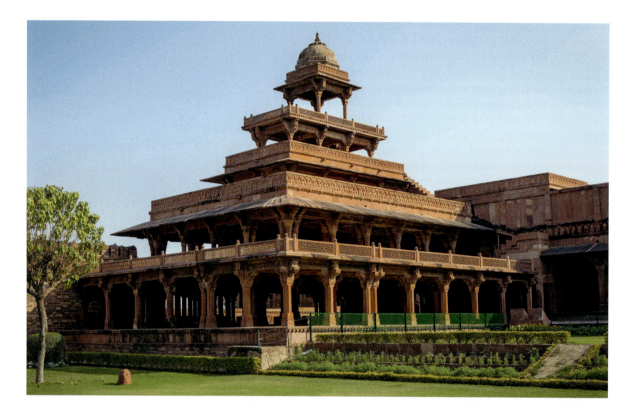

pishtaq in Persian and/
or Islamic architecture,
a gateway consisting of a
rectangular frame around
an arched opening.

architectural polychromy using
different-colored materials
to create decorative patterns
in architecture.

chhatri literally means
"canopy"; a domed-shaped
pavilion, usually elevated and
used as a decorative element
in South Asian architecture.

arcade a covered walkway
made of a series of arches
supported by piers.

jali a perforated stone or
lattice screen, usually featuring
a calligraphic or geometric
ornamental pattern.

capital the distinct top section,
usually decorative, of a column
or pillar.

monumental gateway that caps the steep staircase leading
to Fatehpur Sikri's congregational mosque. The 177-foot-
high (54-meters-high) gateway recalls the grand scale of
Central Asian Timurid architecture, and the prominent
pishtaq draws on Persian architectural vocabularies. The
use of different colors of sandstone accented by white
marble harkens back to the **architectural polychromy** of
earlier Delhi Sultanate architecture (see Fig. 10.5), while
the ***chhatris*** along the roofline come from royal Rajasthani
architectural traditions, in which they were used as free-
standing memorial markers. In Mughal architecture, they
are transformed into elevated decorative elements.

Compared to such well-known European palaces
as Versailles, Fatehpur Sikri's royal area presents a dif-
ferent conception of palatial architecture. Rather than
being one large edifice, it is comprised of intimately
scaled red sandstone buildings connected by courtyards
and gardens. The structures, sometimes featuring open
arcades further connecting them to surrounding spaces,
were adorned with carpets, canopies, and other textiles—a
royal encampment made permanent in stone. The space
was arranged from a semi-public zone to increasingly
private ones. Akbar's public audience hall (numbered 5 in
Fig. 11.1) sat closest to the entrance; next came his private
audience hall and other elite administrative structures;
and finally, there were the private residential quarters of
the ruler and the royal women. The tallest structure is
the Panch Mahal (**Fig. 11.3**, numbered 3 in **Fig. 11.1**), a five-
storied, columned pavilion marking the boundary
between the administrative and residential zones. Its
top story takes the form of a domed *chhatri*, furthering
its visual prominence. Originally framed with ***jali*** screens
and curtains, it provided a shaded, breezy place from
which the royal women could watch the activities while
maintaining their privacy. Mughal women observed

purdah, meaning they remained secluded from high-rank-
ing men who were not members of their family; however,
that does not mean they were invisible and powerless.
In fact, Mughal queens and princesses were active in
politics, and were important patrons of the arts. Such
structures as the Panch Mahal provide evidence of their
position within royal society.

Perhaps Fatehpur Sikri's most unusual building is
the Diwan-i-Khas, Akbar's private audience hall. A pillar
capped by an oversized **capital** comprised of elaborately
carved brackets dominates the interior space (**Fig. 11.4**).

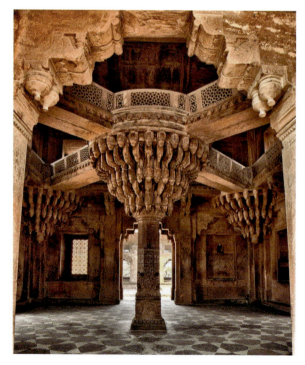

Stepped brackets of this type come from Hindu and Jain temple architecture, in which they function as eave supports; here they have been repeated to create a circular form, providing another example of Mughal architecture's innovative synthesis. Catwalks lead from the room's corners to a platform on the capital, which appears to have been where Akbar sat. Similarly to Ashokan pillars (see Figs. 3.1 and 3.2), the massive column draws on ancient Buddhist-Hindu symbolism of the axis mundi (the center of the world and/or the connection between heaven and earth). But, rather than being topped by a carved lion, here, the pillar was crowned by the ruler himself. Akbar's audience hall thus embodied his power by placing him literally and figuratively above all who entered.

Also located at Fatehpur Sikri was the royal workshop, which produced a wide range of illustrated manuscripts, including court histories, medicinal and philosophical treatises, Persian romances, and Hindu epics. Akbar expanded the workshop set up by his father, Humayun (reigned 1530–40 and 1555–56). In 1540 a rival ruler had forced Humayun to flee north India. The exiled emperor sought refuge at the court of the ruler Shah Tahmasp (reigned 1524–76) in neighboring Safavid Iran until he was able to return, bringing with him a contingent of Safavid artists. The resulting mix of Persian and Indian artists shaped Mughal painting. Additionally, by the late sixteenth century, European prints circulated at court. They also contributed to the developing Mughal painting style, which, as with that of architecture, synthesized disparate elements into a uniquely Mughal visual style.

An illustration from a genealogy of the Hindu god Krishna, one of Vishnu's incarnations (see Chapter 3) provides an excellent example of Akbar-period painting (**Fig. 11.5**). Created in the 1590s (by which point Akbar had left Fatehpur Sikri for Lahore, with the royal workshop following the emperor), the painting depicts the blue-skinned deity holding up a mountain to protect villagers from destructive rain torrents sent by the god Indra. As part of his ruling strategy, Akbar had various Hindu epics translated into Persian. Because the epics had not previously been illustrated in manuscript form, the court artists invented the compositional and representational tactics used. Here, the depiction of the rocky mountain filling the image's upper half is drawn from sixteenth-century Persian painting, whereas the bejeweled, garlanded Krishna at center follows **iconography** laid out in Hindu religious texts. The variety, expressiveness, and sense of volume in the portrayals of the villagers reflect the centrality of the human form in South Asian art from the Maurya dynasty onward, as well as the growing influence of European prints. The latter is visible, for example, at the painting's left edge, in the depiction of the female figure carrying two children, which recalls European images of the Virgin Mary with baby Jesus and John the Baptist.

Under the patronage of Akbar's eldest son, Salim, who adopted the imperial title "Jahangir" ("World Seizer"), painting reached new heights. Jahangir (ruled 1605–27) had a keen eye for painting and appreciated artistic individualism, as he recounts in his memoirs:

I derive such enjoyment from painting and have such expertise in judging it that, even without the artist's name being mentioned, no work of past or present masters can be shown to me that I do not instantly recognize who did it. Even if it is a scene of several figures and each face is by a different master, I can tell who did which face. If in a single painting different persons have done the eyes and eyebrows, I can determine who drew the face and who made the eyes and eyebrows.

During Jahangir's reign, the overall size of the royal workshop decreased, but the status of individual artists rose, with painters becoming known for particular subjects. Illustrated manuscripts became less popular, surpassed by a taste for single-page paintings placed in albums. Around 1615 court artists began creating **allegorical portraits** with complex iconography that combined the idea of Jahangir's supreme power with spiritual themes.

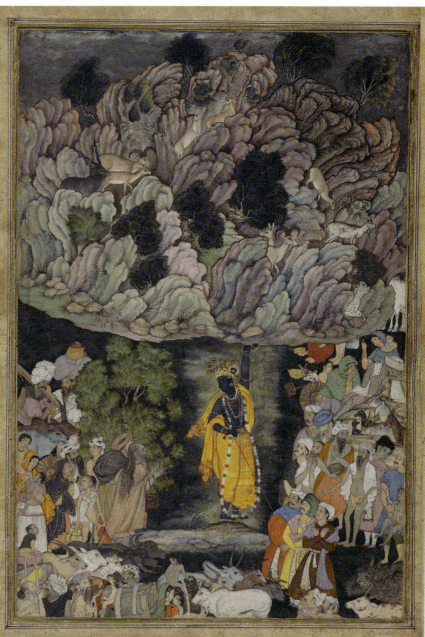

11.5 "Krishna Holds Up Mount Govardhan to Shelter the Villagers of Braj," folio from a *Harivamsa* (*Legends of Krishna*) manuscript, Mughal, c. 1590–95. Ink, opaque watercolor, and gold on paper, 11⅜ × 7⅞ in. (28.9 × 20 cm). Metropolitan Museum of Art, New York.

iconography images or symbols used to convey specific meanings in an artwork.

allegorical portrait a portrait that uses visual elements as metaphors to convey complex meanings.

Mughal paintings were typically small in scale, finely detailed, and intended for intimate viewing, either within illustrated books or bound albums. Mughal painting was heavily influenced by Timurid painting traditions, particularly the setup of the court workshop, in which multiple artists contributed to the final product.

The workshop's artists began the process of creating a painting (**Fig. 11.6**) by preparing the materials to be used. These included thick, multilayered paper (similar to handmade card stock) that was painstakingly burnished with a polishing stone so that the paint sat on the surface, allowing for greater detail (**1**); paintbrushes, the finest consisting of only a few squirrel hairs, again to allow the application of fine detail; and richly colored opaque watercolors made from pigments mixed with a binder, typically gum arabic from an acacia tree (**2**). Pigments could be made from ground minerals (such as lapis lazuli for ultramarine blue), plants (such as indigo for dark blue), insects (such as kermes for crimson), or metals (such as gold leaf for gold). Producing the paints was often a complicated and expensive process, and for that reason thickly applied and vibrant colors signified luxury.

Under the direction of the workshop supervisor, an artist, seated on the floor and working on a board on his lap, sketched the desired subject (**3**). Meanwhile, the space for the painting was blocked out on the final paper sheet, with ruled lines above and below for the calligrapher to add his work, if writing was to be included on the page. The artist then drew the image freehand or transferred the preparatory sketch onto the paper through pouncing, the process of applying charcoal dust over pinholes pierced along the drawing, leaving faint marks on the paper below.

Next, the colors were applied one by one (**4**). Each layer was left to dry and the back of the paper was rubbed to erase any brushstrokes on the surface. Metallic paints, such as gold and silver, were applied near the end of the process and polished to a high shine. Finally, tiny textured details were added (**5**).

1. The thick, handmade paper is burnished with a special stone to give it a smooth finish.

2. The prepared pigments are mixed with binder and water in seashells, whose small size and nonreactive materials provide ideal containers for the paints. The mixture must be smooth, with no granules, so that the paint applies evenly.

3. The artist prepares a sketch of the desired subject that will be transferred to the final paper sheet either through hand copying or by pouncing.

4. Once the image has been lightly outlined on the prepared, ruled paper, flat areas of color are applied one by one. An additional piece of paper is often used to protect the painting from smudging.

5. Finally, the artist, using the smallest possible brush, adds the minute, finishing details.

11.6 (1–5) The Mughal manuscript painting process.

In a painting signed by portrait-specialist Bichitr, Jahangir gives preference to a Sufi shaykh over kings (**Fig. 11.7**). The figure of Jahangir, enthroned on an hourglass, dominates the composition. A large sun-and-moon halo centered on the emperor's head suggests that he, like the sun and moon, is a cosmic body radiating light (the Mughals traced their lineage to a mythical Mongol princess who was impregnated by a ray of light). Below Jahangir, two angels write in Persian on the hourglass, "O Shah [King], May the Span of Your Life be a Thousand Years." To the left of the angel in green is a footstool with some sort of multi-headed figure, most likely based on an imported European figurine; Bichitr's signature is atop the footstool. In the background is an elaborate carpet, which Bichitr has depicted as if from above, in contrast to the painting's other elements shown from the side.

A line of four figures fills the painting's left side. In first place, being handed a book by Jahangir, is the bearded Shaykh Husayn Chishti, who headed an important Sufi shrine where Jahangir had resided for three years (note that the shaykh uses a cloth to receive the book so as to uphold protocol by not touching the emperor). Next is an Ottoman sultan, perhaps intended to represent Bayezid I (ruled 1389–1402), who notably was defeated by Jahangir's ancestor, Timur, or perhaps meant merely as a generic representation of an Ottoman ruler. England's King James I (ruled 1603–25) occupies third place. Bichitr probably based James I's portrait on a painting that an English ambassador had given Jahangir as a diplomatic gift. Finally, in the bottom corner, Bichitr depicts his own likeness, holding a painting of two horses, an elephant, and another self-portrait, but there the artist bows in humility before the emperor.

In addition to highlighting Bichitr's artistic ability, the painting reflects the growing interconnectedness of the Early Modern world. Moreover, despite its message that Jahangir put spiritual priorities ahead of worldly ones, its details celebrate the luxurious trappings of Mughal courtly culture. Note the intricate carpet, the finely woven, transparent cotton cloth of Jahangir's *jama* (long shirt-like garment), and his copious jewelry—turban pins, necklaces, bracelets, rings—featuring diamonds, rubies, emeralds, and pearls.

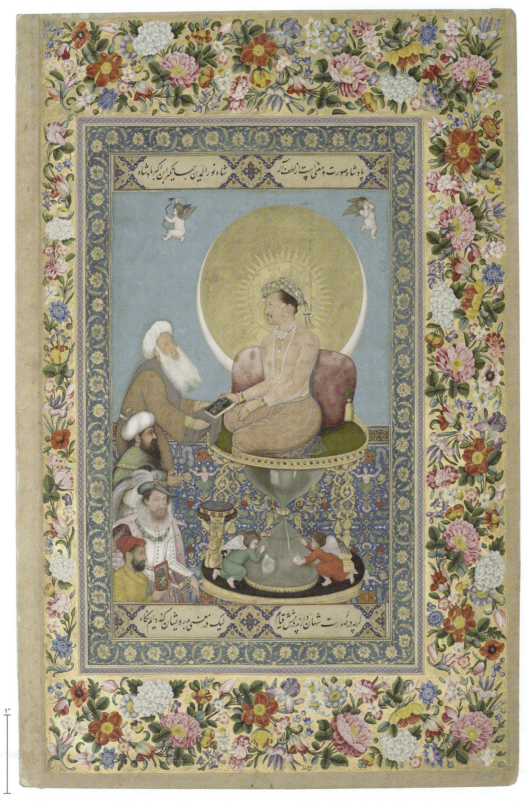

Arabic/Persian text in the upper border of the painting:

پادشاه صورت و معنی است پشت این بگیر از لطف آ ... شاه نورالدین جهانگیر ابن اکبر پادشاه

Arabic/Persian text in the lower border of the painting:

... لیک در صورت بینان و درویشان کعبه ... گاه ... ایک در معنی درویشان و پشمینه ... قیام

11.7 Bichitr, *Jahangir Preferring a Sufi Shaykh to Kings,* Mughal, *c.* 1615–18. (Border added 1755–56 by Muhammad Sadiq.) Opaque watercolor, gold and ink on paper, 10 × 7 in. (25.4 × 17.8 cm). Freer Gallery of Art, Smithsonian Institution, Washington, D.C.

pile carpet a textile floor covering with an upper layer of pile (knotted pieces of yarn) attached to a woven backing.

warp in textile weaving, the stationary, vertical threads attached to a loom, over and under which the weft threads are passed to make cloth.

weft in textile weaving, the crosswise, horizontal threads on a loom that are woven over and under the warp threads to make cloth.

While the carpet in Bichtr's painting appears European—most likely Venetian—in design, the Mughals, in fact, were renowned for producing high-quality **pile carpets** of their own, much coveted by elite Europeans of the period. The tradition of piled-wool carpets was not indigenous to South Asia, but rather, Central Asians and Persians introduced it to the subcontinent, probably concurrently in both North India and the Deccan. Historical sources record that Akbar brought skilled weavers from Iran to set up carpet looms at his capitals in Agra, Fatehpur Sikri, and Lahore. To make a pile carpet, a weaver individually knots small pieces of yarn around the **warp** strings attached to the loom and then secures them in place with **weft** strings. The ends of the knots form the pile that makes the rug plush. Additionally, by choosing different colors of yarn for the various knots, the weaver creates patterns. The finer the yarn used, the softer the rug, and the more intricate the design can

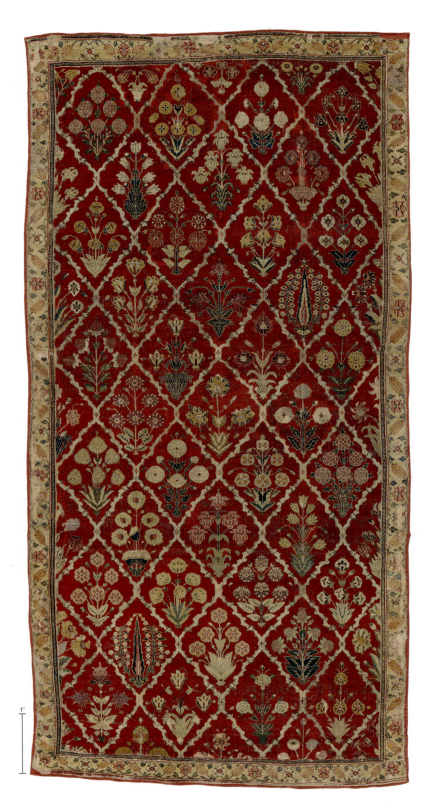

1'

11.8 Floral carpet, Lahore, Pakistan, Mughal, seventeenth century. Cotton, silk, and wool, 12 ft. 7 in. × 6 ft. 8 in. (3.84 × 2.03 m). The Textile Museum, Washington, D.C.

on textiles and other media (compare, for example, the flowers in **Fig. 11.8** with those carved in relief at the Taj Mahal, **Fig. 11.0**). The carpet's floral sprays are naturalistic in some respects—one often can identify the specific type of flower depicted—but still clearly **stylized**, with blossoms symmetrically arranged around a central stem. Like much Mughal art, their depiction combines aspects of European and Persian floral representations to create something distinctly Mughal in style.

The Mughal Empire reached its height of power and wealth during the reign of Jahangir's son and successor, Shah Jahan ("King of the World," ruled 1628–58). The emperor commissioned lavishly illustrated manuscripts and albums, sumptuous textiles (the carpet in **Fig. 11.8** most likely dates to his reign), opulent jewelry, and finely crafted luxury items (such as his wine cup, Fig. 0.4). He also oversaw the construction of dozens of royal residences and founded a new capital, Shahjahanabad (now Old Delhi), featuring the largest mosque in India. The monument for which he is most remembered, though, is the Taj Mahal (**Fig. 11.9**), the tomb for his beloved wife, Mumtaz Mahal (died 1631). Built largely between 1632 and 1647 and designed, according to most accounts, by Ustad Ahmad Lahori, the Taj Mahal is today world-famous, yet scholars continue to disagree on aspects of its meaning. A central question is whether Shah Jahan, who was buried there after his death in 1666, intended from the start for it to serve as his tomb as well. The fact that his cenotaph's placement in the main chamber both breaks the tomb's symmetry and interrupts the careful patterning of the floor suggests that it is not original to the design; however, it is impossible to know for certain. What is unequivocally clear, as court chroniclers recorded, is that the monument was designed to commemorate the Mughals' magnificence. As one historian wrote in the 1630s, when the tomb was still under construction, "it will be the masterpiece of the days to come, and that which adds to the astonishment of humanity at large."

The Taj Mahal, the official name of which was Rauza-i Munawwar (the Illumined Tomb) after the Prophet Muhammad's tomb in Medina, is part of a larger tradition of Mughal **mausolea**. Mughal royalty memorialized their wives, husbands, and parents through monumental tombs in walled garden complexes meant to represent the mansions and gardens awaiting the faithful in paradise. For example, Emperor Jahangir's powerful wife, Nur Jahan (1577–1645), supervised the design and construction of a royal mausoleum in Lahore for her husband after his death in 1627. Five years earlier, in 1622, she had ordered the construction of an elegant garden tomb in Agra for her parents, Mirza Ghiyas Beg and Asmat Begum. Known as I'timad ud-Daula's Tomb, the structure's white marble exterior is embellished with exquisite *parchin kari* inlay, a design feature later adopted by the Taj Mahal's designers. The tombs sponsored by Nur Jahan, like most Mughal mausolea, were located in the middle of *charbaghs*, with water channels dividing the quadrants, and fragrant flowers and fruit trees evoking paradise.

Taking this monumental tomb tradition further, the Taj Mahal was designed as a 42-acre (17-hectare) waterfront complex in Agra that included bazaars and

be (see Seeing Connections: Matters of Cloth, p. 57). In Lahore, Mughal weavers often used cashmere goat wool and silk, producing particularly fine rugs, as in this seventeenth-century example (**Fig. 11.8**).

The carpet's design is typical of seventeenth-century Mughal courtly style. It consists of a thin floral border and large, red-colored field with rows of flowering plants placed within a trellis-like grid. Note that the carpet is meant to be viewed from one specific side, like a picture. In fact, there are strong links between the floral motifs used in Mughal manuscript paintings and those found

11.10 LEFT BELOW **Plan of the Taj Mahal and Moonlight Garden,** Agra, India, *c.* 1632–47.

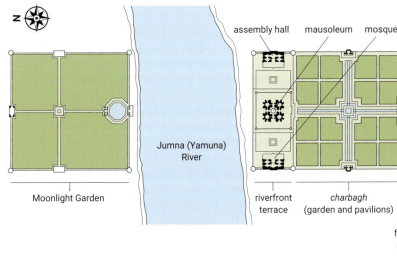

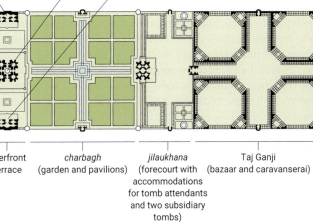

assembly hall mausoleum mosque

Jumna (Yamuna) River

Moonlight Garden

riverfront terrace

charbagh (garden and pavilions)

jilaukhana (forecourt with accommodations for tomb attendants and two subsidiary tombs)

Taj Ganji (bazaar and caravanserai)

stylized treated in a mannered or non-naturalistic way; often simplified or abstracted.

mausoleum (plural **mausolea**) a building or freestanding monument that houses a burial chamber.

parchin kari an inlay technique in which small pieces of carefully cut and fitted colored stone are used to create patterns or images; often called *pietra dura* in English sources, adopting the Italian term.

inlay decoration embedded into the surface of a base material.

charbagh a Persian term referring to a garden divided into four equal parts.

caravanserai lodgings constructed along trade routes at regular intervals for use of travelers; also sometimes called *ribat* or *han.*

bilateral symmetry symmetrical arrangement along a central axis so that the object or plan is divided into two matching halves.

caravanserais, a forecourt with attendants' quarters and monumental red sandstone gateway, the *charbagh* and reflecting pool, and, at the end, a raised terrace holding the mausoleum, a mosque, and an assembly hall. Because the tomb is at the end of the *charbagh*, rather than the middle, the Taj Mahal may seem unusual amongst Mughal mausolea. In fact, the tomb's plan conformed to its environs. During Shah Jahan's time, roughly forty-four garden complexes belonging to the Mughal elite lined Agra's Jumna River, as the Taj Mahal did, and most featured a waterfront structure with a garden behind. Moreover, directly across the river from the tomb was the imperial Moonlight Garden, a four-part garden of the same width as the Taj complex and featuring an octagonal-shaped reflecting pool (**Fig. 11.10**). If we consider the two sides as conceptually linked, then the tomb is, in effect, at the center of the garden.

In addition to continuing the stylistic synthesis found at Fatehpur Sikri, architecture under Shah Jahan now also followed formalized conventions, epitomized by the Taj Mahal. The tomb, as the most important structure, is the only building in the complex constructed solely of white marble—the white color symbolizing purity, and the play of light on the marble suggesting illumination. The complex's overall plan as well as the designs of individual buildings feature **bilateral symmetry** and tripartite compositions consisting of a large central element framed by two subsidiary ones. Underscoring the sense of visual order, forms and motifs are repeated, and shapes are standardized. For example, every *chhatri*, regardless of

If objects can be thought of as having biographies, then most art historical analyses focus on the crucial moments around an artwork's "birth": its inception, creation, and initial reception and function. Considering an object's later life can be equally informative, however. Iconic artworks—whether Leonardo da Vinci's *Mona Lisa*, the Great Pyramids of Giza, or the Taj Mahal—have particularly rich life stories, filled with myths, misconceptions, scholarly theories, and popular culture appropriations, all of which illuminate the powerful role that art plays in constructions of identity, history, and fantasy.

Today, the Taj Mahal, one of the most photographed monuments in the world, is used in global popular culture to signify a range of qualities—luxury, perfection, exoticness—or as a stand-in for India itself. Advertisements invoke its image to sell everything from curry spice to cars to cameras. Often, the fact that it is a tomb seems to go unrealized or ignored; otherwise how does one explain it as the inspiration for a casino in New Jersey? In India, the Taj Mahal has long been viewed as the ultimate monument to love, inspiring poetry, paintings, and, more recently, Valentine's Day cards.

As the art historian Ebba Koch notes, there seem to be more myths about the Taj Mahal than serious scholarship. At times, the categories interact, with scholarly debate being forced to respond to a particular misconception that, often for political reasons, gains prominence. For example, beginning in the seventeenth century, some European authors, disbelieving that Indians could build something so magnificent, contended that the Taj Mahal was actually designed by an Italian architect or a French jeweler. During British colonial rule (1858–1947), which depended upon a belief in white, European superiority for its justification, these theories gained steam; however, they were quickly disproven by both British and Indian scholars. Recently, another story has come to the fore: that the Taj Mahal was originally a Hindu temple dedicated to the god Shiva. The primary proponent of this myth, P. N. Oak, founder of the Institute for Rewriting Indian History in New Delhi, published a book on the subject in 1968. Oak, and other extreme Hindu nationalists, could not bear the idea that India's most famous monument is a Muslim tomb. Despite irrefutable evidence to the contrary, Oak's theory continues to live on, due in part to the ease of spreading misinformation online and in part to current political and religious tensions within India. The endurance of such a myth serves as a reminder that the stories told about art reflect people's fears as well as their desires.

Discussion Question

1. Choose an iconic artwork, such as the Taj Mahal, and find an example of its reuse in contemporary advertising. What qualities is it being employed to invoke, and how do they relate to the commodity or service being advertised? How does the advertisement reframe, or even transform, the original meaning of the work?

size, has the same silhouette. Likewise, the niches on the buildings' **facades** echo the shape of the central *pishtaqs*. Care is paid to proportions and balance: the tomb's main dome measures exactly the same height as the facade, and the four **minarets** at the corners of the **plinth** serve as a frame for the **chamfer-cornered** square central structure. This strict rationality is balanced with sumptuous details, which at the Taj Mahal are employed to reference paradise. They include carved and inlaid flowers, as well as inlaid **calligraphic** inscriptions from the Qur'an, the holy book of Islam, emphasizing the themes of the Last Judgment and the heavenly rewards awaiting the faithful. The *parchin kari* inlay is made from semiprecious stones including lapis lazuli, amber, carnelian, and amethyst. It is so exquisitely done that a single flower may be formed of more than thirty pieces of inlay. All these aspects give the Taj Mahal the grandeur, harmony, and beauty for which it is famed.

For the last eight years of his life, Shah Jahan was imprisoned by his son Aurangzeb (ruled 1658–1707), who was eager to take power and expand the empire. Aurangzeb's military campaigns were successful, but expensive, contributing to the empire's eventual decline. Over the course of the eighteenth century, Mughal control over the subcontinent weakened considerably, and as political power decentralized, regional artistic practices flourished (see **Figs 11.17–11.20**). Yet, at the same time, the Mughal capital of Delhi remained a hub for cultural, intellectual, and pleasurable pursuits. During the reign of Muhammad Shah (ruled 1719–1748) in particular, the city attracted poets, mystics, scholars, musicians, dancers, and artists.

A work by the painter Mir Miran dated to 1742 (**Fig. 11.11**) highlights some of the period's artistic trends, including a growing interest in depicting the spectacle of courtly entertainment and life in the royal women's residences. On the left side of the painting, the Mughal queen Udham Bai (Muhammad Shah's third wife and mother to his heir) sits on a low golden throne and leisurely smokes a *huqqa* (see **Fig. 11.15** for more about *huqqas*). She is surrounded by attendants, and together they watch a satirical performance taking place on the terrace before them. Some of the performers, wearing European-style hats and holding muskets, play the part of Portuguese soldiers (for more about the Portuguese in South Asia, see **Fig. 11.14**). Near the center of the painting, a young performer bedecked in a hat and white cravat and holding a sword and shield faces a portly man holding a piece of paper (the paper records the painting's date). An inscription above the man's head identifies him as "bird holder." Another inscription labels the older woman in the foreground as "hunchback." Whether they were portraying characters in a favorite story of the period is unknown. However, they do reveal that in Delhi, just as in many other parts of eighteenth-century Europe and Asia, people and things perceived as odd or exotic were employed for entertainment. The relationship between pleasure and spectacle is underscored by the centrality to the composition of the act of looking between various groups of figures. Note, for example, the female figure who appears in the central window of an elevated palace room located beyond the terrace at right and how her gaze mirrors that of the queen, connecting the two figures diagonally across the page.

facade any exterior face of a building, usually the front.

minaret a tower at a mosque or Islamic tomb; can be used to give the call to prayer and also functions as a visible marker on the skyline.

plinth a base or platform upon which a structure rests.

chamfered corner a cutaway corner that forms a sloping edge.

calligraphy the art of expressive, decorative, or carefully descriptive hand lettering or handwriting.

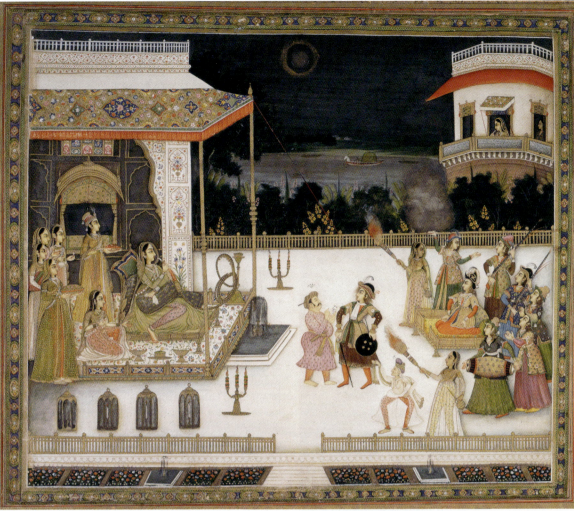

11.11 Mir Miran, *Queen Udham Bai Entertained,* Mughal, 1742. Opaque watercolor and gold on paper, mounted on an album page, 10⅞ × 12⅞ in. (27.5 × 32.7 cm). San Diego Museum of Art, California.

The artistic developments of the period also include several stylistic changes. Mughal painters were increasingly interested in employing spatial conventions such as perspective to present a wider view of a scene. To aid in this effort, they often doubled the width of the paper they used (compare for example, the dimensions of **Figs. 11.5** and **11.7** to those of **Fig. 11.11**), which provided more space to show the palaces, gardens, and beyond. Here, for example, we see flowers and fountains in the foreground, the white marble terrace encircled by a gold railing in the middle, and the River Jumna beyond, with a full moon above. Night scenes, featuring moonlight, candlelight, and, sometimes, fireworks, also became increasingly popular. Artists contrasted the inky darkness of the sky with the gleaming white and gold of palace architecture and the various hues of the scene's sumptuous textiles. In this case, these elements all worked together to underscore Udham Bai's high status at court.

Three years before this painting was made, in 1739, the Persian ruler Nadir Shah sacked Delhi. He and his troops slaughtered thousands of Delhi's inhabitants before making off with much of the Mughal treasury. This event hastened the Mughals' decline, and eventually the emperor became merely a figurehead. In 1858, the dynasty officially ended when the British, who had taken control of India, exiled the last ruler (see Chapter 15).

Art of the Cosmopolitan Deccan

The Deccan is the plateau that connects the northern and southern portions of the Indian subcontinent (see **Map 11.1**). In the early sixteenth century, when Babur was establishing the Mughal Empire in north India, control of the Deccan was divided amongst several Muslim sultanates as well as the Portuguese, who had conquered the port of Goa in 1510. The sultanates were splinter states from an earlier Muslim kingdom, which itself had split off from the expansive Delhi Sultanate in the fourteenth century (see Chapter 10). The Deccan's location, paired with its wealth—stemming from diamond mines and fertile soil producing high-quality cotton—made it a magnet for ambitious noblemen, artists, and merchants. It also eventually attracted the attention of the Mughals, who used military might to expand their empire southward. By 1687, the Mughals had conquered all the Deccan sultanates.

In the nearly two centuries prior to their defeat, however, the independent kingdoms of the Deccan flourished and produced imaginative, original art. In their courts, cities, and ports, local Dakani-speaking Muslim nobles, Telugu and Marathi-speaking Hindu elites, Central Asian and Persian immigrants, East African soldiers, Turkish canon-makers, Christian missionaries, Portuguese colonialists, and Northern European

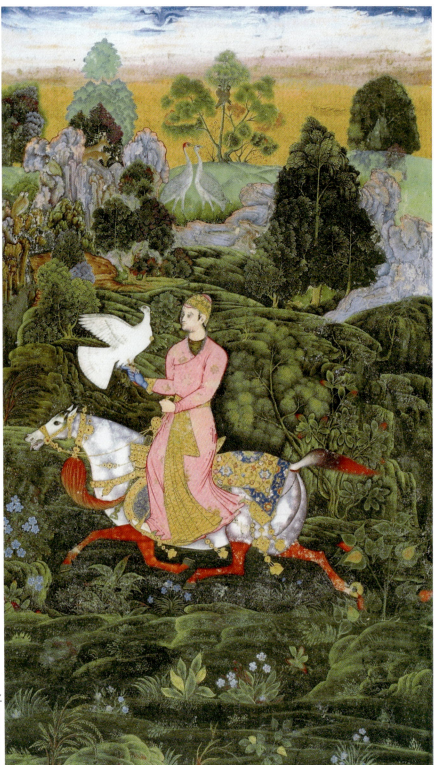

11.12 Farrukh Beg, *Sultan Ibrahim Adil Shah II Hawking*, Bijapur, India, c. 1590. Ink, opaque watercolor, gold, and silver on paper, 11¼ × 6⅛ in. (28.6 × 15.6 cm). Institute of Oriental Manuscripts, Russian Academy of Sciences, St. Petersburg, Russia.

who wrote verses praising Muslim Sufi shaykhs as well as Saraswati, the Hindu goddess of learning and music. He founded a new capital city, and under his patronage, court artists produced lyrical, poetic paintings, such as this portrait in which Sultan Ibrahim, holding a hawk in his right hand, rides a horse across a lush landscape (**Fig. 11.12**). The horse is bedecked with a golden bridle and fine saddle cloth, and its legs and the lower half of its tail are red from henna, the dye viewed as having both decorative and medicinal properties. Such adornments combined with Ibrahim's refined dress convey the ruler's exalted status. The periwinkle-blue rocks in the background, taken from Persian painting traditions (compare to **Fig. 11.5**), coupled with the band of golden sky, give the scene a fantastical quality. The various pairs of birds dotting the landscape and a distinctive palette of deep greens, gold, pink, and orange imbue the picture with a decidedly romantic feel. In contrast to Mughal portraiture, which tends toward mimesis with regard to facial features (see **Fig. 11.7**), Ibrahim is depicted in an idealized manner as a young, smooth-faced Persian prince.

What makes this painting particularly intriguing is that the artist, Farrukh Beg (c. 1545–c. 1619), also worked at the Mughal court. He began his career around 1580 in Kabul before moving to the Mughal imperial workshops in Agra and Lahore. Around 1590 Farrukh Beg appears to have shifted to Bijapur, where he remained for about a decade before returning to the Mughal court. An extraordinary painter, he was praised in the chronicles of both courts—the Mughal emperor Jahangir called him "one of the peerless of his age." Yet, for a long time, art historians debated whether or not the Farrukh-of-the-Deccan was the same person as the Farrukh-of-the-North. The confusion stemmed from a few factors: in Bijapur, he was known as Farrukh Husayn rather than Farrukh Beg. Additionally, his style changed noticeably as he moved from one court to the other and back again. But, as this case illuminates, style is not merely intrinsic to an artist. Rather, it is a result of training, exposure, and conscious choice. Indeed, part of Farrukh Beg's talent was his ability to produce art which, by being at the forefront of the particular culture in which he was working, pleased his patrons. His career highlights not only the movement of artists during this period but also the metamorphoses in style that occur as artists encounter new imagery, ideas, and patrons.

Artists were not the only mobile members of the Deccan courts. Noblemen constantly shifted allegiances from one sultanate to another, or arrived from Central Asia, Iran, and Africa. Indeed, one of the distinguishing features of the Early Modern Deccan is the prominent roles that East Africans (primarily from present-day Ethiopia) played. Referred to as Habshis or Sidis, they were brought over as enslaved soldiers, but—in contrast to other parts of the world (such as the Americas)—in South Asia, some enslaved men from Africa rose through the ranks to assume powerful positions in society. This was the case with the nobleman Ikhlas Khan (d. 1656), depicted here in a striking mid-seventeenth-century portrait (**Fig. 11.13**). Named Malik Raihan (Ikhlas Khan was a title bestowed upon him later), he grew up in

traders interacted, and the visual culture reflects this dynamic mixture. In many ways, the multiculturalism of the Deccan exemplifies the growing cosmopolitanism of the Early Modern era.

The reign of Ibrahim 'Adil Shah II of Bijapur (ruled 1580–1627) was a high point for artistic production. Like his northern contemporary Akbar (see **Figs. 11.1–11.5**), Ibrahim fostered a syncretic courtly culture that incorporated Persian and Indic religious, literary, and artistic traditions. Ibrahim himself was a musician and poet

the 'Adil Shah court alongside Ibrahim's son and successor, Muhammad 'Adil Shah (ruled 1627–56). When Muhammad ascended to the throne, Malik Raihan was promoted from enslaved soldier status to secretary to military commander and eventually to governor of a key province. Some historians speculate that he was the real power behind the throne.

More painted depictions of Ikhlas Khan survive than any other Deccan Habshi, a reflection of his status and perhaps even an indication that he had his own workshop of painters, just as some high-ranking Mughal nobles did. This portrait, in which he wears an elegant, fur-lined, brocaded jacket and sits ensconced by sumptuous pillows with an attendant behind him, certainly communicates his high position at court. Notably, he is not presented as an outsider but rather as a fully integrated member of Bijapur's society. The artist Muhammad Khan, who signed his name on the purple bolster pillow in the foreground, depicted Ikhlas Khan holding a document in one hand and a sword in the other, signifying respectively the sitter's administrative and military power.

A comparison of this portrait to that of Ibrahim 'Adil Shah II hawking (**Fig. 11.12**), made roughly sixty years earlier, highlights stylistic changes in Bijapur painting. By the mid-seventeenth century, Mughal influence over the state was increasing, and correspondingly, artists were adopting Mughal visual conventions. Note, for example, the emphasis on naturalism in depicting Ikhlas Khan's facial features. Additionally, some of the floral motifs on the textiles reflect Mughal courtly style (see **Fig. 11.8**). Yet the portrait of Ikhlas Khan remains a distinctively Deccan artwork; the Mughal elements add another layer of cosmopolitanism.

Bijapur's cosmopolitanism was augmented by its border with Portuguese Goa (1510–1961). In 1415, the Portuguese had begun building an empire—what is considered to be the first modern colonial empire—eventually controlling territory in South America, Africa, South Asia, and East Asia. In 1510, the Portuguese seized the port of Goa, strategically important because of its large natural harbor, from the 'Adil Shahis, who briefly controlled it. After that, throughout much of the sixteenth century, the Portuguese, with the aid of a large fleet of unbeatable warships, controlled the lucrative Indian Ocean trade. In 1530, Velha (Old) Goa became the capital of their South Asian holdings, and soon thereafter of their empire's eastern section, stretching from Mozambique to Nagasaki. During the city's heyday (mid-sixteenth–mid-seventeenth centuries), some 200,000 inhabitants fueled construction projects. The Portuguese used architecture, particularly religious architecture, to convey their authority. The Jesuit Church of Bom (Good) Jesus, completed in 1605, is one such example (**Fig. 11.14**, p. 236).

Christianity was not new to the Indian subcontinent (St. Thomas is believed to have visited India in 52 CE, and many people along the Malabar coast in southern India practiced Syrian Christianity); however, Roman Catholicism, the religion of the Portuguese, was new. In 1542 the priest and co-founder of the Jesuit order, St. Francis Xavier, arrived in India. He spent five years there, during which time he is said to have converted many

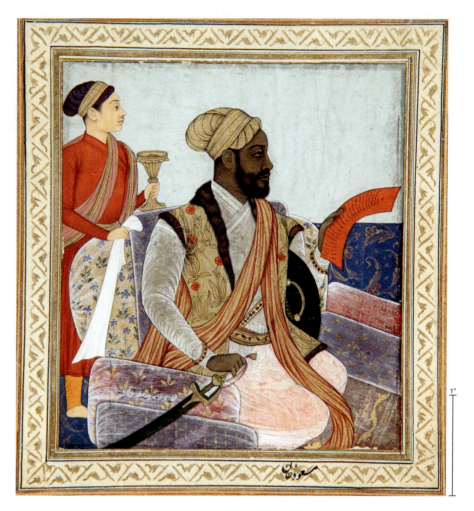

locals, before traveling to East Asia for further missionary work. In 1552, he died on an island off the coast of China. Eventually, when his body was discovered to be apparently miraculously preserved, it was brought back to Goa and enshrined in the Church of Bom Jesus.

In addition to housing St. Francis Xavier's body, the church serves as an excellent example of **Baroque** architecture in South Asia. The Baroque style, which first emerged in late sixteenth-century Europe, employs the vocabulary of **Classical** and **Renaissance** architecture in new, dynamic ways. It became particularly popular as a way of communicating the triumph of the Catholic Church. Here, the Baroque style is visible in the building's three-story facade through the variety of **pilasters** and **moldings** around doors and windows, the round windows on the third floor, and the triangular, curving roofline punctuated by the ornate panel containing "IHS" (an abbreviation of the Latin "Iesus Hominum

11.13 Muhammad Khan, _Ikhlas Khan with a petition_, Bijapur, India, c. 1650. Opaque watercolor and gold on paper, 4¾ × 4¼ in. (12 × 10.8 cm). San Diego Museum of Art, California.

Baroque a style of art and decoration that emerged in western Europe c. 1600–1750, characterized by a sense of drama and splendor achieved through formal exuberance, material opulence, and spatial projection in order to shape the viewer's experience.

Classical from, or in a style deriving from, ancient Greece or Rome.

Renaissance a period of Classically inspired cultural and artistic change in Europe from approximately the fourteenth to the mid-sixteenth centuries.

pilaster a flat, rectangular vertical projection from a wall; usually has a base and a capital and can be fluted.

molding a decorative architectural feature that covers the transition between two surfaces, such as the dividing line from one story, portal, or window framing, to another, or to the roofline of a building.

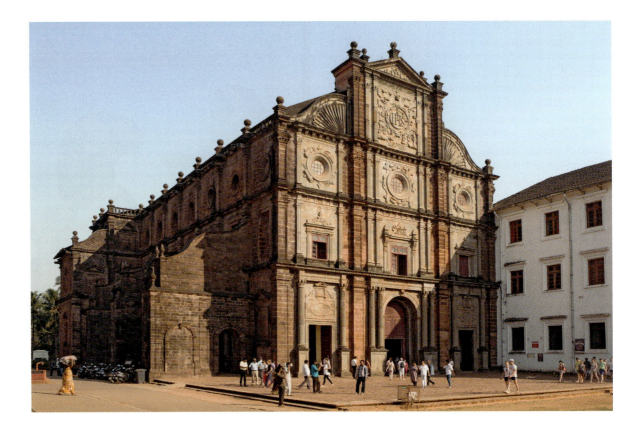

11.14 Church of Bom Jesus, Velha (Old) Goa, India, 1605.

Salvator," meaning Jesus, Savior of Men). Additionally, all three European **Classical orders**—Doric, Ionic, and Corinthian—can be found on the building. The church follows a cruciform plan with a single **aisle**, rather than three as had been common in Europe, to allow better visibility of the main altar and its decoration. It is worth noting that the **buttresses** on the side were added much later and that the building's laterite and basalt stone originally was covered with white plaster (the plaster was removed in 1950 in a mistaken effort to preserve the church better). While materials might have varied, similar churches could be found from Brazil to Macao. The Portuguese used Baroque architecture throughout their empire, creating a global visual language of power and domination in which Church and State were one.

Increased cross-cultural contact not only brought diverse people, religions, and ideas together, it also introduced new commodities, which in turn led to the popularity of new types of luxury objects. The prime example of this is tobacco, a crop from the Americas, which the Portuguese introduced in India. By the seventeenth century, tobacco was among the most important commodities passing through Goa, and smoking tobacco through a finely crafted *huqqa* (also spelled hookah) became a fashionable pastime among the Deccan elite.

A *huqqa* consists of several parts: a long stem holding a brazier with charcoal to burn the tobacco, a base (also referred to as a bowl) filled with water, through which the tobacco smoke passes, and a pipe through which the user inhales the vaporized smoke (see **Fig. 11.11**). A luxury *huqqa* set would also have included a serving tray and a ring to stabilize the base; however, it is primarily the bases, like this mid-seventeenth-century example (**Fig. 11.15**), that survive. This base is particularly significant

as a fine early example of bidriware. *Bidri*, named for the city of Bidar, was a metalwork technique specific to the Deccan in which items were cast from a zinc alloy, surface designs then inlaid with silver and brass, and finally the background covered with a paste and polished to a rich black sheen. The deep, velvety blackness of the background enhanced the silver and brass designs, which would have sparkled in candle- and moonlight. Here, the design features rose bushes in full bloom. Roses are symbols of the beloved (the object of desire) in both Persian and Urdu poetry, and thus, the floral decoration would have held romantic and literary connotations for

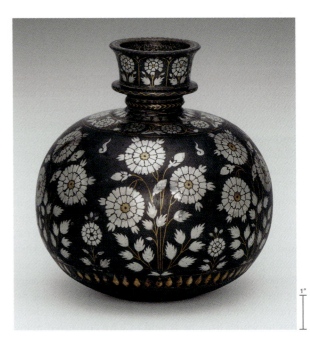

11.15 FAR RIGHT ***Bidri huqqa (water pipe) bowl with roses,*** Bidar, India, *c.* 1650. Zinc alloy with silver and brass inlay, diameter 6½ in. (16.5 cm), height 7⅜ in. (18.5 cm). Cleveland Museum of Art, Ohio.

Deccan viewers of the period. The rose motif also would have echoed the flowers found in the sumptuous garden settings where elite men and women relaxed and enjoyed their *huqqas*. Because of the cost of the materials (zinc had to be imported from Rajasthan or China) and the skill involved, bidriware was expensive. Thus, a *bidri* object would have signified an owner's wealth; a poetically and finely ornamented *bidri huqqa* set would have demonstrated cosmopolitanism as well.

Artistic production in the Deccan did not end in the late seventeenth century when the Mughals conquered the region, but it did fundamentally change in response to the shifts in the political landscape and patronage structures. In several cases, artists formerly employed by the royal courts in the Deccan found new patrons amongst the Rajput rulers of Rajasthan and the Punjab Hills who had helped lead the Mughals' military push southward. The movement of these Deccan artists northward happened around the same time that the many Rajput courts were becoming increasingly vibrant artistic centers.

Art from Rajasthan and the Punjab Hills

The title Rajput comes from the Sanskrit term *raja-putra*, meaning son of a king. Sometime around the sixteenth century, it came to denote a group of rulers and nobles, primarily Hindu, who claimed descent from an ancient warrior caste. The areas they controlled tended to be small states located in northern and western India— spanning from the deserts of Rajasthan to the foothills of the Himalayas—that fell under the suzerainty of the Mughal Empire (see **Map 11.1**). Each raja (king) ruled over his ancestral dominions from his palace in the kingdom's capital city, while also being required to provide military and other support to the Mughal emperor. Some rulers were unfailingly loyal to the Mughals, while others resented the relationship.

The Mewar raja, Rana Jagat Singh (ruled 1628–52), a contemporary of Shah Jahan, chafed at Mughal supremacy. A number of projects that he commissioned displayed Mewar's authority. They ranged from lakeside palaces at the capital of Udaipur to a seven-volume illustrated manuscript of the *Ramayana*, a Hindu epic. The story of the god Rama, an incarnation of Vishnu, and his quest to rescue his wife, Sita, from the demon Ravana, had long inspired South Asian art (as well as Southeast Asian art—see Fig. 7.7). But illustrated manuscripts of the epic were a relatively new phenomenon, with a Persian translation made for Akbar at Fatehpur Sikri seeming to have inaugurated the trend in northern India. The *Ramayana* held a special place for Mewar's rulers, who traced their lineage to the Solar (Sun) dynasty of legendary warriors that included Rama. That special status is indicated by the scope of Jagat Singh's project: approximately 450 full-page paintings illustrate the multi-volume manuscript. An inscription dates its production to 1649–53, but most scholars believe it would have taken longer than four years to complete.

Its pages employ the horizontal format of earlier Indian manuscripts (see Fig. 10.10), and the paintings feature bright, saturated colors and animated figures in profile. The court artists favored flatness and an omniscient viewpoint over depth and shading. For example, the swirling, chaotic illustration of the siege of Lanka by Rama and his monkey and bear allies (**Fig. 11.16**) shows the inside of Ravana's walled palace as well as outside. As with the Great Departure relief at Sanchi's Great Stupa (see Figs. 3.0 and 3.5), the visual narrative incorporates more than one moment in time. Ravana, easily recognizable because of his multiple heads and arms, is depicted twice: once inside his palace and again on its roof. Throughout

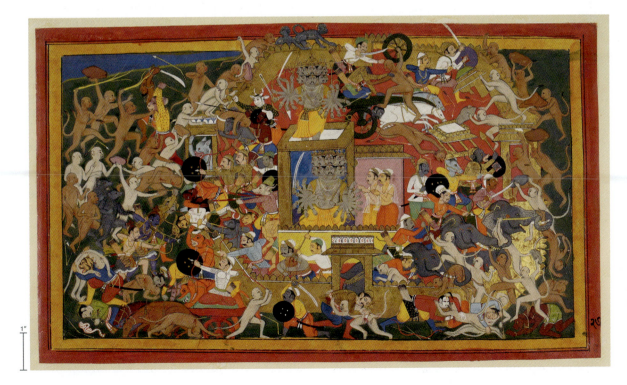

11.16 Sahibdin, "The Siege of Lanka," folio from a *Ramayana* manuscript, Udaipur, Rajasthan, India, Mewar dynasty, *c.* 1649–53. Opaque watercolor and gold on paper, 9 × 15¼ in. (22.9 × 38.7 cm). British Library, London.

11.17 BELOW **Plan of Jaipur,** Rajasthan, India, founded 1727.

11.18 BOTTOM **Jantar Mantar observatory,** Jaipur, Rajasthan, India, founded 1727.

the manuscript's illustrations, the artists conveyed the narrative in multiple ways: some paintings focus on a single moment, while others depict several points in time, as many as eleven in one image. All these qualities serve to distinguish Mewar painting—and thus Mewar identity—from Mughal painting and rule (see **Figs. 11.5** and **11.7** for comparison). As always, though, it is important to be precise in how we frame the differences. In the past, writers sometimes classified Mewar's painting style as "Hindu," and the Mughals' as "Islamic," but this categorization is inaccurate. First, an image's subject, its function, and its style are three separate things—"Hindu art" refers to the function and/or subject matter, not its style. Second, the court artists did not necessarily follow the same religion as their royal patrons. In fact, just as Mughal court painters were both Hindu and Muslim,

the senior Mewar court artist primarily responsible for the illustrations in Jagat Singh's *Ramayana* was a Muslim named Sahibdin.

The Rajput rulers most loyal to the Mughals were the Kachhwahas of Amber. Those close ties coupled with the rajas' military and administrative skills made them powerful. In 1727, as Mughal dominance waned, Sawai Jai Singh Kachhwaha (ruled 1700–44) founded a new capital city on a plain six miles (nine or so kilometers) south of the kingdom's older hill fortress capital of Amber. The new capital, named Jaipur in honor of its founder, was designed to display Jai Singh's growing stature. Unique for the period, the city followed a grid-plan comprised of nine large rectangular blocks separated by long, broad avenues. The royal compound, including a pleasure garden and artificial water tank that Jai Singh had constructed a decade earlier, filled two of the blocks; the rest included residential dwellings, shops, and temples. Building proceeded quickly, with most of the work completed in seven years. Royal order required uniformity in the appearance of all city structures. Originally, the Mughal-inspired buildings were painted cream, but later, the color was changed to pink, giving Jaipur its nickname of "the Pink City." In many ways, the city served as a backdrop for the spectacle of royal processions. The main boulevards, which lead to Hindu temples on surrounding hills, were wide enough for six elephants to walk abreast. In 1799, the multi-story Hawa Mahal (Palace of Breezes) was built so that the royal women, who—like Mughal royal women (see **Fig. 11.3**)—practiced *purdah*, could sit behind its screened facade and watch the various processions while remaining unseen by the general public (and thus preserving their honor).

Traditionally, scholars have interpreted Jaipur's grid-plan as arising from building ideals presented in ancient Indian Sanskrit texts, specifically the concept of the **mandala**, which can take the form of a nine-part square (see Fig. 6.15). Jaipur's plan is not a square, but it is assumed that a hill in the northwest corner prevented anything from being built there, so the ninth block was added to the southeast corner instead (**Fig. 11.17**). However, more recently, scholars have noted that Jaipur's plan also resembles a Mughal *charbagh*, with square plots divided by walkways. In fact, in 1713 Jai Singh commissioned a pleasure garden in the form of a *charbagh*, and, fourteen years later, when Jaipur was founded, that garden was incorporated into the royal compound at the heart of the city. Perhaps the garden provided the inspiration for the larger city plan encompassing it.

Jai Singh clearly was interested in understanding the world from a range of perspectives. He collected maps and was an expert astronomer. In fact, he was responsible for some of the world's earliest observatories, one of which, the Jantar Mantar (**Fig. 11.18**), was built within Jaipur's palace grounds. The Mughal emperor had asked him to develop a more accurate calendar, and Jai Singh hypothesized that the larger the instruments, the more precise their measurements. Thus, he and his advisors designed freestanding structures, built of stone, with the finer parts made of brass. This collection of giant eighteenth-century instruments, with their dramatic

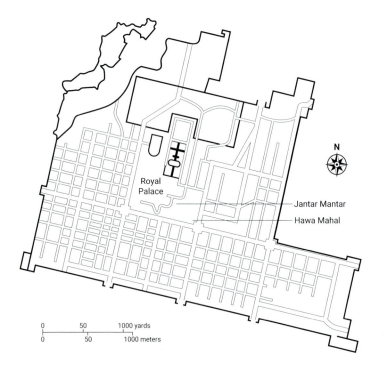

Royal Palace

Jantar Mantar

Hawa Mahal

N

| 0 | 50 | 1000 yards |
| 0 | 50 | 1000 meters |

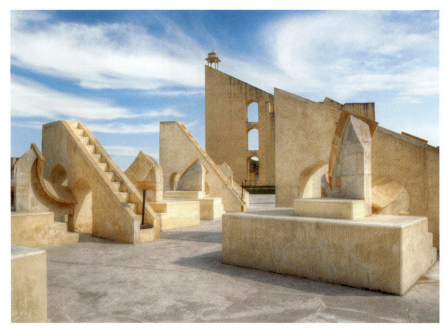

forms open to the sky, reinforces the geometric underpinnings of the royal capital.

As Mughal power declined during the late eighteenth and early nineteenth centuries, the autonomy of regional states in north and central India increased. Consequently, distinctive local approaches to art flourished at their courts. Each area had its own group (sometimes family) of painters, who worked in a particular style and privileged certain subjects. For example, in the Kangra region of the Punjab, in the foothills of the Himalayan mountains, court artists favored a soft, cool palette, in contrast to the warm, saturated colors of Mewar painting. Charming depictions of nature—rolling hills punctuated by lush foliage—are populated by finely featured, beautiful young women and men. Kangra paintings tend to emphasize the themes of love, eroticism, and the pleasures of courtly life, as in this entertaining and idealized depiction of a royal hunt (Fig. 11.19). Like the "Siege of Lanka" illustration, this painting captures multiple moments in time. At the top of the image, in the center, a prince and princess holding hawks travel on horseback through a royal hunting enclosure. The prince looks in the distance toward a young huntress shooting a deer. That same young woman, recognizable by her blue-and-white headdress, appears two more times in the foreground. On the right, she makes love with a handsome courtier, who simultaneously aims his bow and arrow at a tiger, suggesting the multifaceted nature of his skill set. As with the erotic sculptures adorning the Hindu temples at Khajuraho (see Fig. 7.14), a bit of humor is added to the sensual scene: the courtier's horse, waiting just below, wears a blind, as if to shield him from the explicit sexual display. The painting, like the other works on paper discussed in this chapter, was meant to be viewed by a select audience—in this case, elite members of Kangra's court. Everything about the image—its eroticism, its humor, even the softly beautiful style in which it was painted—was intended to heighten the pleasure of the viewer's experience.

While many of the South Asian courtly paintings from the Early Modern period are roughly the size of one or two pieces of contemporary notebook paper (both the

Kangra and Mewar paintings discussed here are about nine inches by fifteen inches), in fact, paintings on paper were made in a wide range of sizes. Some works are just a few inches high and can be held in the palm of one's hand. Others reach more than two feet and cannot be held by a single person. For example, at the Rajput kingdom of Marwar, between around 1765 and 1830, court artists at the capital of Jodhpur produced monumental manuscripts with pages measuring roughly a foot and a half high and four feet wide. Five hundred illustrated folios from these extraordinary manuscripts survive, including this painting by the artist Bulaki (Fig. 11.20). The manuscripts were left unbound (as were other smaller Rajput manuscripts). To be viewed, each massive page was picked up and held aloft by at least two attendants (one at each edge). Most likely this would have occurred in a courtly setting, with someone reciting the manuscript's text aloud as the audience viewed the paintings from a distance.

11.19 *Pleasures of the Hunt,* Kangra, Punjab Hills, India, *c.* 1800. Ink, opaque watercolor, gold and silver on paper, 9⅞ × 14⅛ in. (25.1 × 36.2 cm). Metropolitan Museum of Art, New York.

11.20 Bulaki, "The Three Aspects of the Absolute," folio 1 from *Nath Charit* (*Stories of the Naths*), Jodhpur, India, Marwar dynasty, 1823. Opaque watercolor, gold, and tin alloy on paper, 18½ × 48⅜ in. (47 cm × 1.23 m). Mehrangarh Museum Trust, Jodhpur, Rajasthan, India.

These late eighteenth- and early nineteenth-century Marwar paintings are notable not only for their size, but also for their innovative compositions and, in some cases, new subject matter. The Marwar ruler Man Singh (reigned 1803–43) was an ardent devotee of the Nath yogic sect of Hinduism. Under his patronage, new Nath religious texts were composed in the local dialect of Marwari, and three of the ten surviving monumental manuscripts are these new Nath treatises. Because the texts had never been illustrated, the painters had no models to follow to put into visual form what were often complex, esoteric ideas. For example, to illustrate the opening section of the *Nath Charit* (*Stories of the Naths*), the artist Bulaki was tasked with depicting the metaphysical idea of the formless and timeless Absolute, from which cosmos and consciousness are thought to be created. How does one paint that which has no beginning or end? Bulaki's solution was a shimmering gold color field, completely empty in the left square. In the center square a Nath *siddha* ("perfected one") emerges from the luminous gold ground. From the *siddha* emanates cosmic matter, depicted in the right-hand square as a silver (actually tin alloy) sea. The bold, abstract nature of these paintings is striking, even today.

The rise of the Mughal Empire brought with it immense wealth, power, and artistic achievement. Artists and patrons situated within smaller contemporaneous states added to the diversity and cosmopolitanism of Early Modern South Asian art. As the Mughal Empire weakened during the eighteenth and nineteenth century, the subcontinent witnessed economic stagnation and political fragmentation, eventually leading to the rise of the British East India Company and the colonization of South Asia (see Chapter 15). However, the political decline did not lead to artistic stagnation. On the contrary, as Bulaki's painting demonstrates, the decentralization of power allowed regional artistic practices to flourish, many of which continued to produce highly original and dynamic artworks throughout the nineteenth century.

Discussion Questions

1. This chapter argues that many of the changes marking the Early Modern era are visible in South Asian art from the period. Pick one development and explain how it manifests in two different artworks.

2. This chapter discusses seven different South Asian paintings, all works on paper. Choose two and compare them stylistically. For example, how did the artists represent space (foreground, background, depth) and employ color? Recognizing that artistic style is a choice, what are some reasons why the artists might have chosen to work in the styles that they did?

3. Four of the seven paintings can be classified as portraits. Choose one and compare it to a portrait (in any medium) introduced in another chapter, keeping in mind the question of what exactly it means for something to be a portrait. That is, what are some of the different ways in which someone's "likeness" can be conveyed?

4. Research prompt: this chapter shows one example of later Mughal art (**Fig. 11.11**). Research another example and compare it to an artwork discussed in this chapter.

Further Reading

- Asher, Catherine B. and Talbot, Cynthia. *India before Europe*. Cambridge, U.K. and New York: Cambridge University Press, 2006.

- Bindman, David, Preston Blier, Suzanne, and Gates Jr., Henry Louis (eds.). *The Image of the Black in African and Asian Art*. Cambridge, MA and London: The Belknap Press of Harvard University Press, 2017.

- Dehejia, Vidya. "The Treatment of Narrative in Jagat Singh's *Ramayana*: A Preliminary Study." *Artibus Asiae* 56, 1996, pp. 303–24.

- Haidar, Navina Najat and Sardar, Marika. *Sultans of Deccan India 1500–1700: Opulence and Fantasy*. New Haven, CT and London: The Metropolitan Museum of Art, New York, distributed by Yale University Press, 2015.

- Koch, Ebba. *The Complete Taj Mahal and the Waterfront Gardens of Agra*. London and New York: Thames & Hudson, 2012.

Chronology

1510–1961	Goa is under Portuguese control	c. 1632–47	The construction of the Taj Mahal
1526–1857	The Mughal Empire	1649–53	A lavishly illustrated manuscript of the *Ramayana* is produced for the Mewar ruler Jagat Singh
1556–1605	The rule of the Mughal emperor Akbar		
c. 1570–85	Fatehpur Sikri serves as the Mughal capital		
1580–1627	The rule of Ibrahim 'Adil Shah II of Bijapur	17th–19th centuries	Painting flourishes in the Punjab Hills in northern India
1605	The Church of Bom Jesus is consecrated in Goa	1727	The city of Jaipur is founded
1605–27	The rule of the Mughal emperor Jahangir, during which allegorical portraiture becomes popular	1765–1830	Monumental manuscripts are produced at the royal court of Jodhpur

Blue-and-White Porcelain around the World

Invented in China during the Tang dynasty (618–906 CE), porcelain became a highly sought-after commodity around the world. In the Yuan dynasty (1279–1368), Chinese manufacturers imported cobalt pigment from the region of present-day Iran to make the distinctive blue glaze, and they then exported blue-and-white porcelain back to West Asia. Cobalt-decorated porcelain also gained popularity within China, where audiences favored iconography with religious and literary symbolism (see Fig. 8.12).

As commercial maritime routes linked Eurasia, Africa, and the Americas in a network of globalized trade, markets for blue-and-white porcelain expanded. By the seventeenth century, blue-and-white Chinese porcelain was sold throughout the world. To meet the vast domestic and foreign demand, Chinese manufacturers turned to large-scale production in such places as the city of Jingdezhen, still home today to many of the world's largest ceramics factories. Jingdezhen workshops employed a number of production and design techniques—including the division of labor, and standardized forms and decorations—well before Europeans implemented them in the mid-eighteenth century.

This plate (**Fig. 1**), made in Jingdezhen, appealed to domestic consumers with its Confucian theme of the Four Arts: calligraphy, painting, music, and strategy. Two women seated opposite one another play a game of strategy known as *weiqi*. A third has a zither in her lap, while two more sit beside implements for writing and painting. Europeans enjoyed such images, too. Unaware of the specific iconography, they delighted what they took to be novel and exotic scenes of Chinese culture.

The popularity of Chinese blue-and-white porcelain drove imitations in numerous other cultures. When locally available resources proved insufficient, discovery of new materials and invention of new technologies allowed closer emulation of Chinese models. For example, local potters in regions of present-day Iran and Turkey made imitations of Chinese porcelain, using the same sources of cobalt

that they exported to China. The iconography of this example (**Fig. 2**), produced in the Safavid Empire of Iran (1501–1736), approximates a Chinese pleasure boat and several pagodas for the central panel. The images and patterns fill nearly the entire surface of the dish, reflecting a taste for dense ornamentation that was shared by both Safavid and European audiences in the seventeenth century.

1 Plate from Jingdezhen, China, 1662–1722. Porcelain, underglaze cobalt, diameter 14⅞ in. (37.7 cm). Victoria and Albert Museum, London. **EAST ASIA**

2 Dish from Safavid Iran, 1616–42. Painted earthenware, diameter 17 in. (43.3 cm). Victoria and Albert Museum, London. **WEST ASIA**

In the Netherlands, dishes resembling the Safavid example were both imported from China and produced locally. In many cases, European blue-and-white ceramics adopted European subjects and styles, while retaining material and/or stylistic similarities to Chinese wares. In this example of Delftware (**Fig. 3**), named after the Dutch trading city of Delft where it was made, the materials clearly resemble Chinese blue-and-white porcelain, but the design is wholly European. The Christian imagery, including winged cherubs on the rim and a biblical vision of Jacob's Ladder (a staircase to heaven described in the Book of Genesis), are rendered in various shades of hazy blue that allow the scene to appear in a more naturalistic European style.

In addition to their stylistic and iconographic differences, blue-and-white ceramics manufactured outside of China also used different materials and techniques. Neither the Safavid nor the Dutch wares are true porcelain, which is made of a clay that produces a vitreous (glasslike) white body when fired at very high temperatures. Rather, they are earthenware, a more porous but easily fired material. Safavid and Dutch potters emulated the white body and blue decoration of Chinese porcelain with tin-based glazes and paint.

The same was true at Puebla de Los Angeles (in present-day Mexico), which specialized in producing imitations of Chinese porcelain. With the help of Spanish merchants plying trade routes from Manila to Acapulco, Chinese porcelain became a popular commodity in Latin America. The potters at Puebla satisfied the local demand with blue-and-white earthenware decorated with more Spanish colonial imagery. The central image in this dish (**Fig. 4**) features a two-headed eagle, the symbol of the European Habsburg emperors who colonized the region. Coincidentally, the eagle was also a significant motif in Aztec mythology.

3 Plate from the De Roos Factory, Delft, Netherlands, 1690–1710. Tin-glazed and painted earthenware, diameter 9 in. (22.9 cm). Victoria and Albert Museum, London. **EUROPE**

4 Dish from Puebla de Los Angeles, Mexico, 1650–1700. Tin-glazed and painted earthenware, diameter 23 in. (58.8 cm). Victoria and Albert Museum, London. **NORTH AMERICA**

Discussion Questions

1. To what extent is each of the objects discussed here "original"? Can emulation and imitation be considered creative acts? Explain.

2. Find another artwork in this textbook that can be discussed as a global commodity. How does it compare to the porcelain examples shown here?

Further Reading

- Diercks, Femke. "Inspired by Asia: Responses in the Dutch Decorative Arts." In K. Corrigan, J. van Campen, and F. Diercks (eds.). *Asia in Amsterdam*. New Haven, CT: Yale University Press, 2016: 246–53.
- Leibsohn, Dana. "Made in China, Made in Mexico." In R. Otsuka and D. Pierce (eds.). *At the Crossroads: The Arts of Spanish America and Early Global Trade, 1492–1850*, Denver, CO: Denver Art Museum, 2012: 11–41.
- Pierson, Stacey. "The Movement in Chinese Ceramics: Appropriation in Global History." *Journal of World History* 23, no. 1 (2012): 9–39. doi:10.1353/jwh.2012.0013

12

Art in Late Imperial China

1368–1795

12.0 Detail of *The Fifth Dalai Lama with
Episodes from His Life.*

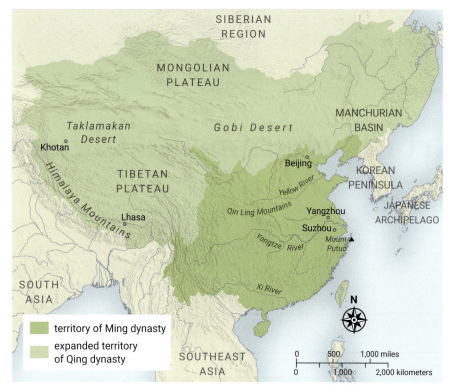

Introduction

Historians refer to the period of the Ming (1368–1644) and Qing (1644–1912) dynasties together as the Late Imperial period. The global Early Modern era, beginning around 1500, overlaps with part of the Late Imperial period; and the transition from Early Modern to modern occurs around 1800, coinciding with the death of an important Qing ruler, known by his reign name as the Qianlong emperor (ruled 1736–95, died 1799). Recognizing significant historical changes within and outside of the Qing Empire, this chapter examines art from 1368 to 1795.

This period is characterized by tremendous growth—in population, industry, wealth, literacy, and artistic expression. It began when a native, ethnically Han-Chinese dynasty—the Ming—defeated the previous Mongol Yuan dynasty. With the Ming revival of Song dynasty (960–1279) institutions, earlier styles inspired artists of the imperial painting academy, while scholars took civil-service examinations and swelled the ranks of officialdom. Eventually, candidates outnumbered available positions, and fierce competition led unsuccessful scholars to redirect their energies to private and commercial pursuits. In carefully designed garden retreats, they used their cultural knowledge to expand social networks and secure patronage. Flourishing commercial markets offered them additional opportunities, and luxury items allowed discerning consumers to demonstrate their aesthetic taste.

The pursuit of consumer luxuries gave way, albeit briefly, to more pressing matters when various crises afflicted the last years of the Ming dynasty. Taking advantage of internal rebellions, the Manchus, an ethnic group from northeast Asia, captured the capital, Beijing, and declared in 1644 a new dynasty, the Qing (Map 12.1). Initially, loyalists resisted the new regime, but eventually the Manchus consolidated power. Prosperity returned as the Manchus reigned over a great, heterogeneous empire with boundaries exceeding those of

hanging scroll a format of East Asian painting that is typically taller than it is wide; generally, hanging scrolls are displayed temporarily and may be rolled up and stored easily.

literati painters educated artists, including scholar-officials, who brought literary values into painting, and pursued abstraction and self-expression in their art.

calligraphy in East Asian painting, the formal, expressive properties of lines (e.g. thick/ thin, dark/light, wet/dry) made with a flexible brush.

previous dynasties. The Manchu emperors embraced Tibetan Buddhism, and at their courts they employed the services of Buddhist teachers (*lamas*) and Jesuit missionaries alike. At court, the Qianlong emperor amassed an art collection surpassing those of his predecessors. His commissions showed both his eclectic taste and his astute use of art and architecture as vehicles to assert universal, cultural authority.

Art during China's Late Imperial period responded to perennial needs as well as new audiences. On the one hand, artwork demonstrated religious devotion and furthered political ambition; on the other, growing wealth from commercial markets and changing social structures brought art and luxury items to people of lower status, such as women and merchants.

Art for Court Officials and Retired Recluses

As part of a general restoration of government institutions, the Ming dynasty revived the court painting academy. There, artists looked to Song dynasty precedents for stylistic inspiration (see Figs. 8.4, 8.9, and 8.10). The court painter LIU Jun (active *c.* 1475–*c.* 1505) relied on Song history for his subject, too. In his **hanging scroll** *The First Song Emperor Visiting His Prime Minister Zhao Pu on a Snowy Night* (Fig. 12.1), Liu placed the emperor prominently in front of a landscape screen. Wearing a light-colored robe embellished with a dragon, the emperor leans toward his prime minister, Zhao Pu, to seek counsel on military strategy.

Adhering to the historical record of this actual event, Liu set the narrative in a wintry landscape. Bamboo stalks bend under the weight of snow, which also blankets the ground and rooftops. Distant mountains rise against a night sky. In the foreground, imperial servants brace themselves against the cold air, while a charcoal brazier inside provides heat for the minister and his imperial guest. Half obscured by the pillar, the minister's wife brings a warm drink. Liu intended his viewers to feel the chill and be drawn to the important conversation between the Song emperor and his prime minister.

Liu utilized considerable artistic skills not to convey his personal values, as **literati painters** did (see Figs. 8.13 and 8.14), but rather to bring a historical event vividly to life. To that end, the **calligraphic** brushwork—as in the foreground slope and the leafless tree—must not draw too much attention to itself. Above all, Liu emphasized naturalistic representation, capturing seasonal weather, using meticulously fine lines for rendering architecture, and curbing excessively expressive brushstrokes. Typical of Ming court paintings, Liu's *Snowy Night* displayed the academy's high standards and affinity for Song styles. Additionally, it broadcast a flattering message of respect for sage officials, which in turn granted political legitimacy to the Ming dynasty.

A message of political legitimacy is also the purpose of a painting of a giraffe and attendant (Fig. 12.2 and see Fig. 0.9 for the full work). Although dated to the sixteenth century, this image is based on an earlier one by court painter SHEN Du (1357–1434), which celebrated the arrival

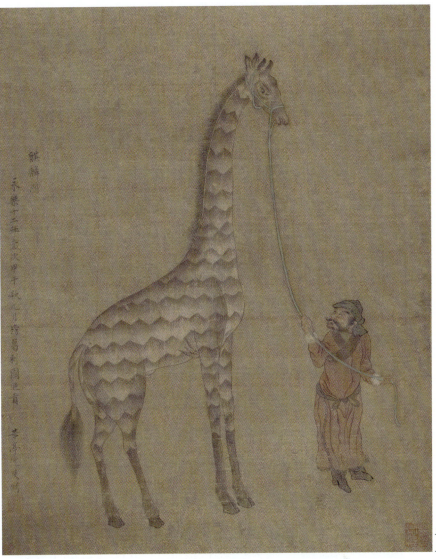

of a remarkable gift from the ruler of Malindi (a coastal city in present-day Kenya) to the Yongle emperor (ruled 1403–24). The giraffe with its Malindi groom attests to the extraordinary maritime voyages undertaken by Admiral ZHENG He (1371–1433). During the reign of the Yongle emperor, Zheng led fleets of as many as 300 ships carrying up to 30,000 men on seven expeditions to extend to areas of Southeast Asia, Arabia, and East Africa the Ming hegemony and the tribute system. On the return of one such expedition, Zheng transported the giraffe among his cargo. Within the context of the political-economic tributary system, the giraffe functions like other diplomatic gifts to signify recognition of Ming authority. But the Ming court's interpretation of the giraffe as a *qilin*, a mythical beast that appears only during times of sagacious rulers, facilitated its further signification as an **auspicious** portent. Like the *Five-Colored Parakeet* (see Fig. 8.7) of Song emperor Huizong (ruled 1101–24), this painting uses a descriptive style accompanied by an inscription record to document the good omen (see Fig. 0.9). Vigorous maritime expeditions notwithstanding, the Yongle emperor may have wished for further signs to buttress his reign, which began not with orderly succession, but with him usurping the throne from his nephew.

Wary about challenges to political legitimacy, the Yongle emperor took steps to eradicate dissent, including a purge of scholars. Such purges could have a chilling effect, causing talented scholars to retire early or avoid official service altogether. In withdrawing from court politics, some scholars assumed the posture of the recluse, whose self-imposed isolation from politics earned him an unstained reputation (see Fig. 4.16). But real isolation to remote mountains required sacrificing the pleasures and comforts of home. Moreover, the value of becoming a hermit could be realized, paradoxically, only by making sure that others took notice of this identity. Thus, retired officials created more convenient and effective substitutes: gardens.

Located far from the capital Beijing, Lingering Garden in Suzhou (**Fig. 12.3**, p. 246) offered a suitable and symbolic setting for retired officials. Originally commissioned by a Ming official, XU Taishi, in 1593, Lingering Garden does not—indeed cannot—retain its original appearance. Unlike other types of art, gardens undergo constant change driven by seasons and growth cycles, as well as at the hands of successive owners, who expand and alter them. Nonetheless, Lingering Garden represents approaches to garden composition during the Late

12.1 ABOVE LEFT **Liu Jun, *The First Song Emperor Visiting His Prime Minister Zhao Pu on a Snowy Night*,** Ming dynasty. Hanging scroll, ink and colors on silk, 56⅜ × 29½ in. (1.43 m × 74.9 cm). Palace Museum, Beijing.

12.2 ABOVE RIGHT **Formerly attributed to Shen Du, *Tribute Giraffe with Attendant*, detail,** Ming dynasty, sixteenth century. Hanging scroll: ink and color on silk, 31½ × 16 in. (80 × 40.6 cm). Philadelphia Museum of Art, Pennsylvania.

auspicious signaling prosperity, good fortune, and a favorable future.

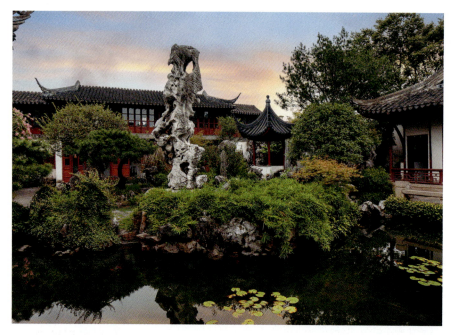

Imperial period, or the Ming and Qing dynasties (1368–1912). Highly eroded rocks and irregularly shaped ponds provide the garden with the fundamental, constitutive elements of the universe in manageable form. Like the centuries-old tradition of Chinese landscape painting, which combined mountains (*shan*) and water (*shui*), gardens were microcosms, or miniature worlds.

The purpose of Lingering Garden was not food production; rather, it nourished the spirit and the mind. Furthermore, in place of a profusion of showy flowers, gentlemen typically preferred plants with symbolic associations, such as pine, bamboo, and blossoming plum. These so-called "three friends of winter" persevered in inclement weather and therefore suggested moral virtues, such as strength and resilience. The naming of gardens and their special features, including rocks, plants, buildings, and views, also allowed their owners to demonstrate their virtues and abilities. For example, the name of the nearby Master of the Nets Garden refers to fishing nets, thereby invoking the trope of a rustic fisherman, equal in virtue to the hermit. Special features, including rocks, plants, buildings, and views, could be named, too; for example, the eroded rock seen at the center of **Fig. 12.3** is "Crown Cloud Peak." Meandering paths and surprising vistas orchestrated leisurely physical movement, which contrasted with the regular, hierarchical spaces and formal choreography of the court (compare this garden, **Fig. 12.3a**, to **Fig. 12.14**). Modest buildings facilitated intimate gatherings, where friends consolidated their social bonds through shared activities, such as composing poetry, discussing artwork, and admiring the carefully constructed "naturalness" of the garden.

Retired scholar-artists in the Suzhou region also cultivated a distinctive painting style, called the Wu school. Named after an ancient designation for the Suzhou region, the Wu school was not in fact a school, but a style informed by **literati** aesthetics as first articulated by the Song dynasty scholar SU Shi (1037–1101; see Chapter 8). Su gave primacy to poetry and calligraphy, artforms that play important roles in *Poet on a Mountaintop* (**Fig. 12.4**) by SHEN Zhou (1427–1509).

In this **album** leaf, Shen depicts a single, robed figure—a scholar-poet—standing on a stone bluff. The hermit-like figure has left the temple retreat behind, and viewers follow his gaze into the vast distance. But his gaze also directs viewers' attention to a poem inscribed as if floating in the sky. Shen the painter becomes Shen the calligrapher and poet; likewise, viewers become readers:

> White clouds—like a sash—encircle the mountains' waists.
> A stone terrace flies into the void; a narrow path in the distance.
> Alone, I lean on my bramble staff; far and free I gaze.
> Prompted by the murmuring brook, I reply, whistling.

The imagery of the poem encourages the reader to look again at the painting, with particular motifs, actions, relationships, and especially, sounds in mind. The calligraphy, too, prompts appreciation of the expressive brushwork of wavering lines, ink dots, and other marks

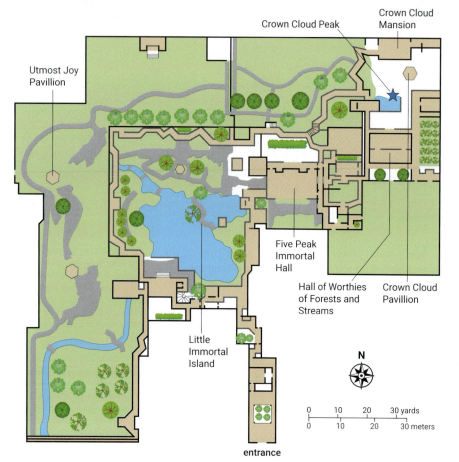

12.3 TOP **Lingering Garden,** view of Crown Cloud Peak as seen from Hall of Worthies of Forests and Streams, Suzhou, China, originally designed in the Ming dynasty, expanded and renovated in the Qing dynasty. 5¾ acres (around 2.3 hectares).

12.3a ABOVE **Plan of Lingering Garden, Suzhou, China.**

literati in Confucian cultures of East Asia, the social group of educated men who would typically pursue government service as a career, but could also put their skills in reading, writing, and related arts to work through tutoring, writing, and painting.

album a format of two-dimensional artwork such as painting, calligraphy, or photography, in which individual leaves, or pages, may be bound together like a book to form an album.

白雲如帶東山腰
磊空細路遠横倚
杖藜舒眺望欲自鳴
澗落吹簫沈周

12.4 Shen Zhou, *Poet on a Mountaintop,* from *Landscape Album: Five Leaves by Shen Zhou, One Leaf by Wen Zhengming,* 1496. Album leaves mounted as a handscroll: ink and colors on paper, 17⅜ × 21 ft. 8 in. (44.1 cm × 6.6 m). Nelson-Atkins Museum of Art, Kansas City, Missouri.

format in East Asia, painting types that include the hanging scroll, handscroll, album leaf, and fan.

stoneware a type of ceramic that is relatively high-fired and results in a non-porous body (unlike terra-cotta, or earthenware).

12.5 Qiu Ying, *Appreciating Antiquities in the Bamboo Garden,* Ming dynasty. Album leaf: ink and color on silk, 13¼ × 16¼ in. (33.7 × 41.3 cm). Palace Museum, Beijing.

that make up the landscape. Shen's depiction of figures and architecture may be simplified and sometimes awkward, comparing unfavorably to the refinement and attention to detail in court paintings such as Liu's *The First Song Emperor*, but it is deliberate. Like Yuan dynasty artists GUAN Daosheng and NI Zan (compare to Figs. 8.14 and 8.16), Shen purposefully rejects courtly polish and precious materials (colors, silk) in favor of the literati ideals of authentic, individual expression through modest means (ink, paper). Rather than appealing to the pomp of the political arena, *Poet on a Mountaintop* seeks intimate appreciation by like-minded individuals. This kind of experience is facilitated by the small **format** of the album leaf, which is best viewed alone or in pairs.

The garden environment and the activities of scholar-officials are pictured in *Appreciating Antiquities in the Bamboo Garden* (**Fig. 12.5**) by professional painter QIU Ying (*c.* 1494–*c.* 1552). At the composition's center, two gentlemen look at an album of fan-shaped paintings, while a third reaches for a grayish-blue *guan*-ware (a type of **stoneware**) incense burner that has a form modeled on that of an ancient bronze vessel. Around the privileged trio are not only ceramic vessels mimicking the forms of ancient bronze but also actual ancient bronze ritual vessels (see Figs. 2.4, 2.6, 2.9, 2.10), including one that has been repurposed to display red coral branches (lower center).

Also on display are paintings in a variety of formats (see Fig. 8.2a–e), including the screens that shield the servants' activities from the view of the leisurely gentlemen. Although the gentlemen focus on art objects, Qiu did not overlook such garden elements as the half-obscured rock (compare to Fig. 12.3) rising over a screen in the upper left, or the material trappings of the well-to-do, including the

speckled bamboo chairs, *guan*-ware teabowls on delicate pedestals on the table near the servant on the right, a table for playing the game go (Chinese: *weiqi*) at upper right, and a **lacquered** black zither (a stringed instrument) on a low table at left. Dogs, boy servants, and young women—whose make-up and dress also delight the eye—complete this picture of available commodities in the robust Ming economy.

Luxury Objects

The market for luxury objects, like those included in Qiu's *Appreciating Antiquities*, included paintings. Colorful and meticulous, Qiu Ying's paintings fetched high prices. They had enormous appeal and were often copied and forged. Yet Qiu's reputation was not ironclad. The very qualities that made his paintings immediately appealing rendered him vulnerable to charges of vulgarity. Elite literati values continued to favor restraint, subtlety, subjectivity, and autonomy—attributes seemingly absent from Qiu's painting. Still, Qiu faced high demand, compelling him to use assistants, sometimes called "ghost painters," to fulfill commissions. One such ghost painter was his daughter, known as Miss Qiu, though she possibly was named Zhu (active *c.* 1563–c. 1580).

In addition to assisting with her father's paintings, Miss Qiu painted and signed her own artworks. For a deluxe album of twenty-four images of the **bodhisattva** Guanyin (Sanskrit: Avalokiteshvara), she used gold ink on dyed black paper. In this leaf, Guanyin sits in a position of royal ease, left foot resting lightly on a lotus flower (**Fig. 12.6**). The youthful attendant holding the vase is Longnu, daughter of the dragon king. Prominently displayed on the flat rock are a scroll and encased book, probably *sutras* mentioned in an accompanying poem

12.6 Miss Qiu, *Guanyin and Longnu,* Ming dynasty. Leaf from an album of twenty-four leaves, *Portraits of Guanyin.* Gold ink on dyed paper, 11⅝ × 8¾ in. (29.5 × 22.2 cm). Herbert F. Johnson Museum of Art, Cornell University, Ithaca, New York.

(not pictured here). The landscape setting consists of frothy waves lapping against a rocky outcrop, reminding viewers of Mount Putuo (Sanskrit: Potalaka), the island believed to be Guanyin's sacred home.

The name "Guanyin" literally refers to this *bodhisattva*'s capacity to "observe the sounds of the world." The *bodhisattva*'s **iconography**, notably the elaborate jewelry, remains fairly consistent across time and space (see Figs. 8.19 and 9.1). But in responding to prayers, this merciful *bodhisattva* could appear in a variety of forms. The other twenty-three images that make up Miss Qiu's album demonstrate the *bodhisattva*'s capacity to take whatever form—young or old, male or female—necessary to rescue supplicants from peril. Some basis for Guanyin's gender fluidity was laid centuries earlier in *sutras*, but beginning in the eleventh century, non-canonical texts and artwork interacted dynamically to remake the image of Guanyin, the Bodhisattva of Infinite Compassion, as female. A female image emphasized Guanyin's appeal to women hoping to conceive children or praying for safe childbirth. But, regardless of form, Guanyin is recognizable by the presence of a miniature figure of Amitabha **Buddha** (the buddha who presides over the Western Pure Land, a Buddhist paradise, see Figs. 6.9 and 6.16) in the crown.

In this era, **seals** (sometimes called "chops") found on artworks can indicate authorship when affixed by artists, ownership when affixed by collectors, or judgment when affixed by connoisseurs. Two seals on this album belong to a woman, XIANG Li, attesting to her religious piety and also suggesting a female audience for paintings by women artists in an art world otherwise dominated by men. Her husband, XIANG Yuanbian, was a wealthy businessman and noteworthy art collector. For several years, Xiang Yuanbian and Qiu Ying enjoyed a mutually beneficial relationship. Xiang provided housing and access to his extensive collection of antique paintings, and Qiu made artwork and tutored the Xiang children. The close relationship between Miss Qiu's father and his patron probably benefited Miss Qiu, too. Her album of images of Guanyin demonstrates familiarity with religious subject matter and fluency with brush and ink.

In the Late Imperial period, women constituted an expanding consumer population. Supported by a booming economy, rates of literacy rose and the publishing industry flourished, creating a virtuous cycle that greatly benefited female readers and writers. These trends merge in a set of illustrations for an edition of *The Story of the Western Wing* published in 1640 (**Fig. 12.7**), a popular play about the romance between a scholar, ZHANG Sheng, and a beauty, CUI Yingying, also known as Oriole. Whereas standard book illustrations were **monochromatic** and pictured protagonists directly, this edition by publisher MIN Qiji (born 1580, died after 1661) is multicolored and features more complex strategies of representation. This illustration (number 19 of 20) uses a variation of **isometric perspective** and a graphic style consisting of fine outline and bright colors. By mimicking styles of professional painters such as Qiu Ying (see **Fig. 12.5**), this album distinguished itself as a luxury object for wealthier viewers. In addition, the most sophisticated Ming audiences were familiar with seeing pictures-within-pictures, and

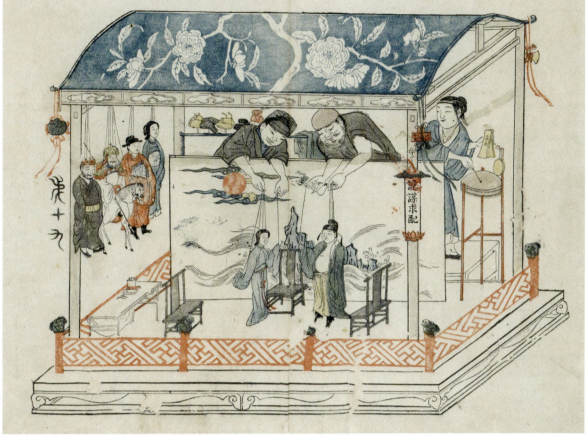

they delighted in this and other leaves from this album, which incorporated **material culture**—maps, lanterns, ceramics, stationery, jade bracelets, and so forth—into the retelling of the romance.

This illustration cleverly stages the drama's penultimate act as a puppet performance, a popular form of dramatic entertainment. The stage props—a painted screen, three plain chairs, and a long writing table—give the setting a refined, scholarly air. Two puppeteers manipulate marionettes representing Oriole's maid and Zhang's chief rival. To the right, a musician provides percussive accompaniment by playing clappers and a drum. At left, four puppets hang by their strings. Two of the four, Oriole and Zhang (wearing a blue robe and a red robe, respectively) watch and wait, like spectators hoping for a happy ending.

Not all commodities during the Ming dynasty were produced for domestic consumers. Merchants from the region around the Indian Ocean, the Arabian peninsula, and Europe traded in Ming goods, notably **porcelain**. Since Neolithic times (*c.* 4000–*c.* 2000 BCE and earlier), ceramics had been manufactured in locations throughout East Asia (see Figs. 1.3, 1.4, and 1.5). Low-fired **earthenware** was the basis for developing glazed stoneware, which required higher temperatures, but resulted in a harder and less porous product. Porcelain called for even higher temperatures and a special clay, kaolin, but the extra fuel and effort yielded a finer product: porcelain could be made quite thin without compromising its integrity, and the white body provided a neutral ground for colorful decoration (**Fig. 12.8**).

12.8 **Vase,** Ming dynasty, 1506–21. Porcelain painted in underglaze blue, height 6½ in. (16.5 cm). Victoria and Albert Museum, London.

material culture the materials, objects, and technologies that accompany everyday life.

porcelain a smooth, translucent ceramic made from kaolin clay fired at very high temperatures.

earthenware pottery fired to a temperature below 1,200 degrees Celsius; also called terra-cotta.

The earliest examples of porcelain date to the Tang dynasty (618–906), but widespread manufacture and export grew markedly during China's Late Imperial period. Blue-and-white designs developed during the Yuan dynasty (see Fig. 8.12) and appealed especially to consumers in West Asia, where the color combination

Individual human beings often seek to distinguish themselves from the general populace, and one means to this end is through acquiring distinctive things, such as works of art. When economies grow and commodities proliferate, people look to experts for guidance. In Late Imperial China, novice art collectors relied on connoisseurs. The connoisseur's keen eye and decisive opinion informed the categorization and ranking of an astonishing array of items that could be bought or sold, traded or gifted, proudly displayed or discarded with embarrassment. In the field of painting, one man's judgment outweighed others': DONG Qichang (1555–1636).

The fame of Dong, a government official, rests on his artistic activities, which included calligraphy and painting. He came to artistic maturity when the Chinese tradition of landscape painting was well over five centuries old. Chinese painters had already mastered illusionism, connected painting to poetry, rejected naturalism, developed archaism, created individual styles, and used abstraction to express subjective experience (see Chapter 8). In Dong's time, artists painted in a variety of styles, and expanding markets contributed to a blurring of boundaries between popular and elite artwork.

Dong lamented what he perceived as a descent into vulgarity. To counter this trend, he created a theory of painting, which he called the "Southern and Northern Schools." Using styles and social hierarchy, he constructed two artistic lineages. He grouped professional artists who worked in meticulous, fine styles, in the Northern School. In the Southern School, he placed amateur artists— such as Shen Zhou and other Wu school painters—who preferred

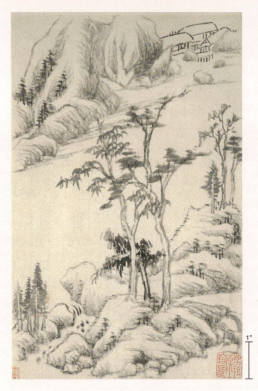

12.9 Dong Qichang, *Landscapes after Old Masters*, Ming dynasty. Leaf from an album of eight leaves: ink on paper, 9⅝ × 6⅜ in. (24.4 × 16.2 cm). Edward Elliott Family Collection. Gift of Douglass Dillon, 1986. Metropolitan Museum of Art, New York.

abstract and expressive approaches. Dong favored the Southern School, and his ideas privileged his own work, along with those of the scholar-amateurs and literati, at the expense of professional artists. The posthumous reputations of such artists as Qiu Ying (whom Dong did, in fact, praise) suffered when Dong's writings became widespread and bluntly applied.

Dong's own paintings are characterized by highly abstracted forms, calculated visual tensions, and references to earlier masters in his Southern School. Dong modeled his composition and brushwork in this leaf from an album, *Landscapes after Old Masters* (**Fig. 12.9**), after a Yuan dynasty painter, NI Zan (see Fig. 8.16), but Dong's landscape moves further away from the natural world. The ground plane tilts unsettlingly, and his manner of shading results in deliberately impossible rock formations. To viewers seeking naturalism, he retorted that painting cannot equal nature for the marvels of mountains and water, but nature cannot equal painting for the marvels of brush and ink.

As a collector and connoisseur, Dong wrote colophons (inscriptions on paintings) that expressed such judgments about the work of other artists, such as "the number one Dong Yuan under heaven," an assessment that is still preserved on the mounting of *Wintry Groves and Layered Banks* (see Fig. 8.1). In a world of abundance, Dong dispensed advice to painters and guidance to art collectors, in both cases drawing distinctions among myriad commodities.

Discussion Questions

1. Compare the attitudes and paintings of Dong Qichang to those of Shitao (discussed later in this chapter). How does each position his artwork in the history of Chinese painting?

2. Does Dong Qichang's placement of artworks into specific categories remind you of similar categorizations in other eras and places? Explain.

orthodox in Chinese landscape painting, the style advocated by Dong Qichang; typically executed in ink only or with limited, light colors, such paintings tend to be abstract, relying on schematic conventions for rendering rocks, mountains, trees, and buildings, and often make reference to earlier painters' styles.

originated and where the cobalt for the blue pigment was mined. This small vase (**Fig. 12.8**) has a flared foot, a spherical body, and a long, straight neck. Floral patterns adorn all three parts and draw attention to a medallion centered on the neck. Interlaced vines frame Arabic script reading "Al-Jalil," one of the ninety-nine names of God in Islam. Whereas the floral motifs derive from a common decorative vocabulary suitable for many consumers, the writing indicates that the vase was designed for audiences among Muslim communities within and outside the Ming Empire. This market differentiation for blue-and-white porcelain attests to the mass production of goods for global export (see Seeing Connections: Blue-and-White Porcelain around the World, p. 241).

Ming porcelain was but one item in the global circulation of things, ideas, and people at the time. Although Ming maritime expeditions ceased not long after Zheng

He's death, and imperial governments focused attention on land-based matters, nevertheless trade and travel continued and intensified over time. In the mid-sixteenth century, the Portuguese established a commercial port in Macao (see Fig. 9.17). In 1601, the Jesuit Matteo Ricci (1552–1610) came to the Ming court at the invitation of the emperor to contribute to his longstanding interest in astronomy, a field of knowledge related directly to record-keeping and political legitimacy. Ricci's impact not only as a missionary but also as a cultural interpreter is preserved in a European illustrated book (see Seeing Connections: Images of Orientalism, p. 261).

The Ming-Qing Transition

In 1644, Manchu forces captured the Ming capital of Beijing and established a new dynasty, the Qing. The Ming court retreated southward, and loyal officials rallied

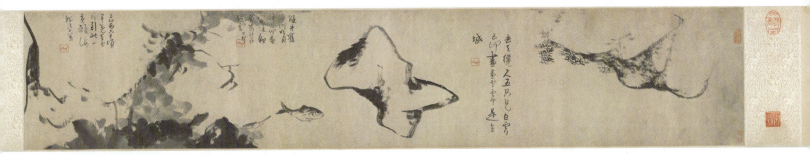

around first one Ming prince and then another, but the Qing forces quashed all attempts at restoration. Yet Qing victory did not end expressions of loyalty to the vanquished Ming. Though references to the Ming dynasty were perceived as treasonous, such painters as Bada Shanren devised ways to express their views.

Born a prince of the Ming imperial family, ZHU DA (1626–1705), also known as Bada Shanren, a name meaning "Mountain Man of the Eight Greats," escaped Manchu persecution by hiding his identity, leaving his family, feigning insanity, and becoming a Buddhist monk. He became an artist, too, painting monochromatic landscapes in the **orthodox** style and **flower-and-bird** subjects that favored strangeness over conventional beauty.

Bada Shanren's painting *Fish and Rocks* (**Fig. 12.10**), a short **handscroll** dated *c.* 1691, begins at right with an overhanging rocky mass edged with chrysanthemums. As the scroll unrolls to the left, an oddly shaped rock appears as if suspended. A fish gazes at the rock, while a smaller one darts toward a mass of lotus leaves to the left. Bada's approach to painting was calligraphic and abstract. His technique combined thick, dry brushstrokes for contours with wetter blots for texture and foliage. He used finer lines, too: blunt ones for flower petals and curved ones for fish bellies. Forms were simplified, but Bada's artwork was not simple.

Bada Shanren arranged the painting's motifs in a deliberately disorienting manner, with rocks levitating, fish seen from the side, and flowers growing downward. His representation of a topsy-turvy world is further expressed in three poetic inscriptions placed within the composition. The first poem reads:

> Separated from heaven by only a foot and a half,
> All that is seen are white clouds moving.
> You say why paint yellow flowers?
> Among the clouds is a golden city.

As a Ming prince, Bada Shanren was once only "a foot and a half" from heaven, or the imperial throne. "Yellow flowers" and "golden city" also refer to the Ming dynasty. But his painted flowers grow upside-down, and his poem's city is lost among the clouds. Thus, Bada Shanren drew on a long-established literati tradition of combining poetry, calligraphy, and expressive painting (see Figs. 8.14 and 8.16) to give form to the distressing experience of identity loss. Many of his paintings include cryptic inscriptions, clear enough to suggest his political sympathies to the Ming dynasty but sufficiently ambiguous to avoid censorship.

Not the only Ming prince to survive dynastic transition, Bada had a younger, distant cousin named ZHU RUOJI (1642–1707), who went by numerous names, including Shitao (meaning "Stone Wave"). A toddler when the Ming dynasty collapsed, Shitao came to maturity as the Qing consolidated power. Like his cousin Bada, he took refuge in Buddhist monasteries. But driven by his ambitions in the realms of religion and art, he sought an audience with the emperor in 1684 and remained in the capital Beijing for several years. Having met with the emperor but failed to secure imperial sponsorship, the disappointed Shitao returned to the south, where he settled in Yangzhou, and eked out a living as a painter. As a result of traveling widely, he was able to draw on his familiarity with several regional painting traditions. Fiercely independent, he defied categorization, famously declaring that the "whiskers and brows of the ancients cannot grow on my face.... Although sometimes [my paintings] might resemble those by another, it is he who follows me, and not I who deliberately imitate him."

Shitao painted this self-portrait (**Fig. 12.11**) in his early thirties. Wearing monk's attire, he supervises a monkey and a young assistant, who together use a shoulder pole to carry a pine sapling. Shitao's self-portrait represents both the external, corporeal appearance, as well as his internal, mental life. He used a fairly naturalistic approach for depicting facial features, thereby rendering a particular, identifiable visage. His posture—upright yet relaxed—communicates both informality and watchfulness. Shitao treated other motifs in a more abstract and generalized

12.10 Bada Shanren, *Fish and Rocks*, **detail,** Qing dynasty, *c.* 1691. Handscroll: ink on paper, 11. in. × 5 ft. 2 in. (29.2 cm × 1.58 m). Cleveland Museum of Art, Ohio.

flower-and-bird painting in East Asia, a genre of painting that includes vegetable, avian, and insect subjects.

handscroll a format of East Asian painting that is much longer than it is high; typically viewed intimately and in sections, as the viewer unrolls it from right to left.

12.11 Shitao, *Self-Portrait Supervising the Planting of Pines*, **detail,** Qing dynasty, 1674. Handscroll: ink and light color on paper, 15. in. × 5 ft. 7 in. (40 cm × 1.7 m) National Palace Museum, Taipei.

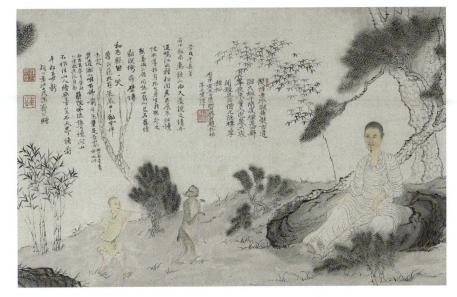

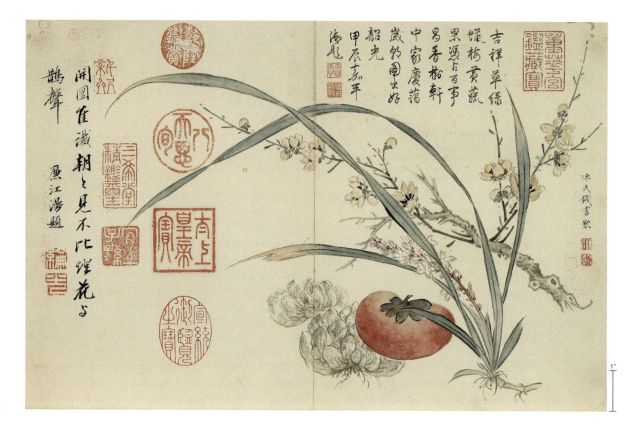

woodblock a relief printing process where the image is carved into a block of wood; the raised areas are inked. (For color printing, multiple blocks are used, each carrying a separate color.)

vanishing point when discussing perspective in two dimensions, the point on the horizon at which parallel lines seem to converge and disappear.

ruled-line painting using rulers and compasses to render architecture and other complex, engineered structures with meticulous care.

linear perspective a system of representing three-dimensional space and objects on a two-dimensional surface by means of geometry and one or more vanishing points.

manner, relying on long-standing patterns of handling brush and ink. These motifs—which include the scaly bark of the pine trees, the bamboo leaves, the rock's rough surface, and his robe's loose folds—contribute significantly to the construction of Shitao's self-image. His costume and accessories, such as his staff, communicate religious identity and a degree of authority, and the pine and bamboo are associated with longevity and integrity, respectively.

The activity of planting pines and the addition of a trained monkey are unusual. Shitao's choice implies not only unconventionality in general, but also a particular, symbolic meaning. The planting of pines depicted here was part of a larger project in which Shitao participated: restoring the grounds of a Buddhist temple. That restoration alludes to yet another—the restoration to power of the Ming dynasty.

Whereas the Ming–Qing transition influenced the lives and artwork of Bada Shanren and Shitao, by the time CHEN Shu (1660–1736) was born, the Qing dynasty had consolidated its rule, which meant that Chen could benefit from a stabilized and growing economy. Moreover, as the competition for limited positions in the government bureaucracy stiffened, the education of daughters along with sons became increasingly important. Intelligent daughters, elite families reasoned, would make the best mothers for preparing sons to pass the imperial examinations and to become ministers of state. This pattern precisely describes the life of Chen, whose successful and dutiful son secured her reputation. (A similarly dutiful son preserved the reputation of the early Joseon woman painter, Saimdang: see Chapter 9.)

Chen painted in a variety of genres and styles, such as landscapes in the orthodox manner, religious figures (including Guanyin), narrative figure paintings, and meticulously fine-lined flower-and-bird compositions. She used a looser, more calligraphic approach for a painting of visual and palatable delights in artwork suitable for holiday gift-giving (**Fig. 12.12**). In *Auspicious Flowers*, edible lily bulbs combine with a persimmon to form a homophonous message (a play on words that share pronunciation but have different meanings): "May a hundred matters unfold as you wish." To the (viewer's) right of the grayish clusters of lily bulbs and bright, red-orange persimmon, Chen depicted an orchid plant and a branch of blossoming plum—plants that literati prized for their subtle scent and perseverance, respectively. These flowers, which add contrast in shape and texture in Chen's painting, frequently appear in pictures celebrating the new year.

Chen placed her signature and seals at the right edge of the page, where they do not detract from the painting. The inscriptions and seals of later collectors occupy more space. These subsequent additions disrupt the careful balance of the artist's original composition, but they provide historical documentation and testify to the painting's continued value. The poetic inscription at the upper right, as well as several prominent seals, belong to the Qianlong emperor, discussed later in this chapter.

Late Imperial Cities: Suzhou and Beijing

Throughout China's Late Imperial period, cities were engines of economic growth, and by bringing patrons and artists together, they acted as crucibles for art. Although the city had been represented in art by the Song period (see Fig. 8.5), urban images now reached an audience well

outside the imperial court. **Woodblock** print technology made this bird's-eye view featuring a gate to the city of Suzhou (**Fig. 12.13**) popularly available.

As announced by the title in the upper-right corner of the composition, *Three Hundred and Sixty Trades* focuses on the city's tremendous economic productivity. The print's visual rhetoric may be described as "more is more." In the foreground, customers meander among many shops and restaurants outside the city moat. In the middle ground, boats laden with merchandise signify the important role of water transportation. A city of canals, Suzhou benefited from its proximity to the Yangtze River, which conveyed Suzhou's luxury commodities, such as books, silks, and paintings, to markets in Beijing and elsewhere. Finally, in the background, the commercial thoroughfare stretches from the gate beyond a sea of rooftops to a **vanishing point** on the distant horizon.

Like artists working in the **ruled-line painting** tradition (see Fig. 8.5), the unknown print designer demonstrated attention to detail, as in the construction of the masonry gate and the inscription on every shop sign. In addition, the artist adapted the foreign technique of **linear perspective**. Here, the purpose for employing linear perspective was less about scientific knowledge and more about imparting an exotic quality to the print. Such

12.13 Unknown artist, *Three Hundred and Sixty Trades,* Qing dynasty, 1723. A pair of polychrome woodblock prints representing the area near Changmen, one of the gates of the city of Suzhou, 42¾ × 22 in. (1.09 m × 55.9 cm). Umi-Mori Art Museum, Hiroshima, Japan.

12.14 ABOVE **Forbidden City, Beijing.** 3,150 × 2,460 ft., 178 acres. (c. 960 × 750 m, 72 hectares).

12.15 RIGHT **Hall of Supreme Harmony,** Ming dynasty, 1406, rebuilt Qing dynasty, 1697. Height 115 ft. (35 m). Forbidden City, Beijing.

low relief (also called bas-relief) raised forms that project only slightly from a flat background.

facade any exterior face of a building, usually the front.

bay a space between columns, or a niche in a wall, that is created by defined structures.

polychrome displaying several different colors.

hip roof a roof that slopes upward from all four sides of a building.

thangka a Tibetan term for a painting on either cotton or silk cloth that can be rolled up like a scroll (in Nepali the same type of painting is called *paubha*); typical subjects include mandalas, portraits of revered teachers, and religious icons.

icon an image of a religious subject used for contemplation and veneration.

exoticism, combined with hand coloring and the subject matter's vitality, responded to contemporary urban taste for novelty and dynamism. Indeed, the appeal of *Three Hundred and Sixty Trades* reached beyond Suzhou, as indicated by the export of such prints to Japan in the Edo period (1615–1868).

Suzhou was wealthy and splendid, but it could not outdo the grandeur and power of the capital, Beijing. Established in the Yuan dynasty, Beijing grew in subsequent eras, and the imperial palace within—known, for reasons of strictly controlled access, as the Forbidden City (**Fig. 12.14**)—acquired its characteristic appearance in the Late Imperial period. Centuries-old principles of city building inform the Forbidden City's north–south orientation, use of walls and a moat to establish boundaries, limited and controlled access points, attention to symmetry, and stately architecture (see Fig. 6.6). City planners used geomancy (interpreting topography and environmental conditions; also

known as *fengshui*) not only to select the most auspicious sites for human habitation, but also to express political hierarchy, which granted the central position to the ruler. At the heart of the Forbidden City, the emperor assumed his exalted seat in the Hall of Supreme Harmony (**Fig. 12.15**).

Like many other structures in the Forbidden City, the Hall of Supreme Harmony was first erected in the Ming dynasty. It subsequently required rebuilding and renovation, but such maintenance has not fundamentally altered the use of materials and form of imperial architecture (see Figs. 6.9 and 6.13), and the activities performed there remained consistent.

A three-tiered marble platform with carved balustrades elevates the hall to a height well above the vast courtyard, giving the emperor a commanding position over grand assemblies of military and civilian personnel. Of the three staircases leading to the hall, the central one is widest. It is fitted with a ramp featuring elaborate

low-relief sculptures of dragons, reserving it for the emperor's exclusive use. The emperor sat in a palanquin (an enclosed seat used for transporting an individual) held aloft by servants walking on both sides of the ramp.

Relying on mass and height to impress viewers, the hall is painted in bright vermilion, with twelve wooden columns dividing the broad **facade** into eleven **bays**. The central bay is widest, while those at each end are narrower. Like the Parthenon in Athens, Greece, the Hall deviates subtly from regular geometry. The deviations are both visual and symbolic: narrowed bays at the edges generate visual density and enhance the appearance of strength, whereas the wider central bay emphasizes the emperor's position.

Elaborate, **polychrome** brackets support the two massive **hip roofs** of glazed yellow tiles. The brackets also allow the eaves to extend well beyond the column perimeter, and to arc gracefully. Along the ridges, glazed ceramic sculptures in the forms of mythical beasts and figures punctuate the hall's silhouette, demonstrate imperial rank, and provide apotropaic (possessing the power to ward off evil influences) protection.

The Power of Tibetan Buddhist Art

When founding emperor Shunzhi (ruled 1644–61) ascended the throne in the Forbidden City, establishing the Qing dynasty in 1644, military campaigns did not come to an end. Qing forces continued to fight loyalist rebellions, capturing the last Ming princes four decades later. In the meantime, westward, in what would eventually become the expanded sphere of Qing influence, a new geopolitical situation was taking shape in the areas of the Tibetan plateau and Mongolian steppe.

In 1642, Tibet was unified under the leadership of Nyawang Lobsang Gyatso, better known as the Fifth Dalai Lama (1617–82). Painted sometime after his lifetime, this brightly colored and finely detailed *thangka* surrounds the Fifth Dalai Lama with key episodes from his life (**Fig. 12.16**). The composition and style of this *thangka* traces back to Nepalese precedents (see Fig 5.19), but it is more elaborate and meticulously detailed. It also informed by Chinese traditions of representing sacred landscape (see Fig. 6.9).

Within a blue-green landscape, episodes from the life of the Fifth Dalai Lama are arranged in counter-clockwise beginning from the upper left, which pictures his descent from Mount Potalaka, the *bodhisattva* Avalokiteshvara's pure land. This event is marked, like others that are believed to be miracles, by the presence of a rainbow. After the unification of Tibet, the Fifth Dalai Lama initiated a fifty-year reconstruction of the monumental Potala Palace in Lhasa. In the lower left of the *thangka*, this structure with its distinctive "red palace" is set into a predominately white structure, or "white palace." On the right edge, the first Qing emperor welcomes the Dalai Lama in 1653 in a different architectural setting, the Forbidden City, characterized by rectangular enclosures punctuated by central gateways (see **Fig. 12.14**). In reality, this diplomatic meeting established a delicate and mutually agreeable balance between the Qing emperor, who practiced Tibetan Buddhism, and the Dalai Lama as a theocratic head of state. In the painting's upper right, the Potala Palace (named after Mount Potalaka) is depicted again as the setting of the Dalai Lama's death in 1682. The *thangka* is simultaneously an **icon**, a portrait, and a narrative picture. Depending on the audience's point of view, it may serve as the focus of religious ritual, commemorate a significant individual, or chronicle a life.

The *thangka's* composition is a variation of the **mandala** form (see Figs. 6.12 and 8.21), and it takes earlier Buddhist portraits as a model (see Fig. 5.19). The central deity here, though, is the Fifth Dalai Lama. Tibetan Buddhism maintains that the Dalai Lama (a title literally describing a teacher whose knowledge or wisdom is a great as the ocean) is an incarnation of Avalokiteshvara. In keeping with this belief, the *thangka* frames the central figure with a halo and **mandorla**. Tiny Buddhist deities

mandala typically comprised of concentric circles and squares, a spiritual diagram of the cosmos, used in Hinduism, Buddhism, and other Asian religions.

mandorla (in religious art) a halo or frame that surrounds the entire body.

12.16 Anonymous, *The Fifth Dalai Lama with Episodes from His Life,* eighteenth century. Pigments on cloth, 33⅜ × 20⅞ in. (84.8 × 53 cm). Rubin Museum of Art, New York.

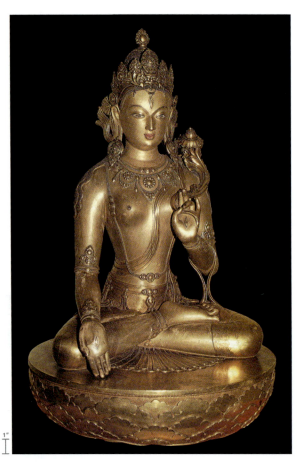

12.17 Zanabazar, *White Tara*, c. 1686. Gilt bronze, height 27⅛ in. (69.9 cm). The Fine Arts Zanabazar Museum, Ulaanbaatar.

on the palms of her hands distinguish her from other popular forms, such as the Green Tara. White Tara sits on a moon disk set upon a lotus pedestal, and she wears a five-pointed crown. She is bedecked with earrings, necklaces, and bracelets typically worn by *bodhisattvas*, and the icon itself has an exquisite quality reminiscent of jewelry. Note the scalloped edges of the lotus throne and the flourish at the shoulder. These stylistic features are particular to Mongolian Buddhist art of this period.

In his later years, Zanabazar established monasteries throughout Mongolia, including in the present-day capital of Ulaanbaatar. Despite his leadership, friction between Mongol tribes increased. In 1688, Zanabazar and his armies fled Dzungar (another Mongolian tribe) forces. The Qing offered protection, but also seized the opportunity to win control of areas—not only the Mongolian steppe but also the Tibetan plateau—that the Dzungars governed or, in the case of Tibet, had attacked. By 1720, Qing armies drove Dzungars from Tibet; by 1760, they completely defeated the Dzungars. Consequently, the Qing greatly expanded its territory.

The Qianlong Emperor and Art

The completion of military campaigns and consolidation of a heterogeneous empire occurred under the Qianlong emperor (1711–1799, hereafter "Qianlong"). Qianlong reigned continuously for sixty years, from 1736 to 1795, at a time when, elsewhere in the world, revolutions brought the United States of America into being and shifted the order of European nation-states.

Qianlong is remarkable for, among other things, his avid interest in art. Like his much earlier predecessor, Emperor Huizong of the Song dynasty, Qianlong practiced calligraphy, wrote poems, and collected widely. Qianlong included especially significant objects such as Huizong's *ru* ware narcissus planter (see Fig. 8.8) in a double portrait (see **Fig. 12.19**). More generally, he marked cherished possessions with seals and inscriptions. For example, Qianlong's seals appear on calligraphies attributed to Wang Xizhi and Su Shi (see Figs. 4.12 and 8.6), and his poem appears at the upper right of Guo Xi's *Early Spring* (see Fig. 8.4). These artworks appealed to him not only because they were beautiful and rare, but also because of their antiquity. They were collectible traces of the Chinese past. Through his art collection, Qianlong adopted the Chinese cultural past as his own and demonstrated stewardship over cultural heritage, thus lending additional legitimacy to Manchu Qing rule.

Qianlong also collected more recent artwork, including the paintings of Chen Shu, a virtuous widow who reared her children according to Confucian principles. More than a sign of aesthetic taste, Qianlong's ownership of her paintings signaled an endorsement of ideal Confucian womanhood. Not surprisingly, Qianlong's inscription and several of his seals appear prominently on Chen's *Auspicious Flowers* (**Fig. 12.12**).

Imperial collecting and patronage expanded markedly under Qianlong. The imperial household employed legions of artists skilled in metal-working, woodworking, lacquer, textiles, architecture, garden design, painting, and printmaking. Most were subjects of the Qing dynasty,

sit in lotuses that emerge from ritual implements—*vajra* and bell—held in his hands. The Dalai Lama wears the yellow hat and saffron robes of his particular monastic order, the Geluk.

The power of Tibetan Buddhism had enormous appeal, as Buddhist beliefs in icons constituted a form of powerful magic that it was believed could protect armies and determine the outcome of battles. Such power was recognized not only by the Manchu emperors, but also and earlier by the Mongols. It was the Mongol chief Altan Khan who bestowed in 1578 the title "Dalai Lama" upon his teacher, who became known as the Third Dalai Lama. A similar teacher-disciple relationship formed between the Fifth Dalai Lama and Altan's great-nephew, Öndör Gegeen Zanabazar (1635–1723).

At a young age, Zanabazar demonstrated such exceptional intelligence and ability that as a teenager he was sent to study with the Fifth Dalai Lama. His stay in Lhasa coincided with the reconstruction of the Potala Palace, providing the talented youth ample opportunity to observe and learn from highly skilled artists, too. As a religious teacher, Zanabazar became a trusted spiritual advisor to the second Qing emperor, Kangxi (ruled 1661–1722); as an artist, he became Mongolia's greatest sculptor, celebrated for his bronze icons, such as this one of White Tara (**Fig. 12.17**). As distinct from Mahayana Buddhism, in which Tara is a deity (see Fig. 5.15), Tibetan Buddhism sees her variously as a female *bodhisattva* or female Buddha. In Zanabazar's gilt bronze icon, she takes the form of White Tara with her right hand in a **mudra** granting infinite generosity, and her left holding a pure, white lotus. Eyes

vajra a term meaning thunderbolt or diamond; in Hinduism and Buddhism, a ritual weapon with the properties of a diamond (indestructibility) and a thunderbolt (irresistible force) to cut through illusions that obstruct enlightenment.

mudra a symbolic gesture in Hinduism and Buddhism, usually involving the hand and fingers.

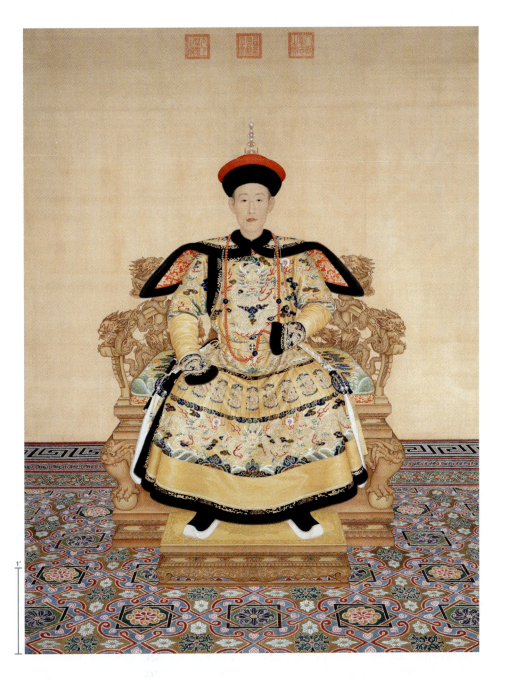

12.18 **Giuseppe Castiglione (also known as Lang Shining),** ***"Imperial visage" of the Qianlong emperor,*** Qing dynasty, 1736. Hanging scroll: color on silk, 7 ft. 2½ in. × 6 ft. (2.2 × 1.83 m). Palace Museum, Beijing.

but some were foreigners. Among the latter, Giuseppe Castiglione (1688–1766) was born in Milan and belonged to the Jesuit order of the Catholic Church. At the Qing court, Castiglione took the name Lang Shining, serving not one but three emperors, the last of whom was Qianlong. Qianlong's favorite portraitist, Castiglione painted this official representation of the fairly youthful emperor in resplendent regalia that combined Chinese and Manchu markers of imperial authority (Fig. 12.18). Dragons embroidered on Qianlong's robe and carved into his throne are longstanding Chinese symbols of the emperor; Manchu elements of Qianlong's costume include the hat, cape, and use of fur trim.

For this portrait, Castiglione drew on Chinese and European art traditions to create a style that is **intercultural**. In the Chinese tradition, he used a flexible brush to apply ink and colors onto silk. Additionally, the frontal pose while seated on a throne, the blank background, and the imperial seals impressed at the composition's upper edge are recognizable Chinese conventions. At the same time, the **orthogonal** lines of the carpet and the edges of the throne demonstrate understanding of linear perspective, a foreign invention. A European approach to **naturalism** is apparent in the use of light and shadow to model the elaborate dragons carved on the throne, as well as in the careful differentiation of textures, from the carpet's nubby fibers to the soft fur lining the imperial costume. Light reflects off the yellow satin robe, and slight shadows reveal how the fabric folds at the emperor's elbows and in his lap. For Qianlong's face, however, Castiglione used minimal shadows. From a Chinese point of view, dark shadows on the face signaled poor artistry, or, worse, inauspiciousness.

Castiglione's finely tuned combination of local and foreign approaches to image-making results in an arresting imperial portrait. It not only documents Qianlong's appearance but also attests to imperial command of the means and modes of representation.

intercultural in art history, contact between cultures and/or those artworks that draw upon and integrate two or more distinct cultures; it may also recognize the already eclectic nature of a given culture.

orthogonal when creating perspective in two dimensions, the diagonal parallel lines (visible or invisible) that recede from an object in the foreground or midground to a vanishing point on the horizon line.

naturalism representing people or nature in a detailed and accurate manner; the realistic depiction of objects in a natural setting.

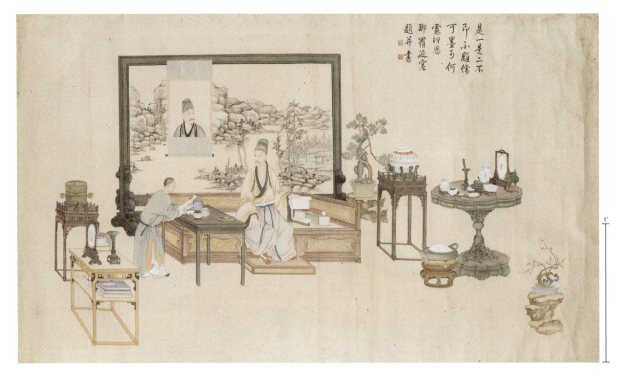

12.19 Anonymous, *One or Two?*, c. 1736–95. Affixed hanging for standing screen and colors on paper, 30⅛ × 58 in. (76.5 cm × 1.47 m). Palace Museum, Beijing.

Qianlong's command over representation is further documented by the sheer diversity of his portraits, including ones that place him like European leaders astride a horse, or—more in keeping with familiar East Asian pictorial conventions—as a *bodhisattva* at the center of a mandala. Qianlong assumes yet another guise, the role of a Han Chinese scholar, in this portrait-in-a-portrait known by the first line of its riddle-like inscription (**Fig. 12.19**):

One and/or two?
Not together, yet not separate.
Perhaps Confucian, perhaps Mohist,
Why worry, why ponder.

One or Two? emphatically situates Qianlong in literati tradition by means of the emperor's costume; the combination of calligraphy, poetry, and painting; and the visual reference to earlier compositions of scholars in their study (see Fig. 8.17). But whereas the literati exercised aesthetic selectivity, Qianlong was omnivorous. The array of objects—ancient and contemporary, two- and three-dimensional landscapes, various media, formats, and styles—offer opportunities to review the accumulated art history of the realm, but perhaps more significantly, they demonstrate his exertion of authority over all of it. The puzzling inscription extends that authority to philosophy, too. It invokes specifically the teachings of Confucius (551–479 BCE) and Master Mo (470–391 BCE). The answer to the and/or propositions lies in the Buddhist tenet of non-duality, which holds that separation between self and other—like other oppositions—is but an illusion. The central question posed by *One or Two?* is whether the picture presents one portrait (and one "real" sitter) or two portraits. In the original context, the "real" Qianlong emperor seated in front of the picture (which would have been affixed to a standing

screen), would have superseded both images of himself in the painting. Qianlong's presence would further substantiate, too, his capacity to comprehend philosophical paradoxes that caused others anxiety.

Qianlong's omnivorous approach to art extended to garden design. For many sites, he appropriated features found in the gardens of retired scholars, such as the artificial ponds, miniature mountains, meandering paths, and viewing pavilions in Lingering Garden (**Fig. 12.3a**). But in one of his gardens, Qianlong pursued a different, exotic aesthetic. At the Yuanmingyuan summer palace five miles northwest of the Forbidden City, a diverse team of artists and architects (including Castiglione), along with scientists and engineers serving at the Qing court, created the Eternal Spring Garden, consisting of buildings, fountains, and gardens based on European styles. Because these so-called "European palaces" were destroyed by British and French forces in 1860 during the Second Opium War, their appearance must be discerned from their remains and from artistic renderings, such as this print from a **copperplate engraving** (**Fig. 12.20**) by the Manchu court artist Ilantai (flourished c. 1749–93).

A student of Castiglione, Ilantai used European techniques of representation in the copperplate engraving, including linear perspective to create depth, and **cross-hatching** to model forms. The medium was foreign, too. Qianlong had previously commissioned from France copperplate engravings along with their original plates, but this set of twenty *Pictures of the European Palaces and Waterworks* by Ilantai was the first to be manufactured domestically, demonstrating the global circulation of art technologies and their adaptation at the Qing court.

As Ilantai's engraving shows, the west facade of the Calm Seas Palace—one of several buildings in Eternal Spring Garden—boasted masonry walls, **Corinthian capitals**, and ornately scalloped embellishments. Prominently featured, the elaborate fountain used sculptures of the

copperplate engraving a type of printing in which a smooth sheet or plate of copper is etched or engraved with a design and then ink applied onto the plate for printing.

cross-hatching a technique in which groups of close parallel lines are drawn or painted across one another; used to darken or infill an area within a design.

Corinthian an order of Classical architecture characterized by slender fluted columns and elaborate capitals decorated with stylized leaves and scrolls.

capital the distinct top section, usually decorative, of a column or pillar.

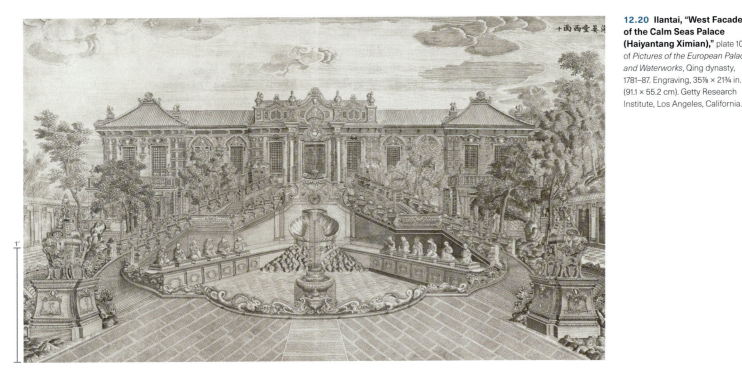

12.20 Ilantai, "West Facade of the Calm Seas Palace (Haiyantang Ximian)," plate 10 of *Pictures of the European Palaces and Waterworks*, Qing dynasty, 1781–87. Engraving, 35⅞ × 21¾ in. (91.1 × 55.2 cm). Getty Research Institute, Los Angeles, California.

twelve animals of the Chinese zodiac to tell time, with the horse spouting water to indicate eleven in the morning. At noon, all the animals would spout together. Even as Qianlong fashioned an image of "Europe" in a display of **Occidentalism**, so too did an image of "China" emerge in the eighteenth-century European imagination, giving rise to admiration, debate, distortion, and imitation. A vogue for objects and artworks described as *Chinoiserie*, such as blue-and-white porcelain with charming decoration, was part and parcel of **Orientalism** (see Seeing Connections: Images of Orientalism, p. 261).

In the 1750s Qianlong conquered areas of Inner Asia rich in natural resources. This jade sculpture (**Fig. 12.21**), more than seven feet high and the largest in existence, was made from a single, massive boulder hewn from quarries near the Inner Asian city of Khotan. The sculpture depicts the work of the legendary sage king Yu, who is credited with taming the waters. Diligent and untiring, Yu surveyed the land and rivers, connecting roads and channels, building embankments, and clearing headwaters until the empire was ordered, thereby establishing peace and prosperity. Transformed into a mountain landscape, this sculpture features not important sages or noble recluses, but rather teams of laborers driving chisels with mallets, heaving levers, and clearing rubble amidst the trees and rocky ledges. As a medium, jade provided a verdant color for this ideal landscape and invoked longstanding associations with eternity and golden ages of the distant past (see Figs. 1.7 and 1.8). Qianlong commissioned this sculpture, and in response to a painting on the same subject in his imperial collection, he wrote:

> One looks up to Yu's dignity and appreciates his calluses, for one not only knows him as a hydraulics leader and dynastic founder but also sees him climbing mountains and cutting woods. Thus one is filled with both veneration and admiration.

Occidentalism refers to non-European cultures conceiving of European cultures in stereotyped ways, attributing either romanticized or negative qualities to them.

Chinoiserie objects and images characterized by European tastes and ideas about China.

Orientalism refers to European cultures conceiving of North African, West Asian, and Asian cultures in stereotyped ways, attributing either romanticized or negative qualities to them.

12.21 *Yu the Great Taming the Waters*, Qing dynasty, completed *c.* 1787. Jade sculpture, height 7 ft. 4⅛ in. (2.24 m), 5⅞ tons (5.3 tonnes). Palace Museum, Beijing.

As artisans were shaping the jade boulder's simulated channels, Qianlong brought to completion a major diversionary canal begun seventy-five years earlier by his grandfather. Like paintings of monumental landscapes or auspicious omens (see Figs. 8.4 and 8.7), this massive jade boulder attests to the connection between art and political legitimacy. In this case, the source of that legitimacy derives explicitly from human activities that re-form nature to meet human objectives.

The Late Imperial period, beginning with the Ming dynasty, reached its apogee during the reign of Qianlong. A dynamic and growing economy provided the context for a tremendous variety of artwork and architecture. The court continued to be a major patron, artwork such as Miss Qiu's album continued to meet religious needs, and the literati continued to express their values and identity through cultural forms. Interest in art grew among lower-ranking social groups, including women, who put forth their points of view and spurred reactions from elite connoisseurs. Geopolitics in the seventeenth century affected many regions and peoples, bringing new prominence to Tibetan Buddhist art and giving rise to careful expressions of ambivalence toward the Manchu Qing dynasty. New technologies of image-making and contact with foreign cultures contributed to novel forms of art. Under the Qianlong emperor, the might and wealth of the Qing dynasty were undisputable, and things European were easily managed and even charmingly domesticated, as in the European Palaces and Waterworks. In the centuries to come, however, contact with Europeans would prove significantly more challenging, and artists would channel their talents to critique government failures and social ills, and to effect change.

Discussion Questions

1. In Late Imperial China, what kinds of prints were made, for whom, and why?

2. This chapter features paintings by male and female artists. It also includes images of a variety of individuals. Select two or three artworks to discuss how they construct gender.

3. Some artworks in the Ming and Qing dynasties advanced political agendas; others expressed dissenting views. Using examples from this chapter, explain how political power (or objection to political power) was expressed.

4. Further research: the vigorous economy of the Late Imperial period supported a great many painters, far more than this chapter could discuss. Find another painter active in the Ming and/or Qing period. Compare an artwork by that painter to one(s) in this chapter.

Further Reading

- Clunas, Craig. *Empire of Great Brightness: Visual and Material Cultures of Ming China, 1368–1644*. Honolulu, HI: University of Hawai'i Press, 2007.

- Debreczeny, Karl. *Faith and Empire: Art and Politics in Tibetan Buddhism*. New York: Rubin Museum of Art, 2019.

- Rawski, Evelyn S. and Rawson, Jessica (eds.). *China: The Three Emperors, 1662–1795*. London: Royal Academy of Arts, 2005.

- Weidner, Marsha. "The conventional success of Ch'en Shu." In Marsha Weidner, ed. *Flowering in the Shadows: Women in the History of Chinese and Japanese Painting*. Honolulu, HI: University of Hawai'i Press, 1990.

- Yü, Chün-fang. "Guanyin: the Chinese transformation of Avalokiteshvara." In Marsha Weidner, ed. *Latter Days of the Law: Images of Chinese Buddhism, 850–1850*. Lawrence, KS: Spencer Museum of Art, University of Kansas; Honolulu, HI: University of Hawai'i Press, 1994.

Chronology

1368–1644	The Ming dynasty	1640	Min Qiji publishes a deluxe illustrated edition of *The Story of the Western Wing*
1405–33	Ming Admiral Zheng He voyages to Southeast Asia, South Asia, the Arabian peninsula, and East Africa	1644–1912	The Manchu Qing dynasty
1406	The Hall of Supreme Harmony is constructed in the Forbidden City	1660–1736	The life of model Confucian mother and artist Chen Shu
1414	The Imperial Painting Academy is re-established	1674	Shitao paints his self-portrait *Supervising the Planting of Pines*
1436	Blue-and-white porcelain resumes production after a gap of about eighty years	c. 1686	Zanabazar sculpts *White Tara*
1555–1636	The life of official, artist, and connoisseur Dong Qichang	1715–66	The Jesuit painter Giuseppe Castiglione (aka Lang Shining) serves at the imperial court
1593	The Ming official Xu Taishi commissions Lingering Garden	1736–95	The reign of the Qianlong emperor
1601–10	The Jesuit artist Matteo Ricci (b. 1552) arrives at the Ming court and spends the remaining duration of his life in China	1781–87	Ilantai makes the engravings *Pictures of the European Palaces and Waterworks*
		1787	The carving of the jade boulder *Yu the Great Taming the Waters* is completed

Images of Orientalism

Today we consider the term "the Orient" to be outdated; yet for many, this geographic descriptor still evokes vague but potent images of distant lands. For some, those lands are China, Japan, and Korea; for others, India and Indonesia. Yet others imagine Arabia and North Africa. Such variation compels us to think critically about whether "the Orient" actually refers to a specific place.

In considering this matter, the scholar Edward Said (1935–2003) saw that answers corresponded to geo-political viewpoints, such as those held by the French military leader Napoleon Bonaparte (1769–1821), by officials of the British Empire, or by the United States government during the post-World War II era. In short, Said argued that "the Orient" is a fiction. It denotes not a location, but a relationship born of western European (and later U.S.) imperial agendas and intent on exercising power over people living elsewhere. Said also believed that the application of these agendas required not only military force, but also an ideology, or set of ideas constituting a worldview, that justified one people ruling over another. This ideology he called "Orientalism." Thus, Orientalism depended on many outside the military, including scientists and missionaries whose efforts could justify imperialism by adding knowledge and saving souls. Orientalism depended, too, upon images that constructed relationships of unequals.

In the seventeenth century, many Europeans learned indirectly about China and Chinese things through an encyclopedic book, *China Illustrata*, by the German Jesuit and polymath Athanasius Kircher (1602–1680). Based in Rome, Kircher did not travel to China himself, but instead had access to firsthand accounts by fellow Jesuits, such as Matteo Ricci (1552–1610). In one of many engravings Kircher made for his book, Ricci stands at left opposite Paul Xu Guangqi, an early Chinese convert to Catholicism (**Fig. 1**).

In this engraving, Kircher used the image of the Virgin and Child at the top of the composition and the crucifix at the center to grant Christianity the highest authority. At first glance, the two men may appear to be portrayed as equals. During the seventeenth and eighteenth centuries, the wealth and power of

1 Athanasius Kircher, *Matteo Ricci and Paul Xu Guangqi,* from *China Illustrata*, 1667. Page height: 12⅝ in. (32 cm). **EUROPE**

the Manchu Qing dynasty impressed Europeans. It was the source of desirable goods such as tea, silk, and porcelain (see Seeing Connections: Blue-and-White Porcelain around the World, p. 241). With its vast bureaucracy of scholar-officials, the Qing was also a formidable example of rational government, inspiring European Enlightenment thinkers. Still, Christianity was

considered a European religion, and, when examined closely, it becomes clear that Kircher's print gives Ricci the upper hand, literally and figuratively. Ricci's gesturing left hand connects to the crucifix, while Xu lowers his right hand submissively. The two folding fans imply that the Chinese man, and therefore Chinese culture, had only charming trinkets to offer in exchange for the blessings of the Church.

No European figure appears in Thomas and William Daniell's depiction of the rock-cut Shiva temple at Elephanta, an island off present-day

2 LEFT **Thomas and William Daniell, "Part of the Interior of Elephanta,"** plate 8 from *Antiquities of India*, the fifth set of *Oriental Scenery*, 1800. Colored aquatint print. British Library, London. EUROPE

3 BELOW LEFT **Artist unknown, "Approaching,"** (from an unidentified series) of *Japanese Geisha and Chinese Man*, late Meiji era, postmarked 1904. Collotype with hand coloring: ink on card stock, 3½ × 5½ in. (8.9 × 14 cm). Museum of Fine Arts, Boston, Massachusetts. EAST ASIA

disseminated through the new technology of photography (see Seeing Connections: The Spread of Photography, p. 300). In this hand-colored photographic postcard, which was mailed in France in 1904, a woman wearing Japanese-style costume stands behind a seated man (**Fig. 3**). His loose jacket and wide trousers are Chinese in style, and he wears his hair in a long braid, in conformity with Manchu Qing law.

The two figures act out a little drama in a theatrical setting with limited props: a heavy curtain, a European-style chair, a pamphlet, and a folding fan. Smiling, she raises her arm, and her sleeve falls enticingly. He seems unaware of her approach. In that regard, we the viewers have a privileged point of view. The figures put themselves on display for our enjoyment, and we anticipate the flirtation between this "Japanese geisha" and "Chinese man." However artificial the scene, the photographic medium encourages viewers to see it as reality. Thus, photographs become a powerful tool for transforming the complex lives of actual people in distant places into fanciful and superficial specimens for the Orientalizing gaze.

Discussion Questions

1. Compare the photographic postcard discussed here (**Fig. 3**) to the photographs discussed in Seeing Connections: The Spread of Photography, p. 300. What made photography a particularly powerful tool for disseminating Orientalist images?

2. How does Orientalism operate today? Find a recent artwork, advertisement, or movie clip to bring to a discussion on contemporary Orientalism.

Further Reading

• Dirlik, Arif. "Chinese History and the Question of Orientalism." *History and Theory* 35 (1996): 96–118.
• Ray, Romita. *Under the Banyan Tree: Relocating the Picturesque in British India.* New Haven, CT: Yale University Press, Paul Mellon Centre BA, 2013.
• Said, Edward. *Orientalism.* New York: Pantheon Books, 1978.

Mumbai (**Fig. 2**; for more on Elephanta, see Chapter 5). Two locals, signified by their dress and dark skin, along with several cows, give a sense of the temple's scale, which—while already impressive—has been exaggerated. Indeed, while the Daniells, who spent eight years traveling throughout South Asia, took pains to represent aspects of the monument accurately (such as the guardian figures flanking the doorways of the temple's inner sanctum), they nevertheless composed the scene to fit what is often classified as the colonial picturesque style. An aesthetic concept made popular in the late

eighteenth century by British writers and artists, picturesque refers to a landscape or scene that is appealing because of how it combines beauty with natural wildness or architectural ruins. Here, the asymmetrical composition, dramatic use of light and shadow, crumbling columns, and inflated scale mark the scene as picturesque. The aesthetic was particularly popular in the colonial context because it presented the conquered territory as in need of taming, modernizing, or saving.

By the early twentieth century, images of distant places and populations could be widely

13

Art in Early Modern Korea and Japan

1600–1900

13.0 Detail of Yi Taekgyun, *Books and Scholars' Accoutrements* (*chaekgeori*).

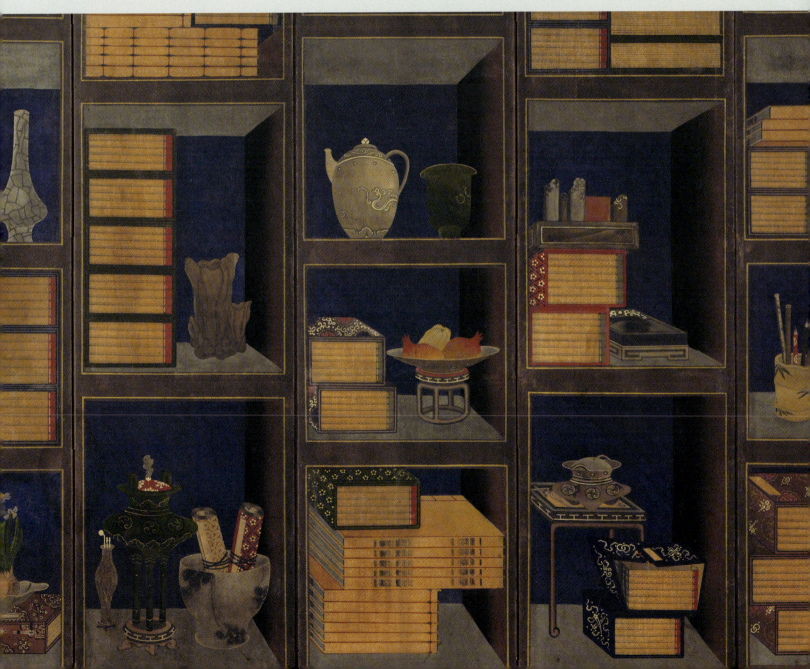

Map 13.1 Joseon Korea and Edo Japan, *c.* 1750.

literati in Confucian cultures of East Asia, the social group of educated men who would typically pursue government service as a career, but could also put their skills in reading, writing, and related arts to work through tutoring, writing, and painting.

jingyeong sansuhwa Korean "true-scenery landscape painting," or "true-view landscape painting" depicting real scenery on the Korean peninsula in styles demonstrating innovation and a degree of independence from earlier (Chinese) models (see also *shinkeizu*).

woodblock printing a relief printing process where the image is carved into a block of wood; the raised areas are inked. (For color printing, multiple blocks are used, each carrying a separate color.)

Daoism originating in China, a philosophy and religion that advocates pursuit of the Dao (the "Way"), as manifested in the harmonious workings of the natural world and universe; Daoist practice also includes worship of immortals and numerous popular deities.

Introduction

The late Joseon period (*c.* 1600–1910) in Korea and the Edo period (1615–1868) in Japan overlap with the Early Modern era of global history. Throughout the world, wealth and city-building issued from maritime trade and imperialism. But on the Korean peninsula and Japanese archipelago, economic growth and urbanization occurred under conditions largely separate from areas outside East Asia. Recognizing how threats had come from overseas, war-weary governments in both regions carefully calibrated their contact with foreigners. As another mechanism for social stability, they also advanced policies informed by Confucian values. While establishing a basis for general peace and prosperity, these measures did not prevent imported things and ideas from reaching domestic consumers. Nor did they eliminate tension and movement between classes. As a result, the mixture of wealth and social striving created crucibles for artistic innovation in both Korea and Japan.

During the late Joseon period, the court directly affected how art developed, by operating official kilns and commissioning work from artists of the Royal Bureau of Painting. The court's policy of confining outside contacts to diplomatic missions to Qing China and Edo Japan, along with its support of Neo-Confucianism, also altered the socio-cultural landscape by reconfirming the status of the class of civil officers called *yangban*, who had established themselves at the center of power in the fifteenth century. Late Joseon art documents their leisure activities and intellectual views, including an interest in empirical and practical learning. By the nineteenth century, however, increasing wealth among the middle and lower classes challenged the primacy of

Confucian values, such as frugality. Late Joseon artwork also attests to shifting patterns of wealth, along with a growing taste for rare and imported luxuries.

As in the case of late Joseon, in Japan Tokugawa government policies changed the conditions for art and culture, leading to, among other things, the flowering of diverse styles. Longstanding aristocratic taste was adopted by others outside the court, including the military. At the same time, popular culture flourished in rapidly growing cities, notably the capital, Edo (now Tokyo). Urban growth also presented problems, and the government made numerous attempts to enforce social hierarchy, minimize social mobility, and curb vice. Still, Edo's entertainment quarters offered a heady mixture of delightful pleasures to rich samurai and wealthy merchants. However cruel and exploitative the realities of the theater and the sex industries, well-known Kabuki actors and glamorous courtesans captivated Edo denizens and inspired artists, and with the development of inexpensive woodblock prints, images of these appealing figures reached audiences near and far.

Painted Views in Late Joseon Korea, 1592–1910

By the late sixteenth century, the Joseon dynasty (1392–1910) had already ruled for two centuries. During that time, Neo-Confucianism replaced Buddhism as the state religion, and Neo-Confucian beliefs, such as the importance of reciprocal social obligations (a primary example being that between a benevolent ruler and wise government officials) had taken root. Additionally, the *yangban* class of government grew in power and wealth, and their elite status and **literati** values were expressed in such artwork as meritorious portraits and landscapes in the An Gyeon style (see Fig. 9.6). Although members of the *yangban* embraced a common philosophy, they nevertheless formed political factions that weakened the government, making it vulnerable to foreign attack. Factional strife erupted before the 1592–98 Imjin Wars when Japanese Momoyama military leader Hideyoshi invaded Joseon. Joseon had not yet recovered fully when the Manchu army, which was pressuring Joseon to aid its conquest of Ming dynasty China, attacked the Korean peninsula in 1627 and again 1636. Although Joseon harbored a pro-Ming stance (the Ming had assisted Joseon during the Imjin Wars in beating back Hideyoshi's forces), in exchange for peace it recognized Manchu supremacy. Thus, the Joseon dynasty endured and, in time, flourished again. Wary of outsiders, it limited foreign contact to diplomatic missions to Beijing and Edo. But wariness mixed with curiosity, and the art of the later Joseon period reveals evidence of foreign inspiration along with innovation emerging from domestic socio-economic development.

Like art elsewhere called "modern," that of late Joseon Korea reflects an interest in individual experience, as well as a dynamic relationship between elite and popular cultures. The roles of the Joseon court and Buddhist temples as patrons and tastemakers did not disappear entirely,

but they yielded much of their authority to the *yangban* literati elite, the so-called "middle people" (*jungin*), and the *sangmin*, or commoners.

In the early Joseon period, artists such as An Gyeon drew inspiration from Chinese painters of the Song (960–1279) and Yuan (1279–1368) dynasties. By making references to canonical literature and emulating antique Chinese styles, An's artwork conferred prestige on collectors such as Prince Anpyeong. But in the late Joseon, JEONG Seon (1676–1759) presented an altogether new vision captured in the term ***jingyeong sansuhwa***, which may be translated as "true-scenery landscape painting" or "true-view landscape painting."

What distinguishes eighteenth-century "true-view landscape painting" from earlier landscapes? In part, it is the decision to portray real, local scenery, such as when Jeong painted the Diamond Mountains, the spectacular range east of the Joseon capital of Hanyang (present-day Seoul) (**Fig. 13.1**). Additionally, style plays a role. Jeong abandoned stylistic qualities associated with Song dynasty painting, such as reliance on ink wash to create subtle, atmospheric effects. Instead, he embraced a vocabulary of brushstrokes based on the aesthetic ideas of the Chinese Ming dynasty painter, theorist, and high official Dong Qichang (see Fig. 12.9), to represent places immediately recognizable to his viewers.

Using ink and pale colors, Jeong portrayed from a bird's-eye view the multitude of forested inner peaks and bare granite outer pinnacles that make up the Diamond Mountains. Close inspection reveals use of conventional brushstrokes: wavering lines for mountain contours and horizontally elongated dian (marks made by abbreviated touches of the brush, as distinct from lines or ink wash) for foliage. By Jeong's time, instructions for brushstrokes, along with canonical compositions, circulated throughout East Asia via **woodblock-printed** manuals of Chinese painting. Emissaries returning home brought such manuals, along with Chinese and European paintings, to the Joseon court, where Jeong may have seen them. Although the Joseon government felt loyal to the Ming and were suspicious of the Manchu conquest of China and the establishment of their Qing dynasty in 1644, interest in Qing culture grew throughout the eighteenth century, including the exchange between Qing China and Europe.

Yet *Panoramic View* does not resemble earlier local or foreign models. Instead, Jeong paid close attention to distinctive topographical qualities, such as the Diamond Mountains' abundance of the sharp, needle-like peaks and the promontory of Diamond Terrace near the composition's center. His inclusion of recognizable features—for example, the Jangan Monastery with its Bridge of the Flying Rainbow set into the valley foreground—suggests firsthand observation. Indeed, Jeong traveled to the Diamond Mountains more than twenty times. But at the same time, the composition's circular shape calls attention to the painting's artifice. Its circular composition is comprised of lighter and darker portions that recall the round, black-and-white *yin-yang* symbol of **Daoist** origin. Thus, the term "true scenery" encompasses two meanings that may seem opposed, but are resolved: first, the

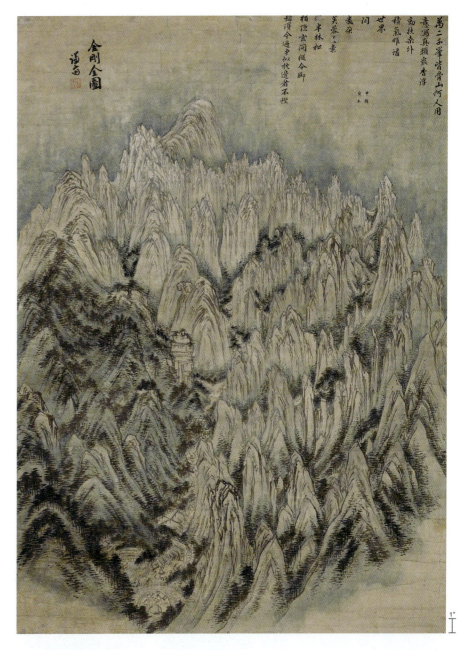

non-fictional site; and second, a preference for ideal, or exemplary landscapes.

Typical of East Asian painting traditions, *Panoramic View* bears texts. At top left, Jeong inscribed the title, signed his name, and affixed his **seal**. At top right, a later admirer took a cue from Jeong's composition to arrange a poetic inscription like an arch above a date, probably referring to 1794. The poem describes the difficult challenge of depicting the Diamond Mountains, here also called "All Bone Mountain":

Twelve thousand peaks of All Bone Mountain,
Who would even try to portray their true images?
Their layers of fragrance float beyond the *pusang* tree;
Their accumulated **qi** swells expansively throughout
 the world.
Rocky peaks, like lotus flowers, emit whiteness;
Pine and juniper forests obscure their entrance to
 the profound.

13.1 Jeong Seon, *Panoramic View of the Diamond Mountains (Geumgang-san)*, Joseon dynasty, late 1740s. Hanging scroll: ink and colors on paper, 40⅝ × 37 in. (1.03 m × 94 cm). Leeum, Samsung Museum of Art, Seoul.

seal either a small piece of hard material (stone) with an incised design, which is rolled or stamped on clay to leave an imprint; or the impression it leaves, generally of a person's name. Used in East Asia to signify ownership or authenticity, like a signature.

qi in Chinese philosophy, the vital force that animates life, being, and the cosmos.

This careful sojourn, on foot through Mount
 Geumgang,
How can it be compared with the view from one's
 pillow?

In lines 3 through 6, the admirer praised the mountains' superb traits: scents that surpass the legendary *pusang* tree, numinous energy, and terrain imbued with vitality. Jeong's impressive oeuvre of landscape paintings has led to ongoing questions about whether he worked as a court painter. Evidence clearly points to his appointment to several minor government positions, none of which was in the painting academy. But Jeong's artistic talent may have been the basis for promotions he received from King Yeongjo (ruled 1724–76), and he may have painted as a means to supplement his income, too. Jeong was born into an *yangban* family, and however impoverished they were, the prevailing social hierarchy privileged *yangban* over artists. Thus, even though Jeong's artistic accomplishments far exceeded his abilities as a government official, social pressures led him to focus on his official positions and literati affiliations. Jeong's patrons, too, avoided mentioning monetary payments when commissioning paintings so as to prop up his *yangban* status.

This tricky social situation continued to affect artists throughout the late Joseon period, including KIM Hongdo (1745–after 1806). Kim was a prolific artist, becoming especially known for **genre painting** although he also produced true-scenery landscape paintings. He was the favorite artist of King Jeongjo (1776–1800), and, as a court painter, Kim would have responded to requests for palace furnishings, royal gifts, and painted documentation of rituals and ceremonies (*uigwe*). The latter sometimes required numerous painters to collaborate on illustrated books, long handscrolls, and monumental, eight- or ten-panel screens that featured hundreds of figures hierarchically arranged in palace settings. The careful observation and meticulous detail required for such projects are apparent on a less grandiose scale in *Painting of Gyujang Pavilion* (**Fig. 13.2**).

For this painting, Kim used a high vantage point from which the viewer—ostensibly King Jeongjo himself—could see the entirety of the pavilion and its immediate environs. The main two-story building is elevated on a stone plinth and set within a gated courtyard. Vermilion-red columns and gables provide a bright contrast against the dark grey tiles of the **hip-and-gabled roof**. Outside the walls, trees create a lush, verdant environment, and a lotus pond closer to the foreground provides a place for gathering and relaxing. In the background, mountains rise above misty woods. Close inspection reveals the use of texture strokes for the distant peaks and wet, horizontal marks for the woods. The calligraphic approach here differs from the meticulous rendering of masonry structures or the colorful application of mineral-green pigments throughout the rest of the composition. In *Gyujang Pavilion* Kim blended a fine, polished style long associated with court painters with the vocabulary of brushstrokes associated with literati painters, such as Dong Qichang, which were published in woodblock-printed Chinese painting manuals and spread to other areas of East Asia.

The fusion of styles present in *Gyujang Pavilion* resonates with the painting's subject. In 1776, the year he ascended to the throne, King Jeongjo, a noted bibliophile and avid collector of Chinese books, established Gyujang Pavilion Library. Gyujang Pavilion Library housed not only books but also portraits of King Jeongjo's grandfather and predecessor, King Yeongjo, which suggest the Library's political importance. At Gyujang Pavilion Library, scholar-officials consulted books and also produced work related to government administration. Strategically for King Jeongjo, Gyujang Pavilion was located within the grounds of Changdeok Palace, allowing him to gather scholar-officials to advance his political priorities. Painted in 1776 and incorporating visual references to scholarly Chinese styles promoted in woodblock-printed books, Kim's *Gyujang Pavilion* probably commemorates the Library's founding. Seven years later, King Jeongjo would establish a system of painters-in-waiting at the Library. (Similar institutions of court painters-in-waiting operated in the Song and Ming dynasties; see, for example, Figs. 8.4, 8.9, and 12.1) Locating Joseon court painters at the Library, King Jeongjo made evident the close relationship between art and politics. Kim, however, would seek ways to overcome the limitations of his *jungin* status. Toward

13.2 Kim Hongdo, *Painting of Gyujang Pavilion,* Joseon dynasty, 1776. Hanging scroll: ink and colors on silk, 56⅜ × 45¾ in. (1.43 × 1.16 m). National Museum of Korea, Seoul.

1'

that end, he may have deliberately withheld his signature from court commissions. *Gyujang Pavilion* is the only court painting that bears a signature, inscribed in the upper-right corner, attesting to Kim's role as a court painter. By contrast, Kim inscribed his name on literati-style paintings, which promoted a scholarly image for himself.

Painted views of late Joseon Korea would not be complete without a closer look at the activities of *yangban, jungin,* and *sangmin.* Along with Kim Hongdo, SIN Yunbok (1758–1813) is known for genre painting, which brought relatively prosaic and humble subject matter newly into the realm of painting. In *An Amusing Day in a Field in Spring*, Sin depicted a social gathering outdoors (Fig. 13.3). *Amusing Day* is not overtly sensuous, but it does test the boundaries of decorum. In this **leaf** from an **album** of thirty images, a group of seven men of the rich upper classes, identifiable as married men by their distinctive black horse-hair hats, partakes in a pleasant outing. In the foreground, a musical trio plays the flute, a two-stringed fiddle, and a zither. Look carefully to see the two tuning pegs of the fiddle held by the musician seated in the middle. Among the audience, younger men and older men assume positions standing or seated, according to seniority. The older men are distinguished, too, by the immediate company of *gisaeng*, female entertainers or courtesans. Attractively attired and with upswept hair, the *gisaeng* appear less than excited about their male company. One turns away from the man beside her and wraps her arms around her knees; the other pauses between puffs on her pipe.

To perpetuate hierarchy and ensure social stability, *yangban* families observed strict social rules. Their sons undertook rigorous education to prepare for civil-service examinations. Examination success led to government positions, which secured the family's *yangban* status. Observing Neo-Confucian ideals of propriety, wives and daughters were sequestered. In this context, *gisaeng* represented a conundrum. They belonged to the lower class, yet they were often attractive, intelligent, talented and educated in dance, literature, painting, and calligraphy, and therefore entertaining to *yangban*. Like celebrated courtesans of the Edo period, *gisaeng* lived a life of paradoxes. They were both appealing and unenvied; they experienced great privilege but remained beholden to others.

Yangban Interests in Late Joseon Korea, 1592–1910

Besides being the subjects of art, *yangban* were themselves artists. For them, the most esteemed form of art was **calligraphy**, an artistic tradition that originated with the fourth-century Chinese calligrapher WANG Xizhi (see Fig. 4.12). The foremost Joseon calligrapher was KIM Jeonghui (1786–1856). Kim's powerful style suggests his life circumstances, which included nearly ten years' banishment to remote Jeju Island (see Map 13.1), but it also demonstrates deep study of language and writing, research that reached across boundaries to include scholars in Joseon Korea and Qing China.

The example here (Fig. 13.4) is a paired couplet (two lines of rhymed poetry) mounted as **hanging scrolls** that

13.3 ABOVE **Sin Yunbok, *An Amusing Day in a Field in Spring*,** Joseon dynasty, eighteenth century. Album leaf: ink and color on paper, 11⅛ × 13⅞ in. (28.3 × 35.2 cm). Gangsong Art Museum, Seoul.

13.4 LEFT **Kim Jeonghui, untitled calligraphy couplet,** Joseon dynasty, nineteenth century. Ink on paper, 49 × 11¼ in. (1.25 m × 28.6 cm). Leeum, Samsung Museum, Seoul.

leaf a single page from an album (a format of painting).

album a format of two-dimensional artwork, such as painting, calligraphy, or photography, in which individual leaves, or pages, may be bound together like a book to form an album.

calligraphy in East Asian painting, the formal, expressive properties of lines (e.g. thick/thin, dark/light, wet-dry) made with a flexible brush.

hanging scroll a format of East Asian painting that is typically taller than it is wide; generally, hanging scrolls are displayed temporarily and may be rolled up and stored easily.

could have been displayed on either side of a painting or doorway. Through text and style, Kim's couplet communicates his learnedness. He used Chinese characters (Korean: *Hanja*), writing: "Loving antiquity, I spend time collecting stele fragments / Researching the classics, for several days I fail to write poetry." The parallel phrases describe Kim as a scholar searching for the most ancient traces of calligraphy on stone **steles**. Some such traces predate Wang Xizhi, and they demonstrate a bold, monumental aesthetic driven in part by the tools and materials of steles—chisel and stone—as opposed to the fluidity and refinement of brush and ink.

To capture the boldness typical of steles, Kim used thick, unmodulated brushstrokes. He also compressed the strokes, reducing the blank spaces within characters, making most of them appear heavy and ponderous. But Kim's couplet offers visual relief, too, such as in the more spacious voids within words for "ancient" (古) and "days" (日). Varied proportions and alignments of brushstrokes result in a calculated awkwardness, which communicates artlessness or authenticity, especially when compared to the refinement of Wang Xizhi's style. Finally, the breaks and ragged edges in Kim's brushstrokes make his calligraphy resemble ancient steles, with cracks and erosion bearing witness to endurance.

A different, new kind of scholarship is suggested in paintings of aquatic creatures by JANG Hanjong (1768–1815). In this panel from an eight-panel folding screen, court painter Jang portrayed with remarkable accuracy a seabass (lower left) and stingray, along with a variety of crabs (**Fig. 13.5**). Such careful observation may bring to mind earlier, imperial depictions of exotic animals, which were interpreted as **auspicious** omens (see Figs. 0.9 and 8.7). But Jang's picture responds more immediately to a late Joseon approach to learning, called *silhak*, which emphasized empirical observation as the foundation of knowledge. Furthermore, Jang did not treat the animals as abstract symbols of human meaning, instead, he demonstrated attention to their natural habitats. Thus, fish, crab, and, in the other panels, turtles, are placed according to their marine, freshwater, or inter-tidal environments. Although Jang was not known to have traveled to the seacoast, his contemporary Yu Jaegeon wrote, "When Jang was young he bought various fish, crabs and tortoises and closely examined their scales and shells in order to paint them." Additionally, Jang's position at court placed him in the vicinity of the Gyujang Pavilion Library and in close contact with scholars like Kim Jeonghui, who returned from exile in littoral places including Jeju Island, where they would have encountered such sea creatures. In *Painting of Aquatic Life*, Jang effectively combined the longstanding style typical of court paintings with new, modern conceptions of the natural world.

Scholarly attitudes also played a role in ceramics production, but the history of late Joseon ceramics is somewhat tied to the violent events of the 1590s. In 1592 and again in 1597, Japanese military warlord TOYOTOMI Hideyoshi attempted invasions of the Korean peninsula. The invasions—known as the Imjin Wars—failed, but Hideyoshi's forces captured thousands of Korean potters, whose ***buncheong* stoneware** pieces (see Fig. 9.8) were especially desirable for use in *wabi-cha*, a rustic form of tea ceremony (see Chapter 9). Taken to Japan, the *buncheong* potters made an impact on the direction of ceramics there. In Korea, fewer kilns produced *buncheong* as they responded to the rising demand for **porcelain**. In the fifteenth century, the Joseon court adopted porcelain for royal and official purposes, establishing several official kilns to supply dishes, bowls, jars, burial items, and memorial tablets. As the taste for porcelain spread beyond the court and central government, regional kilns met the greater demand.

This "full-moon" jar (**Fig. 13.6**) points to porcelain's popularity and the aesthetic values of the *yangban*, for whom the jar's simple style was not a shortcoming but a strength. Whereas paintings of dragons or grapevines adorn some contemporaneous jars, the plainness and white color of this jar convey Confucian values of frugality and purity, respectively. Slight imperfections in surface

stele (plural **steles**) a carved stone slab that is placed upright and often features commemorative imagery and/ or inscriptions.

auspicious signaling prosperity, good fortune, and a favorable future.

silhak the School of Practical Learning espoused by Joseon Confucian scholars interested in political reform.

buncheong a variety of Korean stoneware created with white slip.

stoneware a type of ceramic that is relatively high-fired and results in a non-porous body (unlike terra-cotta or earthenware).

porcelain a smooth, translucent ceramic made from kaolin clay fired at very high temperatures.

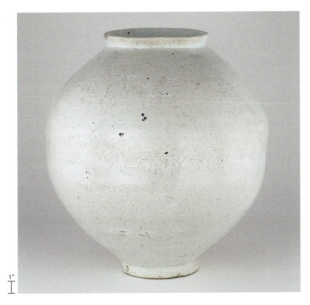

1"

and symmetry indicate an acceptance of natural accidents of the creative process. Although the jar's original function is not known, its impressive size and unforced austerity create a sense of solemnity.

The austerity of the full-moon jar becomes more pronounced when compared to YI Taekgyun's (1808–after 1883) ten-panel **chaekgeori** folding screen, with its dazzling array of ceramics and other objects. Yi's *Books and Scholars' Accoutrements* (**Fig. 13.7** and **Fig. 13.0**) emerges from a dynamic interaction of late Joseon court, social classes, and material culture. Beginning in 1784, the formal examinations for court painters-in-waiting

included *chaekgeori* as a subject matter. Seven years later, King Jeongjo installed a *chaekgeori* screen behind his throne and proclaimed to his officials, "These are not real books, but paintings." Jeongjo's screen exclusively pictured books as a way to promote Neo-Confucian values—studiousness, modesty, frugality, and so forth—among the *yangban* officials.

Made about a century later, this example contains many books, but more than half of the thirty-five nooks include objects. Brushes and an inkstone, Chinese ceramic and bronze vessels, and fruit and flowers convey a range of associations from the scholarly to the auspicious, from seeking high official rank to wishing for wealth. The range of items captures the ambitions of *jungin* (which included artisans and bureaucrats who served the court as clerks, interpreters, accountants, and medical experts) and the *sangmin* (which included merchants, whose wealth and power sometimes raised them beyond their supposedly inferior, commoner class).

With commercial trade curtailed, diplomatic missions presented a legitimate way to import exotic goods. *Jungin* who accompanied government officials to Beijing could return with desirable commodities, especially foreign books, but also jewelry, silver, gold, antiques, rare birds, flowers, and alarm clocks. Thereafter, wealthy merchants might acquire these items and painters could depict them, too. In the Korean painting genre of *chaekgeori*, Qing luxury culture combines with the attitudes of *yangban*, *jungin*, and *sangmin*.

The effectiveness of *chaekgeori* relies, in part, on **trompe l'oeil** techniques to create the illusion of complex shelving. These techniques, which include **linear perspective**, have

13.6 FAR LEFT **"Full-moon" jar,** Joseon dynasty, eighteenth century. Glazed white porcelain, height 18½ in. (47 cm). British Museum, London.

chaekgeori literally "books and things"; a genre of Korean painted folding screens that sometimes uses *trompe l'oeil* techniques to depict books, decorative art objects, and foreign goods such as eye glasses, popular during the late Joseon period.

trompe l'oeil from the French meaning to "deceive the eye"; a visual illusion in art, in which a painted image appears as a three-dimensional object.

linear perspective a system of representing three-dimensional space and objects on a two-dimensional surface by means of geometry and one or more vanishing points.

13.7 Yi Taekgyun, *Books and Scholars' Accoutrements* **(chaekgeori),** Joseon dynasty, late 1800s. Ten-panel folding screen, ink and color on silk, 6 ft. 5¾ in. × 12 ft. 11½ in. (1.98 × 3.95 m). Cleveland Museum of Art, Ohio.

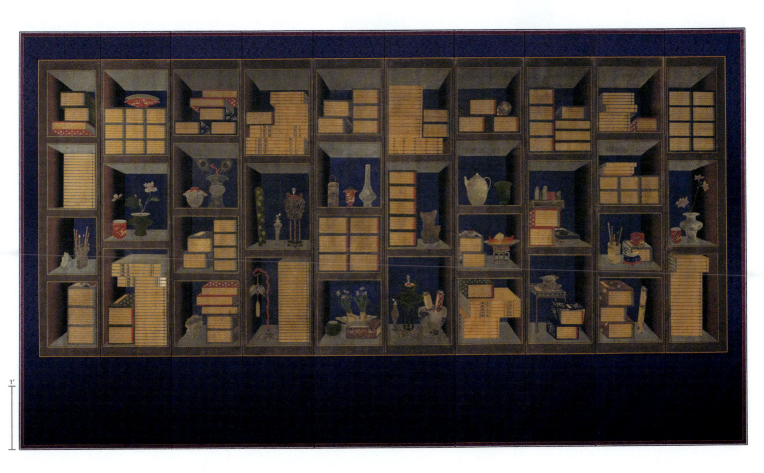

1'

a long history traceable to the early Italian Renaissance (*c.* 1400–1500), but in East Asia they are more directly the legacy of Giuseppe Castiglione (1688–1766), whose compellingly illusionistic paintings won him the favor of three Qing emperors (see Fig. 12.18). By adapting such **illusionistic** techniques, Yi not only signaled his awareness of prestigious Qing imperial painting, but also made the materiality of the books and objects all the more persuasive.

Yi was a court painter and painted in a courtly idiom, but *Books and Scholars' Accoutrements* may not be a court painting. Close inspection of a painted seal placed on its side so that the incised side faces the viewer (the square, red shape in **Fig. 13.0**, upper shelf at viewer's right) reveals Yi Taekgyun's name. Because court paintings were rarely signed, the presence of Yi's signature—in this witty, somewhat "hidden" manner—suggests that this screen was probably a private commission. King Jeongjo may have originally intended to limit the motifs of *chaekgeori* strictly to books and for *chaekgeori* to promote **Neo-Confucian** values, but over the course of the late Joseon, social hierarchies and associated values of Neo-Confucianism were weakened, and the majority of *chaekgeori* display instead, as in **Fig. 13.7**, the growing attractions of exotic and luxury commodities.

Elite Art in Edo Japan, 1615–1868

As in late Joseon Korea, government policies affected the culture and art of the Edo period. Following the failures of

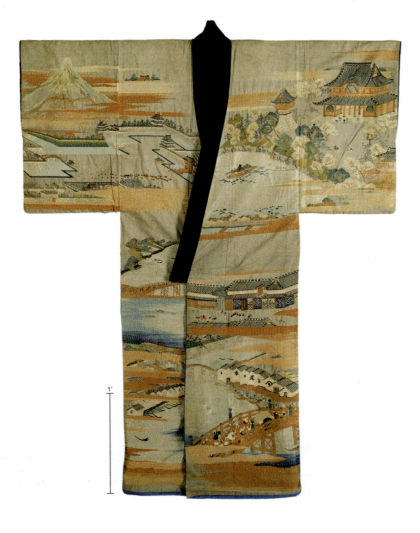

13.8 Robe (*juban*) with scenes of the city of Edo, mid-nineteenth century. Cotton thread embroidery of grey, plain-weave cotton, 57 × 47½ in. (1.45 × 1.21 m). National Museum of Japanese History, Nomura Collection, Sakura, Japan.

Hideyoshi's invasions of the Korean peninsula, power in Japan passed to TOKUGAWA Ieyasu (known as Ieyasu, 1542–1616), the third and last of the Momoyama period military leaders (see Chapter 9). In 1603, Ieyasu became the shogun—a title bestowed by the emperor—and founded the Tokugawa *bakufu* (literally "tent government"; *bakufu* is the form of government commonly called Shogunate), headquartered in the new city of Edo (now Tokyo). But the beginning of the Edo period (named for the capital) is dated to 1615, when the last of Ieyasu's rivals recognized his authority. Battle weary and wary of foreigners, the Tokugawa government instituted reforms aimed at achieving long-term stability. It adopted a Confucian social hierarchy, with military officers, or samurai, substituting for the top class of scholar-officials, and it closed borders, excepting diplomatic missions from Joseon and trade at the southern port of Nagasaki with Dutch and Chinese merchants (see **Map 13.1**).

The Tokugawa required feudal lords to maintain residences in the capital, Edo, where the shogun could keep a close watch on any rivals. Maintaining such residences proved costly to the feudal lords, who were thus discouraged from building independent militias and instead poured money into outdoing one another in areas of art, fashion, and entertainment. To facilitate travel to and from residences in their home districts, the government established a system of roads linking the major cities of Kyoto, Osaka, and Edo. These conveniently located roads and stations equally accommodated pilgrims and tourists. Domestic travel on well-maintained highways nourished an interest, felt by court, military, as well as commoners, in scenic places. So, too, was there widespread enthusiasm for vernacular styles of art and architecture. In urban areas, a new social group called the *chōnin* emerged, and with them arose popular art marked by inventiveness, humor, and drama. Despite efforts by the Tokugawa *bakufu* to control society by limiting vice and foreign contact, pleasure districts and foreign things nevertheless attracted great attention. The art of the Edo period testifies to this multifaceted and dynamic culture.

After Edo became the capital, the city expanded until its population reached about one million. It was a hub of economic and cultural activities and became itself a motif for art, as in this man's robe, or *juban* (**Fig. 13.8**). Two major landmarks assume privileged places in the robe's design: Mount Fuji rises on the wearer's right sleeve (on the left as the viewer looks at it), Edo Castle dominates the left. Consisting of numerous towers, wards, walls, gates, bridges, and moats, which in reality covered well over 100 acres, the castle grounds actually spread across both sleeves.

In the early seventeenth century, Edo Castle was a vast construction site, drawing hundreds of artisans, including painters of the prestigious Kanō school (see Fig. 9.17), to Edo. This splendid seat of government would have impressed the many feudal lords, called *daimyō*. They and their retinues form the procession pictured within the walled, castle grounds (the wearer's right sleeve). Whereas Mount Fuji, Edo Castle, and the *daimyō* appear in the upper half of the robe, the lower half features commercial warehouses lining the Sumida River and

The striking design of this robe combines the natural tan hue of elm-bark fiber with indigo-dyed cotton cloth pieces (**Fig. 13.9**). Meandering patterns of embroidery at the cuffs and hem contrast boldly with the striped pattern woven into the attush. The cut of this robe, with its angled sleeves, along with the attush material and embroidery patterns, mark it as belonging to the Ainu, Indigenous people of the regions of Hokkaido and northeastern Honshu of present-day Japan, and areas of present-day Russia, including Sakhalin and the Kuril Islands. From a young age, Ainu daughters learned from their grandmothers and mothers how to transform elm tree bark into cloth (attush). They also learned to consider social rank when designing embroidery patterns that also pleased the gods and therefore protected the wearer. Each robe is unique, but the style of an individual designer or of a region may be detected in two or more examples. The neat indigo stripes of this attush along with the carefully set applique and gentle curves of the embroidery are also seen in a robe collected from the village of Tsuishikari, Hokkaido in 1888 and now in the National Museum of History of the Smithsonian Institution, in Washington D.C.

Although robes such as this were made in the area of Japan in the Edo period, they fit awkwardly—or not at all—into histories of Edo period art. Why? The primary answer lies in the dominant role that national narratives play in art history. The modern discipline of art history came into being in the nineteenth century, a critical time in the formation of modern nation-states. Such states needed to create coherent national identities for their citizens, and art history—especially in the form of public museums—was enlisted to forge them, using such categories as "Japanese art." (For more, see Chapter 16.) Such national categories were then applied anachronistically to determine which artworks from centuries past would be recognized as part of a nation's artistic heritage.

The case of this Ainu robe reveals problems in the national narrative. Whereas other elements of the robe are wholly Ainu, the cotton pieces come from trade, sanctioned by the

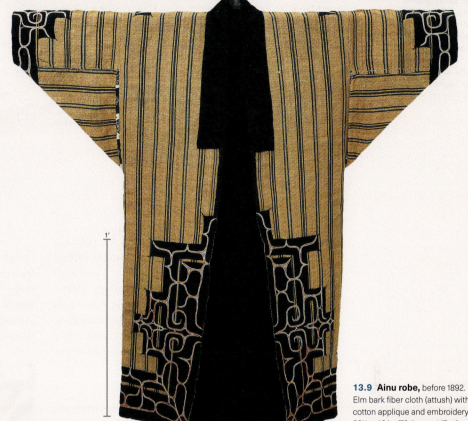

13.9 Ainu robe, before 1892. Elm bark fiber cloth (attush) with cotton applique and embroidery, 28½ × 46 in. (72.4 cm × 1.17 m). Detroit Institute of Arts, Michigan.

Tokugawa government. Trade could be mutually beneficial, but at times, conflicts led to rebellions on the part of the Ainu, and the Tokugawa responded with coercion, violence, and the exertion of control over Ainu territory. Later, the Meiji government of Japan annexed Hokkaido outright. In the eyes of the government, the Ainu were assimilated into a homogeneous Japanese citizenry. Additionally, the national narrative of Japanese art history did not, by definition, include the artwork of perceived outsiders. Ainu art, like the Ainu themselves, became invisible.

Despite generations of discrimination, the Ainu (meaning "human") have endured. In 2019, the Japanese government passed a bill recognizing the Ainu of Hokkaido as the Indigenous people of Japan and supporting a new museum dedicated to Ainu culture. A more global and inclusive art history demands that we think critically about national narratives. Eventually, we could thus develop frameworks of interpretation adequate to the task of seeing the excellence and meaning of artworks such as this Ainu attush robe.

Discussion Questions

1. Compare the Ainu robe to the *juban* (**Fig. 13.8**). Describe and analyze the different approaches to design.

2. Find another example of Ainu art. How might it expand popular conceptions of East Asian art?

chōnin crowding the bridge and shore. Thus, the robe's composition echoes the social hierarchy envisioned by Tokugawa policy. That the robe takes the contemporary city of Edo as its chief motif, however, speaks to the city's vitality and artistic creativity. In that regard, its chief rival was the imperial city of Kyoto.

Kyoto was home to a great many painters working in a number of styles and traditions. About fifty years after

Jeong Seon began painting the Diamond Mountains in Korea, IKE Taiga (known as Taiga, 1723–1770)—who had contact with Joseon true-scenery painters accompanying diplomatic missions to Edo—and TOKUYAMA Gyokuran (also IKE Gyokuran, known as Gyokuran, 1727–1784) directed their attention to the real sites near them. Dated to around 1760, Taiga's landscape of Mount Asama (not illustrated) was the first **shinkeizu**. His spouse,

shinkeizu Japanese "true-scenery," or "true-view" landscape painting; represents real, local places in a range of styles informed by literati taste and European visual strategies (see also *jingyeong sansuhwa*).

bunjinga Japanese "literati painting," in the Edo period inspired by Ming dynasty Chinese literati painters such as Dong Qichang. Dong's theory of painting also provided the alternate name, "*nanga,*" or "Southern [School] Painting," for *bunjinga.*

literati painters educated artists, including scholar-officials, who brought literary values into painting, and pursued abstraction and self-expression in their art.

Gyokuran, drew inspiration for this folding fan painting from the less dramatic, but nevertheless notable, setting of Akashi Bay (**Fig. 13.10**).

In Gyokuran's lyrical painting, the empty spaces become the bay, dotted with a few fishing boats and low-lying wooded shoals. Fluid lines of calligraphy float across the watery landscape and attest to her considerable skills in handling brush and ink. In irregular columns from right to left, the poem reads:

> On Akashi Bay
> this evening's moon is now
> glittering brightly—
> boats out on the waters are
> sailing to the distant sea.

Intermingling poetry and painting, Gyokuran wrote the word "moon" (月) at the beginning of the third line so that it hovers in the indistinct place where one might find its reflection shimmering in the water (**Fig. 13.10a**).

In both Joseon Korea and Edo Japan, paintings of local landscapes refer to a tradition originating in China, but that acknowledgment of a foreign heritage does not diminish their artistic value or originality. On the contrary, it is no small achievement to contribute something new to a tradition rather than reject it altogether, particularly when that tradition includes revered artists and renowned artworks. In Gyokuran's case, the achievement is all the more remarkable given the limited social roles and educational opportunities afforded to women. Gyokuran had the good fortune to have women poets in her family and an artistic spouse whose bohemian attitude mirrored hers.

Living in Kyoto, Taiga and Gyokuran were among painters working in the literati manner, or **bunjinga**. They drew inspiration from Late Imperial Chinese **literati painters**, especially Chinese paintings by Dong Qichang (see Art Historical Thinking, Dong Qichang and Distinction, p. 250), and adapted motifs and techniques from woodblock printed manuals of painting that circulated throughout East Asia. *Bunjinga* artists connected themselves to an esteemed tradition that claimed superiority to courtly and professional styles of painting.

The central role of expressive brushwork is not exclusive, however, to *bunjinga*. Also working in Kyoto, ITŌ Jakuchū (known as Jakuchū, 1716–1800) used a dramatic range of ink tones and brushstrokes for an important Buddhist event in his *Vegetable Nirvana* (**Fig. 13.11**). Born into a prosperous family of greengrocers, Jakuchū eventually left the business to a younger brother and became

a professional artist. He studied the painting collections at Zen temples in Kyoto, and saw himself as a Buddhist layman. *Vegetable Nirvana* blends his interest and experiences in an image that is at once delightful and profound. Reclining atop a woven basket platform in the middle of the composition, the forked-root radish plays the role of the Buddha in the *parinirvana* (compare to Fig. 0.12). Distressed turnips and gourds turn themselves upside-down. Enlightened vegetables, by contrast, retain their composure at the daikon-buddha's passing. The humor in Jakuchū's picture is undeniable, but it also refers to discussions of plants as sentient beings, which dated back to the ninth century and were ongoing.

Vegetable Nirvana exemplifies only one style within Jakuchū's astonishing artistic range that extended from clever, calligraphic sketches of poets to superbly polished depictions of colorful roosters. His oeuvre—including a set of thirty paintings making up the "colorful realm" of all living beings, as well as a pair of folding screens, *Birds and Animals in the Flower Garden* (not shown here), which anticipates the aesthetic of computer pixels—testifies to the vitality of painting in Kyoto.

The Chinese literati tradition and the collections of Buddhist institutions provided Kyoto artists with rich resources of inspiration. But in Kyoto the court remained the predominant arbiter of taste, and the themes and styles of the Heian period (see Figs. 6.18 and 6.19) proved vital to artists and patrons of the Edo period.

Whereas Taiga and Gyokuran brought originality to landscape by looking to local geography, ŌGATA Kōrin (known as Kōrin, 1658–1716) revived themes and styles from the past to create fresh images. Born into a family that once supplied textiles to the wives and daughters of the imperial family and military elite, Kōrin lived well but briefly on an inheritance from a declining business. After selling the family's treasures and his home, he spent the last twenty years of his life not only painting screens, but also designing garments and **lacquerware**

for discerning patrons. His penchant for luxurious materials and startling combinations of color, texture, and pattern served equally well in creating stationery boxes for scholarly men and robes for fashionable women. For furnishing their homes, Kōrin painted ***byōbu***, such as *Red and White Plum Blossoms* (**Fig. 13.12**). *Byōbu* functioned as portable room dividers (see Fig. 9.17), creating private areas behind them while providing opulent backdrops for those seated in front of them.

Kōrin's name provides the basis for the naming of the Rinpa style of painting ("rin" from Kōrin, and "pa" meaning school or group), although the artistic contributions of earlier artists such as HON'AMI Kōetsu (known as Kōetsu, 1558–1637) and TAWARAYA Sōtatsu (known as Sōtatsu, 1570–1643) should be recognized. The Rinpa style draws inspiration from the aesthetic standards of the Heian court, which favored poetic subject matter, elegant compositions, the use of gold and silver, and an abstract approach to represented three-dimensional space (see Figs. 6.18 and 6.19). In *Red and White Plum Blossoms*, Kōrin sets two plum trees—a young tree with red blossoms and an old tree with white blossoms—against a sumptuous gold background. When the two folding screens are properly placed, a serpentine brook cuts through the middle. Mesmerizing eddies of silver stir the water, while irregular pools of ink are mixed with blue-green pigments—a technique called *tarashikomi*, in which a second layer of ink or pigments is added while the first is still wet—to form patches of moss or lichen on the trees. Fine limbs bear tiny buds and not too many flowers, forming a delicate filigree against Kōrin's bold, gold abstraction. Incidentally, Rinpa painting proved inspirational to European Modernists, such as Gustav Klimt (1862–1918).

Sometimes Kōrin collaborated with his younger brother Kenzan (1663–1743), whose ceramics earned their own name, Kenzan ware. After spending part of his adulthood pursuing the scholarly arts of poetry and

13.12 Ōgata Kōrin, *Red and White Plum Blossoms*, Edo period, *c.* 1710–16. Pair of two-panel folding screens: ink and colors, silver, and gold leaf on paper, each screen 5 ft. 1⅝ in. × 5 ft. 7⅞ in. (1.57 × 1.72 m). MOA Museum of Art, Atami, Shizuoka Prefecture, Japan.

calligraphy, Kenzan began making pottery, initially on the outskirts of Kyoto and later in the city center. An interesting shape and bright colors make this set of side dishes immediately attractive (**Fig. 13.13**). No two alike, the ten dishes are variations on a theme. Each takes the form of maple leaves that have fallen atop one another, along with eddies or waves of water. Their colors—green, yellow, and red—convey the autumn season, a time of beauty, but also of nostalgia and regret.

Kenzan draws on both his facility with the brush and his poetic sensibility. The leaf-and-water combination refers to a well-known poetic theme: red maple leaves falling on the Tatsuta River in autumn. Enduring poems on this theme by Heian period courtiers inspired paintings, ceramics, and other decorative arts by Kenzan and his generation.

The relationship between Heian literature and courtly taste in the Edo period is central to Prince Yoshihito's (1579–1629) retreat, Katsura Imperial Villa (**Figs. 13.14** and **13.15**). In the Heian period novel by Lady Murasaki Shikibu, *The Tale of Genji*, the protagonist, Prince Genji, builds his last palace along the Katsura River in Kyoto (for the illustrated handscrolls of *The Tale of Genji*, see Figs. 6.18 and 6.19). Built in the first half of the seventeenth century, Prince Yoshihito's villa along the Katsura River mimics specific features described in *The Tale of Genji*, such as the lake and artificial islands, and strives for an understated elegance in keeping with Heian taste.

Imperial architecture in East Asia and indeed throughout the world typically employs symmetry and ostentatious decoration to project power and authority, but Katsura Villa embraces irregular forms and subdued ornament to provide an informal yet elegant setting for family, intimates, and courtiers. In some places, the villa adopts the rustic aesthetic Sen no Rikyū used for the Taian Teahouse (see Figs. 9.18 and 9.18a)—for example, the meandering paths to slow one's pace, and thoughtful juxtapositions of natural materials and subtle patterns.

13.13 TOP **Ōgata Kenzan, *Mukōzuke* (side dishes) *with Tatsuta River design in overglaze enamels*,** Edo period, eighteenth century. Diameter 6⅜–7 in. (16.2–17.8 cm). Miho Museum, Shiga Prefecture, Japan.

13.14 ABOVE **Drawing of Katsura Imperial Villa, Kyoto, Japan.**
A. Detached Palace
B. Gepparō Teahouse
C. Shōkintei Teahouse
D. Shōkatei Teahouse
E. Shōiken Teahouse

13.15 Shōkintei Teahouse at Katsura Imperial Villa, Kyoto, Japan. Edo period, c. 1620–63. Imperial Household Agency, Japan.

Shōkintei Teahouse (see **Fig. 13.15**), one of the villa's several buildings, captures the quiet yet dynamic relationship between the plain geometry of the interior and the contrasting colors and textures of the meticulously manicured "natural" environment of the exterior. The absence of carved wood timbers or painted **coffered** ceilings in the teahouse does not indicate poverty. Instead, the plain lattices, checkerboard-pattern sliding screens, and bare framing demonstrate extreme restraint and painstaking consideration for the quality and effect of every element. Acute aesthetic attention was characteristic of Heian court culture, and this concept permeates Katsura Villa. After establishing diplomatic contact with additional foreign states in the Meiji period (1868–1912), the villa inspired Modernist artists and architects outside of Japan, including the American Frank Lloyd Wright (1867–1959).

"The Floating World": Popular Themes and Art in Edo Japan, 1615–1868

Even as artworks expressed elite sophistication and power, dynamic urban cultures in Japanese cities—such as Kyoto and Osaka, but Edo particularly—fueled the development of popular themes and art forms. To maintain political stability, the Tokugawa *bakufu* mandated a system of "alternating residence," in which all lords (*daimyō*) or their sons were required to reside in Edo under the close watch of the shogun. The expenditures of the *daimyō* and their households helped the city to grow. The entertainment districts—comprised of theaters, teahouses, and brothels—benefited especially from

the presence of moneyed men, and the personalities and activities of the entertainment districts inspired the creation of *ukiyo-e*. "E" means pictures, and "ukiyo" means "floating world." *Ukiyo*, a Buddhist term originally referring to the illusory and ephemeral world from which one should detach oneself, took on a new meaning in the Edo period. Instead of fostering an attitude of detachment, *ukiyo* now emphasized that the fleeting pleasures of theater, teahouses, and tourism were to be savored while they lasted.

The term *ukiyo-e* does not specify a particular medium. In other words, pictures of the floating world could take the form of paintings or prints. One example of an *ukiyo-e* painting is *Three Women Playing Musical Instruments* (**Fig. 13.16**) by KATSUSHIKA Ōi (known as Ōi, active *c.* 1818–after 1854), the daughter of the artist Hokusai. Ōi placed three women against an unpainted silk ground. They form a lively musical trio, and their postures suggest a measure of self-possession. Two play the *shamisen* using a bow and a plectrum, respectively, and the third plucks the strings of a *koto*. The women wear boldly patterned kimonos, which attract the viewer's attention, but Ōi's painting does not emphasize seduction. With their gazes turned inward and their bodies facing each other, the women appear fully absorbed in their music-making.

Paintings such as Ōi's *Three Women* were beyond the financial means of most residents of Edo. But woodblock-printed images, which could be produced in multiples, generated artworks that cost as little as a bowl of noodles. The first prints featured subject matter related to the pleasure districts, such as this print by

coffered a recessed panel, or series of panels, in a ceiling.

ukiyo-e literally, "pictures of the floating world," referring to paintings and especially woodblock prints that took as their subject matter the pleasures and sites of Edo Japan, including *kabuki* theater, courtesans, and places of leisure and travel.

13.16 Katsushika Ōi, *Three Women Playing Musical Instruments,* Edo period, *c.* 1818–44. Hanging scroll: ink and color on silk, 18¼ × 26½ in. (46.4 × 67.3 cm). Museum of Fine Arts, Boston, Massachusetts.

13.17 Okumura Masanobu, *Large Perspective Picture of a Kaomise Performance on a Kabuki Stage* **(***Shibai kyōgen butai kaomise ō-uki-e***),** *c.* 1745. Woodblock print, ink on paper, with hand-applied color, 15⅛ × 24⅝ in. (38.4 × 62.5 cm). Art Institute of Chicago, Illinois.

kabuki a form of dance-drama developed in Edo Japan and characterized by stylized movement, elaborate costume, and bold make-up.

OKUMURA Masanobu (known as Masanobu, 1686–1764), which depicts the packed interior of a **kabuki** theater (**Fig. 13.17**). Some men and women in the audience direct their attention to the stage, but as many or more are having private conversations, ordering food and drink from waitstaff, and distracted by the little dramas playing out all around them.

To enhance the sense of theater as spectacle, Masanobu adopted linear perspective, and his print is hand colored. The orthogonal lines of the balcony seats, ceiling beams, and raised walkway at the left are somewhat inconsistent but nevertheless create the illusion of an interior space and direct the viewer's gaze toward the stage. Linear perspective became known in Japan through imported European prints of street scenes and cityscapes. When viewed through a zograscope (an optical device with a magnifying lens that enhanced the perception of depth of a flat picture, see **Fig. 13.18**), the imagery in these prints appeared to float off the page, creating an illusion of three-dimensional space. Such images were therefore dubbed *uki-e*, or floating pictures (not to be confused with *ukiyo-e*, which are pictures of the floating world). The combination of relatively lowly subject matter and visual trickery led to an understanding of linear perspective as a manipulable novelty, less suitable for the most esteemed art but appropriate for woodblock prints that depicted the superficial delights of Edo's teahouses, brothels, and theaters. Because of the association with popular, even vulgar realms, linear perspective would not be widely adopted. By contrast, the desire for multiple colors would fuel technological innovation. Masanobu's print is essentially black and white; the yellow and two shades of ocher were added by hand. About two decades after this print was made, the labor-intensive process of hand coloring would give way to polychrome print technology.

The earliest woodblock prints of the Edo period portrayed the pleasure districts, which the Tokugawa government segregated and regulated with varying success. The government imposed sumptuary laws (prohibiting personal spending on clothing and luxury items), and censored all manner of political topics. Artists were punished for infractions, as in the famous case of KIT-AGAWA Utamaro (known as Utamaro, 1753–1806). For daring to depict the Momoyama period military leader Hideyoshi, Utamaro was jailed for three days and manacled for nearly two months. To evade censors, artists found opportunities for witty subterfuge. For example, when regulations against depicting actors were imposed in the 1840s, UTAGAWA Yoshiiku (known as Yoshiiku, 1833–1904) pictured fish and turtles with faces that closely resembled well-known actors. An earlier artist in the Utagawa lineage (apprentice artists took the name of their masters), Yoshitora (flourished *c.* 1836–87) also

13.18 Suzuki Harunobu, *A Teenage Boy and Girl with a Viewer for an Optique Picture; Kōbō Daishi's Poem on the Jewel River of Kōya,* Edo period, c. 1788. Polychrome woodblock print, ink and color on paper, 10¾ × 7¾ in. (23.7 × 19.7 cm). Metropolitan Museum of Art, New York.

1. First, a publisher commissions a design from an artist. Next, the design is transferred onto translucent papers and affixed to blocks, one for each color, to guide the woodblock cutters.

2. The woodblock cutters chisel and cut away the wood surface until only those areas of the design to be printed are raised in relief.

3. These raised portions receive ink or pigment.

13.19 (1–5) ABOVE AND RIGHT **The polychrome woodblock printing process.**

4. The printers lay the same piece of paper onto each woodblock in succession and rub the reverse side of the paper to transfer the colors (or, in the case of embossing, the patterned texture) onto the paper.

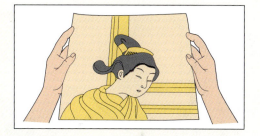

5. The finished polychrome print.

In East Asia the earliest woodblock prints, which relied on technologies dating not later than the Tang dynasty (618–906), featured Buddhist images and texts. These prints were monochromatic, the result of pressing paper against a single woodblock that had been carved and inked. The multicolor *ukiyo-e* prints of the early Edo period therefore required coloring by hand (see **Fig. 13.17**).

In 1765, SUZUKI Harunobu (known as Harunobu, 1725–1770) designed the first full-color *ukiyo-e* prints. These prints, called *nishiki-e* (literally, "brocade-pictures," likening them to textiles woven from threads of many different colors), called for multiple woodblocks, one for each color. For example, the robes of the standing adolescent boy in this print (**Fig. 13.18**) required the use of at least four blocks. For added subtlety, a technique called "blind printing" used a specially carved block to produce the embossed textures of the diamond-patterned wall and the flowering tree. To ensure proper alignment of colors and patterns, artisans developed a system of registration notches (*kentō*). Thus, a remarkably systematic and efficient process replaced laborious hand coloring (**Fig. 13.19**).

The quality and success of polychrome woodblock prints depended on the collaboration of at least four specialists: the publisher, the designer, woodblock cutter, and printer. Typically, the publisher saw the project through from beginning to end, organizing the other specialists, procuring materials, and managing the sales.

manipulated faces for a comical effect (see Fig. 0.1), although in this case, censorship was not a concern.

Exaggerated facial expression, a star of the stage, and luxury come together in prints of actors such as this depiction of ICHIKAWA Ebizō IV (**Fig. 13.20**, p. 278) by TŌSHŪSAI Sharaku (known as Sharaku, active 1794–95). Kabuki actors were a subject from the very beginning of *ukiyo-e* and print designers, who typically portrayed the male leads as handsome and heroic, the villains as duplicitous, and the *onnagata* actors—male actors who played female roles—as the epitome of femininity. *Onnagata*, such as the famous SEGAWA Kikunojō II

(1741–1773), were both the object of male sexual desire and the model of fashion for women. (Although the early history of kabuki included women actors, in 1629 the government banned female performers as part of its efforts to control morality, and until the ban was repealed in the late nineteenth century, kabuki theater consisted of all-male casts.) Sharaku's prints stepped away from such ideals. Using the "big head" composition, which tightly frames the subject's face and upper body, Sharaku portrayed Ebizō in his role as the samurai warrior TAKEMURA Sadanojō. Wearing a tense expression, Sadanojō kneads his hands in worry. He has come to a fateful realization:

13.20 **Tōshūsai Sharaku, Ichikawa Ebizō IV as Takemura Sadanojō in the Play Koinyōbō Somewake Tazuna,** Edo period, 1794. Polychrome woodblock print, ink, color, white mica on paper, 14½ × 9¼ in. (36.8 × 23.5 cm). Metropolitan Museum of Art, New York.

cartouche inset boxes for short phrases, providing identifying information such as title, series, artist, publisher, and/or date.

Western a term used in the modern era to claim shared civilization and institutions originating in Europe among predominantly white people; term extended to North America and other parts of the world heavily marked by European colonization.

13.21 BELOW **Katsushika Hokusai,** *Under the Wave off Kanagawa,* from the series *Thirty-six Views of Mount Fuji,* Edo period, c. 1830–32. Polychrome woodblock print, ink and color on paper, 10 × 15 in. (25.4 × 38.1 cm). Metropolitan Museum of Art, New York.

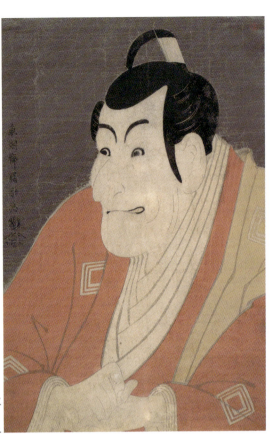

in order to keep his honor, he must commit suicide. The viewer is offered no relief from Sadanojō's anguish, and the plain but luxurious mica background—which sparkles when seen from different angles, but may appear grey in photographs—intensifies the drama. The nested squares of the actor's family crest, identifying him as a member of the prestigious Ichikawa Danjurō lineage, echo the pattern of drapery folds connecting face and hands, where suffering finds expression.

All of Sharaku's dramatic prints of actors appeared in a brief, ten-month span. His arresting portraits demonstrated considerable skill, and in their rather unflattering, even caricature-like portrayals of their subjects, defied conventions. The sudden appearance and disappearance of Sharaku's prints, which are characterized by outstanding quality and an original style, have generated much art-historical speculation about Sharaku's identity and origins, which remain a mystery.

Actor prints appear, too, in the impressive oeuvre of KATSUSHIKA Hokusai (known as Hokusai, 1760–1849), who also produced spectacular paintings in front of live audiences, notebooks filled with comic sketches, do-it-yourself dioramas, and board games. As a print designer, Hokusai depicted birds, flowers, beautiful women, wrestlers, warriors, and ghosts, but he is best known for a landscape series produced in his seventies. In *Under the Wave off Kanagawa* (Fig. 13.21), affectionately known as "The Great

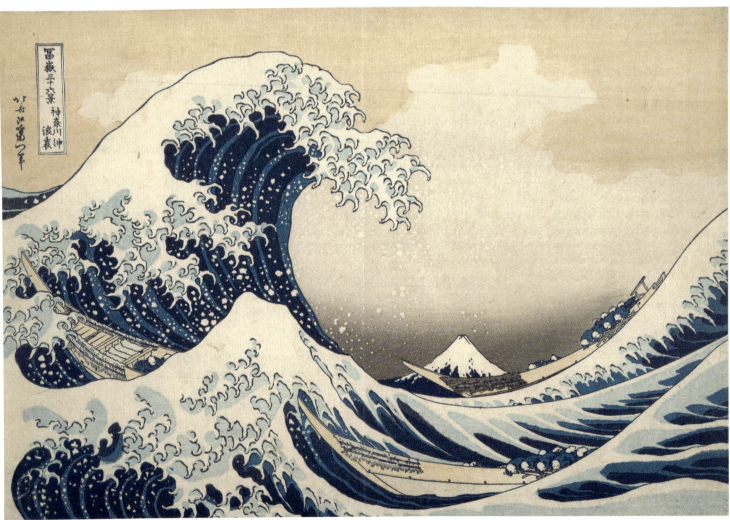

Wave," Hokusai paired the traditional elements of East Asian landscape—mountains and water—in a manner that is at once terrifying and captivating.

A magnificent wave breaks into a multitude of tiny claws, mimicking its overall hooked shape. Whereas viewers experience a vicarious thrill, the fishermen in the three boats shown in the scene must navigate real danger. In earthquake-prone Japan, huge waves could be threatening, and in Hokusai's print the safety of dry land—Mount Fuji—looks impossibly far away, and disorientingly wave-like. Hokusai combined swooping shapes, intense shades of blue made from imported "Prussian blue" pigment, and an unexpected point of view to capture the ocean's power and viewers' conflicted attitudes toward it. For Edo Japan, the sea provided sustenance, protection, and marvels from faraway places, but it could also be destructive and bring invaders.

At the far left of *Under the Wave off Kanagawa*, Hokusai's signature appears. Beside it, the **cartouche** provides the print's title and indicates that it belongs to a series, *Thirty-Six Views of Mount Fuji*. The series proved so successful that ultimately Hokusai provided an additional ten designs to produce a total of forty-six prints.

In the realm of landscape prints, Hokusai's inventiveness has but one chief rival: UTAGAWA Hiroshige (known as Hiroshige, 1797–1858). Hiroshige's *Mannen Bridge, Fukagawa* (**Fig. 13.22**) also features Mount Fuji, but this time the viewer takes a turtle's point of view. Suspended from the crossbar of a pale wooden bucket, the turtle gazes beyond Mannen Bridge's darker timbers. Quiet yet supreme, Mount Fuji rises against the colors of the setting sun.

The prolific Hiroshige cast his perceptive eye most famously on scenes along the well-traveled Eastern Sea Road (Tōkaidō), connecting Edo to Kyoto. This print, identified by cartouches at the upper right, belongs to a series closer to home. Mannen Bridge was a familiar place, but Hiroshige used the captive animal to add new layers of meaning. Mannen Bridge literally means "ten-thousand-years bridge," and the turtle symbolizes longevity. This turtle's life hangs in the balance, because it is for sale. Sellers of fish and reptiles located themselves near bridges, and customers purchased the creatures in order to release them as a means of attaining karmic merit, according to Buddhist belief.

Yet even when the original meanings were poorly understood or entirely misinterpreted, prints by Hiroshige and other *ukiyo-e* artists garnered, and continue to garner, much enthusiasm, especially from Impressionist painters but also from photographers and cinematographers of more recent times. By the late Edo period, *ukiyo-e* prints circulated internationally not only because they existed in multiple copies, but also because the government's policy of seclusion came to an end. In 1853, Commodore Matthew C. Perry of the United States Navy led a fleet to Edo (now Tokyo) harbor, forcing the Tokugawa *bakufu* to open ports to trade. Other nations followed with similar demands.

As Tokugawa rulers feared, foreign contact destabilized the government and contributed eventually to the Meiji Restoration of the emperor's power in 1868.

In the meantime, European and American consumers enthusiastically imported Japanese products, including ceramics, fans, kimonos, and lacquerware. For avant-garde artists in Paris, London, and elsewhere in Europe, Japanese woodblock prints became a catalyst for Modernist styles. Japan's new hold on the **Western** imagination filled a void left by China's decline following the mid-nineteenth-century Opium Wars, and the eighteenth-century enthusiasm for *Chinoiserie* yielded to nineteenth-century *Japonisme* (see Seeing Connections: Images of Orientalism, p. 261).

In time, foreigners would come to appreciate late Joseon art, too. For example, the full-moon jar (**Fig. 13.6**) caught the attention of the Hong Kong-born British ceramicist Bernard Leach (1887–1979), who lived in Japan and studied in the Kenzan tradition. Leach acquired the

13.22 Utagawa Hiroshige, *Mannen Bridge, Fukagawa*, from the series *One Hundred Famous Views of Edo*, 1858. Polychrome woodblock print, ink and color on paper, 14 × 9½ in. (35.6 × 24.1 cm). Metropolitan Museum of Art, New York.

Chinoiserie objects and images characterized by European tastes and ideas about China.

Japonisme objects and images characterized by European taste and ideas about Japan.

jar while traveling in Korea when that country was under Japanese colonial rule (1910–45).

Art history and geopolitical history meet in the circulation of such artworks as the full-moon jar and *ukiyo-e* woodblock prints. The physical displacement of artworks from their origins to Europe and the United States is a consequence of Western imperialism. Art historical study of these works is a related phenomenon: only when such artworks circulate among the Western so-called cultural elite do they become incorporated into the modern field of art history, which, not coincidentally, originated in the West. On the Korean peninsula and the Japanese archipelago, the seventeenth century began with isolationist and conservative Confucian policies aimed at establishing stability. Growing wealth and urbanization ensued, fostering art that was distinctive and remarkably modern in character. The stable conditions could not be sustained, however. In the nineteenth century, Western empires intent on expanding trade collided with the Tokugawa *bakufu*, igniting a chain reaction of dramatic changes that would alter the course of art and culture in East Asia.

Discussion Questions

1. Artists often look to the natural world for inspiration, but they do not always stress beauty. Use an example from this chapter to discuss how landscape conveys other ideas or sentiments, such as identity, authority, fear, or history.

2. Who were the tastemakers in Edo Japan? In late Joseon Korea? These periods saw an interaction of elite and popular. Choose an artwork from this chapter to explain the impact of this interaction of class cultures.

3. Many artworks in this chapter are two-dimensional images. But many are also simultaneously objects (e.g. fans, folding screens that divide interior space) or depict objects (e.g. musical instruments, costumes and jewelry, books, vases). Use examples from this chapter to explain what artworks reveal about Joseon or Edo material culture.

4. Further research: only one of forty-six in the series *Thirty-Six Views of Mount Fuji*, Hokusai's "Great Wave off Kanagawa" eclipses the others, and indeed all other Japanese woodblock prints, with its fame. Choose another print, whether by Hokusai or another Edo period artist, that you think deserves more attention. Explain your reasoning; be sure to include analysis and interpretation.

Further Reading

- Fitzhugh, William W. and Dubreuil, Chisato O. *Ainu: Spirit of a Northern People*. National Museum of Natural History, Smithsonian Institution, Washington D.C., in collaboration with University of Washington Press, 1999.

- Jungmann, Burglind. *Pathways to Korean Culture: Paintings of the Joseon Dynasty, 1392–1910*. London: Reaktion Books, 2014.

- Lee, Soyoung, *et al. Diamond Mountains: Travel and Nostalgia in Korean Art*. New York: The Metropolitan Museum of Art, 2018.

- Lippit, Yukio, ed. *The Artist in Edo*. Center for Advanced Study in the Visual Arts (organizer), Washington, D.C.: National Gallery of Art, 2018.

- Screech, Timon. *Obtaining Images: Art, Production, and Display in Edo Japan*. London: Reaktion Books, 2012.

Chronology

	KOREA		JAPAN
1592–98	The Imjin Wars and Hideyoshi's invasions of Korea occur; the late Joseon period begins	1603	Tokugawa Ieyasu becomes shogun
		1615–1868	The Edo period
1627 and 1636	The Manchu invasions of Korea occur	1620–24	Prince Yoshihito begins the initial building of Katsura Imperial Villa
late 1740s	Jeong Seon paints *Panoramic View of the Diamond Mountains*	c. 1710–16	Ōgata Kōrin paints *Red and White Plum Blossoms*
1776	King Jeongjo establishes the Gyujang Pavilion Library and commissions a painting of it from court artist Kim Hongdo	c. 1760	Ike Taiga paints a "true view" ("*shinkeizu*") of Mount Asama
		1765	Suzuki Harunobu designs the first full-color *ukiyo-e* prints
early 19th century	Jang Hanjong paints images of aquatic creatures	c. 1830–32	Katsushika Hokusai designs the series *Thirty-Six Views of Mount Fuji*
1850–49	Calligrapher Kim Jeonghui is exiled to Jeju Island	1853–54	Commodore M. Perry leads a U.S. fleet to force Japan to open to trade
after 1871	Yi Taekgyun paints *Books and Scholars' Accoutrements*	1868	The Meiji Restoration restores power to the emperor

Stolen Things: Looting and Repatriation

In many ways, the history of ancient art is a history of displaced objects. Many artifacts, from Asia and elsewhere, currently in European and North American collections, have been collected under circumstances today viewed as theft: pillaged in military conflict or stolen by looters to be sold in the lucrative market for ancient art. Looting and illicit trade in antiquities lead to substantial loss of contextual information for the artifacts and continued destruction of archaeological sites. Recently, some governments have demanded the return of antiquities to their countries of origin, raising the question: who owns the past? This question has philosophical, ethical, and legal dimensions, so there are no easy answers. The three examples discussed here have been returned to their countries of origin, yet many others remain disputed (see, for example, Fig. 0.11).

Civil war in Cambodia from 1967 to 1975, followed by a brutal period of genocide, and years of residual conflict, resulted in extensive loss of the country's artistic heritage. The murder of intellectuals, including historians, by the Khmer Rouge regime and the widespread destruction of official records make it difficult to prove which Cambodian artworks around the world were illegally obtained and should be returned. There are success stories, however: Two sandstone sculptures from the tenth century, depicting the Hindu warriors Bhima (**Fig. 1**) and Duryodhana engaged in combat, were recently repatriated. The pair originally formed the focal point of the northern Cambodian shrine, Prasat Chen. In 1972, thieves hacked off the figures at their ankles; the feet remained in place at the site. Bhima ended up in the Norton Simon Museum in California in 1976, while a private collector owned Duryodhana until putting it up for sale at auction in 2011. Before the sculpture could be sold, scholars pieced together the pair's history and even identified several other probably looted sculptures owned by U.S. museums. It took years of negotiation and threats of legal action, but in 2014, Bhima and Duryodhana were finally returned. Since then, other Prasat Chen sculptures have also been repatriated.

War, in this case foreign invasion, also led to the looting of a monolith (**Fig. 2**) from a cemetery in Aksum (also spelled Axum), the capital of a powerful ancient empire in the highlands of Ethiopia. The huge monument, made from a single block of stone, is one of several grave markers that may be linked to King Ezana, who ruled around 350 CE. Their crisply carved surfaces replicate the walls of Aksumite palaces, reimagining those ancient buildings as multi-storied towers. During the Italian invasion of Ethiopia in the 1930s, this fallen grave marker was taken as war loot and shipped to Rome. There it was repaired and erected in a public square, emulating the obelisks (a stone pillar, usually with a pyramid as the capstone) that ancient Roman emperors brought back to their capital after conquering Egypt. After Italy's defeat in World War II, Ethiopia demanded repatriation of the monolith, but it was not returned until 2005. Today the monolith stands once more in the center of the burial ground, next to the other (newly stabilized) monuments of ancient Aksum.

1 **Bhima,** Prasat Chen shrine, Koh Ker, Cambodia, c. 925–50 CE. Sandstone, height 5 ft. 1¾ in. (1.57 m). National Museum, Cambodia. (Pictured as displayed at the Norton Simon Museum, California.) **SOUTHEAST ASIA**

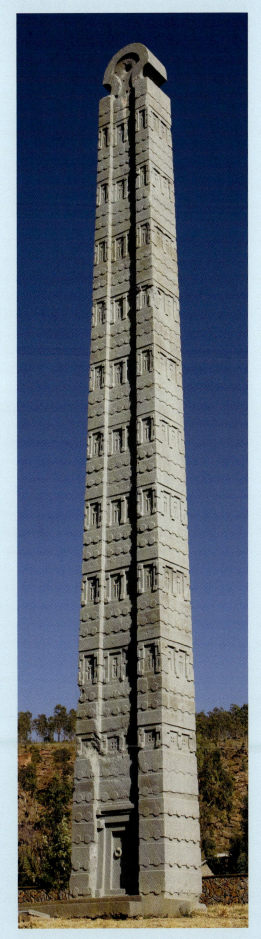

2 **Monolith,** Aksum, Ethiopia, 350 CE, height 79 ft. (24.08 m). **AFRICA**

Rapid economic development, rather than war, led to the theft of this painted stone relief (**Fig. 3**). In China in the late twentieth century, the pace of archaeological discoveries quickened as towns and cities expanded into farmland, and infrastructure projects uncovered ancient settlements and centuries-old tombs. New wealth also fueled breathtaking growth and skyrocketing prices in the market for art and antiquities. Not surprisingly, illicit trade grew, too. In March 2000, U.S. Customs officials seized a relief sculpture that had been consigned for auction in New York City. The sculpture depicts a warrior figure standing atop a water buffalo and crowned by a phoenix. It belonged to the tomb of Wang Chuzhi (863–923), a military governor who served the Tang and Later Liang dynasties. Wang's tomb, located to the southwest of present-day Beijing, was discovered in 1980. In 1994, looters used dynamite to blast into the tomb, damaging murals (including one depicting an early example of a landscape), and stole this and other painted relief sculptures. In 2001, this relief was returned to China and is now in the collection of the National Museum of China in Tiananmen Square, Beijing.

Antiquities from every region have been stolen during periods of colonialism, armed conflict, and peace. The three examples of successful repatriation discussed here are the exception to the rule. More often than not, stolen art is never returned to its place of origin. Even when artworks are returned, the valuable historical information and cultural legacies that are lost when an object is illegally or carelessly removed from its original context can never be recovered.

3 **Painted stone relief depicting a warrior** from the Later Liang dynasty, *c.* 923 CE; unearthed in 1994 from the tomb of Wang Chuzhi at Quyang, Hebei province, China. Marble with paint, height 3 ft. 9 in. (1.14 m). **EAST ASIA**

Discussion Questions

1. The artworks discussed here all ultimately were repatriated. For other works, that is often not the case. Identify an example of a disputed work which has not yet been repatriated: What are some of the issues surrounding the object and its ownership?

2. Trafficking Culture (traffickingculture.org) is an organization that researches the global trade in looted artifacts. What types of evidence do they use to track objects' movements and better understand how the illegal trade in artworks operates?

Further Reading

• Barnes, Julian E. "Alleging Theft, U.S. Demands Rare Sculpture Go Back to China." *The New York Times*, March 30, 2000. https://www.nytimes.com/2000/03/30/nyregion/alleging-theft-us-demands-rare-sculpture-go-back-to-china.html

• Davis, Tess. "Returning Duryodhana." *Bostonia.* Summer 2014. http://www.bu.edu/bostonia/summer14/cambodia/.

• Kersel, Morag. "Illicit Antiquities Trade." In N. Silberman, ed. *The Oxford Companion to Archaeology*, 2nd edn, vol. 3. Oxford, U.K.: Oxford University Press, 2013, pp. 67–69.

• Rod-ari, Melody. "Returning "Home": The Journey and Afterlife of Repatriated Objects." In Allysa B. Peyton and Katherine Anne Paul (eds.). *Arts of South Asia: Cultures of Collecting*. Gainesville, FL: University of Florida Press, 2019, pp. 239–58.

• UNESCO World Heritage Centre. "Aksum." https://whc.unesco.org/en/list/15/ (last accessed April 9, 2020).

14

Art in Early Modern and Modern Southeast Asia

1550–1980

14.0 Detail of *Ramakien* murals,
Wat Phra Kaew complex, Bangkok,
c. 1808 and later (this segment of the
mural was last updated in 1974).

Introduction

The nearly four and a half centuries covered in this chapter—between circa 1550 and the 1980s, corresponding with the Early Modern and modern eras—brought immense technical, social, economic, and political changes, all of which affected artistic creation. Many of the changes may be traced back to the advent of global sea routes during the Early Modern era. In this regard, Southeast Asia, with its strategic location linking the Indian Ocean, Pacific Ocean and seas south of China, was often at the center of the developments taking place.

A snapshot of Southeast Asia around 1600 would show a region prosperous from maritime trade and dotted with cosmopolitan port-cities where people, goods, and ideas from across the world mingled. Several large states dominated mainland Southeast Asia, where Theravada Buddhism was the primary religion, and rulers patronized Buddhist sites as a way of legitimizing power. The Thai Ayutthaya kingdom (1351–1767) was one of the most important states, and during the seventeenth century its capital was a cultural hub producing refined artworks. In much of island Southeast Asia, smaller states vied for power, and Islam was the main religion. The mixing of Islamic beliefs with older cultural systems was visible at the royal courts, where an increasing variety of luxury items enhanced visual environments. European empires reached into Southeast Asia, but at this time only the Philippine archipelago was largely colonized. After gaining control of the Philippines in 1565, the Spanish introduced Christianity and founded the city of Manila, the primary port linking markets in the Americas to those of Ming dynasty China. Over the next few centuries, Southeast Asian artistic production flourished, helping to shape distinct cultural identities.

By about 1850, most of Southeast Asia was subject to direct European imperial control. Foreign dominance relied on products of the Industrial Revolution, such as deadlier weapons. But the ideologies cannot be overlooked. Biased ideas of progress, nationalism, and European cultural superiority shaped the colonizers' actions, which included building infrastructure, extracting resources, and limiting the rights of native inhabitants. Modernity, including Modernism in art, became associated with Westernization—a conflation that is still being untangled today. In one view, colonization caused a rupture in culture. As the nineteenth century ended and the twentieth century began, technologies, such as photography, along with new artistic styles and educational systems, were transforming Southeast Asian art. Yet artists fused these changes with preexisting visual practices such that modernity, too, was transformed.

After World War II ended in 1945, people throughout Southeast Asia engaged in long-anticipated projects of nation-building. They heralded the arrival of independence and decolonization, but political instability and even war followed the colonizers' withdrawal. Some nations were caught in the Cold War between the Soviet Union and the United States; in the cases of Vietnam, Cambodia, and Laos, the consequences were tragic. These complicated realities shaped artistic development. Over the twentieth century, the work of artists throughout Southeast Asia challenged viewers to confront difficult truths, but it also fostered a sense of community and identity.

Signs of Royalty in Early Modern Southeast Asian Art

From the ancient bronze drums of the Dong Son culture found at numerous sites (see Fig. 1.21), to the meticulous depiction of ships on the stone-carved reliefs of Borobudur (see Fig. 7.3), to the massive quantity of ceramics salvaged from a late fifteenth-century shipwreck off the coast of Hoi An, Vietnam (see Fig. 10.8)—much of Southeast Asian art speaks to the importance of maritime trade in the region. That long-standing significance intensified during the Early Modern era, which brought the advent of transcontinental sea routes and high global demand for pepper and other spices grown in Southeast Asia. During the sixteenth, seventeenth, and eighteenth centuries, as the region prospered from trade, people from a range of locales—Europe, West Asia, East Asia, and, of course, various parts of Southeast Asia—encountered one another in bourgeoning port-cities situated along rivers and coasts on both mainland and island Southeast Asia (Map 14.1; see also Map 10.1). Art throughout the region embodied the cultural mixing and cosmopolitanism of the period.

At the same time, during these centuries, existing differences among the subregions of Southeast Asia grew, and distinct cultural identities—such as Thai, Javanese, Vietnamese, and Burmese—began to solidify in ways that impacted much later beliefs related to nationalism. In part, these developments resulted from royal states, both large and small, using courtly culture and the maintenance of sacred sites to construct identities that would enhance their power. The differences also resulted from

Map 14.1 Southeast Asia during the Early Modern period.

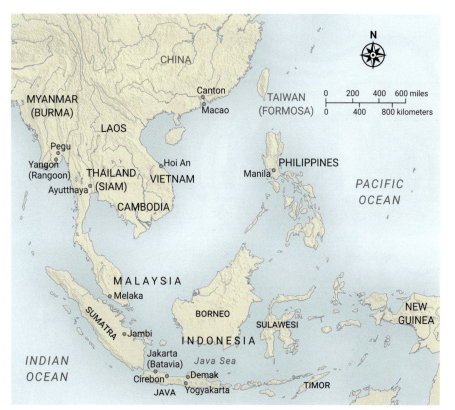

religious changes. In earlier centuries, fluid versions of Hinduism and Buddhism incorporating local indigenous beliefs had been practiced across the whole of Southeast Asia. By the Early Modern era, Islam had largely replaced the dharmic faiths in the southern peninsular and island zones, Theravada Buddhism dominated in the western portions of the mainland, and Confucianism, introduced from China, had taken hold in Vietnam. In the east—in the Philippine archipelago—the Spanish colonizers imposed Christianity on the local population.

On the Indonesian island of Java, Islam began to replace Hinduism as the main religion in the early sixteenth century, after the defeat of the powerful Majapahit Empire (1293–1527) by the Demak Sultanate (1475–1568; for more on the spread of Islam and early Islamic architecture in Demak, see Chapter 10). Between the sixteenth and eighteenth centuries, political power was fragmented. Small states, particularly along Java's north coast, vied with one another for control. During the seventeenth century, the Mataram Sultanate (1586–1755) attempted to bring the whole island under its dominion. The kingdom failed to do so; however, it did succeed in codifying a particular Javanese approach to courtly culture, which then spread to its rival states and became a potent signifier of royal power. Specifically, the accommodating nature of Javanese Islam allowed Muslim rulers to continue embracing local practices and beliefs, which drew on the Hindu/Buddhist ideal of the divine ruler as well as the Javanese belief that a ruler's sacred possessions, such as manuscripts and weapons, held supernatural powers that conferred the right to rule. These beliefs were blended with the revered role of kingship within Islam, in which a sultan was viewed as God's shadow on earth, to create a flexible and inclusive, yet distinctly Javanese

culture embodied in the period's art. Royal courts became centers for artistic patronage—of elite entertainment in the form of shadow puppetry, dance, and music, and also of luxury objects, such as textiles, manuscripts, jewelry, and weapons. Such objects, like this magnificent cloth banner, or royal flag, from the West Javanese port city of Cirebon (**Fig. 14.1**), signified the ruler's status and authority. Sometimes such objects were also believed to offer spiritual protection.

This particular banner, datable to the eighteenth century, is one of the earliest examples of **batik**. Batik is a method of **resist-dyeing** practiced in many parts of the world, but it is especially associated with Java. In batik, the artist applies wax freehand to cloth specially prepared with oil, lye, and paste; the artist "draws" the design with the aid of a tool called a canting that dispenses the wax. The fabric is then dyed, after which the wax is removed to reveal the design underneath. Here, the artist dyed the fabric dark indigo blue, and the design is in the cloth's natural cream color. In many other examples, the wax drawing and dyeing processes were repeated, rendering the design in multiple colors. Regardless of the number of colors used, for batik to be successful, the cloth must be not only properly prepared, but also smooth and finely woven. In the pre-industrial era, high-quality cotton typically was imported from the Indian subcontinent, as in this example.

The banner's striking design consists of a central image of the legendary double-bladed sword, Zulfiqar, surrounded by Arabic **calligraphy**. Muslims believe that the archangel Gabriel gave the sword to the Prophet Muhammad, the founder of Islam, who passed it to his son-in-law Ali so that he could perform great feats. The sword's image, thus, signifies both religious piety and

14.1 Royal banner, Cirebon, West Java, Indonesia, eighteenth century. Handspun cotton, silk, natural dyes, batik, mordant printing. 5 ft. 7¾ in. × 10 ft. 6⅞ in. (1.72 × 3.22 m). Jakarta Textile Museum, Jakarta.

batik a method originating in Java of producing colored designs on textiles by dyeing them, having first applied wax to the parts to be left undyed.

resist-dyeing when dyeing textiles, the various methods used to create patterns by preventing the dye reaching the cloth in certain areas.

calligraphy the art of expressive, decorative, or carefully descriptive hand lettering or handwriting.

chronogram an inscription in which specific letters, interpreted as numerals, stand for a particular date when rearranged.

hilt the handle of a weapon.

scabbard a sheath used to cover the blade of a sword or dagger.

embossed an object or surface that has been carved, molded, or stamped in relief.

wayang kulit an Indonesian shadow-puppet play.

military strength. Between the sword's large blades is a sequence of stand-alone Arabic letters, which scholars have suggested function as a **chronogram** giving a date corresponding to 1776 CE, perhaps the year the banner was made. The banner also displays Qur'anic verses, talismanic geometrical diagrams (that is, diagrams believed to possess special powers to ward off evil and bring good fortune), and calligraphy in the shape of lions, which, again, relate back to Ali, often called "the lion of God." Similar banners were made for the powerful Turkish Ottoman Empire, with whom Java's coastal ports had close contact, and likely inspired this one. Thus, while on the one hand the design was pan-Islamic in nature, on the other hand, the batik technique was specific to Java. The banner's perceived potency derived equally from both its pan-regional and local qualities.

The most important Javanese courtly items were the ruler's sacred possessions, which were considered to be *pusaka* (sacred heirlooms imbued with spiritual power; see Fig. 10.9). The belief was that such sacred royal accoutrements held supernatural powers that conferred the right to govern. One of the most important of such possessions was the *keris* (also spelled *kris*), an asymmetrical dagger with a distinctive blade patterning, called its

14.2 Si Genji Keris, Jambi, Sumatra, Indonesia, seventeenth century. Gold, wood, iron, nickel, precious stones, length 17⅝ in. (45 cm). National Museum of Indonesia, Jakarta.

pamor, and a highly decorated **hilt** and **scabbard**. The *keris* was simultaneously a functional weapon, a carefully crafted artwork to be admired, and a spiritual object with its own character and magical powers, which could bring either good or bad luck. Just as magnetic forces or radio waves cannot be seen, a *keris*'s supposed power is invisible. This unseen power required special treatment, starting with the *keris*'s creation. Because its potency was understood to be a gift from God, *keris*-makers undertook religious ceremonies before beginning work. Owners needed to study their *keris*; the possessor of a *keris* might tap on its blade and listen to the sound, or even sleep with it, to see how it affected his or her dreams. The importance and decorative forms of the *keris* originated in central Java and predate the arrival of Islam, but they spread to other parts of Southeast Asia during the Early Modern period.

One of the most lavish *keris*, called the Si Genji Keris and datable to the seventeenth century (**Fig. 14.2**), was made for the Jambi sultanate in southeast Sumatra, an important pepper-growing region. A *keris*'s curving blade was often compared to a snake, and its hilt to a bird; here, the carved wooden hilt literally takes the shape of a bird's head, with a ring of gems at the base of its neck. Elegantly scattered gold flowers and leaves decorate its blade, with several small mythic creatures adorning it as well. Its gold-plated scabbard is **embossed** with a repeating floral pattern. According to tradition, a Javanese metalsmith forged the blade in a single day—on Friday, the holiest day of the week in Islam. He then cooled it in a mixture of waters from twelve rivers to infuse it with supernatural strength and power. The last Jambi ruler to own this *keris* was Sultan Ratu Thaha Safiuddin (ruled 1855–1904), who died resisting Dutch colonial rule.

In pursuit of trading opportunities, the Dutch first arrived in Southeast Asia in the late sixteenth century. They soon realized the tremendous profits possible through trade with Asia, especially if they used military force to maintain a monopoly over a particular area's resources. By 1619, the Dutch East India Company (*Vereenigde Oost-Indische Compagnie* or VOC) had established the city of Batavia (now Jakarta) on Java's north coast as the center of their Asian holdings. For most of the Early Modern period, the Indonesian areas under Dutch control were limited, and the region largely remained independent. However, the Dutch slowly acquired territory such that by 1749 the company was able to turn the Mataram Sultanate into a vassal state. Still, extensive Dutch colonization of Indonesia did not happen until the nineteenth century (see **Fig. 14.9**), and even then, local Javanese rulers continued to patronize the arts. Their patronage ensured that courtly practices—including the creation of fine batik cloth, *keris*, and **wayang kulit**, a particular type of puppet performance in which expert puppeteers manipulate flat shadow puppets to act out stories drawn from indigenous myths, Persian heroic tales, and Hindu epics—continued well into the early twentieth century. Many live on even today, prized as important parts of Indonesian heritage that embody the syncretism of Javanese courtly culture (see Art Historical Thinking: Intangible Cultural Heritage and *Wayang Kulit*).

14.3 Ki Bekel Prawirasucitra, shadow puppet (*wayang kulit*) of Tugu Wasesa, from the consecrated set Kyai Nugroho, 1908, Yogyakarta, Indonesia. ABOVE LEFT puppet shown illuminated from the front; ABOVE RIGHT puppet shown in silhouette as seen through a screen. Water-buffalo hide and horn, pigments, cotton, gold leaf. Puppet without control rod: 29 × 15⅛ in. (73.7 × 38.4 cm); Puppet with control rod: 39½ × 15⅛ in. (1 m × 38.4 cm). Yale University Art Gallery, New Haven, Connecticut.

In 1972, the United Nations Educational, Scientific, and Cultural Organization (UNESCO) adopted the Convention Concerning the Protection of the World Cultural and Natural Heritage. Its aim is to help preserve sites with "outstanding universal value to humanity," such as the Indonesian monuments of Borobudur and Prambanan (see Chapter 7). In recent decades, however, the idea of what constitutes cultural heritage has broadened to include not just tangible sites and objects, but also artistic practices, skills, and knowledge that have been passed down over time. Correspondingly, in 2003 UNESCO adopted the Convention for the Safeguarding of the Intangible Cultural Heritage. The Indonesian government quickly succeeded in having batiking (see **Fig. 14.1**), *keris*-making (see **Fig. 14.2**), and *wayang kulit* deemed Masterpieces of Oral and Intangible Heritage of Humanity.

As early as the eleventh century, Javanese court poets were making references to shadow puppets; however, the oldest surviving puppets date only to the eighteenth century. Constructed of intricately cut and painted buffalo leather, the puppets have articulated body parts that expert puppeteers manipulate by moving long thin rods as they perform behind a screen illuminated by a lamp or other light source. The puppet illustrated here (**Fig. 14.3**) is from a set made and consecrated in 1908 for Prince Tejokusumo, son of Sultan Hamengkubuwono VII of Yogyakarta (see **Fig. 14.10**). Made by the artist Ki Bekel Prawirasucitra, it depicts a character from the Hindu epic, the *Mahabharata*, named Bhima (Indonesian: Bima) in his form as Tugu Wasesa, king of Gilingwesi. The figure's large, curved fingernail identifies it as Bhima.

In *wayang kulit*, audience members choose whether to sit in front of the screen so that they see only the puppets' silhouettes (as at right in **Fig. 14.3**) or behind it so that they see the puppets in full color (as at left in **Fig. 14.3**), in which case they also see the puppeteers and musicians at work. To be visually compelling in either context, the puppets need to have dynamic outlines as well as to be beautifully gilded and painted, as in this example.

Indeed, the Bhima puppet, with its exquisitely crafted lace-like cutouts, especially visible in the elaborate headdress, is a work of art. Yet it is also just one part of a larger artwork: the *wayang kulit* performance, which requires not only additional puppets, but also a screen, light source, puppeteers, musicians, musical instruments, and of course, a story. Understanding *wayang kulit* as intangible heritage highlights this larger context as well as the multiple domains of expertise required. It shifts the focus from objects to people and knowledge. In having *wayang kulit* recognized as a Masterpiece of Intangible Heritage, the Indonesian government's goal is to preserve that knowledge and, through UNESCO-funded training, pass it on to future generations.

Discussion Question

1. To preserve something is to freeze it at a particular state or moment in time. The preservation of heritage, whether tangible or intangible, has many benefits. But, like most things, there are trade-offs. Thinking about *wayang kulit*, what are some of the benefits to preserving it as a Masterpiece of Intangible Heritage? What are some of the downsides?

14.4 Shwedagon Pagoda,
Yangon (Rangoon), Myanmar
(Burma), originally built
sixth–tenth centuries, rebuilt
fourteenth–eighteenth centuries,
renovated thereafter.

Sacredness and Cosmopolitanism in Early Modern Southeast Asian Art

In contrast to the fragmented island zone, mainland Southeast Asia was controlled by several large polities during the Early Modern era and the primary religion was Theravada Buddhism rather than Islam. But like Islam, Buddhism was a crucial tool through which rulers justified and upheld their power. They did this in part by specifically promoting the Sri Lankan form of Theravada Buddhism as a way of unifying the state and monastic communities. (By this point, the Indian subcontinent was no longer viewed as a center for Buddhist learning. Instead, Sri Lanka was commonly seen as having the "purest" form of the religion because of Buddhism's early transmission to the island as well as the reforms undertaken by the ruler Parakramabahu I in the twelfth century—see Fig. 5.16.) To gain merit and demonstrate piety, mainland Southeast Asian rulers also patronized the construction, maintenance, and remodeling of Buddhist sacred sites. One such place—considered the most sacred site in Myanmar (Burma)—is the 326-foot-high golden *stupa* called the Shwedagon Pagoda (**Fig. 14.4**).

The Shwedagon Pagoda sits atop Singuttara hill at the center of the city of Yangon (Rangoon). The hill is ringed with monasteries and punctuated by four staircases, aligned with the cardinal directions, that lead to the pagoda's platform. There, smaller shrines and **buddha** statues encircle the main *stupa*. The monumental gold-plated brick structure is believed to contain a number of sacred **relics**. The story is that two merchant brothers

traveled to India and visited the historical Buddha on the forty-ninth day after his Enlightenment. They offered him food, and in return he gifted them eight of his hairs and delivered a prophecy: the brothers would find three more sacred relics. Back home, with the help of a local king, the brothers did indeed discover objects (walking stick, water dipper, and robe) belonging to three buddhas from previous ages. The relics were interred in Singuttara hill, which is how it became the location for the Shwedagon Pagoda that now enshrines all three of the sacred items.

Like many actively worshipped, long-standing religious monuments (see, for example, the Minakshi Temple, Figs. 10.15–10.18), the Shwedagon Pagoda has been modified continuously over the centuries, and assigning a specific completion date is therefore difficult. Archaeological evidence suggests the original structure dates to sometime between the sixth and tenth centuries CE; however, the monument as it stands today largely results from royal patronage between the fourteenth and eighteenth centuries. Notable patrons include the fifteenth-century Mon queen Shin Saw Bu (ruled 1453–72). She had the hill terraced, increased the pagoda's height, and donated her weight in gold to adorn it. In 1768 an earthquake brought down the top of the *stupa*, but a few years later, King Hsinbyushi (ruled 1763–1776) of the powerful Burmese Konbaung dynasty (1752–1885) had it rebuilt and raised it to its current height.

The pagoda's form follows pan-Buddhist conventions in which a *stupa* consists of three main parts: a tiered base, bell-shaped body, and top spire. Here, however, in typically Burmese fashion, the parts merge together so

stupa a mound-like or hemispherical structure containing Buddhist relics.

buddha; the Buddha a buddha is a being who has achieved the state of perfect enlightenment called Buddhahood; the Buddha is, literally, the "Enlightened One"; generally refers to the historical Buddha, Siddhartha Gautama, also called Shakyamuni and Shakyasimha.

relics the bodily remains of, or other items believed to have come into physical contact with, the divine.

that the effect is of a single unified shape, rather than of distinct parts pieced together (compare, for example, to the Great Stupa at Sanchi, Fig. 3.3). To this end, the **harmika** has been omitted to give the spire a more graceful, streamlined shape and add to the overall elegant, ethereal appearance of the sacred site.

One of the most powerful polities in mainland Southeast Asia during the Early Modern era was the Thai kingdom of Ayutthaya (called "Siam" by foreigners). Founded in 1351 and lasting for more than four hundred years, the kingdom was governed from its capital city of the same name, situated fifty miles upriver from the Gulf of Siam, at the confluence of three rivers. Ayutthaya's location made it an important trading hub and prosperous city, with an estimated population of 150,000. With four hundred monasteries and temples, it also was a center for Theravada Buddhism, the dynasty's official religion—although Hindu rituals formed the basis for many of the royal ceremonies.

The rulers of Ayutthaya cultivated diplomatic ties with various powers across Eurasia, and the kingdom's cosmopolitanism reached its peak during the reign of King Narai (ruled 1656–88), who appointed several foreigners, including a Greek, to important government positions. Narai sent a delegation to the court of Louis XIV (ruled 1643–1715) in France, and was even said to have worn Persian-style clothes with a Malay *keris* tucked in his sash to welcome the ambassadors from the Persian Safavid Empire (1501–1736). Upon Narai's death there was some backlash to this openness. The French were expelled, his Greek advisor was executed,

and China became Ayutthaya's main trading partner. In 1767, Ayutthaya fell to its long-standing Burmese rivals, led by King Hsinbyushi of the Konbaung dynasty (see Fig. 14.4). In terms of Ayutthaya's visual culture, what was not sacked by the Burmese armies was taken away by later Thai kings in the building of their new capital city, leaving precious little evidence of its cultural sophistication and artistic splendor.

The few objects that do survive, including this cabinet (**Fig. 14.5**), are striking. Wooden cabinets, such as this one, typically held manuscripts or other valuable objects. In this case, the elaborate **lacquer** and **gilded** decoration reflects Ayutthaya artistry. The side panels are adorned with painted landscapes, while the front and back panels depict large figures. The three-headed figure on the right back panel could be the Hindu god Brahma, but its mate has no recognizable attributes. Note the elongated forms of the two figures, their curving stances, and the flame-like details, all classic characteristics of Ayutthaya style. The style employed for the front panels differs slightly; the figures there are less delicate and elongated. This variance suggests that the front and back panels were not made at the same time (the back panels may have been from an older cabinet and were reused here). The front left panel depicts a European, thought to be the French king Louis XIV, and the right panel shows a Persian or Indian, perhaps the Mughal emperor Aurangzeb (ruled 1658–1707). Narai exchanged ambassadors with both rulers, and these panels probably date to his reign. Some scholars have questioned the identity of the right figure by pointing out its composite nature: while the turban

harmika a square, fence-like enclosure that symbolizes heaven and appears at the top of a *stupa*.

lacquer a liquid substance derived from the sap of the lacquer tree; used to varnish wood and other materials, producing a shiny, water-resistant coating.

gilded covered or foiled in gold.

14.5 Cabinet, Thailand, Ayutthaya dynasty, *c.* 1650–1750. Lacquered and gilded wood, 5 ft. 4⅝ in. × 46½ in. (1.65 × 1.18 m). National Museum of Bangkok. The image on the left shows the back panels decorated with two figures, perhaps Hindu deities. The right image shows the front panels decorated with a European, perhaps the French King Louis XIV, and a Persian or Indian, perhaps the Mughal emperor Aurangzeb.

seems Indian, the trousers are too short to be either Indian or Persian, the belt appears Thai, and the figure sports a Malay or Javanese *keris*. Whoever he was intended to represent, the cabinet's decoration captures the cosmopolitanism of Ayutthaya and the cross-cultural contacts that marked Early Modern Asia more generally, beyond Southeast Asia, inviting comparison with such works as *Jahangir Preferring a Sufi Shaykh to Kings* (see Fig. 11.7), which also depicts foreign leaders, or even with Japanese *namban* screens, which portray foreign merchants, sailors, and servants (see Fig. 9.17).

The trans-oceanic mobility of people, objects, and ideas that marked the era is also fully captured in a small Christian sculpture of the Virgin Mary (Fig. 14.6) made during the eighteenth-century in Manila, the Filipino city founded by Spanish colonizers in 1571. The Spanish had first established a permanent settlement on the island of Cebu in the middle of the Philippine archipelago in 1565; however, just a few years later, they relocated north to the island of Luzon, where they founded Manila along one of the world's deepest natural harbors (see Map 14.1). It formed the ideal location for the large Spanish ships laden with silks, porcelain, and other goods from Ming dynasty China, as well as spices from Southeast Asia, to

14.6 The Virgin of the Immaculate Conception, Philippines, Hispano-Philippine, eighteenth century. Ivory, partly gilded and polychromed; halo: silver; eyes: glass, 10¼ × 3⅛ × 2⅞ in. (26 × 7.9 × 7.1 cm). Metropolitan Museum of Art, New York.

dock on their way to Acapulco on the west coast of what was then called New Spain. The ships would return from the Americas with a range of commodities, the most important being silver from mines located in what are today the countries of Mexico, Bolivia, and Peru. During the Early Modern period, those mines produced roughly eighty percent of the world's supply of silver, most of which ended up in Chinese imperial coffers, and the Spanish established themselves as the intermediaries in this exchange of goods for silver. The advent of direct, continuous trade between the Americas and Asia was such a crucial event that some economic historians date the birth of global trade to 1571, the year of Manila's founding. Manila quickly grew into an eclectic, urban hub. By the mid-seventeenth century, it had roughly 42,000 inhabitants, about half of whom were Filipinos. Chinese merchants, artisans, and other workers (many of whom had come to the Philippines before the Spanish arrived) made up the next largest group, followed by the Spanish colonizers, who were much smaller in number.

The ivory sculpture of the Virgin Mary featured here was likely made by a Chinese or Chinese-Filipino artist residing in Manila. The figure's pose—hands clasped in prayer and eyes in a downward gaze—indicates that the sculpture depicts the Virgin of the Immaculate Conception. This form of Mary was particularly popular throughout the global Catholic communities of the Early Modern period: Spain and Portugal as well as their colonies in Asia and the Americas. Similar ivories of the Virgin of the Immaculate Conception were made in Portuguese Goa on India's west coast, for example. The devotional statues were then exported and sold to Catholics around the world. That this sculpture was made in the Philippines is confirmed by the particular way the Virgin's mantle is tucked in the back (not visible here). The figure's subtle, graceful curve follows the shape of the elephant tusk from which the majority of the sculpture was carved. The artist constructed the back of Mary's head and hair from separate pieces of ivory so that glass eyes could be inserted. This addition of glass eyes was common in Spanish devotional sculptures in order to make them appear more realistic. Since elephants are not native to the Philippines, the ivory had to be imported. It may have come from mainland Southeast Asia, Sri Lanka, the Indian subcontinent, or even Africa. The silver used for her crown likely came from the mines in the Americas. The silver and ivory's preciousness signifies the Virgin Mary's esteemed status in Catholicism; the materials also embody the importance of global trade at the time.

In many respects, the devotional sculpture resists being assigned to a fixed location. The materials from which it was made, the artist who made it, and the object itself all likely moved from one location to another. Indeed, rather than understanding the artwork as the product of a single specific culture, we might see it as a product of multiple intersecting yet distinct cultures: that of global Catholicism, the Chinese diaspora, and colonial Manila. At the same time, because the sculpture was made in the Philippines, it can serve as a reminder of the central place that Southeast Asia held with regard to many of the developments of the Early Modern era.

Modernism and Identity in Southeast Asian Art

As early as the sixteenth century, European powers began conquering territory in Southeast Asia (see, for example, **Fig. 14.6**); however, throughout the Early Modern period, most of the region still remained under local rule. This situation changed during the modern era. By the end of the nineteenth century, the majority of Southeast Asia was under foreign imperial control (**Map 14.2**): Burma and Malaya were controlled by the British, the Philippines first by Spain and then the United States, Indonesia by the Dutch, and Vietnam, Laos, and Cambodia by the French. Only Thailand escaped outright European occupation. How was Thailand (known as Siam in the nineteenth century) able to remain independent? The country's geography helped protect it somewhat, as did strategic concessions to European powers. Credit is also due to the early rulers of the Chakri dynasty (1782 to present) who provided the country with a firm, unified, political, intellectual, and cultural structure, visible in art from the period.

The first ruler of the Chakri dynasty, Rama I (ruled 1782–1809), enacted a series of administrative and religious reforms intended to strengthen the relationship between the monarchy and the Thai Buddhist establishment. Rama I also founded the city of Bangkok to serve as the new capital and moved the prized Emerald Buddha there. The semi-precious green stone icon of the Buddha seated in meditation is only 26 inches (66 cm) high, but it is believed to have great powers, bestowing legitimacy on those who possess it and offering protection to those around it. A fifteenth-century chronicle written around the same time that the Emerald Buddha first emerged posits that in 44 CE, the celestial architect Vissukamma sculpted the icon from a wish-granting jewel. The Emerald Buddha then descended from the heavens to earth to offer itself to deserving Buddhist rulers, including the Maurya emperor Ashoka (see Chapter 3). Despite this account, it is likely that the sculpture dates to the early or mid-fifteenth century. In 1784, Rama I had a temple, Wat Phra Kaew, constructed in Bangkok to hold the Emerald Buddha (**Fig. 14.7**, p. 292). It is still enshrined and actively worshiped there today. Wat Phra Kaew is located within the same large enclosure as the royal palace, which Rama I had built in 1782. The presence of the Emerald Buddha within Rama I's palace-temple complex showcased his possession of the icon, thereby highlighting the legitimacy of his rule and his efforts to protect his constituents.

Between 1785 and 1807, Rama I also supervised the compiling of the *Ramakien*, the Thai national epic based on the ancient Hindu *Ramayana*. While the story of the god Rama's search for his wife Sita (Thai: Nang Sida), kidnapped by the demon Ravana (Thai: Thotsakan), was originally South Asian, it had been known in Thailand since at least the thirteenth century, and had become an important part of Thai culture. The epic served a didactic purpose, exemplifying devotion, sacrifice, and leadership. The version compiled by Rama I adapted the story's details—names, places, weapon types, dress—to a Thai context, and codified the content.

In 1808, Rama I had the interior walls of Wat Phra Kaew's expansive enclosure decorated with **murals**, divided into 178 scenes, depicting the entire, newly codified *Ramakien*. The large, colorful, and compositionally

mural a painting made directly on the surface of a wall.

Map 14.2 South Asia and Southeast Asia, with areas of colonial control during the nineteenth and twentieth centuries as well as current country boundaries demarcated.

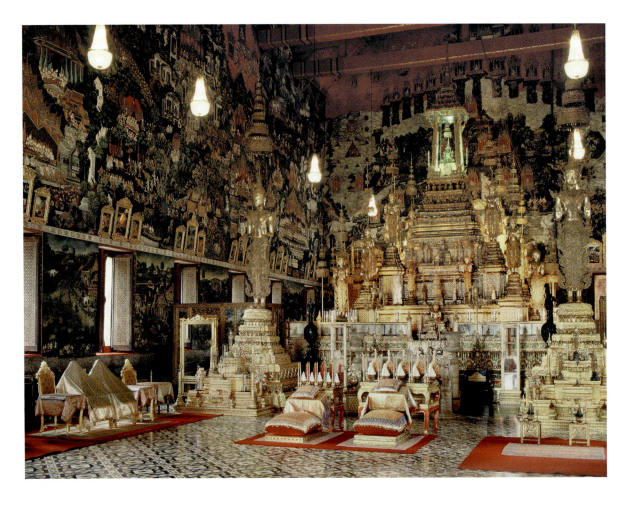

14.7 **Interior of the Chapel of the Emerald Buddha,** Wat Phra Kaew complex, Bangkok, Thailand. Emerald Buddha: fifteenth century; chapel: *c.* 1808 and later.

complex images begin at the north gate and continue clockwise. Since their original completion in the early nineteenth century, the murals have undergone major restoration four times (the earliest in 1832 and most recently in 1982). While the paintings' contents were largely maintained during each restoration, their current appearance reflects stylistic changes within Thai mural painting. Specifically, between the second half of the nineteenth century and the early twentieth century, the Chakri rulers encouraged interest in European art, resulting in the selective introduction of **linear perspective**. For example, artists employed perspective in depicting the palaces (**Fig. 14.8**, left side), while retaining a distinctively Thai decorative style for many of the figures. This more local style is particularly visible in the striking depiction of the white monkey, Hanuman, Rama's most important ally (**Fig. 14.8** and **Fig. 14.0**). In one scene (**Fig. 14.0**), Hanuman has used his supernatural powers to make himself gigantic and threatens to devour a palace and its guards. Note the decorative swirls in his body and his flame-like ears—these aspects typify Thai painting of the eighteenth and nineteenth centuries. These royally sponsored murals reflect the mixture of continuity and gradual change that Thailand was undergoing during the period.

Beyond Thailand, the rest of Southeast Asia endured various levels and types of colonial rule. Between 1830 and 1870, for example, Indonesians suffered under the so-called Cultivation System, a Dutch policy that set production quotas for export commodities and raised taxes,

leading in some places to starvation conditions. Javanese artist Raden Saleh (*c.* 1811–1880) provides an interesting case study into the complexities of this period. A member of the local aristocracy, Saleh made a career as a painter working with oil on canvas in a European style. Moreover, Saleh lived, studied, and exhibited his artwork in Europe. In 1829, just before the implementation of the Cultivation System, the Dutch government, persuaded by a Belgian artist who recognized Saleh's talent, sent the young man to the Netherlands to study painting. Saleh went on to live in France and Germany, where he met the leading intellectuals of the day and continued to paint and exhibit his art. In 1850, after gifting a painting to King William II of the Netherlands, Saleh was bestowed the title "King's Painter." After twenty-three years in Europe, he returned to Java in 1852 and served the government as an official painter. Saleh's successes provided him with the means to build a mansion in Batavia (now Jakarta), but the prejudices of colonialization—which viewed a brown-skinned person, no matter how well-educated and successful, as inferior to a white person—constrained him, and he was shunned by much of colonial Batavian society.

Saleh's best-known and most enigmatic work, *The Arrest of Pangeran Diponegoro* (**Fig. 14.9**) from 1857, was the only **history painting** he completed. The image depicts the Dutch capture in 1830 of Prince Diponegoro, considered a hero in Indonesia for leading a five-year armed resistance to colonial rule. Scholars today are divided on whether the painting is proof that Saleh lacked concern for the Indonesian cause, siding with the Dutch instead,

linear perspective a system of representing three-dimensional space and objects on a two-dimensional surface by means of geometry and one or more vanishing points.

history painting a genre of painting that takes significant historical, mythological, and literary events as its subject matter.

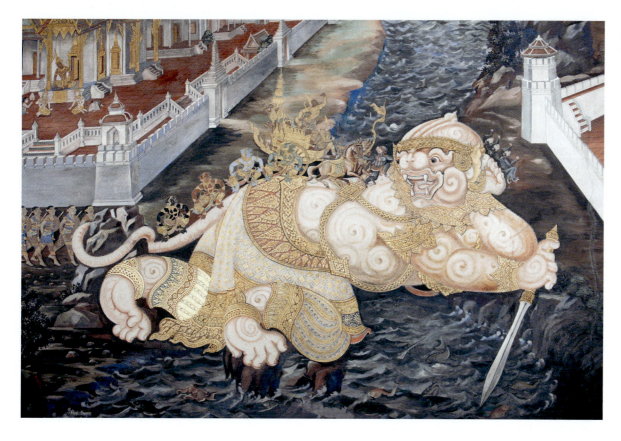

14.8 Detail of *Ramakien* **murals,** Wat Phra Kaew complex, Bangkok, *c.* 1808 and later (this segment of the mural was last updated in 1972 by the artist Sawong Timudom).

or is an early example of Indonesian nationalist sentiment in art. Differences between Saleh's painting and an earlier depiction (*c.* 1835) by the Dutch artist Nicolaas Pieneman suggest to some scholars that *The Arrest of Pangeran Diponegoro* does present a nationalist view. In Saleh's painting, Diponegoro, on the building steps surrounded by Dutch officers and grieving women, stands defiant, on the same level as his captor, rather than positioned lower and in a submissive stance. Additionally, there is no Dutch flag visible, as there was in the work of Pieneman. Finally, Saleh has depicted the Dutch (but not the Indonesians) with curiously big heads, which to a Javanese audience suggested that they were monster-like. Whatever Saleh's feelings about the Dutch may have

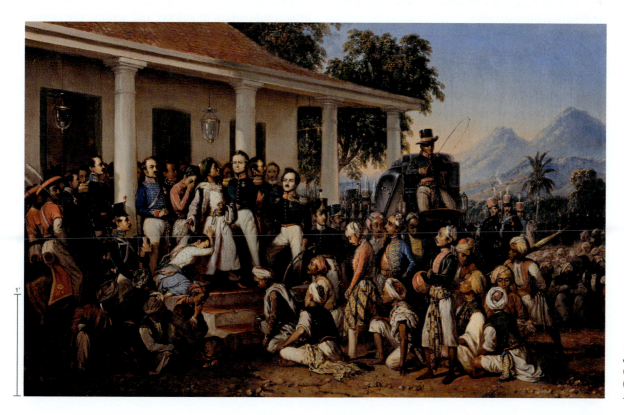

14.9 Raden Saleh, *The Arrest of Pangeran Diponegoro,* 1857. Oil on canvas, 44 in. × 5 ft. 10½ in. (1.12 × 1.79 m). Museum Istana, Jakarta.

Modernism and Identity in Southeast Asian Art **293**

14.10 FAR RIGHT Kassian Céphas, *Studio Portrait of Two Javanese Dancers*, Yogyakarta, Indonesia, late nineteenth–early twentieth century. Albumen print, 7 × 5 in. (17.6 × 12.4 cm). Rijksmuseum, Amsterdam, Netherlands.

been, his career and work were unusual—although not wholly unique—for the period.

Despite the economic hardships that Indonesians endured under Dutch rule, members of the local aristocracy, particularly in central Java, maintained their support of esteemed artforms, such as batik, dance, and *wayang kulit*, ensuring their continuation (see Art Historical Thinking: Intangible Cultural Heritage and *Wayang Kulit*, p. 287). The royal patrons and their artists diligently preserved visual practices central to Javanese identity. Simultaneously, they selectively adopted aspects of modernity, including new technologies like photography, that aided their efforts of communal and self representation.

Photography arrived in Southeast Asia shortly after its invention in Europe (see Seeing Connections: The Spread of Photography, p. 300). The new technology used a mechanical device (a camera) that produced images through a physical reaction between a sensitive surface (such as a chemical-coated glass or paper negative) and light reflecting off objects in the world. Compared to, say, painting or drawing, it allowed images to be captured quickly, with seeming accuracy, and reprinted multiple times. By 1845, European photographers were producing pictures of famous monuments such as Borobudur (Figs. 7.1–7.4). By the late 1850s, several regional rulers had embraced photography at their courts, seeing it as a potent new vehicle for, among other things, displaying their status in international circles. Such leaders included the Javanese ruler Sultan Hamengkubuwana VI (r. 1855–1877) of Yogyakarta. (Thailand's King Mongkut, also known as Rama IV, who ruled 1851–1868, was another enthusiastic early patron of photography.) It was at the court of Sultan Hamengkubuwana VI in the late 1860s that the young Kassian Cephas (1845–1912) learned photography, making him Indonesia's first Indigenous professional photographer.

Educated at a Protestant Christian missionary school, the young man took the name of Cephas when, at the age of fifteen, he converted to Christianity. Several years later, while employed in Yogyakarta, he was trained in photography by the Dutchman Simon Willem Camerik, at the request of Sultan Hamengkubuwana himself. In 1871, Cephas became the sultan's official court photographer. His primary responsibilities included taking portraits of the royal family and producing photographs to be presented as parting gifts to European elites visiting Yogyakarta. A year later, Cephas also opened a commercial studio in the city, and throughout his career, he created work for the Dutch government and scholars. For example, he produced a series of photographs capturing classical Javanese dances being performed at the royal court, to be published as **collotype** prints for publication on the subject by Isaac Groneman, the sultan's physician and an amateur scholar. Cephas also took photographs of Prambanan (Figs. 7.5–7.6) and Borobudur for the Dutch Archaeological Union (Archaeologische Vereeniging).

Taken at Cephas's studio, this photograph (**Fig. 14.10**) captures a pair of Javanese dancers bedecked in the elegant costumes, make-up, and jewelry that they would wear for performances. Facing each other, the young female

1"

and male dancers strike poses that emphasize their lithe physiques, the dramatic lines of their distinctive headdresses, and the overall theatricality of the scene. The studio setting, with its carpet, heavy wooden table, and painted backdrop of a misty garden, typifies that found in urban photographic studios throughout the world in the late nineteenth and early twentieth centuries. Through this combination of subject and setting, the picture speaks to photography's ability to mediate local identity, often embedded in history and heritage, with the global cosmopolitanism marking many aspects of modernity.

In general, Cephas's work and career resemble those of other early professional photographers from cultures outside of what was deemed the West (see Art Historical Thinking: The Idea of the West, Westernization, and Modernization). Like Lala Deen Dayal in India (see Fig. 15.3), Antoin Sevruguin in Iran, and Martín Chambi in Peru, Cephas was a self-made man, able to carve out a career and life in the growing urban middle class by working for locals as well as foreigners, by running a commercial establishment but also taking government commissions, and above all, by keeping up with technology. To that end, in 1886, Cephas bought a new, faster camera, one able to capture pictures in 1/400th of a second. Interestingly, despite—or perhaps because of—his success, in 1891, he and his two sons were granted legal status as Europeans by the Dutch colonial government. Their desire to be classified as such suggests that the social problems encountered by Raden Saleh forty years earlier had not disappeared. The event also suggests that race was, to some degree, a matter of bureaucracy in Dutch Indonesia.

collotype in photography, a process that employs a glass plate coated in a light-sensitive gelatin solution to produce high-quality prints, useable for publication, from a photographic negative.

Changes in Southeast Asian art during the nineteenth and twentieth centuries are sometimes described as part of the process of Westernization, which in turn is often conflated with modernization. The assumptions behind such statements are worth examining critically: what is the West, what does it mean to Westernize, and is that the same as to modernize?

In its simplest usage, "west" is a geographical direction. We describe India as west of China, for example. However, there is another, much more complex usage of "the West" (usually with a capital W) that refers to cultural heritage, including philosophies, arts, musical forms, literary works, religions, and political systems. Beginning in the eighteenth century, Europeans invented a concept—Western civilization—contending that people of white European descent share an unbroken chain of history and progress from ancient Greece to the present, characterized by beliefs, values, institutions, and technologies associated with Europe. This is a recent conception. No people in the ancient or medieval world would have understood themselves as part of, or outside of, something called "Western civilization."

The catchall idea of Western civilization emerged during the modern industrial era, when European nations were colonizing the lands of other people throughout the world, including in Southeast Asia. Today, some scholars, such as philosopher Kwame Anthony Appiah, have argued that Western civilization is a myth constructed to justify European imperialism and racism. By its very existence, the term "Western" falsely suggests a binary contrast with the terms "Eastern," a generalized way of referring to Asian cultures, and "non-Western," which lumps widely disparate groups into a single category that usually connotes "non-white" and "non-Christian." In this construction, if the West is viewed as the birthplace of progress, rationalism, and liberty, then the East, or the non-West more generally, becomes the location of unchanging traditions, suspect religions, and savage despotism, in need of rescuing by the West. The idea of a homogenous East in contrast to the West also is directly related to the concept of Orientalism (see Seeing Connections: Images of Orientalism, p. 261), which stereotypes and exoticizes Asian cultures.

Modernity was a key rationale of European colonizers: they believed that because what they conceived of as progress—and thus modernity—belonged to the West, their authority over other people was justified. Westernization, the process by which a culture adopts beliefs and practices associated with Western civilization, became conflated with modernization, a wide-ranging process that involves transformations to technology, government, economics, social structures, and artistic expressions. Not only was the complexity of change simplified and distorted, but also efforts by societies outside the West to modernize, whether through new forms of art, styles of dress, or modes of transportation, were labeled as foreign and inauthentic.

Art history as a discipline developed in Europe during the nineteenth century, the height of European imperialism. As a product of that place and time, it adopted assumptions such as the idea that Modernism was unique to Western art (that is, art from Europe and from societies that white European colonizers established in North America, Australia, New Zealand, and South Africa). Today, such beliefs are no longer tenable. Art historians now see Westernization and modernization as related but distinct phenomena. They also recognize multiple forms of modernity, and their research is bringing to light the diversity of modern art made by artists throughout the world.

Discussion Question

1. Choose one of the artworks or buildings discussed in this section of Chapter 14, and examine it: which aspects might be considered evidence of Westernization? Of modernization?

Colonialism perhaps most visibly marked the urban built environment in the parts of Southeast Asia that were under direct foreign control: European colonizers introduced unfamiliar architectural styles and industrial materials into novel structures that suited their needs (see Seeing Connections: Empire Building, p. 318). This transformation is particularly apparent on the Malay Peninsula, where the British founded the island city of Singapore and expanded cities such as Kuala Lumpur, which means "muddy confluence," referring to its location at the confluence of the Gombak and Klang rivers.

As Kuala Lumpur grew in population and density, the Indigenous wood-and-thatched architecture—used throughout much of Southeast Asia because of its suitability to the climate and available resources—became a liability. After fire swept the city, the British official in charge ordered it rebuilt with brick. Then, the city was named the capital of the Federated Malay States under control of the United Kingdom, and another construction boom ensued in 1896. This time, the British architect A. B. Hubback (1871–1948) designed many of the new civic buildings in an eclectic style often termed Indo-Saracenic—"Indo" referring to India and "Saracenic" to Islamic architecture. (Although "Saracen" is technically a term used by medieval Christian European writers to refer specifically to Arab Muslims, the British did not differentiate between Arabs and Muslims more generally.) The British developed the style for use in colonial India, but they saw it as appropriate for Malaya as well because of the predominance of Islam in the region. The style combined Mughal architectural elements, such as onion-shaped domes and *chhatris* (see Fig. 11.2), with aspects of Victorian **Gothic Revival**, as well as the occasional detail from West Asian and North African Islamic architecture. These decorative elements were applied to buildings that otherwise were conventionally constructed to suit their modern administrative functions, often featuring elements such as clock towers, which signified both modernity and control (dictating when work needed to begin and end).

In addition to designing administrative buildings for Kuala Lumpur, Hubback served as architect for the Jamek **Mosque** (Fig. 14.11, p. 296), which functioned as the city's main **congregational mosque** from its construction in 1909 until the building of newly independent Malaysia's national mosque, Masjid Negara, in 1965. Prominently located at the spot marking the confluence of the two rivers, the Jamek Mosque exemplifies the Indo-Saracenic

chhatri literally means "canopy"; a domed-shaped pavilion, usually elevated and used as a decorative element in South Asian architecture.

Gothic Revival the renewed popularity of the European Gothic style of architecture during the nineteenth century.

mosque a Muslim place of worship.

congregational mosque also called a Friday mosque, or *jama masjid* in Arabic, the main mosque in a city or town and the location of Friday prayers, when the entire community comes together.

14.11 A.B. Hubback, Jamek Mosque, Kuala Lumpur, Malaysia, 1909.

style. Significantly, the style came to be seen as the appropriate choice for Southeast Asian mosques, supplanting traditional structures (see Figs. 10.6 and 10.7). Domes and **minarets**, which before the nineteenth century had not been part of Southeast Asian mosques, quickly became ubiquitous, and regional forms of Islamic architecture gave way to a more pan-Islamic vision, albeit one defined from a European perspective.

The new architectural styles, whether Indo-Saracenic or **Neoclassical** or something else, marking colonized spaces, were applied to a broad range of buildings: mosques and palaces, but also court houses, post and telegraph offices, railway stations, and schools, including art schools with curriculums based on European models of art education. For example, in the Vietnamese city of Hanoi, the French government founded the École Supérieure des Beaux-Arts d'Indochine (the Indochina College of Fine Arts; now Hanoi University of Fine Art) in 1925. Like the art schools the French government established in its other colonies, the École focused on **Academic art**, emphasizing rigorous, standardized training and European styles of painting, especially Neoclassicism and **Romanticism**, and later on, **Impressionism**. The school trained many of Vietnam's leading modern artists, including Lê Phổ (1907–2001) and Trần Văn Cẩn (1910–1994). By the first few decades of the twentieth century, many urban centers in Southeast Asia—as well as South Asia and East Asia—housed similar European-inspired art schools.

Some artists, nonetheless, chose to travel abroad to the colonial center itself to receive their education, where they competed on par with their European peers. For example, during the latter part of the nineteenth century, Felix Hidalgo (1853–1913) and Juan Luna (1857–1899) left the Philippines to study and work in Spain. Both artists mastered Academic history painting, with its large scale and dramatic narratives painted in an idealized and exaggerated form of realism, and both won awards for their work. At the national art exposition in Madrid in 1884, Luna's painting, *Spoliarium*, earned the gold medal, beating out the competition and demonstrating the supposed intellectual and artistic superiority of Europeans was a myth.

Nearly four decades later, the Filipino artist Victorio C. Edades (1895–1985) also chose to study abroad, but by then the Philippines was ruled by the United States. (Spain lost control of the Philippines to the U.S. after the Treaty of Paris in 1898, and in the 1899–1902 Philippine–American War, U.S. forces defeated Filipino independence fighters.) Edades, therefore, traveled to the west coast of the United States to study painting and architecture at the University of Washington. Two experiences from his nine-year stay in North America shaped Edades's approach to art. First, he financed much of his education by working at the salmon canneries in Alaska. There, living and working in harsh conditions alongside other Filipinos, he developed a respect for the toil of laborers. Second, in the early 1920s, he saw a traveling version of the International Exhibition of Modern Art, which had debuted at the New York Armory Hall in 1913. Better known as the Armory Show, this influential exhibition was the first large showcase of modern art in the United States and introduced audiences to the work of **avant-garde** European artists, such as Paul Cézanne, Pablo Picasso, and Marcel Duchamp. Edades was drawn in particular to Cézanne's use of color and form.

When Edades returned to the Philippines in 1928, he was determined to affect the shape of Filipino art, which was still largely dominated by Academic-style painting. He believed that art could do more than represent an

idealized, sanitized version of reality; it could convey an unvarnished view of the world filtered through the mind and feelings of the artist. Edades arranged for a solo exhibition of his work to be held at the Philippine Columbian Club in Manila. The thirty artworks on display included the huge, more than 10½-foot-long painting, *The Builders* (**Fig. 14.12**). His most renowned work, it encapsulates his interpretation of Filipino **Modernism**. An array of distorted, muscular figures twist and bend, laboring to move large stone blocks. The palette is earthy, suggesting the dirt and grime of their work. Dark outlines contrast with ocher-hued highlights, and bold, ***impasto*** brushstrokes add further drama to the scene. The painting is considered central to the history of Filipino art, but it was not immediately well received, as audiences were unsure how to see it. Edades, nonetheless, continued to campaign for a more modern artistic approach. Throughout the 1930s he made a series of public murals in Manila, organized the School of Fine Art and Architecture at the University of Saint Tomas, and founded the "Thirteen Modernists" group of artists, who engaged their academic peers in debate.

Alongside such artistic debates, calls for political and social reform, as well as anti-imperialist sentiment, were gaining strength throughout much of Southeast Asia. By the 1920s and 30s, the Dutch, British, French, and Americans had consolidated their power in the region, leading to increasing inequality and an emergent sense of nationalism within Indigenous populations. The onset of World War II in 1939 and the brutal Japanese occupation of Southeast Asia from 1941 to 1945 upended life for both colonizers and colonized. In post-war years, after more struggle, Vietnam, the Philippines, Myanmar (Burma), and Indonesia gained independence, followed thereafter by Cambodia, Laos, Malaysia, and Singapore. Other changes accompanied these events: immigration, extensive urban growth, and the maturation of national identities, to name a few. In certain instances, political instability and prolonged armed conflict followed, such as in 1954 when Communist Vietnamese forces defeated colonial French troops and Vietnam split into two parts. The United States became involved in the conflict, resulting in a two-decade-long war, which also affected Cambodia and Laos. Artistic production, of course, was impacted by these events. In some cases,

artists played a role in both recording the changes taking place and shaping the conversations surrounding them.

For example, the turbulent road to independence in Singapore's post-war history is reflected in **woodblock prints** made by politically active artists—sometimes called the Malayan Modern Woodblock Movement—in the 1950s and 1960s. In 1945, when the Japanese occupation ended, the British regained control of the Malay peninsula. Although their empire was waning (India, for example, gained its independence in 1947; see Chapter 15), the British were reluctant to relinquish Singapore and the Malay peninsula because of their maritime strategic importance and rubber reserves, respectively. Eventually, a plan for power-sharing and incremental internal self-governance was put into place. However, when the Malayan Communist Party, which played a vital role in resisting the Japanese during the war, was left out of the arrangements, the party began agitating for self-rule. (Singapore would eventually become a sovereign state in 1965, but the process was a slow and complicated one.) During the 1950s, young idealistic artists, such as Lim Yew Kuan (1928–2021)—sometimes considered the founder of Singapore's modern woodblock print movement—joined the leftist, anti-imperialist cause, making prints that critiqued social inequality and advocated for a collective consciousness. The graphic quality and easy reproducibility of monochrome woodblock prints made them an appealing medium for the activist-artists, but they also must have been inspired by the Woodcut Movement in 1930s and 1940s China (see Fig. 16.7), which used prints to promote political and economic liberation.

Like many Singaporeans of the period, Lim Yew Kuan had immigrated from China. In 1938, fleeing instability in China (Japan had invaded the previous year), Lim traveled to Singapore to join his father, Lim Hak Tai, who had been appointed the first principal of Nanyang Academy of Fine Arts (NAFA), Singapore's main art school. In 1956, the younger Lim founded the Equator Art Society, which used art to promote anti-colonialism and highlight the plight of the working classes. When his father died in 1963, Lim, who had trained and taught at NAFA and also lived in London for a few years, became the school's next principal. While guiding the school, Lim continued to create **Social Realist** paintings and woodblock prints.

Modernism a movement that promotes a radical break with past styles of art and the search for new modes of expression.

impasto the texture produced by paint applied very thickly.

woodblock printing a relief printing process where the image is carved into a block of wood; the raised areas are inked. (For color printing, multiple blocks are used, each carrying a separate color.)

Social Realism art that depicts subjects of social concern, in a style true to life.

14.12 Victorio Edades, ***The Builders,*** 1928. Oil on wood, 47¾ in. × 10 ft. 6⅞ in. (1.21 × 3.22 m). Cultural Center of the Philippines, Manila.

14.13 Lim Yew Kuan, *After the Fire* (*Bukit Ho Swee*), c. 1966. Woodblock print on paper, 18 × 24⅛ in. (45.5 × 61 cm). National University of Singapore Museum.

uncommonly large for a woodblock print, immediately conveys the intense environmental destruction of such fires: the ground is littered with debris, the sky is dark, and the trees bare. The print's black lines are thick and powerful, like charred wood. The grain of the woodblock, visible in sections, adds to the picture's emotional quality by bonding artistic material and subject together. It takes a bit longer to notice the human figures in the scene. Bending over, cleaning up, or staring at the remains, they seem lost and alone amongst the debris, as if their sense of communal living had also been destroyed. Lim's image reminds us that modernity comes at a cost and progress may be doubtful.

In northern Vietnam, the long, difficult decades between the Japanese invasion in 1940 and economic liberalization in 1986 were challenging for artists, who nonetheless found ways to express themselves, and in some cases, develop their own versions of Vietnamese Modernism. One such artist was Nguyen Tu Nghiem (1919–2016). Nghiem, like others young artists of the time, enrolled at the École des Beaux-Arts de l'Indochîne in Hanoi. There he was trained in European styles of oil painting. But in 1945, his studies were cut short when the Việt Minh (League for the Independence of Vietnam), led by Ho Chi Minh, launched the August Revolution to liberate Vietnam from the French and Japanese. The August Revolution marked the beginning of the First Indochina War (1946–1954). Nghiem joined the cause and made art in support of Vietnamese independence. When the war ended, he traveled north by bicycle. During that trip he encountered Vietnamese folk art and village traditions, which spurred a life-long interest in Vietnam's heritage—everything from Dong Son Bronze Age art (see Fig 1.21) to local festivals.

Beginning around 1960, Nghiem also became interested in self-expression through form, blocks of color, and brush stroke—aspects of art that were strongly

Made at the very end of the modern woodblock print movement, *After the Fire* (**Fig. 14.13**) is perhaps Lim's most famous work. He composed the image from an assortment of photographs documenting *kampung* fires (*kampung* is the Malay word for village and carries with it a sense of community). Throughout the 1960s, a number of such devastating fires occurred and were a source of controversy. Some suspected that the fires, which spread quickly throughout the wood-and-thatch buildings, were deliberately set. With the villages gone, Singapore's Housing Development Board (HDB) appropriated the land to build high-rise apartments, where 80 percent of Singapore's population now live (see Fig. 17.20). Lim's work, which at 1.5 feet high and 2 feet wide is

Chronology

1351–1767	The Ayutthaya kingdom in Thailand	1830–70	The Dutch implement the Cultivation System (forced deliveries) in Java
1571	Spanish colonizers found the Filippino city of Manila, facilitating trade between Asia and the Americas	1871	Kassian Céphas becomes court photographer to Sultan Hamengkubuwana VI of Yogyakarta
1619	The Dutch East India Company takes control of the Javanese city of Sunda Kelapa, renaming it Batavia (now Jakarta)	1898	The Spanish–American War ends with the Philippines passing from Spanish to U.S. control
1656–88	The rule of Ayutthaya king Narai	1899–1902	Philippine–American War
1767	The capital city of Ayutthaya falls to the invading Burmese army	1909	The Jamek Mosque in Kuala Lumpur is completed; it is designed by A. B. Hubback in the Indo-Saracenic style
1768	An earthquake damages the Shwedagon Pagoda, after which King Hsinbyushi of the Burmese Konbaung dynasty has it repaired, raising it to its current height	1941–45	The Japanese occupation of Southeast Asia during World War II
1782	The Chakri dynasty of Thailand is established; the city of Bangkok is founded	1945–65	Period of decolonization in Southeast Asia, with countries one by one becoming sovereign states
1825–30	The Java War against the Dutch; led by the Javanese prince Diponegoro	1955–75	The Vietnam (American) War

discouraged by the communist government, which instead promoted Socialist Realism, such as that being made in Maoist China at the same time (see, for example Fig. 16.16). In fact, the government-run Artists' Association banned the exhibition of **abstract** art, which it saw as too **Western** and individualistic. Nghiem, nevertheless, experimented with abstraction, particularly during the 1970s and 1980s. *Saint Giong* (**Fig. 14.14**), with its palette of primary colors and bold, angular, almost calligraphic forms, is perhaps his most abstract work. He argued that it was still fundamentally Vietnamese in character, both because ancient Vietnamese art had also made use of abstraction and because the painting's subject, Giong, was a legendary hero, one of the Four Immortals venerated in north Vietnam. According to belief, Giong miraculously transformed from a silent young village boy to a giant who saved the land from foreign invaders before ascending to the heavens on his majestic horse. In Nghiem's Modernist interpretation of this village imagery, the horse is represented by the white forms, and the yellow shape at center is Giong in his battle armor. Cultural reforms undertaken by the Vietnamese government in the 1980s finally allowed Nghiem to exhibit his Modernist works, like *Saint Giong*. In 1985, he had his first solo exhibition in Hanoi, and in 1990 he received a national award for his representations of Giong.

In many ways, Nghiem's art and the trajectory of his career is best understood vis-à-vis Vietnam's particular history. Overall, the shape of modern art in Southeast Asia appears intimately connected to the individual histories of the many modern nation-states that make up the region: Victorio Edades's paintings are entwined with the Philippines' history under Spanish and then U.S. colonial rule, and Lim Yew Kuan's woodblock prints, likewise, address the context of post-war Singapore. At the same time, the experiences of colonization, independence, nation-building, and modernity mark much of the art made in Southeast Asia during the nineteenth and twentieth centuries. During the Early Modern era,

even as the various countries within Southeast Asia were developing the distinct ethnic characteristics that we recognize today—Thai, Javanese, Burmese, for example—the widespread onset of increased global trade, cosmopolitanism, and the growth of urban centers shaped artistic developments across locales as well. From 1500 to 1980, the story of Southeast Asian art is one of change paired with continuity, of local streams within global currents.

14.14 Nguyen Tu Nghiem, *Thanh Giong (Saint Giong)*, 1980. Gouache on paper, 31 × 30¾ in. (78.5 × 78 cm). Hugentobler Collection, Zurich, Switzerland.

Discussion Questions

1. Choose an artwork discussed in this chapter that demonstrates the cosmopolitan, cross-cultural nature of Southeast Asian art during the Early Modern era. Analyze how it does so.

2. Modernism was a global phenomenon in art, but it was one that took distinct forms in different places. Choose an artwork from this chapter that dates to the late nineteenth or twentieth century, and analyze how the artist interpreted Modernism to fit the local context as well as their own priorities and experiences.

3. Research prompt: by the Early Modern era, other religious practices had replaced Hinduism in much of Southeast Asia; however, one location in the region where Hinduism remains the primary belief system is the Indonesian island of Bali. Research a Balinese monument or artwork related to Hinduism dating to the Early Modern or modern eras. How does it compare to the works discussed in this chapter?

Further Reading

- Bennett, James. *Crescent Moon: Islamic Art and Civilisation in Southeast Asia*. Canberra: National Gallery of Australia, 2006.

- McGill, Forrest, ed. *The Kingdom of Siam: The Art of Central Thailand, 1350–1800*. San Francisco, CA: Asian Art Museum, 2005.

- Mrázek, Jan. "The visible and the invisible in a Southeast Asian world." In Rebecca Brown and Deborah Hutton (eds.). *A Companion to Asian Art and Architecture*. Malden, MA: Wiley-Blackwell, 2011, pp. 97–120.

- Newton, Gael, *et al. Gardens of the East: Photography in Indonesia, 1850s–1940s*. Canberra: National Gallery of Australia, 2014.

- Rod-ari, Melody. "The Emerald Buddha and pandemics." *Smarthistory*, January 5, 2021. https://smarthistory.org/emerald-buddha/ (Accessed March 21, 2021).

abstract altered through simplification, exaggeration, or otherwise deviating from natural appearance.

Western a term used in the modern era to claim shared civilization and institutions originating in Europe among predominantly white people; term extended to North America and other parts of the world heavily marked by European colonization.

The Spread of Photography

The invention of photography was announced in France in 1839. Soon afterward it was practiced around the world, as photographers traveled and local artists adopted the medium. Because a photograph is produced with the aid of a mechanical device—the camera—the resulting image is often viewed as objective fact. Yet a photograph is a constructed image, with the maker choosing what to capture and what to exclude. As the invention of photography coincided with European imperialism, it often was used as an instrument of power and diplomacy.

The Italian-British photographer Felice Beato (1832–1909) was perhaps the first photojournalist to cover international military conflicts. This photograph (**Fig. 1**) shows the ruined facade of an Indian ruler's summer residence. In 1857, Indian soldiers employed by the British East India Company, which controlled much of South Asia, rebelled (see Chapter 15).

A decisive battle, which killed more than 2,200 Indian troops, took place in and around this palace. Beato's photograph, with human remains strewn in the foreground, suggests an eerie calm after the British troops' violent victory. But in fact, Beato arrived at the site months after the combat, forcing him to re-create the event. He had bones dug up and scattered in a kind of macabre scene. Here, photography abets the masquerade of artifice as historical truth.

Beato traveled widely throughout Asia, and his photographs, whether taken in India, China, Japan, or Burma (now Myanmar), were of enormous interest to European audiences far from such sites. But Europeans were not alone in their enthusiasm for photography. In India, where the medium arrived in the 1840s, modern photographic techniques joined with traditional painting conventions, allowing the two media to coexist on a single surface.

For instance, Ghasiram Haradev Sharma (1868–1930), the chief painter at the Shrinathji temple in Rajasthan and an accomplished photographer, blended the courtly tradition of Rajasthani portrait painting (see Chapter 11) with photography. His approach retained photographic realism in some areas while achieving painterly qualities in others. In his *Portrait of Bhadariji Devarajaji* (**Fig. 2**), Ghasiram

covered the surface behind the sitter with a solid field of green paint and painted the flowers on the carpet. In contrast, he allowed the tones of the underlying photograph to remain visible through the thin paint on the curtains and clothing. Surprisingly, he rendered the face and hands entirely out of paint, merely mimicking the look of a photograph. The clothing and props also show transcultural mixing: the turban and jewelry are of Indian origin, while the carpet and the vase on the table are of European design.

Such transcultural mixing is even more marked in a group portrait (**Fig. 3**) taken in a palace courtyard in Opobo, a trading center of Nigeria's Ijo (Ijaw) people. The Ijo photographer posed the king wearing his crown, seated under a huge fringed parasol flanked by wooden columns. The symmetrical arrangement of the royal entourage mirrors the formal positions that these leaders took during Ijo ceremonies. They wear a variety of imported headgear and attire alongside locally produced, prestigious cloth, referring to their participation in intercontinental trade, as well as their wealth and social standing in the community. The sitters and the Nigerian photographer produced an image of confident authority, taken at a time in the late nineteenth century when the British were attempting to exert colonial control over the region.

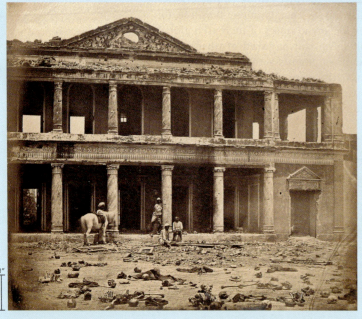

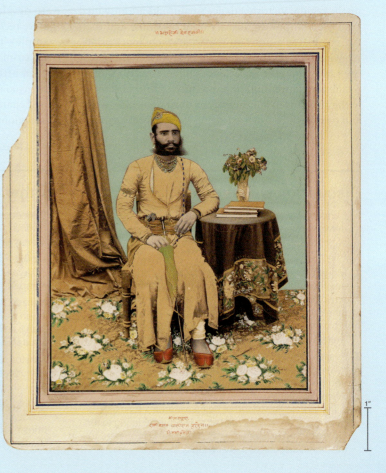

1 ABOVE **Felice Beato, *Interior of Secundra Bagh, Lucknow, after the slaughter of two thousand rebels by the 93rd (Highlanders) Regiment of Foot in 1857,*** 1858. Albumen print, 10⅛ × 11⅞ in. (25.7 x 29.9 cm). **EUROPE / SOUTH ASIA**

2 RIGHT **Ghasiram Hardev Sharma, *Portrait of Bhadariji Devarajaji,*** 1890s. Opaque watercolor and gold on albumen silver print, 9¾ × 7⅞ in. (24.5 × 20 cm). Royal Ontario Museum, Toronto, Canada. **SOUTH ASIA**

The British were in East Asia, too. There, they instigated the Opium Wars and were among the eight-nation alliance, which also included the United States, that defeated the Boxer Rebellion of 1899–1901. At the time, the Empress Dowager Cixi (1835–1908) held power in the Manchu Qing dynasty. Having supported the Boxers and then suffered a humiliating defeat, she needed to shore up her image. Cixi's diplomatic strategy included the use of photography. In a group portrait taken by the photographer Xunling (c. 1880–1943), four women of the U.S. legation along with the photographer's young daughter surround the Empress (**Fig. 4**). In embroidered robes and pearl overlay, Cixi sits on a throne. Above her, a banner announces her title as Dowager Empress of the Great Qing Empire and proclaims for her long life. Among the women, Cixi demonstrates special favor to Sarah Pike Conger (1843–1932), wife of a U.S. envoy to Beijing, by holding her hand.

As these four examples demonstrate, the spread of photography was entwined with European and U.S. imperial expansion, but it was also a global medium that allowed people to represent themselves in ways that mixed local artistic conventions with the new photographic techniques.

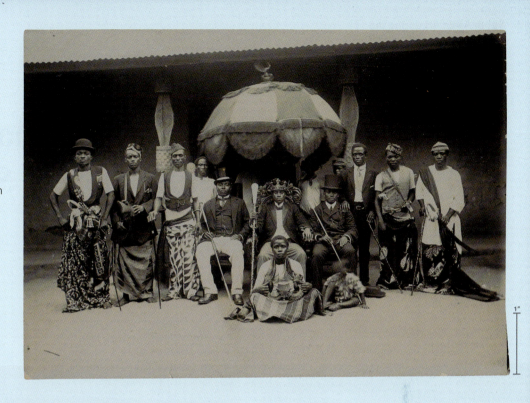

3 ABOVE **Unknown photographer (possibly Jonathan Adagogo Green)**, *Untitled* **(Portrait of an Ijo king, probably Frederick Sunday Jaja, and his court)**, Opobo, Nigeria, *c.* 1895. 5¾ × 8⅛ in. (14.3 × 20.6 cm). Royal Commonwealth Society, Cambridge University Library, Cambridge, England. **AFRICA**

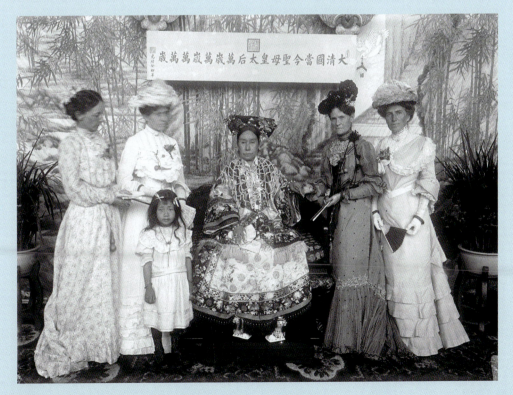

4 **Xunling**, *Empress Dowager Cixi with Women of the U.S. Legation,* 1903. Black-and-white photographic print. Freer Gallery of Art and Arthur M. Sackler Gallery, Smithsonian Institution, Washington, D.C. **EAST ASIA**

Discussion Questions

1. In **Figs. 1** and **2**, what aspects of the image are "real," and what aspects are constructed?

2. What made photography such a potent instrument of power and diplomacy in the second half of the nineteenth and early twentieth centuries? Do you think it still holds that power today?

Further Reading

- Dewan, Deepali. *Embellished Reality: Indian Painted Photographs.* Toronto, Canada: Royal Ontario Museum Press, 2012.

- Geary, Christraud. "Roots and Routes of African Photographic Practices: From Modern to Vernacular Photography in West and Central Africa." In Gitti Salami and Monica Blackmun Visonà (eds.). *A Companion to Modern African Art.* Malden, MA: John Wiley, 2013, pp. 74–95.

- Hogge, David. "The Empress Dowager and the Camera: Photographing Cixi, 1903–04." http://visualizingcultures.mit.edu/empress_dowager/cx_essay01.html

- Morris, Rosalind C., ed. *Photographies East: The Camera and Its Histories in East and Southeast Asia.* Durham, NC: Duke University Press, 2009.

15

Art in Colonial and Independent South Asia

1800–1980

15.0 Detail of Bhupen Khakhar,
You Can't Please All.

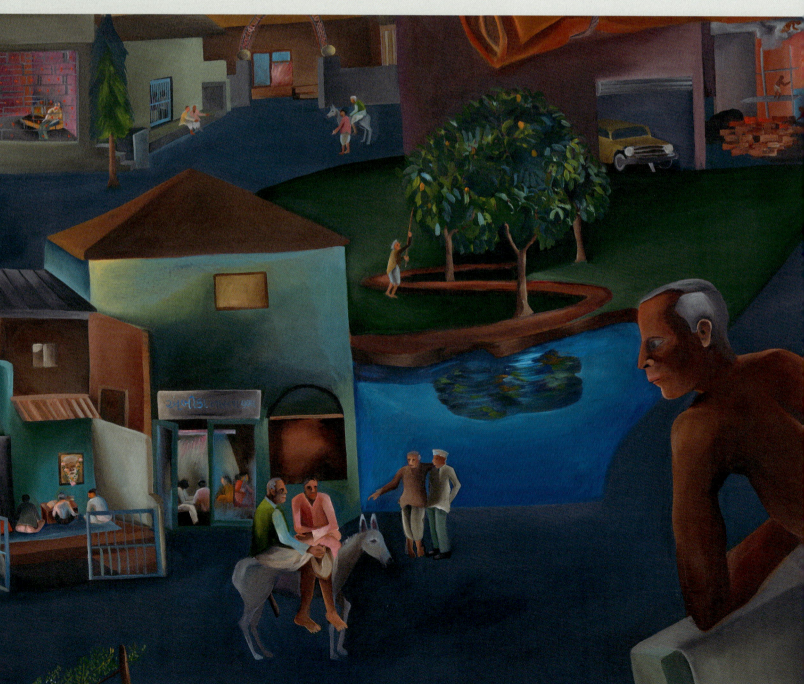

Introduction

In the modern era, South Asia, like much of the world, saw profound changes affecting nearly every aspect of society. Art of this period—between roughly 1800 and the 1980s—responded to and engaged with several major developments, from Western colonial rule, Modernism, and nationalism to technological advances, urbanization, and the movement for women's rights.

Although the Portuguese conquered ports in South Asia in the sixteenth century, and several additional European powers established trading posts there during the seventeenth century, it was from the late eighteenth century onward that colonialism firmly took hold. By 1793 the British East India Company, a trading corporation that acted as a sovereign power, was in complete control of the subcontinent's northeastern regions of Bengal and Bihar. A large army as well as strategic alliances with local rulers allowed the Company to expand its holdings swiftly throughout South Asia in the following decades. Changes to longstanding systems of artistic patronage accompanied these political shifts, with new patrons and audiences for art appearing alongside—and in some cases replacing—existing ones.

Then in 1858, a year after a widespread but ultimately unsuccessful rebellion by Indian troops in the Company's employ, the British government transferred control of India from the corporation to the crown, meaning that the region was officially incorporated into the British Empire. The majority of South Asia would remain under British control until 1947. Like other modern imperial powers, Britain built infrastructure such as railways and schools throughout its empire, with the goal of better controlling the population and extracting resources. These developments further altered the visual environment of South Asia.

In the early twentieth century, the struggle for South Asia's independence gained strength, as did art's role in these movements. Independence was finally won in 1947. However, the triumph of liberation was accompanied by the devastating partition of the Indian subcontinent into the modern nations of India and Pakistan. In 1971, after a brutal war, Bangladesh was formed from East Pakistan. As in many parts of the world, Modernism in art was associated with Westernization (see Art Historical Thinking: The Idea of the West, Westernization, and Modernization, p. 295) in ways that South Asian artists had to grapple with as they sought to answer the question of what modern art for their newly emerging nations should look like. In the latter part of the twentieth century, artistic production continued to change as artists explored the complex realities and layered identities that mark postcolonial societies.

South Asian Art during the Colonial Era, c. 1775–1947

In 1613, when the British East India Company (EIC), which had been formed to counter Dutch trade in Asia, established its first post in India, the Mughal Empire was at its height (see Chapter 11). At first, the foreign traders seemed to pose little threat to the empire. As Mughal power declined, however, the EIC became increasingly involved with ruling. It opened trading factories in Madras (now Chennai), Bombay (now Mumbai), and Calcutta (now Kolkata). The EIC hired local soldiers known as sepoys and started collecting taxes, fought the French (who also had a presence in South Asia), and, in 1757, gained control of the eastern Indian province of Bengal, after defeating the local Mughal governor. By 1803, the EIC was powerful enough to place an advisor at the Mughal court. Thereafter, although a Mughal emperor still sat on the throne in Delhi, the EIC essentially was ruling much of the subcontinent.

Some European artists, such as Thomas and William Daniell (see Seeing Connections: Images of Orientalism, Fig. 2, p. 261), ventured to India during this period; however, they were few in number. As a result, British EIC officials who wanted to document their time in South Asia, including the people, animals, and architecture they encountered, turned to local Indian artists. Many of these artists came from families who had served as painters to the Mughal court and thus were trained in the Mughal idiom, which included small-scale works on paper, featuring opaque watercolor applied with meticulous detail (**Fig. 15.1**). While continuing to work within this established visual practice, the artists, to please their new patrons, simplified compositions and adopted European techniques of **perspective** and shading. Art historians often classify these stylistically blended works made for British patrons as "Company painting" or "Company School painting." The terminology is misleading, in that the artists did not all work in the same style, nor did they work solely for the British. Many still produced images for Mughal nobility or local regional rulers. Indeed, it is important to note that Indian courtly painting continued to evolve (see, for example, Figs. 11.19 and 11.20) alongside these new developments. That said,

perspective the two-dimensional representation of a three-dimensional object or a volume of space.

15.1 Shaykh Zayn al-Din, *Indian Roller on Sandalwood Branch,* Calcutta, India, 1779. Opaque watercolor on paper, 30 × 38 in. (76.2 × 96.5 cm). Minneapolis Institute of Art, Minnesota.

Company painting provides an interesting window into the changes taking place.

One of the best-known examples is a series of pictures made for Mary, Lady Impey, wife of Sir Elijah Impey, Calcutta's Chief Justice. In 1777, Mary, a natural historian, hired three artists, Shaykh Zayn al-Din, Bhawani Das, and Ram Das, to document local flora and fauna, as well as aspects of the Impeys' home life in Calcutta. The artists were all trained at the nearby Mughal provincial capital of Patna. Over the next five to six years, they produced roughly 300 large watercolors, of which 120 survive, mostly studies of birds. The project's scope reflects Mary's elevated status in colonial India. The structures of imperialism allowed the Impeys to gain wealth and social standing in Calcutta that would have been difficult for them to acquire back in England. The painting illustrated here **Fig. 15.1**, p. 303), completed by Shaykh Zayn al-Din in 1779, depicts a type of bird called the Indian roller perched on a sandalwood tree branch. The prominent blank background is consistent with European natural studies of the period. But at the same time, in keeping with his Mughal training, the artist skillfully composed the elegant scene, with the bird's shape echoed in the cluster of leaves at the right, and each feather of the roller's distinctive blue wings carefully rendered. This intermingling of conventions continues in the inscription at the lower left: Mary penned part of it in English, and the artist, writing in Persian, filled in the rest, including his name as well as the type of tree and bird.

Other paintings made for Mary documented the Impeys' home, servants, and carriages, and those images capture the highly structured nature of relationships between the British colonizers and the Indians they employed and governed. Colonial cities like Calcutta were divided into what the British classified as "white towns" and "Black towns," and the movement of Indians within perceived British spaces was closely regulated. Boundary walls, fences, and gateways marked the colonial city, heightening the impression of imperial control over the native people and land, but also in turn controlling the movements of the British who lived in those spaces. Even in the most regulated environments, however, the separation was never as clear cut as it was made to seem, and in select cases, different, more intimate interactions between British and Indians took place. EIC officers learned Indian languages, a few collected South Asian art and took to wearing South Asian dress, and some married (either officially or unofficially) Indian women.

An album of paintings made for the Scottish officer William Fraser (1784–1835) provides a more intimate view of British–Indian relations, albeit one still filtered through the demands of colonial administration and respectability. Fraser was an EIC agent in charge of the territory around Delhi during the reign of the Mughal emperor Akbar II (r. 1806–37). Fraser was deeply sympathetic to Mughal culture: he studied Persian and was an admirer of the north Indian poet Ghalib (1797–1869). He also had several Indian wives (up to six or seven by some accounts) with whom he fathered multiple children.

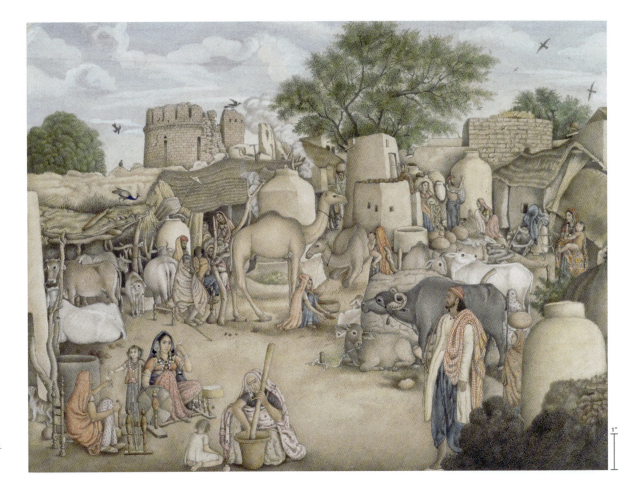

15.2 Delhi-based Mughal artist (possibly Ghulam Ali Khan or a member of his circle), "A Street Scene in the Village of Rania," from the *Fraser Album*, made for William Fraser, Rania, Haryana, *c.* 1816–20. Watercolor, 12⅜ × 16½ in. (31.4 × 41.9 cm). British Library, London.

Between approximately 1816 and 1820, Fraser hired several artists—often identified as the Mughal painter Ghulam Ali Khan (active *c.* 1810s–1850s) and members of his artistic circle—to produce an album of what might be considered highly sensitive ethnographic portraits. The images depict groups of local tax collectors with whom Fraser worked, as well as holy men, dancing girls, and courtiers. The village of Rania was the subject of several paintings, including the one illustrated here (**Fig. 15.2**). The artist depicted the close-knit nature of nineteenth-century village life in charming detail. Camels, cows, and water buffalo mingle alongside men and women going about their daily tasks outside of thatched-roof, mudbrick dwellings. Like other Company School paintings, it combines finely detailed work with shading and perspective. Here, the sense of depth and volume is even greater than that in *Indian Roller on Sandalwood Branch*, produced three decades earlier. Notice in the left foreground of the village scene the young woman making yarn on a spinning wheel with a small girl standing by her side. They most likely depict Fraser's principal wife and daughter, who lived in Rania. Thus, on the one hand, the painting must have been a deeply personal memento for Fraser, but on the other hand, the careful accounting of chimneys, cattle, and people was needed for revenue assessment, which was Fraser's job as an EIC civil servant.

As the nineteenth century progressed, the EIC gained increasing control over the Indian subcontinent, until the summer of 1857, when, angered by oppressive British policies, sepoys across India rebelled. The uprising was not quelled until 1858, by which point there had been many deaths on both sides (for more on the Sepoy Rebellion, see Seeing Connections: The Spread of Photography, Fig. 1, p. 300). Realizing India was too important to leave to a corporation to run, the British government dissolved the EIC and took direct control. The Mughal emperor was exiled to Burma (now Myanmar), and a viceroy was appointed to govern the Raj, as British rule in India was called. The colonial government built infrastructure (see Seeing Connections: Empire Building, p. 318), established institutions, and set out to study India's people and history systematically—all in a quest for efficient, effective rule. Recognizing the relationship between knowledge and power, the British produced histories of South Asia, including histories of its art and architecture, which attempted to justify their presence. For example, early scholars viewed ancient Buddhist art as the apex of Indian artistic production, followed by a long decline, a narrative that served the colonialist government. The Archaeological Survey of India, founded in 1861, began documenting and restoring select monuments, such as the Buddhist Great Stupa at Sanchi (see Fig. 3.3), shown here in a photograph taken mid-restoration *c.* 1882 (**Fig. 15.3**).

The new technology of photography (see Seeing Connections: The Spread of Photography, p. 300), practiced in India by the 1840s, played a crucial role in the colonial agenda. Photography produces images through a physical reaction between a sensitive surface (such as a chemical-coated glass or paper negative) and light reflecting off objects in the world. As a result of this direct physical relationship to what it depicts, photography

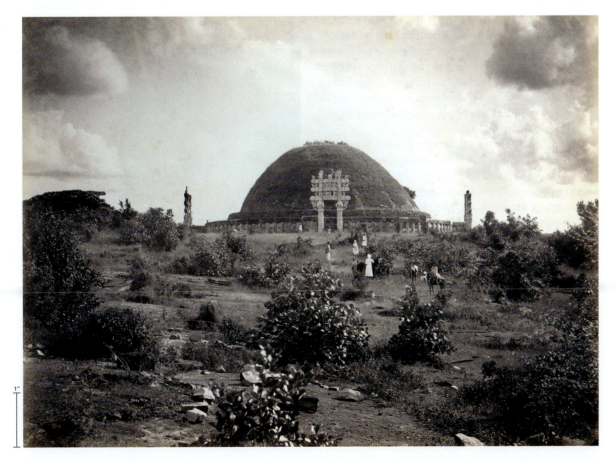

15.3 Lala Deen Dayal, **"General View of Sanchi Tope (Stupa) looking north,"** from *Views of Bhopal and Sanchi* album, *c.* 1882. Albumen print, 8 × 10⅜ in. (20 × 26.4 cm). Alkazi Collection of Photography, Delhi, India.

was commonly understood as impartial documentation and therefore central to the studies of India's land, monuments, and people. At the same time, because photographs were in fact constructed images shaped by the photographers' choices and by the impressions that they or those who commissioned them wanted to create, pictures could be framed to present a certain viewpoint. Many images, for example, adopted a **picturesque** approach, marking India as a place of romantic ruins, as this photograph of Sanchi does. This image was taken by Lala Deen Dayal (1844–1905), India's most celebrated nineteenth-century photographer.

Although the British were the first to practice photography in South Asia, Indians quickly took up the technology too. Dayal, who trained as a surveyor at a civil-engineering college in northern India, taught himself photography in the early 1870s while working for the Central Indian Public Works Department. That office assisted in the restoration of monuments such as Sanchi, and Dayal's early photography documented these activities. Eventually he set up his own studio practice, photographing not only architectural monuments, but also military troop maneuvers, British officials, Indian royalty, and the urban middle class. He was admired for his technical skill, sense of composition, and production of luminous **albumen prints** from the glass plate negatives used at the time. Note here, for example, how Dayal exposed the print's edges for extra time in order to darken the clouds and leave a halo around the **stupa**. Note also how he posed people (who, because of exposure times, had to stay still while the photograph was taken) to form an asymmetrical path of sorts leading the viewer's eye to the **stupa**'s **torana**, thereby emphasizing the scene's picturesque qualities. Dayal's success also resulted from his ability to maneuver between British and Indian society, and between commercial and traditional **patronage** systems. He went on to become the official photographer to the Nizam of Hyderabad, the leading Indian prince of the British Raj, and to run three commercial studios with a staff of more than fifty people, including British and German photographers.

The painter Raja Ravi Varma (1848–1906) is another example of a South Asian artist who **appropriated** new technologies and visual languages to forge a high-profile, successful career. By the late nineteenth century, British Victorian-era **Academic art**, including portraits, nudes, and sentimentalized **history paintings**, had become popular in India. Additionally, artists' status in society was rising. Varma, a member of the royal family of the kingdom of Travancore, located in Kerala in southern India, was India's first "gentleman-artist." He learned oil painting by watching European painters employed at Travancore's court, and made his name with commissioned portraits of India's royalty before turning his attention to history painting. Well educated in Sanskrit literature and wanting to show that India's ancient culture equaled the West's (see Art Historical Thinking: The Idea of the West, Westernization, and Modernization, p. 295), Varma illustrated scenes from Hindu epics in a Victorian Academic style that employed **atmospheric perspective** and **chiaroscuro** modeling, ennobled its subjects, and

used formulas for rendering nature. However, Varma set his scenes in aggrandized Indian courtly environs, with female figures modeled after ideals of beauty in Kerala.

In 1892, Varma and his brother set up a printing press to produce **chromolithographs** (also called oleographs) of his oil paintings for mass consumption. In a chromolithograph of a scene from the Hindu epic the *Mahabharata* (**Fig. 15.4**), Varma depicts a swan visiting a beautiful princess, Damayanti, to extol the virtues of a king named Nala. Damayanti falls madly in love with Nala just from the swan's words (in the story, the swan can talk), and the princess and king eventually marry. These prints were immensely popular with all strata of society, so much so that Varma's images of Hindu gods and goddesses still provide the template for the contemporary religious posters that are ubiquitous in Indian visual culture.

When Varma died in 1906, he was a national celebrity; however, the opinions of his work in Indian intellectual and artistic circles had fallen. Critics lambasted his paintings for adopting a European style, not being authentically Indian, and lacking spirituality. Additionally, at a time when women were increasingly viewed as the preservers of tradition within a changing society, Varma's images of women, which included semi-nudes as well as richly dressed, voluptuous women who looked assertively at the viewer, were considered immodest and crass.

This shift in critical reception reflected a growing nationalist movement calling for self-government (*swaraj*) and self-sufficiency (*swadeshi*), as well as the rise of what is often referred to as the Bengal School of Art, the name loosely given to a group of artists and their followers based in Calcutta, specifically at the Calcutta School of Art. Led by the painter Abanindranath Tagore

15.4 FAR RIGHT **Raja Ravi Varma, *A Swan Telling Damayanti of Nala's Love,*** c. 1900. Chromolithograph, published by Anant Shivaji Desai Motibazar of Bombay, printed by Ravi Varma Press. Wellcome Collection, London.

(1871–1951) and the British art teacher E. B. Havell, the group pushed for a national style of art that rejected **Western** visual modes and materials and instead looked to India's own artistic achievements, such as Mughal painting, for inspiration. Tagore and others also aligned themselves with pan-Asianism, an intellectual movement that promoted the idea of Asia's strength as stemming from its spirituality, in contrast to Europe's material-ism. The Japanese *nihonga* artists, Yokoyama Taikan and Shunso Hishida, along with the artist-philosopher Kakuzo Okakura, pan-Asianism's chief proponent (see Art Historical Thinking: Okakura Kakuzō and Entangled Art Histories, p. 325), even visited Tagore in Calcutta. Tagore admired their use of delicate washes (semi-trans-parent layers of color), which he adopted to give a sense of softness and ethereal spirituality to his small-scale watercolors, many of which featured Mughal or other historically themed subjects.

Tagore's most famous painting, *Bharat Mata* (*Mother India*, **Fig. 15.5**), was smade in response to nationalist events of 1905. Against local sentiment, the British Raj partitioned Bengal into two parts, leading to major unrest and increasing demands for self-rule. Tagore's paint-ing personifies India as a modest, middle-class Bengali woman, in contrast to the bejeweled, curvaceous women in Varma's paintings. Like a Hindu goddess, she has four arms that hold four attributes. Here, the attributes rep-resent the goals of the *swadeshi* movement—that is, the things that India should be able to provide for itself: food, symbolized by the grain in her lower left hand; secular knowledge, indicated by the book in her upper left hand; clothing, as shown by the white cloth in her upper right hand; and spirituality, represented by the prayer beads in her remaining hand.

As this influential painting demonstrates, *swadeshi* art tended to conflate Hindu culture with the Indian nation, to the discomfort of minority communities, particularly Muslims. The Bengal School artists were also eventually criticized for being too elite, nostalgic, and backward-looking. The question that kept emerg-ing was: what should art for a modern Indian nation look like? As the push for Indian independence grew and as Indian painters became more aware of European **avant-garde** movements, artists sought answers in a number of places. For example, Jamini Roy (1887–1972), a Calcutta artist who, like Abanindranath Tagore, trained in European academic painting techniques before reject-ing them, turned to rural artistic practices, particularly those of the Santhal tribe in western Bengal, for inspira-tion. Stimulated by the content, style, and materials of Santhal painting, Roy used organic pigments in earthy colors, thick black outlines, and simplified forms to create bold and rhythmic works. Amrita Sher-Gil (1913–1941), India's first professional female artist, born to an Indian father and a Hungarian mother, strove to give voice to the women and girls of India's villages by making them the focus of her images (see Going to the Source: Amrita Sher-Gil on Modern Indian Art, p. 308). In contrast, Abanindranath Tagore's uncle, the Nobel Prize-winning poet Rabindranath Tagore (1861–1941), who took up painting at the age of sixty-three, looked

15.5 **Abanindranath Tagore, *Bharat Mata,*** 1905. Watercolor on paper, 10½ × 6 in. (26.7 × 15.3 cm). Rabindra Bharati Society, Calcutta, India.

toward the unconscious mind and Indigenous art from around the world.

A few years before he began painting, Rabindranath Tagore founded the experimental school, the Vishva Bharati University at Shantiniketan, that also shaped the development of modern Indian art in significant ways. In contrast to the universalist approach he adopted in his own artwork, Tagore's vision for Shantiniketan was strongly rooted in ancient Indian holistic models of edu-cation and in village life, which he saw as an antidote to life in the colonial city. In the 1930s and 40s, under the leadership of the artist Nandalal Bose (1882–1966), the Kala Bhavana (Institute of Fine Arts) at Vishva Bharati University became a vital center for art education and production. Bose had been a student of Abanindranath Tagore at the Calcutta School of Art, and his early work was closely aligned, both stylistically and conceptually, with that of his teacher. However, after 1919, when Bose joined Shantiniketan, his approach shifted. He saw art as something that should matter to people's everyday lives, and he sought to blur the distinction between modern, urban artists and local craftspeople. He even incorporated village women's art practices into Shantiniketan's curric-ulum. In his own work, alongside paintings and prints, he designed murals, posters, and children's books. He valued unified compositions and bold lines, as well as artistic collaborations, over any particular visual style.

chiaroscuro in two-dimensional artworks, the use of light and dark contrasts to create the impression of volume when modeling three-dimensional objects and figures.

chromolithograph color print produced by lithography, a method of printing in which the surface of the printing plate is treated to repel ink except where required; used particularly in the late nineteenth and early twentieth centuries.

Western a term used in the modern era to claim shared civilization and institutions originating in Europe among predominantly white people; term extended to North America and other parts of the world heavily marked by European colonization.

nihonga a Japanese term meaning "Japanese-style painting"; refers to painting in traditional materials (ink and/or colors on silk or paper) and often in traditional formats and genres.

avant-garde an emphasis in modern art on artistic innovation, which challenged accepted values, traditions, and techniques; derived from the French for "vanguard."

In 1934, after completing her art training in Paris, the Indian-Hungarian painter Amrita Sher-Gil returned to India. Although she died young in mysterious circumstances, Sher-Gil left an indelible mark on twentieth-century Indian art through her paintings, her strong views on modern art, and her unconventionally libertine lifestyle. In an article published in a prominent newspaper, *The Hindu*, in 1936, Sher-Gil laid out her thoughts on the current state of art in India, comparing it to the fifth-century Buddhist wall paintings in the caves at Ajanta (see Chapter 5) and her own approach to painting. Below are the last two paragraphs of the essay, in which she forcefully sums up her perspective, one that no doubt was controversial with other Indian artists.

15.6 Amrita Sher-Gil, *Bride's Toilet*, 1937. Oil on canvas, 57⅜ × 35 in. (1.45 m × 88.9 cm). National Gallery of Modern Art, New Delhi.

The fundamental idea of that form of Indian Art which drew its inspiration from Ajanta (that really great and eternal example of pure painting) was right to begin with because it started with the principle of the primordial importance of significant form, but unfortunately, except for a few men of talent who have wrestled successfully with the coils of mythological convention, this Art has developed an illustrative tendency that has gone to the detriment of the fundamental principles and tends to devitalize and render it effeminate in execution.

Mistake of Feeding on Tradition: It has committed the mistake of feeding almost exclusively on the tradition of mythology and romance, and no Art can do that with impunity for any length of time. Art cannot imitate the forms of the past (because, for one thing, imitation is a form of debility and so the work thus created will necessarily be feeble); it must draw its inspiration from the present to create the forms of the future. I am an individualist evolving a new technique that, though not necessarily Indian in the traditional sense of the word, will yet be fundamentally Indian in spirit. With the eternal significance of form and color I interpret India, and principally the life of the Indian poor, on the plane that transcends the plane of mere sentimental interest.

Discussion Questions

1. In her painting *Bride's Toilet*, made a year after she wrote the newspaper piece, Sher-Gil depicts a girl being prepared for her wedding by female relatives. Compare this image to Sher-Gil's description of her artistic approach in her essay. How do her ideas play out visually?

2. Based on her comments, how might Sher-Gil have assessed Abanindranath Tagore's painting *Bharat Mata* (**Fig. 15.5**)? How might she have assessed Nandalal Bose's print *Bapuji* (**Fig. 15.7**)?

linocut a relief print created by carving lines and shapes in a block covered with linoleum or a similar substance.

Around the same time that Vishva Bharati University opened, Mohandas (Mahatma) Gandhi (1869–1948) launched his Non-Cooperation Movement, which asked Indians to stop participating in activities that economically aided the British colonial government. That movement lasted only a few years, but was followed by subsequent nonviolent acts of resistance. Bose, who was a close follower of Gandhi, believed that art had a crucial role to play in the nationalist movement, and devoted much energy to that endeavor. For example, at Gandhi's request, Bose helped design murals, organize exhibitions of Indian art, and even, in one instance, create a model Indian village for meetings of the Indian National Congress. One of Bose's best-known works is a **linocut** print depicting Gandhi, affectionately called *Bapuji* (Father) (**Fig. 15.7**) by many Indians, that the artist made in 1930 to commemorate the Salt March, an act of civil disobedience against the British salt monopoly. Over twenty-four days, Gandhi and thousands of fellow Indians marched 240 miles (almost 390 km) from his spiritual retreat to Dandi, a town on the Arabian sea, where they broke the law by making salt through evaporation. For the print, Bose chose to create a pared-down image of Gandhi in his iconic appearance: walking, holding a wooden staff in one hand, and wearing a simple homespun half-*dhoti* (a type of loose clothing worn by Hindu males that is wrapped around the lower part of the body and thrown over the shoulder). Gandhi's bold but quiet determination is reflected in the image's strong composition (notice the diagonal lines created by his legs, staff, and folds of the fabric), and stark white lines against the solid black background.

In the early decades of the twentieth century, at the same time that Gandhi was leading his nonviolent, Non-Cooperation movements, and artists, such as Abanindranath Tagore and Nandalal Bose, among many others, were exploring the shape of modern Indian art, the subcontinent's British rulers were overseeing the construction of a new imperial capital in Delhi. From the beginning of their time in India, the British

15.7 FAR LEFT **Nandalal Bose, "Bapuji," Gandhi on the Salt March to Dandi,** 1930. Linocut print, 13⅞ × 8⅞ in. (35 × 22.3 cm). Art Institute of Chicago, Illinois.

was announced in 1911, when England's King George V was visiting Delhi for a grand royal assembly or *durbar*. In part, moving the seat of government from Calcutta to Delhi was intended as a way to escape the growing nationalist fervor in Bengal. It also drew on Delhi's weighty status as the capital of the Mughal Empire and the Delhi Sultanate before that. Edwin Lutyens (1869–1944), known for designing British country houses, was appointed chief architect and given, among other things, the task of designing the Viceroy's House (**Fig. 15.8**), which was to be New Delhi's centerpiece. Herbert Baker (1862–1946), who designed a number of important structures in colonial South Africa, including the government buildings in Pretoria, was brought in as a collaborator. Many other British architects and city planners contributed to the capital's design, which included not only governmental buildings, but also residential and commercial neighborhoods. New Delhi is a garden city that combines a grid plan with roundabouts connected by boulevards. The main ceremonial avenue, King's Way (now named Rajpath), runs from India Gate (a commemorative arch honoring the Indian soldiers who died during World War I), passes by the twin Secretariat buildings designed by Baker to house government offices, and ends at the Viceroy's House.

The viceroy at the time imagined that the architecture would markedly incorporate Indian visual traditions; however, Lutyens was not overly impressed with South Asian architecture. He eventually came to admire aspects of Mughal architecture and garden design, as well as the Great Stupa at Sanchi (see **Fig. 15.3**), but he thought that New Delhi's architecture should emulate the **Classicism** of the best European imperial monuments, with only subtle nods to the Indian context. The Viceroy's House embodies his vision. It has simple, clean lines, and a columned **facade**. The huge structure—larger than the French palace of Versailles—is horizontal in emphasis, except for the prominent central dome, the hemispherical shape of which mimics Sanchi's *stupa*. The bronze

employed architecture to express imperial power (see Seeing Connections: Empire Building, p. 318), but New Delhi was to be the crowning achievement: a new, planned capital with monumental buildings, open spaces, and broad avenues that would embody the might of the British Empire, on which, it was said, the sun never set. The plan

Classicism from, or in a style deriving from, ancient Greece or Rome.

facade any exterior face of a building, usually the front.

15.8 Edwin Lutyens, Viceroy's House (Rashtrapati Bhavan), completed 1932, New Delhi.

dome sits on a white stone drum that is carved with a repeating pattern reminiscent of the railing at Sanchi. In addition to white stone, the building is clad in parts in red sandstone—in that regard, it recalls, in a subdued manner, the **architectural polychromy** of Mughal architecture. The most obvious Mughal reference, however, is the expansive tiered garden behind the structure, modeled on Mughal royal gardens in Kashmir. Covering fifteen acres, in the 1930s and 1940s the garden required a staff of more than 400 for its upkeep.

The grandeur of the architecture could not prevent the empire's end. The British Empire's glorious new capital was inaugurated in 1931, only sixteen years before India became an independent country. New Delhi thereafter became the capital of the world's largest democracy, and the Viceroy's House became Rashtrapati Bhavan, the official residence of the President of India.

Art in Independent South Asia, 1947–80

At midnight on August 15, 1947, after a long struggle, the Indian subcontinent finally achieved independence from British rule. However, the triumphant and celebratory moment was marred by violence and tragedy. British and South Asian leaders had decided to split the subcontinent into two countries: India, a Hindu-majority secular republic, and Pakistan, an Islamic state. This partition—and the chaos, fear, and animosity that followed—led to the deaths of an estimated five hundred thousand to one million people, and the displacement of ten to fifteen million more. Thus, the period following independence was full of optimism but also trauma, and artistic production embodied both.

Each country, India and Pakistan, was left scarred and incomplete. Pakistan was comprised of two disconnected regions on the west and east sides of India, an unsustainable situation. In 1971, after a war that killed and displaced more people, East Pakistan seceded and became Bangladesh. During the 1947 partition, the Punjab region had been split in two, with the main city, Lahore, going to Pakistan. The Indian government, which had inherited the British-designed New Delhi as its national capital, used the loss of Lahore as a reason to create a new capital city for the state of Punjab, one that would embody a **Modernist** vision for the new nation. India's first prime minister Jawaharlal Nehru (1889–1964) commissioned the Swiss-French architect Le Corbusier, considered one of the pioneers of international Modernism, to design the planned city of Chandigarh (see Fig. 0.8). The leaders of Pakistan, likewise, rather than using the Mughal-era city of Lahore as the country's capital, conceived of a new city, Islamabad, that would embody Pakistan's identity as a modern Islamic nation.

A modern Islamic national identity also found expression in the work of Pakistan's most celebrated twentieth-century artist, Sadequain Naqqash (1930–1987), commonly known as Sadequain. Born in a small town outside Delhi, he started his career as a calligrapher-copyist before devoting himself to painting from the mid-1950s onward. He experimented with artistic styles, drawing freely from a variety of mid-twentieth-century movements, without feeling attached to any of them. It was Urdu **calligraphy** and poetry (Urdu is a north Indian language written in Arabic script), more than anything else, which formed the ideological heart of his work. In this he was not alone. A number of Pakistani artists of the period experimented with calligraphy. In fact, between 1955 and 1975, artists from a variety of Muslim countries—from Sudan to Iran—embraced what art historians have labeled "calligraphic modernism." Arabic calligraphy had been central to Islamic art since the formation of the religion (see, for example, Fig. 10.1). Exploring the expressive qualities of the Arabic script through **abstraction** and adaption—sometimes using thick, calligraphic-like lines to create forms unrelated to writing (as in **Fig. 15.9**)—therefore felt simultaneously new and authentic.

15.9 Sadequain, *Industry and Agriculture* (also known as *Industry and Agriculture I*), 1965. Mural, 6 ft. 6 in. × 12 ft. (1.98 × 3.66 m). State Bank of Pakistan, Karachi.

15.10 Tyeb Mehta, "Untitled," from *Diagonal Lines* series, 1973. Oil on canvas, 5 ft. 9½ in. × 8 ft. 6 in. (1.77 × 2.59 m). Peabody Essex Museum, Salem, Massachusetts.

What made Sadequain a nationally known, almost heroic figure in 1960s Pakistan were his monumental-sized murals. Over the course of his life, he completed more than thirty-five such works, mostly in Pakistan, but a number at institutions abroad as well. The State Bank of Pakistan commissioned Sadequain to make ten paintings for the walls of its headquarters in the southern Pakistani city of Karachi. The largest mural, called *Treasures of Time*, is 10 feet high, 62 feet long (around 3 × 19 meters), and illustrates the intellectual advances of humankind through key figures from Socrates to the Buddha. Like his other artworks, Sadequain's murals adopt a range of artistic styles. The one illustrated here, *Industry and Agriculture* (**Fig. 15.9**), made for the State Bank in 1965, uses a highly abstracted, calligraphic-like style for its celebratory message. When we look closely at the bold, black lines, on the right side we see fields of grain and on the left, busy factories, with two central figures—one male, one female—uniting these two sides of progress.

Sadequain was far from the only South Asian artist to experiment with bold forms and mid-century Modernist movements. Indian artists Tyeb Mehta (1925–2009) and M. F. Husain (1915–2011) both embraced an **Expressionist**, semi-abstract approach to painting, albeit with very different effects, one highlighting the trauma of the period and the other its optimism.

Tyeb Mehta, who was a young man living in Bombay at the time of partition and independence, witnessed the violence between religious communities firsthand, and those memories stayed with him. He went on to study painting at Bombay's Sir J. J. School of Art, and then to live and study in London and travel to New York, where he was struck by the work of **Abstract Expressionist** painters.

The artwork he produced after his return to India in 1969 displayed not only his international viewpoint but also the religious dissonance within his own country, and his discomfort with the system of hereditary caste. Tethered bulls, falling birds, and isolated groupings of figures form the primary subjects of his semi-abstract paintings. Mehta also adopted a fractured diagonal line as a signature visual device, as in the example here (**Fig. 15.10**): a white, jagged line cuts through blocks of bright but discordant color, some forming ambiguously shaped, despondent, and broken figures. Mehta's paintings convey a sense of despair and division without directly picturing specific events. As with other global Modernist painters of the period, he focused on formal visual elements in an attempt to transcend the particular.

The work of M. F. Husain (1915–2011), another Bombay/Mumbai artist who embraced a similar approach to painting, embodies the optimism prevalent in the decades following independence. In many ways, his career parallels India's twentieth-century history. Like numerous others, Husain was born to a poor, rural family and moved to the city in search of work. (The population of Bombay/Mumbai doubled between 1900 and 1950, and since then has increased tenfold.) Husain began his career painting Hindi cinema billboards and eventually joined the Bombay Progressive Artists Group, founded in 1947, a few months after independence. The group's six members strove to create art that was both modern and Indian, and to paint with absolute freedom. The group did not stay together long, but it helped launch Husain's career.

With his larger-than-life personality matching his prolific production of large-scale paintings celebrating

Expressionist art that is highly emotional in character, with colors, shapes, or space being distorted and non-naturalistic as a means to convey vivid extremes of subjective experience and feeling.

Abstract Expressionism a style of art originating in the United States after World War II in which artists rejected representation in favor of the gestural residue of paint dripped, splashed, and applied in other unorthodox ways.

India through fragmented references to religious stories and iconic cultural figures, Husain quickly received acclaim at home and abroad. In 1971, the São Paulo Biennial in Brazil displayed his work alongside that of the European artist Pablo Picasso. Then, in the 1990s, as right-wing religious groups increasingly gained political influence in India, Husain's work became the target of Hindu nationalists who were offended by the Muslim artist's depictions of Hindu goddesses. The harassment increased to the point that Husain had to leave his homeland. He died in exile.

Husain's work featured here is a painted glass skylight (**Fig. 15.11**) made for Our Lady of Salvation Church (commonly called the Portuguese Church) in Mumbai. The window, painted with dividing lines so that it resembles stained glass, illustrates the biblical story of the miracle of the loaves and fishes, when Jesus fed a multitude with only five loaves of bread and two fish. In his typical fashion, Husain distilled the story down to a few simple, iconic forms to give immediacy to the viewing experience. Husain worked in a **painterly** style, and his art projected a sense of liberation through bold shapes, color, line, and brushstroke, as evident here.

Charles Correa (1930–2015), India's leading twentieth-century architect, designed Our Lady of Salvation Church, which was built between 1974 and 1977 on the site of the original Franciscan Catholic structure from 1596. (Christianity is India's third-largest religion, with a long history on the subcontinent, dating back by many accounts to the first century CE.) Like their artist colleagues, South Asia's modern architects faced the challenge of how to honor India's heritage while also looking to the future.

15.11 ABOVE **Detail of M. F. Husain, painted glass window,** 1985, Our Lady of Salvation Church (Portuguese Church), Mumbai, India.

painterly characterized by color and texture, rather than line.

one-point perspective a perspective system with a single vanishing point on the horizon.

15.12 Charles Correa, Our Lady of Salvation Church (Portuguese Church), Mumbai, India, 1974–77.

Correa believed that different climates and living patterns shaped the regional development of architecture. Thus, rather than focusing on earlier styles or types of ornament, Correa's solution was to explore how people interacted with the built environment and to translate those patterns into modern design. Correa was also concerned with urban planning and low-cost housing. He developed two key concepts for India-specific designs. One was that buildings should intrude as little as possible on the natural environment and be designed to conserve energy. The other was that spaces "open to the sky," such as courtyards and transitional indoor–outdoor zones, like verandas (covered porches), should be key design features because of India's predominantly warm climate.

For the Portuguese Church (**Figs. 15.12** and **15.13**), Correa wanted to revisit the principal elements of Christianity based on the life of Christ. He designed a series of separate covered spaces (baptistery, nave, and sanctuary), each one corresponding to a part of Jesus's life (baptism, public life, and crucifixion), with courtyards linking them together. The elements flow from one to the other to promote air circulation, and high concrete shells capping the covered spaces serve as flues for the rising hot air. Correa left the concrete bare and the woodwork plain in order to provide a simple, unadorned environment for worship; in the baptistery, Husain's painted window piercing the ceiling of the main shell provides the primary visual focus.

While neither Husain nor Mehta completely abandoned the human figure in their paintings, they and their contemporaries actively engaged with abstraction, which was internationally popular during the postwar period. They firmly believed that their artwork should be experienced rather than read, and they strove to connect with something universal. That attitude among South Asian artists began to shift in the late 1970s and early 1980s. By that point, the political and economic challenges faced by developing countries such as India were clear, and artists, who were mostly cosmopolitan, urban intellectuals, increasingly played the role of outsiders, critiquing existing power structures and social inequities. Some of them criticized the earlier Modernist artists for succumbing to a Western colonizing, capitalist view of the world. This period saw the rise of postcolonial art criticism, led in India by the writer and curator Geeta Kapur. Postcolonial criticism rejects the idea that art can be understood and appreciated through universal standards and ideals. Instead, it sees art as a culturally constructed form of discourse. In that vein, many South Asian artists began embracing storytelling, figural art for its potential to question dominant narratives and highlight societal problems. They turned to Mughal, Rajasthani, and Punjabi court paintings, folk art, popular culture, and their personal experiences for inspiration, juxtaposing imagery in ambiguous and unexpected ways to create layers of meaning.

One of the main centers for this new approach was the central Indian city of Baroda, home to Maharaja Sayajirao University. Two of the most influential artists of this period were Gulammohammed Sheikh (born 1937) and Bhupen Khakhar (1934–2003), who both studied in the

Fine Arts Department there. After they completed their degrees, Khakhar continued to live and work in the city, while Sheikh became a member of the faculty. Like many of his peers, Khakhar eschewed European-style **one-point perspective** in favor of a more undefined, dreamlike space. He adopted the brash colors of popular art and decor, and he deliberately developed a naive, awkward style focusing on the daily lives of ordinary people. He was fascinated with the human body, particularly the male body. His best-known work is a painting created in 1981, *You Can't Please All* (**Fig. 15.14**), through which he publicly

15.13 Plan of Our Lady of Salvation Church (Portuguese Church).

15.14 Bhupen Khakhar, *You Can't Please All*, 1981. Oil on canvas, support: 5 ft. 9¼ in. × 5 ft. 9¼ in. (1.76 × 1.76 m); frame: 5 ft. 10¾ in. × 5 ft. 11⅜ in. × 1⅝ in. (1.8 × 1.8 × 1.8 m). Tate Modern, London.

proclaimed his sexual orientation as a gay man—a bold act at the time. A nude male figure, representing the artist himself, stands on a balcony and watches a scene unfold in the town below. Using **continuous narrative**, the distant scene recounts Aesop's fable of a father and son taking a donkey to market. At first the man sits on the donkey while his son walks. After passersby criticize him for making his son walk, both get on the donkey, only to be accused of cruelty to the animal. In response, they attempt to carry the donkey, but it falls and dies. While digging the donkey's grave, the father says to his son, "You can't please all."

Observers often note the centrality of the human figure in South Asian art, from ancient times through the twentieth century, and see it as a defining cultural feature. While many twentieth-century artists retained an interest in the figural, it is important to recognize that, at the same time, other artists were engaging in pure abstraction. For example, while her colleagues at Maharaja Sayajirao University were exploring storytelling, figural art, Nasreen Mohamedi (1937–1990), also an esteemed faculty member there in the 1970s and 1980s, was producing distinctive **Minimalist** ink-and-pencil drawings.

Born in Karachi (part of India at the time, later part of Pakistan), Mohamedi studied in London and Paris, lived in Bahrain, and traveled to Iran and Turkey before settling in Baroda. Her art drew on a range of inspirations: from European art movements such as **Constructivism** and Minimalism, to modern technology and industrial design, to Japanese Zen Buddhism and Sufism (Islamic mysticism). Throughout her career, she took carefully composed photographs capturing the abstract patterns she saw in the world around her, and these pictures served as studies for her drawings. Her work transitioned from pages covered in subtly shifting grids and lines in the 1970s to more three-dimensional, triangular configurations in the 1980s, such as this example (**Fig. 15.15**). Two blocks of subtly shaded parallel lines run diagonally from right to left and serve as the backdrop for three bold, bended lines, like abstracted mountain peaks, punctuating the center of the composition. Through this limited repertoire of markings, Mohamedi sought to explore the relationship between time and space. She wrote that she wanted to make "the maximum of the minimum."

Mohamedi's work serves to remind us of the diversity of South Asian art during the latter part of the twentieth century. She also exemplifies another important trend of the era: the rise to prominence of female artists. Concurrent with the women's movement in the 1970s, a few female artists, such as Mohamedi, began to enter the art scene. By the 1980s, their numbers had increased. Anjolie Ela Menon, Arpita Singh, Gogi Saroj Pal, Nalini Malani, and Mrinalini Mukherjee (see Fig. 17.14), are just a few of the female artists who were active during this period (and many are still active today). They adopted a

15.15 Nasreen Mohamedi, *Untitled,* early 1980s. Ink and graphite on paper, 22⅜ × 28½ in. (56.6 × 72.1 cm). Private collection, courtesy Talwar Gallery, New York.

15.16 Nilima Sheikh, **"Champa before her marriage with her mother,"** from the series of 12 paintings *When Champa Grew Up*, 1984–85. Tempera on sanghaneri paper, 8¾ × 13⅞ in. (22 × 35 cm). Leicester Museum & Art Gallery, U.K.

15.16a Nilima Sheikh, **"Tensions in the Household and Persecution of the New Bride,"** from the series of 12 paintings *When Champa Grew Up*, 1984–85. Tempera on sanghaneri paper, 8⅝ × 13¾ in. (22 × 35 cm). Leicester Museum & Art Gallery, U.K.

wide range of artistic approaches, each with their own vision and objectives, some choosing to address gender issues directly in their work.

Nilima Sheikh (b. 1945) is one such example. Her artwork explores displacement, violence, modern history, cultural heritage, and landscape, among other things, always with a commitment to telling the varied stories of womanhood. Sheikh, like many twentieth-century South Asian artists, originally trained in Western-style oil painting, but in the 1980s she set out to learn about historical painting practices in South Asia. She documented the motifs, tools, and methods of the *picchwai* painters of Nathdwara, Rajasthan (*picchwai* are large Hindu devotional paintings on cloth) as a means of advocating for the need to sustain such heritage. At that time, she also began working with traditional materials herself, using handmade paper and brushes, with paint tempered with gum arabic.

In *When Champa Grew Up* (**Figs. 15.16, 15.16a**), Sheikh employs a serial form—twelve individual folios, each less than 9 × 14 inches in size—to tell the story of a young woman she knew who was killed in a dowry-death, a term

used to describe the death of a relatively new bride at the hands of her husband or his family, usually after continued attempts to extract more dowry (property or money given by the bride's family). In the first folio (Fig. 15.16), we meet Champa (a pseudonym Sheikh gave to the victim) as a young girl on her bicycle. That the freedom and independence she enjoys are to be short lived is foreshadowed by the crouched figure of her mother doing dishes in the lower left corner of the scene. The next few paintings depict Champa's marriage and move to her in-laws' home. In the seventh image, "Tensions in the Household and Persecution of the New Bride" (Fig. 15.16a), we see Champa cooking at the small kerosene stove (the same stove that eventually will be used to burn her to death) at the composition's center. She looks up in fear and surprise as a male figure to the right appears to whip her and a blob-like figure to the left (most likely her mother-in-law) throws a rolling pin at Champa's head. Sheikh has fractured the pictorial space into a series of disjointed rectangles, as if to convey Champa's confusion in that moment. The remaining folios depict her murder, with the final image showing a group of women performing ritualized mourning. The small-scale, intimate format of the series requires the viewer actively to lean in and look closely, highlighting the way in which such stories of domestic violence can easily be ignored unless one chooses to pay attention.

The use of a fragmented pictorial plane to encourage the viewer to see a scene in a new way occurs in a very different context in the work of the photographer Raghubir Singh (1942–1999). Photography's role as an artistic medium expanded in the last quarter of the twentieth century, and Singh was perhaps one of the best-known South Asian photographers from the period. In the early 1970s, when black-and-white photography still dominated the art scene, Singh was experimenting with color. Although he lived abroad for much of his life, where it was easier to make a living as a professional photographer, his subject remained his homeland. He spent three decades capturing the changes occurring in India's cities and countryside. His images focus on the seemingly unimportant, in-between moments of everyday life, and counter the visual cliché of a "timeless," picturesque India presented by the work of many foreign photographers.

While working in Mumbai in 1989 and the early 1990s, Singh developed a new visual approach, using the reflections and frames created by windows and mirrors to create complex, multilayered images. The resulting pictures, such as *Zaveri Bazaar and Jeweller's Showroom, Bombay, Maharashtra* (Fig. 15.17), in which the camera looks out through the glass doors of a jewelry shop to the busy street beyond, convey a sense of spontaneity, while highlighting Singh's conceptual process. Singh's photographs speak not only to their own fragmentary

15.17 Raghubir Singh, *Zaveri Bazaar and Jeweller's Showroom, Bombay, Maharashtra,* 1989. Chromogenic print photograph, 10 × 14¾ in. (25.4 × 37.5 cm). Metropolitan Museum of Art, New York.

nature but also to the frames and blind spots that shape the way we view the world more generally.

Between approximately 1800 and 1980, South Asia endured not only profound changes but also conflicts—ones that literally fractured the Indian subcontinent, breaking it into the modern nations of India, Pakistan, and Bangladesh. Art evolved alongside these developments and disruptions. Artists adapted to new systems of patronage, technologies, and materials. In various ways, they answered the question of what modern art might look like. They used art to celebrate their new nations and process the trauma of Partition and other acts of violence. They explored the layers of their own identities as well as those of others. As artists became more diverse, so did the art they produced. But that was only the beginning. In the early 1990s India's economic liberalization created a fertile environment for contemporary art to flourish there, and globalization affected South Asian art overall, leading to yet more changes, disruptions, and diversity (see Chapter 17).

Discussion Questions

1. What were some of the ways that South Asian artists responded to colonization during the nineteenth century?

2. One of the issues central to twentieth-century South Asian art is the question of how artists and architects might engage with Modernism in ways meaningful to local traditions and concerns. Which approach adopted by an artist—or artists—particularly struck a chord with you and why?

3. Several of the South Asian artworks discussed in this chapter deal with gender or sexuality in some way. Choose two examples and compare how they either reinforced or resisted societal expectations.

4. Research prompt: there are many more twentieth-century South Asian artists than those featured in this chapter. Choose one such artist and research his or her work. In what ways does it fit with the themes and trends discussed in this chapter?

Further Reading

- Bean, Susan, *et al. Midnight to the Boom: Painting in India after Independence from the Peabody Essex Museum's Herwitz Collection*. Salem, MA: Peabody Essex Museum in association with Thames & Hudson, 2013.

- Dadi, Iftikhar. *Modernism and the Art of Muslim South Asia*. Chapel Hill, NC: University of North Carolina Press, 2010.

- Correa, Charles. *A Place in the Shade: The New Landscape and other essays*. Ostfildern, Germany: Hatje/Cant, 2012.

- Eaton, Natasha. *Mimesis across Empires: Artworks and Networks in India, 1765–1860*. Durham, NC and London: Duke University Press, 2013.

- Mitter, Partha. *The Triumph of Modernism: India's Artists and the Avant-garde 1922–1947*. London: Reaktion Books, 2007.

Chronology

1750s–1850s	So-called Company School painting flourishes in India	1930	Mahatma Gandhi leads the Salt March, an act of civil disobedience against British rule in India
1857–58	The Sepoy Rebellion, after which control of the Indian subcontinent passes from the British East India Company to the British Crown	1931	The capital of New Delhi is inaugurated
1861	The Archaeological Survey of India is founded	1934–41	Amrita Sher-Gil is active as a professional painter in India
1870s–1905	Lala Deen Dayal is active as a professional photographer	1947	The Indian subcontinent achieves independence and is partitioned into India and Pakistan
1892	Indian artist Raja Ravi Varma and his brother set up a chromolithographic printing press to reproduce his artwork for a wider audience	1961–65	Sadequain completes a number of large murals for the State Bank of Pakistan
1905	The British Raj splits Bengal into two states; in response, Abanindranath Tagore creates the painting *Bharat Mata*	1971	M. F. Husain's artwork is displayed at the São Paulo Biennial in Brazil alongside Picasso's; after civil war, East Pakistan secedes and becomes Bangladesh
1919	Artist Nandalal Bose joins the faculty at Shantiniketan's Vishva Bharati University, the school founded by the poet/artist Rabindranath Tagore	late 1970s–80s	Postcolonial art criticism emerges; there is a marked rise in the number of women professional artists in India

Empire Building

Throughout history, architecture and empire have gone hand in hand. Ruling lands separated by thousands of miles requires a demonstration of power and the creation of infrastructure. During the nineteenth century a new type of empire developed, one that harnessed modern technologies to dominate more of the globe, which in turn necessitated new types of architecture. By the 1880s, colonizing nations in Europe had claimed control over almost all of Africa and large parts of Asia, and both Japan and the United States shared their imperial ambitions. Architects constructed a range of buildings that were a visual expression of colonial authority. Although constrained by the rules of their own communities, they were often free to experiment with ambitious new models when working in distant colonies.

The railroad was one of the most important nineteenth-century technologies deployed as a means of control. It expedited the movement of troops and the transfer of raw materials from the colony to the colonizer, and it was a potent signifier of imperial power. Built between 1878 and 1887 as the showpiece of the British Empire's Indian railway system, the Victoria Terminus (**Fig. 1**)—today known as Chhatrapati Shivaji Terminus—exemplifies the architecture of colonial-era Bombay (Mumbai).

As with other new civic buildings in the city, the style of Victoria Terminus is primarily Neo-Gothic, an architectural style used by European and American architects to cloak modern buildings in an aura of medieval Christianity. Here, however, the references to Gothic churches, such as spires, turrets, and arches, mingle with Indian elements, for example the rounded domes at either end of the central facade that echo the form of *chhatris* (elevated, dome-shaped pavilions found in Indian architecture). English architect Frederick William Stevens (1847–1900) worked with students from Bombay's Sir J. J. School of Art to execute the building's decorative details, mixing European and Indian designs. A 14-foot statue personifying "progress" caps the enormous building, creating a seemingly integrated vision of European and Indian cultures united under the cause of imperial advancement.

Swift communication, through post and telegraph, was another key element of modern imperialism. Correspondingly, post offices

became standard features in colonial cities. The Central Post Office (**Fig. 2**) built in Saigon (Ho Chi Minh City), the colonial capital of French Indochina (Vietnam), features a prefabricated cast-iron frame interior, an architectural development stemming from new industrial processes that allows for large, open interior spaces. Two wall maps hang near the entrance, one of Saigon and the other highlighting the telegraph lines in Vietnam and Cambodia. The exterior is Neo-Baroque (named after the dramatic, exuberant style of art and architecture formed in seventeenth-century Europe), and

1 TOP **Chhatrapati Shivaji Terminus (formerly Victoria Terminus),** Mumbai (formerly Bombay), India, 1878–87, Frederick William Stevens, architect. Exterior View. SOUTH ASIA

2 ABOVE **Central Post Office,** Ho Chi Minh City (formerly Saigon), Vietnam, 1886–91, Alfred Foulhoux, architect. Interior view. SOUTHEAST ASIA

its facade is decorated with the names of important European scientists and philosophers, underscoring what the French saw as their cultural superiority.

European architectural styles communicated colonial authority and an international, modern

3 Presidential Office Building (formerly the Meiji Japan's Governor-General's office), Taipei, Taiwan, 1912–19, Uheji Nagano and Matsunosuke Moriyama, architects. Exterior view. **EAST ASIA**

outlook so powerfully that non-European imperial powers adopted them too. After Japan colonized Taiwan in 1895, the Japanese borrowed from historical European architecture and blended these aspects with a few Japanese features, as well as modern engineering elements such as reinforced concrete, to create their administrative buildings. Their goal was to convey an internationally recognizable sense of imperial rule. The Japanese Meiji Governor-General's Office in Taipei (**Fig. 3**)—today known as the Presidential Office Building—features a broad, symmetrical facade with a central portico (porch supported by columns) and a tower, the tallest in Taiwan at the time, looking out over a spacious open plaza. Although the use of European styles was controversial at home (see Chapter 16), Japanese architects used it abroad to communicate Japan's new role as a global power.

In the early twentieth century, architects used colonial sites as an opportunity to experiment freely with new styles. In Asmara, Eritrea, Italian architects embraced Modernism in buildings and in urban planning. Asmara was occupied by Italian soldiers in 1889, and it was organized as

4 Fiat Tagliero station, Asmara, Eritrea, 1938, Giuseppe Pettazzi, architect. Exterior view. **AFRICA**

an urban capital after 1935, when it became the base for the Fascist Italian government's invasion of neighboring Ethiopia. Italian settlers poured into the new city, and buildings in a range of Modernist styles were constructed. One of the most striking is the Fiat Tagliero Station (**Fig. 4**) designed by Futurist architect Giuseppe Pettazzi (1907–2001) to look like an airplane, with 98-foot cantilevered wings and a two-story central structure featuring wrap-around windows. Italian Futurism began in the early twentieth century and embraced the things it associated with the new century: speed, technology, youth, and

violence. It was fitting, therefore, that a building serving automobiles resembles an airplane, two state-of-the-art forms of transportation. Additionally, the building sat on the road to the airport from which the Italians launched chemical weapon airstrikes on the Ethiopians, with the vigorous Modernism of the architecture matching the brutality of modern warfare.

Discussion Questions

1. Why do you think imperial administrators chose to construct buildings in European styles? Why did they not choose to adopt local forms of architecture?

2. Many monumental colonial buildings, such as those discussed here, not only continue to be used for their original (or similar) functions but have also become important urban landmarks. Do you think it is possible, or even necessary, for these buildings to shed their associations with foreign rule in order to be celebrated aspects of a city's heritage? Explain.

Further Reading

- Denison, Edward, Ren, Guang Yu, and Gebremedhin, Naigzy. *Asmara: Africa's Secret Modernist City.* London and New York: Merrell Publishers, 2007.
- James-Chakraborty, Kathleen. "Empire Building." *Architecture Since 1400.* Minneapolis, MN: University of Minnesota Press, 2014.
- Metcalf, Thomas. *An Imperial Vision: Indian Architecture and Britain's Raj.* Berkeley, CA: University of California Press, 1989.
- Wright, Gwendolyn. *The Politics of Design in French Colonial Urbanism.* Chicago, IL: University of Chicago Press, 1991.

16

Modernity and Identity in East Asian Art

1850–1980

16.0 Detail of Pan Yuliang, *Self-Portrait*.

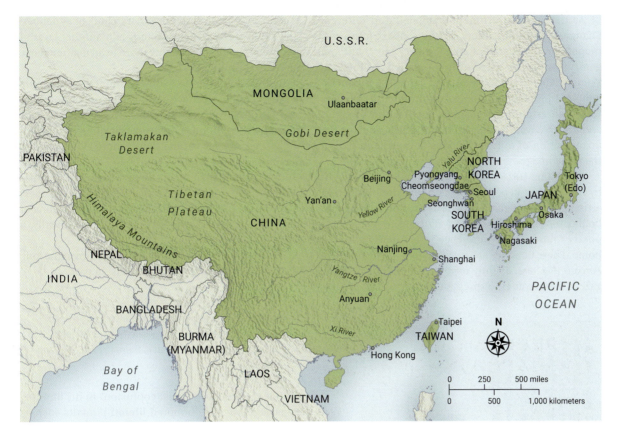

Map 16.1 East Asia, *c.* 1970.

Introduction

At the beginning of the nineteenth century, the modern nation-states known as Mongolia, Taiwan, and China; North Korea and South Korea; and Japan did not exist (Map 16.1). An emperor ruled the Sino-Manchu Qing dynasty, a king sat on the Joseon throne, and a shogun headed the Tokugawa military government headquartered in Edo (Tokyo). Established in 1644, 1392, and 1603, respectively, these heads of state presided over flourishing elite cultures characterized by rising wealth, urban centers, commercial activity, and respect for knowledge. Their cultures fired the imaginations of people well beyond East Asia, and their vigorous economies drew the attention of Western empires intent on expanding trade.

East Asia's entry into the modern era was marked by internal rebellions and wars between foreign powers and the Qing dynasty. These events signaled the start of unprecedented transformation. Beginning in the late nineteenth century, impressed by Western sciences and technological development, East Asian governments—old and new alike—undertook exhaustive efforts to modernize their militaries, industries, educational institutions, and transportation and communication infrastructure. During the difficult years of the early twentieth century, artists took to documenting wars, boosting morale, and casting a critical eye on the human toll. Deeply patriotic and acutely sensitive to the changing world, they invented new forms and images to give voice to suffering, mobilize the public, question authority, and transcend the everyday.

For much of the twentieth century, East Asian countries navigated a world that falsely pitted modernity against long-standing East Asian identities. In choosing one, they stood accused of forsaking the other. In the postwar era, some East Asian artists pursued avant-garde styles, participating in a cosmopolitan world of interconnected urban centers. Other artists worked in popular styles and Socialist Realism. Although their artwork primarily addressed domestic audiences, these artists also had opportunities for international exchange. As the 1970s drew to a close, East Asian artists could look back on a century of extraordinary experimentation and peer into a future of widened horizons.

Confronting New Challenges

Throughout East Asia, governments would confront new challenges by the turn of the twentieth century. The first to do so was the Sino-Manchu Qing, the last Chinese dynasty (1644–1912). In the eighteenth century, the wealth and power of the Qing were unrivaled. But in the mid-nineteenth century, this situation changed irrevocably as foreign governments chipped away at Qing sovereignty and domestic unrest shook the empire to its core. The Qing suffered the first of numerous defeats to foreign militaries in the Opium War of 1839–42, a war in which the Chinese attempted to end the illegal trade of opium into its borders. But the British prevailed and forced the opening of ports such as Shanghai to foreign trade and settlement. Ironically, Shanghai soon became a safe haven from violence caused by the Taiping Civil War (also known as the Taiping Rebellion, 1850–64), a millenarian revolt induced by natural disasters and economic hardship. The deadliest conflict of the nineteenth century, the Taiping Civil War caused some twenty million deaths and displaced some thirty million people. Yet it was just one of several internal uprisings in the Qing Empire.

Shanghai School not literally a school, but a style of Chinese painting characterized by bright colors, bold compositions, and lively content that responded to the eclectic and commercial tastes of audiences in late nineteenth- and early twentieth-century Shanghai.

naturalism representing people or nature in a detailed and accurate manner; the realistic depiction of objects in a natural setting.

abstract altered through simplification, exaggeration, or otherwise deviating from natural appearance.

literati in Confucian cultures of East Asia, the social group of educated men who would typically pursue government service as a career, but could also put their skills in reading, writing, and related arts to work through tutoring, writing, and painting.

illusionism making objects and space in two dimensions appear real; achieved using such techniques as foreshortening, shading, and perspective.

Western a term used in the modern era to claim shared civilization and institutions originating in Europe among predominantly white people; term extended to North America and other parts of the world heavily marked by European colonization.

As the Qing government struggled and faltered, Shanghai grew from a modest fishing village into a cosmopolitan, international port. Chinese merchant and gentry families resettled near populations of English, French, American, Russian, and Japanese businesspeople. In Shanghai, money, ambition, and diversity fueled entertainment, fashion, intellectual thought, and creative work with novel approaches, such as the juxtaposition of different modes of representation in the same image.

REN Xiong (1823–57), who fled the turmoil wrought by the Taiping Rebellion, was among the pioneering artists of the **Shanghai School**. His dazzling brushwork, bold compositions, and smart allusions to history and poetry found a ready audience in his newly adopted home. These qualities are apparent in his arresting *Self-Portrait* (**Fig. 16.1**). Slightly off center, Ren fixes a steady gaze at the viewer. His expression can be read alternately

16.1 Ren Xiong, *Self-Portrait*, Qing dynasty, China, c. 1856–57. Hanging scroll: ink and color on paper, 46¼ × 30¾ in. (1.18 m × 78.1 cm). Palace Museum, Beijing.

as confrontational, assured, and watchful, or as deliberately elusive. His clenched hands add another layer of emotional complexity, and his shorn head may reference a monastic connection.

Ren used light and shadow to model the contours of his finely chiseled face and his lean upper body, but for his robe, trousers, and shoes, he dispensed with **naturalistic** techniques. Instead, thick lines and sharp angles describe a costume that is more akin to imaginary armor than to falling fabric. In effect Ren traded observation for insight. In other words, the juxtaposition of two styles—naturalistically rendered face, upper body, and hands with **abstract** exaggerations of costume—conveys, immediately and dramatically, a sense of dilemma.

Ren described the dilemma troubling him in the long inscription framing his body. It reads, in part:

> In this vast world—what lies before my eyes?
> I smile and bow and go around flattering people to extend connections, but aware of what affairs?
> In the great confusion, what is there to hold onto and rely on?

Indeed, Ren faced "great confusion" in his lifetime. He engaged in time-honored **literati** pursuits such as music and poetry—the latter two evident in his inscription—yet he was pressed into military service against the Taiping and made a living as a professional painter. Despite his professed confusion, in his self-portrait Ren nevertheless artfully resolved tensions among traditional conventions, popular taste driven by Shanghai's commercial culture, and European techniques of **illusionism**. In the coming years and decades, political and military crises intensified confusion and instability throughout East Asia.

In 1853, Commodore Matthew C. Perry of the U.S. Navy arrived in Edo demanding that Japan open to trade. Facing military action by the United States, the Tokugawa government ended policies that limited diplomatic relations to its East Asian neighbors, and it loosed trade restrictions to allow foreign merchants besides the Chinese and Dutch (see Chapter 13). Fifteen years later, the shogun resigned, ending the Edo period and ushering in the Meiji Restoration. Fully restored to power and keen to avoid the semicolonial situation afflicting the Qing, Japan's emperor embarked on a campaign of rapid modernization, including the shaping of a modern nation-state and attendant nationalist attitudes. During the Meiji period (1868–1912), modernization efforts reached beyond the scientific and technological to encompass the cultural realm. Art museums and public exhibitions, for example, helped to buttress a modern national identity.

For a number of reasons, including the belief that European modes of representation were objective, scientific, and modern, East Asian artists pursued **Western** styles of art. Instead of seeking instruction from established East Asian painting masters, they studied architecture, sculpture, and painting, as well as industrial arts and design, with foreign teachers in newly formed

schools, especially in Japan, but also in European academies. Among them, KURODA Seiki (1866–1924) went to Paris initially to study law but eventually turned instead to art. As Japanese reformers debated the proper role and content of art for a modernizing nation, Kuroda's *Morning Toilette* (**Fig. 16.2**) became a lightning rod for controversy when it was displayed at the 1895 National Industrial Exhibition in Kyoto.

An example of *yōga*, *Morning Toilette* trades ink and colors on paper for oil on canvas. It depicts a female nude, standing before a full-length mirror. A canonical theme in the European tradition, the nude did not have a place in pre-modern East Asian culture. In Meiji Japan, it became a valued subject for Kuroda and like-minded artists not only because it represented an artistic ideal of finding beauty in the human form, but also because it was the basis of art: artists needed to master the nude before they could accurately represent clothed figures. Kuroda's treatment of the nude—with the casual, graceless posture, the awkward intimacy of primping, the flattened space and visible *impasto*—is similar to that of the French Impressionists, such as Edgar Degas (1834–1917). At the same time, **Impressionist** and **Post-Impressionist** artists in Europe were deeply influenced by the informal poses and flattened spaces found in Japanese **woodblock prints** (see Chapter 13).

In terms of medium, subject, and style, *Morning Toilette* demonstrates Kuroda's adoption of the **Modernist** approach to art that he encountered in Paris. This approach reflected the idea that art should transcend strictly utilitarian, didactic functions, and it is clearly indicated by Kuroda's choice to depict a female nude. However, Modernism was not universally embraced in Meiji Japan. The general public attending the National Industrial Exhibition may have supported reformist views that techniques such as **linear perspective** and *chiaroscuro* demonstrated scientific advancement, but the police and some members of the general public took a patriarchal view. They worried that the nude would be morally corrupting to women, children, or people of lower socioeconomic status. In a letter to friends, Kuroda defended his work, "Nude paintings are not damaging to the future of Japanese art, not to mention aesthetics worldwide. Damaging? It's a necessity! It should be greatly promoted...." Sharing Kuroda's view, jurors awarded *Morning Toilette* a bronze medal, and Kuroda went on to become an influential teacher to Japanese, Korean, and Chinese artists. Still, debate persisted over which kinds of art best served the nation's interests.

Questions about the value of the nude in modern art arose elsewhere in East Asia. One example occurred in 1916 when Korean artist KIM Gwanho (1890–1959) won a prize in a state-sponsored exhibition in Japan for his painting *Sunset*, which depicted two nude female figures. In deference to public morality, Korean newspapers refused to publish the painting. A second example arose in 1925 when the Chinese painter and educator LIU Haisu (1896–1994) publicly defended the use of nude models at his Shanghai Art Academy. At that time, a young republican government struggled to

16.2 Kuroda Seiki, *Morning Toilette*, 1893. Oil on canvas, 5 ft. 10¼ in. × 38⅝ in. (1.78 m × 98.1 cm). Destroyed by fire in World War II.

yōga a Japanese term for Western-style painting, or oil painting.

impasto the texture produced by paint applied very thickly.

Impressionism a style of painting developed in Paris beginning in the late 1860s; typically without extensive preparatory work, using bright color and broken brushwork, and capturing momentary effects of light, atmosphere, and color. Central subjects are landscapes and scenes of everyday life.

Post-Impressionism a term coined by British artist and art critic Roger Fry in 1910 that refers not to a movement, but to a shared aesthetic attitude: namely, that an artist should develop novel ideas and techniques that move beyond both Academic convention and Impressionism.

woodblock printing a relief printing process where the image is carved into a block of wood; the raised areas are inked. (For color printing, multiple blocks are used, each carrying a separate color.)

Modernism a movement that promotes a radical break with past styles of art and the search for new modes of expression.

linear perspective a system of representing three-dimensional space and objects on a two-dimensional surface by means of geometry and one or more vanishing points.

chiaroscuro in two-dimensional artworks, the use of light and dark contrasts to create the impression of volume when modeling three-dimensional objects and figures.

form a modern Chinese nation-state after the 1911–12 revolution toppled the Qing dynasty. (At this moment, Mongolia also declared independence.) In attempting to modernize Chinese art, Liu drew inspiration from seeing modern paintings by Japanese artists he had seen while traveling in Japan in 1919 and from the independent attitudes of his artistic heroes, Vincent van Gogh (1853–1890) and Shitao (see Fig. 12.11). Like Kuroda's work, Liu's efforts in art education influenced many young painters, among them PAN Yuliang (also ZHANG Yuliang, 1895–1977).

Pan's biography suggests the challenges and possibilities newly available to talented and hardworking people, including women. Orphaned and sold into prostitution, Pan gained the attention of a wealthy official. She became his second wife and moved to Shanghai, where she enrolled at Liu's Shanghai Art Academy in 1920. After graduating, Pan continued her studies in France and Italy before returning to China in 1929 to take up a teaching post. Despite her artistic success, she decided in 1937 to return to France. The reasons for her move remain unclear, but they may have been related to her disadvantaged social background and to the Japanese invasion of China.

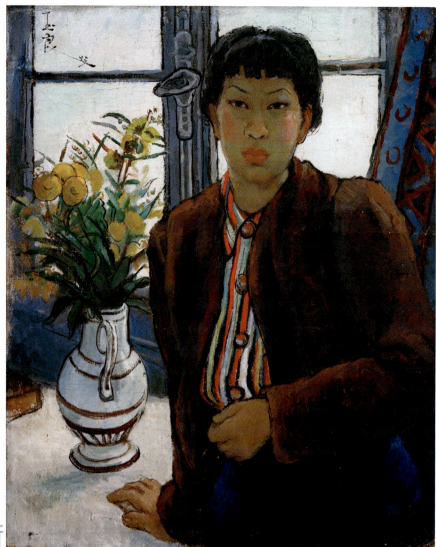

by patriotism, too, these artists accused their compatriots of becoming "Westernized" in their haste to modernize. Instead, they championed East Asian forms of art, and they promoted cultural nationalism as captured in terms such as *guohua* ("national painting") in China and *nihonga* ("Japanese painting") in Japan.

Artists and critics debated the process of modernization and the formation of a national identity in realms other than painting, too. In the 1920s, for example, the Japanese critic YANAGI Sōetsu (1889–1961) began promoting the handicrafts of anonymous, ordinary creators. On the one hand, Yanagi reacted against the dehumanizing aspects of rapid industrialization and the expensive, lavish trend in tea wares promoted by the newly wealthy captains of industry. On the other hand, he drew inspiration from the Arts and Crafts Movement—a late nineteenth-century design movement begun in Britain that focused on quality handcraft as a reaction to industrialization—and sought local equivalents of creative integrity. With potters KAWAI Kanjirō (1890–1966) and HAMADA Shōji (1894–1978), he created the term *mingei* ("folk art"), which denoted both a category of art objects and an artistic movement. In Yanagi's formulation, *mingei* possessed a particular kind of beauty, consisting of such qualities as naturalness, irregularity, intimacy, inexpensiveness, and honesty. *Mingei* need not have a utilitarian function, but typically they were everyday objects such as teapots, tables, and textiles made by skilled, if unnamed, artisans.

Made the year Hamada founded his kiln in the small town of Mashiko, north of Tokyo, this vase embodies the *mingei* aesthetic (**16.4**). It has a sturdy foot, swelling body, and squat neck—useful for storing and pouring liquids. The uneven silhouette preserves the actions of the potter's hands in shaping the vase on the wheel. In this way, the vase is honest about the labor required in its making.

16.3 Pan Yuliang, *Self-Portrait*, 1945. Oil on canvas, 28⅞ × 23½ in. (73.3 × 59.7 cm). National Art Museum of China, Beijing.

patron, patronage a person or institution that commissions artwork or funds an enterprise.

guohua a Chinese term meaning "national painting"; refers to painting in traditional materials (ink and/or colors on silk or paper) and often in traditional formats and genres.

nihonga a Japanese term meaning "Japanese-style painting"; refers to painting in traditional materials (ink and/ or colors on silk or paper) and often in traditional formats and genres.

16.4 FAR RIGHT **Hamada Shōji, Vase,** 1931. Stoneware with clear ash glaze, wax-resist decoration, and a secondary iron-bearing glaze. Height 15¼ in. (38.7 cm). Victoria and Albert Museum, London.

In this self-portrait (**Fig. 16.3**) from 1945, Pan poses before casement windows in her Paris studio. Leaning against a table set with a vase of bright-yellow flowers, and wearing a striped blouse and fitted jacket, she gazes directly at the viewer. The genre of portraiture has a long history in both East Asia and Europe, but Pan's choice of oil painting announces her engagement with European artwork. Pan's *Self-Portrait* attests to her confident handling of light and color, manipulation of space, and representation of the human body. In the thick lines, flat colors, and compositional structure, her work bears comparison to her French colleague, Henri Matisse (1869–1954). Pan's painting presents a woman who has crossed into another culture, and it foreshadows the experiences of future generations of expatriate artists.

In the late nineteenth and early twentieth centuries, as East Asian governments rushed to modernize, artists responded to swiftly changing conditions. They lost old systems of practice and **patronage**, but they gained a fresh, perhaps greater, sense of self-determination as they enrolled in art schools, formed artist collectives, exhibited in public venues, and took part in vital debates about the purpose of art. But other artists took a contrary view and lamented the loss of revered traditions. Driven

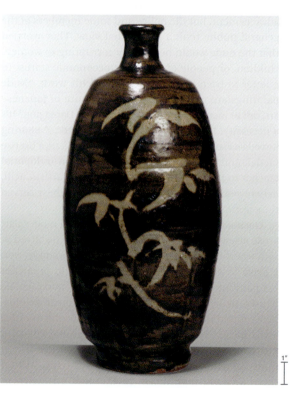

How we see art history now is informed by our current concerns. But ideas and frameworks that were developed long ago continue to exert influence, too. Often, our vision of Asian art is informed by scholars who worked at the turn of the twentieth century. At that time in the field of Japanese art, the key figure was OKAKURA Kakuzō (1863–1913).

In the 1880s and 1890s, as the Meiji government was modernizing the nation-state, Okakura was deeply involved in all major aspects of creating an art history for Japan. He was a founding member of two art schools, a curator in the Imperial Museum (now Tokyo National Museum), and a founder of an important art journal. In addition, he worked on government-sponsored surveys of art and architecture that determined which paintings, sculptures, and buildings—such as the *Shaka Triad* and Phoenix Hall (see Chapter 6)—would be deemed cultural "treasures." Those surveys effectively created a canon of Japanese art.

These activities suggest that Okakura's impact in the field of art history is geographically bounded, separate from the world outside Japan. But in truth, Okakura worked in an already entangled art history. At university, he was a student of Harvard-educated Ernest Fenellosa (1853–1908), who became a life-long colleague and recommended him for a position at the Museum of Fine Arts, Boston (MFA). At the MFA from 1904 until his death, Okakura worked alongside Ananda Coomaraswamy (1877–1947) to develop one of the world's leading collections of Asian art.

Yet well before his arrival in Boston, Okakura introduced Japanese art and culture to global audiences at world fairs: for the World's Columbian Exposition of 1893 in Chicago, Okakura was involved in the Japanese exhibit, which was modeled after the Phoenix Hall. He was similarly influential also in ensuring Japanese exhibits were included in the 1900 Universal Exposition in Paris.

In 1902, Okakura spent the better part of the year in Calcutta (now Kolkata), India, where he found camaraderie among Rabindranath and Abanindranath Tagore, and Nivedita (née Margaret Elizabeth Noble, an Irish-born follower of Ramakrishna). While in Calcutta, Okakura became attuned to the oppressive conditions of British colonialism and wrote *Ideals of the East*, in which he asserted "Asia is one." For the Tagores and Nivedita, Okakura's statement suggested both a pan-Asian spirituality that could counter Western culture, as well as a unified Indian resistance to British imperialism. Okakura's knowledge of Japanese painting proved inspiring, too, and Abanindranath experimented with layers of transparent washes in his search for a kind of pan-Asian aesthetic (see Chapter 15).

During his life, Okakura helped set the foundation for Japanese art history.

Posthumously, Japanese translations of his writings were influential, too. When Japanese colonialism was in ascendance, Okakura's statement of "Asia is one" was changed to "Asia is One," a pretense to a timeless truth for justifying the Japanese colonization of East and Southeast Asia before and during World War II. Even Okakura's name was shifted from his given name Kakuzō to a rarely used and more intimate name, Tenshin. More recent art historical scholarship has tried to separate Okakura's original ideas from later accretions. But it also recognizes that Okakura's history of Japanese art is inextricably entwined with the history of art history.

Discussion Questions

1. Can you deduce the influence of Okakura Kakuzō in this textbook? Search through the contents and do some research to see if featured artworks in the collection of the MFA, Boston were acquired when Okakura worked there.

2. Look again at Abanindranath Tagore's *Bharat Mata* (see Fig. 15.5). Compare it closely to Japanese paintings such as Josetsu's *The Gourd and the Catfish* (see Fig. 9.13). Which stylistic qualities could be described as deliberately pan-Asian on the part of Tagore? Which are culturally distinctive?

The resulting horizontal ridges affect the appearance of the **wax-resist** decoration and the **glazes**, which pool or drip in an irregular and uncontrolled manner, resulting in a rich layering of tones and textures. Here, the vase is also honest about the materials of which it is constituted. The abstract ornament has the gestural energy of **calligraphy**, but it also resembles bamboo. The whole is understated without becoming plain, attractive without being pretentious. It also reveals Yanagi's deep appreciation for Korean ceramics—including *buncheong* ware and porcelain moon jars (see Fig. 13.6)—that exemplified the *mingei* aesthetic.

Mingei proved enormously successful, preserving and nourishing Indigenous craft traditions in Japan and elsewhere. The impact on Korean ceramics is perhaps most significant, as Yanagi himself collected Korean ceramics and spearheaded the effort to establish a museum of Korean art in Seoul, which opened in 1924. But, *mingei* had a darker side, too. Yanagi's search for creative integrity was guided by European examples of **Orientalism**, which was used to justify the colonialization of populations and lands thought to be innocent of modern ideas and industrialization. Notwithstanding Yanagi's genuine appreciation of Korean objects, *mingei* reimagined Korean culture, alongside the cultures of marginalized communities of the expanding Japanese Empire—the Taiwanese, the Ainu, and the Okinawans, for example—as the beneficiaries of the Japanese colonial government. In other words, the category of *mingei* allowed the colonizers to claim credit for discovering artwork that had been neglected and rescuing cultural traditions that were at risk of disappearing. The modern, industrialized world with its logic of "colonize or be colonized" was at once the force that threatened the continuation of long-standing artistic practices as well as the catalyst that compelled Yanagi, Hamada, and others to (re)valorize those newly endangered artforms. Hamada's vase, along with the paintings by Ren, Kuroda, and Pan, suggest a few of the many possibilities for confronting such new challenges and creating modern East Asian art.

Art in Wartime East Asia

Even though East Asia was consumed with armed conflicts from the late nineteenth to the mid-twentieth centuries, artists nevertheless resolved to continue with their work. Much artwork was destroyed in the violence, but surviving examples show a range of responses to wartime events.

mingei a Japanese term meaning "folk art"; refers to a movement championed by Yanagi Sōetsu, which favored unpretentious everyday objects made by skilled, anonymous artists.

wax-resist a technique of ornamentation in which wax is applied to a surface before applying coloring; the areas of wax "resist" the coloring.

glaze a substance fused onto the surface of pottery to form a smooth, shiny decorative coating.

calligraphy the art of expressive, decorative, or carefully descriptive hand lettering or handwriting.

Orientalism refers to European cultures conceiving of North African, West Asian, and Asian cultures in stereotyped ways, attributing either romanticized or negative qualities to them.

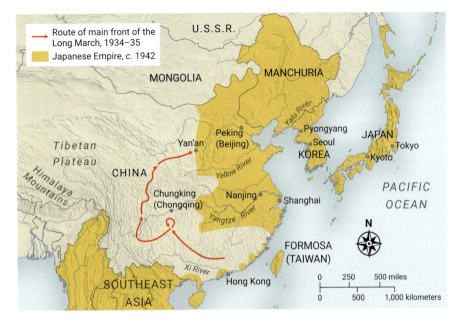

Route of main front of the
Long March, 1934–35
Japanese Empire, c. 1942

Map 16.2 East Asia,
c. 1930s–1942.

16.5 Mizuno Toshikata,
*Hurrah! Hurrah! For the Great
Japanese Empire! Great
Victory for Our Troops on the
Assault on Seonghwan!*, 1894.
Woodblock print: ink and color on
paper, 13⅞ × 28 in. (35.2 × 71.1 cm).
British Library, London.

dominated woodblock prints of the Edo period (see Chapter 13), Meiji period artists such as Toshikata adapted the art form to document current events and to create political propaganda. Although he did not witness the July 29, 1894 battle, Toshikata featured two smartly dressed artists—KUBOTA Beisen (1852–1906) and KUBOTA Kinsen (1875–1954)—at the front of the knot of reporters in the composition's lower right, as if to vouchsafe the print's veracity. At the center, a sword-wielding officer assumes a commanding stance, while well-equipped riflemen in orderly ranks fire on the hapless, retreating Qing army. Shots exploding as red bursts at left echo visually the "Rising Sun" military flag at right.

Casting the enemy as backward, inept, and at times less than human, this kind of artful propaganda played well to home audiences and helped to ensure support for war. The Battle of Seonghwan was but an opening volley of the First Sino-Japanese War (1894–95), which ended with Japan winning control of Qing territories such as Taiwan, and assuming influence over Korea (see Seeing Connections: Empire Building, p. 319, Fig. 3).

After victory in another conflict, the Russo-Japanese War of 1905, Korea became a Japanese protectorate. In 1910 Japan annexed Korea outright and assumed the dual roles of colonizer and modernizer. The impact of Japanese colonial rule (1910–45) on Korean art may be seen in the life and work of YI Inseong (also Lee In-sung, 1912–50). While still in his teens, Yi was accepted into the Joseon Art Exhibition. A prestigious public venue initiated by the Japanese colonial government, the Joseon Art Exhibition ostensibly supported Korean artists but also served colonial interests as an instrument of cultural assimilation. Yi's talent garnered him an opportunity

Of all the governments in East Asia, Japan's Meiji government modernized most rapidly, and it subsequently pursued an imperialist agenda with the ultimate goal of colonizing East and Southeast Asia (**Map 16.2**). One of the first confrontations between Meiji and Qing forces occurred at the Battle of Seonghwan (about 45 miles south of Seoul) in Korea in 1894. The woodblock print artist Mizuno TOSHIKATA (1866–1908) captured the drama from the Meiji point of view in his triptych *Hurrah! Hurrah! For the Great Japanese Empire! Great Victory for Our Troops on the Assault on Seonghwan!* (**Fig. 16.5**).

Whereas delightful subjects of the floating world

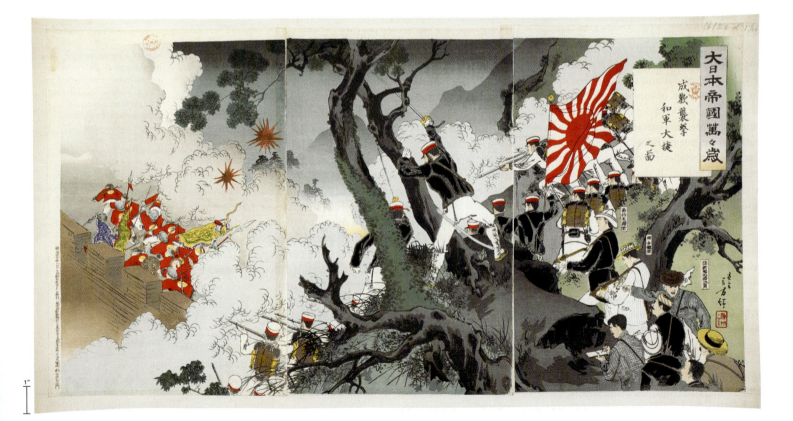

16.6 Yi Inseong, *Valley in Gyeongju*, 1934. Oil on canvas, 51⅛ in. × 6 ft. 4½ in. (1.3 × 1.94 m). Leeum, Samsung Museum of Art, Seoul.

for further study in, not surprisingly, Japan. The year of his return to Korea, Yi painted *Valley in Gyeongju* (**Fig. 16.6**). The painting's saturated palette and thick *impasto* demonstrates Yi's awareness of Modernist art styles such as Post-Impressionism. At the same time, *Valley in Gyeongju* is an example of a trend that began in the 1920s called "Local Color," which emphasized local customs and local types of people. In his choice of subject Yi cast his gaze on a Korean landscape of scattered trees, a broad plain, and distant mountains. In the foreground, a trio of figures may represent a family, composed of a young man seated at right and a young woman carrying a child on her back. The landscape is idyllic and charming, but the figures' expressions and postures convey an undercurrent of isolation and waiting, or from a more geo-political point of view, of quiet resistance and endurance.

During Japanese colonial rule, pastoral representations of the Korean landscape could be seen as demonstrating the good stewardship of the Japanese, but also as communicating opposition to colonialism. Rising at the horizon of Yi's landscape, the remains of Cheomseongdae, a seventh-century observatory of the Silla kingdom (*c.* 300–935 CE) in Korea, allude to a time when prestige and power flowed in a different direction, namely from the Korean peninsula to the Japanese archipelago (see Chapter 6 and Seeing Connections: Gold Crowns across Asia, p. 76).

As military confrontations escalated in the run-up to the Second Sino-Japanese War (1937–45)—a conflict that merged with World War II after the Japanese attack on Pearl Harbor—many Chinese artists supported mobilization efforts. *Roar, China!* is a woodcut by LI Hua (1907–1994)

16.7 Li Hua, *Roar, China!*, 1936. Woodcut, 9 × 6½ in. (22.9 × 16.5 cm). Printed in *Modern Woodcut*, vol. 14 (1936). Lu Xun Memorial, Shanghai, China.

that visualizes a more general, but nevertheless urgent, call to awaken the nation (**Fig. 16.7**). Bound to a wooden post, a naked and blindfolded man cries out. Tense with anguish, his body bursts with pent-up energy, but it is not assured that he will seize the nearby knife to cut himself free.

16.8 Ding Cong, *Images of Today, 1944*, 1944. Handscroll: ink and color on paper, 11¼ × 59 in. (28.6 cm × 1.5 m). Spencer Museum of Art, The University of Kansas.

Li used an old medium in a new way to intensify and amplify his call to take action. China has a long history of woodblock prints, but it was not until the 1930s **Woodcut Movement** that artists themselves undertook the carving and printing in addition to the designing. Under the leadership of writer and social critic LU Xun (1881–1936), politically active artists drew inspiration from **Expressionist** artists such as Käthe Kollwitz (1867–1945) and learned to make woodcuts. In *Roar, China!* Li deftly simplified and exaggerated the body (note the elongated lines of the hands and feet) in order to heighten the impression of agony. The sharp edges of the thick lines, too, convey pain and pressure.

Compared to paintings, woodcuts have the added advantage of inexpensive reproducibility. *Roar, China!* reached viewers not only at public exhibitions throughout China but also in periodicals. Due to the multivalent (open to multiple interpretations) quality of Li's image, which paid homage to Russian writer Sergei Tretyakov's 1926 anti-imperialist play of the same title, viewers could interpret the source of bondage differently. The American Harlem Renaissance poet Langston Hughes (1901–1967), for example, recognized the inequity of a segregated system when he visited Shanghai in 1934. His poem, "Roar, China!" also channels Tretyakov's call for liberation. The communist cause found increasing support as more and more people recognized that oppression resulted not only from colonialism but also from racism, misogyny, and capitalism.

Founded in 1921, the Chinese Communist Party embraced the political and economic analyses of the German philosophers Karl Marx and Friedrich Engels. During its first twenty-five years of existence, the Party pursued an anti-imperialist goal of liberation from Western and Japanese colonial powers alongside advancing socio-economic changes, which included rights for women and workers.

Throughout much of the 1920s and into the 1930s, relations were tense between the Chinese Communist Party and the Nationalist government. But in 1936, the two agreed to set aside their animosities to form a united front against Japanese imperialism. Under Emperor Hirohito (ruled 1926–89), Japan's East Asian empire expanded beyond his predecessor's annexation of Korea (1910) and his own installation of a puppet regime in Manchuria (1931). In 1937, the Second Sino-Japanese War erupted, and by 1942 Japan occupied nearly the entirety of China's coast and controlled major cities, including Beijing, Shanghai, and Nanjing (see **Map 16.2**).

Artists were not spared from the widespread violence and destruction. Some died in the hostilities, others fled inland, and still others suffered the new, colonial conditions. Much artwork was also lost, but a few works documenting the era remain. JIANG Zhaohe's monumental *Refugees* of 1943 (not illustrated), for example, captured the desperate plight of wartime victims with profound solemnity. The artist and political cartoonist DING Cong (1916–2000) took a different tack with his *Images of Today, 1944* (**Fig. 16.8**).

Ding's *Images of Today, 1944* begins at the right with a hapless student straining to comprehend an out-of-date text, while modern books are strewn on the floor. Behind him, a banner unfurls with the painting's title, artist, and date. As with other East Asian **handscroll** paintings, *Images of Today, 1944* proceeds from right to left, but instead of discrete, narrative scenes or a continuous landscape, Ding casts thirty or so characters into a visual anthology of a failed society. The teacher's growing family needs food, not books; a secret handshake between shady dealers will keep cash flowing in an inflationary economy; and the ostensibly patriotic tiger painting by a willfully blind artist looks disturbingly like a wolf, but this shortcoming is of no consequence to venal patrons whose red ribbons hanging at the painting's lower edge announce their intent to commission artwork from him. These vignettes are followed by images related to censorship, war profiteering, poverty, hunger, and migration.

Immediately after the Japanese attack on Shanghai in 1937, Ding committed his efforts as an artist to unite the nation in the struggle against foreign aggression. His anti-Japanese cartoons rallied viewers to participate in the resistance, but the villains in *Images of Today, 1944* are not the Japanese military. Rather, Ding's painting is a scathing indictment of the moral bankruptcy of the wealthy and powerful within China.

Ding's visual satire belongs to the category of *manhua*, translated as "cartoons." In the early twentieth century, the modern concept of political cartoons came to China not directly from France, but from Japan, where the equivalent term is *manga*. Alongside the woodcut artists, cartoonists infused their art with political content, social commentary, and a sense of urgency, which derived from deliberately exaggerating, distorting, and simplifying the representations of bodies and faces. For example, in *Images of Today, 1944*, the censor aptly wields a magnifying glass, but the magnification of his eyeball takes viewers from the realistic or natural worlds into the realm of comedy. Even as Ding adapted cartoons—a modern

Woodcut Movement in 1930s China, the collective effort of the writer Lu Xun and artists to use woodcuts as a vehicle for education, mobilization, and social change.

Expressionism (1) art that is highly emotional in character, with colors, shapes, or space being distorted and non-naturalistic as a means to convey vivid extremes of subjective experience and feeling. (2) modern Expressionism is associated with several movements, including German Expressionism in the early twentieth century and Abstract Expressionism in the mid-twentieth century.

handscroll a format of East Asian painting that is much longer than it is high; typically viewed intimately and in sections, as the viewer unrolls it from right to left.

In May 1942, the future of China's Communist Party remained uncertain. Retreating from Nationalist forces in 1934–35, the Red Army undertook an epic 5,600-mile "Long March" to re-establish a wartime headquarters at Yan'an in a remote area of Shaanxi province (see **Map 16.2**). There, communist leaders, including Mao Zedong, simultaneously fought against Japanese military forces and advanced the communist revolutionary agenda. Mao's 1942 "Talks at the Yan'an Forum on Literature and Art" outlined a strategy of propaganda to accomplish both goals. The following is a short excerpt from the second of two "Talks."

In the world today all culture, all literature and art, belong to definite classes and are geared to definite political lines. There is in fact no such thing as art for art's sake, art that stands above classes, art that is detached from or independent of politics. Proletarian literature and art are part of the whole proletarian revolutionary cause; they are, as Lenin said, "cogs and wheels" in the whole revolutionary machine. Therefore, Party work in literature and art occupies a definite and assigned position in Party revolutionary work as a whole and is subordinated to the revolutionary tasks set by the Party in a given revolutionary period. Opposition to this arrangement is certain to lead to dualism or pluralism, and in essence amounts to "politics: Marxist; art: bourgeois," as with Trotsky. We do not favor overstressing the importance of literature and art, but neither do we favor underestimating their importance. Literature and art are subordinate to politics, but in their turn exert a great influence on politics.

Envisioning an expansive role for art and an audience well beyond the imperial court and socioeconomic elite of past eras, Mao asserts elsewhere in his "Talks" that henceforth the primary audience for art should consist of the masses: the workers, peasants, and soldiers. To understand this audience, writers and artists must live among and learn from them. The education of writers and artists also required ideological study of Marxism-Leninism. Artists who persisted in abstract, Modernist styles as well as those who depicted subjects incomprehensible to the primary audience or irrelevant to political goals as outlined by Mao, were required to undergo a process of rectification, which could include confessing errors and being subjected to public humiliation.

The "Talks" coincided with promulgating a Yan'an style of woodcuts that, contrary to the expectations of the avant-garde, rejected artwork such as in *Roar, China!* (see **Fig. 16.7**), which adapted a European avant-garde style. The Yan'an style of woodcuts would favor forms and content more familiar and accessible to peasants. Especially after the founding of the People's Republic of China in October 1949, Mao's "Talks" continued to guide cultural policy in ways that could be perceived as both progressive and oppressive.

Discussion Questions

1. Mao notes that literature and art "exert a great influence on politics." Do you agree or disagree? Explain using examples from this chapter.
2. Which artwork in this chapter exemplifies the idea of "art for art's sake" or "art that is detached from politics"? Discuss why Mao would object to that artwork.

genre—for his own purposes, his choice of medium and format suggests that aspects of Chinese painting could be modern, too.

Art and the Atomic Bomb

The widespread suffering caused by the colonial ambitions of the Meiji and succeeding Taishō (1912–26) and Shōwa (1926–89) governments cannot be ignored, but neither can the devastation inflicted by the atomic bombs that the United States dropped at the end of World War II on the cities of Hiroshima and Nagasaki. Debate continues over whether the use of these weapons was warranted, but regardless, the world irreversibly entered the nuclear age.

The nuclear age was and continues to be fraught with dread and anxiety, especially and unsurprisingly for Japanese citizens who witnessed the explosions. Japanese popular culture gave birth to a metaphor for nuclear weapons—Godzilla, a powerful monster that spews radioactive breath, indiscriminately destroying people and property. By contrast, photographs by Shōmei TŌMATSU (1930–2012) are less dramatic but equally affecting. Some capture the scars of victims of nuclear radiation, but the photograph reproduced here features a different aspect, a nuclear artifact, as indicated by its title, *"Atomic Bomb Damage," Wristwatch Stopped at 11:02, August 9, 1945* (**Fig. 16.9**).

Extracted from the ruins of Nagasaki, the charred watch nestles against a background resembling the cushioned, satin lining of a jewelry box or funerary casket.

The photograph thus suggests that the watch is both precious and lifeless. The watch no longer fulfills its intended purpose as a timekeeper, yet it marks indelibly the precise time of the detonation, a moment of grave significance. The power of this image issues from not only Tōmatsu's spare composition but also the medium itself. Unlike other forms of image-making such as painting, photography has a distinctive purchase on reality (see Seeing Connections: The Spread of Photography, p. 300). Artistic decisions still bear on the resulting photograph, but the photograph would not be possible without

16.9 Shōmei Tōmatsu, *"Atomic Bomb Damage," Wristwatch Stopped at 11:02, August 9, 1945,* 1961, printed in 1998. Gelatin silver print, 14¼ × 12¾ in. (36.2 × 32.4 cm). Taka Ishii Gallery, Tokyo.

daguerreotype a unique photograph fixed on a silver-coated copper plate, cased under glass.

lithography a printing process in which images are drawn on a flat surface, such as fine-grained limestone or a metal plate, using a greasy substance; ink is then applied to the wetted surface, being repelled by the damp areas and sticking only to the greasy areas to print the desired image.

avant garde an emphasis in modern art on artistic innovation, which challenged accepted values, traditions, and techniques; derived from the French for "vanguard."

Gutai an avant-garde art group formed in Japan in 1954.

Kyūshū-ha an influential post-World War II avant-garde art group that formed in Kyūshū, Japan in the 1950s.

Dada an informal international movement that arose during World War I; its adherents rebelled against established standards in art and what they considered morally bankrupt European culture.

16.10 Kenzō Tange, Yoyogi National Gymnasium, 1961–64. Tokyo.

the phenomenon of light reflecting off the surface of the objects represented and subsequently acting on light-sensitive material. Tōmatsu took advantage of photography's documentary capacity to reveal the wreckage wrought by the nuclear blasts and the poignant fragility of human life that is implied by the watch-face, which may be all that remains of the person who once wore it. In other work, Tōmatsu trained his camera on another uneasy subject: the postwar U.S. occupation of Japan.

Tōmatsu was not the first artist in East Asia to choose photography as his medium. **Daguerreotype** equipment first arrived in Japan in the 1840s, and in 1860 the Italian-British photographer Felice Beato (1832–1909) embedded with British and French forces during the Second Opium War (1856–60), documenting images of military battles. (See also Beato's photograph of Secudra Bagh in Lucknow, India, Fig. 1 in Seeing Connections: The Spread of Photography, p. 300.) By the turn of the century, the technology had spread, and photography studios from Canton to Tokyo offered portrait services. By the 1920s, photography-based **lithography** displaced earlier technologies for producing mass-distributed images in urban centers. Early photographic genres included painterly compositions modeled after monumental landscapes, Orientalizing fantasies for the tourist trade, and political portraits and military scenes for propaganda. Tōmatsu's *Wristwatch* hails from a later period, informed by abstraction and Modernism.

Postwar Artistic Practices

The end of World War II brought additional political recognition to Mongolia, which had declared its independence when the Qing dynasty ended, became a People's Republic in 1924, and fought on the side of Allied forces. But its geographical location between the Soviet Union and China required on-going diplomacy. For the rest of East Asia, war's end did not mean the end of hostilities. In some places, one enemy replaced another. In other places, antagonism was kept precariously in check. During World War II, Nationalists and Communists in China put aside differences to form an alliance known as the Second United Front (the First United Front having occurred just over two decades earlier, to fight warlordism), but at the end of the war they resumed fighting one another. China's civil war lasted from 1945 to 1949, ending with the Nationalist retreat to Taiwan and Mao Zedong declaring the founding of the People's Republic of China (PRC) on October 1, 1949. On the Korean peninsula, Japan's withdrawal did not restore a single, unified Korea. Rather, Soviet and U.S. governments agreed to divide the region along the 38th parallel into two countries, North Korea and South Korea. Finally, a demilitarized Japanese nation began rebuilding while accommodating a U.S. military occupation that was not always benevolent or welcome.

The postwar situation in East Asia was at times shaky, but this did not prevent investment in infrastructure, human capital, and nation-building efforts. For example, Japanese architect Kenzō TANGE (1913–2005) took charge of reconstructing Hiroshima, including the building of the Hiroshima Peace Memorial Park and Museum (1954). Whereas Tange's work in Hiroshima encourages a sense of solace, his Yoyogi National Gymnasium in Tokyo (**Fig. 16.10**) elicits awe.

Commissioned for the 1964 Olympic Games, which broadcast Japan's new image to the world, Tange's design combines the sculptural qualities of reinforced concrete with the sweeping elegance of a steel-cable suspension roof. Like the work by his architectural hero Le Corbusier (see Fig. 0.8), the concrete portions of Yoyogi National Gymnasium rise gracefully into curved shapes. The massive building, which brings together two arcs,

slightly offset like a pinwheel, seems to spin and float. The illusion of movement or rotation is aided by the vertical accents framing the band of windows, the ribs on the roof, and the slack bend of the ridge. Tange's building would not have been possible without modern, industrial materials, and its exuberant shape partakes in space-age imagination.

Like earlier political rulers' commissioning of temples or expansions of castles (see Figs. 6.13 and 9.16), the Japanese government sponsorship of Yoyogi National Gymnasium projected a positive image of itself to numerous constituencies. At the same time, politically engaged **avant-garde** artists questioned postwar government policies, resisted consumer culture, and defied social norms by creating artworks that broke long-standing artistic boundaries. Like avant-garde artist communities elsewhere in the world, they formed artist groups, such as **Gutai** and **Kyūshū-ha**, and they exhibited unconventional artwork and staged public art events. For example, for the second Gutai Art Exhibition in 1956, Atsuko TANAKA (1932–2005) walked around the gallery space while wearing her 50-kilogram *Electric Dress* of 200 flickering light bulbs, provoking the audience to reconsider conventional ideas about clothing, technology, and art. In the 1960s, a trio of artists—Genpei AKASEGAWA, Natsuyuki NAKANISHI, and Jiro TAKAMATSU—who formed the group "Hi-Red Center" took their work out of the gallery and into public spaces, such as commuter trains (*Yamanote Line Incident*, 1962). With the twin goals of expanding the boundaries of art and effecting sociopolitical change around the world, avant-garde artists often drew inspiration from **Dada**, and they participated in international art circles such as **Fluxus**. Perhaps the best-known East Asian artist in this regard is Yoko ONO (born 1933). In 1964, the thirty-year-old Ono created a **performance** called *Cut Piece* (**Fig. 16.11**).

In *Cut Piece*, Ono knelt on stage with a pair of scissors placed nearby. Members of the audience were invited one by one to pick up the scissors and cut off a piece of her clothing (**Fig. 16.11**). Men and women alike participated in the somewhat improvised performance, creating intimate contact between artist and viewers. Bit by bit, Ono's clothing was taken away as souvenirs; whether the person wielding the scissors was aggressive or respectful, she maintained her composure. The performance ended at her discretion, but not before the audience had the opportunity to see its complicity in social regimes of violence and oppression. Ono performed *Cut Piece* in cities in several countries—Japan, the United States, and Great Britain—and depending on location, the nature of that violence and oppression differed. For example, viewers in New York and London were more likely than audiences in Kyoto and Tokyo to see Ono as an exotic "Oriental" woman and sexualized object (see Seeing Connections: Images of Orientalism, p. 261). Thus, a racial dimension is added to the perceptions of gender. Still, Ono exerted artistic agency, and in *Cut Piece* she advanced the cause of **feminist art** by drawing attention to the long and problematic history of the objectification of women in art. Ono herself performed the work again in 2003 in Paris, France, and in 2015 it was notably

16.11 Yoko Ono, *Cut Piece*, performance in Tokyo in 1964.

Fluxus an international community of creative artists and writers active during the 1960s and 1970s; the group's experimental art performances emphasized artistic process over finished product.

performance art linked to theater and dance, ephemeral events with a strong visual focus orchestrated by visual artists before an audience.

feminist art associated with the Feminist Movement of the 1960s and 1970s, art critically informed by women's experiences.

Happenings an artwork that takes the form of an event, often improvised and with artist(s) and audience as participants.

installation a work of art created at the site where it is located, often using physical elements on the site; creates an immersive experience for the viewer.

16.12 Yayoi Kusama, *Infinity Mirror Room—Phalli's Field*, 1965. Installation view. Floor show, Castellane Gallery, New York.

performed by the Canadian musician and artist known as Peaches (also Merrill Nisker, b. 1966)—reflecting Ono's continuing artistic influence and relevance.

The female body and sexuality are themes that arise in the work of another East Asian artist, Yayoi KUSAMA (born 1929). Born in Japan, Yayoi Kusama created *Infinity Mirror Room—Phalli's Field* during her time in the United States between 1957 and 1972 (**Fig. 16.12**). During those eventful years, she was active in New York art circles, making work in various media including painting, sculpture, and antiwar performances. She also staged **Happenings** during which she painted polka dots on audience-participants. *Phalli's Field* of 1965 adopted her signature polka dots for another art medium, an **installation**, which immersed

16.13 Nam June Paik, *TV Buddha*, 1974. Video installation with bronze Buddha sculpture, 5 ft. 3 in. × 7 ft. ½ in. × 31½ in. (1.85 m × 2.15 m × 80 cm). Stedelijk Museum, Amsterdam.

viewers in a space designed by the artist. In *Phalli's Field*, Kusama filled a room with hundreds of bright red, polka-dotted soft sculptures. Color and pattern give her work a **Pop Art** sensibility, and the phallic forms introduce themes of disembodiment and sexuality. Mirrored walls replicate the strange, stuffed tubers along with any persons in the room ad infinitum, creating an effect that is at once hallucinatory and transcendent. For this photograph, Kusama placed herself in this fantasy room. By doing so, she blurred conventional boundaries between self and art, between subject and object.

As with Ono and Kusama, Korean American artist Nam June PAIK (1932–2006) participated vigorously in international, avant-garde circles. Born in Seoul, Paik and his family fled the Korean War (1950–53), stayed briefly in Hong Kong, then moved to Japan. Paik pursued postgraduate study in music in what was then West Germany, where he met other avant-garde artists, and

experimented with combining music and television sets in art performances. One of the pioneering artists of Fluxus, Paik moved to the United States in 1964 and continued his experiments in the then-new medium of **video art**.

Paik's 1974 *TV Buddha* (**Fig. 16.13**) uses a closed-circuit camera and a television to broadcast the image *of* the Buddha *to* the Buddha. The viewer's gaze alternates from one Buddha to the other. The physical confrontation between sculpture and television evokes other kinds of oppositions: between object and image; religious icon and media icon; tradition and modernity; elite art and mass media. But *TV Buddha* also raises questions about cross-cultural outcomes. For example, does technology transform spiritual practice into an egocentric exercise? Or is *TV Buddha* intended to be funny? Mocking or optimistic, Paik's video art probed conventional thinking, and at times was an uncanny omen of future developments. His piece *Good Morning, Mr. Orwell* used the international satellite to connect broadcasters and artists in New York, Paris, Germany, and South Korea. It aired, fittingly, on New Year's Day, 1984, to a worldwide audience of more than 25 million viewers. Even in its technical difficulties, *Good Morning, Mr. Orwell* resembled before its time the kind of multimedia, collaborative livestream that digital technologies have now made ubiquitous.

For East Asian artists, the postwar era presented previously unimagined possibilities. Technological developments introduced new materials and new media, social changes fueled political action, and the new world order quickened communication and travel. Sociopolitical agendas of justice and equality, along with anti-war movements, drew together avant-garde artists in urban centers such as Tokyo, New York, and Cologne, where they vociferously challenged the status quo. Even those artists who chose not to experiment in new media or who were not at the forefront of social protests were equally dedicated to making art that was current and relevant.

Pop Art a movement beginning in the mid-1950s that used imagery from popular or "low" culture, such as comic books and consumer packaging, for art.

video art a form of art that uses moving images and sound recordings.

16.14 Lee Ufan, *From Point*, 1975. Glue and mineral pigments on canvas, 6 ft. 4 ½ in. × 9 ft. 6⅝ in. (1.94 × 2.91 m). The National Museum of Art, Osaka, Japan.

Critic and artist LEE Ufan (b. 1936), for example, shifted away from the emphasis on industrial objects and ordinary things, which characterized his activity with the Japanese avant-garde **Mono-ha** movement, to painting. Lee's paintings of the mid-1960s to mid-1970s were, like some of the work by other Korean artists such as KIM Whanki (also Kim Hwan-gi, 1913–1974) and PARK Seo-bo (b. 1931), **non-figurative** and dominated by monochrome, largely neutral colors. These stylistic qualities later led the Korean art critic Lee Yil to coin the term Dansaekhwa, literally "monochrome painting," to refer to this body of work by Lee, Park, and other Korean artists. In Dansaekhwa, focus is placed on the very materials of painting, emphasizing marks, patterns, and textures on the surface of the canvas, as in Lee's aptly titled *From Point* (**Fig. 16.14**). In this painting, Lee repeated a series of red-orange marks that originate in a single circular point. Each time, he began at the left of one of three columns, pressing his brush against the canvas until an orderly row of ever paler points was completed. Then, he reloaded his brush with pigment until the canvas was filled. *From Point* deliberately avoids depicting any subject, whether a figure, a narrative, or a landscape, any of which would hide the decisions and actions of the painter. Instead, this painting is a record of the artist's process. Because that process unfolds in time, *From Point* may also be interpreted as marking time.

When paintings such as *From Point* were first exhibited, responses were decidedly mixed. One reaction questioned whether such paintings were finished or whether they were paintings at all. In this regard, Lee succeeded in the goal of using a conventional artform—painting—to challenge conventions. In place of the artifice of representational painting, along with the kinds of political and commercial agendas associated with it, Lee proposed an authentic and direct relationship between artist and audience as equals, the latter actively engaged in making sense of *From Point*.

Whereas Lee returned to painting only after having experimented with **Conceptual art** forms, the Chinese artist CHANG Dai-chien (*pinyin*: Zhang Daqian, 1899–1983) adhered to painting—traditional Chinese painting—throughout his life. His work provides a dramatic retrospective look at the relationship between political events and artistic possibilities for much of the twentieth century. Chang's colorful life included studying textile weaving and dyeing in Kyoto during China's early republican period (1911–37), when Japan served as a model of modernization. He then settled in the growing metropolis of Shanghai, where he painted *guohua* in an astonishing variety of genres and styles. Learning from living masters and antique masterpieces alike, he fooled collectors and museums with his forgeries. In the 1940s, Chang copied early Buddhist murals from remote Dunhuang (see Fig. 6.9), reintroducing this forgotten art to new audiences. In 1949, Chang moved overseas, as part of the international migrations of the postwar era. He built Chinese-style homes and gardens (see Fig. 12.3) in Argentina, Brazil, and California before spending the final years of his life in Taiwan. On a trip to Paris in 1956, he exchanged paintings with Pablo Picasso (1881–1973). Prodigiously talented, the

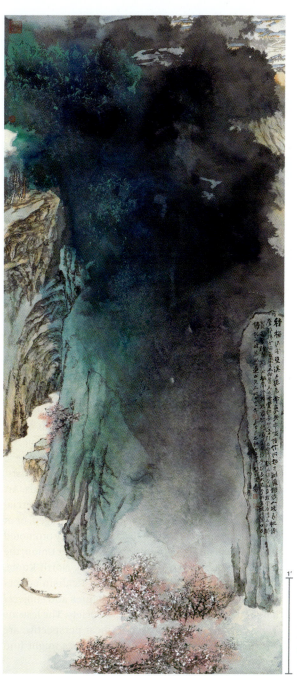

two embodied their respective traditions; their meeting represented a kind of cultural summit.

Dating to the year before his death, Chang's *Peach-Blossom Spring* (**Fig. 16.15**) captures his command of the East Asian painting tradition, as well as his innovative response to both his failing eyesight and **Abstract Expressionism**. Chang splashed black ink and blue-green mineral **pigments**, allowing the watery medium to mix and bleed freely on the paper. To the edges of this expressive abstraction, he added outlines and contours, which caused houses, trees, a massive bluff, and a deep grotto to emerge. At the bottom of this **hanging scroll**, blossoming peach trees and a lone fisherman in a skiff provide motifs to identify the narrative.

Chang based this landscape painting on "Peach-blossom Spring" by the recluse poet TAO Qian (*c.* 365–427).

16.15 Chang Dai-chien, *Peach-Blossom Spring*, 1982. Hanging scroll: ink and color on paper, 6 ft. 10¼ in. × 36⅝ in. (2.09 m × 93 cm). Collection of Cemac, Ltd.

Mono-ha a Japanese term meaning "school of things"; refers to a movement of Korean and Japanese artists in Tokyo in the mid-1960s who explored the use of everyday and industrial materials in art.

non-figurative artwork that does not depict figures or motifs, and instead presents abstract elements such as line, shape, color, pattern, or textures.

Conceptual art a term that emerged in the 1960s for art practices that emphasize ideas rather than any aesthetic qualities or physical materials.

Abstract Expressionism a style of art originating in the United States after World War II in which artists rejected representation in favor of the gestural residue of paint dripped, splashed, and applied in other unorthodox ways.

pigment any substance used as a coloring material in paint, such as dry powders made from finely ground minerals.

hanging scroll a format of East Asian painting that is typically taller than it is wide; generally, hanging scrolls are displayed temporarily and may be rolled up and stored easily.

Tao's poem recounts the tale of a fisherman who by chance navigates past groves of peach trees and through a grotto to discover a paradise, a long-hidden refuge to which villagers fled generations earlier from war. He enjoys a brief stay in the peaceful community, which has remained unharmed by turmoil. Before leaving, the fisherman promises never to reveal this utopia to others. But later, he cannot resist divulging the secret; as he tries to return with others, alas, he cannot retrace the path.

Over the centuries, the story of "Peach-blossom Spring" inspired artists throughout East Asia (see Fig. 9.6) and resonated with audiences who, all too familiar with war's devastating effects, longed for a peaceful utopia. Chang's *Peach-Blossom Spring* suggests that the subject continued to be meaningful. In his inscription, Chang happily described his home in Taiwan as a paradise. In his painting, he revitalized a venerable tradition of landscape (see Figs. 8.1, 8.3, 8.4) with his dazzling blend of abstraction and representation.

"Art for the People"

Artists such as Chang Dai-chien treated the past as a benefit, not a burden, but this attitude was not universal. Avant-garde artists in East Asia generally regarded the past with skepticism and tried in various ways to break free from its confinements. In the People's Republic of China (PRC), rejecting the past was often official policy as artists followed Mao's directive to make "art for the people."

In 1949, after the founding of the PRC, the Chinese Communist Party (CCP) set about reforming art, artists, and art institutions to conform to communist goals. Art deemed bourgeois—including abstract and commercial art, as well as *guohua*—was censored, discouraged, or at best intermittently tolerated. Instead, the party promoted **Socialist Realism**, a style adopted by the Soviet Union, the People's Republic of Mongolia (1924–92), North Korea, and other socialist nations. Socialist Realism adapts techniques of naturalism to depict figures and subjects that promote the ideals of a socialist society. The lessons of life drawing, *chiaroscuro*, and linear perspective are harnessed to create images that audiences might find persuasive and stirring.

HUA Tianyou (1901–1986) used the Socialist Realist style for a **relief** sculpture, *The May Fourth Movement* (**Fig. 16.16**). The subject of Hua's sculpture is a pivotal event from history, the May Fourth Movement. The movement began with a student demonstration in 1919, following news of the negotiations of the Versailles Treaty at the Paris Peace Conference, which set the terms of peace after World War I. China had supported the Allies in that war, but the terms of the Treaty of Versailles were unfavorable toward China. Angered and frustrated by the situation, more than three thousand Chinese students mounted a protest on May 4, 1919. They gathered at Tiananmen Square, a visible and symbolic place immediately south of the Forbidden City at the heart of the capital, Beijing.

In the background of *The May Fourth Movement*, Hua sculpted in low relief Tiananmen Gate with its characteristic, Late Imperial architecture (see Fig. 12.14). Hua's command of linear perspective is clear, but his focus was the human drama unfolding in the foreground. Among the twenty-five carefully staged figures, a young man giving a speech and a young woman distributing

16.16 BELOW **Hua Tianyou,** *The May Fourth Movement*, **panel for the** *Monument to the People's Heroes,* Tiananmen Square, Beijing, 1958. Marble relief (shown in black-and-white photograph), 6 ft. 6 in. × 13 ft. (1.98 × 4.29 m).

16.17 FAR RIGHT **Monument to the People's Heroes,** looking northwest, Tiananmen Square, Beijing. Epitaph composed by Mao Zedong and inscribed in Zhou Enlai's handwriting. Completed in 1958. Granite and marble, height 125 ft. (38.1 m).

pamphlets form a dynamic pivot. Slightly off-center, they draw the attention of other students, workers wearing caps and shorter trousers, and a peasant, recognizable by his straw hat. The latter are idealized representatives of key socialist classes: workers and peasants. Across the composition, Hua used attentive expressions and emphatic gestures to capture the students' resolve.

Hua's *May Fourth Movement* is one of eight reliefs by him and other artists that form a carefully honed historical narrative that begins with the 1839–42 Opium War and ends with the crossing of the Yangtze River by the Red Army to defeat the Nationalists in 1949. This visual story of political liberation forms the base of the *Monument to the People's Heroes* (Fig. 16.17). The monument rises at the very site of the 1919 May Fourth Movement. It stands at the center of an expanded Tiananmen Square: to the north lies Tiananmen Gate, entrance to the Forbidden City and the place where Mao Zedong declared the founding of the PRC; to the east the National Museum of China houses an encyclopedic collection of Chinese art; and to the west, party leaders meet in the Great Hall of the People. The last two buildings were constructed in 1959 as part of the Ten Great Buildings campaign to commemorate the nation's tenth anniversary. At the southern end of Tiananmen Square, a final building—the Mausoleum of Mao Zedong—was completed in 1977.

Throughout the Maoist years and into the present, the *Monument to the People's Heroes* has been the site of repeated commemoration in China. Crowned by a stone version of a traditional-style roof, the ten-story-tall **monolithic** monument is a memorial to scores who died for the revolutionary cause. On its north face, it declares in Mao Zedong's calligraphy, "Eternal glory to the people's heroes!" The south face bears an epitaph composed by Mao but inscribed in the calligraphy of another communist leader, ZHOU Enlai.

Completed in 1958, the monument drew on the labors of seventeen different work units, although architects LIANG Sicheng (1901–1972) and his wife LIN Huiyin (also Phyllis Lin, 1904–1955), deserve credit for the design. Both Liang and Lin studied architecture in the United States, and they worked strenuously to understand and preserve China's architectural heritage. Shaped by their formidable knowledge of Chinese and Western architecture, the monument transformed Tiananmen Square into a modern, public space of political memory. Incidentally, Lin Huiyin's niece, the American architect Maya Lin (born 1959), would later make an impact in the design of national memorials with the Vietnam Veterans Memorial, completed in 1982 in Washington, D.C.

Public spaces such as Tiananmen Square function as secular pilgrimage sites. In East Asia, another example may be found in Pyongyang, the capital of North Korea, where the Mansu Hill Grand Monument originally focused on a single colossal statue of leader Kim Il-sung (see Fig. 17.17). Upon a massive base, Kim takes a firm stance, raises an arm skyward, and gazes confidently into the distance. Both Mansu Hill Grand Monument and Tiananmen Square use art and architecture to create a shared history as the basis for national identity and patriotism. Mass-produced posters can have a similar

毛 主 席 去 安 源

一九二一年秋，我们伟大的导师毛主席去安源，来自点燃了安源的革命烈火。

effect. During the Great Proletarian Cultural Revolution (1966–76), millions of posters disseminated propaganda messages throughout China. Posters responded effectively to the call for historical revision stemming from political struggles, and they embodied socialist ideals in the process of their making. *Chairman Mao Goes to Anyuan* (Fig. 16.18) by LIU Chunhua (born 1944) exemplifies these qualities.

Liu's composition combines Socialist Realism with more theatrical touches, including dramatic lighting and the placement of Mao alone against a vast landscape. Mao strides determinedly toward the city of Anyuan, where, the picture implies, he—and not LIU Shaoqi, as depicted in an earlier painting (not illustrated)—will lead the 1922 coal miners' strike. Such historical revision might raise questions of representational accuracy, but in the process of making this image, Liu Chunhua solicited the input of the Anyuan coal miners themselves to buttress the central role that the poster gives to Mao. Additionally,

16.18 Liu Chunhua, *Chairman Mao Goes to Anyuan,* 1968. Poster: color lithograph on paper, 37½ × 29⅞ in. (95.3 × 75.9 cm).

monolith/monolithic a single large block of stone.

and all but one of the artists (that artist was recalled from his studies in Prague and forced to spend a year painting portraits of socialist leaders). With this experience behind him, Tsultem turned his energies to the study and promotion of *Mongol zurag*, or "Mongolian painting," to prevent the wholesale replacement of Mongolian art traditions with Socialist Realism (see Fig. 0.6).

In China, during the Cultural Revolution, some artists faced severe persecution, leading in certain cases to mental illness, bodily harm, and death. Art policies were not relaxed until after Mao's death in 1976, which brought the Cultural Revolution to an end. Independently and in groups, artists cautiously tested government tolerance for abstract styles, subjective expression, and content that lay outside the socialist agenda. One instance of such testing occurred in 1979, when a group of artists known as the Stars exhibited their work publicly and without explicit state approval, outside the government-operated China National Art Gallery (now National Art Museum of China). Initially, the artists received a sympathetic response, notably among art administrators, who themselves had suffered during the Cultural Revolution and other political campaigns. But on the exhibition's third day, police shut it down. Undeterred, the artists staged a march toward Tiananmen Square. Originally intended as the site of sanctioned state rituals, the square had since become also the place for spontaneous protests that, echoing the sentiments of the students of the May Fourth Movement, called for reform.

Successful in their demonstration, the Stars received official approval to reopen their show. Among the artworks from the Stars exhibition was *Silence* (**Fig. 16.19**), by self-taught sculptor WANG Keping (born 1949). *Silence* resembles a roughly hewn head with one eye blocked and the mouth stopped. In terms of style, the sculpture rejects Socialist Realism and favors abstraction, which encourages viewers to interpret it metaphorically and universally. *Silence* protests the harmful restraints that the Cultural Revolution placed on artists, but it also sounds a cautionary note to all audiences.

China's Cultural Revolution cast into sharp relief both the power of art and the vulnerability of artists. Impassioned images, political propaganda, censorship, and coercion—such features characterized that period in Chinese history, yet these phenomena also occurred throughout East Asia as governments and citizens confronted war and revolution. Over the course of the late nineteenth and twentieth centuries, East Asian artists reformed traditional media and invented new ones to call attention to injustice and suffering, and to confront unprecedented challenges to self and society. Participating increasingly in international forums, they contributed to the public discourse on such issues as identity, tradition, modernization, oppression, and liberation. By the turn of the millennium, East Asian nations would be hosts to international art exhibitions, the first being the Gwangju Biennale in South Korea in 1995. Its theme of "Beyond the Borders" signaled the participation of East Asian artists in a fully globalized contemporary art scene.

16.19 Wang Keping, *Silence*, 1978. Wood, height 18⅞ in. (47.9 cm). Collection of the artist.

older artists who formed a state-sanctioned "painting revision group" offered guidance to Liu (who was then a student) and applied their more advanced skills to *Chairman Mao Goes to Anyuan*, polishing its illusionism and enhancing its visual rhetoric. The result satisfied guidelines articulated by Mao in 1942 (see Going to the Source: Mao Zedong on Literature and Art, p. 329), as well as the new ideals of Mao's wife, JIANG Qing, who dominated art policy during the Cultural Revolution.

The Cultural Revolution's artistic ideals intensified tendencies already present in Socialist Realism. For example, Jiang's directive that art must be "red, bright, and shining" emphasized visual qualities that made heroic figures absolutely unambiguous. Unfortunately, such directives had a dark side, too. Not only during the Cultural Revolution and not exclusively in China, artists stood accused of political subversion. For example, in Mongolia in 1968, authorities also questioned the political allegiance of the long-serving chair of the Union of Mongolian Artists, Nyam-Osoryn Tsultem (1923–2001), because the "First Exhibition of Young Artists" included images that rejected Socialist Realism, among them abstract paintings. Tsultem successfully defended himself

Discussion Questions

1. In building a nation, what kind of art is best and why? Refer to examples in this and other chapters.

2. East Asian cultures boast an immense archive of religious and secular narratives, and artists rely on iconography and traditional conventions to represent them. But unprecedented changes beginning in the late nineteenth century presented new stories. What strategies did artists use for conveying new stories? Use two examples from this chapter to compare and contrast those strategies.

3. The philosopher and social critic Marshall McLuhan claimed that "The medium is the message." The period discussed in this chapter saw the invention and introduction of numerous new art media into East Asia. What messages are embedded in the new media adapted by East Asian artists? Choose an example from this chapter to discuss.

4. Further research: this chapter introduces multiple art movements and new styles (for example, *mingei*, the Woodcut Movement, Dansaekhwa, and more). Choose one to research and build on the discussion of that movement in this chapter.

Further Reading

- Andrews, Julia and Shen, Kuiyi. *The Art of Modern China*. Berkeley, CA: University of California Press, 2012.
- Chong, Doryun, Hayashi, Michio, Kajiya, Kenji and Sumitomo, Fumihiko (eds.). *From Postwar to Postmodern, Art in Japan 1945–1989*. New York: The Museum of Modern Art, 2012.
- Horlyck, Charlotte. *Korean Art: From the 19th Century to the Present*. London: Reaktion Books, 2017.
- Ikeda, Asato, McDonald, Aya Louisa, and Tiampo, Ming. *Art and War in Japan and Its Empire, 1931–1960*. Leiden, Netherlands: Brill, 2013.

Chronology

	CHINA		KOREA
c. 1856–57	After fleeing the Boxer Rebellion and moving to Shanghai, Ren Xiong paints his Self-Portrait	1910–45	A period of Japanese colonialism
		1924	Yanagi Sōetsu's efforts lead to the opening of a museum of Korean art in Seoul
1911–12	The Xinhai Revolution overthrows the Qing dynasty and establishes the Republic of China (ROC)	1934	Yi Inseong paints *Valley in Gyeongju*
		1945	At the end of WWII, the Korean peninsula is partitioned into North Korea and South Korea
1930s	The Woodcut Movement; Pan Yuliang moves to France	1950–53	The Korean War
1937–45	Second Sino-Japanese War and World War II; Mao Zedong delivers his "Talks on Literature and Art" at the Communist wartime base at Yan'an in 1942	1972	A monumental statue of Kim Il-sung is installed at Mansu Hill Grand Monument in Pyeongyang
1945–49	The Communist Revolution ends with the ROC retreating to Taiwan and the founding of the People's Republic of China (PRC)	1984	Nam June Paik broadcasts *Good Morning, Mr. Orwell*
			JAPAN
1966–76	The Cultural Revolution; Liu Chunhua's *Chairman Mao Goes to Anyuan* is reproduced in posters	1868	The Meiji Restoration returns power to the emperor; Japan begins rapid modernization
1979	Wang Keping's *Silence* is shown in the Stars' exhibition	1893	Kuroda Seiki paints *Morning Toilette*
	MONGOLIA	1894–1945	Japan pursues an imperial agenda to colonize East and Southeast Asia
1924	Mongolia becomes a People's Republic	1902	Okakura Kakuzō sojourns in India
1968	Nyam-Osoryn Tsultem is questioned following "The Young Artists Exhibition"	1945	Atomic bombing of Hiroshima and Nagasaki; the end of World War II
		1945–52	U.S. occupation of Japan
		1957–72	Yayoi Kusama lives and works in the U.S.
1990	The first democratic elections are held in July; 18 months later, the People's Republic of Mongolia ceases to exist	1964	Kenzō Tange's Yoyogi National Gymnasium is completed for the Olympic Games hosted by Tokyo

17

Contemporary Asian Art

1980s to the Present

17.0 Detail of Gonkar Gyatso,
Dissected Buddha.

Introduction

Art in Asia and by Asian artists in the contemporary period has much in common with contemporary art elsewhere. Such qualities may be traced to widespread changes that fall under the umbrella term "globalization." In many ways, art has always been global, a point demonstrated by artwork discussed throughout the preceding chapters of this book. For thousands of years, long-distance trade, migration, the spread of technology, and cultural encounters have deeply affected artistic production. After World War II and the subsequent processes of decolonization, however, intercultural contact intensified and the pace quickened. Seeking economic and education opportunities or escaping war and natural disaster, people from many parts of the world including Asia migrated, establishing sizable diasporic communities. East Asian, South Asian, and Southeast Asian diasporas developed in cities throughout North America, western Europe, and Australia, but they also sprang up in wealthy urban centers within Asia, such as Singapore (see, for example, Fig. 14.13). With the end of the Cold War in 1991, the velocity of globalization increased again and trade liberalized, too. Most recently, digital technologies such as the Internet and social media have led and continue to facilitate unprecedented transnational engagement.

Such changes support increasingly international and pluralistic markets and audiences for art. Asia has seen the creation of new auction houses, galleries, and museums, as well as a general flourishing of contemporary art in a range of media, including installation, video, and performance. South Korea's Gwangju Biennale—Asia's first such art exhibition—began in 1995. An explosion of biennials and triennials in Asia followed, from Kochi to Kathmandu to Taipei. Not all Asian countries participate fully in a globalized, contemporary art scene, however. The policies of the North Korean government, for example, have affected the conditions for making art. Similarly, internal instability and the after-effects of war have impacted Myanmar (Burma), Laos, and Cambodia. Still, even in those cases, domestic and diasporic artists are at work.

The abundance of post-1980s Asian art makes it impossible to do full justice to the array of artists, artworks, ideas, and practices. Thus, rather than focusing on regional or chronological developments since the late 1980s, which may appear to but do not give a comprehensive account, this chapter explores a handful of key visual strategies and their conceptual purposes that are employed by Asian and Asian diasporic artists. These strategies are not the only ones, but they do offer ways of unpacking how artworks convey meaning or evoke emotion. In this manner, the chapter provides an art historical toolkit. Use the vocabulary terms, analysis techniques, and questions provided here to explore and make sense of contemporary artworks well beyond the following examples.

Artistic Quotation and Repurposing

A strange bulbous object, combining smooth curved surfaces and jagged golden seams, quietly draws viewers' curiosity (Fig. 17.1). The object's dimensions approximate the height of a child or the shape of a seated bear—living beings. An animated quality may stem from its greenish hue, too, which could conjure an association with the kingdom of plants, perhaps mosses or lichen. Yet a resemblance to animals or plants is not needed for this sculpture to seem somehow alive or growing: the convex contours push outward and gold oozes from the fissures. The sculpture—in its medium and sense of arrested vitality—engages with the history of art.

To create this artwork, titled *Translated Vase*, the artist Yeesookyung (also YEE Sookyung, born 1963 in South Korea) repurposed discarded ceramic fragments. Although the fragments come from modern reproductions, they resemble Goryeo period celadons (see Fig. 9.3) in color and pattern, and thus serve as a vehicle of artistic quotation. Yeesookyung referenced artistic technique, too, by adapting the method of *kintsugi* (literally, "golden joinery") from its original function of repairing the chips and cracks of precious celadons and other valued ceramics to a new purpose for creating **abstract** sculpture. The 24-carat-gold seams in *Translated Vase* convey simultaneously the value of repairing broken objects and the value of the act itself of repairing. In this work Yeesookyung carefully gathered fragments of tradition, marvelously

abstract altered through simplification, exaggeration, or otherwise deviating from natural appearance.

17.1 Yeesookyung, *Translated Vase*, 2011, Celadon fragments with epoxy and gold, 26 × 25¼ × 38¼ in. (66 × 64 × 97 cm). Museum of Fine Arts, Boston, Massachusetts. **EAST ASIA**

refashioning them in an odd yet playful matter for contemporary audiences.

In her artistic reference to iconic artwork (in this case, Korean Goryeo celadons), Yeesookyung's work exemplifies a major trend of contemporary art: the proliferation of quotation and repurposing. Of course, earlier artists have already done this (see for example, 12.9). Nevertheless, as ways of viewing the world associated with **Postmodernism** became increasingly prevalent in the late twentieth century, the frequency, range, and purpose of visual references in contemporary art shifted. One tenet of Postmodernism maintains that everything has already been done, and thus we are always citing something or someone else, intentionally or not. Also, Postmodernism questions ideologies assumed to be natural or universal, such as whether progress is unambiguously good or whether one culture is superior among others. With this questioning attitude, artists explore the potential of **intertextuality** to confront master narratives and accepted truths. They expand their visual sources beyond conventional categories of art to include film and television, advertisements, political propaganda, street art, utilitarian items, and objects typically considered **kitsch**. They also question such concepts as authenticity, beauty, tradition, and identity. Yeesookyung's *Translated Vase*, for example, gives visual form to current questions: what is the value or place of artistic traditions in the contemporary world? And, when the broken pieces of the past have been gathered together, what is the purpose of the newly mended whole? By identifying an artwork's borrowed elements and considering what they mean in their new context, viewers can begin to unpack the artist's intentions.

Often artists repurpose neither actual objects nor object fragments, but imagery from famous artworks. Using colored sand, LEE Mingwei (born 1964 in Taiwan) enlarged and transposed a work by Pablo Picasso into an **installation** and **performance** piece, *Guernica in Sand* (**Fig. 17.2**). The choice of reference is significant politically and artistically. Politically, Picasso's *Guernica* (1937) protests the bombing of the Basque town of Guernica, perpetrated by the Nazis at the behest of military dictator Francisco Franco during the Spanish Civil War (1936–39). The bombing gained notoriety for deliberately targeting civilians and inciting terror with its scorched-earth strategy. To convey the brutality and chaos, Picasso used **abstraction** to exaggerate panicked expressions and to fracture the space, respectively. Further, the abstraction allows for a universal message condemning violence against any civilian population, whether or not one has directly experienced such trauma. The young Lee saw *Guernica* in New York City, by chance, when his family was moving from Taiwan to the Dominican Republic, and the memory stuck with him.

Whereas Picasso's *Guernica* gives permanent form to the aftermath of a brutal act, Lee's artwork was designed to be impermanent. *Guernica in Sand* unfolded in three stages. Some 800 hours of labor preceded the first stage, when viewers saw an inert sand "painting" in a state of near completion. During the dynamic second stage, Lee worked on the last portion of the composition (note the artist's tools placed at the far edge of the work, near the head emerging from the window in **Fig. 17.2**) and simultaneously he invited viewers to walk on the artwork. A white bench-like stone (see **17.2**, lower right corner) gave viewers a destination where they could take a seat and observe. Over the course of the second stage, Lee continued to add sand to finish the artwork, but spectators were already invited to walk on it. Thus, *Guernica in Sand* was simultaneously completed and "ruined," depending on one's point of view.

In the third stage, Lee and his assistants returned with brooms. In slow motions, they gently swept the composition, erasing the image based on *Guernica* (**Fig. 17.2a**). At this point, this first artistic quotation gives way to a second one: Tibetan Buddhist sand mandalas (see Seeing Connections: Art and Ritual, p. 159). Like sand mandalas, *Guernica in Sand* is a reminder of the constancy of change. Lee's *Guernica in Sand* enjoined viewers and artists alike to step into the on-going (re)creation of the art historical **canon**.

Sometimes what the artist references is not a specific image, but rather a type of imagery. Such imagery could be as diverse as when the Mongolian artist Nyam-Osoryn Tsultem invoked East Asian Buddhist paintings with the decorative clouds in his *Assembly of Clouds* (see Fig. 0.6), or when the artist Tejal Shah (born 1979 in India) adopted in *Southern Siren: Maheshwari* (**Fig. 17.3**) the exuberant visual tropes employed in south Indian films, specifically the song-and-dance sequences. In this digital photograph, Shah framed Maheshwari, a *hijra*-identified woman (*hijra* is a term used to refer to transgender, transsexual, third gender, and intersex people in South Asia), as the star of this unabashedly fanciful and joyously **camp** scene. The fantasy aspects of the scene were informed by Maheshwari's own desires that she told to the artist. Caught in a dramatic pose, Maheshwari is simultaneously romancing and being romanced by the handsome hero. The light rays in the background converge on him, but it is Maheshwari who appears multiple times in the composition. A pair of miniature images of her in a flirtatious stance top a tulip on the left edge. Even smaller versions arranged in spirals form the blue centers of large red flowers, which upon closer inspection reveal themselves to be made from the image of a single rose repeated five times.

Roses and tulips appear frequently in Urdu-language love poetry to symbolize the beloved, and red roses also hold significance for many members of the *hijra* community, who see themselves in the flowers. *Hijras* have a long history in South Asia. They were recognized as a third gender from Vedic times onward. However, in the mid-nineteenth century, the British colonial government introduced laws that forced many *hijras* into begging and prostitution and left them susceptible to

violence. In recent years, through activism, the *hijra* community has made some gains, including legal recognition as a third gender in some South Asian countries (although such recognition is not a blanket solution). Shah, an artist-activist who seeks to represent a plurality of queer identities in her artwork, began working with *hijra* human-rights activists, and this artwork grew out of that collaboration.

In *Southern Siren: Maheshwari*, Shah layered and repeated images throughout the digital photograph to create a kaleidoscopic, **collage**-like effect. Other contemporary artists layer visual and historical referents densely as a way to engage with **postcolonialism**. Like Postmodernism, an engagement with postcolonialism seeks to deconstruct accepted truths, categories, and ways of viewing the world in order to expose the

17.3 **Tejal Shah,** *Southern Siren: Maheshwari,* 2006. Digital photograph on Alpha cellulose paper, 57½ × 38 in. (1.46 m × 96.5 cm). **SOUTH ASIA**

collage a technique in which cut paper pieces and other flat materials of all types and sizes are combined and stuck to another surface to make a design; from the French *coller*, "to glue."

postcolonialism the historical period or condition representing the aftermath of Western colonization; also, the associated socio-political critique of imperialism and its effects.

The story of humanity is an epic of migration—from Africa, across Eurasia, over oceans, all round the world. Diaspora, a term originally referring to the dispersal of Jewish people beyond the lands of Israel, can describe other displaced groups. Whatever the circumstances, the experience of leaving the place of one's immediate ancestors and moving to an unfamiliar land can be traumatic, engendering feelings of loss and alienation.

In the age of modern nation-states, the diasporic communities must also answer to laws and policies that regulate the movement of peoples and determine citizenship. Chinese American artist Hung LIU 1948–2021) made these themes of diaspora visible in *Resident Alien* (**Fig. 17.4**).

Liu appropriated the form of a legal document: the resident alien identification card, commonly called "green card," held by immigrants deemed by the United States

government to be "lawful permanent residents." By enlarging that ID card and turning it into a painting, however, Liu encouraged the viewer to look anew at this bureaucratic document. The painting highlights the government's authority to determine identity and conveys in monumental and artistic form the outsized role that one piece of paper plays in an immigrant's life. (Note that Liu substituted the date of her immigration to the U.S. for her birthdate.)

A In the upper left-hand corner, the words "fortune cookie" have been written in imitation of computer-generated font and reversed, substituting as a legal name. A sweet treat associated with restaurants serving Chinese cuisine, the fortune cookie developed on American soil. The fictitious name not only raises questions about what is and is not "alien," but also confronts Orientalist constructions of Chinese women as "sweet treats," that is, sexualized objects.

B In terms of naturalistic style and cropping, Liu's portrait conforms to bureaucratic conventions for an identity card. But it also attests to her artistic training in the official style of Socialist Realism during the Maoist period (1949–76).

C The painted fingerprint, like the painted photograph and the false name, raises questions about authenticity and truth in representation. Is a painted fingerprint as reliable as an actual fingerprint? Is a painted photograph a photograph?

D The signature on this "resident alien" card functions also as the artist's signature. She wrote from left to right "Liu Hung" in Chinese, placing her family name first as in Chinese convention. Moreover, the signature ties her to a long tradition of calligraphy as an especially esteemed artform (see Fig. 4.13).

17.4 Hung Liu, *Resident Alien*, 1988. Oil on canvas, 5 ft. × 7 ft. 6 in. (1.52 × 2.29 m). San José Museum of Art, California. **EAST ASIAN DIASPORA / U.S.**

underlying power structures at work. The focus of postcolonialism, however, is specifically on the lasting impact of colonialism on formerly colonized countries and on **diasporic** subjects related to those countries. Thus, cultural **appropriation** and exchange, as well as the reframing of historical events and the blending and fracturing of identities, are common themes in postcolonial art.

The art of the Singh Twins (see Figs. 0.0 and 0.2) provides an example of this visual strategy. These British-born identical twin sisters and artistic collaborators grew up in northern England as part of a large, extended Sikh family who had immigrated from India's

Punjab region in 1948. After their first trip to India in 1980, the twins became fascinated by South Asian paintings on paper, sometimes referred to as miniature paintings, produced between the sixteenth and nineteenth centuries (see Chapter 11 for more about such works on paper).

The Singh Twins' work, such as the painting *The Last Supper* from 1994–95 (see Fig. 0.2), combines the dense detail and flattened space found in many Mughal, Rajasthani, and Pahari paintings, with European artistic aesthetics and eclectic references to global popular culture. Through this purposeful mixing, the artists' work expresses the multifaceted identity of immigrants,

diaspora a population whose roots lie in a different geographic location.

appropriation borrowing images, objects, or ideas and inserting them into another context.

and it challenge stereotypes about acceptable styles and **iconography** within contemporary art. The Singh Twins consciously adopted a medium that is both **Western** and Asian, traditional and modern. They also have deliberately merged their professional identities, going so far as to dress alike at events, in order to call into question the valorization of individuality so central to modern Western understandings of art.

In this rediscovery of South Asia's traditional paintings on paper, the Singh Twins were among the first, but they were not alone; others, such as the Pakistani American artist Shahzia Sikander (born 1969 in Pakistan), also began exploring the narrative potential of the medium during the late 1980s to the early 1990s. When Sikander was a student at National College of Art in Lahore, she decided to learn the techniques associated with the small-scale works on paper. Like the Singh Twins, Sikander juxtaposed traditional visual elements with iconography from Western artistic traditions and popular culture, often in ways that challenge postcolonial legacies. She further added personal, gestural markings to create images that deconstruct the meticulousness traditionally associated with the medium.

From 2001 onward, she began employing digital animation in conjunction with her paintings, thereby adding the elements of movement, sound, and time to her work, which heighten its storytelling and transformational potential. These animations often play with visual forms by breaking them down or putting them together in new ways. In *The Last Post*, a high-definition video animation that addresses British colonial history in Asia, including

the opium trade with China, we see the protagonist—a red-coated official from the East India Company (see Chapter 15)—loom large over the globe, before splitting into pieces and then reappearing again to inhabit various spaces, including a Mughal imperial audience hall (**Fig. 17.5a–d**). The accompanying soundtrack, created by Du Yun (born 1977), a New York-based artist and composer, adds to the haunting quality of the work, which speaks both to British hegemony over Asia and the inevitable collapse of that power.

Unexpected Juxtapositions: Mining Popular Culture

Sometimes, but not always, a contemporary artwork's use of quotation introduces unexpected juxtapositions informed by popular culture. For example, this 9-foot-high image of the **Buddha** uses a riotous collage of stickers—everything from smiley faces to cartoon pandas to corporate logos—to form the Buddha's body (**Fig. 17.0**, p. 338, and **Fig. 17.6**, p. 344). It is not an image one might expect, and that is precisely the point. By deliberately combining cultural referents in ways that are surprising and often humorous, artists can draw attention to problems and incongruities within existing ways of viewing the world. Whether through parody, absurdity, or whimsy, artists employ humor to open a space for dialogue and use irreverence to allow even the most sacrosanct aspects of society to be seen anew.

Here, the artist Gonkar Gyatso (born 1961), a member of the Tibetan diaspora, brings together the throwaway

17.5a–d Shahzia Sikander, *The Last Post,* 2010. Four stills from an animation (in sequential order, starting at top left and proceeding clockwise). SOUTH ASIAN DIASPORA / U.S.

iconography images or symbols used to convey specific meanings in an artwork.

Western a term used in the modern era to claim shared civilization and institutions originating in Europe among predominantly white people; term extended to North America and other parts of the world heavily marked by European colonization.

Buddha a buddha is a being who has achieved the state of perfect enlightenment called Buddhahood; the Buddha is, literally, the "Enlightened One"; generally refers to the historical Buddha, Siddhartha Gautama, also called Shakyamuni and Shakyasimha.

read the bubbles of dialogue or discern what the colorful stickers show—is that Puss-in-Boots brandishing a sword?—the more one loses sight of the Buddha and the qualities of non-attachment he embodies.

WANG Guangyi (born 1957 in China) also juxtaposes imagery from disparate realms, but in the case of his *Great Criticism* series, only two realms are involved: the mass cultures of political propaganda and consumer capitalism. The two primary motifs in his *Great Criticism: Coca-Cola* are the Chinese communist triumvirate, on the one hand, and the logo of a ubiquitous soft drink, on the other (**Fig. 17.7**). Jaws firmly set and brows furrowed in concentration, the worker, peasant, and soldier strike in unison a defiant pose. Their muscular bodies, the dramatic **foreshortening** of their arms, and the composition's bold, graphic lines and flat colors make reference to the official style of **Socialist Realism**, particularly as it was used during the Cultural Revolution (see Chapter 16). In one collective hand, the figures grasp Mao's "Little Red Book," and in their other hands, a fountain pen. The pen's sharp, metal nib makes contact with the Coca-Cola logo. A straightforward interpretation sees the pen, as was so often described by Mao, as a weapon. But does this particular pen pierce Coca-Cola, or does it write the logo?

The timing of Wang's painting is suggestive. By the mid-1990s, the Chinese Communist Party had officially adopted an economic policy called the "socialist market economy." Global brands established footholds in China's economy, generating both excitement and consternation. For some, memories of the Cultural Revolution had lost their sting, and a nostalgic attitude toward Mao ensued. In that context, Wang's juxtaposition of a pop aesthetic with political imagery, dubbed by critics as "political pop," captured both the contradictions of the economic transformation and related feelings of anxiety. Likewise, the scattering of random, machine-stamped numbers invites speculation as to their meaning—might they refer to bar codes, or to government accounting or economic calculations?—but *Great Criticism: Coca-Cola* withholds clear answers.

17.6 Gonkar Gyatso, ***Dissected Buddha,*** **2011.** Collage, stickers, pencil and colored pencil, and acrylic on paper, 9 ft. 2¼ in. × 7 ft. 6½ in. (2.8 × 2.3 m). Promised Gift of Margaret Scott and David Teplitzky, Metropolitan Museum of Art. © Gonkar Gyatso. **EAST ASIAN DIASPORA / U.K.**

materialism of stickers with the readily recognizable sacred imagery of the meditating Buddha. As the artist explains, "My current work comes out of a fascination with material and pop culture and a desire to bring equal attention to the mundane as well as the extraordinary, the imminent and the superfluous...As my own experience has been one that reflects a kind of hybridity and transformation, my work also holds this quality." Originally trained in long-standing Tibetan painting forms and techniques (see Fig. 12.16) before attending art school in London, Gyatso, through his work, challenges assumptions about what Tibetan art looks like: he creates images in which banal material items are transformed into something spiritual, and spiritual images are turned into political and social commentary. *Dissected Buddha* depicts the Buddha seated in meditation and reaching down to touch the earth. The sacred axis, or soul pole, is visually emphasized—but is it centering or splitting the image? The small airplanes, rockets, and cars whizzing around can be read as the armies of Mara attempting to distract the Buddha as he achieves enlightenment (compare to Fig. 3.8). However, the more the viewer explores these elements, the more the details captivate the viewer's attention and destabilize the image. As one attempts to

17.7 FAR RIGHT **Wang Guangyi,** ***Great Criticism: Coca-Cola,*** 1994. Oil on canvas, 6 ft. 5 in. × 6 ft. 5 in. (2 × 2 m) **EAST ASIA**

As popular and elite artforms converged in contemporary art all around the world, the Japanese artist Takashi MURAKAMI (born 1962 in Japan) was reminded of such convergence, or "flattening," already present in aspects of Japanese culture. Looking at twentieth-century Japanese animation and Edo **woodblock prints**, Murakami noticed their shared use of flat colors and emphasis on two-dimensional design (see Figs. 0.1 and 13.18). In 2000, he published his theory, calling the new contemporary aesthetic "Superflat." Even before the publication, however, Murakami's qualities of Superflat already characterized such works as *DOB in the Strange Forest (Blue DOB)*, made in 1999 (**Fig. 17.8**).

Surrounded by whimsical mushrooms, a cartoon-like figure pitches forward on tiptoes, an alarmed look on its face. Globular "ears" inscribed with letters "D" and "B," along with the "O" of its face give the figure its name, DOB. With gloved hands, enlarged feet, and round ears, DOB resembles Mickey Mouse, but it was through analysis of characters that reflect Japanese popular culture, such as Doraemon, a character from a *manga* series, and Sonic the Hedgehog from the video-gaming world, that Murakami found his inspiration. The Superflat aesthetic pertains not only to the artwork's references to popular culture, but also to its bright, unmodulated colors. Furthermore, DOB appears repeatedly in Murakami's paintings and sculptures, functioning as the artist's alter ego, or avatar, and becoming a kind of trademark, thus "flattening" the differences between "high" art and consumer capitalism. No stranger to the commercial world, Murakami has partnered with the luxury brand Louis Vuitton and collaborated with American rapper and entrepreneur Kanye West. In this early artwork, DOB's animated expression and the mushrooms' buoyant shapes transport audiences to an ostensibly commercial-free zone of childhood wonderment and enchantment. But, for Japanese viewers, the mushrooms—which gaze uncannily back at DOB—could also recall the terrifying shapes of clouds generated by atomic bombs, like those dropped on Hiroshima and Nagasaki.

Thus, the lightheartedness created by some juxtapositions can be a means to address in accessible ways difficult subjects, from nuclear holocaust to racism to the aftermath of colonialism. The artist Eko Nugroho (born 1977 in Indonesia) employed this strategy in the machine-embroidered tapestry banner *Dog People* (**Fig. 17.9**), which depicts a line of men wearing large dog-head masks above an inscription in gold on the orange background.

Nugroho is based in the city of Yogyakarta, a long-standing center for Javanese art. Under the Suharto's dictatorship (1967–98), the arts in the city—and throughout Indonesia—suffered, only to rebound in 1998 with renewed vigor as many artists, particularly young artists, adopted strongly activist stances. In general, street art, from murals to graffiti to posters, is a major form of artistic expression in Yogyakarta, and provides inspiration for many contemporary artists. Working in a range of media, Nugroho combines elements of street art and cartoons with aspects of Indonesia's traditional arts, such as textiles. He frequently employs wordplay juxtaposed with hybrid or, as in this example, masked figures in order to address painful topics. This particular work

17.8 ABOVE **Takashi Murakami, *DOB in the Strange Forest (Blue DOB)*,** 1999. Fiber-reinforced plastic, resin, fiberglass, acrylic and iron, 5 ft. × 12 ft. 8 in. (1.52 × 3.86 m). The Broad, Los Angeles, California. **EAST ASIA**

17.9 LEFT **Eko Nugroho, *Dog People*,** 2007. 6 ft. 6⅝ in. × 59 in. (2 × 1.5 m). Courtesy of the artist and Dr. Wiyu Wahono. **SOUTHEAST ASIA**

foreshortening in two-dimensional artworks, the illusion of a form receding into space: the parts of an object or figure closest to the viewer are depicted as largest, those furthest as smallest.

Socialist Realism a style of art promoted in socialist nations, such as the People's Republic of China (PRC), and characterized by naturalistic but idealized representation of the body, clearly readable expressions and gestures, and narrative content promoting socialist ideals.

woodblock a relief printing process where the image is carved into a block of wood; the raised areas are inked. (For color printing, multiple blocks are used, each carrying a separate color.)

manga the Japanese term referring to cartoons, comics, and graphic novels.

plays on a common sign found in public spaces during the Dutch colonial era (1800–1945): "No entry for dogs and natives." On this banner, however, the text reads "No entry for dogs and non-natives." By reversing the original

17.10 Ai Weiwei, *Trace*, 2014. Lego® blocks and wallpaper. Installation in 2017 at Hirshhorn Museum and Sculpture Garden, Washington, D.C. **EAST ASIA**

message, Nugroho simultaneously offered a critique of colonialism while commenting on current xenophobia in Indonesia.

For many years, AI Weiwei (born 1957 in China) has, like his famous poet father Ai Qing (1910–1996), used his art as a platform to draw attention to political and social injustice. Over the course of his career, Ai's concern for human rights has expanded beyond the boundaries of his native China to encompass the world at large, as in the case of *Trace*, an installation piece originally designed for and exhibited at the former Alcatraz Federal Penitentiary in San Francisco Bay in 2014. Since then, Ai's installation has been updated for other venues, such as the Hirshhorn Museum in 2017 (**Fig. 17.10**).

In this view, two elements of the installation are visible in the curved space of the museum interior: colorful portraits—assembled from ubiquitous interlocking plastic bricks manufactured by a Danish toy company—on the floor, and an intricately patterned wallpaper on one wall. The Hirshhorn iteration of *Trace* included a third element, interactive kiosks where visitors could learn about the 176 individuals whose portraits appeared in the installation. Some of the individuals, such as Nelson Mandela, may already be familiar, but others are not so famous. At the kiosks, visitors realized that although the portrait sitters come from over thirty nations, they share the experience of persecution—having been either detained, interrogated, exiled, or in many cases imprisoned—for their activities in support of human rights and free speech.

This experience of persecution is shared by the artist, too. Ai Weiwei's portrait does not appear in the exhibition, but Ai's design of the wallpaper, incorporating handcuffs, surveillance cameras, and Twitter bird logos, refers to the consequences of his social-media activities. As a result of his political protests, Ai was put under surveillance for almost a decade, was under house arrest in 2010, and jailed for three months in 2011. Forbidden to leave China until 2015, he currently lives in Berlin. In *Trace* the perils of a digitally connected world are referenced, too, through the pixelated effect of the material used for the portraits. The delightful pleasures associated with childhood toys turn to danger in the evocation of digital footprints, or "traces" that users leave online or in the grainy photographs captured by surveillance cameras.

Provoking Audiences: Shock and Ambiguity

In a world crowded with imagery, some artists go beyond unexpected juxtapositions; they employ shock to grab viewers' attention and subvert dominant messages. By creating works that confront conventional sensibilities, these artists open a space for new messages and alternative viewpoints. By contrast, other artists resist the idea that artwork must have a clear, discernible message, by using ambiguity to create space for contemplation.

In this work (**Fig. 17.11**), which is part of the series *From Vietnam to Hollywood*, Dinh Q. Lê (born 1968 in Vietnam) uses shock—the shock of bold color coupled with the image of the handgun pointed and then cocked at the woman's head, reminiscent of the well-known photograph of General Nguyen Ngoc Loan killing Viet Cong suspect Nguyen Van Lem with a pistol in Saigon in 1968—to compel viewers to look more closely. That closer look reveals how Lê created the piece from multiple large photographs cut into strips and woven together. Here, Lê employed vernacular Vietnamese grass-mat weaving techniques on modern materials. The photographic images he reproduced and then combined in the series come from Hollywood movie stills, news photographs (like the one of General Nguyen killing Nguyen Van Lem), and found snapshots—all related to the Vietnam (American) War, which stretched from 1955 to 1975. The visual jolt generated by the deconstruction and juxtaposition of these sometimes familiar, often volatile scenes pushes viewers to consider how the conflict has been presented in popular media.

Lê, who immigrated to the United States with his family when he was ten years old, is interested in exploring how images inflect views of the past. He explains his childhood, "... growing up in Simi Valley, California with the distant memories of a country whose culture and imagery was being fed back to me via mainstream television and

17.11 **Dinh Q. Lê,** *Untitled 9,* **from the series** *From Vietnam to Hollywood,* 2004. Woven photograph, Fuji Professional Color Paper, 33½ in. × 5 ft. 7 in. (85 cm × 1.7 m). **SOUTHEAST ASIAN DIASPORA / U.S.**

film," professing that "...it was at times difficult to pinpoint which memories were mine or popularly inherited." Lê returned to Vietnam in the 1990s, in part to explore his homeland for himself. In his art, which includes video and installation as well as two-dimensional works such as those in the *From Vietnam to Hollywood* series, he makes use of pre-existing materials of various types—including mid-twentieth-century Vietnamese prints and drawings as well as interviews with war survivors—to question dominant historical narratives.

Citizens of Beijing responded with shock to an installation by XU BING (born 1955 in China) that relied on

the manipulation of text and drew on long-standing associations between words and power. Visitors to the installation of *Book from the Sky* (**Fig. 17.12**), which opened at the China Art Gallery in Beijing in 1987, expressed frustration and anxiety. At a distance, Xu's installation appears serene, even sacred. Undulating scrolls of printed text sweep down from the ceiling and form a backdrop against a far wall. Below the graceful arcs, sets of printed books are displayed, revealing their traditional accordion folds and bindings. The installation invokes the calm order of an exalted reading room. But when viewers drew closer to try to read the texts printed on the scrolls and

17.12 **Xu Bing,** *Book from the Sky,* 1987–91. Handprinted books and ceiling and wall scrolls printed from wood letterpress type; ink on paper. Detail and installation in 1989 at The National Fine Art Museum, Beijing. **EAST ASIA**

avant-garde an emphasis in modern art on artistic innovation, which challenged accepted values, traditions, and techiques; derived from the French for "vanguard."

stupa a mound-like or hemispherical structure containing Buddhist relics.

Modernism a movement that promotes a radical break with past styles of art and the search for new modes of expression.

macramé knotting cord or string in patterns to make decorative items.

books, they were confounded. In material, format, and composition—such as the page frames, columns, and font sizes—*Book from the Sky* conformed to conventions of printing. Even the individual characters (which were printed from individually hand-carved wood blocks made over a two-year period) consisted of strokes executed in a recognizable, centuries-old style. Yet, not a single word was legible.

Appearing simultaneously mute and eloquent, Xu's *Book from the Sky* has been both attacked as a meaningless exercise in nihilism and hailed as an **avant-garde** critique of Cultural Revolution propaganda (see Fig. 16.18), which emptied words of meaning. Audiences who do not read Chinese, of course, are not able to appreciate the sense of loss or disorientation the artist intended to induce, and for them Xu Bing would later make artworks using his Square Word Calligraphy to generate, in contrast, a delightful shock of recognition for English-language readers (see Fig. 0.10).

In *Temporary Insanity* (**Fig. 17.13**), the artist Pinaree Sanpitak (born 1961 in Thailand), combined ambiguity and surprise to create an artwork that is simultaneously playful and contemplative. The multimedia installation consists of about fifty standing silk pillows in various bulbous shapes and warm hues. Each pillow is embedded with its own motor that responds to sound and movement. The motors are set at individual frequencies, so that the pillows move in various ways at different times. Some of the pillows never stop shaking, while others rock gently after being activated. The installation propels visitors to interact with the art in such ways as jumping and shouting (to activate the motors) that transgress normal patterns of behavior in a gallery space, creating a sense of unexpectedness that might be delightful or disconcerting (or delightfully disconcerting), depending upon one's perspective. For Sanpitak, collectively the pillows suggest the experience of temporary insanity.

In contrast to the bold, graphic, political pointedness of many of the works in this chapter, Sanpitak's art approaches its subject—the human, particularly the

female, experience—in more abstract, philosophical, and often gently humorous ways. Her work, which spans a variety of media—painting, sculpture, textiles, ceramics, performance, and culinary arts—can be understood in part as an ongoing meditation on the female form, or more specifically, the breast. Sanpitak sees the breast as a metaphor for womanhood, and she also relates it to the sacred form of a Buddhist **stupa**. Her artworks allude to—without directly reproducing—these forms, thereby creating a layer of ambiguity that encourages reflection.

A similar use of ambiguity to inspire contemplation is found in the Indian artist Mrinalini Mukherjee's (1949–2015) large-scale sculptural works, such as *Apsara* (**Fig. 17.14**), from the 1980s. In the prevalent global **Modernism** of the mid- to late twentieth century, a sharp line was often drawn between art, something seen as a product of artistic merit and creativity, and craft, viewed as the result of learned skills and techniques. Through her monumental fiber sculptures, Mukherjee deliberately blurred that line. Using thick, heavy utilitarian rope in natural fibers such as jute, sisal, and hemp, attached to a metal armature, the artist would tie knots, in the style of **macramé**, and

17.13 BELOW **Pinaree Sanpitak,** ***Temporary Insanity,*** 2004. Textiles, installation with sound. **SOUTHEAST ASIA**

17.14 FAR RIGHT **Mrinalini Mukherjee,** ***Apsara,*** 1985. Knotted natural fiber on metal armature, height 6 ft. 3 in. (1.91 m). Private collection on loan to the Metropolitan Museum of Art, New York, in 2019. **SOUTH ASIA**

make folds, in a laborious process that could take up to a year to complete. The resulting symmetrical but organic shapes, monumental in scale, occupy a space between figural and abstract art. Some pieces, with their bulbous forms and curving lines, appear sensuous, others seem foreboding, and many have names drawn from Hinduism, but they avoid any visual reference to iconography. They are at once familiar and strange.

Suspended above the ground, *Apsara*, with its name evoking the celestial maidens of the dharmic faiths, suggests a graceful figure descending from the heavens. Yet, upon prolonged viewing, *Apsara* begins to appear plant-like, or even insect-like. As the visitor moves around the three-dimensional work, its shape shifts again and becomes an abstract meditation on the materiality of the fiber—pliable, yet strong and formidable. The bold biomorphic forms of these artworks, made from humble materials, defy categorization and were strikingly different from what most artists in India were creating at the same time (see Chapter 15). However, because Mukherjee was a female artist who worked primarily in fiber, her art was often overlooked or marginalized. Only toward the end of her life, in the twenty-first century, did her work garner widespread critical acclaim.

The combination of an identifiable shape—a deer—with an unfamiliar coat of glassy orbs aims to stop viewers in their tracks (**Fig. 17.15**). The spheres concentrate, bend, and scatter light to draw attention to the animal, but they also distort and encase it in an impenetrable gem-like crust. Sculptor Kohei NAWA (born 1975 in Japan) positioned this taxidermied deer—head turned counter to the direction of its body, hind legs further apart—in a state of suspended animation, thereby encouraging a strange mirroring effect on viewers, who likewise arrest their own movement in order to gaze in wonderment at this enchanting creature.

Since the early 2000s, Nawa has been affixing artificial crystal glass marbles of varying diameters to the surfaces of taxidermied animals, toys, and other objects. To name the resulting artworks, he invented the term "PixCell," which intentionally sounds like the word "pixel," the smallest unit of light or color for digital images and computer screens. Thus, each of the individual marbles may be likened to a pixel. The word "cell" is also embedded in Nawa's neologism, and in that way, he also draws attention to a related interest in the basic unit of biology. Both the term PixCell and Nawa's *PixCell Deer #24* bind the artificial to the natural, provoking viewers to ponder what to make of this strange outcome. The deer appears alternately decorated and diseased, bejeweled and burdened. To see past the crystal balls for a better view of the animal, viewers may step closer to *PixCell Deer #24* and lean toward it. For their efforts, they may be met with magnified details of the deer's hair or distorted images of anything within sight, multiplied and scattered by the transparent spheres. Even as *PixCell Deer #24* reflects the surrounding context, so may viewers project their experiences and knowledge onto it. For some, the sculpture may resemble the deer depicted in Kasuga Deer Mandala, a type of Japanese religious painting. In that context, the deer bears a large, bright mirror on its back, and it is a

messenger of Shintō deities. But whether or not such an association was intended remains ambiguous. More immediately, Nawa's *PixCell Deer #24* presents a central conundrum of the digital age—the inextricable positive and negative impacts of technological advances that mediate between the human and the non-human worlds. *PixCell Deer #24* offers not a solution, but a prompt to ruminate on the matter.

Revisiting Monumentality and Ephemerality

Compared to some of the other artistic strategies examined here, which have heightened resonance in our contemporary moment, monumentality has a very long history in art. Indeed, the desire to commemorate oneself, one's reign, one's god, or one's culture through grand, imposing artworks occurs again and again. Monumentality—the quality of permanence, greatness, and enduring significance—presents a powerful strategy to overcome the ephemeral, fleeting nature of life.

That ephemerality can become immediately, even alarmingly present when illness strikes. In 1991, the Chinese painter Irene Chou (also ZHOU Luyun, 1924–2011) suffered a stroke, and after a convalescence and a move from Hong Kong to Brisbane, Australia, she returned to art with renewed vigor. Her long-standing interest in

17.15 Kohei Nawa, *PixCell Deer #24*, 2011. Mixed media: taxidermied deer with artificial crystal glass, height 6 ft. 8¾ in. (2.05 m). Metropolitan Museum of Art, New York. **EAST ASIA**

17.16 Irene Chou, *The Universe VI*, c. 1998. Ink and mixed media on hemp paper, 30 in. × 7 ft. (76 cm × 2.13 m). Private Collection. **EAST ASIA**

vitality at both the microscopic, cellular level and the cosmic scale appears in *The Universe VI* (**Fig. 17.16**).

Across a dramatic sky—lit supernaturally by black and white orbs alike—a single, sweeping **calligraphic** brushstroke unfurls. It seems at once a flash of energy emitted by the universe and the mark of the artist's unbridled creativity. This otherworldly contrail hovers above an uncanny landscape of spare little buildings and delicate trees. A strange climate of colored breezes flows through undulating branches, and greenish waters seep toward dwellings tucked against an enigmatic sphere with a bright red dot. The monochromatic upper portion of *The Universe VI* seems separate from the narrow, colored landscape below, but close inspection reveals a network of filaments connecting top and bottom.

Throughout her work, including *The Universe VI*, Chou drew on her knowledge of monumental landscape painting in East Asian art and its established vocabulary of artistic conventions. As part of the New Ink Painting Movement in Hong Kong, Chou cast aside those conventions, but kept the use of ink and paper. Finding inspiration in Modernist movements of the mid-twentieth century, she created imagery to capture in monumental form the microcosms of the body and its capacities for birth and rebirth. In the dark yet luminous *The Universe VI*, the thin membrane between ground and sky suggests the close relationship between the majestic and the mundane, or between monumentality and ephemerality.

The Mansu Hill Grand Monument in Pyongyang emphatically expresses political power, but it also

calligraphy the art of expressive, decorative, or carefully descriptive hand lettering or handwriting; in East Asian painting, the formal, expressive properties of lines (e.g. thick/thin, dark/light, wet/dry) made with a flexible brush.

17.17 **Mansu Hill Grand Monument,** Pyongyang, North Korea, 1972; statue of Kim Jong-il (on the right) added in 2012. Bronze, height: 66 ft. (20.12 m). **EAST ASIA**

demonstrates the interrelationship of the enduring and the transitory (**Fig. 17.17**). Originally, the monument, made by North Korean artists, featured a single sculpture representing KIM Il-sung (1912–1994), the country's first ruler. More recently, an image of KIM Jong-il (1941–2011) was added. More than sixty feet tall, these bronze statues project monumentality in terms of scale, installation, and medium. The statues are further elevated on a set of pedestals, carefully designed to demonstrate political continuity and differentiation between father (who raises his right arm) and son. Even though both Supreme Leaders are now deceased, through their gigantic sculptural proxies they still preside cheerfully, confidently, and approvingly over an expansive plaza where patriotic and political rituals take place. Further, these apparently everlasting statues belong to a venerable and enduring artistic tradition that immortalized political leaders as diverse as Mao Zedong, Vladimir Lenin, and Julius Caesar. Colossal figures such as the Statue of Liberty have also made ideals visible.

Yet monumental sculptures are sometimes subject to change. Kim Jong-il's death presented an opportunity to make adjustments to the Mansu Hill Grand Monument. The statue of Kim Il-sung was not only shifted to the left, but also updated to look older, friendlier, and more stylish. Just two years after the statue of Kim Jong-il was installed, it too received a modest makeover. A sportier jacket made him a little less imposing, a little more approachable.

Whereas larger-than-life statues of government leaders assert political authority directly, monumental forms associated with other realms, such as commerce and sports, make more diffuse claims to power. Thus, in these realms, ever taller skyscrapers and ever larger stadiums are apt vehicles of monumentality. But height or size alone do not guarantee enduring significance. Structures such as Beijing National Stadium, affectionately likened to a bird's nest, and the Bank of China Tower in Hong Kong (**Fig. 17.18**) demonstrate the continuing importance of form.

A longtime hub for international trade and financing, the city of Hong Kong boasts a dramatic skyline crammed with high-rises. Victoria Peak and the surrounding hills once gave the skyline a green frame, but skyscrapers—each clamoring for attention—now dominate the view. In this crowded field, the Bank of China Tower designed by I. M. Pei (1917–2019) is no longer the tallest, but it remains arguably the most visually arresting building in Hong Kong. A chief practitioner of **Modernist architecture**, Pei eschewed color and ornament, relying chiefly on clean lines and regular geometry for design. I. M. Pei's portfolio includes the John F. Kennedy Presidential Library in Boston and the Louvre pyramid in Paris.

Like other Modernist buildings, the Bank of China Tower uses modern materials, including reinforced concrete, steel, and glass (compare to Fig. 0.8). But, instead of the typical **monolithic** rectangular form, Pei broke the box into four triangular wedges, each culminating at a different height and creating a tapered form. Thus, massiveness coexists with elegance. Additionally, in departing from the Modernist box, the building's asymmetry creates a dynamism without sacrificing stability. On the contrary,

17.18 I. M. Pei, Bank of China Tower, Hong Kong, completed in 1989. Height 1,033 ft. 6 in. (315 m). **EAST ASIA**

the resulting shape and internal bracing system provide structural integrity, an important consideration in a region vulnerable to earthquakes and typhoons. Bold outlines further emphasize the underlying geometry of the triangles, and they give the Tower a graphic quality that is immediately recognizable. Even when the windows reflect the sky and clouds, creating a kind of camouflage that appears to dissolve the Tower's materiality, the outlines clearly announce its presence. Day and night, it stands as a testament not only to the architect's vision but also to economic might.

In *Morning Glory* (**Fig. 17.19**, p. 352) the artist Sopheap Pich (born 1971 in Cambodia) draws viewers' attention through the contrasts created by the sculpture's monumental size, the transparency of its structure, and the ephemerality of its subject matter. Formed from the humble materials of bamboo and rattan, traditionally used in rural Cambodia for objects such as baskets or fish traps, the 17-and-a-half-feet-long sculpture celebrates the trumpet-shaped morning glory flower, which blooms for just a few hours before wilting. Through this piece, Pich, born in a small agricultural town, not only spoke to the tension between permanence and impermanence, he also transformed a bitter childhood memory into something beautiful. The artist was a young boy when, between 1975 and 1979, the brutal Khmer Rouge regime

17.19 Sopheap Pich, *Morning Glory*, 2011. Rattan, bamboo, wire, plywood, and steel. 6 ft. 2 in. × 8 ft. 7 in. × 17 ft. 6 in. (1.88 × 2.62 × 5.33 m). Solomon R. Guggenheim Museum, New York. **SOUTHEAST ASIAN DIASPORA / U.S.**

killed more than 1.7 million Cambodians and inflicted unspeakable suffering on the rest of the population. During this time, food was scarce, and the small weed-like morning glory flowers, which grow abundantly in Cambodia, became important sources of nourishment.

As political refugees, Pich and his family left the country in 1979. The trauma of the Khmer Rouge era, as well as the subsequent trauma of displacement, informs his artwork. With the help of his assistants, Pich transforms bamboo and rattan into carefully crafted, arresting forms, from gigantic hearts to images of the Buddha, seemingly monumental and fragile at once. In some works, the metal wire used to join together the pieces is made from melted-down, unexploded ordnances that the United States military dropped on Cambodia, Laos, and Vietnam during the 1960s and 1970s, adding another layer to the transformative and historically weighty nature of Pich's art-making.

Putting It Together

A visitor encountering *The Cloud of Unknowing* by the Singaporean artist HO Tzu Nyen (born 1976), is confronted with a compelling, enigmatic multi-channel video installation: large screens show a 17–28-minute video (the exact length and number of screens varies based on the exhibition location) set in a nondescript housing block in which eight characters, each in their own apartment, are confronted with a mysterious cloud (**Fig. 17.20**). An inscrutable soundtrack plays from speakers discretely placed around the exhibition space, adding to the sense of theatricality. As the video continues, the cloud becomes progressively invasive and the characters become increasingly hysterical, until at the end, the viewer realizes that the cloud now inhabits the exhibition space rather than being confined to the video (a trick accomplished by smoke machines behind the screens). The work's title, *The Cloud of Unknowing*, may reflect the viewer's response—what is going on? What does the artwork "mean," if anything? Is the artist connecting this work with the medieval Christian mystical text of the same name?

Stepping back and thinking about the visual and conceptual strategies, we see a variety—perhaps *all* of the strategies discussed in this chapter—at play. *The Cloud of Unknowing* conveys monumentality but also speaks to ephemerality. The video's ambiguity creates space and time for contemplation, punctuated at the end by shock, when the cloud materializes and representation becomes reality. The juxtaposition between the grimy apartment building and the ethereal mist is paired with an odd mix of obsessive activities performed by the characters in their apartments. As one studies the piece more closely, references to other artworks and to traditions of art history emerge: the tasks performed by characters allude to specific paintings by European and Chinese artists, including Caravaggio (1571–1610), Bernini (1598–1680), MI Fu (1051–1107), and WEN Zhengming (1470–1559). Inspiration came, too, from French philosopher Hubert

17.20 Ho Tzu Nyen, *The Cloud of Unknowing*, 2011–2012. Four-channel color video installation, with sound, 17min. Installation view: *MAM PROJECT 016: Ho Tzu Nyen*, Mori Art Museum, Tokyo, February 4–May 27, 2012. © Ho Tzu Nyen Photo: Morita Kenji, courtesy Mori Art Museum. **SOUTHEAST ASIA**

Damisch (1928–2017), who examined the significance of clouds in art. The installation's soundtrack mixes fragments from some two hundred songs mentioning clouds in their lyrics; in this case, the sheer number of references renders them nearly undiscernible. In some ways, *The Cloud of Unknowing* mirrors globalization itself, with the threads of interconnection becoming so intertwined as to be indistinguishable.

The Cloud of Unknowing also embodies the contemporary conditions of Asian art. Ho created it to represent Singapore at the 2011 Venice Biennale, the oldest and most important of these global artistic events that have proliferated in recent decades. The piece is rooted in the cultural histories of both Asia and Europe, like much of recent Asian art and like Singapore itself, which became a British colony in 1819, but is now an independent republic known for its international business links and modern urban environment. Shot in an abandoned block of Housing Development Board (HDB) apartments, low-income housing in which the majority of Singaporeans live, the setting of Ho's film thus evokes a most particular memory for Singaporeans. Yet the architecture is generic enough to be anywhere. Likewise, the various ethnicities of the characters reflect the diversity of Singapore's inhabitants, while simultaneously enhancing the artwork's global, universal feel. *The Cloud of Unknowing*, like many works of contemporary Asian art, is rooted in geography yet not constrained by it, draws inspiration from the past but reflects the current moment, and ultimately rewards prolonged engagement and contemplation.

Discussion Questions

1. On the basis of globalization, this chapter brings together Asian artwork from all over the world. Choose two artworks to compare and contrast, paying special attention to the ways in which they illuminate globalization as a complex and far-reaching process.

2. This chapter organizes the artworks not by subject, genre, or medium, but rather by artistic strategies. Select two artworks to compare in terms of subject, genre, or medium.

3. Select an artwork dating to before 1980, and analyze it according to one of the artistic strategies presented in this chapter.

4. Further research: identify an artwork you think should be added to this chapter. Be sure to explain how one or more visual strategies operate in that artwork.

Further Reading

- Harris, Jonathan. *The Global Contemporary Art World*. Malden, MA: Wiley-Blackwell, 2017.
- Hung, Wu. *Contemporary Chinese Art*. London: Thames & Hudson, 2014.
- Mukherji, Parul Dave, Ahuja, Naman P. and Singh, Kavita. *InFlux: Contemporary Art in Asia*. New Delhi: SAGE Publications, 2013.
- Sturken, Marita and Cartwright, Lisa. *Practices of Looking: An Introduction to Visual Culture*. Oxford, U.K.: Oxford University Press, 2001.
- Turner, Caroline and Antoinette, Michelle (eds.). *Contemporary Asian Art and Exhibitions*. Canberra: Australia National University Press, 2014.

Chronology

1984	Hung Liu emigrates from China to the U.S.	2003	Tejal Shah co-founds *Larzish*, India's first international film festival of sexuality and gender plurality
1989	Xu Bing's *Book from the Sky* provokes audiences in the National Fine Art Museum, Beijing; the Bank of China Tower, designed by I. M. Pei, is completed	2003–5	Dinh Q. Lê creates his *From Vietnam to Hollywood* series
1991	The Cold War ends with the dissolution of the Soviet Union, thus furthering the process of globalization	2007	The first iPhone is released; Lee Mingwei's *Guernica in Sand* is exhibited at the Chicago Cultural Center
1995	The First Gwangju Biennial is held in South Korea	2011	The Tōhoku earthquake and tsunami lead to the Fukushima Daiichi nuclear disaster; Ai Weiwei is detained by the Chinese government for 81 days
1980s/1990s	Artists such as the Singh Twins and Shazia Sikander begin experimenting with techniques and materials associated with traditional South Asian paintings on paper	2012	A bronze sculpture of Kim Jong-il is added next to that of Kim Il-sung at the Mansu Hill Grand Monument
1998	In Indonesia, the 33-year Suharto dictatorship ends; thereafter, many artists adopt an activist stance in their work	2019	A posthumous retrospective exhibition of Mrinalini Mukherjee's art is held at the Metropolitan Museum of Art in New York
2000	Takashi Murakami first exhibits his "Superflat" artwork in Tokyo and Los Angeles	2019–20	The beginning of the global pandemic Covid-19
2002	Yeesookyung begins her *Translated Vase* series		

18

Epilogue: Asian Art in Planetary Perspective

18.0 Anish Kapoor, in collaboration with
Arata Isozaki, Ark Nova, Lucerne Festival,
Matsushima, Japan.

Introduction

Art has long acted as a bridge between humans and the environment. Images of wild creatures swim and stalk the surfaces of ancient cliffs and caves; carvings of fruiting trees signal auspiciousness at temples; and floral imagery adorns palaces and plates. Geological features, such as mountains, inspire much Asian art from Hindu temples to landscape paintings. Architecture, gardens, and textiles provide a means to control surroundings and temper the climate, and when earthquakes or droughts occur, artwork across Asia and beyond may reflect on natural threats and disasters. *The Great Wave* (see Fig. 13.21), arguably the most recognizable work of Asian art throughout the world, for example, depicts boats tossed about by giant waves, against which the fishermen on board must brace themselves.

During the fairly stable conditions of the Holocene (the period beginning *c.* 11,600 BCE, after the Last Glacial Maximum, or last ice age), to the best of our knowledge, it appears that by and large, humans could count on seasonal patterns and normal temperatures. Thus, for artists and the cultures in which they worked, climate receded literally and figuratively into the background. With ever more advanced technologies, humans exerted ever more control over the world around them, domesticating plants and animals, clearing forests and digging canals, building cities and empires, and trading goods and traveling across the globe. Socio-political issues gained increasing attention as the human conquest of natural forces seemed complete. But the sense of nature as passive or easily subject to human will is a false one. In *Volcanic Ash Series #4*, the Indonesian artist Arin Dwihartanto Sunaryo (born 1978) reminds viewers of nature's tremendous energy (Fig. 18.1).

In this triptych, Sunaryo uses volcanic ash spewed in 2010 from Gunung Merapi, Indonesia's most active volcano. Since 2005, the painter has been experimenting with synthetic resin to create abstract compositions that appear to freeze motion, to capture the moment when flux becomes static, when an instant becomes history. To make the works, Sunaryo strategically splashes the resin-and-ash mixture on large glass plates. The resin quickly dries, preserving the liquid's flow. Then Sunaryo and his assistants carefully remove the hardened material from the glass and flip it so that the heretofore-unseen undersurface becomes the painting's face.

Just as Sunaryo is among many artists who are turning their attention to the subject of the environment and humans' relationship to it, so too art historians are exploring the ways that environmental conditions have affected artistic development around the world. With mounting evidence that human activity has altered Earth's systems, the attention to the environment is taking on urgency. In recognition of the scope and scale of these human-generated alterations, some scientists believe that the Holocene has ended and they propose that we are living in a new geological unit of time, the Anthropocene. Whether they date the Anthropocene's start to the onset of agriculture in the Neolithic era or to the Industrial Revolution of the nineteenth century, scientists generally agree that since the mid-twentieth century a great acceleration in the changes is occurring. The effects are widespread, obeying no national borders, but, even as recently as 2020, for many people they have seemed abstract and easy to ignore amongst life's day-to-day realities.

Art has long made the invisible visible, and contemporary artists have used this capacity to full advantage to bring attention to global problems of climate change, pollution, loss of biodiversity, and so forth. They have created—and continue to create—art that pushes us to see our situation in new ways, and that offers a sense of solidarity as we search for solutions. In helping us confront the problems presented by the Anthropocene, artists remind us of art's power to shape not only our understanding of past and present, but also the very form of the future. In examining their art, we shift our global perspective to a planetary one.

Seeing the Problems of the Anthropocene

What happens to the bottle caps, the plastic toys, the out-of-fashion jewelry we discard? Modern waste-disposal systems—comprised of trash bins, sanitation workers, incinerators, landfills, and in some cases, barges of trash headed to other countries' landfills—make the detritus vanish from sight, but is it gone? For his artistic series *Trash*, the Indian artist Vivan Sundaram (born 1943) worked with waste-pickers to sift through trucks of garbage unloaded at his warehouse-scale studio. Carefully selected, arranged, and photographed, Sundaram's repurposed junk sardonically imitates, in

18.1 **Arin Dwihartanto Sunaryo,** *Volcanic Ash Series #4,* 2012. Volcanic ash and pigmented resin, mounted on triptych panel, 57½ in. × 17 ft 11⅜ in. (1.46 × 5.47 m). Solomon R. Guggenheim Museum, New York. Guggenheim UBS MAP Purchase Fund, 2012.161. © Arin Dwihartanto Sunaryo. SOUTHEAST ASIA

18.2 ABOVE **Vivan Sundaram, photograph from the *Trash* series,** 2009. Digital print, 56½ in. × 16 ft. 6 in. (1.44 × 5.01 m). **SOUTH ASIA**

18.2a RIGHT **Detail of the *Trash* series.**

mixed media artwork made from a combination of different materials.

the form of satellite imagery, the type of global city that generated the trash (**Fig. 18.2**). The picture glitters, but is this gold? Does our trash *really* become someone else's treasure? On the one hand, viewers experience delight as—surprise!—the initial misrecognition of an aerial urban view of a regional airport gives way to recognition of single-use plastic packaging and children's toys (**Fig. 18.2a**). Marveling at the artist's ingenuity and patience in giving a second life to modern rubbish, on the other hand, must yield to dawning realization of dystopia. Sundaram's visual rhetoric argues that the Earth,

and therefore, we—as its inhabitants—are inundated by our material waste.

The exponential growth of cities and suburbs around the world coupled with a growth in consumerism has led not only to excess (in the form of trash) but also to loss (loss of land, loss of traditional practices). In *High Rise: Lake City Drive* (**Fig. 18.3**), the Pakistani **mixed-media** artist Huma Mulji (born 1970) conceived of placing a taxidermy water buffalo atop a faux-marble column to visualize the displacement of animals and the forfeiture of agricultural land as luxury homes are rapidly built to accommodate

the materialistic desires of Pakistan's upper classes. The illustration here shows the artist's preparatory sketch, including her construction notes. The resulting artwork has been exhibited in multiple venues; each time it takes a slightly different form. Like much Pakistani contemporary art, Mulji's work directly engages political and social issues with sly humor. Here, the absurd juxtaposition of the animal and the column satirizes Pakistan's desire to be forward-looking while preserving traditional values. A postcolonial take on the Ashokan pillars that dotted the Indian subcontinent during ancient times (see Figs. 3.1 and 3.2), *High Rise: Lake City Drive* pushes us to question what we see as monumental and what so-called progress may cost us, humans and animals alike.

The Chinese American artist Zhang Hongtu (born 1943) posed similar questions in an untitled painting from 2010 (**Fig. 18.4**). In the foreground, four monkeys sit on a mesa and gaze at a watery landscape in the background. Zhang's composition compels viewers to copy the monkeys' gaze and, in so doing, it provides an opportunity to shift away from an anthropocentric point of view: the human actions that have helped cause the changes

of the Anthropocene have consequences for animals as well. Here, the monkeys bear witness to a built environment that is largely submerged; in this dark vision of the future, the sole remnant of what was once Beijing is the CCTV (China Central Television) building, identifiable by its signature hollow silhouette. Curiously, perhaps ironically, the proud CCTV headquarters (designed by the Dutch architect Rem Koolhaas) now resembles an iceberg, seemingly afloat in a world of polar ice melt and rising seas.

The repercussions from rising sea levels are not just distant, dystopian threats, but rather immediate concerns, particularly in the world's lowest-lying lands. In Bangladesh, where nearly half of its population lives within 33 feet (10 meters) of sea level, even a slight rise in the world's oceans can have devastating effects. Choices made by the government in the name of economic development can exacerbate the situation.

For example, in the southwest coastal region of Bangladesh, the amount of saline (salt) in the water table has risen, meaning that many of the crops crucial to traditional farming can no longer be grown. In 1994 the government decided to open this region to shrimp farming for export, a growing industry but one that requires the land to be deliberately flooded. This, in turn, introduced salt water even further inland, which eventually polluted all the well water and devastated the area's natural resources. In 2009 the Bangladeshi photographer Munem Wasif (born 1983) drew attention to the struggle of the people who live there through a series of photographs called *Salt Water Tears*. Like many photographers interested in social justice, Wasif's challenge is to create pictures that will show the grim reality without compromising the dignity of his subjects. In a photograph showing three brothers pushing boats laden with containers of fresh water through mud at low tide (**Fig. 18.5**, p. 358), Wasif accomplished this task by taking

18.5 Munem Wasif, Untitled photograph from the series *Salt Water Tears: Lives Left Behind in Satkhira, Bangladesh,* 2009. SOUTH ASIA

18.6 Kimsooja, *Cities on the Move: 2727 Kilometers Bottari Truck,* 1997. Still from a 7:03-minute silent video loop. EAST ASIA / EAST ASIAN DIASPORA

an ethereal, slightly **abstract** approach to capturing the scene. As Wasif explains, "It's a beautiful photograph, but once you know the story behind it, it becomes tragic. They have had to work so hard to get this water—they can't hold down a normal job as well."

Eventually such ecological devastation leads to dislocation. But that is not the only reason why people are forced to move. Shifting national boundaries and the growth of cities, among other things, also lead to necessary migration. A 7:03-minute video-loop, part of a larger project called *Cities on the Move* by the Korean artist Kimsooja (born 1957), draws specifically on the

artist's resettlement to various towns and cities in Korea during her lifetime (**Fig. 18.6**). In the film, the camera frames Kimsooja from behind. Her darkened silhouette rises above colorful *bottari* (a Korean word referring to tied bundles of cloth), which are strapped down to an unseen truck. As the truck moves, Kimsooja and her *bottari* remain mesmerizingly fixed, whereas the background changes from evergreen forest on a mountain slope to urban thoroughfares flanked by high-rises and advertisements. By inserting a stationary migrant into a moving landscape, the video invites reflection on the individual's experience of dislocation.

Dislocation, the video proposes, is isolation with no end in sight. Viewers focus on the human figure, but her focus remains hidden. Scenery files past, but progress is uncertain. The figure never faces the camera, and no sound accompanies the video. In short, the artwork provides little information about the figure's identity or story. Only the *bottari* provide a reference to domesticity, to female experience, to a life history, and to a culture. But the *bottari* conceal more than they reveal, keeping their contents under wraps.

Whereas Kimsooja's *Cities on the Move* strives to represent visibly an inner, emotional experience of migration, the Korean artist Do Ho Suh's *Bridging Home* captures the quandary when immigrants settle in new places (**Fig. 18.7**). In Liverpool, England, Suh created a small structure modeled after his parents' Korean home. Its architectural vocabulary—timber frame, lattice windows, and tile roof (see Fig. 9.7)—set it apart from the multi-story brick buildings on either side. But more arresting is its awkward, precarious suspension, which evokes the immigrant's sometimes uneasy state of in-between-ness.

18.7 Do Ho Suh, *Bridging Home,* 84–86 Duke Street, Liverpool, U.K., 2010. Mixed media installation. **EAST ASIA / EAST ASIAN DIASPORA**

Suh's *Bridging Home* is at once about the particularity of a foreign, Korean presence in England and about general conditions the world over. Painted on the building at left is a point of information and follow-up question: "There are 3951 people for every km² in this city. Do you like your neighbours?"

The problems of the Anthropocene—global disruptions to Earth's systems and the political economies that generate those disruptions—are sobering. As human populations rise (the total population of the world has grown from approximately 2.5 billion people in 1950 to 7.6 billion in 2018), all manner of systems will come under increasing pressure. Even when natural disasters, such as earthquakes or volcanic eruptions, occur, the consequences are magnified because of population increases. These six artworks represent just the tip of the iceberg when it comes to contemporary Asian artists concerned with issues of population growth, pollution, sea-level rise, human and animal life, and migration and immigration. Realizing common cause, many more artists are taking action, using their art to raise awareness. The picture they paint may not be pretty, but we must not shut our eyes.

Art Answers

The changes of the Anthropocene are so vast, so unprecedented as to overwhelm. What can be done? The solution lies not in any one person, country, or field of expertise. Sustaining familiar and beloved life on Earth requires the will, the talents, and the efforts of many. This book began with early fragments of human creativity in Asia, well before our species developed the capability to dominate the Earth's ecosystems. It concludes with some artworks that encourage reflection, inspire hope, and

nourish the spirit of community essential for us not merely to survive, but also to flourish.

Based in New Delhi, Ravi Agarwal (born 1958) merges art with activism. He uses photography to document the many losses of the Anthropocene. A recent work, *Power – Nature – 2*, combined photography with printmaking to make visible the effects of the loss of wolves in Scotland (**Fig. 18.8**). In this image, the viewer's gaze sweeps across a Scottish landscape. Several strips of color in the foreground—dark gray, green, brown, and taupe—suggest the different ways that humans manipulate the Earth's surface to suit their needs. By contrast, the sky—the site of

18.8 Ravi Agarwal, *Power – Nature – 2,* 2017. Photographic print, 15¼ × 22⅞ in. (38.6 × 58 cm). **SOUTH ASIA**

Living creatures are not the only ones whose existence is threatened by changes of the Anthropocene; monuments are also in peril. The nearly four-hundred-year-old Taj Mahal, for example, is suffering damage because of unchecked industrial growth in Agra, India and increased tourism to the site. Air pollution has discolored its white marble domes, screens, and minarets (see Fig. 11.9). More alarmingly, acid rain is eating away at the stone, and the drying Yamuna River may destabilize the monument's foundation. In the absence of coordinated and sustained worldwide efforts to rein in pollution, and in the face of ever-increasing numbers of visitors (who bring revenue but also wear-and-tear) to popular monuments, how can we preserve the world's

artistic heritage? To answer this question, art historians are collaborating not only with artists and museums but also with scientists, engineers, and computer programmers.

At the Taklamakan Desert's eastern end, near the oasis city of Dunhuang in China, a sandstone cliff is the unlikely site of the world's greatest concentration of Buddhist art. There, nearly five hundred cave-temples were hewn into the cliff between the fourth and fourteenth centuries. Altogether they house two thousand sculptures and about 45,000 square meters of mural paintings (see Figs. 4.20 and 6.9). Interest in the cave-temples grew exponentially throughout the twentieth century: the number of visitors swelled from some 10,000 in the 1980s

to well over one million in recent years. But such recognition presents the site's custodians with a dilemma: how can the request for accessibility be met without generating undue wear on the artwork caused by, for example, changes in humidity and temperature from the very presence of visitors?

Led by artists and scholars, the Dunhuang Academy recently has completed full-scale replicas of three caves (**Fig. 18.9** shows one of these). The full-scale replicas allow audiences to inspect the sculptures and murals at length and with better artificial lighting. Because the physical replicas may be transported, they also make possible opportunities for viewers with limited mobility or who could otherwise not undertake the journey to remote Dunhuang. To reach yet more viewers, the Dunhuang Academy has launched Digital Dunhuang, which features an increasing number of virtual-reality experiences of the caves.

In other instances, laser scanning and 3-D printing have been used to create replicas of monuments around the world. These new technologies bring awareness of the plight of our shared heritage, while simultaneously helping to archive that legacy.

Discussion Question

1. Explore the e-dunhuang.com site. What are the benefits and the limitations of experiencing sites of artistic heritage virtually?

18.9 **Visitors at the "Cave Temples of Dunhuang: Buddhist Art on the Silk Road"** exhibit at the Getty Center, Los Angeles, California, on May 9, 2016, viewing a full-scale, hand-painted replica of Mogao Cave 285 from Dunhuang, China. **EAST ASIA**

celestial drama—may appear to be beyond human reach, but the patterns here only masquerade as clouds. Agarwal has superimposed onto the sky an image of hunters accompanied by their dogs. The near hunter aims his rifle at a wolf, perhaps the last one, the death of which will secure the land for sheep to graze. But wolves are a keystone species in ecosystems, and their extirpation leads to the unintended consequences of deforestation and soil degradation. Agarwal's image juxtaposes cause with effect, revealing the denuded Scottish landscape as the outcome of human action.

Agarwal not only helps us to see the problems of the Anthropocene, but also models international cooperation as a necessary part of the solutions. *Power – Nature – 2* resulted from a short-term residency with Edinburgh Printmakers. Printmaking was a new medium for him,

and so he had to rely on expert printmakers for guidance. Like his collaboration with those printmakers, the resulting exhibition, "Na'dar/Prakriti: Dialogical Possibilities: Nature and Wildness in Scotland and India (2017–18)," emphasizes the imperative to work across borders, which also informs his curatorial work, scholarly writing, and grassroots activism. For example, to mitigate the poisonous effects of improperly disposed electronic waste, Agarwal founded Toxics Link, a non-governmental organization.

Like Agarwal, Chinese American Maya Lin (born 1959) combines her artistic activities with grassroots activism. Best known for designing the Vietnam Veterans Memorial in Washington, D.C., Lin uses the Internet as an artistic medium in her on-going memorial to the planet: whatis-missing.org. Layered audio clips, photographs, videos,

and maps testify to the current disappearance of habitat and species, or the "Sixth Extinction." Lin enjoins her global audience to share their stories—whether bearing witness to loss in the natural world or spreading news of ecological conservation. Like the natural world, the artwork itself is in a constant state of flux, and therefore cannot be captured in a static textbook illustration. Pause here and visit whatismissing.org.

Nearly three decades before Agarwal's residency in Scotland and Lin's digital memorial, the Filipino artist Roberto Villanueva (1947–1995) erected a monumental, but intentionally ephemeral, installation: *Archetypes: Cordillera's Labyrinth* (Fig. 18.10). In the years leading up to this installation, Roberto (the name he chose to use beginning in 1987) had been deeply concerned about the colonial legacies of land use and the damage to Indigenous tribal communities in the Philippines. With *Archetypes: Cordillera's Labyrinth*, Roberto resisted the forces of capitalism and commodification by collaborating with members of the Ifugao people and, as he put it, with nature. Together, they created an eco-conscious community. From nature, Roberto "borrowed" materials that would be returned once the artwork was completed and made to disappear. Alongside Ifugao volunteers, Roberto worked according to Indigenous methods to build the labyrinth The audience was immersed in the artwork, as they walked through its spiral form to reach the central, communal space, which imitated an Ifagao sacred meeting place. Through music and dance, Roberto played the role of an Ifugao shaman (*mumbaki*), who would nurture people, motivate communities to work toward common goals, and mediate between the visible and numinous realms. At the final "Dismantling the Maze" event, Roberto invoked rain, reminding viewers of its essential, life-giving role in agrarian societies.

The life-giving power of rainwater is also invoked in the award-winning design of the Friendship Hospital (not illustrated) in Satkhira, Bangladesh, completed in 2018. Designed by Bangladeshi architect Kashef Chowdury (born 1970) and made of local, low-cost materials, the hospital responds to the increasingly brackish water of its environs by featuring a multipurpose canal. The zigzag canal collects potable rainwater for hospital use, differentiates the inpatient from the outpatient buildings, and serves as a focal feature in the shaded courtyards that moderate the temperatures and facilitate airflow. Friendship Hospital offers a restorative environment commensurate with the goal of fostering health.

The possibility of restoration and renewal also can be found in the work of the Japanese artist Hiroshi Sunairi (born 1972). Since 2006, Sunairi has been distributing seeds from trees that survived the August 6, 1945 atomic bombing of his hometown Hiroshima. He calls this activity and the related artwork *Tree Project*. During his grade-school years in Japan, Sunairi encountered survivors of the bombing. Their stories formed the crux of a collective public memory, but as time passes, there are fewer and fewer survivors to renew that public memory. In this context, *hibaku* ("A-bombed") trees constitute a living memorial. They are quiet, resilient reminders of, and warnings against, nuclear war.

Yet, the *hibaku* trees also represent the inter-connectedness of life on earth. The protagonist of Sunairi's *Tree Project Film* is Chikara Horiguchi, a master gardener who has been caring for the 170 *hibaku* trees of Hiroshima. The film makes the case for fruitful collaborations centered

18.10 **Roberto Villanueva with his artwork** *Archetypes: Cordillera's Labyrinth,* 1989. Runo reeds, stone, wood, and other materials, 150 × 2000 ft. (46 × 610 m). The Cultural Center of the Philippines, Manila. Courtesy of Eva Corazon Abundo-Villanueva and Napoleon A. Villanueva. **SOUTHEAST ASIA**

18.11 Swarna Chitrakar, *Coronavirus patrachitra* scroll, 2020. Fabric paint on cloth.

SOUTH ASIA

on peace and nature. In the course of his care, Horiguchi has provided Sunairi with not only seeds to give away but also pruned clippings. In related artwork, Sunairi formed these branches and twigs into the shape of a reclining elephant whose recurring form in the artist's oeuvre underscores one of his key messages: remember. Pause here to see pieces of Sunairi's *Tree Project* at sunairi.wordpress.com.

As these preceding examples demonstrate, art has the power to foster collaboration. It can also educate. Population growth, loss of animal habitat, and increased international travel are among the changes over the last century that have led to an increase in infectious diseases, including such new viruses as HIV/AIDS, hepatitis C, and COVID-19. Combatting their spread, especially in communities with low rates of literacy and limited access to health care, can be challenging. In India's West Bengal region, the artistic practice of *patachitra* ("paintings on cloth") has been adapted to educate people about misconceptions, preventative measures, and treatments related to new diseases.

For generations, *patachitra* artists have traveled from village to village (and more recently, from international festival to festival) to perform their illustrated storytelling, which combines paintings with songs, such that each artist acts as painter, songwriter, and performer. Their narrative painting typically takes a vertical scroll format, with the first scene illustrating the main character of a story drawn from religion, popular folklore, or contemporary events. In spring 2020, the artist Swarna Chitrakar (born 1974) created a scroll with scenes illustrating the symptoms of the virulent new disease, COVID-19. The seven-minute accompanying song is punctuated with the chorus, "Hearing about Coronavirus/ My heart is breaking/ How will I express my feelings?" Housebound because of the pandemic, Chitrakar sang out the poignant narrative as her husband recorded her performance on his cell phone. That video went, as they say, viral, receiving more than 99,000 views on social media and providing comfort, community, and information at an uncertain time. Since then, Chitrakar has made several more COVID-19 works, including the five-scene scroll illustrated here (**Fig. 18.11**). It begins with an image of the coronavirus as a giant, red demonic figure with horns. On the right side of the second scene, Chitrakar depicted people washing their hands and wearing masks, as a way to prevent the spread of the disease, which still hovers above. On the left side, people visit a medical professional to receive vaccines. In a later segment, the coronavirus crouches in the corner crying, as masked people distribute food to the needy. Through her *patachitra*, Chitrakar prods her audience to take actions that will keep themselves and their community healthy.

Difficult conditions call for resiliency and collaboration. These traits lie at the heart of a project by the Japanese architect Arata Isozaki (born 1931) and the British-Indian sculptor Anish Kapoor (born 1954). From above, their Ark Nova resembles a giant, purple doughnut (**Fig. 18.0**). Inside, Ark Nova's curved plastic membrane creates, depending on the particular mix of sun and

cloud, a mottled magenta or pink light that envelops everyone within the space (**Fig. 18.12**). The membrane also connects top to bottom within the center of the space. Resembling a double-sided trumpet bell, this inner membrane interrupts the space and emphasizes Ark Nova's appealing sculptural quality. But Ark Nova is also functional: it houses a performance stage and seating for up to five hundred people. The seating takes the form of cedar benches made from trees felled by the Tōhoku earthquake and tsunami in Japan.

Isozaki and Kapoor designed Ark Nova after the devastating 2011 earthquake and tsunami, which triggered the Fukushima Daiichi nuclear disaster. The impact of the 9.1-magnitude Tōhoku earthquake caused a tsunami with 30-foot waves (the death toll of 15,896 in the Tōhoku earthquake and tsunami is exceeded only by the 2004 Banda Aceh earthquake and tsunami, when an estimated 230,000 people were killed). At Tōhoku, the water rushed up to six miles inland, and most seriously, it inundated the Fukushima nuclear power plant, causing a catastrophic failure and nuclear meltdown. Radioactive materials leaked from Fukushima have been detected on North American shores. Five years after the disaster, in Tōhoku, some 150,000 people still lived in temporary housing.

The rebuilding efforts in terms of infrastructure and community are demanding and long term. In this context, Ark Nova offers momentary and much-needed sanctuary. A mobile concert hall, it provides a stage for musicians from local communities and around the world to perform. The first performances in 2013 occurred in Matsushima, about 80 miles (130 km) north of the now-defunct Fukushima nuclear power plant. Since then, Ark Nova has migrated to Sendai (2014), Fukushima (2015), and Tokyo (2017). In all these locations, it is a bright reminder of fortitude and community, which are so essential to human survival and flourishing.

The name, Ark Nova, references Noah's ark, in Abrahamic religions believed to be a lifeboat that saved human and animal populations from epic flooding. Isozaki and Kapoor designed their new ark as a rescue operation, too. It does not resemble a boat, and the challenges facing humanity today are not limited to flooding. Instead, this strange, new mobile form of instant architecture can bring respite to the suffering and renew the bonds among disparate communities. In this regard, Ark Nova has much in common with the most enduring artworks, Asian and otherwise. We might consider such artworks as gifts and testaments to humanity. Whether they display technological ingenuity, commemorate acts of courage, celebrate romantic love, or skim the surface of the divine, art invites us to expand our experience of what it is to be human. It draws us together, and in being drawn together, we may transcend our individual selves.

18.12 **Anish Kapoor, in collaboration with Arata Isozaki, Ark Nova,** Lucerne Festival, Matsushima, Japan, 2013. P.V.C., 60 × 95 × 120 ft. (18 × 29 × 36 m). Courtesy the artist and Lucerne Festival. **SOUTH ASIA / SOUTH ASIAN DIASPORA AND EAST ASIA, RESPECTIVELY**

Discussion Questions

1. Choose an artwork from any of the previous chapters and analyze it with the Anthropocene in mind.

2. Which of the artworks in this chapter resonates with you and your experiences? Explain.

Further Reading

- Belanus, Betty. "Painting the Pandemic: Coronavirus *Patachitra* Scrolls in West Bengal, India." *Folklife* (Nov. 9, 2020). https://folklife.si.edu/magazine/crisis-coronavirus-patachitra-scrolls-west-bengal-india (accessed 14 May, 2021).

- Demos, T. J., Scott, Emily Eliza, and Banerjee, Sunbhankar (eds.). *The Routledge Companion to Contemporary Art, Visual Culture, and Climate Change.* Milton, U.K.: Taylor & Francis, 2021.

- Kusserow, Karl, ed. *Picture Ecology: Art and Ecocriticism in Planetary Perspective.* Princeton, NJ: Princeton University Art Museum, 2021.

- Lee, De-nin D., ed. *Eco-Art History in East and Southeast Asia.* Newcastle upon Tyne, U.K.: Cambridge Scholars Publishing, 2019.

Glossary

abstract altered through simplification, exaggeration, or otherwise deviating from natural appearance.

Abstract Expressionism a style of art originating in the United States after World War II in which artists rejected representation in favor of the gestural residue of paint dripped, splashed, and applied in other unorthodox ways.

abstraction artistic styles that transform a recognizable image into shapes and lines.

Academic art conventional painting or sculpture made under the influence of an art academy, a state-sponsored society for the formal training of artists and exhibition of their work.

aisle a passage along either side of a nave, separated from the nave by a row of columns or piers.

album a format of two-dimensional artwork such as painting, calligraphy, or photography, in which individual leaves, or pages, may be bound together like a book to form an album.

albumen print a type of photographic print that uses an egg-white emulsion to bind the photographic chemicals to the paper; commonly used between the 1860s and 1890s.

allegorical portrait a portrait that uses visual elements as metaphors to convey complex meanings.

amalaka a stone disk shaped liked the amala (a lobed fruit said to have purifying medicinal powers), that sits atop the *shikhara* of a north Indian Hindu temple.

ambulatory a place for walking, especially an aisle around a sacred part of a religious space.

amphora an ancient pottery vessel with a narrow neck, large oval body and two handles, used for storage or bulk transportation of foodstuffs.

aniconic 1) the indirect visual representation of divine beings through symbols or abstract images. (2) opposition to visual depictions of living creatures or religious figures.

anthropomorphic described or depicted with human characteristics (in art: images of people).

appropriation borrowing images, objects, or ideas and inserting them into another context.

apsara a celestial maiden.

apsidal relating to an apse: a semicircular recess.

arcade a covered walkway made of a series of arches supported by piers.

archaism the use of forms dating to the past and associated with a golden age.

architectural palimpsest a structure that has been changed over time and shows evidence of that change.

architectural polychromy using different-colored materials to create decorative patterns in architecture.

architrave a beam resting on top of columns or stretching across an entranceway.

atmospheric perspective a means of representing distance based on the way atmosphere affects the human eye, where details are lost, outlines are blurred, colors become paler, and color contrasts less pronounced.

auspicious signaling prosperity, good fortune, and a favorable future.

avant-garde an emphasis in modern art on artistic innovation, which challenged accepted values, traditions, and techiques; derived from the French for "vanguard."

bailey in castle architecture, a high-walled courtyard that exposes attackers.

balustrade a decorative railing, especially on a balcony, bridge, or terrace.

barrel vault also called a tunnel vault; a semi-cylindrical ceiling that consists of a single curve.

Baroque a style of art and decoration that emerged in western Europe *c.* 1600–1750, characterized by a sense of drama and splendor achieved through formal exuberance, material opulence, and spatial projection in order to shape the viewer's experience.

batik a method originating in Java of producing colored designs on textiles by dyeing them, having first applied wax to the parts to be left undyed.

bay a space between columns, or a niche in a wall, that is created by defined structures.

bi flat, perforated disks made of nephrite, first found in the Liangzhu culture.

bilateral symmetry symmetrical arrangement along a central axis so that the object or plan is divided into two matching halves.

bodhisattva in early Buddhism and Theravada Buddhism, a being with the potential to become a buddha; in Mahayana Buddhism, an enlightened being who vows to remain in this world in order to aid all sentient beings toward enlightenment.

boss a round, knob-like projection.

brackets wooden supports that channel the weight of the roof to the supporting lintels and posts.

bronze an alloy consisting primarily of copper with some tin, and often small amounts of other metals and/or minerals.

Bronze Age a period of human history characterized by the use of bronze, beginning around 4000 BCE, but different according to particular geographical area; ends with the advent of iron technology.

buddha, the Buddha a buddha is a being who has achieved the state of perfect enlightenment called Buddhahood; the Buddha is, literally, the "Enlightened One"; generally refers to the historical Buddha, Siddhartha Gautama, also called Shakyamuni and Shakyasimha.

buncheong a variety of Korean stoneware created with white slip.

bunjinga Japanese "literati painting," in the Edo period inspired by Ming dynasty Chinese literati painters such as Dong Qichang. Dong's theory of painting also provided the alternate name, "*nanga*," or "Southern [School] Painting," for *bunjinga*.

burnishing (of ceramics) polishing the surface by means of rubbing with a hard tool.

bust a sculpture of a person's head, shoulders, and chest.

buttress an external support to an architectural structure, usually made of brick or stone.

byōbu a format of Japanese painting taking the form of flat or folding screens, often paired.

calligraphy (1) the art of expressive, decorative, or carefully descriptive hand lettering or handwriting. (2) in East Asian painting, the formal, expressive properties of lines (e.g. thick/thin, dark/light, wet/dry) made with a flexible brush.

camp an aesthetic sensibility embracing things that are exaggerated, overly theatrical, ironic, and/or kitschy.

canon a set of what are regarded as especially significant artworks.

cantilever a horizontal beam, slab, or other projecting structural member that is anchored at only one end.

capital the distinct top section, usually decorative, of a column or pillar.

caravanserai lodgings constructed along trade routes at regular intervals for use of travelers; also sometimes called *ribat* or *han*.

cartouche inset boxes for short phrases, providing such identifying information as title, series, artist, publisher and/or date.

celadon (also known as green ware): a wide range of ceramics with a common greenish hue.

chaekgeori literally "books and things"; a genre of Korean painted folding screens that sometimes uses *trompe l'oeil* techniques to depict books, decorative art objects, and foreign goods such as eye glasses, popular during the late Joseon period.

chaitya a Buddhist prayer hall with a *stupa* at one end.

chakravartin literally, "wheel-turner," a Sanskrit title used to refer to an ideal, just ruler, often in relationship to the dharmic faiths of Buddhism, Hinduism, and Jainism.

chamfered corner a cut-away corner that forms a sloping edge.

Chan literally "meditation," Chan is a school, or sect of Mahayana Buddhism. Adapting aspects of Daoism, Chan emphasizes immediate, sometimes unorthodox realization of enlightenment, and direct transmission of teachings from master to disciple, beginning with the founding master Bodhidharma. Known in Korea as Seon, and in Japan as Zen.

charbargh a Persian term referring to a garden divided into four equal parts.

chevron pattern in the shape of a V or upside-down V.

chhatri literally means "canopy"; a domed-shaped pavilion, usually elevated and used as a decorative element in South Asian architecture.

chiaroscuro in two-dimensional artworks, the use of light and dark contrasts to create the impression of volume when modeling three-dimensional objects and figures.

Chinoiserie objects and images characterized by European tastes and ideas about China.

chinsō commemorative portraits of revered Zen teachers.

chromolithograph color print produced by lithography, a method of printing in which the surface of the printing plate is treated to repel ink except where required; used particularly in the late nineteenth and early twentieth centuries.

chronogram an inscription in which specific letters, interpreted as numerals, stand for a particular date when rearranged.

Classical/Classicism from, or in a style deriving from, ancient Greece or Rome.

Classical orders a codified grouping of columns and capitals that originated in ancient Greece with the Doric order (a spare, round capital), Ionic order (a scrolled capital), and Corinthian order (an ornate capital with acanthus leaves), to which the ancient Romans added the Tuscan order (a variant on the Doric) and Composite order (a mixture of the Ionic and Corinthian).

cloister a covered walkway, lined with a colonnade, walled on the outside and open to a courtyard; usually found in religious buildings.

coffer, coffered a recessed panel, or series of panels, in a ceiling.

collage a technique in which cut paper pieces and other flat materials of all types and sizes are combined and stuck to another surface to make a design; from the French *coller*, "to glue."

collotype in photography, a process that employs a glass plate coated in a light-sensitive gelatin solution to produce high-quality prints, useable for publication, from a photographic negative.

colonnade a long series of columns at regular intervals that supports a roof or other structure.

colophon a statement at the end of a book, which records such information as the date and location of completion, name of calligrapher, and patron. In East Asia, colophons are also written on paintings and calligraphy, and their content may be expressive and wide-ranging.

composition the organization of elements in a work of art, distinct from its subject matter.

Conceptual art a term that emerged in the 1960s for art practices that emphasize ideas rather than any aesthetic qualities or physical materials.

cong hollow, squared tubes made of nephrite found in the Liangzhu culture.

congregational mosque also called a Friday mosque, or *jama masjid* in Arabic, the main mosque in a city or town and the location of Friday prayers, when the entire community comes together.

Constructivism an art movement that originated in Russia in the 1920s, in which mechanical objects are combined into abstract forms.

contextual analysis the method of examining and understanding an artwork by considering it in relation to its relevant context, whether historical, religious, social, and so forth.

continuous narrative multiple events combined within a single pictorial frame.

contrapposto Italian for "counterpoise," a posture of the human body that shifts most weight onto one leg, suggesting ease and potential for movement.

contour line the outline that defines a form.

copperplate engraving a type of printing in which a smooth sheet or plate of copper is etched or engraved with a design and then ink applied onto the plate for printing.

corbel a wood, stone, or brick wall projection, such as a bracket, that supports a structure above it.

corbeling an overlapping arrangement of wood, stone, or brick wall projections positioned so that each course extends farther from the wall than the course below.

corbeled vault an arched ceiling constructed by offsetting successive rows of stone (corbels) that meet at the top to form an arch shape.

Corinthian an order of Classical architecture characterized by slender fluted columns and elaborate capitals decorated with stylized leaves and scrolls.

cross-hatching a technique in which groups of close parallel lines are drawn or painted across one another; used to darken or infill an area within a design.

cursive (of a script) flowing, with some letters joining together.

Dada an informal international movement that arose during World War I; its adherents rebelled against established standards in art and what they considered morally bankrupt European culture.

daguerreotype a unique photograph fixed on a silver-coated copper plate, cased under glass.

Daoism originating in China, a philosophy and religion that advocates pursuit of the Dao (the "Way"), as manifested in the harmonious workings of the natural world and universe; Daoist practice also includes worship of immortals and numerous popular deities.

darshan the auspicious devotional act of seeing and being seen by a deity, holy person, or sacred object in Hinduism.

diadem a crown or ornamented headband worn as a sign of status.

diaspora a population whose roots lie in a different geographic location.

dogū clay figurines made during the Final Jōmon period, *c.* 1000–*c.* 400 BCE.

drum a cylindrical stone block that forms part of a column.

dry fresco a wall or ceiling painting on dry plaster, as opposed to on wet plaster.

dry lacquer a technique of making sculpture or vessels in which pieces of hemp cloth are soaked in lacquer and then layered over a core of wood and clay. Each layer of lacquer-soaked cloth must dry completely before adding the next.

earthenware pottery made of clay, unglazed, and baked to a temperature below 1200 degrees Celsius (2200 F), producing not entirely watertight but nevertheless hard and durable objects. Also called terra-cotta.

effigy a sculpture or model, usually created for its symbolic and/or material value in relation to the thing it represents.

elevation typically, the external facade of a building, but can be any exterior face of a building viewed as a vertical plane.

emaki a Japanese term for a handscroll painting typically viewed in sections, from right to left. It is wider than it is tall, and when rolled up, it is easily stored and portable.

embossed an object or surface that has been carved, molded, or stamped in relief.

Esoteric Buddhism schools of Mahayana Buddhism involving secret teachings available only to initiates who, with the aid of an advanced instructor, have completed certain rituals or reached certain levels of understanding.

expressionism, Expressionism (1) art that is highly emotional in character, with colors, shapes, or space being distorted and non-naturalistic as a means to convey vivid extremes of subjective experience and feeling. (2) modern Expressionism is associated with several movements, including German Expressionism in the early twentieth century and Abstract Expressionism in the mid-twentieth century.

facade any exterior face of a building, usually the front.

fan painting a format of East Asian painting in which the image is painted on an oblong, round, or folded fan.

feminist art associated with the Feminist Movement of the 1960s and 1970s, art critically informed by women's experiences.

figurative art that portrays human or animal forms.

filigree a type of decoration typically on gold or silver, characterized by ornate tracery.

finial an ornament at the top, end, or corner of an object or building.

flower-and-bird painting in East Asia, a genre of painting that includes vegetable, avian, and insect subjects.

Fluxus an international community of creative artists and writers active during the 1960s and 1970s; the group's experimental art performances emphasized artistic process over finished product.

folio one leaf of a book.

foreshortening in two-dimensional artworks, the illusion of a form receding into space: the parts of an object or figure closest to the viewer are depicted as largest, those furthest as smallest.

formal analysis the method of examining and understanding an artwork's form, including its medium and materials, formal elements, and principles of design.

format in East Asia, painting types that include the hanging scroll, handscroll, album leaf, and fan.

fresco a wall or ceiling painting on wet plaster (also called true fresco or *buon* fresco); wet pigment merges with the plaster, and once hardened the painting becomes an integral part of the wall; painting on dry plaster is called *fresco secco*.

frieze any sculpture or painting in a long, horizontal format.

gable the roughly triangular upper section of an exterior wall created by a roof with two sloping sides.

gabled roof a roof with two sloping sides.

gallery an interior passageway or other long, narrow space within a building.

garbhagriha a Hindu temple's innermost sanctum; a small, dark space, where the main icon of a deity is housed.

genre a category of art, determined primarily on the basis of subject matter. In Chinese painting, genres include: figure painting, landscapes, and flower-and-bird, for example.

genre painting an art historical category of paintings that feature scenes of everyday life.

gilded covered or foiled in gold.

glaze a substance fused onto the surface of pottery to form a smooth, shiny decorative coating.

Gothic Revival the renewed popularity of the European Gothic style of architecture during the nineteenth century.

gopuram (also **gopura**) a monumental tower at the entrance of a Hindu temple complex, especially in south India.

ground plane (referring to the ground represented in two-dimensional artwork): in linear perspective, the ground plane appears to recede to the horizon line; in a picture with a sharply uptilted ground plane, no horizon appears within the picture.

guohua a Chinese term meaning "national painting"; refers to painting in traditional materials (ink and/or colors on silk or paper) and often in traditional formats and genres.

Gutai an avant-garde art group formed in Japan in 1954.

halo a circle of light depicted around the head of a holy figure to signify his or her dignity.

handscroll a format of East Asian painting that is much longer than it is high; typically viewed intimately and in sections, as the viewer unrolls it from right to left.

hanging scroll a format of East Asian painting that is typically taller than it is wide; generally, hanging scrolls are displayed temporarily and may be rolled up and stored easily.

Happenings an artwork that takes the form of an event, often improvised and with artist(s) and audience as participants.

harmika a square, fence-like enclosure that symbolizes heaven and appears at the top of a *stupa*.

hierarchical scale the use of size to denote the relative importance of subjects in an artwork.

high relief raised forms that project far from a flat background.

hilt the handle of a weapon.

hip roof a roof that slopes upward from all four sides of a building.

hip-and-gabled roof a composite roof design that combines a hip roof in the lower portion, and in the upper portion, one that slopes from two opposite sides with two gables (vertical triangular shapes) at the ends.

history painting a genre of painting that takes significant historical, mythological, and literary events as its subject matter.

Holocene the current geologic period, beginning approximately 11,600 years before the present.

hypostyle hall a large room with rows of columns or pillars supporting the roof.

icon an image of a religious subject, used for contemplation and veneration.

iconoclasm the intentional destruction or rejection of images on religious or political grounds.

iconography images or symbols used to convey specific meanings in an artwork.

illumination decorative designs, handwritten on a page or document.

illusionism making objects and space in two dimensions appear real; achieved using such techniques as foreshortening, shading, and perspective.

impasto the texture produced by paint applied very thickly.

Impressionism a style of painting developed in Paris beginning in the late 1860s; typically without extensive preparatory work, using bright color and broken brushwork, and capturing momentary effects of light, atmosphere, and color. Central subjects are landscapes and scenes of everyday life.

incise, incised cut or engraved.

inscription writing added to an artwork, either by the artist or by admirers and later collectors.

inlay decoration embedded into the surface of a base material.

installation a work of art created at the site where it is located, often using physical elements on the site; creates an immersive experience for the viewer.

intercultural in art history, contact between cultures and/or those artworks that draw upon and integrate two or more distinct cultures; it may also recognize the already eclectic nature of a given culture.

International Style a modern form of architecture that emerged in the 1920s and 1930s, characterized by the use of simple cubic forms, absence of applied ornamentation, open interior spaces, and the use of industrial steel, glass, and reinforced concrete.

intertextuality in literary studies, refers to the relationship between texts as when one text shapes the meaning of another, or when a part of one work is inserted, along with its original meanings, into another.

isometric perspective a strategy of representing three-dimensional objects and/or space on a two-dimensional surface in which oblique sides are rendered as diagonal, parallel lines, and sides that are parallel to the picture plane are presented frontally.

jade a general term for hard, typically green minerals, including nephrite and jadeite.

jali a perforated stone or lattice screen, usually featuring a calligraphic or geometric ornamental pattern.

jatakas stories of the Buddha's past lives.

Japonisme objects and images characterized by European taste and ideas about Japan.

jingyeong sansuhwa Korean "true-scenery landscape painting" or "true-view landscape painting" depicting real scenery on the Korean peninsula in styles demonstrating innovation and a degree of independence from earlier (Chinese) models (see also *shinkeizu*).

kabuki a form of dance-drama developed in Edo Japan and characterized by stylized movement, elaborate costume, and bold make-up.

karesansui a Japanese dry landscape garden; commonly known as a Japanese rock garden.

keystone a central stone, wider at the top than the bottom, placed at the summit of an arch to transfer the weight downward.

kitsch an object or design considered to be unrefined and in poor taste, typically due to garish ornamentation or overt sentimentality.

kondō literally, "golden hall"; the main hall of a Japanese Buddhist temple.

Kyūshū-ha an influential post-World War II avant-garde art group that formed in Kyūshū, Japan in the 1950s.

lacquer a liquid substance derived from the sap of the lacquer tree, used to varnish wood and other materials, producing a shiny, water-resistant coating.

lacquerware containers and other objects made with lacquer, a liquid substance derived from the sap of the lacquer tree; used to varnish wood and other materials, producing a shiny, water-resistant coating.

lantern ceiling a ceiling with four sloped surfaces rising at an angle from the walls to meet a flat, square plane parallel to the floor.

leaf a single page from an album (a format of painting).

linear perspective a system of representing three-dimensional space and objects on a two-dimensional surface by means of geometry and one or more vanishing points.

linga an abstract representation of the Hindu god Shiva that denotes his divine generative energy.

linocut a relief print created by carving lines and shapes in a block covered with linoleum or a similar substance.

literati in Confucian cultures of East Asia, the social group of educated men who would typically pursue government service as a career, but could also put their skills in reading, writing, and related arts to work through tutoring, writing, and painting.

literati painters educated artists, including scholar-officials, who brought literary values into painting, and pursued abstraction and self-expression in their art.

lithography a printing process in which images are drawn on a flat surface, such as fine-grained limestone or a metal plate, using a greasy substance; ink is then applied to the wetted surface, being repelled by the damp areas and sticking only to the greasy areas to print the desired image.

lost-wax casting a method of casting metals such as bronze in which a clay mold surrounds a wax model and is then fired; when the wax melts away, molten metal is poured in to fill the space.

low relief (also called bas-relief) raised forms that project only slightly from a flat background.

macramé knotting cord or string in patterns to make decorative items.

mandala typically comprised of concentric circles and squares, a spiritual diagram of the cosmos, used in Hinduism, Buddhism, and other Asian religions.

mandapa a porch or hall located before the inner sanctum of a Hindu temple.

mandorla (in religious art) a halo or frame that surrounds the entire body.

manga the Japanese term referring to cartoons, comics, and graphic novels.

mantra a sacred utterance; a word or sound believed to hold spiritual power that is repeated during meditation as a concentration aid.

manuscript a handwritten book or document.

material culture the materials, objects, and technologies that accompany everyday life.

mausoleum (plural **mausolea**): a building or freestanding monument that houses a burial chamber.

megalith a large stone used as, or as part of, a monument or other structure.

mihrab prayer niche, usually concave in shape with an arched top, located in the *qibla* wall of a mosque and indicating the direction of Mecca.

mimesis the attempt to imitate or represent reality.

minaret a tower at a mosque or Islamic tomb; can be used to give the call to prayer and also functions as a visible marker on the skyline.

mingei a Japanese term meaning "folk art"; refers to a movement championed by Yanagi Sōetsu, which favored unpretentious everyday objects made by skilled, anonymous artists.

Minimalism an artistic style in which elements are pared down to the bare minimum.

mithuna in South Asian cultures, an amorous couple, representing fecundity and considered auspicious.

mixed media artwork made from a combination of different materials.

Modernism a movement that promotes a radical break with past styles of art and the search for new modes of expression.

Modernist architecture a twentieth-century architectural movement that embraced modern industrial materials, a functional approach to design, and a machine aesthetic that rejected historical precedent and ornament.

molding a decorative architectural feature that covers the transition between two surfaces, such as the dividing line from one story, portal, or window framing, to another, or to the roofline of a building.

Mono-ha a Japanese term meaning "school of things"; refers to a movement of Korean and Japanese artists in Tokyo in the mid-1960s who explored the use of everyday and industrial materials in art.

monochrome made from shades of a single color.

monolith/monolithic a single large block of stone.

mosque a Muslim place of worship.

motif a distinctive visual element in an artwork, the recurrence of which is often characteristic of an artist's or a group's work.

mudra a symbolic gesture in Hinduism and Buddhism, usually involving the hand and fingers.

mungbangdo literally "scholar's study painting," a genre of Korean still-life painting in which books are the primary motif among items associated scholarly pursuits. In the sub-genre of *chaekgeori* (also called *chaekgado*), the items are arranged in a bookshelf.

mural a painting made directly on the surface of a wall.

naturalism/naturalistic representing people or nature in a detailed and accurate manner; the realistic depiction of objects in a natural setting.

negative space areas of a composition not occupied by objects or figures.

Neoclassicism a style of art and architecture that emerged during the eighteenth century in Europe and the Americas, inspired by Classical Greek and Roman examples, and characterized by order, symmetry, and restraint.

Neo-Confucianism drawing on Confucianism, Daoism, and Buddhism, a philosophy originating in China that provides a system of beliefs that undergird governance, especially civil-service examinations (flourishes in China, Korea, Japan, and Southeast Asia).

Neolithic a period of human history in which polished stone implements prevailed, roughly beginning about 10,000 BCE and persisting until the use of bronze metal implements. In East Asia, the Neolithic ends and the Bronze Age begins roughly around the second millennium BCE.

nephrite a hard, fibrous mineral used in the Liangzhu culture for making ritual objects; often called jade.

nihonga a Japanese term meaning "Japanese-style painting"; refers to painting in traditional materials (ink and/or colors on silk or paper) and often in traditional formats and genres.

Nio (also known as *kongo rikishi*): paired guardian statues often found at Buddhist temples in Japan.

non-figurative artwork that does not depict figures or motifs, and instead presents abstract elements such as line, shape, color, pattern, or textures.

Occidentalism refers to non-European cultures conceiving of European cultures in stereotyped ways, attributing either romanticized or negative qualities to them.

ocher a naturally occurring clay pigment that ranges in color from yellow to red, brown, or white.

one-point perspective a perspective system with a single vanishing point on the horizon.

onna-e literally, "women's painting," the category of Japanese painting characterized by heavy pigments, indirect expression of emotional content, and themes of pathos.

openwork decoration created by holes that pierce through an object.

oracle bones turtle plastrons and ox shoulder bones used for divination in the Shang state. Oracle bones are among the earliest examples of Chinese writing.

Orientalism refers to European cultures conceiving of North African, West Asian, and Asian cultures in stereotyped ways, attributing either romanticized or negative qualities to them.

orthodox in Chinese landscape painting, the style advocated by Dong Qichang; typically executed in ink only or with limited, light colors, such paintings tend to be abstract, relying on schematic conventions for rendering rocks, mountains, trees, and buildings, and often make reference to earlier painters' styles.

orthogonal when creating perspective in two dimensions, the diagonal parallel lines (visible or invisible) that recede from an object in the foreground or midground to a vanishing point on the horizon line.

otoko-e literally, "men's painting," the category of Japanese painting characterized by ink monochrome and/or light colors, facial expressions, physical gestures, and themes of humor and action.

pagoda in East Asia, the *stupa* form: a tall structure that houses Buddhist reliquaries.

painterly characterized by color and texture, rather than line.

palette (1) an artist's choice of colors. (2) the tray, board, or other surface on which an artist mixes colors of paint.

parchin kari an inlay technique in which small pieces of carefully cut and fitted colored stone are used to create patterns or images; often called *pietra dura* in English sources, adopting the Italian term.

parinirvana the death of someone who has achieved nirvana, or enlightenment, during his or her lifetime.

patina a layer of color applied to, or occurring along with related physical changes naturally over time upon, an object.

patron, patronage a person or institution that commissions artwork or funds an enterprise.

performance art linked to theater and dance, ephemeral events with a strong visual focus orchestrated by visual artists before an audience.

perspective the two-dimensional representation of a three-dimensional object or a volume of space.

petroglyph an image created on a rock surface through incision, picking, carving, or abrading.

physiognomy the shape, proportion, and composition of facial features.

picturesque an eighteenth-century aesthetic ideal of wild or natural beauty; in pictures, it tended to emphasize ruins, asymmetrical composition, and the grandeur of nature.

piece-mold casting method of casting metals such as bronze in which the mold is formed around a clay model, then cut into several pieces, and reassembled for casting.

pigment any substance used as a coloring material in paint, such as dry powders made from finely ground minerals.

pilaster a flat, rectangular vertical projection from a wall; usually has a base and a capital and can be fluted.

pile carpet a textile floor covering with an upper layer of pile (knotted pieces of yarn) attached to a woven backing.

pingdan an aesthetic sensibility promoted by the literati, *pingdan* is reserved in style, mild in taste.

pishtaq in Persian and/or Islamic architecture, a gateway consisting of a rectangular frame around an arched opening.

plinth a base or platform upon which a structure rests.

polychrome displaying several different colors.

Pop Art a movement beginning in the mid-1950s that used imagery from popular or "low" culture, such as comic books and consumer packaging, for art.

porcelain a smooth, translucent ceramic made from kaolin clay fired at very high temperatures.

postcolonialism the historical period or condition representing the aftermath of Western colonization; also, the associated socio-political critique of imperialism and its effects.

Postmodernism a late twentieth-century reaction to Modernism, typically defined by a rejection of grand narratives, absolute truth, and objective reality.

post-and-lintel a form of construction in which two upright posts support a horizontal beam (lintel).

Post-Impressionism a term coined by British artist and art critic Roger Fry in 1910 that refers not to a movement, but to a shared aesthetic attitude: namely, that an artist should develop novel ideas and techniques that move beyond both Academic convention and Impressionism.

potsherd broken piece of ceramic, especially one found at an archaeological site.

pradakshina in Hindu, Buddhist, and Jain practice, the ritual of walking around (circumambulating) a sacred place or object.

provenance the history of an artwork's ownership.

qi in Chinese philosophy, the vital force that animates life, being, and the cosmos.

qibla **wall** the wall in a mosque that indicates the direction toward which Muslims face to pray, usually indicated by the presence of a *mihrab*.

radiocarbon dating a scientific method of determining the age of an object, based on the presence of carbon-14 in organic material.

rammed earth a building technique in which damp earth is compressed, usually within a frame or mold, to form a solid structure.

register a horizontal section of a work, usually a clearly defined band or line.

relic the bodily remains of, or items believed to have come into physical contact with, the divine.

relief raised forms that project from a flat background.

reliquary a container for relics (items associated with a deceased sacred individual), which is often elaborately decorated.

Renaissance a period of Classically inspired cultural and artistic change in Europe from approximately the fourteenth to the mid-sixteenth centuries.

representational art that depicts a recognizable person, place, object, or other subject.

resin a highly viscous organic substance, insoluble in water, that is secreted by some plants and trees, such as pine, and hardens into an enamel-like, smooth finish. The term is also used for synthetic substances that set in a similar fashion.

resist-dyeing when dyeing textiles, the various methods used to create patterns by preventing the dye reaching the cloth in certain areas.

rock-cut carved from solid stone, where it naturally occurs.

Romanticism a movement from the late eighteenth through the mid-nineteenth centuries in European culture, concerned with the power of the imagination, and valuing intense feeling.

rubbing an image made by applying powdered ink onto a sheet of paper placed against a shallowly carved or textured surface.

ruled-line painting using rulers and compasses to render architecture and other complex, engineered structures with meticulous care.

scabbard a sheath used to cover the blade of a sword or dagger.

screen painting a format of East Asian painting, consisting of one or more panels; functions as a moveable piece of furniture to frame a significant area or subdivide a space.

seal either a small piece of hard material (stone) with an incised design, which is rolled or stamped on clay to leave an imprint; or the impression it leaves, generally of a person's name. Used in East Asia to signify ownership or authenticity, like a signature.

Shanghai School not literally a school, but a style of Chinese painting characterized by bright colors, bold compositions, and lively content that responded to the eclectic and commercial tastes of audiences in late nineteenth- and early twentieth-century Shanghai.

shikhara literally, "mountain peak," the tower above the inner sanctum of a Hindu temple, used specifically for north Indian temples.

shinkeizu Japanese "true-scenery," or "true-view" landscape painting; represents real, local places in a range of innovative and hybrid styles informed by literati taste and European visual strategies (see also *jingyeong sansuhwa*).

shogun a title granted by the Japanese emperor to the military leader and de facto ruler during the Kamakura, Muromachi, Momoyama, and Edo periods.

silhak the School of Practical Learning espoused by Joseon Confucian scholars interested in political reform.

slip a layer of fine clay or glaze applied to ceramics before firing.

Social Realism art that depicts subjects of social concern, in a style true to life.

Socialist Realism a style of art promoted in socialist nations, such as the People's Republic of China (PRC), and characterized by naturalistic but idealized representation of the body, clearly readable expressions and gestures, and narrative content promoting socialist ideals.

spire a tall, slender pointed structure on the top of a building.

spolia building materials or reliefs salvaged from other works and reused in a different structure.

stele, steles a carved stone slab that is placed upright and often features commemorative imagery and/or inscriptions.

stoneware a type of ceramic that is relatively high-fired and results in a non-porous body (unlike terra-cotta, or earthenware).

striated marked by lines or grooves.

stupa a mound-like or hemispherical structure containing Buddhist relics.

stupi the finial, often shaped like a bulbous pot, situated at the high point of a Hindu temple.

style characteristics that distinguish the artwork of individuals, schools, periods, and/or cultures from that of others.

stylized treated in a mannered or non-naturalistic way; often simplified or abstracted.

sutra in Buddhism, a scripture containing the teachings of the Buddha; more generally, a collection of teachings in Sanskrit, relating to some aspect of the conduct of life.

tableau a stationary scene of people or objects, arranged for artistic impact.

tantra Hindu and Buddhist esoteric philosophies and spiritual practices; the term also refers to the mystical texts that lay out such philosophies and practices.

taotie the name given to the composite animal mask frequently found on Shang bronzes.

tapestry a decorative textile in which pictures and/or designs are woven into the fabric.

tempera a fast-drying paint made from a mixture of powdered pigment and a binding agent, typically egg yolk.

tenshu the keep of a Japanese castle.

terra-cotta baked clay; also known as earthenware.

thangka a Tibetan term for a painting on either cotton or silk cloth that can be rolled up like a scroll (in Nepali the same type of painting is called *paubha*); typical subjects include mandalas, portraits of revered teachers, and religious icons.

Tibetan Buddhism centered in Tibetan regions, a branch of Esoteric (also Vajrayana or Tantric) Buddhism, which features secret teachings, requiring the assistance of an advanced instructor to access and understand, as well as the institution of reincarnated spiritual teachers, or *lamas*.

tokonoma an indoor alcove used to display artwork and seasonal plant cuttings.

torana a gateway marking the entrance to a Buddhist, Hindu, or Jain sacred structure.

trefoil a decorative shape, consisting of three lobes, like a clover with three leaves.

triptych a three-part work of art, often three panels attached together.

trompe l'oeil from the French meaning to "deceive the eye"; a visual illusion in art, in which a painted image appears as a three-dimensional object.

ukiyo-e literally, "pictures of the floating world," referring to paintings and especially woodblock prints that took as their subject matter the pleasures and sites of Edo Japan, including *kabuki* theater, courtesans, and places of leisure and travel.

underglaze a color or design applied to pottery before it is glazed and fired.

urna one of the thirty-two markers of a buddha or a *bodhisattva*; a tuft of hair or small dot between the eyebrows that symbolizes a third eye.

ushnisha one of the thirty-two markers of a buddha or a *bodhisattva*; a protuberance from the head, usually a topknot of hair.

vajra a term meaning thunderbolt or diamond; in Hinduism and Buddhism, a ritual weapon with the properties of a diamond (indestructibility) and a thunderbolt (irresistible force) to cut through illusions that obstruct enlightenment.

vanishing point when discussing perspective in two dimensions, the point on the horizon at which parallel lines seem to converge and disappear.

video art a form of art that uses moving images and sound recordings.

vihara a retreat for Buddhist monks and nuns.

vimana the tower above the inner sanctum of a Hindu temple in south India.

votive an image or object created as a devotional offering to a deity.

wabi in traditional Japanese arts, acceptance and contemplation of simplicity, and detachment.

wabi-cha rustic style of *chanoyū*, promoted by tea master Sen no Rikyū.

warp in textile weaving, the stationary, vertical threads attached to a loom, over and under which the weft threads are passed to make cloth.

wax-resist a technique of ornamentation in which wax is applied to a surface before applying coloring; the areas of wax "resist" the coloring.

wayang kulit an Indonesian shadow-puppet play.

weft in textile weaving, the crosswise, horizontal threads on a loom that are woven over and under the warp threads to make cloth.

Western a term used in the modern era to claim shared civilization and institutions originating in Europe among predominantly white people; term extended to North America and other parts of the world heavily marked by European colonization.

woodblock printing a relief printing process where the image is carved into a block of wood; the raised areas are inked. (For color printing, multiple blocks are used, each carrying a separate color.)

Woodcut Movement in 1930s China, the collective effort of the writer Lu Xun and artists to use woodcuts as a vehicle for education, mobilization, and social change.

yaksha a semi-divine male earth spirit.

yakshi a semi-divine female earth spirit.

yōga a Japanese term for Western-style painting, or oil painting.

yosegi-zukuri a Japanese technique for making wood sculpture by joining multiple blocks together.

Zen Buddhism literally meaning "meditation," a Japanese school of Mahayana Buddhism that traces its founding to Bodhidharma.

zoomorphic having an animal-like form.

Bibliography

INTRODUCTION

Bryson, Norman. "The gaze in the expanded field." In Hal Foster, ed. *Vision and Visuality*. Seattle, WA: Bay View Press/Dia Art Foundation, 1988, pp. 91–94.

Lewis, Martin W. and Wigen, Kären. *The Myth of the Continents: A Critique of Metageography*. Berkeley and Los Angeles, CA: University of California Press, 1997.

Mathur, Saloni. "Diasporic Body Double: The Art of the Singh Twins." In Rebecca M. Brown and Deborah S. Hutton (eds.). *A Companion to Asian Art and Architecture*. Malden, MA: Wiley-Blackwell, 2011, pp. 318–38.

CHAPTER 1

Bangudae Petroglyphs Institute, University of Ulsan, ed. *Bangudae: Petroglyph Panels in Ulsan, Korea in the Context of World Rock Art*. Seoul: Hollym, 2013.

Baker, Donald L. "Introduction: The Contours of Korea's Cultural History." In J. P. Park, Burglind Jungmann, and Juhyung Rhi (eds.). *A Companion to Korean Art*. Hoboken, NJ: Wiley-Blackwell, 2020.

Chakrabarti, Dilip K. *The Oxford Companion to Indian Archaeology: The Archaeological Foundations of Ancient India, Stone Age to AD 13th Century*. New Delhi: Oxford University Press, 2006.

Chang, K. C., *et al*. *The Formation of Chinese Civilization: An Archaeological Perspective*. New Haven, CT: Yale University Press, 2005.

Childs-Johnson, Elizabeth. "Jades of the Hongshan Culture: The Dragon and Fertility Cult Worship." *Arts Asiatiques* 46 (1991): 82–95.

Coningham, Robin and Young, Ruth. *The Archaeology of South Asia: From the Indus to Asoka, c. 6500 BCE–200 CE*. Cambridge, U.K.: Cambridge University Press, 2015.

Habu, Junko, Lape, Peter V., and Olsen, John W. *Handbook of East and Southeast Asian Archaeology*. New York, NY: Springer New York: 2017..

Mizoguchi, Koji. *An Archaeological History of Japan: 30,000 BC to AD 700*. Philadelphia, PA: University of Pennsylvania Press, 2002.

Reid, Anthony. *A History of Southeast Asia: Critical Crossroads. The Blackwell History of the World*. Malden, MA: Wiley Blackwell, 2015.

Stark, Miriam T., ed. *Archaeology of Asia*, vol. 7 in the Blackwell Studies in Global Archaeology. Malden, MA: Blackwell, 2006.

Yang, Xiaoneng, ed. *The Golden Age of Chinese Archaeology: Celebrated Discoveries from the People's Republic of China*. Washington, D.C.: National Gallery of Art, 1999.

Yang, Xiaoneng, ed. *New Perspectives of China's Past: Chinese Archaeology in the Twentieth Century*. New Haven, CT: Yale University Press, 2004.

CHAPTER 2

Byington, Mark, ed. *The Han Commanderies in Early Korean History*. Cambridge, MA: Korea Institute, Harvard University, 2013.

Liu, Cary Y., Nylan, Michael, Barbieri-Low, Anthony, et al. *Recarving China's Past: Art, Archaeology, and Architecture of the "Wu Family Shrines."* Princeton, NJ: Princeton University Art Museum; New Haven, CT: Yale University Press, 2005.

Pai, Hyung Il. "Culture Contact and Culture Change: The Korean Peninsula and Its Relations with the Han Dynasty Commandery of Lelang." *World Archaeology* 23, no. 3 (1992): 306–19.

Powers, Martin. *Art and Political Expression in Early China*. New Haven, CT: Yale University Press, 1991.

Underhill, Anne P., ed. *A Companion to Chinese Archaeology*. Chichester, U.K.: Wiley-Blackwell, 2013.

Wu, Hung. *Monumentality in Early Chinese Art and Architecture*. Oxford, U.K.: Oxford University Press, 1996.

Wu, Hung. *The Wu Liang Shrine: The Ideology of Early Chinese Pictorial Art*. Stanford, CA: Stanford University Press, 1992.

CHAPTER 3

Asher, Frederic M., ed. *Art of India: Prehistory to the Present*. Chicago, IL: Encyclopaedia Britannica, 2003.

Behrendt, Kurt A. *Art of Gandhara in the Metropolitan Museum of Art*. New York, NY: Metropolitan Museum of Art, 2007.

Cummins, Joan, ed. *Vishnu: Hinduism's Blue-Skinned Savior*. Nashville, TN: Frist Center for the Visual Arts; Ahmedabad, India: Mapin Publishing, 2011.

Dehejia, Vidya. "On Modes of Narration in Early Buddhist Art." *Art Bulletin* 72 (1990): 374–92.

Embree, Ainslie T., ed. *Sources of Indian Tradition*. 2 vols. New York, NY: Columbia University Press, 1988.

Fisher, Robert E. *Buddhist Art and Architecture*. London: Thames & Hudson, 1993.

Flood, Gavin. *An Introduction to Hinduism*. New York, NY: Cambridge University Press, 1996.

Fogelin, Lars. *An Archaeological History of Indian Buddhism*. Oxford, U.K.: Oxford University Press, 2015.

Karlsson, Klemens. "The Formation of Early Buddhist Visual Culture." *Material Religion* 2, no. 1 (2006): 68–96.

Pal, Pratapaditya, ed. *The Peaceful Liberators: Jain Art from India*. London and New York, NY: Thames & Hudson, 1994.

Whitfield, Susan. *Silk, Slaves, and Stupas: Material Culture of the Silk Road*. Oakland, CA: University of California Press, 2018.

Willis, Michael. *The Archaeology of Hindu Ritual: Temples and the Establishment of the Gods*. Cambridge, U.K.: Cambridge University Press, 2009.

CHAPTER 4

Allard, Francis, Sun, Yan, and Linduff, Kathryn M. (eds.). *Memory and Agency in Ancient China: Shaping the Life History of Objects*. Cambridge, U.K.: Cambridge University Press, 2018.

Barnes, Gina. "A Hypothesis for Early Kofun Rulership." *Japan Review* 27 (2014): 3–29.

Byington, Marc E., ed. *The Rediscovery of Kaya in History and Archaeology*. Cambridge, MA: Early Korea Project, Korea Institute, Harvard University, 2012.

Byington, Marc E., ed. *The Samhan Period in Korean History*. Vol. 2. Cambridge, MA: Early Korea Project, Korea Institute, Harvard University, 2009.

Coaldrake, William H. *Architecture and Authority in Japan*. London and New York: Routledge, 1996.

Harris, Victor, ed. *Shintō: The Sacred Art of Ancient Japan*. London: British Museum Press, 2001.

Haugen, Angela Jean. "Mounded Tomb Cultures of Three Kingdoms Period Korea and Yamato Japan: A Study of Golden Regalia and Cultural Interactions." M.A. thesis: The Ohio State University, OH, 2010.

Hudson, Mark J. "Rice, Bronze, and Chieftains: An Archaeology of Yayoi Ritual." *Japanese Journal of Religious Studies* 19, nos. 2/3 (June–September 1992): 139–89.

Hudson, Mark J., and Barnes, Gina. "Yoshinogari. A Yayoi Settlement in Northern Kyushu." *Monumenta Nipponica* 46, no. 2 (1991): 211–35.

Mason, Penelope. *History of Japanese Art*, 2nd edn. revised by Donald Dinwiddie. Upper Saddle River, NJ: Pearson Education, 2005.

Miller, Laura. "Rebranding Himiko, the Shaman Queen of Ancient History." *Mechademia* 9 (2014): 179–98.

Mizoguchi, Koji. *The Archaeology of Japan*. Cambridge, U.K.: Cambridge University Press, 2013.

Morris, Martin N. "From the Ground Up: The Reconstruction of Japanese Historic Buildings from Excavated Archaeological Data." *Japan Review*, no. 11 (1999): 3–30.

Nelson, Sarah M. *The Archaeology of Korea*. Cambridge, U.K.: Cambridge University Press, 1993.

Pak, Young-sook. "The Origins of Silla Metalwork." *Orientations* 19, no. 9 (1988): 44–53.

Portal, Jane. *Korea: Art and Archaeology*. London: British Museum Press, 2000.

Rhie, Marilyn M. *Early Buddhist Art of China and Central Asia*. Leiden, Netherlands; Boston, MA: Brill, 1999.

Thorp, Robert L. and Vinograd, Richard Ellis. *Chinese Art and Culture*. New York: Harry N. Abrams, 2001.

Whitfield, Roderick, Whitfield, Susan, and Agnew, Neville. *Cave Temples of Mogao at Dunhuang: Art and History on the Silk Road*. Los Angeles, CA: Getty Conservation Institute and the J. Paul Getty Museum, 2000.

CHAPTER 5

Behl, Benoy K. *The Ajanta Caves: Artistic Wonder of Ancient Buddhist India*. New York: Harry N. Abrams, 1998.

Chicarelli, Charles F. *Buddhist Art: An Illustrated Introduction*. Chiang-Mai, Thailand: Silkworm Books, 2004.

Cummins, Joan. *Indian Painting: from Cave Temples to the Colonial Period*. Boston, MA: MFA Publications, 2006.

Dehejia, Vidya and Davis, Richard H. "Addition, Erasure, and Adaption: Interventions in the Rock-Cut Monuments of Mamallapuram." *Archives of Asian Art* 60 (2010): 1–18.

European Synchrotron Radiation Facility. "Ancient Buddhist Paintings From Bamiyan Were Made Of Oil, Hundreds Of Years Before Technique Was 'Invented' In Europe." *ScienceDaily*, ScienceDaily.com, April 22, 2008.

Hutt, Michael. *Nepal: A Guide to the Art and Architecture of the Kathmandu Valley*. New Delhi: Adroit, 2010.

Jackson, David P. *Mirror of the Buddha: Early Portraits from Tibet*. New York: Rubin Museum of Art, 2011.

Kim, Jinah. *Receptacle of the Sacred: Illustrated Manuscripts and the Buddhist Book Cult in South Asia*. Berkeley, CA: University of California Press, 2013.

Klimburg-Salter, Deborah. *The Kingdom of Bamiyan: Buddhist Art and Culture of the Hindu Kush*. Naples and Rome, Italy: Instituto Universitario Orientale and Instituto Italiano per il Medio ed Estremo Oriente, 1989.

Lavy, Paul. "As in Heaven, So on Earth: The Politics of Visnu, Siva, and Harihara Images in Preangkorian Khmer Civilisation." *Journal of Southeast Asian Studies* 34 (2003): 21–39.

Llewelyn, Morgan. *The Buddhas of Bamiyan.* Cambridge, MA: Harvard University Press, 2012.

Ngô Văn Doanh. *My Son Relics.* Hanoi: The Gioi Publishers, 2005.

Owens, Bruce McCoy. "Monumentality, Identity, and the State: Local Practice, World Heritage, and Heterotopia at Swayambhu, Nepal." *Anthropological Quarterly* 75, no. 2 (2002): 269–316.

Siriweera, W. I. *History of Sri Lanka.* Colombo: Dayawansa Jayakodi & Company, 2004.

Taniguchi Yoko. "Cultural Identity and the Revival of Values After the Demolition of Bamiyan's Buddhist Wall Paintings." In Nagaoka Masanori, ed. *The Future of the Bamiyan Buddha Statues: Heritage Reconstruction in Theory and Practice.* Cham, Switzerland: Springer, 2020.

van Dyke, Yana. "Sacred Leaves: The Conservation and Exhibition of Early Buddhist Manuscripts on Palm Leaves." *The Book and Paper Group Annual* 28 (2009): 83–97.

CHAPTER 6

Ashley, Kathleen and Plesch, Véronique. "The Cultural Processes of 'Appropriation.'" *Journal of Medieval and Early Modern Studies* 32, no.1 (Winter 2002): 1–15.

Akiyama, Terukazu; translated and adapted by Maribeth Graybill. "Women Painters at the Heian Court." In Marsha Weidner, ed. *Flowering in the Shadows: Women in the History of Chinese and Japanese Painting.* Honolulu, HI: University of Hawai'i Press, 1990, pp. 159–84.

Béguin, Gilles. *Buddhist Art: An Historical and Cultural Journey.* Bangkok: River Books, 2009.

Bogel, Cynthea J. *With a Single Glance: Buddhist Icon and Early Mikkyō Vision.* Seattle, WA: University of Washington Press, 2009.

Byington, Marc E., ed. *The Rediscovery of Kaya in History and Archaeology.* Cambridge, MA: Early Korea Project, Korea Institute, Harvard University, 2012.

Byington, Marc E., ed. *The Samhan Period in Korean History.* Cambridge, MA: Early Korea Project, Korea Institute, Harvard University, 2009.

Fisher, Robert E. *Buddhist Art and Architecture.* New York: Thames & Hudson, 1993.

Harrell, Mark. "Sokkuram: Buddhist Monument and Political Statement in Korea." *World Archaeology* 27, no. 2 Buddhist Archaeology (October 1995): 318–35.

Karetzky, Patricia Eichenbaum. *Early Buddhist Narrative Art: Illustrations of the Life of the Buddha from Central Asia to China, Korea, and Japan.* Lanham, MD: University Press of America, 2000.

Kim, Youn-mi, ed. *New Perspectives on Early Korean Art: From Silla to Koryŏ.* Cambridge, MA: Korean Institute, Harvard University, 2013.

Lee, Junghee. "The Origins and Development of the Pensive Bodhisattva Images of Asia." *Artibus Asiae* 53, no. 3/4 (1993): 311–57.

Lee, Soyoung and Patry Leidy, Denise. *Silla: Korea's Golden Kingdom.* New York: The Metropolitan Museum of Art, 2013.

McCallum, Donald F. "The Earliest Buddhist Statues in Japan." *Artibus Asiae* 61, no. 2 (2001): 149–88.

McCallum, Donald F. *The Four Great Temples: Buddhist Archaeology, Architecture, and Icons of Seventh-Century Japan.* Honolulu, HI: University of Hawai'i Press, 2008.

Portal, Jane. *Korea: Art and Archaeology.* London: British Museum Press, 2000.

Rong, Xinjiang. "The Nature of the Dunhuang Library Cave and the Reasons for Its Sealing." Trans. Valerie Hansen. *Cahiers d'Extrême-Asie* 11 (1999–2000): 247–75.

Seckel, Dietrich, *Buddhist Art of East Asia.* Trans. Ulrich Mammitzsch. Bellingham, WA: Western Washington University, 1989.

Sharf, Robert H. "The Buddha's Finger Bones at Famensi and the Art of Chinese Esoteric Buddhism." *The Art Bulletin* 93, no. 1 (March 2011): 38–59.

Shimizu, Yoshiaki. "The Rite of Writing: Thoughts on the Oldest Genji Text." *RES: Anthropology and Aesthetics* 16 (Autumn 1988): 54–63.

Stanley-Baker, Richard, *et al. Reading the Tale of Genji: Its Picture Scrolls, Texts and Romance.* Leiden, Netherlands: Brill, 2009.

Steinhardt, Nancy Shatzman. "China's Earliest Mosques." *Journal of the Society of Architectural Historians,* 67, no. 3 (September 2008): 330–61.

Ten Grotenhuis, Elizabeth. *Japanese Mandalas: Representations of Sacred Geography.* Honolulu, HI: University of Hawai'i Press, 1999.

Walley, Akiko. *Constructing the Dharma King: The Hōryūji Shaka Triad and the Birth of the Prince Shōtoku Cult.* Leiden, Netherlands: Brill, 2015.

Yiengpruksawan, Mimi Hall. "The Phoenix Hall at Uji and the Symmetries of Replication." *The Art Bulletin* 77, no. 4 (December 1995): 647–72.

CHAPTER 7

Dehejia, Vidya. *Art of the Imperial Cholas.* New York: Columbia University Press, 1990.

Desai, Devangana. *Khajuraho: Monumental Legacy.* New Delhi and New York: Oxford University Press, 2000.

—. *The Religious Imagery of Khajuraho.* Mumbai: Franco-Indian Research, 1996.

Freeman, Michael and Jacques, Claude. *Ancient Angkor.* Bangkok: River Books, 1999.

Frédéric, Louis. *Borobudur.* New York: Abbeville Press, 1996.

Jessup, Helen Ibbitson. *Art & Architecture of Cambodia. World of Art.* New York: Thames & Hudson, 2004.

Kaimal, Padma. "Shiva Nataraja: Multiple Meanings of an Icon." In Rebecca M. Brown and Deborah S. Hutton (eds.). *A Companion to Asian Art and Architecture.* Malden, MA: Wiley-Blackwell, 2011, pp. 471–85.

Kerlogue, Fiona. *Arts of Southeast Asia (World of Art).* London and New York: Thames & Hudson, 2004.

Mannikka, Eleanor. *Angkor Wat: Time, Space, and Kingship.* Honolulu, HI: University of Hawai'i Press, 1996.

Maxwell, Thomas S. *Of Gods, Kings, and Men: The Reliefs of Angkor Wat.* Chiang Mai, Thailand: Silkworm Books, 2006.

Michell, George. *The Hindu Temple: An Introduction to its Meaning and Forms.* Chicago, IL: University of Chicago Press, 1988.

Michell, George, *et al. The Great Temple at Thanjavur: One Thousand Years, 1010–2010.* Mumbai: Marg Foundation, 2010.

Miksic, John N., *et al. Borobudur: Majestic, Mysterious, Magnificent.* Yogyakarta, Indonesia: Taman Wisata Candi Borobudur, Prambanan & Ratu Boko, 2010.

Rian, Iasef Md, Park, Jin-Ho, Ahn, Hyung Uk, and Chang, Dongkuk. "Fractal geometry as the synthesis of Hindu cosmology in Kandariya Mahadev temple, Khajuraho." *Building and Environment* 42 (2007): 4093–4107.

Sears, Tamara. "In the Gaze of the Guru: *Shikshadana* Scenes at Khajuraho." In Anila Verghese and Anna L. Dallapiccola (eds.). *Art, Icon, and Architecture in South Asia: Essays in Honour of Dr. Devangana Desai.* New Delhi: Aryan Books International, 2015, pp. 151–68.

CHAPTER 8

Bickford, Maggie and Ebrey, Patricia Buckley. *Emperor Huizong and Late Northern Song China.* Harvard East Asian Monographs 266. Cambridge, MA: Harvard University Asia Center, 2006.

Clunas, Craig. *Art in China.* 2nd edn. Oxford, U.K.: Oxford University Press, 2009.

Hammers, Roslyn Lee. "'Khubilai Khan Hunting': Tribute to the Great Khan." *Artibus Asiae* 75, no. 1 (2015): 5–44.

Jing, Anning. "The Portraits of Khubilai Khan and Chabi by Anige (1245–1306), a Nepali Artist at the Yuan Court." *Artibus Asiae* 54, no. 1/2 (1994): 40–86.

Li, Zhiyan, Bower, Virginia L., and Li, He (eds.). *Chinese Ceramics: From the Paleolithic Period through the Qing Dynasty.* New Haven, CT: Yale University Press, 2010.

Weidner, Marsha, ed. *Latter Days of the Law: Images of Chinese Buddhism, 850–1850.* Lawrence, KS: Spencer Museum of Art, University of Kansas, 1994.

Weidner, Marsha, *et al. Views from Jade Terrace: Chinese Women Artists, 1300–1912.* Indianapolis, IN: Rizzoli, 1988.

Watt, James C. Y., ed. *The World of Khubilai Khan: Chinese Art in the Yuan Dynasty.* New York: The Metropolitan Museum of Art, 2010.

Wyatt, Don. *The Blacks of Premodern China.* Philadelphia, PA: University of Pennsylvania Press, 2009.

Wyatt, Don. "The Image of the Black in Chinese Art." In David Bindman, Suzanne Preston Blier, and Henry Louis Gates, Jr. (eds.). *The Image of the Black in African and Asian Art.* Cambridge, MA: The Belknap Press of Harvard University Press, 2017.

CHAPTER 9

Coaldrake, William Howard. *Architecture and Authority in Japan.* London and New York: Routledge, 1996.

Dutton, Anne, trans. "The Enlightenment of Chiyono." In Stephen Addiss, ed. *Zen Sourcebook Traditional Documents from China, Korea, and Japan.* 2000, pp. 175–79.

Jungmann, Burglind. "Changing Notions of 'Feminine Spaces' in Chosŏn Dynasty Korea: The Forged Image of Sin Saimdang (1504–1551)." *Archives of Asian Art* 68 (2018): 47–66.

Jungmann, Burglind. "Sin Sukju's Record on the Painting Collection of Prince Anpyeong and Early Joseon Antiquarianism." *Archives of Asian Art* 61 (2011): 107–26.

Keene, Donald. *Yoshimasa and the Silver Pavilion: The Creation of the Soul of Japan.* New York: Columbia University Press, 2006.

Kim, Kumja Paik. *Goryeo Dynasty: Korea's Age of Enlightenment.* San Francisco, CA: Asian Art Museum, 2003.

Kuitert, Wybe. *Themes in the History of Japanese Garden Art.* Honolulu, HI: University of Hawai'i Press, 2002.

Lee, Sang Hae. "Continuity and Consistency of the Traditional Courtyard House Plan in Modern Korean Dwellings." *Traditional Dwellings and Settlements Review* 3, no. 1 (1991): 65–76.

Lee, Soyoung and Jeon, Seung-chang. *Korean Bucheong Ceramics from Leeum, Samsung Museum of Art.* New York: The Metropolitan Museum of Art/ Yale University Press, 2011.

Levine, Gregory P. A. *Daitokuji: The Visual Cultures of a Zen Monastery.* Seattle, WA: University of Washington Press, 2005.

Lippit, Yukio. "Goryeo Buddhist Painting in an Interregional Context." *Ars Orientalis* 35 (2008): 192–232.

Lippit, Yukio. *Japanese Zen Buddhism and the Impossible Painting.* Los Angeles, CA: The Getty Research Institute, 2017.

Lippit, Yukio. "Of Modes and Manners in Japanese Ink Painting: Sesshū's 'Splashed Ink Landscape' of 1495" *The Art Bulletin* Vol. 94, no. 1 (March 2012): 50–77.

McBride II, Richard D. "Koryo Buddhist Paintings and the Cult of Amitabha: Visions of a Hwaom-Inspired Pure Land." *Journal of Korean Religions* 6, no. 1 (April 2015): 93–130.

Nishikawa, Kyōtarō. *Chinsō chokoku.* In *Nihon no bijutsu*, no. 123. Tokyo: Shibundō, 1976.

Ogawa, Morihiro. "A Famous Fourteenth-Century Japanese Armor." *Metropolitan Museum Journal* 24 (1989): 75–83.

Pitelka, Morgan. *Handmade Culture: Raku Potters, Patrons, and Tea Practitioners in Japan.* Honolulu, HI: University of Hawai'i Press, 2005.

Pitelka, Morgan. "Warriors, Tea, and Art in Premodern Japan." *Bulletin of the Detroit Institute of Arts* 88, no. 1/4 (2014): 20–33.

Portal, Jane. *Korea: Art and Archaeology.* London: British Museum Press, 2000.

Ruch, Barbara. "Unheeded Voices: Winked-at Lives." In Adriana Boscaro, Franco Gatti, and Massimo Raveri (eds.). *Rethinking Japan* vol. 1 "Literature, Visual Arts, and Linguistics." New York: St. Martin's Press, 1990, pp. 101–9.

Ruch, Barbara, ed. *Engendering Faith: Women and Buddhism in Premodern Japan.* Ann Arbor, MI: Center for Japanese Studies, The University of Michigan, 2002.

Shimizu, Yoshiaki, ed. *Japan: The Shaping of Daimyo Culture, 1185–1868.* Washington, D.C.: National Gallery of Art, 1988.

Wang, Ching-ling. "Reconsidering a Fourteenth-Century Buddhist Painting of the Water-Moon Avalokitesvara in the Rijksmuseum." *The Rijksmuseum Bulletin* 66, no. 2 (2018): 100–19.

Watsky, Andrew M. "Representation in the Nonrepresentational Arts: Poetry and Pots in Sixteenth-Century Japan." *Impressions* 34 (2013): 140–49.

Yamada, Shoji. *Shots in the Dark: Japan, Zen, and the West.* Chicago, IL: University of Chicago Press, 2011.

Yamafune, Kotaro. "Portuguese Ships on Japanese Namban Screens." M.A. thesis. Texas A&M University, 2012.

CHAPTER 10

Balaram Iyer, T. G. S. *History and Description of Sri Meenakshi Temple.* Madurai, India: Sri Karthak Agency, 2013.

Branfoot, Crispin. "The Tamil Gopura: From Temple Gateway to Global Icon." *Ars Orientalis* 45 (2015): 78–112.

Brown, Roxanne M. *The Ming Gap and Shipwreck Ceramics in Southeast Asia.* Bangkok: Siam Society under Royal Patronage, 2009.

Farhad, Massumeh, *et al. The Art of the Qur'an: Treasures from the Museum of Turkish and Islamic Arts.* Washington, D.C.: Arthur M. Sackler Gallery, Smithsonian Institution, 2016.

Guy, John. *Woven Cargoes: Indian Textiles in the East.* London and New York: Thames & Hudson, 1998.

Hillenbrand, Carole. *Introduction to Islam: Beliefs and Practices in Historical Perspective.* London and New York: Thames & Hudson, 2015.

Michell, George. *Architecture and Art of Southern India: Vijayanagara and the Successor States 1350–1750. The New Cambridge History of India.* Cambridge, U.K.: Cambridge University Press, 1995.

O'Neill, Hugh. "South-East Asia." In Martin Frishman and Hasan-Uddin Khan (eds.). *The Mosque: History, Architectural Development & Regional Diversity.* London and New York: Thames & Hudson, 1994, pp. 224–40.

Pal, Pratapaditya. *The Peaceful Liberators: Jain Art from India.* London and New York: Thames & Hudson; Los Angeles, CA: Los Angeles County Museum of Art, 1994.

Titley, Norah M. *The Ni'matnāma Manuscript of the Sultans of Mandu.* London and New York: Routledge, 2005.

Verghese, Anila. "Deities, Cults and Kings at Vijayanagara." *World Archaeology* 36, no. 3 (2004): 416–31.

Wagoner, Phillip B. "'Sultan among Hindu Kings': Dress, Titles, and the Islamicization of Hindu Culture at Vijayangara." *The Journal of Asian Studies* 55, no. 4 (1996): 851–80.

CHAPTER 11

Aitken, Molly Emma. *The Intelligence of Tradition in Rajput Court Painting.* New Haven, CT and London: Yale University Press, 2010.

Asher, Catherine B. "Fantasizing the Mughals and Popular Perceptions of the Taj Mahal." In Christiane Brosius, Sumathi Ramaswamy, and Yousuf Saeed (eds.). *Visual Homes, Image Worlds: Essays from Tasveer Ghar, The House of Pictures.* New Delhi: Yoda Press, 2015, pp. 121–35.

Asher, Catherine B. "Jaipur: City of Tolerance and Progress." *South Asia: Journal of South Asian Studies* 37 (2014): 410–30.

Dalrymple, William and Sharma, Yuthika (eds.). *Princes and Painters in Mughal Delhi, 1707–1857.* New York: Asia Society Museum; New Haven, CT and London: Yale University Press, 2012.

Denny, Walter B. "Carpets, Textiles, and Trade in the Early Modern Islamic World." In Finbarr Barry Flood and Gulru Necipoglu (eds.). *A Companion to Islamic Art and Architecture.* Walden, MA: Wiley-Blackwell, 2017, pp. 972–95.

Diamond, Debra, Glynn, Catherine, and Singh Jasol, Karni. *Garden & Cosmos: The Royal Paintings of Jodhpur.* Washington D.C.: Arthur M. Sackler Gallery, Smithsonian Institution, 2008.

Hutton, Deborah. *Art of the Court of Bijapur.* Bloomington, IN: Indiana University Press, 2006.

Koch, Ebba. "Taj Mahal: Architecture, Symbolism, and Urban Significance." *Muqarnas* 12 (2005): 128–49.

Lal, Ruby. *Empress: The Astonishing Reign of Nur Jahan.* New York: W.W. Norton and Company, 2018.

McInerney, Terence, with Kossak, Steven M. and Haidar, Navina Najat. *Divine Pleasures: Paintings from India's Rajput Courts: The Kronos Collections.* New York: The Metropolitan Museum of Art, 2016.

Rice, Yael. "Moonlight Empire: Lunar Imagery in Mughal India." In Christiane Gruber, ed. *The Moon: A Voyage through Time.* Toronto, Canada: The Aga Khan Museum, 2019, pp. 56–62.

Richards, John F. "Early Modern India and World History." *Journal of World History* 8/2 (1997): 197–209.

Singh, Kavita. *Real Birds in Imagined Gardens: Mughal Painting between Persia and Europe.* Los Angeles, CA: Getty Research Institute, 2017.

Zebrowski, Mark. *Gold, Silver and Bronze from Mughal India.* London: Laurence King Publishing, 1997.

CHAPTER 12

Berger, Patricia. *Empire of Emptiness: Buddhist Art and Political Authority in Qing China.* Honolulu, HI: University of Hawai'i Press, 2003.

Brown, Claudia/ *Great Qing: Painting in China, 1644–1912.* Seattle, WA: University of Washington Press, 2014.

Cahill, James. *The Painter's Practice: How Artists Lived and Worked in Traditional China.* New York: Columbia University Press, 1994.

Clunas, Craig. *Chinese Paintings and Its Audiences.* Princeton, NJ: Princeton University Press, 2017.

Debreczeny, Karl. *Faith and Empire: Art and Politics in Tibetan Buddhism.* New York: Rubin Museum of Art, 2019.

Hay, Jonathan. *Shitao: Painting and Modernity in Early Qing China.* Cambridge, U.K.: Cambridge University Press, 2001.

Keita, Maghan. "Africans and Asians: Historiography and the Long View of Global Interaction." *Journal of World History* 16, no.1 (March 2005): 1–30.

Kleutghen, Kristina. *Imperial Illusions: Crossing Pictorial Boundaries in the Qing Palaces.* Seattle, WA: University of Washington Press, 2015.

Liu, Heping. "Picturing Yu Controlling the Flood: Technology, Ecology, and Emperorship in Northern Song China." In Dagmar Schäfer, ed. *Cultures of Knowledge: Technology in Chinese History.* Leiden, Netherlands: Brill, 2012, pp. 91–126.

Ma, Yachen. "Picturing Suzhou: Visual Politics in the Making of Cityscapes in Eighteenth-Century China." Ph.D. diss. Stanford University, 2007.

Peterson, Barbara Bennett. "The Ming Voyages of Cheng Ho (Zheng He), 1371–1433." *The Great Circle* 16, no. 1 (1994): 43–51.

Sturman, Peter, *et al. The Artful Recluse: Painting, Poetry, and Politics in Seventeenth-Century China.* Santa Barbara, CA: Santa Barbara Museum of Art, 2012.

Watt, James C. Y. "The Giraffe as the Mythical Qilin in Chinese Art: A Painting and a Rank Badge in the Metropolitan Museum." *Metropolitan Museum Journal* 43 (2008): 111–15.

Weidner, Marsha, ed. *Flowering in the Shadows: Women in the History of Chinese and Japanese Painting.* Honolulu, HI: University of Hawai'i Press, 1990.

Weidner, Marsha. *Latter Days of the Law: Images of Chinese Buddhism, 850–1850.* Lawrence, KS: Spencer Museum of Art, University of Kansas; Honolulu, HI: University of Hawai'i Press, 1994.

Wilson, Samuel M. *The Emperor's Giraffe and Other Stories of Cultures in Contract.* Boulder, CO: Westview Press, 1999.

Wu, Hung. *The Double Screen: Medium and Representation in Chinese Painting.* Chicago, IL: University of Chicago Press, 1996.

CHAPTER 13

Chung, Byungmo, *et al. Chaekgeori: The Power and Pleasure of Possessions in Korean Painted Screens.* Seoul, Korea: Dahal Media, 2017.

Dubreuil, Chisato O. "Ainu Art on the Backs of Gods: Two Exquisite Examples in the DIA Collection." *Bulletin of the Detroit Institute of Arts* (2002) 72, no. 1/2: 4–17.

Fischer, Felice. *Ike Taiga and Tokuyama Gyokuran: Japanese Masters of the Brush.* Philadelphia, PA: Philadelphia Museum of Art; New Haven, CT: Yale University Press, 2007.

Guth, Christine. *Art of Edo Japan: The Artist and the City, 1615–1868.* New York: Harry N. Abrams, 1996.

Kim, Hongnam. *Korean Arts of the Eighteenth Century: Splendor and Simplicity.* New York: Weatherhill and Asia Society Galleries, 1993.

Kim, Sunglim. "*Chaekgeori:* Multi-dimensional Messages in Late Joseon Korea." *Archives of Asian Art* 64, no. 1 (2014): 3–32.

Kim, Sunglim: *Flowering Plums and Curio Cabinets: The Culture of Objects in Late Chosŏn Korean Art,* Seattle, WA: University of Washington Press, 2018.

Kingdon, Nathaniel. "Half the Picture: Korean Scholars and the Environment in the Early Nineteenth Century." In De-nin D. Lee, ed. *Eco-Art History in East and Southeast Asia.* Newcastle-upon-Tyne, U.K.: Cambridge Scholars Publishing, 2019, pp. 47–85.

Lippit, Yukio. *Colorful Realm: Japanese Bird-and-Flower Paintings by Itō Jakuchū*. Washington, D.C.: National Gallery of Art, 2012.

McCormick, Sooa. "Re-Reading Imagery of Tilling and Weaving in the Context of the Little Ice Age. In De-nin D. Lee, ed. *Eco-Art History in East and Southeast Asia*. Newcastle-upon-Tyne, U.K.: Cambridge Scholars Publishing, 2019, pp. 1–45.

The Metropolitan Museum of Art presents a video montage of the Diamond Mountains, Korea: https://www.metmuseum.org/metmedia/video/collections/asian/diamond-mountains (Accessed October 18, 2021).

Park, J. P. "The Anxiety of Influence: (Mis)reading Chinese Art in Late Chosŏn Korea (1700–1850)." *The Art Bulletin* 97, no. 3 (2015): 301–22.

Park, J. P. *A New Middle Kingdom: Painting and Cultural Politics in late Chosŏn Korea (1700–1850)*, Seattle, WA: University of Washington Press, 2018.

Portal, Jane. *Korea: Art and Archaeology*. New York: Thames & Hudson, 2000.

Screech, Timon. "The Meaning of Western Perspective in Edo Popular Culture." *Archives of Asian Art* 47 (January 1994): 58–69.

Singer, Robert T., ed. *Edo: Art in Japan 1615–1868*. Washington, D.C.: National Gallery of Art, 1998.

Hiroshige, with essays by Smith II, Henry D. and Poster, Amy G. *One Hundred Famous Views of Edo*. New York: G. Braziller; Brooklyn Museum of Art, 1992.

Takeuchi, Melinda. *Taiga's True Views: The Language of Landscape Painting in Eighteenth-Century Japan*. Stanford, CA: Stanford University Press, 1992.

Thompson, Sarah E., and Harootunian, H. D. *Undercurrents in the Floating World: Censorship and Japanese Prints*. New York: Asia Society Galleries, 1991.

Yi, Song-mi. "Artistic Tradition and the Depiction of Reality: True-View Landscape Painting of the Choson Dynasty." In Judith G. Smith, ed. *Arts of Korea*. New York: The Metropolitan Museum of Art, 1998.

Yi, Song-mi. *Searching for Modernity: Western Influence and True-View Landscape in Korean Painting of the Late Choson Period*. Seattle, WA: University of Washington Press, 2015.

CHAPTER 14

Andaya, Barbara Watson and Andaya, Leonard Y. *A History of Early Modern Southeast Asia, 1400–1830*. Cambridge, U.K.: Cambridge University Press, 2015.

Davis, Lucy. "Eco-Art Histories as Practice: Woodcut and Cuttings of Wood in Island Southeast Asia." In De-nin D Lee, ed. *Eco-art History in East and Southeast Asia*. Newcastle upon Tyne, U.K.: Cambridge Scholars Publishing, 2019.

Fraser-Lu, Sylvia and Stadtner, Donald M. (eds.). *Buddhist Art of Myanmar*. New York: Asia Society Museum in association with Yale University Press, New Haven, CT and London, 2015.

Kraus, Werner. "Raden Saleh's Interpretation *of The Arrest of Diponegoro*: An Example of Indonesian 'Proto-Nationalist' Modernism." *Archipel* 69 (2005): 259–94.

Lee, Sarah and Siew, Sara (eds.). *Reframing Modernism: Painting from Southeast Asia, Europe and Beyond*. Singapore: National Gallery Singapore, 2016.

Leibsohn, Dana and Priyadarshini, Meha. "Transpacific: Beyond Silk and Silver." *Colonial Latin American Review*, Vol. 25, no. 1 (2016): 1–15.

Low, Sze Wee, ed. *Between Declarations and Dreams: Art of Southeast Asia since the 19th century*. Singapore: National Gallery Singapore, 2015.

Malcolm, Louise, ed. *Two Vietnamese Modernists: Bùi Xuân Phái & Nguyen Tu Nghiem: Paintings from*

the Hugentobler Collection. Zurich, Switzerland: Offizin Zürich Verlag, 2016.

Moore, Elizabeth Howard. "Unexpected Spaces at the Shwedagon." In Rebecca M. Brown and Deborah S. Hutton (eds.). *A Companion to Asian Art and Architecture*. Malden, MA: Wiley-Blackwell, 2011. 178–200.

Park, Jessie. "Made by Migrants: Southeast Asian Ivories for Local and Global Markets, ca. 1590–1640." *The Art Bulletin*, Vol. 102, Issue 4 (2020): 66–89.

Reid, Anthony. *A History of Southeast Asia: Critical Crossroads*. Malden, MA: Wiley-Blackwell, 2015.

Rod-ari, Melody. "Beyond the Ashes: The Making of Bangkok as the Capital City of Siam." In Jessica Joyce Christie, Jelena Bogdanovic, and Eulogio Guzman (eds.). *Political Landscapes of Capital Cities*. Boulder, CO: University Press of Colorado, 2016, pp. 155–79.

Taylor, Nora A. and Ly, Boreth (eds.). *Modern and Contemporary Southeast Asian Art: An Anthology*. Ithaca, NY: Cornell Southeast Asia Program Publications, 2012.

CHAPTER 15

Brown, Rebecca M. *Art for a Modern India, 1947–1980*. Durham, NC: Duke University Press, 2009.

Chattopadhyay, Swati. "Blurring Boundaries: The Limits of 'White Town' in Colonial Calcutta." *Journal of the Society of Architectural Historians* 59, no. 2 (June 2000): 154–79.

Dalma, Yashodhara. *Amrita Sher-Gil: Art and Life: A Reader*. New Delhi: Oxford University Press, 2014.

Desai, Vishakha. *Conversations with Traditions: Nilima Sheikh and Shahzia Sikander*. New York: Asia Society, 2001.

Dewan, Deepali and Hutton, Deborah. *Raja Deen Dayal: Artist-Photographer in 19th-Century India*. Ahmedabad, India: Alkazi Collection of Photography in association with Mapin, 2013.

Eaton, Natasha. "'Swadeshi' Color: Artistic Production and Indian Nationalism, ca. 1905–ca. 1947." *The Art Bulletin* 95, no. 4 (December 2013): 623–41.

Fineman, Mia, *et al. Raghubir Singh: Modernism on the Ganges*. New York: Metropolitan Museum of Art, 2017.

Guha-Thakura, Tapati. *Monuments, Objects, Histories: Institutions of Art in Colonial and Postcolonial India*. New York: Columbia University Press, 2004.

Jackson, Ashley. *Buildings of Empire*. Oxford, U.K.: Oxford University Press, 2013.

Jain, A. K. *Lutyens' Delhi*. New Delhi: Bookwell, 2010.

Kapur, Geeta, *et al. The grid, unplugged: Nasreen Mohamedi*. New York: Talwar Gallery, 2009.

Khullar, Sonal. *Worldly Affiliations: Artistic Practice, National Identity, and Modernism in India, 1930–1990*. Oakland, CA: University of California Press, 2015.

Mitter, Partha. *Art and Nationalism in Colonial India: Occidental Orientations*. Cambridge, U.K, and New York: Cambridge University Press, 1994.

Wille, Simone. *Modern Art in Pakistan: History, Tradition, Place*. London: Taylor & Francis, 2017.

CHAPTER 16

Chiu, Melissa and Zheng, Shengtian (eds.). *Art and China's Revolution*. New Haven, CT: Yale University Press, 2008.

Clark, John. *Modern Asian Art*. Honolulu, HI: University of Hawai'i, 1998.

Denton, Kirk A., ed. *Modern Chinese Literary Thought: Writings on Literature, 1893–1945*. Stanford, CA: Stanford University Press, 1996.

Dower, John W. "Throwing off Asia II: Woodblock Print of the Sino-Japanese War (1894–95)." MIT

Visualizing Cultures: https://ocw.mit.edu/ans7870/21f/21f.027/throwing_off_asia_02/toa_essay01.html (Accessed October 27, 2021).

Ho, Christine. "The People Eat for Free and the Art of Collective Production in Maoist China." *The Art Bulletin* 98, no. 3 (July 2016): 348–72.

Kee, Joan. "Points, Lines, Encounters: The World According to Lee Ufan." *Oxford Art Journal* 31, no. 3 (2008): 405–24.

Kikuchi, Yuko. "Hybridity and the Oriental Orientalism of *Mingei* Theory." *Journal of Design History* 10, no. 4 (1997): 343–54.

Kikuchi, Yuko. *Japanese Modernisation and* Mingei *Theory: Cultural nationalism and Oriental Orientalism*. New York: Routledge, 2004.

Kim, Youngna. "Artistic Trends in Korean Painting during the 1930s." In Marlene J. Mayo and J. Thomas Rimer (eds.). *War, Occupation, and Creativity: Japan and East Asia, 1920–1960*. Honolulu, HI: University of Hawai'i Press, 2001, pp. 121–48.

Khullar, Sonal. "Parallel Tracks: Pan Yuliang and Amrita Sher-Gil in Paris." In Carolien Stolte and Yoshiyuki Kikuchi (eds.). *Eurasian Encounters: Museums, Missions, Modernities*. Amsterdam: Amsterdam University Press, 2017.

Kim, Youngna. *Modern and Contemporary Art in Korea: Tradition, Modernity, and Identity*. Elizabeth, NJ: Hollym International Corporation, 2005.

Mitter, Partha. "Rabindranath Tagore and Okakura Tenshin in Calcutta: The Creation of a Regional Asian Avant-garde Art." In Dogramaci Burcu, Hetschold Mareike, Lugo Laura Karp, Lee Rachel, and Roth Helene (eds.). *Arrival Cities: Migrating Artists and New Metropolitan Topographies in the 20th Century*. Leuven, Belgium: Leuven University Press, 2020, pp. 147–58.

Munroe, Alexandra. *Japanese Art after 1945: Scream against the Sky*. New York: Abrams, 1994.

Murai, Noriko and Lippit, Yukio. "Okakura Kakuzō: A Reintroduction." *Review of Japanese Culture and Society* 42 (December 2012): 1–14.

Tang, Xiaobing. *Origins of the Chinese Avant-garde: The Modern Woodcut Movement*. Berkeley, CA: University of California Press, 2007.

Teo, Phyllis. *Rewriting Modernism: Three Women Artists in Twentieth-Century China: Pan Yuliang, Nie Ou, and Yin Xiuzhen*. Leiden, Netherlands: Leiden University Press, 2016.

Tseng, Alice Y. "Kuroda Seiki's 'Morning Toilette' on Exhibition in Modern Kyoto" *Art Bulletin* 90, no. 3 (Sept. 2008): 417–40.

Tsultemin, Uranchimeg. "Introduction to 'Buddhist Art of Mongolia: Cross-Cultural Connections, Discoveries, and Interpretations." *Cross-Currents: East Asian History and Culture Review* (e-journal) 31: 1–6.

Tsultemin, Uranchimeg. "Mongol Zurag: Nyam-Osoryn Tsultem and Traditional-style Painting in Mongolia." *Orientations* (March–April 2017): 135–42.

Vinograd, Richard. *Boundaries of the Self*. Cambridge, U.K.: Cambridge University Press, 1993.

Yamamura, Midori. *Yayoi Kusama: Inventing the Singular*. Cambridge, MA: MIT Press, 2016.

Yoshimoto, Midori. "Women Artists in the Japanese Post-War Avant-Garde: Celebrating a Multiplicity." *Women's Art Journal* 27, no. 1 (Spring–Summer 2006): 26–32.

CHAPTER 17

An, Kyung. *Who's Afraid of Contemporary Art? An A to Z Guide to the Art World*. London: Thames & Hudson, 2017.

Amirsadeghi, Hossein. *Korean Art: The Power of Now*. London: Thames & Hudson, 2017.

Brandon, Claire. *Shahzia Sikander: Apparatus of Power.* Hong Kong: Hong Kong University Press, 2017.

Elliott, David and Ozaki, Tetsuya. *Bye Bye Kitty!!!: Between Heaven and Hell in Contemporary Japanese Art.* New York: Japan Society, 2011.

Chiu, Melissa. *Contemporary Art in Asia: A Critical Reader.* Cambridge, MA: MIT Press, 2011.

Ciclitira, Serenella, ed. *Korean Eye: Contemporary Korean Art.* New York: Skira, 2010.

—. *Korean Eye 2: Contemporary Korean Art.* New York: Skira, 2013.

Jhaveri, Shanay, ed. *Mrinalini Mukherjee.* Mumbai: The Shoestring Publisher, 2019.

Kee, Joan. "Introduction Contemporary Southeast Asian Art: The Right Kind of Trouble." *Third Text* 25, no. 4 (July 2011): 371–81.

Kim, Youngna. *Modern and Contemporary Art in Korea.* The Korea Foundation, 2013.

Shah, Tejal. *"What are You?"* Mumbai: Galerie Mirchandani + Steinruecke, 2006.

Spielmann, Yvonne. *Contemporary Indonesian Art; Artists, Art Spaces, and Collectors.* Singapore: Nus Press, 2017.

Taylor, Nora A. and Ly, Boreth (eds.). *Modern and Contemporary Southeast Asian Art: An Anthology.* Ithaca, NY: Cornell Southeast Asia Program Publications, 2012.

CHAPTER 18

Das, Aurogeeta, *et al. Many Visions, Many Versions: Art from Indigenous Communities in India.* Washington, D.C.: International Arts and Artists, 2018.

Hashmi, Salima, *et al. Hanging Fire: Contemporary Art from Pakistan.* New Haven, CT and London: Asia Society Museum and Yale University Press, 2009.

Kim, Soo-ja, *et al. Kimsooja: Archive of Mind.* Seoul: National Museum of Modern and Contemporary Art, 2017.

Lee, Luchia Meihua and Silbergeld, Jerome (eds.). *Zhang Hongtu: Expanding Visions of a Shrinking World.* Queens, NY: Queens Museum; Durham, NC: Duke University Press, 2015.

Spielmann, Yvonne. *Contemporary Indonesian Art: Artists, Art Spaces, and Collectors.* Singapore: Nus Press, 2017.

Sundaram, Vivan, and Sambrani, Chaitanya. *Vivan Sundaram: Trash.* New Delhi: Photoink, 2008.

Sources of Quotations

INTRODUCTION

p. 18 Nemerov, Howard. *A Howard Nemerov Reader.* Columbia, MO: University of Missouri Press, 1991, p. 223.

CHAPTER 2

pp. 46–47 Inscription on the Xing Hou *Gui.* Trans. Oliver Moore. *Reading the Past: Chinese.* London: British Museum Press, 2000, pp. 33, 38–47.

p. 50 Sima Qian, *Shiji (Records of the Grand Historian), juan 6.* Trans. De-nin D. Lee.

CHAPTER 4

pp. 86–87 Wang Xizhi, *Orchid Pavilion* (preface). Trans. H. C. Chang in John Minford and Joseph S. M. Lau (eds.). *An Anthology of Translations: Classical Chinese Literature: From Antiquity to the Tang Dynasty,* vol. 1. New York: Columbia University Press and The Chinese University of Hong Kong, 2000, p. 480.

pp. 88–89 Zhang Hua, *Admonitions of the Instructress to Court Ladies.* Trans. in Shane McCausland, ed. *Gu Kaizhi and the Admonitions Scroll.* London: British Museum Press, 2003, p. 16.

CHAPTER 5

p. 101 Xuanzang. Trans. Li Rongxi. *The Great Tang Dynasty Record of the Western Regions.* Berkeley, CA: Numata Center for Buddhist Translation and Research, 1996, pp. 37–38.

CHAPTER 6

p. 131 Kūkai, *Goshōraimokurokku (Inventory of Imported Items).* Trans. Cynthia J. Bogel. "Canonizing Kannon: The Ninth-Century Esoteric Buddhist Altar at Kanshinji." *The Art Bulletin* 84, no.1 (March 2002), p. 39.

p. 133 Genshin. Trans. (with slight modifications) A. K. Reishchauer. "Genshin's Ojo Yoshu: Collected Essays on Birth into Paradise." *The Transactions of The Asiatic Society of Japan,* Second Series, Vol. VII (December 1930): 68–69.

SEEING CONNECTIONS 4: THE ART OF WRITING

p. 138 Lady Ise. Trans. John Rosenfield. *Japanese Arts of the Heian Period: 794–1185.* New York: Asia Society, 1967, pp. 121–22.

p. 139 Calligraphy on a bowl from Iran. Trans. in Maryam Ekhtiar and Claire Moore (eds.). "A Resource for Educators." *Art of the Islamic World.* New York: The Metropolitan Museum of Art, 2012, pp. 6–7.

CHAPTER 7

p. 151 *Shilpa Parkasha (Light on Art),* book 1, v. 391–92. Trans. Vidya Dehejia. *Indian Art.* London: Phaidon, 1997, pp. 164–65.

CHAPTER 8

p. 164 Unknown author, "Fan Kuan" in *Xuanhe huapu (Catalogue of Painting of the Xuanhe Reign).* Trans. De-nin D. Lee.

p. 165 Guo Xi, *Linquan gaozhi ji (Lofty Appeal of Forests and Streams).* Trans. in Victor H. Mair et al. (eds.). *Hawai'i Reader in Traditional Chinese Culture.* Honolulu, HI: University of Hawai'i Press, 2005, pp. 380–87.

p. 166 Su Shi, *Poems Written on the Cold Food Festival.* Trans. adapted from Wu-Chi Liu and Irving

Yucheng Lo (eds.). *Sunflower Splendor: Three Thousand Years of Chinese Poetry.* Bloomington, IN: Indiana University Press, 1975, p. 347.

p. 168 Empress Yang Meizi. Trans. adapted from Hui-shu Lee. *Empresses, Art, and Agency.* Seattle, WA: University of Washington Press, 2010, p. 170.

p. 180 Cai Xiang. Trans. Stephen W. Bushell. *Description of Chinese Pottery and Porcelain: Being a Translation of the T'ao Shuo.* Oxford, U.K.: Clarendon Press, 1910, p. 124.

CHAPTER 9

p. 185 Wang Geon. Trans. Ki-baek Yi. Quoted in Jane Portal. *Korea: Art and Archaeology.* London: British Museum Press, p. 81.

p. 191 Sin Sukju, *Hwagi (Record on Painting),* 1445. Trans. De-nin D. Lee. See also: Burglind Jungmann. "Sin Sukju's Record on the Painting Collection of Prince Anpyeong and Early Joseon Antiquarianism." *Archives of Asian Art* 61 (2011): 120.

p. 192 Yi Yulgok, "Sin Saimdang: The Foremost Woman Painter." Trans. in Young-key Kim-Renanad, ed. *Creative Women of Korea: The Fifteenth through the Twentieth Centuries.* Armonk, NY, and London: An East Gate Book, 2004, p. 60.

p. 193 "Burning of the Sanjō Palace." Trans. Edwin O. Reischauer. *Translations from Early Japanese Literature.* Cambridge, MA: Harvard-Yenching Institute, Harvard University Press, 1951, p. 301.

p. 196 Daigaku. Trans. Thomas Hare. Quoted in Yukio Lippit. *Japanese Zen Buddhism and the Impossible Painting.* Los Angeles, CA: The Getty Research Institute, 2017, p. 17.

p. 198 Sesshū. Trans. in Yukio Lippit. "Of Modes and Manners in Japanese Ink Painting: Sesshū's 'Splashed Ink Landscape' of 1495." *The Art Bulletin* 94, no. 1 (March 2012): 61.

CHAPTER 10

p. 215 *Book of Delights.* Trans. Norah M. Titley. *The Ni'matnāma Manuscript of the Sultans of Mandu.* London: Routledge, 2005, p. 4.

CHAPTER 11

p. 227 Jahangir. Trans. in Wheeler M. Thackston, ed. *The Jahangirnama: Memoirs of Jahangir.* Washington, D.C., New York, and Oxford, U.K.: Freer Gallery of Art, Smithsonian Institution, and Oxford University Press, 1999, p. 268.

p. 230 Muhammad Amin Qazwini, *Padshahnama.* British Library, Or. 173, fol. 234b. Trans. Ebba Koch. "The Taj Mahal: Architecture, Symbolism, and Urban Significance." *Muqarnas* 22 (2005): 128.

CHAPTER 12

p. 246 Shen Zhou. Trans. De-nin D. Lee.

p. 251 Bada Shanren, inscription on *Fish and Rocks.* Trans. in Fangyu Wang and Richard M. Barnhart. *Master of the Lotus Garden: The Life and Art of Bada Shanren (1626–1705).* New Haven, CT: Yale University Press, 1990, p. 128.

p. 251 Shitao, excerpt from *Huayu lu.* Trans. De-nin D. Lee.

p. 258 Inscription on *One or Two?* Trans. De-nin D. Lee.

p. 259 Qianlong. Trans. Heping Liu. "Picturing Yu Controlling the Flood: Technology, Ecology, and Emperorship in Northern Song China." In Dagmar Schäfer, ed. *Cultures of Knowledge: Technology in*

Chinese History. Leiden, Netherlands: Brill, 2012, p. 112.

CHAPTER 13

p. 265 Inscription on *Panoramic View of the Diamond Mountains (Geumgang-san).* Trans. Yi Song-mi. "Artistic Tradition and the Depiction of Reality: True-View Landscape Painting of the Choson Dynasty." In Judith G. Smith, ed. *Arts of Korea.* New York: The Metropolitan Museum of Art, 1998, p. 346.

p. 268 Kim Jeonghui, *untitled calligraphy couplet.* Trans. De-nin D. Lee and P. J. Ivanhoe.

p. 268 Yu Jaegeon, *Yihyanggyeonmullok* (Paju: Munhakdongne, 2008). Trans. Nathaniel Kingdon. "Half the Picture: Korean Scholars and the Environment in the Early Nineteenth Century." In De-nin D. Lee, ed. *Eco-Art History in East and Southeast Asia.* Newcastle-upon-Tyne, U.K: Cambridge Scholars Publishing, 2019, p. 63.

p. 269 King Jeongjo. Trans. Sunglim Kim. "*Chaekgeori*: Multi-dimensional Messages in Late Joseon Korea." *Archives of Asian Art* 64, no. 1 (2014): 7.

p. 272 Gyokuran. Trans. Stephen Addiss. "The Three Women of Gion." In Marsha Weidner, ed. *Flowering in the Shadows: Women in the History of Chinese and Japanese Painting.* Honolulu, HI: University of Hawai'i Press, 1990, p. 257.

CHAPTER 15

p. 308 Amrita Sher-Gil. "Modern Indian Art: Imitating the Forms of the Past." *The Hindu* (November 1, 1936). In Vivan Sundaram, ed. *Amrita Sher-Gil: A Self-Portrait in Letters & Writings.* New Delhi: Tulika Books, 2010, pp. 249–55 (quoted text from p. 255).

CHAPTER 16

p. 322 Ren Xiong, inscription on his *Self-portrait.* Trans. Richard Vinograd. *Boundaries of the Self.* Cambridge, U.K.: Cambridge University Press, 1993, p. 129.

p. 323 Kuroda Seiki. Trans. Alice Y. Tseng. "Kuroda Seiki's 'Morning Toilette' on Exhibition in Modern Kyoto," *The Art Bulletin* 90, no. 3 (Sept. 2008): 435.

p. 329 Mao Zedong. "Talks at the Yan'an Forum on Literature and Art." In Kirk A. Denton, ed. *Modern Chinese Literary Thought: Writings on Literature, 1893–1945.* Stanford, CA: Stanford University Press, 1996, p. 474.

CHAPTER 17

pp. 346–47 Interview with Dinh Q. Lê, by Zoe Butt, published in *Independent Curators International Dispatch,* April 16, 2010. http://curatorsintl.org/images/assets/Dinh_Q_Le.pdf (Accessed July 27, 2018).

CHAPTER 18

p. 358 Interview with Munem Wasif, by Theresa Malone, published in *The Guardian,* September 26, 2016. https://www.theguardian.com/artanddesign/2013/sep/26/munem-wasif-best-photograph (Accessed February 21, 2022).

Sources of Illustrations

Images listed by figure number unless otherwise stated. All maps by Peter Bull.

p. 1 Metropolitan Museum of Art, New York, Gift of Florence and Herbert Irving, 2015 (2015.500.1.31) **pp. 2–3** San Diego Museum of Art, Edwin Binney 3rd Collection/Bridgeman Images.

p. 10 South Asia 2 Photo Trustees of the British Museum, London **p. 10 South Asia 7** Asian Art Museum, San Francisco, The Avery Brundage Collection (B60S597) **p. 10 South Asia 10** V. Muthuraman/IndiaPictures/Universal Images Group/Getty Images **p. 10 South Asia 15** Freer Gallery of Art, Smithsonian Institution, Washington, D.C., Purchase Charles Lang Freer Endowment (F1942.15) **p. 10 South Asia 18** By kind permission of Victoria Memorial Hall, Kolkata **p. 10 South Asia 23** Courtesy of the artist and Project 88 **p. 10 Mainland Asia 3** Metropolitan Museum of Art, New York, Charlotte C. and John C. Weber Collection, Gift of Charlotte C. and John C. Weber, 1992 (1992.165.8) **p. 10 Mainland Asia 4** Granger Historical Picture Archive/Alamy Stock **p. 10 Mainland Asia 12** National Palace Museum, Taipei **p. 10 Mainland Asia 13** Victoria and Albert Museum, London, Given from the Bloom Collection (C.108-1928) **p. 10 Mainland Asia 21** © Xu Bing Studio **p. 10 Peninsular and Island East Asia 5** TNM Image Archives **p. 10 Peninsular and Island East Asia 8** Los Angeles County Museum of Art, California, Gift of the David Bohnett Foundation, Lynda and Stewart Resnick, Camilla Chandler Frost, Victoria Jackson and William Guthy, and Laura and Bill Benenson (M.2008.102) **p. 10 Peninsular and Island East Asia 9** National Museum of Korea, Seoul **p. 10 Peninsular and Island East Asia 16** Leeum, Samsung Museum of Art, Seoul **p. 10 Peninsular and Island East Asia 17** Museum of Fine Arts, Boston, William Sturgis Bigelow Collection, Bridgeman Images **p. 10 Peninsular and Island East Asia 22** © Kimsooja Studio. Image courtesy Alex Vervoodt Gallery. Still from 11-day performance throughout Korea, commissioned by ARKO, Korea **p. 10 Southeast Asia 1** Courtesy Maxime Aubert **p. 10 Southeast Asia 6** Photo Trustees of the British Museum, London **p. 10 Southeast Asia 11** Adel Newman/Shutterstock **p. 10 Southeast Asia 14** Christie's Images/Bridgeman Images **p. 10 Southeast Asia 19** Collection of NUS Museum, National University of Singapore **p. 10 Southeast Asia 24** Courtesy of the artist and Tyler Rollins Fine Art.

0.0 © The Singh Twins: www.singhtwins.co.uk **0.1** Museum of Fine Arts, Boston, William Sturgis Bigelow Collection/Bridgeman Images **0.2** © The Singh Twins: www.singhtwins.co.uk **0.3** Metropolitan Museum of Art, New York, Zimmerman Family Collection, Gift of the Zimmerman Family, 2012 (2012.444.2) **0.4** Victoria and Albert Museum, London, Purchased with Art Fund support, and the assistance of the Wolfson Foundation, Messrs Spink and Son, and an anonymous benefactor (IS.12-1962) **0.5** Los Angeles County Museum of Art, California, Costume Council Fund (AC1995.118.4) **0.6** Courtesy Mongolian National Modern Art Gallery, Ulaanbaatar **0.7** Robert Harding/Alamy Stock **0.8** Francois-Olivier Dommergues/Alamy Stock **0.9** Philadelphia Museum of Art, Pennsylvania, Gift of John T. Dorrance, 1977/Bridgeman Images

0.10 © Xu Bing Studio **0.11, 0.11a, 0.11b, 0.11c** Photo Trustees of the British Museum, London **0.12, 0.12a, 0.12b, 0.12c** Kōyasan Reihōkan Museum **0.13** © The Archives of Huang Yong Ping. Courtesy of the Archives of Huang Yong Ping and Gladstone Gallery, New York and Brussels **0.14** Art Gallery of New South Wales, Gift of Mr. Sydney Cooper, 1962 (EC29.1962). Photo AGNSW **0.15** Metropolitan Museum of Art, New York, Purchase, Edward C. Moore Jr. Gift, 1928 (28.63.1).

1.0 Ulsan Petroglyph Museum, South Korea **1.1** Courtesy Maxime Aubert **1.2** Ulsan Petroglyph Museum, South Korea **1.3** Kyonghui University Museum, Seoul **1.4** Photo Ogawa Tadahiro **1.5** Metropolitan Museum of Art, New York, Charlotte C. and John C. Weber Collection, Gift of Charlotte C. and John C. Weber, 1992 (1992.165.8) **1.6** Liaoning Institute of Archaeology, Shenyang **1.7** Metropolitan Museum of Art, New York, Purchase, Friends of Asian Art Gifts, 1986 (1986.112) **1.8** Martha Avery/Getty Images **1.9** Peter Bull **1.10** © SUN Zhouyong, Shaanxi Academy of Archaeology **1.10a** Peter Bull **1.11** TNM Image Archives **1.12** Suzuki Kaku/Alamy Stock **1.13** Randy Olson/National Geographic Stock **1.14** Mike Goldwater/Alamy Stock **1.15** Photo Scala, Florence **1.16** National Museum, New Delhi/Bridgeman Images **1.17 above**, **1.17 below** Photo Trustees of the British Museum, London **1.18** Photo Luisa Ricciarini/Bridgeman Images **1.19** agefotostock/Alamy Stock **1.20** Photo Trustees of the British Museum, London **1.21** Erich Lessing/akg-images.

2.0 imageBROKER/Alamy Stock **2.1** Granger Historical Picture Archive/Alamy Stock **2.2** Heritage Image Partnership Ltd./Alamy Stock **2.2a** Peter Bull **2.3** Freer Gallery of Art, Smithsonian Institution, Washington, D.C., Acquired under the guidance of the Carl Whiting Bishop Expedition (F1985.35) **2.4** Granger Historical Picture Archive/Alamy Stock **2.5** Peter Bull **2.6** Bridgeman Images **2.7** Sanxingdui Museum Guanghan **2.7a** Peter Bull, after Lothar van Falkenhausen **2.8** National Museum of Korea, Seoul **2.9, 2.9a** Photo Trustees of the British Museum, London **2.10, 2.10a** With permission of the Royal Ontario Museum. Photo ROM **2.11** © Asian Art & Archaeology, Inc./Corbis via Getty Images **2.12** Peter Bull **2.13** Laurent Lecat/akg-images **2.14** Mawangdui Tomb 1, Changsha, Hunan Province, Hunan Provincial Museum **2.14a, 2.14b** Peter Bull **2.15, 2.16** Tomb 1, Mancheng, Hebei Province, Hebei Provincial Museum **2.17** Princeton University Art Museum/Art Resource, New York/Scala, Florence **2.18** Photo Werner Forman Archive/Universal Images Group/Getty Images **2.19** National Museum of Korea, Seoul (Bongwan 250).

SC1.1 The History Collection/Alamy Stock **SC1.2, SC1.3** CPA Media Pte Ltd./Alamy Stock **SC1.4** Ashmolean Museum, University of Oxford/Bridgeman Images **SC1.5** Jean-Louis Nou/akg-images.

3.0 Freer Gallery of Art, Smithsonian Institution, Washington, D.C., Purchase – Charles Lang Freer Endowment (F1949.9a-d) **3.1** British Library Board. All Rights Reserved/Bridgeman Images **3.2** Jean-Louis Nou/akg-images **3.3** imageBROKER/Alamy Stock **3.4** Photo De-nin D. Lee **3.5** Dinodia Photos/Alamy

Stock **3.6** G. Nimatallah/De Agostini Picture Library/akg-images **3.7 above**, **3.7 below** Metropolitan Museum of Art, New York, Bequest of Joseph H. Durkee, 1898 (99.35.3024) **3.8** Freer Gallery of Art, Smithsonian Institution, Washington, D.C., Purchase – Charles Lang Freer Endowment (F1949.9a-d) **3.9** Jean-Louis Nou/akg-images **3.10** The Avery Brundage Collection, Asian Art Museum, San Francisco (B60S597) **3.11** Peter Bull **3.12** Jean-Louis Nou/akg-images **3.13** Metropolitan Museum of Art, New York, Gift of Florence and Herbert Irving, 1993 (1993.477.2) **3.14** Peter Bull **3.15** Metropolitan Museum of Art, New York, Samuel Eilenberg Collection, Gift of Samuel Eilenberg, 1987 (1987.142.323) **3.16** Hari Mahidhar/Shutterstock **3.17** mdsharma/Shutterstock **3.18** Bridgeman Images **3.19** Art Resource, New York.

SC2.1 Heritage Image Partnership, Ltd./Alamy Stock **SC2.2** Gyeongju National Museum, Korea. National Treasure 191 **SC2.3** Agency for Cultural Affairs; The Museum, Archaeological Institute of Kashihara, Nara Prefecture.

4.0 Best View Stock/Alamy Stock **4.1** Metropolitan Museum of Art, New York, The Harry G. C. Packard Collection of Asian Art, Gift of Harry G. C. Packard, and Purchase, Fletcher, Rogers, Harris Brisbane Dick, and Louis V. Bell Funds, Joseph Pulitzer Bequest, and The Annenberg Fund Inc. Gift, 1975 (1975.268.378) **4.2** TNM Image Archives **4.3** Fukuoka City Museum, Fukuoka. Agency for Cultural Affairs **4.4** Photo Kyodo News Stills/Getty Images **4.5** Peter Bull **4.6** TNM Image Archives **4.7** Los Angeles County Museum of Art, California, Gift of the David Bohnett Foundation, Lynda and Stewart Resnick, Camilla Chandler Frost, Victoria Jackson and William Guthy, and Laura and Bill Benenson (M.2008.102) **4.8** Imperial Household Agency, Tokyo **4.9** Bridgeman Images **4.10** Buyeo National Museum, Seoul **4.11** Museum of Fine Arts, Boston, Morse Collection/Bridgeman Images **4.12, 4.13** Palace Museum, Beijing **4.14, 4.15** Photos Trustees of the British Museum, London **4.16** Courtesy Nanjing Museum, Jiangsu **4.17** Photo Asian Art Museum, San Francisco **4.18** Michael Runkel/Robert Harding/Diomedia **4.19** Metropolitan Museum of Art, New York, Fletcher Fund, 1935 (35.146) **4.20, 4.20a** © Dunhuang Foundation.

5.0 Jon Arnold Images Ltd./Alamy Stock **5.1** Peter Bull **5.2** dbimages/Alamy Stock **5.3** Nikreates/Alamy Stock **5.4** Suzanne Held/akg-images **5.5** Nagoya University. Photo Masayoshi Nokubo **5.6** Peter Bull **5.7** Anders Blomqvist/Stone/Getty Images **5.8** Shutterstock **5.9** Robert Wyatt/Alamy Stock **5.9a** Peter Bull **5.10** Jason Bazzano/Alamy Stock **5.11** imageBROKER/Alamy Stock, **5.11a** Vikrant Sardana/Alamy Stock **5.11b** Maria Heyens/Alamy Stock **5.11c** randomclicks/Alamy Stock **5.11d** V. Muthuraman/IndiaPictures/Universal Images Group/Getty Images **5.11e** dbimages/Alamy Stock **5.12** Newark Museum, New Jersey (82.183) **5.13** Godong/Alamy Stock **5.14** Photo Christophel Fine Art/Universal Images Group/Getty Images **5.15** Photo Trustees of the British Museum, London **5.16** Olga Khoroshunova/Alamy Stock **5.17, 5.17a** Asia Society Museum, New York, Mr. and Mrs. John D. Rockefeller 3rd Acquisitions Fund (1987.1)/Art Resource, New York **5.18** Matteo Colombo/Digital Vision/Getty Images **5.19** Metropolitan Museum of Art, New York, Gift of Steven Kossak, The Kronos Collections, 1993 (1993.479).

SC3.1 Image Musée Guimet, Paris/Photo MNAAG, Paris, Dist, RMN-Grand Palais SC3.2 Photo Scala, Florence SC3.3 Guyuan Museum, Ningxia Autonomous Region SC3.4 The Shōsōin Treasures, Courtesy of the Imperial Household Agency.

6.0 Benrido, Inc./Toji, Kyoto 6.1 National Museum of Korea, Seoul 6.2 Photo Junro Tomli 6.2a, 6.2b Peter Bull 6.3 Iberfoto/Mary Evans 6.4 Bridgeman Images 6.5 Granger Historical Picture Archive/Alamy Stock 6.6 Peter Bull 6.7 National Museum of China, Beijing 6.8 agshotime/iStock.com 6.9 Zhang Peng/LightRocket/Getty Images 6.10 British Library, London 6.11 Jon Arnold Images Ltd./Alamy Stock 6.12 Manuel Ascanio/Shutterstock 6.12a Peter Bull 6.13 Alex Ramsay/Alamy Stock 6.14 The Picture Art Collection/Alamy Stock 6.15 Benrido, Inc./Toji, Kyoto 6.15a Peter Bull 6.16 © Byōdōin Temple 6.17 Sean Pavone/Alamy Stock 6.17a Peter Bull 6.18 Tokugawa Art Museum Image Archives/DNPartcom 6.19 Tokugawa Art Museum Image Archives/DNPartcom 6.20 Kōzanji/Kyoto National Museum.

SC4.1 Metropolitan Museum of Art, New York, Mary Griggs Burke Collection, Gift of the Mary and Jackson Burke Foundation, 2015 (2015.300.231) SC4.2 Metropolitan Museum of Art, New York, Rogers Fund, 1965 (65.106.2) SC4.3 British Library Board. All Rights Reserved/Bridgeman Images.

7.0 Pictures from History/akg-images 7.1 Adel Newman/Shutterstock 7.2 Peter Bull 7.3 VPC Photo/Alamy Stock 7.4 Gnomeandi/Alamy Stock 7.5 Peter Bull 7.6 Reezky Pradata/Shutterstock 7.7 Collection Nationaal Museum van Wereldculturen (Coll. no. TM-10016191) 7.8 Maria Heyens/Alamy Stock 7.9 Peter Bull 7.10 Badri Narayanan Sundaravardan/Alamy Stock 7.11 Museum Rietberg, Zurich, Gift of Eduard von der Heydt (RVI 501) 7.12 Westend61 RF/Fotofeeling/Diomedia 7.13 M. Borchi/DEA/Getty Images 7.14 Phjpix/Shutterstock 7.15 Universal History Archive/Universal Images Group/Getty Images 7.16 Flowerfotos/Eye Ubiquitous/SuperStock 7.17 Peter Bull 7.18 Alexander Hafemann/Getty Images 7.19 Peter Bull 7.20 Pictures from History/akg-images 7.21 Michael Nolan/Getty Images 7.22 Rosemary Harris/Alamy Stock 7.23 Damian Evans/Khmer Archaeology LiDAR Consortium.

SC5.1 Photo The Asahi Shimbun/Getty Images SC5.2 STR/AFP/Getty Images SC5.3 Courtesy of Drepung Loseling Monastery, Inc. Photo Brian Moorehead SC5.4 HIP/Art Resource, New York.

8.0 National Palace Museum, Taipei 8.1 Photo Kurokawa Institute of Ancient Cultures, Hyogo 8.2a–e Peter Bull 8.3, 8.4 National Palace Museum, Taipei 8.5 Palace Museum, Beijing 8.6 National Palace Museum, Taipei 8.7 Museum of Fine Arts, Boston, Maria Antoinette Evans Fund/Bridgeman Images 8.8, 8.9, 8.10, 8.10a, 8.10b, 8.11 National Palace Museum, Taipei 8.12 Photo Trustees of the British Museum, London 8.13 Princeton University Art Museum/Art Resource, New York/Scala, Florence 8.14 National Palace Museum, Taipei 8.15 Metropolitan Museum of Art, New York, Gift of Florence and Herbert Irving, 2015 (2015.500.1.31) 8.16, 8.17 National Palace Museum, Taipei 8.18 Metropolitan Museum of Art, New York, Fletcher Fund, 1928 (28.56) 8.19 Courtesy Daitokuji Temple, Kyoto 8.20 HelloRF/Zcool/Shutterstock 8.20a, 8.20b Peter Bull 8.21 Metropolitan Museum of Art, New York, Purchase, Lila Acheson Wallace Gift, 1992 (1992.54) 8.22 Metropolitan Museum of Art, New York, Edward C. Moore Collection, Bequest of Edward C. Moore, 1891 (91.1.226).

SC6.1 bpk, Bildagentur für Kunst, Kultur und Geschichte, Berlin/Scala, Florence SC6.2, SC6.2a Inner Mongolia Museum of the People's Republic of China. Photo Kong Qun SC6.3 Photo State Hermitage Museum, St. Petersburg/Vladimir Terebeninby/Alexander Koksharov.

9.0 Sen-oku Hakukokan Museum, Sumitomo Collection, Kyoto 9.1 Cleveland Museum of Art, Ohio, The Severance and Greta Millikin Purchase Fund (1994.25) 9.2 Sen-oku Hakukokan Museum, Sumitomo Collection, Kyoto 9.3 Freer Gallery of Art, Smithsonian Institution, Washington, D.C., Gift of Mason M. Wang (F1984.31) 9.4 Frederic Reglain/Alamy Stock 9.5 The Picture Art Collection/Alamy Stock 9.6 Important Cultural Property of Japan, Tenri Central Library, Tenri University, Nara 9.7 Photo Burglind Jungmann, 2006 9.8 Art Institute of Chicago, Illinois, Bequest of Russell Tyson (1964.936) 9.9, 9.9a Photo Museum of Fine Arts, Boston, Fenollosa-Weld Collection (11.4000) 9.10 Bijyutsuin Laboratory for Conservation of National Treasures of Japan 9.11 Kanazawa Bunko, Yokohama 9.12 Metropolitan Museum of Art, New York, Gift of Bashford Dead, 1914 (14.100.121) 9.13 © Taizō-in Zen Buddhist temple, Kyoto 9.14 Tokyo National Museum 9.15 Charles Mann/Alamy Stock 9.16 miralex/iStockphoto.com 9.16a Peter Bull 9.17 Kobe City Museum/DNPartcom 9.18 Photo Oyamazaki Town Hall, Courtesy Myōkian temple, Kyoto prefecture 9.18a Peter Bull 9.19 Photo Hyogo Prefectural Museum of Art.

10.0 Album/Alamy Stock 10.1 David Collection, Copenhagen, Photo Pernille Klemp (25/2004) 10.2 Peter Bull 10.3 Martin Child/Robert Harding/Diomedia 10.4 Konstantin Kalishko/Alamy Stock 10.5 Novarc Images/Alamy Stock 10.6 teguh santosa kedua/Shutterstock 10.7 Mark De Fraeye/akg-images 10.8 Christie's Images/Bridgeman Images 10.9 Victoria and Albert Museum, London, Purchased with Art Fund support (IS.96-1993) 10.10 Cleveland Museum of Art, Ohio, on loan from the Catherine and Ralph Benkaim Collection (18.2014a and 18.2014b) 10.11 British Library Board. All Rights Reserved/Bridgeman Images 10.12 Peter Bull 10.13 Waj/Shutterstock 10.14 Dinodia Photos/Alamy Stock 10.15 Pranavan Shoots/Shutterstock 10.16 Peter Bull 10.17 Photo Richard Mortel, Riyadh, Saudi Arabia 10.18 Andrey Khrobostov/Alamy Stock.

SC7.1 Photo Didier Tais SC7.2 Peter Bull SC7.3 Image Professionals GmbH/Alamy Stock SC7.4 Leo Daphne/Alamy Stock SC7.5 Insights/Universal Images Group/Getty Images.

11.0 Photo © Deborah Hutton 11.1 Peter Bull 11.2 imageBROKER/Alamy Stock 11.3 Steve Speller/Alamy Stock 11.4 Charles O. Cecil/Alamy Stock 11.5 Metropolitan Museum of Art, New York, Purchase, Edward C. Moore Jr. Gift, 1928 (28.63.1) 11.6 Peter Bull 11.7 Freer Gallery of Art, Smithsonian Institution, Washington D.C., Purchase Charles Lang Freer Endowment (F1942.15) 11.8 The Textile Museum, Washington, D.C., Gift of James D. Burns (1994.12.1) 11.9 Photo Amos Chapel 11.10 Peter Bull 11.11 San Diego Museum of Art, Edwin Binney 3rd Collection/Bridgeman Images 11.12 The Picture Art Collection/Alamy Stock 11.13 San Diego Museum of Art, Edwin Binney 3rd Collection/Bridgeman Images 11.14 Prisma by Dukas Presseagentur GmbH/Alamy Stock 11.15 Cleveland Museum of Art, Ohio, Severance and Greta Millikin Purchase Fund (2020.207) 11.16 British Library Board. All Rights Reserved/Bridgeman Images 11.17 Peter Bull 11.18 Skreidzeleu/Shutterstock 11.19 Metropolitan Museum of Art, New York, Cynthia Hazen Polsky and Leon B. Polsky Fund, 2002 (2003.37) 11.20 Mehrangarh Museum Trust, Jodhpur, India and His Highness Majaraja Gaj Singh of Jodhpur.

SC8.1 Victoria and Albert Museum, London, Salting Bequest (C.720-1910) SC8.2 Victoria and Albert Museum, London (419-1874) SC8.3 Victoria and Albert Museum, London, Bequeathed by Mr. John George Joicey (C.1761-1919) SC8.4 Victoria and Albert Museum, London, Bequeathed by A.P. Maudslay (C.32-1931).

12.0 Rubin Museum of Art, New York (C2003.9.2 (HAR 65275)) 12.1 Palace Museum, Beijing 12.2 Philadelphia Museum of Art, Pennsylvania, Gift of John T. Dorrance, 1977/Bridgeman Images 12.3 RooM the Agency/Alamy Stock 12.3a Peter Bull 12.4 Nelson-Atkins Museum of Art, Kansas City, Missouri, Purchase William Rockhill Nelson Trust (46-51/2) 12.5 Palace Museum, Beijing 12.6 Herbert F. Johnson Museum of Art, Cornell University. From an album of twenty-four portraits of Guanyin/acquired through the generosity of Judith Stoikov, Class of 1963, supplemented by the George and Mary Rockwell Fund, and gift of Warner L. Overton, by exchange (2002.012.026) 12.7 Museum für Ostasiatische Kunst, Cologne (R 62,2 [no.19])/bpk 12.8 Victoria and Albert Museum, London, Given from the Bloom Collection (C.108-1928) 12.9 Metropolitan Museum of Art, New York, Edward Elliott Family Collection, Gift of Douglas Dillon, 1986 (1986.266.5a–k) 12.10 Cleveland Museum of Art, Ohio, John L. Severance Fund (1953.247) 12.11, 12.12 National Palace Museum, Taipei 12.13 Umi-Mori Art Museum, Hiroshima 12.14 Sipa/Shutterstock 12.15 travellinglight/Alamy Stock 12.16 Rubin Museum of Art, New York (C2003.9.2 (HAR 65275)) 12.17 Courtesy The Fine Arts Zanabazar Museum, Ulaanbaatar 12.18, 12.19 Palace Museum, Beijing 12.20 Getty Research Institute, Los Angeles (86-B26695) 12.21 Palace Museum, Beijing.

SC9.1 Heritage Image Partnership Ltd./Alamy Stock SC9.2 Album/Alamy Stock SC9.3 Museum of Fine Arts, Boston, Leonard A. Lauder Collection of Japanese Postcards/Bridgeman Images.

13.0 Cleveland Museum of Art, Ohio, Leonard C. Hanna, Jr. Fund (2011.37) 13.1 Leeum, Samsung Museum of Art, Seoul 13.2 National Museum of Korea, Seoul 13.3 Gangsong Art Museum, Seoul 13.4 Leeum, Samsung Museum of Art, Seoul 13.5 National Museum of Korea, Seoul 13.6 Photo Trustees of the British Museum, London 13.7 Cleveland Museum of Art, Ohio, Leonard C. Hanna, Jr. Fund (2011.37) 13.8 © National Museum of Japanese History, Tokyo 13.9 Detroit Institute of Arts, Michigan, Gift of Frederick K. Stearns/Bridgeman Images 13.10 Minneapolis Institute of Art, Minnesota, Gift of the Clark Center for Japanese Art & Culture; formerly given to the Center by Mr. and Mrs. Makiji Hase/Bridgeman Images 13.11 Kyoto National Museum, Japan (AK83) 13.12 Historic Images/Alamy Stock 13.13 Miho Museum, Shiga Prefecture 13.14 Peter Bull 13.15 EvergreenPlanet/Shutterstock 13.16 Museum of Fine Arts, Boston, William Sturgis Bigelow Collection/Bridgeman Images 13.17 Art Institute of Chicago, Illinois, Clarence Buckingham Collection (1925.2285) 13.18 Metropolitan Museum of Art, New York, Harris Brisbane Dick Fund, 1946 (JP3024) 13.19 Peter Bull 13.20 Metropolitan Museum of Art, New York, The Howard Mansfield Collection, Purchase, Rogers Fund, 1936 (JP2650) 13.21 Metropolitan Museum of Art, New York, The Howard Mansfield Collection, Purchase, Rogers Fund, 1936 (JP2569) 13.22 Metropolitan Museum of Art, New York, Rogers Fund, 1919 (JP1184).

SC10.1 Jae C. Hong/AP/Shutterstock **SC10.2** imageBROKER/Alamy Stock **SC10.3** National Museum of China, Beijing/Photo James Tourtellotte.

14.0 © Wichites/dreamstime.com **14.1** © Jakarta Textile Museum **14.2** Photo Mandiri, after Bennett, 2005. Image courtesy James Bennett **14.3** Yale University Art Gallery, New Haven, Connecticut, The Dr. Walter Angst and Sir Henry Angest Collection (2018.130.1.4) **14.4** Ashit Desai/Moment/Getty Images **14.5** National Museum of Bangkok **14.6** Metropolitan Museum of Art, New York, Gift of Loretta Hines Howard, 1964 (61.164.243a, b) **14.7** Robert Harding/Alamy Stock **14.8** Simon Balson/Alamy Stock **14.9** Museum Istana, Jakarta, Indonesia **14.10** Rijksmuseum, Amsterdam, Gift of J. H. Marmelstein, 2005 (RP-F-2001-17-56) **14.11** Steve Allen/Getty Images **14.12** Cultural Center of the Philippines Collection, Manila. Photo Philip Escudero **14.13** Collection of NUS Museum, National University of Singapore **14.14** Collection Paul Hugentobler.

SC11.1 Wellcome Collection, London. Photo Felice Beato (569457i) **SC11.2** With permission of the Royal Ontario Museum. Photo ROM **SC11.3** Reproduced with kind permission of the Syndics of Cambridge University Library **SC11.4** Freer Gallery of Art, Smithsonian Institution, Washington, D.C., Purchase, 1966 (FSA A.13 SC-GR-249).

15.0 © Bhupen Khakhar. Photo Tate, London **15.1** Minneapolis Institute of Art, Minnesota, Gift of Elizabeth and Willard Clark/Bridgeman Images **15.2** British Library Board. All Rights Reserved/Bridgeman Images **15.3** Alkazi Collection of Photography, New Delhi (95.0056-00010) **15.4** Wellcome Collection, London (26593i) **15.5** By kind permission of Victoria Memorial Hall, Kolkata **15.6** National Gallery of Modern Art, New Delhi **15.7** © Art Institute of Chicago, Illinois, Gift of Supratik Bose/Bridgman Images **15.8** Exposure Visuals/Shutterstock **15.9** State Bank of Pakistan Museum, Karachi **15.10** Image © Tyeb Mehta Foundation. Courtesy of Peabody Essex Museum, Gift of the Chester and David Hertitz Collection, 2001 (E301099). Photo Walter Silver **15.11** IndiaPicture/Alamy Stock **15.12** MIT Libraries, Rotch Visual Collections, courtesy of Peter Serene, photographer

15.13 Peter Bull **15.14** © Bhupen Khakhar. Photo Tate, London **15.15** Private Collection. Courtesy Talwar Gallery **15.16** © Nilima Sheikh. Leicester Museum & Art Gallery, purchased from the artist, 1986 (L.F35.1990.1.0) **15.16a** © Nilima Sheikh. Leicester Museum & Art Gallery, purchased from the artist, 1986 (L.F35.1990.7.0) **15.17** Metropolitan Museum of Art, New York, Purchase Cynthia Hazen Polsky Gift, 1991 (1991.1285). Photo © 2021 Succession Raghubir Singh.

SC12.1 Philippe Michel/Dinodia **SC12.2** Efired/Shutterstock **SC12.3** Top Photo Corporation/Alamy Stock **SC12.4** Jack Malipan Travel Photography/Alamy Stock.

16.0 akg-images **16.1** Palace Museum, Beijing **16.2** Tokyo National Research Institute for Cultural Properties (TNRICP) **16.3** akg-images **16.4** Victoria and Albert Museum, London. Given by the Contemporary Art Society (CIRC.1349-1939). © Hamada Shoji, used with permission of Hamada-gama Pottery Co. Ltd. **16.5** British Library Board. All Rights Reserved/Bridgeman Images **16.6** Leeum, Samsung Museum of Art, Seoul **16.7** akg-images **16.8** Spencer Museum of Art, University of Kansas **16.9** © Shōmei Tōmatsu - INTERFACE **16.10** Osugi/Shutterstock **16.11** © Yoko Ono. Photo Minoru Hirata **16.12** © Yayoi Kusama/Victoria Miro Gallery **16.13** Collection Stedelijk Museum, Amsterdam (BA 3536(1-5)). © Nam June Paik Estate **16.14** © Lee Ufan. The National Museum of Art, Osaka. Photo Nic Tenwiggenhorn, Düsseldorf/VG Bild-Kunst, Bonn. © ADAGP, Paris and DACS, London 2022 **16.15** Courtesy of Sotheby's **16.16** Reprinted from *Mao's New World: Political Culture in the Early People's Republic*, by Chang-tai Huang. Copyright © 2001 by Cornell University, Used by permission of the publisher, Cornell University Press **16.17** Best View Stock/Getty Images **16.18** © Liu Chunhua **16.19** © Wang Keping.

17.0 © Gonkar Gyatso. Metropolitan Museum of Art, New York collection/Courtesy Pearl Lam Galleries, Hong Kong/Singapore, Peggy Scott and David Teplitzky **17.1** Museum of Fine Arts, Boston, Edward S. Morse Memorial Fund and Charles Bain Hoyt Fund/Bridgeman Images. © Yeesookyung via Locks Gallery **17.2, 17.2a** *Guernica in Sand*, 2006–present, mixed media interactive installation. Installation view: "Lee Mingwei: Impermanence,"

Chicago Cultural Center, 2007. Photo Anita Kan, courtesy of Lee Studio **17.3** Courtesy of the artist and Project 88 **17.4** Collection of the San José Museum of Art, Gift of the Lipman Family Foundation (2005.32). Image San José Museum of Art, Photography by Douglas Sandberg. Artwork © Hung Liu, courtesy Nancy Hoffman Gallery **17.5a–d** Courtesy of the artist and Pilar Corrias, London **17.6** © Gonkar Gyatso. Metropolitan Museum of Art, New York collection/Courtesy Pearl Lam Galleries, Hong Kong/Singapore, Peggy Scott and David Teplitzky. **17.7** © Wang Guangyi Studio **17.8** Takashi Murakami, *DOB in the Strange Forest* © 1999 Takashi Murakami/Kaikai Kiki Co., Ltd. All Rights Reserved **17.9** Studio Eko Nugroho **17.10** © Ai Weiwei **17.11** Courtesy of the artist and 10 Chancery Lane Gallery **17.12** © Xu Bing Studio **17.13** Courtesy of the artist and Tyler Rollins Fine Art **17.14** Photograph © Randhir Singh. Used with permission of the artist's Estate **17.15** Collection of the Metropolitan Museum, New York, photo Nobutada OMOTE | Sandwich. © Kohei Nawa **17.16** Image courtesy of Hanart TZ Gallery **17.17** Jack Sullivan/Alamy Stock **17.18** M. Borchi/DeA Picture Library/Bridgeman Images **17.19** Courtesy of the artist and Tyler Rollins Fine Art **17.20** Courtesy Edouard Malingue Gallery. Photo by Morita Kenji, courtesy of Mori Art Museum. Image © the artist.

18.0 © Anish Kapoor. All Rights Reserved, DACS/Artimage 2022. Photo Iwan Baan **18.1** Courtesy of the artist and ROH Projects **18.2, 18.2a** © Vivan Sundaram. Photo Pavan Mehta, Delhi **18.3** Courtesy Huma Mulji **18.4** © Zhang Hongtu **18.5** © Munem Wasif/Agence VU' **18.6** Kimsooja Studio. Image courtesy Alex Vervoodt Gallery. Still from 11-day performance throughout Korea, commissioned by ARKO, Korea **18.7** Do Ho Suh, *Bridging Home*, 2010. Mixed-media outdoor installation. Commissioned by Liverpool Biennial 2010. Installation view, Liverpool Biennial, 84–86 Duke Street, 2010. Courtesy of the artist and Lehmann Maupin, New York, Hong Kong, Seoul and London. © Do Ho Suh **18.8** © Ravi Agarwal **18.9** Frederic J. Brown/AFP/Getty Images **18.10** Courtesy of Eva Corazon Abundo-Villanueva and Napoleon Abundo-Villanueva. © Roberto Villanueva **18.11** Image courtesy Banglanatak. © Swarna Chitrakar **18.12** © Anish Kapoor. All Rights Reserved, DACS/Artimage 2022. Photo Iwan Baan.

Index

Page numbers in *italic* refer to illustrations.

B